VISUAL INTELLIGENCE

VISUAL INTELLIGENCE

PERCEPTION, IMAGE, AND MANIPULATION IN VISUAL COMMUNICATION

ANN MARIE SEWARD BARRY

STATE UNIVERSITY OF NEW YORK PRESS

Cover design: Ann Marie Barry
Cover production: Christine I. Muran

Published by
State University of New York Press, Albany

For information, address State University of New York Press,
State University Plaza, Albany, NY 12246

Production by M. R. Mulholland
Marketing by Fran Keneston

Library of Congress Cataloging-in-Publication Data

Barry, Ann Marie.
 Visual intelligence : perception, image, and manipulation in
visual communication / Ann Marie Seward Barry.
 p. cm.
 Includes bibliographical references and index.
 ISBN 0-7914-3435-4 (hardcover : alk. paper). — ISBN 0-7914-3436-2
(pbk. : alk. paper)
 1. Visual perception. 2. Visual communication. 3. Image
processing. 4. Human information processing. I. Title.
 BF241.B29 1997
302.2—DC20 96-42465
 CIP

10 9 8 7 6 5 4 3

In Memory Of
Roger Manvell
Scholar, Mentor, Friend

——■■——

And With Sincere Gratitude
To My Father
And My Husband

CONTENTS

FIGURES

ACKNOWLEDGMENTS

The author gratefully acknowledges the assistance of Boston College, who supported much of the research for this work through a series of grants; Nancy D. Ryan, M.L.S.; and my research assistants at Boston College. SUNY Press and my reviewers also gave invaluable assistance. I am particularly grateful to my husband David for his constant encouragement and support.

I would also like to thank the following for permission to use previously published materials: Will Eisner, "Micro-dictionary of Gestures" in *Comics and Sequential Art* (Tamarac, FL: Poorhouse Press, 1985), 102. G. H. Fisher, "Preparation of Ambiguous Stimulus Materials," *Perception and Psychophysics* 2, no. 9 (1967): 422.

INTRODUCTION

I wish, above all to make you see.

—Josef Conrad

Webster's Dictionary defines intelligence as the ability to learn, understand, or deal with new or trying situations; the skilled use of reason; and the ability to apply knowledge to manipulate the environment or to think abstractly. Most of us recognize in this definition of intelligence a basic tool of our survival—an innate mental characteristic to be developed by education, enhanced by experience, and applied within almost every conceivable context—except the visual. Here we tend not to scrutinize but to accept, following the clichéd adage that "To See Is to Believe."

Yet clearly this is a dangerous practice, especially at a time when manipulation of the visual is the prime stock in trade of most of the American entertainment industry, and therefore one of the foundational pillars of the American culture and economy. Almost a quarter century ago, Donis A. Dondis in *A Primer in Visual Literacy* stressed that just as the introduction of print created a need for universal verbal literacy, so the invention of photography created a universal need for the development of visual literacy:

> In print, language is the primary element, while visual factors, such as the physical setting or design format and illustration, are secondary or supportive. In the modern media, just the reverse is true. The visual dominates; the verbal augments. Print is not dead yet, nor will it ever be, but nevertheless, our language-dominated culture has moved perceptibly toward the iconic. Most of what we know and learn, what we buy and believe, what we recognize and desire, is determined by the domination of the human psyche by the photograph. And it will be more so in the future.[1]

For Dondis and other professional educators and students who worked on the Boston University Television Literacy Project in 1970s,

visual literacy implied an understanding not only of the influence of the photograph, but also of television as a cultural medium, both as a means of mass communication and as a breeding ground for values, attitudes and ideas. Funded by the U.S. Department of Education, the project was designed to develop curriculum for teaching postsecondary students critical television viewing skills.[2] The work that she began not only contributed substantially to the growth of understanding of media effects, but also revealed the depth of our ignorance as a nation as well: although television influence had been a matter of serious concern to academic researchers for a least the previous decade, the critical viewing project nevertheless became the butt of public ridicule when Senator William Proxmire trivialized the research project by dubbing it "Television Watching 101" and giving Boston University's School of Public Communication his much-publicized "Golden Fleece" award. It was a tongue-in-cheek award reserved for agencies and people who had successfully "fleeced" an unwary nation out of funds that were supposed to be used in the public good. Proxmire could not intelligently see what watching television was all about.

Today the irony of this naïveté becomes clear as we realize not only that television is found in 99 percent of all American households, but that it is now also the average American's chief source of information about the world and main source of personal entertainment. Critics warn us repeatedly that we are in grave social danger when we confuse the two, while researchers continue to document how often we do just that. In the American classroom, *Channel One* is delivered to half of our nation's schools providing superficial yet entertaining MTV-like "snippets" under the guise of "news" and information. In the political arena, average voters often cannot discern the difference between paid advertising and media news coverage. As significant world events are ignored, O. J. Simpson trial gossip has dominated the airwaves, and entertainment shows like "Hard Copy" have begun to take on the look of news programming by mimicking serious news style reporting. Increasingly, we are a nation of watchers rather than discriminating readers, of instant believers rather than reflective, visually aware critics.

The extent of visual media's intrusion into our lives can be seen as well in the profusion of video games, personal computers with CD-ROM, portable TVs, increasing film attendance and, of course, those now all-too-familiar statistics that by the time a student graduates from high school, he or she has spent an average of about 13,000 hours in school, but a variously estimated 25,000 hours in front of the television set—25,000 hours designed almost entirely to sell advertising time for the 350,000 commercials included in their viewing time.

No one, in fact, understands visual language like advertising media executives and "creatives," people whose livelihoods depend for the most part on marketing strategy and visual communication expertise. Advertising agency media experts, like Betsy Frank of Saatchi & Saatchi, for example, can and do have a major impact on whether or not a show will be successful through their predictions on show ratings in making up-front media buys. Frank actually receives unsolicited scripts from producers seeking her imprimatur, even before the jockeying for prime spots on network schedules begins.[3]

Former advertising executives also have become influential in electing presidents. Ronald Reagan's reelection to the presidency, for example, was ushered in by the so-called Tuesday Team of advertising experts who were given over half the campaign budget—nearly $25 million—to create the political advertising that eventually reelected him by the greatest margin of electoral votes ever achieved by any American president.[4] Conversely, Senator Barry Goldwater's presidential defeat was at least partially attributable to President Johnson's antinuclear/anti-Goldwater "Daisy" commercial, and Ted Kennedy's presidential hopes were dashed in the aftermath of agreeing to a seemingly innocuous interview with Roger Mudd in 1979.

Visual communication dominates every area of our lives. As sleeping becomes the only activity that occupies children more than watching a video screen, we must become more sensitive to how images shape the fabric of our lives. As unhealthy and unrealistic advertising images become more and more implicated in serious social ills, such as in the psychologically based but physically manifested afflictions of anorexia and bulimia; as tobacco addiction increases among young adolescents and well over 1,000 people die each day of tobacco-related causes, we have still only just begun to recognize how patterns in mass media first legitimize and then normalize socially destructive attitudes and behavior.

As the enormous impact of images on the quality of individual lives becomes clearer, the necessity to educate people to the implications of an image-driven society becomes more critical. Of particular importance is the cancerous increase in violent crime among youth. It is sobering to learn, for example, that according to estimates by the American Psychological Association, by the time a child completes elementary school, he or she has already witnessed 8,000 murders and 100,000 acts of media violence. Although television networks have consistently maintained that no direct causal connection has been established between television viewing and behavior, there is increasing evidence of a close correlation between the violence that millions apparently perceive as entertainment and the increasing violence among youth today—so

much evidence, in fact, that the American Medical Association has cited media violence as one of the nation's leading public health issues.

Well over a decade ago, Pearl, Bouthilet, and Lazar, in a comprehensive survey of existent research on television effects noted that

> Almost all the evidence testifies to television's role as a formidable educator whose effects are both pervasive and cumulative. Television can no longer be considered a casual part of daily life, as an electronic toy. Research findings have long since destroyed the illusion that television is merely innocuous entertainment. While the learning it provides is mainly incidental rather than direct and formal, it is a significant part of the total acculturation process.[5]

Subsequent and ongoing research, especially in the areas of cultivation, social learning, priming effect, and selective use and gratification, have served not only to reinforce the conviction that television is a powerful cumulative force within the learning environment, but also to reveal that the content of what we watch, the way in which it is presented, and the way we watch it ultimately changes the way we live and think.

It now seems comical to us that the first film viewers who saw the Lumière brothers' *Train Arriving at the Station* at the turn of the century jumped out of their seats in fright and started running for the exits. But we must remember that these people were not primitives like the Hollywood-type natives fooled by film projection in an old B-grade Tarzan film. They were otherwise intelligent, perfectly capable people functioning in an industrialized society that led the world economy. What makes them different from a modern audience is that they were *visually naive* in a way in which we today are not.

The advent of film and then of television has accustomed us to the basic forms of visual language, the superficial meaning of which we have learned to read instantly—a fact on which all visual media from commercial signs and billboards to avant garde film have been quick to capitalize. But we have only just recently become aware enough and critical enough of media images to realize that the impact of carefully structured and attitudinally charged images may have unsuspected and unwanted short- and long-term effects.

Early media effects analysis, which essentially sought to isolate simple stimuli in order to understand simple, immediate, and direct responses now seems equally naive as we recognize the complexity of the process by which many different factors combine to build long-term cumulative effects. The U.S. Army study during World War II to determine the change in attitude on soldiers produced by the "Why We Fight

Series" of propaganda films, for example, initially seemed disappointing to behavioral scientists because it seemed the series itself had little direct effect in changing attitudes. Yet this disappointment now seems to have pushed research in exactly the right direction because it forced researchers to begin thinking in terms of multivariate models of influence in the formation of attitudes and behavior through media exposure.

Confucius defined knowledge as to know that we know what we know and that we do not know what we do not know. Herein lies our predicament: We still do not know that we do not know. Although just about everyone understands the outermost import of the visually based messages ubiquitous within the society, most consumers, including educators, remain unaware of exactly how and to what extent their emotions and attitudes have been influenced, even consciously manipulated, by visual language and logic, even as they remain concerned—even panicked at times—by a general correlation between media patterns and social patterns.

Béla Balázs, film theorist, director and scenarist, observed in the 1940s that the popular mentality was to a great extent the product of popular films, which are both an art form and a profit industry, and as such represented "potentially [the] greatest instrument of mass influence ever devised in the whole course of human history." He concluded of the phenomenon that "the question of educating the public to a better, more critical appreciation of . . . films is the question . . . of the mental health of . . . nations."[6]

Although television was still in its infancy when Balázs spoke of the power of film, it is clear that the underlying principle of film's ability to communicate ideas and to affect values and attitudes has grown to include all visual mass media, especially television. Today, groups as widely diverse as the National Coalition on Television Violence, U.S. Senate, and the American Medical Association have begun an all-out effort to reduce violence in media, and long-time academic researchers like George Gerbner of the University of Pennsylvania have continually warned that media images are primary factors in social cultivation—and that as such, they are in a position to threaten both individual human dignity and the social order as a whole.

Television and film are, of course, not the only visual mass media. The trend of all communication is toward the visual—from the fairly recent replacement of the cash register in fast-food chains and cafeterias with computers with icons as keys, to the proliferation of video games by individual purchase and through dedicated cable television channels, to the augmentation and eventual replacement of electronics with photonics (lightwave) and optical amplifiers. AT&T, for example, introduced

Gardner associates the visual arts with "spatial intelligence," a quality that is associated with the right hemisphere of the brain (in complementary relation to linguistic processing which, in right-handed persons, is associated with the left hemisphere) and which can be described as a kind of gift of mental imaging. Navigation for earlier peoples without navigational instruments was possible, for example, because they learned to read the position of stars, the color of the water, and various weather patterns. As their journey progressed, navigators had to envision the position of islands as they sailed, mapping their locations in a mental picture of the journey.[12]

Although what Gardner calls spatial intelligence may indeed be the seat of what we will call "visual intelligence," it may be more likely—using Gardner's schema—that visual intelligence derives from the combinant workings of several intelligences, including an eighth one that Gardner has since identified and that he describes as "patterning." Patterning, Gardner believes, is characterized by the ability to see patterns in nature (Charles Darwin, for example, would rate high in this intelligence) or in human constructions such as computer software.[13] What Gardner describes as "patterning intelligence" is, in fact, very close to what early perceptual psychologists explored at the turn of the century and came to describe as the inner dynamics of gestalt formation.

It is also an attribute of what contemporary perceptual psychologist Richard Gregory has described as the "inner logic" of perception in visual problem-solving. Our ability to see patterns in things, that is, to pull together parts into a meaningful whole, Gregory believes, is the key to perception and to abstract thinking—both of which represent the complex feat of deriving meaning out of essentially separate and disparate elements. The formation of unified images of the way things work, which characterizes abstract thinking, is essentially the same way perception works; abstract reasoning reflects a holistic logic that has its foundation in the evolution of perception and reaches out into new creative realms. More than a singular attribute, visual intelligence is a way of looking at the world, a critical visual awareness that can be developed and exercised in order to think more creatively and to better comprehend the pattern of forces that govern our existence.

The primary thesis of this book is that visual intelligence reflects a quality of creative problem-solving that originates in perceptual process and is characteristic of abstract thinking; that this pattern of thought has its own holistic logic; that this logic can be brought to bear creatively and analytically to solve various kinds of problems; and that this logic operates on every level of awareness from subliminal perceptual process to holistic creative thinking, which allows us to consciously combine differ-

Series" of propaganda films, for example, initially seemed disappointing to behavioral scientists because it seemed the series itself had little direct effect in changing attitudes. Yet this disappointment now seems to have pushed research in exactly the right direction because it forced researchers to begin thinking in terms of multivariate models of influence in the formation of attitudes and behavior through media exposure.

Confucius defined knowledge as to know that we know what we know and that we do not know what we do not know. Herein lies our predicament: We still do not know that we do not know. Although just about everyone understands the outermost import of the visually based messages ubiquitous within the society, most consumers, including educators, remain unaware of exactly how and to what extent their emotions and attitudes have been influenced, even consciously manipulated, by visual language and logic, even as they remain concerned—even panicked at times—by a general correlation between media patterns and social patterns.

Béla Balázs, film theorist, director and scenarist, observed in the 1940s that the popular mentality was to a great extent the product of popular films, which are both an art form and a profit industry, and as such represented "potentially [the] greatest instrument of mass influence ever devised in the whole course of human history." He concluded of the phenomenon that "the question of educating the public to a better, more critical appreciation of . . . films is the question . . . of the mental health of . . . nations."[6]

Although television was still in its infancy when Balázs spoke of the power of film, it is clear that the underlying principle of film's ability to communicate ideas and to affect values and attitudes has grown to include all visual mass media, especially television. Today, groups as widely diverse as the National Coalition on Television Violence, U.S. Senate, and the American Medical Association have begun an all-out effort to reduce violence in media, and long-time academic researchers like George Gerbner of the University of Pennsylvania have continually warned that media images are primary factors in social cultivation—and that as such, they are in a position to threaten both individual human dignity and the social order as a whole.

Television and film are, of course, not the only visual mass media. The trend of all communication is toward the visual—from the fairly recent replacement of the cash register in fast-food chains and cafeterias with computers with icons as keys, to the proliferation of video games by individual purchase and through dedicated cable television channels, to the augmentation and eventual replacement of electronics with photonics (lightwave) and optical amplifiers. AT&T, for example, introduced

the first practical color video phone in 1992, and Technology Futures predicts that by the year 2010 over 50 million households in the United States could have two-way video communications.[7] By then, virtual reality will be a commonplace experience in all areas of education and entertainment, and information terminals will combine voice data with images on a single line.

As we become more and more dependent on the visual for sending and receiving information, we will inevitably become more adept at quickly reading the affective and cognitive aspects of the messages. Speed in reading, however, isn't the same thing as having understanding and control—that is "knowing" and applying knowledge. Even now as photography and film are over a century old and "virtual reality" is a widespread commercial reality, most of us still only vaguely sense how visual communication functions. Rarely if ever do we pause to ask how the effects of visual messages are created, or appreciate how our perceptual logic can increase our aesthetic appreciation of our natural environment, mediated messages and works of art.

"Visual literacy," Braden and Hortin have suggested, "is the ability to understand and to use images, including the ability to think, learn, and express oneself in terms of images."[8] This implies two basic skills: awareness of the logic, emotion and attitudes suggested in visual messages; and the ability to produce meaningful images for communication with others. *Visual intelligence, however, may be described as a quality of mind developed to the point of critical perceptual awareness in visual communication. It implies not only the skilled use of visual reasoning to read and to communicate, but also a holistic integration of skilled verbal and visual reasoning, from an understanding of how the elements that compose meaning in images can be manipulated to distort reality, to the utilization of the visual in abstract thought.*

Today, so ubiquitous is the impact of the visual on our lives, so dire are the consequences of actually believing what we see, that even visual "literacy"—with its sense of simply understanding what we see and being able to converse in a similar language—is not enough.

What is needed is a "visual intelligence"—quite literally an ability to effectively cope with such phenomena as digitized images which mimic photographic realism, to recognize political attitudes embedded within and between images, and to appreciate the implications of such radical developments as the simulated environments of Virtual Reality. Visual intelligence suggests not only the skilled use of reason to understand the visual logic employed in the manipulation of images, such as in slick political campaigning, but also the application of this understanding in order to better our social, economic, and political environ-

ment—whether in terms of media regulation or the use of particular colors to soothe the suffering of mental illness or to increase shopping appetites. Ultimately, and perhaps most importantly, visual intelligence suggests the ability to think in different, more abstract, and more perceptually oriented ways as our linear logic fails us in the presence of overpoweringly beautiful, violent, or political images.

Such visual intelligence implies an integrated perceptual awareness of mediated visual messages—one which permeates all of our thinking—and a mental alertness to the role of media within the whole spectrum of experience. That the visual mode of communication now dominates verbal communication within the American culture cannot be doubted, and it is past time to realize that traditional methods of analysis must be expanded to include perceptual principles and visual mosaic logic as well. Over thirty years ago, Marshall McLuhan pointed out television's demand for total experiential "involvement in all-inclusive *nowness*"[9] and predicted that long-term perspective, integrated logic and critical thinking would be replaced by immersion in the moment and the desire for in-depth experience. Today many social critics believe that this deep and troubling transformation of traditional values is well underway, and it is clear that the related need to become visually intelligent has now become acute.

In 1983, Howard Gardner, a psychologist at Harvard University, initiated a new way of thinking about intelligence and began an educational revolution when he published *Frames of Mind*, in which he identified not a single quality of intelligence but seven different types of intelligence that are relatively autonomous and vary in individuals. Those that he identified are musical intelligence, bodily kinesthetic intelligence, logical-mathematical intelligence, linguistic intelligence, spatial intelligence, interpersonal intelligence, and intrapersonal intelligence. Beginning with the problems that humans solve and working backward to the intelligences that must be responsible for those solutions, Gardner determined that each individual has multiple faculties that are to a significant degree independent of each other, and that are manifested as a collection of aptitudes in which the total is greater than the sum of the parts.

"Intelligences always work in concert," he states, "and any sophisticated adult role will involve a melding of several of them."[10] Individuals who are not particularly gifted in any single intelligence may combine various skills, but others who are particularly gifted in isolated areas may emerge as a Yehudi Menuhin, who requested a violin for his third birthday and became an international performer by the time he was ten years old, or as a Babe Ruth, who recognized before any formal training that he was meant to pitch.[11]

Gardner associates the visual arts with "spatial intelligence," a quality that is associated with the right hemisphere of the brain (in complementary relation to linguistic processing which, in right-handed persons, is associated with the left hemisphere) and which can be described as a kind of gift of mental imaging. Navigation for earlier peoples without navigational instruments was possible, for example, because they learned to read the position of stars, the color of the water, and various weather patterns. As their journey progressed, navigators had to envision the position of islands as they sailed, mapping their locations in a mental picture of the journey.[12]

Although what Gardner calls spatial intelligence may indeed be the seat of what we will call "visual intelligence," it may be more likely—using Gardner's schema—that visual intelligence derives from the combinant workings of several intelligences, including an eighth one that Gardner has since identified and that he describes as "patterning." Patterning, Gardner believes, is characterized by the ability to see patterns in nature (Charles Darwin, for example, would rate high in this intelligence) or in human constructions such as computer software.[13] What Gardner describes as "patterning intelligence" is, in fact, very close to what early perceptual psychologists explored at the turn of the century and came to describe as the inner dynamics of gestalt formation.

It is also an attribute of what contemporary perceptual psychologist Richard Gregory has described as the "inner logic" of perception in visual problem-solving. Our ability to see patterns in things, that is, to pull together parts into a meaningful whole, Gregory believes, is the key to perception and to abstract thinking—both of which represent the complex feat of deriving meaning out of essentially separate and disparate elements. The formation of unified images of the way things work, which characterizes abstract thinking, is essentially the same way perception works; abstract reasoning reflects a holistic logic that has its foundation in the evolution of perception and reaches out into new creative realms. More than a singular attribute, visual intelligence is a way of looking at the world, a critical visual awareness that can be developed and exercised in order to think more creatively and to better comprehend the pattern of forces that govern our existence.

The primary thesis of this book is that visual intelligence reflects a quality of creative problem-solving that originates in perceptual process and is characteristic of abstract thinking; that this pattern of thought has its own holistic logic; that this logic can be brought to bear creatively and analytically to solve various kinds of problems; and that this logic operates on every level of awareness from subliminal perceptual process to holistic creative thinking, which allows us to consciously combine differ-

ent elements in new and surprising ways. Much to our practical and aesthetic delight as human beings, visual intelligence enriches our lives by allowing us to expand our understanding through analogies based on experience. But because received images impact us on a level below our conscious awareness, we must also exercise our critical function to detect how we can be moved—that is, driven to thought or action through our emotions–through a deliberate manipulation of images for commercial, social, or political purposes.

Although the term *visual intelligence* as it is used here should not be read as specifically related to Gardner's classification—it can just as easily be seen as a significant dimension of the quality of general intelligence, or *g* as it is often designated—several of Gardner's observations are directly on point for our discussion: that intelligence has a "natural trajectory" that begins with *"raw patterning ability"*; that at each stage of its development, "intelligence is encountered through a *symbol system*"; that this symbol system can be mapped and mastered; and above all, that without a conscious effort to develop awareness, we will fail at tasks that require this intelligence.

As neurological researcher Margaret Livingstone has observed, "Until recently, only a few aspects of perceptual psychology and aesthetics could be correlated with what was known about how the brain processes information. Now that situation is changing and vision research is at an exciting time in its history."[14] Today communication, art, perceptual psychology, and neurobiology are exchanging insights in a cross-disciplinary dialogue that is revolutionizing our understanding of how we see, what we see, and how we interact within a visually dominated social environment.

At the same time the Boston University group was studying the complexity of television influence, searching for viewing and learning patterns within a kaleidoscope of apparently unrelated programs, for example, a number of mathematicians, physicists, biologists, and chemists working first in isolation and then in tentative groups were also seeking connections between different, complex, and apparently irregular dynamical systems. The result was a whole range of research in nonlinear dynamics emerging from under the umbrella of "Chaos theory": from fractals to fluid dynamics, to the application of "fuzzy" logic in "smart" washing machines and self-focusing and stabilizing camcorders. Above all, the shift in focus yielded revolutionary new insight into nonlinear problem solving.

The world of "hard" science, like the social sciences, was moving inexorably away from linear thinking and toward dynamical systems, yet the initial result was more like a Tower of Babel than a working

dialogue among disciplines. Today this has changed, and the various disciplines are moving in new macroscopic as well as traditional microscopic directions, reaching out to one another, adopting one another's terms, and seeking a common language through which to express universal laws of pattern formation within dynamical systems.

This book attempts just such an interdisciplinary conversation. It views perception, the mind, and media as nonlinear, dynamical systems. It seeks to review some of the most basic elements of visual images that determine what we see and how we see it, to expose some of the patterns of visual understanding which underlie rapidly changing media technology, and to examine their implications and their relation to enduring perceptual principles. In this attempt, it draws from a perceptual paradigm, and cuts across disciplines to utilize a wide body of media effects theory and research as well as aesthetic theory within the fine arts, literature, television, and film. Rather than attempt a comprehensive theory of visual communication as such, it seeks to give the reader an introduction to the basic perceptual principles that underlie the broad spectrum of manifestations of visual power and logic. It is hoped that this in turn will promote a greater insight into the perceptual connections among all areas of life experience.

Above all, however, it approaches visual intelligence as a basic tool of cultural survival. It seeks to build on basic understandings and "visual common sense" by guiding readers through the process and principles of perception to an understanding of the elements of visual communication and the structure and implicit logic of images alone and in succession.

It is written in three parts, ranging from some of the highly theoretical and technical aspects of perception to the everyday social consequences of living in a world permeated by visual influence. Always, the emphasis is on finding hidden overall shapes within the fluctuating dynamics of complexity itself.

Part I explores the process of perception, emotional learning, and the nature and power of images as they reflect spiritual yearnings and political and social uses. Part II explores elements of visual experience as a mapping system that can be thought of as a kind of language, focusing first on how still images are structured and achieve their emotional effects, and then on how images in succession work to develop attitudes and ideas. Video and film are given special attention in relation to how visual meaning is affected by the medium through which it is perceived, and to how visual messages can be and are manipulated rhetorically by various interest groups. This section also includes a "Close-Up" analysis with each chapter, scrutinizing from a multidisciplinary perspective the specific use of images within particular contexts, such as print media,

television and politics, and film, military and social structures. Part III discusses visual images in the context of contemporary social issues in advertising, politics, and media violence. The intent of this last section is to unite theory and practice within particular points of view, utilizing perceptual dynamics to reveal the shapes of social problems.

Because an intelligent approach to images necessarily implies inter-disciplinary concerns, examples and discussion are drawn from a wide variety of sources, held together by the workings of perceptual process as the foundation of intelligence and of creative thought across disciplines. Any time such an interdisciplinary approach is attempted, however, it naturally is heir to a number of problems, including the barriers posed by specialized vocabularies and the seemingly mutually exclusive para-digms of separate disciplines. For this reason, no one today can hope to achieve the kind of grasp of the whole that seemed so possible in the Renaissance, if only because knowledge has increased exponentially in each field since the fourteenth century. Yet this very increase in the depth of knowledge has created an even greater need than ever before for a breadth of view that finds universal shapes and common threads among disciplines that can allow for some cross-pollination of perspective and interdisciplinary conversation, however tentative.

The concept of the Image provides just such a perspective as it runs across all fields of knowledge, informing each with different implications in visual intelligence. The following work explores universal patterns by leaping and lingering in crucial areas of visual concern, in much the same way we perceptually scan images in saccadic movements before we comprehend the whole. I write knowing that a fully nuanced discus-sion of implications and applications is impossible within the confined space of a single work, but also with the confidence that the truly knowl-edgeable will fill in the shapes of ideas suggested here with their own expertise, and with the profound conviction of the need of every field to be informed by visual intelligence and to find in the visual a common ground for communication.

The "Butterfly Effect" discovered by Edward Lorenz in weather patterns, which suggested that "the flap of a butterfly's wings in Brazil" could indeed "set off a tornado in Texas," may very well extend into media effects, allowing a strange attractor such as thematic violence to set off the kind of apparently unpredictable and cataclysmic behavior associated with apparently inexplicable violent crimes. Ultimately it is the purpose of this book to suggest the broad shape of the elements of visual language, of the issues that arise from the way in which images impact viewers, and of the power of the visual image to both reveal and to reshape the world.

I

Perceiving Images

1

PERCEPTION AND VISUAL "COMMON SENSE"

The map is not the territory.

—Alfred Korzybski

Our eyes are truly wondrous windows on the world. The last of our senses to evolve and the most sophisticated, they are our main source of information about the world, sending more data more quickly to the nervous system than any other sense.

Yet what our eyes register is not a picture of reality as it is. Rather our brains combine information from our eyes with data from our other senses, synthesize it, and draw on our past experience to give us a workable image of our world. This image orients us, allows us to comprehend our situation, and helps us to recognize significant factors within it. To clarify how we see, perceptual psychologist J. J. Gibson has made a distinction between the image that appears on the retina, which he called the "visual field," and the mental creation that composes our "visual world." The visual field is created by light falling on our eyes; the visual world, however, interprets these patterns of light as reality. The visual world, then, is an interpretation of reality but not reality itself. It is an image created in the brain, formed by an integration of immediate multisensory information, prior experience, and cultural learning. In short, it is a mental map, but it is not the territory.

This is why although Alfred Korzybski's first principle of general semantics—"the map is not the territory"—may seem at first to state the obvious (who would confuse a road map for the real landscape?), the statement implies much more. It suggests a separation between perception and reality that is fundamental—it is, in fact, a gulf that is never closed. What we refer to as "reality" is really a maplike mental image, the end product of a process that begins with light refraction in the environment and ends in the intricate and complex dynamics of the mind.

What we perceive, then, is no more "real" than a painting of a still life is edible: perception always intercedes between reality and ourselves. The surrealist painter Rene Magritte continually commented on this gap in such paintings as "The Key of Dreams," where word captions seem to contradict the meaning of the images above them: the head of a horse is captioned "the door," a clock "the wind," a pitcher "the bird," a valise, "the valise." Because we see things consistently, we have also come to believe that we see truly. Ultimately, however, we see more what we expect to see than what really "is."

Even when we watch television, we misunderstand approximately 30 percent of what is shown to us. Our emotional state, our mindset at the time, and our prior experience all seem to conspire against our seeing things as they really are.[1] We go about our lives, however, mostly assuming that what we see is what really "is," as if there were no intermediary process—in other words, as if the map were indeed the territory.

On the other hand, much of this assumption is for the most part justified and continually reinforced through experience: when we see a chair in front of us and then sit in it, we know our senses weren't fooling us. Because our evolutionary survival as a species has depended on our ability to recognize and derive meaning from our surroundings, the very fact that we are here tells us that the mechanism of perception is working. If our perceptual maps didn't work, we wouldn't survive to pass along the genes that preprogram the process.

But the trust we have in our senses and our own sense of objectivity is rarely if ever completely justified. Not only are we biologically tuned to overestimate certain aspects of perception, such as height compared to width, but we are also rarely even conscious of the variety of factors impinging on our perspective, especially those derived from subconscious and even primitive forces or from the vagaries of personal experience. Our image of the world is governed by evolutionary principles; it is to a great extent shared by others with the same cultural background; yet it is also uniquely nuanced in each individual.

Evolution, Emotion, and Subliminal Perception

Etched into our perceptual system is the whole evolutionary process of humankind. The reptilian brain, geared for land survival, still operates within us, regulating basic bodily functions below the level of our awareness, and responding to survival threats by preparing the body for fight or flight. The brain's amygdala, the seat of our emotions, dates back to the reptilian era and still plays a primary and dominant role in all our perception. It is the seat of our ability to accurately read

facial expressions, for example, as well as to key into the spirit of conversation or to sense the subtle social cues that signal appropriate behavior. It is this "tuned in" quality of emotional synchrony that is most often found lacking in autistics.[2]

The mammalian brain, which evolved from the reptilian brain about the time of the Ice Age, developed a cortex, which is generally thought of as the seat of our intelligence. Biologically limited in size by the birth canal, the cortex nevertheless expanded as humans continued to evolve until it was forced into folds in order to fit within the skull. Less than a quarter inch thick, the cortex filters the outer world and makes sense of it. In today's human cortex, 100 billion neurons chatter with each other over more than fifty thousand connections; trillions of neural networks allow different areas of the brain to communicate with each other through electrical and chemical signals. Only a small part of this conversation becomes manifest as conscious thought.

Until the mid 1980s, it was generally hypothesized that data from the senses was sent to the sensory neocortex, then to the cortical association areas, then to the subcortical forebrain, then to the musculoskeletal system, the autonomic nervous system, and the endocrine system. Emotion, it was believed, came *after* conscious and unconscious thought processing and was added through the hippocampus. One outspoken proponent of this theory, Richard Lazarus, argued that emotional reaction required cognitive appraisal as a precondition.[3] Research was inconsistent, however, suggesting that the emotional response to stimuli was more complex; and other researchers such R. B. Zajonc acted as gadflies, insisting that researchers like Lazarus were wrong, that "cognition and affect are separable, parallel, and partially independent systems."[4]

The argument remained open until neurobiologist Joseph LeDoux and others, in experiments dating from about the mid-1980s, mapped the work of the loosely defined "limbic system" more precisely.[5] They came to believe that although emotional functions may be mediated by other brain regions, the amygdala—a subcortical region buried deep within the temporal lobe—plays a crucial role in our emotional response to messages from the external world. Acting as a sentry to ready the body in response to danger, the amygdala attaches emotional significance to incoming data and readies the body to act in intense situations by signaling the hypothalamus to secrete hormones, initiating a fight-or-flight response. It alerts the autonomic nervous system and prepares the muscles for movement; and it warns the brain stem to secrete chemicals that heighten alertness and reactivity in key areas of the brain. All of this can occur independently of a conscious decision to act.

The amygdala gets direct input from all the sensory areas and serves as an intermediary between the sensory environment and internal motor response systems. Experiments show that the lateral nucleus of the amygdala (LNA) responds to both conscious and nonconscious input, leading to the conclusion that it may be the critical site for sensory-sensory integration in emotional learning.[6]

This newer research contradicts earlier thought and reveals how sensory signals from the eye travel first to the thalamus and then, in a kind of short circuit, to the amygdala *before* a second signal is sent to the neocortex.[7] The implication of this is that we begin to respond emotionally to situations *before* we can think them through. The ramifications of this fact are significant, suggesting that we are not the fully rational beings we might like to think we are. What this second emotional route signals, in fact, is the likelihood that much of cognition (what Zajonc defined as "those internal processes involved in the acquisition, transformation, and storage of information,"[8]) is merely rationalization to make unconscious emotional response acceptable to the conscious mind.

LeDoux's neurological research confirms what some perceptual psychologists had long suspected: that there are two routes of sensory perceptual processing. The first, an immediate and crude one, runs through the amygdala and readies the body to act before it can cognitively even recognize the need to act. The second, through the neocortex where the signal can be analyzed and then sent to the amygdala, adds emotional response after cognition. Moreover, the process of attaching significance to what we see in either route occurs independently of our conscious awareness. This, according to LeDoux, may explain why we are so inept at understanding where our emotions come from and how they work: "The cortical systems that try to do the understanding are only involved in the emotional process after the fact."[9]

Psychologist and *New York Times* writer Daniel Goleman has used LeDoux's research specifically to formulate a cogent theory on "emotional hijacking" by which he means that the emotions can become so highly activated that we can be taken hostage by them. This, he says, is the result of the "triggering of the amygdala and a failure to activate the neocortical processes that usually keep emotional response in balance."[10] The prefrontal lobe, which keeps emotional balance by "dampening the signals for activation sent out by the amygdala and other limbic centers" acts as a kind of "off switch" to emotions set off by the amygdala. When we are overcome by a rush of emotion, Goleman explains, we have essentially been "hijacked" by a neural response to which no "off switch" has been sufficiently applied. When we are so upset that we

can't think straight, it is because the prefrontal cortex, which is responsible for working memory, has been sabotaged by a kind of "neural static."[11]

When everything functions appropriately, however, precognitive feelings point us in the right direction by tapping the emotional learning of past experience and assisting the neocortex in its ability to make rational decisions. Although we may prefer to believe that we are basically rational beings, it is more accurate to say that reason and emotion play crucial and inseparable roles in our lives, and that at various times, one functions perceptually at the expense of the other.

LeDoux's findings that there are two ways of responding to visual stimuli in the environment—one, through an unconscious nonspecific, emotionally laden reaction (along a thalamo-amygdala pathway), and another, in a detailed perceptual analysis (through a cortical pathway)—also support earlier subliminal research on how we can receive and emotionally respond to messages below the threshold of conscious awareness. Without our realizing it, emotional response can then influence attitudes, thinking, and behavior, allowing us to cognitively congratulate ourselves on our perceptive thinking, while all the while we are in fact being guided by emotionally laden perceptual judgments beneath the level of our awareness.

This emotional response is vital to our well-being, however. Researchers have found, for example, that when damage is caused to the amygdala, although people may not lose the ability to recognize personal identity from faces, they may lose their ability to recognize fear in facial expressions and multiple emotions in a single facial expression.[12] Because personal, social, and economic decisions often rely on such cues, both emotional and cognitive functioning are vital in making effective judgments. Neurologist Oliver Sacks tells the story of a judge who after receiving frontal lobe damage found himself without emotion. To the rationalist, this might seem ideal, but the judge himself realized that without the ability to enter sympathetically into the motives and circumstances of the people who appeared before him, he could not render a just verdict, and he subsequently resigned from the bench.[13] The "Star Trek" characters of Mr. Spock and Data speak directly to just this issue.

Although the traditional assumption had generally been that awareness must mediate between stimulus and response, and therefore that emotion was a postcognitive phenomenon, these newer research findings have shown clearly that emotional response can and does bypass cognitive processing, conscious or unconscious, and that both rational and emotional processing are essential for our perceptual health. In turn, this realization has caused a renewed interest in subliminal

research, which is primarily concerned with how we register messages from the environment before, or without, becoming consciously aware of it.

Subliminal researchers have found it perennially difficult to gain credibility for their findings, primarily because they have been unable to replicate certain studies or convince skeptics that test subjects could not be briefly aware of the stimulus when presented, although they might not later recall being aware. It has also been difficult to define exactly what separates *subliminal* perception (or *unconscious, nonconscious, implicit* perception, or *subception* as it has been variously defined) from consciousness and to qualitatively measure the differences between them.

Further problems with subliminal communication derive from apparently divergent results between studies which have utilized pictures (which are holistically processed in the right brain), and those using words (which are analytically processed in the left brain). As Erdelyi has stated, "different kinds of materials (such as images opposed to words) obey different psychological laws, irrespective of their relationship to consciousness."[14] Even though structure is perceived before meaning, and it is probably easier to derive partial meaning from pictures than from words, most of the research done in subliminal perception per se has been with verbal stimuli—primarily because it had been assumed that cognition always preceded affect. Exceptions to this include studies by Erdelyi and other earlier researchers that showed positive results using visual stimuli alone.[15] When subjects are not required to perform the additional task of converting images into words, research results become more pronounced.

LeDoux's neurological research also supports these findings. Because the pathway between the thalamus and the amygdala is designed to initiate a quick defense response, it is not geared for refined analysis. This means that a signal may be sufficient to cause an emotional response, but still not strong enough to reach conscious thought processes. Crude, rapid, and weak, the signal mobilizes defenses independently of the analytical cortex. This neural "shortcut" may be at least part of what makes the emotional response to subliminal stimuli possible.[16]

As early as 1971, and later in 1984, British researcher in preconscious process Norman Dixon argued for the presence of a dual system—one that was associated with involuntary primary process and emotional thinking, and an evolutionary later one that involved logical, rational, and verbal cognitive operations. Although he speculated that it would be surprising to find two discriminators at work in the nervous system, "one selecting information for the autonomic system, and the

other for conscious and verbal report,"[17] Dixon nevertheless anticipated that "the brain's capacity to register, process, and transmit information is by no means synonymous with that for providing conscious perceptual experience [and that] manifestations of either capacity may occur without the other, and each may be independent of the other."[18] R. B. Zajonc also argued that "affect and cognition are separate and partially independent systems and . . . although they ordinarily function conjointly, affect could be generated without a prior cognitive process."[19] Zajonc also implicated the amygdala as the possible site for the emotional processing of sensory information.[20]

This neural independence also explains the internal emotional response that is derived from such simple stimuli as color alone, and how the emotional "coloring" of a situation—as in light and shadow in photographs, for example—can create emotional bias before conscious judgment is formed. Perceptual processing of color and movement appear to be neurologically preprogrammed and therefore particularly susceptible to subliminal affect. For millions of people raised on the black-and-white Cold War photos of the Soviet Union in *Life* magazine in the late 1940s and 1950s, for example, the image of the Soviet Union as a drab and colorless place very likely influenced the way they envisioned the people and the politics of that country.

The autonomy of primal emotions may also account for the fact that when internal needs remain unsatisfied, they continue to assert themselves, finding a way into consciousness despite our subconscious or conscious refusal to deal with them. At moments of low resistance, they invade our conscious reveries and dreams in the form of related or symbolic images.[21] We may thus already be emotionally "primed" toward accepting or rejecting certain ideas or people through influences of which we never become aware.

This, according to John Bargh, is where the greatest significance of subliminal effects lies—in our lack of critical awareness of the ways in which we may be affected unconsciously by biases, whether subliminally induced or not. When people are aware of a possible bias, his research shows, they can rationally counteract it, but they still may be unable to stop their biases from being activated when their conscious control lets down its guard. Thus people who are aware of the possibility of sex-stereotyping may give "politically correct" adjusted responses when their attitudes are directed to the "average person," but they may nevertheless project unconscious stereotypes when making behavioral judgments about individuals within other less direct circumstances.[22] Worse, when we make such unfounded judgments, we then rationalize and misattribute the source of our attitudes to the person or thing itself

rather than to our own feelings. In the process we further justify our subconscious prejudices as if they were trustworthy judgments, and these judgments in turn affect subsequent perceptual processing.[23]

Research by Krosnik and others has also shown that paired associations can condition long-term attitudes that in turn influence beliefs. They suggest, for example, that an entire childhood spent hearing certain groups of people referred to negatively or seeing them continually associated with negative situations may not only generate a negative attitude but also render that attitude unresponsive to logical argument or to contradictory factual information.[24] The complementary "halo effect," in which the presence of a single positive quality seems to suggest more positive qualities is another such example of a single trait which, when activated, seems to suggest a whole image.[25] A rich tradition of social psychological research also confirms the power of priming effects, our lack of introspective access to behavioral and attitude motivation, and the ability of associative logic to prejudice perceptions.

Thus, although subliminal research has been met with some resistance from the general scientific community, what is uncontested about subliminal processing is that a great deal of perception can and does take place outside of conscious awareness, even though subjects themselves may be unaware of the exact source of thoughts or feelings stemming from unconscious stimuli. There is evidence, for example, for the existence of a perceptual defense—of what Freud called the "censor" and Bruner has called the "Judas eye" (a peephole in speakeasies used for quick identification before allowing someone in).[26] As early as 1949, for example, subliminal exposure to taboo words was shown to have caused elevated galvanic skin response (GSR) in subjects even though the subjects report not seeing the words.[27] Before defensiveness can be exhibited, of course, some mechanism in the subject must appraise the situation for its emotional connotation in order to determine whether to suppress it or not.

In 1917, Poetzl, a Viennese neuropsychologist for whom the "Poetzl procedure" is named, devised a subliminal procedure involving flashing a picture at about 1/100 of a second. Afterward he asked subjects to describe verbally what they had just seen, and then instructed them to dream about the picture that night. Results showed that previously unreported parts of the pictures had indeed found their way into subjects' dreams. Poetzl's studies of subliminal stimulation and repression have been replicated many times since, although the results have been methodologically challenged.[28]

A number of other studies have keyed in to the power of familiarity to raise preference, revealing that repeated exposure to an object will

result in a more positive attitude toward it, even without integrated awareness.[29] Research by Zajonc, for example, suggests that emotional preferences can be developed faster than people can consciously recognize the objects that themselves produce those preferences. After repeated subliminal exposure to certain geometrical shapes, for example, people began to prefer those shapes over others.[30] Garcia and Rusiniak used unconscious noxious stimuli to condition animals away from certain kinds of food.[31]

This particular phenomenon has major consumer attitude implications for large advertising budgets: the larger the company and budget, the more often a message can be sent. The more familiar it becomes, the more likable the product becomes. Practical recognition of this phenomena was seen in the "payola" scandals in the 1950s in which certain radio disk jockeys accepted bribes for repeatedly playing designated records, thus boosting their popularity. We didn't listen to the records because we liked them, we liked them because we listened.

Fallacies of Rationality

Descartes, who saw conscious rationality as the essence of the self, believed we first comprehend an idea and then accept or reject it, with acceptance and rejection being equal choice alternatives. Rational people, in this theory, weigh things equally and then consciously decide on truth or falsity. Spinoza, however, offered a different philosophical viewpoint more consistent with recent neurological research, particularly by neurologist Antonio Damasio. Both have concluded that Descartes erred and that reason is founded on feeling.[32] Spinoza believed that when we comprehend something, we automatically accept it as well. The only choice we have, he thought, is to reject an idea deliberately or not.[33] Rather than a two-stage process of interpreting and then accepting or rejecting an idea, he believed that acceptance was part of interpretation. If the "off switch," which signals "no" to an idea is not activated, processed information—possibly emotionally laden via the thalamo-amygdala pathway—is simply accepted as true.[34]

Communication researcher Daniel Gilbert, who also believes that Spinoza was right, points to our tendency to trust first perceptions as the ironic result of evolutionary efficiency. Because our perceptual system is geared toward gathering information that is optimal for potentially urgent action, we are innately programmed to act first, think later in times of crisis. As LeDoux explains, we are programmed to respond even to false cues because the risk is too great not to,[35] and it is these apparently instinctual responses which move rapidly through the limbic system.

Because our cognitive system developed from our perceptual system, it, too, may be similarly geared to accept first and to ask questions later. The result, Gilbert feels, is an evolutionary cognitive bias toward initially accepting what we see or hear as real.[36] He suggests, in fact, that perceptual process is so intimately linked with comprehension that "people believe the ideas they comprehend as quickly and automatically as they believe in the objects they see."[37] Only subsequently and with conscious effort do we rationally *counteract* initial acceptance of ideas. This is consistent with LeDoux's findings that our quick emotional reflex to danger occurs first, but that it then can be consciously checked by rational perceptual analysis that quickly catches up to the first crisis-oriented response.[38]

Part of the reason for this rapid acceptance response may be that the conscious mind is not the initiator of action, but is more like a separate computer program or even a network of relationships that receives subliminal data from other relatively independent processing areas of the brain and only afterward makes conscious sense of it. In the process of vision, for example, a unified image is achieved out of the work of the specialized areas in the visual cortex by linking the four parallel systems of vision at every level into a vast network. In this network, reentrant connections allow information to flow both ways in different areas to resolve conflicts between cells, the end result of which is a visual image. These visual cells, Semir Zeki speculates, resolve the problem of information processed in different places by firing in synchrony, yielding perception and comprehension simultaneously.[39]

Experiments by Benjamin Libet, a neurophysiologist at the School of Medicine at University of California in San Francisco show a time gap between action and consciousness of action, with the conscious will to act coming only *after* action is initiated, not *before*. A period of delay in the sensation of movement fools the conscious mind into believing that it has decreed the motion, but in reality, the mind only receives the news. In experiments relating conscious finger reflex to brain activity, Libet has shown that the brain begins to prepare for movement a third of a second earlier than the mind decides to act, and that the only real option the mind has is a last-minute "veto."[40] This is consistent with neurological research findings and with Gilbert's view that comprehension includes automatic acceptance. Negative critical function—such as deciding that a statement is not true, or that one's first impression is faulty or inadequate—is secondary and must be deliberately invoked.

If stress is introduced into the process, the critical "off switch" may never be used at all, and what may be seen as patently false under other circumstances may come to be believed as true. Because survival situa-

tions are processed first subliminally through the thalamo-amygdala shortcut, stress is always emotionally loaded. Successful "brainwashing" propaganda efforts in prisoners of war, for example, show how the combination of physical stress, which results in what might be called "critical analysis fatigue," and emotional impact work together to condition thought. Prisoners weakened by torture, illness, or hunger may readily accept as true what under normal circumstances they would consciously reject. When we are under stress, we do not critically assess ideas presented to us. We simply accept them "as is."

Thus, although it may seem to us that our minds are in control and making consciously judicious decisions, and we would like to think that we always judge things in a relatively unbiased fashion or that emotion is only an "additive" to rational thought, exactly the reverse may be true. Even though we can and often do correct misperceptions cognitively if we become aware of inconsistencies, we must actively *choose* to do so. Otherwise, we just cruise along perceptually without critical examination.

Some researchers suggest that even when we know *beforehand* that information is false, we may still persist in believing it.[41] Witness, for example, how often, even without malicious intent, gossip can persist even after it is proven wrong. Procter and Gamble, for example, has for years been unable to squelch rumors that first appeared in the late 1970s that there is some kind of connection between their "man in the moon" corporate logo and the practice of Satanism, even though there is no foundation in reality for the suspicion.[42]

Perceptual Illusion

Given this inherent bias toward accepting what we see as true, it is not so surprising that we should also have developed a sense of play around it: we love optical illusions in magic shows, and we delight in perceptual riddles such as those seen in Escher engravings, where a waterfall can flow uphill, a staircase may never end, or a ladder can be seen as simultaneously in front of and in back of a pillar support. In *The Gold Rush* we laugh at the sight of Chaplin's "Tramp" turned into a giant chicken in the eyes of his starving cabin mate, despite our underlying knowledge of the historical occurrences of cannibalism that it reflects.[43] At the same time, however, we take it very seriously indeed when someone deliberately manipulates our *belief* if we depend on its honesty for our physical, economic, or social welfare.

When we are told that a respected doctor has falsified medical research, no matter in how relatively ineffectual a way, the result is national moral outrage. Media news and photography are good

examples of this: when a newscaster is placed against a manufactured background, yet the story implies an on-the-scene presence, the public wonders what other information has also been manipulated. When we learn that a 1920 photograph of Lenin and Trotsky has been altered to erase the presence of Trotsky for political reasons, we begin to see just how insidious the maneuverings of Stalin were in his pursuit and retention of power. We must, we believe, be able to believe our eyes, for if we cannot, our very survival seems in jeopardy.

The truth about perceptual process, however, is that it is inherently heir to a number of distortions—like the way a straight stick seems to bend under water, or the moon seems so much larger on the horizon than it does overhead. One of the most convincing perceptual illusions we are heir to, for example, is related to the optic disk—the "blind spot" where the nerve receptors leave the retina to form the optic nerve. Because this area has no retinal receptors and therefore no way of receiving visual information, the area is "filled in" perceptually. We are never aware of its presence as a hole on our vision until we deliberately find it under specially enforced conditions, usually at an ophthamologist's office. We see in whole images only because we literally see things that are not there.

This filling-in is only one instance of what occurs generally in perception as well. The first data that the brain perceives, for example, is boundary contours. This allows us to distinguish one object from another and is key to our survival because recognition of boundaries is just what prevents us from walking into trees or over a cliff. Subsequent filling in by averaging occurs whenever other detailed information is absent. According to some vision theory, once the brain has perceived the edges, it fills in missing detail between them by averaging out sensory data, including color and brightness, and smearing the details.

This perceptual filling-in and smearing cognitively parallels how once a particular stereotype is activated, it defines both the shape of our judgment as well as the "filling-in" of missing details. Images formed consciously and unconsciously provide the perceptual borders, and as we then automatically assume the characteristics implied within the whole image, we average out the rough edges and fill in with what isn't really there. As Bargh has suggested, we must deliberately make continual rational adjustments to all of our thinking if we are to avoid the pitfalls of stereotypical, automatic thinking.

What perceptual process is mostly about, in fact, is hypothesis testing, and sometimes the hypotheses are wrong. We are, in fact, continually fooled by what we see—mostly by ourselves, as we incorporate our own cognitive distortions into our perception. Perceptual psycholo-

gist R. L. Gregory, who has conducted extensive research in the area of the "inner logic" of perception in visual problem-solving, has suggested that the way we think abstractly may be directly and developmentally related to the way we perceive.

Our ability to see patterns in things, that is, to pull together parts into a meaningful whole is, he believes, the key both to perception and to abstract thinking. As we look at things in our environment, we are actually performing the enormously complex feat of deriving meaning out of essentially separate and disparate elements. Forming unified wholes—that is, *images* of things—in perception is not dissimilar in principle from forming whole and meaningful ideas out of various impressions. Both reflect a holistic logic that has its foundation in the evolution of perception.

This perceptual ability to holistically organize is, in fact, critical to the simplest perceptions. The grouping of various shapes of leaves, for example, allows us to discern a tree as separate from a telephone pole next to it. Sometimes, however, we can be fooled, and we resolve ambiguities into patterns which are not there. Shapes of both ideas and material things in the half-light of reason often seem to be what they are not, a phenomenon exploited in such apparently disparate things as military camouflage and Hollywood horror films. Film producer and director Steven Spielberg takes full advantage of this in *Poltergeist*, where in a twilight world a gnarled tree benign in daylight can turn into child-eating monster. Sinister shapes, he has shown us, come in the form of objects and ideas.

In exploring this problematic world, Gregory has identified a variety of illusions which illustrate how easily our judgment can be tricked perceptually into forming conceptions of wholes which do not in fact exist. These include resolution of ambiguities, which can be interpreted in more than one way; paradoxes which seem to show the impossible, pitting appearance against knowledge; and distortions, which rely on perceptual biases to confuse cognitive thinking. Classic examples of these include the Necker cube, an ambiguous image which seems to reverse its orientation continually (Figure 1.1); the "Devil's tuning fork" which is possible only when observed in parts, but not as a whole (Figure 1.2); and the Müller-Lyer illusion, in which the central line with spokes directed away from it continues to look longer even though we know it isn't (Figure 1.3). As Gregory puts the case: "Given the slenderest clues to the nature of surrounding objects we identify them and act not so much according to what is directly sensed, *but to what is believed.*"[44] Because *all* stimulus is ambiguous in nature, meaning can come only from the individual through the process of perceiving it.

FIGURE 1.1

Necker Cube. Because it is ambiguous which corner is closest to the viewer, the cube figure continues to reverse itself. First the top-left square seems closest, then the bottom right.

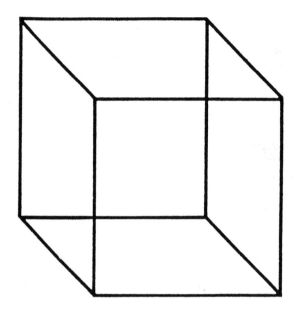

Yet only occasionally do we doubt that what we see is palpably real, even though it may be more accurate to say that we see what we believe to be there. In fact, it is only because humans as a group tend to have evolved the same kind of perceptual abilities that we can agree on any objective "reality" at all. Radical skeptics even insist that "it is not clear that you have the slightest reason to suppose that others have anything you could recognize as experience. When others see things, their visual experience may be something you could not even imagine."[45]

Remnants of Former Perceptual "Truths"

Many early theories on perception now look quaint, even comical, yet others persist into the present and continue to complicate our understanding. Aristotle, for example, championed the "emanation theory" of early Greece, which proposed that vision was the result of the viewer projecting out rays that were then sent back into the eye when they

FIGURE 1.2

Devil's Tuning Fork. An example of an "impossible" figure, the "Devil's tuning fork" seems to have three prongs but a base that can support only two. Only the parts make sense, not the figure as a whole.

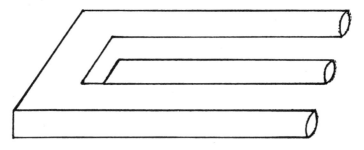

encountered objects. The glow of cat's eyes in the dark seemed to prove that the source of visual rays was from within; belief in the theory eventually gave rise to the myth of the "evil eye," which could send malignant rays outward toward a chosen victim. The emanation theory is also the basis for common expressions such as "the eye is the window of the soul" and "if looks could kill."[46] The converse of this theory, called "emission theory," postulated that objects gave off tiny luminous replicas of themselves.[47]

As proponent of emanation theory, Aristotle reasoned that we must all have a "common sense," that is, a faculty for unifying and synthesizing the data from all of the senses. He located this sense in the heart and believed its function was to give us a focused and meaningful interpretation of the outer world. Memories were formed by "phantasms," which remained after the stimuli were gone; these provided the basis of the imagination, and linked thought and perception.[48] Numerous other theories on sense perception followed, but these were essentially philosophical observations, and in the physiological studies of the seventeenth and eighteenth centuries, investigation for the most part stopped at the image on the retina.[49]

Johannes Kepler, in 1604, was the first to envision a model of the eye as a camera that accurately records what it sees, with the lens as optic and the retina as receptor. While this model seems to make sense, it nevertheless implies a one-to-one correspondence between external reality and perception that really does not exist. In 1637, however, Descartes published an experiment that seemed to "prove" Kepler's hypothesis. He scraped the sclera at the back of the excised eye of a slaughtered ox to

FIGURE 1.3

Müller-Lyer Illusion. Although both lines are of equal length, the bottom one is usually judged to be longer because of the context of the "spokes" or "wings" that lead the eye into the line or away from it.

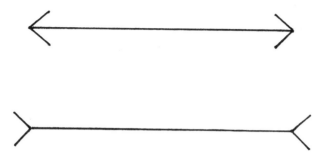

make it translucent, placed it as if it were looking out his window, and on it observed a perfect upside-down, reversed image of the scene outside his window. The eye, it seemed, really was a "camera."

Today, even though we understand that there is no one-to-one correspondence between retinal image and mental image, that it is the mind that actively creates meaning through a process that only just begins with the stimulation of the retina by light, this comparison of eye to camera persists. Popular adages as "Seeing Is Believing" and our continuing trust in eyewitness testimony are based on the assumption that the eye accurately records the scene in little images that are then filed and stored in memory. For many, in fact, the accumulation of practical observation has superseded Aristotle's idea of "common sense." Yet history and the present are filled with examples of people whose eyewitness "common sense" has led them to believe such things as the earth is flat and that pictures do not lie. Yet the eye does not record an image, nor are images stored in memory as whole entities like photographs or slides.[50]

In an elementary way, however, the analogy of eye and camera seems to make perfect sense: the pupil of the eye does correspond in some ways to the aperture in a camera; the lens in each does focus the image onto a back wall—of film in a camera and onto the retina in humans; and in both mechanisms, images are inverted and reversed. But the analogy must stop there, for in many ways, the concept is a false and thoroughly misleading one: the lens of the eye is not a passive, but a dynamic apparatus. It focuses automatically without conscious manipulation, and it achieves clarity only in the retinal fovea—the small central

area of the retina that focuses detail. Where a photograph will show with equal clarity everything at the same distance, the eye must jump in saccadic movements to focus clearly on parts of the scene and then construct the whole from the focal points that it has momentarily examined.

The eye also works in the reverse of the camera image: in a camera, the image is focused directly onto a film that contains the emulsion for capturing it; the receptors of the human retina, however, actually face backward so that it can be in contact with the pigment epithelium, which contains the chemicals necessary for the transformation of light into electrical energy.[51] Unlike a camera lens that must be deliberately selected according to a specific distance or desired effect well beyond the range of human capabilities—as in telephoto or fish-eye panoramic lenses, the eye has a flexible range, but is limited to about 140 degrees horizontally and 120 degrees vertically.

The human eye also is automatically "accommodating," where focus in a camera must be consciously and deliberately changed. Ciliary muscles at the front of the eye tighten to increase the curvature of the lens in order to focus at close range and then relax into normal position when we look away. When these ciliary muscles weaken at around age 45, accommodation ability decreases and our ability to focus on nearby objects becomes increasingly poorer. At this point reading glasses must substitute for what the ciliary muscles can no longer do.

In response to light, the rods and cones in the human retina also play different roles from the chemical emulsions used to capture images on film. Retinal cones determine visual acuity, and rods detect shape. In humans, the fovea is composed only of cones, which are geared to day vision, reaching their limited resolution in darkness within three to four minutes. The periphery, which is better at detecting movement than detail, has both rods and cones—but twenty times more rods. This gears it toward night vision; rods achieve maximum sensitivity in darkness in about twenty to thirty minutes.[52] During the day we can immediately focus on the details of our surroundings, but at night, we see only shapes and forms, and these we can see clearly only after a considerable period of adjustment. Humans have adapted to day vision, and this is why our eyes are very different from those of nocturnal animals, which often have large eyes to increase the size of the image on the retina, corneas that collect light, a retina that is dominated by rods rather than cones, and a back surface (the tapetum) that reflects light to improve night sight. Cats' eyes seem to emanate light because of the presence of a tapetum that reflects incoming light and thereby increases night visibility.

Also unlike the static camera lens, human eyes adjust automatically to light. They are also subject to a variety of problems such as astig-

matism, a visual defect of unequal curvature, usually of the cornea. This prevents light rays from focusing clearly to a single point on the retina, and therefore results in blurred vision. The glasses or contact lenses worn to correct the problem are what most resemble the camera lens: both are rigid in nature and cannot adjust to light except by darkening the whole surface.

Additionally, the image on film is recorded as a fixed one. If we move while snapping the shutter, a blurred picture will result. The image on the retina, however, is in constant motion. Our eyes move in rapid short jerks ("saccades") because to achieve clarity of detail, we must continually redirect the fovea around the scene. The image that we perceive as a result is a mental one, which results from gleaning what remains constant while our eyes are moving. Even when we visually fixate on an object, our eyes are subject to "drift" and "flicker" movements and a superimposed tremor. If the eye is temporarily fixed under experimental conditions, as the eye of the ox in Descartes' experiment, the retinal image from it fades.

Movement is thus essential to vision because our eyes function by noticing and recording change. Without it, they simply record nothing at all. If, for example, the eye is covered completely by a plastic diffusing eye-cap (like half of a Ping-Pong ball) so that it can perceive no edges, perception stops because stimulus information is absent. In homogeneous darkness, when both stimulation and stimulus information are absent, there is also no perception.[53] Despite the eye's continuous motion, however, we do not perceive in a blur because perceptual process functions by detecting what remains invariant, even as our eyes move and we shift our point of view, or both. There is no fixed retinal image as in a photograph, but only a stable mental configuration subject to a variety of influences.

The camera image recorded on film must be also chemically fixed, in order to activate its latent picture. The visual system, however, actively explores the environment, captures and organizes information, and utilizes chemical-electrical processing to form the mental image. And although the photographic image clearly exists only within the camera before processing, the perceptual image is always interpreted as a reality outside of the person rather than as an internal process.

This is because the retinal image that Descartes mistook for the completed image of vision is only the beginning of the process. Our vision is not framed, as through a window, but unbounded. We do not use a separate consciousness to watch our images on an inner screen, but rather we sense that what we see is "out there" in an environment in which we have a presence. As we move through this environment, stim-

ulation from the external world is clearly differentiated from our awareness of our bodies themselves. We use all of our senses to interpret the environment. Therefore, what ultimately sets the eye apart from a camera may be as simple as our direct awareness of the *externality* of the world.

This is why where the camera image is clearly bounded, as is the retinal image, what we perceive seems unbounded.[54] J. J. Gibson emphasizes that the analogy between the eye and a camera must be inherently false because the retinal image is merely the most elementary stage in the complex process called "seeing." The eye, Gibson states, is a biological device for sampling the information available outside in the ambient optic array. In Gibson's view, as we move our gaze or negotiate our bodies through the environment, ambient light within the "ambient optic array" is created by the diffused and multiple reflections of light from textured surfaces around us. This array surrounds us on all sides as a "reverberating flux"[55] and yields information on what Gibson called "invariants"—that is, attributes that do not change as we shift our point of view.

The optic array—on the *outside*—is the stimulus to which the chambered eye responds, and the retinal image is merely a part of the internal mechanism, not its product.[56] "From the earliest stage of evolution," Gibson states, "vision has been a process of exploration in time, not a photographic process of image registration. We have been misled about this by the analogy between eye and camera . . . a camera is not a device with which one can directly perceive the whole environment by means of sampling, whereas an eye does perceive the environment by sampling it."[57]

Our visual image is therefore a good deal different from a photograph. The eye, unlike the camera, is not a mechanism for capturing images so much as it is a complex processing unit to detect change, form, and features, and which selectively prepares data that the brain must then interpret.[58] As we survey the three-dimensional ambient optical array of the environment, properties such as contour, texture, and regularity, which are invariant under perspective transformations, allow us to discriminate objects and to see them as constant and external to ourselves.

This is why two-dimensional information such as occurs in a photograph may be impossible for a person blind from birth to even imagine,[59] and it may even be difficult for sighted people to read, because we cannot move about in it both to observe invariant shapes, textures, and patterns, and to filter out irrelevant information. We are geared for seeing a world in which we are predators, and like other

predators, our eyes, set in the front of our heads, are particularly good at judging depth and distance. Because binocular vision helps us to see in three dimensions by giving a slightly different viewpoint to each eye (separate images that are combined in the brain and interpreted as depth), we exist in a world of space and movement. Preyed-on species, however, exist in a different world. Because they must be eternally vigilant, their eyes are placed at the sides of their heads to allow for an almost total view of their surroundings. Where these nonpredatory species have limited depth vision as a result of this anatomy, we have limited peripheral vision and rely on our superior sense of depth to orient ourselves.

This may account for why people who have never seen photographs before may have to learn how to read them.[60] What makes reading traditional two-dimensional (2-D) X-rays so difficult for their readers, for example, is their lack of depth, a problem complicated by poor contrast resolution and visual "noise." Radiological training to read them effectively involves a finely tuned discrimination between the normal patterns and textures of the body and the typical patterns and textures of abnormal conditions, because the details—such as small nodules of diseases like emphysema—are easily lost and may not, or cannot, be seen. Even though digital imaging enhancement and subtraction techniques can improve detail and contrast, even though "smart machines" can read a safe Pap smear, identify a high-risk loan applicant, and interpret a handwritten zip code, it is unlikely that machine readings will ever fully supplant human diagnosis. Human vision is still the most powerful means of sifting out irrelevant information and detecting significant patterns.[61]

This human perceptual ability to recognize patterns and to select relevant data has proven, in fact, to be the most perplexing obstacle in creating Artificial Intelligence (AI), which sees the mind as a computer that processes strings of data in symbols of 0 or 1. After a series of early AI failures which did not attempt to repeat the human processing of information at all, but rather focused on achieving the same outcome, "connectionist" researchers in the 1970s turned to human models in mental processing of experience, that is, to neural net processing and to "fuzzy logic" as the key to understanding intelligence. Rather than the computer approach of storing data and searching through it all to make a match, neurocomputers work like brain networks, learning patterns by clustering data from a number of samples or examples. Researchers like Bart Kosko at the University of Southern California have developed networks that imitate the brain's ability to make connections in the performance of simple tasks.[62] Results have been successful but limited in

scope, however, imitating the brain only in a small way by creating discrete neural patterns paralleling up to only a few hundred neurons.

In other words, neurocomputers can "learn," but only to a limited degree. What the brain does that machines cannot do is to utilize billions of synapses to access the whole of memory and to instantly recognize invariance, integrate it, generalize from it, and extend itself through analogy. Although neurocomputers can perform a variety of tasks that are beyond human capability because of speed, complexity, or dangerous environment, some of the simplest patterns immediately recognizable to the eye are still elusive to machines.

There is as yet nothing that can replace perceptual process on so grand and efficient a scale. Our automatic complex image processing allows not only for the detection of invariances within the ambient optical array, but also for the recognition of gray states where identities bleed into one another, outside of linear logic. Perception corrects judgments, reduces and compresses complex information, filters out irrelevant information, alters memory, recognizes patterns, extends learning through analogy, and does it all instantaneously. As R. L. Gregory has pointed out, "It is just those aspects of control and the selection of relevant from irrelevant data which are the most difficult to mechanize— though they were the first problems to be solved by organisms."[63] Whatever success "smart machines" have had is due to their mimicry of our own neural brain networks, but as physicist Roger Penrose has noted, the "quality of understanding and feeling possessed by human beings is not something that can be simulated computationally."[64]

Neurology of Perception

R. L. Gregory has posited that vision developed only after our sense of touch, taste, and temperature. In all probability, he suggests, visual perception developed out of the sense of touch "in response to moving shadows on the surface of the skin—which would have given warning of near-by danger—to recognition patterns when eyes developed optical systems."[65]

This optical system represents an interface between the brain and the environment. Characterized by cells responsive to minutely differentiated and specialized aspects of the environment, the optical system is a symphony of millions of nerve cells firing in particular patterns, responding to each of the component parts of the final image such as direction, degree of slant, shape, and color through the activation of specialized areas within the visual cortex. No neural response ever achieves its complete meaning alone, however. Within the visual system, cells

work separately and in concert with one another to activate and to inhibit certain responses, and there is continual feedback among the parts. Perception is a dynamical system that utilizes the input from the body's sensory systems, synthesizes this with memory and understanding, and creates from both an integrated sense of self and mind.

Perceptual process begins first of all as light that bounces off objects in the environment. The process of vision (Figure 1.4) begins when the optic array is focused by the cornea and lens onto the 126 million receptors of the retina—120 million rods and 6 million cones— which line the back of the eye. As the visual system seeks and acts on information from the environment, retinal inputs lead to ocular adjustments and then to altered retinal inputs as the eyes actively engage the environment. Receptors in the retina transform and reduce information from light into electrical impulses ("transduction") that are then transmitted by neurons via the optic nerve, to the lateral geniculate nucleus (LGN) in the brain.

The LGN contains six layers of cells. Cells in the four uppermost, called the parvo-cellular layers, which branch again into two pathways,

FIGURE 1.4

The Eye. Information in light from the ambient optic array passes through the pupil, is focused by the lens onto the foveal area. It then passes along the optic nerve to the brain, first to the LGN and then to the visual cortex.

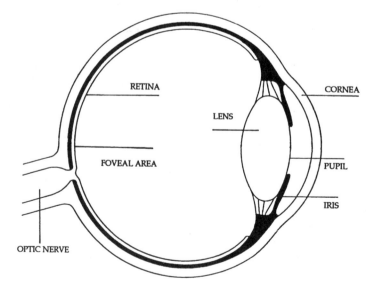

are responsible for perception of color, some contrast, and spatial resolution. The two lowest layers, called the magno-cellular layers, are responsible for perception of movement, depth, and some spatial resolution. Because the "parvo" layers most probably developed from the more primitive "magno" layers, they share some common functions despite their specialization. From the LGN, the two visual systems link to the striate or primary visual cortex, also known as area V1. V1 is separated from other specialized cortical areas by an area called V2. Together V1 and V2 act "as a kind of post office, parceling out different signals to appropriate areas."[66]

Researchers have delineated four parallel systems involved in the different attributes of vision—one for motion, one for color, and two for form.[67] Color is perceived when cells specialized to detect wavelength in "blob" regions of V1 signal two other specialized areas, V4 and the "thin stripes" of V2, which connect with V4. Form in association with color is detected by a circuit of connections between V1 "interblobs," V2 "interstripes," and V4. Perception of motion and dynamic form occur when cells in layer 4B of V1 send signals to areas V3 and V5 and through the "thick stripes" of V2.[68]

Thus, in the visual cortex, the electrical data sent from the retina is processed in thousands of specialized modules, each of which corresponds to a small area of the retina. In this process, data are reduced and compressed, so that the "image" that the cortical stimulus represents, although stimulated by the outside environment, nevertheless has no physical counterpart in external reality. What it contains, however, is a representative map of the entire visual field.

As Goldstein reminds us, "perception is based not on direct contact with the environment, but on the brain's contact with electrical signals that *represent the environment*. We can think of these electrical signals as forming a code that signals various properties of the environment to the brain."[69] In this process, vision is not a truthful recording sent in a one-way delivery of sensory data to the brain, but an active exploratory process that is cyclical and in which there is continual feedback and interaction throughout the visual system.[70] The visual system, in other words, has its own "intelligence." Because all external data is essentially chaotic and ambiguous, the eye—as an extension of the brain that interfaces directly with the environment—works to detect change and nonchange, and to create meaningful sense out of the rush of stimuli from the external world.

What we see, then, is not a direct recording of what's out there, but a mental configuration that we interpret as an image—the end result of a highly exploratory and complex information-seeking system. In the

visual system, parts interact synergistically in an instrumentalized arrangement that plays very much like a symphony, where neurons simultaneously fire in different areas to produce a stable mental image. In the production of this image, multiple structures become involved: after the visual cortex filters and codes information, it is then sent to as many as thirty-two different locations for further processing. As the brain continues to build on what it learns, these separate bits of information are broken down and efficiently stored in different places, ready to be reconstructed again. When we see, we not only utilize invariance in the ambient optical array but also call on our past experience to make it meaningful.

Perhaps nothing makes this interrelationship clearer than cases of newly sighted people, such as patients whose long-standing cataracts have been removed, who must learn how to interpret the new visual stimuli bombarding them but can draw only on experience rooted in a different sense mode, primarily of touch. As neurologist Oliver Sacks has observed, "When we open our eyes each morning, it is upon a world we have spent a lifetime *learning* to see. We are not given the world: we make our world through incessant experience, categorization, memory, reconnection."[71] Because of this, Virgil, one of Sacks's patients, blind for fifty years since early childhood, found himself more disabled after cataract surgery than before it. Because there is no automatic connection between sight and touch to translate one into a map that can be read by the other sense, Virgil's perceptual map was experientially blind. Without visual learning to establish the visual templates necessary to make visual impressions meaningful, his vision had no perceptual coherence, and everything ran together.

As a result, he lost his confidence and ease of movement, found walking "scary," and was unable to recognize objects without touching them. This extended into the abstract as well, so that to understand the orientation and layout of the house, which he could now see but not comprehend, he had to touch a model of the house. He had difficulty recognizing faces, yet could recognize letters fairly easily because he had learned the alphabet by touch in school. Space, which is an essential aspect of sight perception, was extremely confusing to him, and he could not grasp concepts of size or perspective. Because the sightless live in a linear world of sequence and time where sense impressions are built up in sequence, their perceptual maps give them no useful information in perceiving simultaneous space and depth.

Richard Gregory tells a similar story of S.B., a patient who was blinded in his youth and whose sight was restored by a corneal transplant when he was fifty-two. He, too, understood that the blur he saw

was a face only because he could recognize a voice and knew that voices come from faces. Having lived in the sequential and material world imposed by blindness, he could make no sense of a two-dimensional photograph, seeing only patches of color. Visually immature, he did not perceive the usual optical illusions which so interest Gregory, such as those associated with figure-ground reversal, ambiguous figures, apparently bending parallel lines or apparent movement. Without well-established visual experience, he could truly see only what he could first feel. As he discovered that some of the things he loved and found beautiful by touch were visually ugly, that he could not make up his deficit in visual learning, and that socially he could not fit in this new world, he became progressively more depressed and eventually died within two years of his corneal transplant.[72]

While both men had learned to become fully competent in perceiving the world through sound and touch, both their sense of wholeness and their competence were shattered in a perceptual transition they were powerless to make. Ill equipped to perceive the world visually without a developed visual cortex, they could see but not perceive in a visual mode. The difficulties experienced by both men point up both the essential perceptual wholeness sought and developed by the psyche, and the importance of the role played by visual learning and memory in visual perception.

Contemporary visual theories generally assume that the visual memory in sighted people holds a set of representative shapes that capture invariant properties of objects in their various orientations, and that it is these invariant patterns that were lacking in both men. As experience in the visual world grows, these patterns become templates that allow us to recognize basic shapes and to approximate the in-between shapes of various positions. In the process of visually recognizing something, it is fairly well agreed that the retinal image is checked against an experiential template held in long-term memory, and that the memory representation that provides the closest match is selected as the object seen.[73] Hand shadows on a wall, which can be made to imitate rabbits or any number of other characteristic animal profiles, provide simple yet clear examples of such template shapes.

Although it is tempting to assume generally that memories are true in the sense of constancy, however, like the rabbit profile cast on the wall, memory is probably never the exact same shape twice, but only a pattern which remains flexible despite fluctuations and changes over time. Gerald Edelman, for example, sees memory as something that is continually shifting and changing under the influence of new experience. He stresses an open, dynamic and reciprocal relationship between percep-

tion and experience, viewing memory not as fixed, but as ever-evolving and re-creating itself within an open system.[74]

Neuroscientist Bessell van der Kolk also postulates that cognitively processed thoughts and traumatic experiences are recorded and stored separately in different parts of the brain. When people consciously remember traumatic events, blood flow increases to the amygdala and the visual cortex may be stimulated at the same time, resulting in intense visual flashbacks. Routine thoughts, however, stimulate the Broca's area, which is involved in verbal language. Van der Kolk and others speculate that because the Broca's area is not stimulated when traumatic memories are recalled, traumatized people may have great difficulty in verbalizing what has happened to them.[75] This may indicate that when the brain represses the anxiety-provoking experience, it is stored differently from ordinary memories, and may therefore be less accessible to conscious thought and verbalization.[76]

In the process of normal perception, exactly how much preprocessing is done in the retina to match the memory-shape and how the retinal input and memory representations are transformed to bring them into correspondence for perceptual recognition is another area of speculation. Models for shape recognition vary widely and range from the whole shape to simple geometric feature detection such as vertical and horizontal lines, curves and angles; to Fourier models in which the optic array is decomposed into a trigonometric set of components sensitive to intensity, orientation, and spatial frequency; to structural descriptions in which shapes are represented symbolically.

Holistic versus Analytical Perceptual Views

Current schools of thought on perception generally fall into one of two groups. J. J. Gibson's view of perception, which has its roots in early Gestalt theory, supposes that perception is a holistic, direct interpretation of the environment, a natural mechanism for detecting ecologically significant information. The other is essentially analytical, following a computerlike model of information gathering and the build-up of meaning from pieces of separate information gleaned from scanning the environment.

From Newton up to the point of Gibson's publication of his ecological optics theory in 1960, it had been assumed that the essential stimulus properties of light lay in its content—that is, the energy manifested in wave-length and intensity—and that it was this content which resulted in vision. Gibson, however, placed the emphasis on relationship, positing that it was the *transitions* in the natural optic array, not the energy content of the light beam itself, which signal objects as "out there." It is

primarily the *differences* "between spots or patches of light, not the spots or patches themselves"[77] which we see. It is therefore *change* that signals vision and *relationship* that carries meaning.

In this view, as we move about within the ambient optic array, those aspects of the environment which remain constant suggest the forms of objects and people as well as the scale of things. The visual system actively explores and detects information directly from the environment.[78] We can tell size and distance, for example, without elaborate mathematical calculations by sweeping the environment as if it were a grid, with the size of its squares diminishing proportionately into the distance. We recognize shapes by what stays constant, and we see movement by recognizing what aspects remain true while others change. It is not surprising that the impetus for Gibson's theory of Ecological Optics began in his work during World War II with pilots, particularly with the difficulty of landing airplanes on aircraft carriers.

What the brain does, then, is to extract the invariant features of objects from the ever-changing flood of information it receives from the environment, actively constructing a working image of the world. To do this, the brain utilizes an incredibly complex organization of interrelated specialized functions which continually send electrochemical messages back and forth, and which ultimately combine to give us a unified view of the world.

One of the foremost researchers working from a computerlike model of perception, David Marr, has suggested that perception is a three-stage process built in much the same way a computer program is structured and organized: First, a "primal sketch" is formed in which intensities and major features such as the location of edges, corners, bars, and blobs of different size and orientation are discerned. Next, the more subtle characteristics of surface texture and depth are referenced to the viewer in a "2$\frac{1}{2}$-D sketch" that is viewpoint-specific. Finally, a three-dimensional mental model emerges which is centered in the object itself.[79]

Irving Biederman has focused on component recognition of three-dimensional objects through analysis of basic volumetric components termed "geons." These geons are basic configurations—like cylinders, cubes, bricks, curved macaroni, flat topped pyramids, megaphones, and so on—which act like short-cut templates for perception. We recognize these as invariants within three-dimensional shapes, so that perceptual process is speeded up. Objects composed of two or three of these basic configurations can, he believes, be differentiated easily from others by the way the various geons are put together.

Other researchers have directed their attention to texture analysis, which involves the most basic lines and directions within perception.

Anne Treisman, for example, has identified what she calls "primitives" of movement, curve, tilt, color, and line end. In a two-stage process these belong to an automatic and unconscious stage of processing which she calls the preattentive stage. In the subsequent stage of consciously focused attention they are combined to form integrated objects.[80]

Julesz has also identified line segment terminations and crossings, which he terms "textons," as part of the preattentive-level as well.[81] Written language provides an easy illustration of such shape detection. Because letters are symbols that consist of a variety of basic yet distinctive endings and lines, proofreaders can rapidly catch spelling errors because they can detect what does not belong almost instantly. Because we read the shapes of words rather than their individual letters, the way letters are crossed and how letters are serifed or ligatured immediately cues us to whether the letter should be there or not. This is also the way radiologists read X-rays: first internal inconsistencies are spotted; then they are consciously examined to determine the exact nature of the irregularity.

The question, however, is not so much which approach is correct, as it is how they fit together to suggest more comprehensive models of perception. LeDoux's research on emotional processing, for example, incorporated apparently contradictory research into a model of coincident neural networks. Like the recognition of a dual visual system of "magno" and "parvo" pathways that divide gross and detailed functions in visual processing, a recognition of dual networks allows for both larger recognition and detailed building by implying "a physiological rationale for distinguishing two ways [in which] meaning can be achieved cognitively, one that is primitive and rapid, the other more complex and deliberate."[82]

Gestalt Roots

The dynamic principles that organize perceptions into the meaningful wholes were first effectively explored by the Gestalt psychologists Wertheimer, Köhler and Koffka early in the twentieth century. Emphasizing the inherent and the innate over learned experience, they studied how spontaneous forces combined and separated elements to form different entities and how wholes were created out of perceptual parts. Although the concept of the "gestalt" is often described as the whole being different from (or, even more ambiguously, as "more than") the sum of its parts, it may be more accurate to say that a gestalt implies a configuration that is so inherently unified that its properties cannot be derived from the individual properties of its parts. It was the Gestalt

psychologists who first focused on relationship as the key to meaning, and it is this body of theory to which Gibson's ideas are most closely related. Music provides a ready example of how the gestalt works, as well as a simple metaphor of how the brain functions neurologically.

For example, Christian von Ehrenfels, who introduced the term "gestalt" into perceptual psychology, observed an essential parallel between perception and music that revealed the inherent unities of both.[83] Melody, von Ehrenfels believed, must be a function of *relationship*, since when it was transposed into another key, where all of the notes were subsequently different, it was still perfectly recognizable as the same melody. Today several researchers have theorized that in this neurological symphony there may in fact be no central conductor, but rather a kind of democratic synchrony among parts. Gestalt thinking prefigures this thought and places stress on the shape of the internally interactive whole and the synergy created by it.

Erich von Hornbostel in his 1927 essay, "The Unity of the Senses," too, likened perception to the unifying principle in art. In art, he observed, "what is essential . . . is not that which separates the senses from one another, but that which unites them . . . It is the same organizing principle which calls forth organism from mere substance, and which binds the stream of happening into wholes, which makes the line a melody which we can follow, and the melody a figure which we can see in one glance. . . the unity of the senses is given from the very beginning. And together with this the unity of the arts."[84] From the mere substance of the notes of a song or the brush strokes of a painting arise an organic whole imbued with life and wholeness. This is the same essential unity which Aristotle saw as a fundamental principle both in "common sense" and in well-constructed drama.

Gestalt theory at its inception represented the first revolution in thought to break away from the empiricist view of a straight-arrow connection from sensation to brain, to proclaim in vision the inherent sense of unity that the hologram implies, and to recognize the importance of relationship in perceptual meaning. Gestalt primary principles—of simplicity, regularity, symmetry and good continuation—have provided the foundation for more current explorations in perceptual processing.

In early perceptual experiments with light at Frankfort-on-Main,[85] about the time of World War I, Max Wertheimer found that by illuminating two slits in a screen separated by a brief distance within a fraction of a second apart, he was able to produce the effect of movement. Calling the effect the "phi phenomenon," Wertheimer, together with Köhler and Koffka who observed the experiments, began to evolve the revolutionary theory that the key to perception lay in relationship—in something

different from what is found in separate sensations. Up to this point, the focus had been on the sensations themselves. These were considered as content, and the predominant idea was that to understand them, one had to break them down further.

What the phi phenomenon seemed to say, however, is that scientific dissection could never yield adequate answers, because the principles of perception lay in the spaces *between* the elements rather than *in* them. Meaningfulness was to be found in the reaction among the elements and in the relationship which formed a unified whole, not in the separate parts themselves. Focusing on relationship, the Gestalt group sought, according to Koffka, an isomorphic theory of perception that would "lay the foundations of a system of knowledge that [would] contain the behavior of a single atom as well as . . . a human being, with all the latter's curious activities which we call social conduct, music and art, literature and drama."[86]

Today the focus in the study of perception is again on relationship, primarily in terms of how the specialized areas of the visual cortex work together to create a unified perception. It is clear, for example, that reentrant connections allow information to flow both ways between different areas of the visual cortex, that a kind of temporal synchrony is achieved among firing cells, and that some kind of multistage integration occurs simultaneously among specialized parts. "It is no longer possible," comments neurological researcher Semir Zeki, "to divide the process of seeing from that of understanding . . . nor is it possible to separate the acquisition of visual knowledge from consciousness."[87]

From Phi to AM

Through the work of Zeki and others, earlier Gestalt ideas about phi phenomenon have now been considerably nuanced. From an example of the whole as different from the sum of its parts, the phi phenomenon has been recast to reveal the existence of two distinct systems, one responsible for perceiving movement between brief flashes and the other for perceiving movement between long flashes.

As a result of revisiting Gestalt psychologists' experiments with "phi" we have come to understand that the lower level "magno" system quickly detects movement, depth cues and contrast in borders, while the "parvo" system more slowly detects color, shape, and orientation.[88] In Apparent Movement (AM), "the impression of movement from two actually stationary stimuli," according to Gregory, "stems from processing early in the visual system or even in the retina . . . the cortex does not receive signals first from one stimulus, then from the other; rather it

receives a single signal from the motion processor."[89] Phi phenomenon occurs because the brain interprets short-range apparent motion and real motion in the same way.

In the detection of real motion (RM), all the cells in the prestriate area called V5 are responsive, and most are directionally selective,[90] but these areas are attuned to detecting real motion as it occurs normally in nature. When we watch a film, some researchers speculate, because short-range motion detectors in the brain cannot neurologically distinguish between real motion and apparent motion, the flashing of images in rapid succession on the movie screen results in the illusion of continuous motion.[91] Short-range AM itself is merely a consequence of the fact that cells designed to respond to real motion, respond equally well to other stimuli with the proper spatial and timing characteristics.[92] Film changes in luminance are detected in the same way we detect real motion in nature.

Although today the progression from one frame to the next in film is standardized and apparently seamless, early film, which was recorded at speeds between sixteen to twenty-four frames per second, often was seen as "flickering" on the screen as the eye became slightly aware of the time when the shutter was closed and the film mechanically advanced another notch. When film was stabilized at twenty-four frames per second with the advent of synchronized optical sound tracks, the flicker disappeared—even though the idiomatic expression of "seeing a flick" for "going to the movies" didn't.

Frame movement is also responsible for many perceptually convincing filmic special effects, such as when miniature models are used to substitute for elaborate land or cityscapes in disaster films that require convincing footage without the expense of full-scale production. When miniatures are filmed at high speed ("overcranked") and played back at standard speed, the effects of normal gravity, size, and weight are simulated, and we see the event as if it were happening in full scale, in actual time.

Originally limited in speed by the mechanical movement required in pin-registered cameras, today's ultrahigh speed cameras move light past the film, rather than the film past the light, achieving astonishing resolution and realistic special effects. In contrast, films which are undercranked at fewer than twenty-four frames per second but are played back at standard speed have action which looks artificially fast. When action is slowed down and undercranked, as in a choreographed martial arts sequence, it appears normal when played back at regular speed. This effect can also be used to advantage for deliberate special effects which require slow and careful choreography—such as sword fights—but which gain in action and suspense when played back at normal speed.

Event Perception, Media, and Logic

Movement perception is so essential to our being that, like color, it is registered immediately and automatically by the perceptual system. The theory of "event perception," evolved from the work of Gunnar Johansson and Gibson's Ecological Optics theory, which recognizes movement as the key to an "event." Because the visual system has evolved to alert us to danger or to the presence of potential food, we respond to movement first of all as a signal of potentially positive or negative change. An event, then, is something that "happens." When changes in the visual field occur, they demand our notice because through movement, we are better able to understand the object's structure and to resolve ambiguities in the environment. Movement reveals three-dimensional form and separates figure from ground. This is why animals that depend on camouflage for survival freeze when threatened. When they move, they reveal their characteristic shape, size, and direction of action. In fact, whatever moves in any apparently meaningful way in our environment gets our attention.

This simple fact of perception has had reverberating impact in terms of media as entertainment. This is why, despite the fact that we may recognize a film or television show as inane, we may continue to watch it anyway. As McLuhan insisted, part of the reason we watch television is simply because the picture moves. And action films are the easiest way to get and keep our attention.

Because rapid advancement in computer abilities have made spectacular special effects possible, we often see more time, energy, and money spent on action sequences than on script development, and often films are strung together as visual events rather than as artistic wholes. The box office success of films like *Terminator II: Judgment Day* (U.S.A., 1991) attests to the ability of action alone to distract attention from weak plot and inane dialogue. It may, in fact, be only *after* the experience of the film, *if* we analyze the action, that we realize that events did not really make *intelligent* sense at all.

The effect, however, can also be seen in older classic films as well, such as Howard Hawk's mystery thriller *The Big Sleep* (U.S.A., 1946). Based on Raymond Chandler's novel, the film is composed almost wholly of a rapid series of violent outbursts, powerful sensual interactions between the charismatic duo of Bogart and Bacall, and dialogue too quick to analyze. Things happen so fast and the images are so seductive that it may be only after the film is over that we realize that we never really understood what was going on or why. (With Bogart and Bacall on the screen, it probably doesn't really matter anyway.)

Events which occur closely together in time not only get attention but may also become endowed with an inherent cause-effect logic as well. According to Albert Michotte, in fact, close timing of events may, in fact, *force* the impression of causal relationship on our perception despite their mere chronology.[93] This loose perceptual "logic" further explains why action films, despite lack of plot or unified theme, *seem* to tell a story where none essentially exists. Steven Seagal's popular film *Under Siege*, for example, is typical of this kind of "plotting": the take-over of a Naval ship by evil men bent on extortion is merely the set-up for a series of events involving increasingly violent stunts and a series of special effects.

This common and basic error in abstract reasoning may derive from the perceptual phenomenon of relationship derived through proximity and similarity. In perceptual process neighboring points do not have to touch to appear to be logically connected as part of a larger meaningful pattern, in the same way astronomers first perceived constellations in the scattering of night stars. Figure 1.5, for example, shows how similarity and proximity can work to connect separate units. This perceptual tendency may also be factor in such logical fallacies as the nonsequitur (it does not follow) and post hoc ergo propter hoc (after this therefore because of this) simply because perceptual "logic" seems to indicate cause-effect sequence automatically. The reason for this, again, lies in experience.

Gestalt theory was the first to clarify in perception the unconscious and automatic processes at work to organize sensation into experience, suggesting that the process of compression and reduction of visual information pares perceptual elements to their simplest, most efficient form.

The "Law of Prägnanz," which is the first principle on which all other gestalt principles are based, states that a "psychological organization will always be as 'good' [i.e., simple, regular, symmetrical] as the prevailing conditions will allow."[94] As the principle which unifies perceptual elements into a single harmonious whole, this Law of Prägnanz is the early twentieth-century counterpart of Aristotle's concept of "common sense," the gestalt essence of which is efficiency achieved through simplicity, regularity, and symmetry.

Perceptual Principles and Artistic Manipulation

This efficiency begins with stress and with simplicity as a stress reducer. We see an incomplete near-circle as a circle, for example, because the internal stresses of a simpler figure are less. The closer and more like the parts, the greater the attraction among them; the greater

FIGURE 1.5

Gestalt "Good Communication." According to this law of perception, the eye will complete lines according to the simplest, "best" shape suggested. These shapes are perceived as a square in front of a partially obscured triangle and circle.

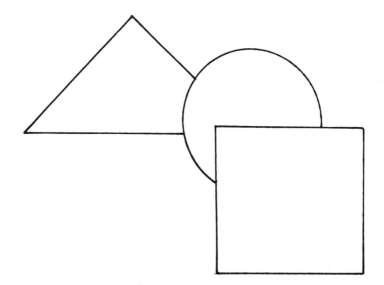

the distance and inequality, the less stability and the less the pull toward unification. Likewise, an open-lined figure, even a series of dots, will be seen as a single triangle, a circle, and a square if, when adding "missing" lines or dots, the resultant mental figures approximate those basic shapes. For the average person, the process is never even noticeable: the eye-brain simply naturally groups elements and "fills in" space to create the "best" and most symmetrical forms (Figure 1.5).[95]

The nineteenth-century Impressionists and Pointillists recognized this before perceptual psychologists did and used it to great advantage to capture the "impression" of reality. Through patterns of light on canvas they seized the moment: artists like Cézanne, Renoir, Monet, and Manet used elongated blobs and round dots of paint distributed in varying densities on the canvas to induce the viewer's eye to create familiar shapes out of simple dots and strokes. Variations in color and texture, rather than specific line edges, are interpreted by viewers as the boundaries of objects, separating them from their backgrounds, and like areas combine to form the shape of familiar objects and people. If impressionistic paintings are viewed close-up, this sense of edges blurs

because the forms and textures of the paint become isolated from each other. At a distance, however, the edges emerge, as larger areas begin to "pull together" perceptually and edges are created by differences in color or brightness. In Pointillism, the effect is even more pronounced since its technique relies on single dots of uniform color and brightness.

The effect of edge boundaries is also enhanced by the subjective perceptual phenomena known as "Mach bands," named after their discoverer Ernst Mach. These are bright and dark strips that appear at the edge of bright and dark areas respectively, accentuating pattern contours. A part of the natural functioning of the visual system, Mach bands appear in any distribution of light and dark as a result of perceptual "lateral inhibition" when photoreceptors in the retina mutually inhibit one another at the boundary between light and dark fields. The same phenomena can also easily be seen in newspaper halftone images where line screens are coarse enough to enable viewers to see the break-up of images into different sized dots within uniformly sized spaces. The smaller the dot and the more white space which then surrounds it, the lighter the area appears. The larger the dot, the darker the area appears. At a distance, as with impressionist paintings, the visual system will discern patterns that create the image, and contours will be enhanced by the Mach band effect.

Other artists, rather than capturing the external patterns of light, have experimented with zones of vision to create experience. Proxemics researcher Edward T. Hall points out, for example, that if viewed by a fixed stare at the appropriate close distance, Rembrandt's paintings can become three-dimensional because he utilized the three sight zones of foveal, macular, and peripheral vision. When the eye of the observer rests on the most detailed center of the painting (comparable to the area that the fovea of the eye can discern in great detail), the other areas around it with less detail will coincide exactly with the viewer's three sight ranges, and a three-dimensional effect will be reproduced. Hall also observes that the same thing is true of other artists such as the Dutch landscape painter Hobbema, whose large detailed canvases, when viewed from a distance close enough to place the outside of the canvas just outside the field of vision, give the impression of actually viewing the countryside. One can look straight ahead into the distance, up to the trees, or down to a brook.[96]

Conversely, much of the impression of distance in perception is due to a progressive loss of contrast in areas of bright and dark as distance increases, primarily as a result of atmospheric perspective. The more particles—such as dust or water molecules in mist—through which the object is seen, the more distant it will appear. On clear morn-

ings particularly after a night rain, for example, far away objects such as houses can seem close enough to count the windows. By late in the day, however, the accumulation of smog from car traffic or industrial waste can make the house itself barely discernible. Experience tells us the house remains in the same location but is obscured by the atmosphere, but in unfamiliar circumstances, we tend to use the gauge of the atmosphere to which we have become accustomed. For this reason, city dwellers are often confused by apparent distances in open spaces such as the desert where there is little air pollution. Distant mountains appear deceptively close, and many tourists have walked for hours toward a destination they believed to be only a short walk away.

This phenomenon is exploited extensively in film to create or extend sets in order to avoid the time and cost of building or traveling. The impressive sets of *Gone with the Wind* (U.S.A., 1939), for example, which so powerfully recreates the antebellum South and the tragic destruction within the Civil War, are mostly matte paintings, with the action filmed in Culver City, California. The "latent image matte painting" technique used in the film involves blocking out part of the image during shooting so that it remains unexposed. In the studio, a painting is done on glass by a matte artist to the size and specifications of the missing scenery, and this is then exposed onto the original film. Sometimes called "photo-impressionism" by practitioners, the art of matte painting is to know exactly how much detail to include in the painting to create the impression that if the camera looked closer, it would indeed find full-scale reality. Over a hundred matte paintings were used in the production of *Gone with the Wind*, including those showing Tara itself.

In the tendency toward efficiency, Gestalt theorists observed, too, that a system left to itself will lose its asymmetries and become more regular as it approaches a time-independent state.[97] This regularity is organized by forces of cohesion and segregation. Equality of stimulation produces cohesion or unification through similarity; inequality or difference produces segregation. This is the principle behind the perceptual associationistic logic discussed earlier. Lines placed closer together and similar colors or shapes tend to form units that are segregated from an apparently receding background. Camouflage can successfully fool the eye by simply repeating in the foreground object the background pattern—which tends to be more unformed and without definitive contours—causing it virtually to disappear. Gestalt psychologist Kurt Koffka explains that foreground shapes are seen as separate only when forces that segregate the figure from its field and hold it in equilibrium are brought into play.[98] In recent visual textures studies, Bela Julesz has

FIGURE 1.6

Gestalt Face or Vase? In this classic Gestalt illustration, figure and ground reverse as the vase and the profiles alternately assert themselves as figures.

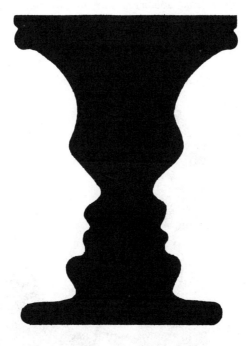

found that connectivity detection is involved in preprocessing the image, even before form recognition itself can occur.[99]

A classic example of the phenomenon of figure-ground formation is the Rubin drawing of two faces in profile (Figure 1.6), which alternatively transforms itself into a vase, depending on which we see as figure and which as ground. When the forces for segregation and cohesion are equivalent, ambiguity results: figure and ground alternate as each asserts itself to become the dominant figure. The vase/faces illustration is ambiguous because it vacillates between two interpretations and cannot be resolved conclusively into one or the other. In the illustration (Figure 1.7), which was first published in *Puck* in 1915 as "*My Wife and My Mother-in-Law*,"[100] whether we see the old woman or the young woman first, we are not only likely to stop looking after we find the first figure, we are also likely to have some difficulty locating the second one. Once we see both, they tend to alternate, and it is difficult to fixate on one.

This is also how perceptual principles imply expectation. Just as we create defined shapes from ambiguous sketches, or read them into clouds

FIGURE 1.7

Wife or Mother-in-Law? First published by Hill in 1915, this classic figure alternates portraits of a young woman turned away and an old woman in profile. The nose of the older woman doubles as the young woman's jaw line.

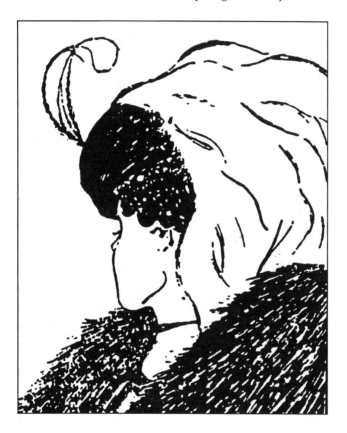

or night stars, we also tend to extend any suggested continuing pattern along the direction previously established, since this also lends stability and creates meaning. A curve, for example, "will proceed in its own natural way, a circle as a circle, an ellipse as an ellipse, and so forth."[101] The suggestion of a shape continues that shape until it is complete, just as the suggestion of a pattern implies its continuance. This "Law of Good Continuation" suggests how we close and continue symmetrical patterns. These in turn become more stable the longer they are maintained.

If as Gregory suggests, perceptual patterns provide the foundation for abstract thought and reasoning, then it is possible to see in this basic

principle of good continuation the roots not only of legitimate generalization but also of negative stereotyping as well, together with the strong level of conviction which some concepts gain over time. On the most basic level of perceptual good continuation, Julesz has found that a person can be influenced by a stimulus not even consciously perceived and that the content of an initial image may impress itself on a subsequent ambiguous image undetected.[102] In this same way, in true subliminal advertising (discussed further in Chapter 6), the likability of the images that surround the product become associated with the nature of product itself.[103]

In the expectation inherent in this concept of good continuation, the Gestalt approach emphasizes inherent perceptual principles rather than learning and experience, but later constructivist psychologists have tempered this view considerably in their own approaches. Although Gibson's ecological optics stays within the Gestalt tradition, for example, stressing that there is enough information directly available in the optic array to discount further processing, the constructivist approach stresses the role of experience in the active observer in mentally processing the whole image. Hochberg, for example, has proposed that saccadic eye movements are part of an active process of mental mapmaking in which parts are pieced together to form an integrated whole. In Biederman's theory mentioned earlier, too, it is primarily our experience which allows us to recognize the shapes of objects from geons, even when they are occluded or partially masked. In the cognitive approach to perception, stress is placed on the role that expectations, memory, and reasoning play in completing the whole.

Interestingly, however, recent research has identified major anatomical subdivisions at the earliest stages of vision, lending credibility to the concept of "visual intelligence" prior to the influence of experience on perception. Discrediting memory-based high-level cognitive explanations for depth perspective, for example, Harvard researchers Livingstone and Hubel have found that simple interactions initiate automatic interpretation of a two-dimensional image into three-dimensional information at a very early point in the visual system, not at higher levels of cognitive processing. Having confirmed and traced the presence of the "magno" system which perceives movement before processing form, and the "parvo" system which is influenced by cognitive factors and perceives form, for example, the researchers "were struck by the similarity between the list of functions ascribed to the magno system and the Gestalt psychologists' list of features used to discriminate objects from each other and from the background."[104]

Whether the stress is on the initial whole or on the processing of parts to build that whole, however, the principle of good continuation

may be said to imply a completion along previously established lines, whether of form or of experience. If, for example, we are led to anticipate what we are about to perceive, any ambiguous stimulus tends to be seen as a reflection of what we expect. This is graphically illustrated in the example from Fisher[105] which progressively modifies the face of a man to become the body of a woman (Figure 1.8). In the ambiguous stimuli at center, a person beginning to read from the left will see the face of a man, and a person reading backwards from the right will see a woman. What is true for the illustration is also true for perception in general: as a sensually derived and mentally completed process that gives meaning to what we see, hear, feel, taste, and smell, perception actively utilizes past experience and current values, attitudes, and needs to anticipate and to interpret the world around us.[106] We are often reminded by perceptual psychologists that we do not see what is there, but rather—preconditioned by need or prior experience—we see what we want or expect to see.

Expectation can also lead to misperception in situations that seem incontrovertibly unambiguous as well, where perception may lead us to thoroughly false conclusions as a result of "built-in" perceptual bias. Artist Adelbert Ames, for example, has designed a number of trompe l'oeil pieces that are absolutely convincing from a particular perspective, but which when seen from other points of view reveal a totally different reality. One Ames "chair," for example, observed through a positioned keyhole shows a regular chair, but seen from another perspective reveals that this illusion is created by carefully hung but unconnected bars suspended in space at different distances and at odd angles, with a rectangle representing the seat painted on a backdrop. The equally famous Ames room illusion also effectively convinces us that men of different sizes are close to one another in a normal room, while in reality, they are the same size but positioned far apart in a room in which the left corner is twice as far away and lower than the right corner. The same effect can be achieved by showing two figures at different distances yet in clear focus, against a background with no depth clues.

This is essentially the same device often used in film "special effects," especially in horror films, where the camera becomes the controlled peephole through which the action is perceived. In the horror classic *Attack of the Fifty-Foot Woman* (U.S.A., 1958) and its 1993 remake for HBO television, for example, special effects create the sense of a woman who grows to fifty feet as a result of an encounter with aliens by simply manipulating perspective: she is positioned well in the foreground, surrounded by miniatures, while her husband is placed a good distance away, within a normal environment. With the use of depth of

FIGURE 1.8

From Man to Woman. The last figure on the right in the top line and the first figure on the bottom line may be seen as metaphors for the ambiguity of experience, into which either a man or woman may be visually read.

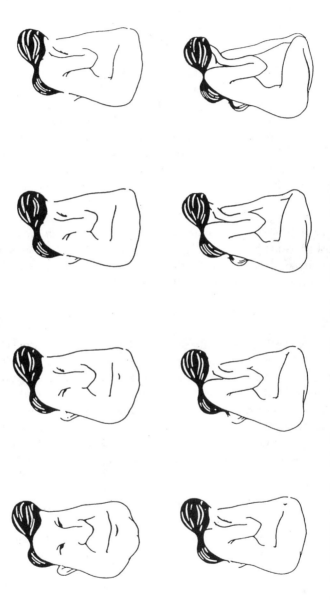

Illustration by G. H. Fischer. Reprinted by permission of the artist and Psychonomic Society.

focus, which equalizes the clarity of the two figures, the two appear to be different sizes, but right next to each other. Without such cues as a gradually diminishing landscape or blurring of the remote figure, the two people seem to be in the same location.

Such filmic special effects and contrivances like the Ames room remind us that "the map is not the territory," and that, as art and perceptual theorist E. H. Gombrich states, "What we see through the peephole does not directly and immediately reveal to us 'what is out there'; in fact, we cannot possibly tell 'what is there'; we can only guess, and our guess will be influenced by our expectations."[107] This is also one of the reasons J. J. Gibson's theory of Ecological Optics stresses that perception should be studied within a natural environment, where people move about within the ambient optic array. As the perceiver moves through the environment, the light reflected from textured surfaces provides information on size and layout directly through invariants—those aspects that do not change within the changing viewpoints. If, for example, the peephole in Ames's room or the camera in *Attack of the Fifty Foot Woman*, were to be moved just slightly to the left or right, the whole of the illusion would be destroyed. This, according to Gibson, is how we perceive in reality: by moving about in an ever-changing environment.

Multisensory Surrounds and Virtual Reality

Recently, special effects have broadened into attempts to overcome the limitations of stationary perspective altogether by developing multisensory surrounds, in which the whole perceptual environment is manipulated in terms of sight, sound and movement. Expensive to produce and most generally accessible to the public in "theme parks" such as Florida's Disney World or Universal Studios, these simulated environments, usually in the form of film rides, move the viewer up, down and sideways in a choreographed computerized program that is coordinated with high resolution film images on a wide-angle, full peripheral view screen. The sense of forward movement is created by manipulating the gradient of optic flow in the visual field while providing enough hydraulic movement in the seat platform to fool the viewer into feeling that he or she is actually experiencing the ride. A similar ordinary experience occurs when, if we are seated in a stationary train and the train next to us begins to move backward, we have the distinct feeling that it is our train that is moving, and that it is moving in a forward direction. In this example the visual alone creates the illusion of motion. In the film ride, when the visual is combined with high-resolution sound that grows and fades in appropriate directions as if things

were rushing by us, and the platform is coordinated to the screen action, the illusion is almost total.

Universal Studio's "Back to the Future," an IMax® simulated ride, is typical of the genre in its devices and masterful engineering. Developed as a thematic off-shoot of the 1985 film written and directed by Robert Zemeckis, the "ride" utilizes a simulated DeLorean car mounted on a four-axes motion base which can move fore and aft, up and down, pitch forward and back, and also roll. Sound waves injected into a highly sophisticated hydraulics system create the sensation of surface texture as you "ride" over rough surfaces. As one of the car's occupants, you feel you are actually moving and participating in a real event, not merely viewing one on a screen. The effect is a recreation of experience and, like perception itself, involves the coordination of the other senses within a perfect synthesis. Perfectly timed coordination is the key: sixty computers operate two giant screens and twelve ride vehicles. They also synchronize the 10,000 watt multichannel surround sound system and IMax high resolution image to the car's movement to within 1/24 of a second, stimulating several senses simultaneously.

Part of this illusion is, of course, based on anticipation. As the illusions created by Ames suggest, we recognize a chair in a disjointed set of wires because we know and understand a chair; likewise, simulated environments rely heavily on suggestibility and prior experience to determine exactly how much and how many sensual stimuli are necessary to satisfy and sustain the illusion.

The trick for theme parks—as for matte paintings in film—is to find an appropriate balance between the lowest costs and the most convincing experience. Like the Impressionist painters of the nineteenth century who used minimal stimulus, so too today, visual technologists have found that sometimes less is sufficient. High-definition television (HDTV), for example, was expected to be instantly a high-demand consumer item in technologically conscious Japan when it came on the market. Surprisingly, however, it was found that only one aspect of HDTV—its wider screen—was sufficient to ensure purchase, and that a satisfactory sense of higher resolution could be obtained by affordable technology that simply doubles the lines. As of this writing, HDTV is seen as not as the most probable next step in television viewing but as the one after. As consumers become used to the level of verisimilitude within this format and exposed to other more fully simulated environments, they will then demand the more sophisticated resolution of true HDTV.

Other efforts to change passive 2-D media into fully interactive 3-D experiences have resulted in the illusion dubbed "Virtual Reality" (VR)

by Jaron Lanier in the mid-1980s. First pioneered by the National Aeronautics and Space Administration (NASA) as a way to simulate extraterrestrial flight experience, VR was soon shown to be relatively inexpensive.[108] Lanier was the first to develop head-mounted stereo screen displays, the "dataglove" and the "datasuit" to deliver multisensory (sight, sound, and touch) information within interactive artificially engineered environments. In VR as it is usually understood, an image is perceived via an optical headset, or by direct projection onto the retina, and sensors in gloves or suits can stimulate contact with objects that exist only as pixels in a computerized virtual surround. VR head gear is worn over the eyes and wired to a computer that is attuned to head movement and simulates what the isolated wearer would perceive within an actual optic array by capturing varying vectors of the ambient optical array mathematically and then smoothing them.

Current commercial VR entertainment games work by utilizing two ocular liquid crystal displays (LCDs) mounted in the head gear to provide stereoscopic vision and a sound source that is accurately placed by the computer as it senses movement. A polarized magnetic field surrounds the game participant, and a receiver mounted in the helmet reads variations in the field. This feeds back the information to the computer so that the visual and aural environment changes precisely as the person moves. Pneumatic data gloves with sensitive pads at the finger tips and in the palms are also tracked by computer and give sense impressions of virtual objects in the environment. A full body sensor suit is now in the commercial works to allow for complete sensory feedback.

The person *feels* present in the fabricated computerized surround and negotiates it in the same way he or she would move through the real world. Just as in Universal's "Back to the Future" ride, sound can be added to enhance the effect. In experimentation with air traffic controllers, in fact, it has been found that sound vector manipulation is the most helpful in locating the position of aircraft most effectively. By anticipating the vectors present in eye and body movement and providing coordinated sense data to all the senses, this computerized world provides a powerful simulation of real experience.

Although VR is still relatively primitive, its outer limits can be defined only by the principles of perception within the mind, and by the capacity of ever-advancing supercomputers to manipulate vast amounts of data at lightning speed. Usually envisioned as existing in the realm of "cyberspace" (a term coined and developed by William Gibson to describe an elaborate global computer network and the virtual environment that it has created, in his novels of the mid- to late 1980s), VR can only model reality. As Rheingold suggests, "No map can ever be as

detailed as the territory it describes," and though the map may be realistic, this does not imply that it is *truthful*.[109] Probably the most important aspect of VR, however, lies in the fact that it is an active experiential medium, directly perceived. This makes its application as a learning tool invaluable, for VR provides what textbooks and instructors, limited primarily to verbal communication and limited visual illustration cannot: people learn more effectively and enjoyably by reasoning and solving problems through *experience* than by being told about them indirectly.

This is why VR has found such great practical popularity in design areas, like simulated architectural environments in which one can virtually walk through plans to test design flaws, and more important, in areas where mistakes cannot be tolerated, but where practice is essential. One medical use of VR, for example, is in the area of avatars (simulated computerized "stand-ins" that interface with the patient in 3-D), which allow surgeons in training to practice delicate operations and to cope with complications which can be programmed into the procedure. VR interfaces with semi-autonomous robots, it is speculated, may be the only possible way to construct space stations in outer space.[110]

Current VR stock market computer programs now also regularly help analysts understand market trends and fluctuations by rendering complex quantitative data into color and three-dimensional schematics on their personal computers. Analysts can move around in 3-D space and time, absorb information faster, and respond more quickly to sudden market spurts. Prospective customers can tour production plants and visit with concrete manifestations of future ideas as part of the company's integrated marketing efforts. Chemical molecular engineers in search of new drugs and DNA secrets, can move with molecules in VR environments with visual and tactile feedback searching for molecular "docking" sites. At least one California psychologist uses VR simulations to treat phobias in his patients by desensitizing them through simulated experience.[111]

The Pentagon's Defense Advanced Research Projects Agency sees VR as playing an essential role in war games training as a smaller number of military will be expected to perform a wider variety of skills in combat situations,[112] while in Japan, couples plan kitchen layouts and cabinetry in VR store set-ups in the morning and the next day see them installed in their own homes. VR has also found a variety of other applications: from recording "the subtle relationships between speed, position, flex and other variables" in a pitch by Roger Clemens to help understand and avoid repetitive stress injuries,[113] to the simulation of murder scenes in judicial trials. In one California trial in 1992, for example, a VR simulation produced on personal computer by a ballistics

expert was considered to be substantially responsible for a manslaughter conviction.[114] Such legal uses have also raised inevitable controversies, however, many of which are perceptually based.

In terms of ultimate illusionary sensory surrounds (such as in VR situations when military trainees sweat, swear, and in general show emotional responses and behavior similar to military in real combat), it is easy to see how both illusion and reality might become confused, but implications may be broader. As a medium of perceptual experience rather than of verbal codes, virtual reality, critics say, may ultimately alter ways of perceiving and thinking beyond even what McLuhan envisioned and warned us about in his writings in the mid-1960s. Whenever a medium is relied on intently, becoming an integral part of the culture, the way people live and perceive their world, McLuhan observed, radically changes.

Jaron Lanier himself points out that perception does seem to change with individual sallies into VR experience, but often in a positive way: because in a synthetic world you adapt to a lower level of detail while at the same time being made aware of your own personal consciousness to an extraordinary degree, he claims, when you return from the simulated world, you tend to experience "the physical world as being hyperreal" and appreciate anew the "existence of consciousness, which is not necessarily apparent in everyday experience." Because there is less of a separation between ourselves and our real environment than there is in virtual worlds, Lanier believes virtual reality "provides an opportunity to sensitize people to the subtlety of the physical world . . . [by] forc[ing] you to notice that you are experiencing things."[115] In this sense, VR is the reverse of what Lanier calls the "dangerous television stupor" of TV and of a computer-dominated consciousness: "With a virtual reality system," he explains, "you don't see the computer anymore—it's gone. All that's there is you."[116]

Yet Lanier does worry about the potential for children to become lost in the VR environment and suggests that there be an age-restriction placed on VR experience.[117] Others also take very seriously the idea that the appeal of nonreality may be destructively strong, especially for children and adolescents who require a variety of escalating challenges in order to mature and function effectively in the real world as adults. Like Salinger's Holden Caulfield who escapes into the movies to find a world where corruption and death do not exist, today's youth, some fear, may become addicted to a synthetic world where sensually exciting entertainment and immediate gratification make the real world seem inadequate by contrast.

Already VR theme parks have spread widely throughout the world, offering a variety of virtual experiences, especially indulgence in some

form of gratuitous violence. Even what seems ordinary everyday experience can turn nightmarish by implication when VR makes it eminently desirable and immediately obtainable. Very early on in VR development, for example, virtual sex became an imminent probability, and the spread of pornography and sexual manipulation a serious concern. Commercial manipulation also started early as Saatchi and Saatchi, then the world's largest advertising agency, began to study the feasibility of transporting students in the classroom via VR to a "hypermall" where they could purchase goods electronically. Given the current pervasiveness of advertising in public schools under the guise of educational programming, particularly as part of "Channel One,"[118] this type of exploitation may be more generally acceptable than might at first be thought.

Despite the disturbing prospect which the preference of living in a VR world and the manipulation of desires suggests, however, VR may prove to be the educational catalyst to involve children and adolescents in true reality by making chemical molecules come alive in chemistry class and allowing students to walk on Venus or through rain forests, explore the pyramids, and move back and forth in space and time to answer questions on geography, climate, history, and other academic areas. It may also become the experiential salvation of people who are physically disabled as well as a positive boon to the mentally ill whose vision of reality may be retrained and normalized through VR therapy.[119] Unlike the repetitive formulas of television programs or the continual looping of video games, VR, fully realized, opens up to people all the possibilities that individual choice ultimately implies within digitally captured or synthetic environments.

But how will perception and consequent judgment function in a world where sophisticated sensual stimulation by media can be used to create and manipulate perceptual experience? Some VR critics warn that the line between illusion and reality may become perceptually nonexistent, even in everyday life. But the central issue of illusion in perception is more basic, and it is wise to remember that with only minimal audio stimulus, Orson Welles's radio broadcast of H. G. Wells's "War of the Worlds" fooled a number of people into believing in 1939 that the Martians really had landed in New Jersey. In studying how the illusion affected people's judgments in this situation, Cantril found that those only minimally affected were well founded in dramatic tradition and therefore were not fooled by format. They picked up on the large number of time and distance cues that would have been impossible if the situation were real. Those most convinced by the radio drama were fooled by the format and dramatic content and made no attempts to check its reality.[120]

Memory, too, can complicate the process of judgment when real experience mixes with mediated vicarious experience in memory. Accumulated memories from media drama may then eventually influence the way current physical reality is perceived when memory is used to judge present situations—particularly in children whose initial judgments are weakened both by a lack of general knowledge about the way the world works and by immature information processing. But adults are also susceptible to memory mixing, particularly when we identify with fictionalized objects, people, and situations because they are familiar within our own life contexts, and especially when decision making must be immediate or is accompanied by stress.[121] "Any medium," McLuhan warned, "has the power of imposing its own assumption on the unwary."[122] Even direct perception itself also has the power of imposing illusion on otherwise intelligent adults.

In the 1950s, in Seattle, Washington, for example, people began discovering small pitted areas in their windshields. As one person told another of the phenomenon and local broadcasts repeated it, a general mild panic ensued as people discovered one after another that their windshields, too, had been pitted. Although those who made the discovery seemed certain that their windshields had been perfectly smooth prior to the mass event, what the event ultimately revealed—after toying with a variety of theories ranging from acid rain to extraterrestrial influences—was that in the course of everyday use, car windshields will always become pitted on the outside. Prior to the scare, people had been looking at their windshields from the smooth inside-out. During the scare, they were looking from the pitted outside-in.[123] Gombrich reminds us in *Art and Illusion*, "Illusion consists in the conviction that there is only one way to interpret the visual pattern in front of us. We are blind to other possible configurations because we literally 'cannot imagine' them."[124]

Brain Wiring

How the mind utilizes information from the visual system to image the external world and to create meaningful experience is still a mystery, even though in the last ten years science has learned as much about the inner workings of the brain as we knew prior to that time. In the center of it all is the recognition that although the brain's neural architecture and the level of chemicals that either accompany or determine how we perceive, think, and act are fairly well determined within our first ten years, the brain itself is an amazingly flexible and programmable mechanism.

The brain's ability to adapt its own areas for necessary use, for example, is evident in cases where because of injury or surgery, part of the brain is missing. Because certain parts of the brain have been associated with particular abilities, it would be reasonable to assume that without these sites, the brain could not function. Yet cases have shown that often knowledge and functional capacity migrates from one area into another, even in cases of stroke in elderly brains. The brain has enormous adaptability. It is however, temporally limited, since there also appears to be a time-clock mechanism for the burgeoning of certain skills. Although a second language may be acquired at any time, for example, learning second languages in childhood makes the acquisition easier and fuller than later in life when the peak learning period for language is over. The windows for development have a limited time frame.

Neurobiologist Carla Shatz explains that there are two broad stages in brain-wiring, an earlier one where experience isn't requisite and a later one when it is.[125] Each perceptual ability has a first critical period in which development must occur. If it doesn't, the ability may be forever impaired or entirely lost. The circuit for vision has a growth spurt at the age of two to four months, peaking at eight months, when each neuron connects to about 15,000 other neurons. If a baby has cataracts at birth and these are not removed until it is past this period of development, it will never learn to see.[126] Connections, which are promoted by activity, will never form. This is why people who have never seen before or who, like Sacks's patient Virgil and Gregory's S.B., have experienced sight only briefly in early childhood encounter what can be insurmountable difficulty in making sense of what their new eyes see.

In language, auditory maps are formed within the first six months. By twelve months, the window closes and infants lose the facility of discriminating sounds not in their own language. Before it is spoken, language is constrained by the pattern of sounds used in native language, so that even when babies babble, they do so in the sounds and rhythms of the language they have heard. Although we retain the capacity to learn other languages, similar languages are easier for us to learn—like the romance family of languages for French or Spanish speakers—and after the age of ten, we will probably never learn to speak a second language like a native.

The same is also true for cognitive abilities. If they are not exercised after their formation, they are lost. Once our neurological systems are established, they become more rigid and less susceptible to change, although they may continue to grow throughout life. The more repetitive our thinking patterns are, the more firmly entrenched they become—like a practiced piano sonata which the more often it is played,

the more fluent and automatic the play becomes. Cortical maps of musicians, however, are less influenced by the number of hours of practice on an instrument than by the age at which the musical instrument is learned: the younger the child is when learning an instrument, the more cortical area becomes devoted to the activity. In a blind child, large visual areas of the brain are reallocated for use by touch and the other senses.[127]

After the initial crucial stage of development is established, variety and repetition become key. Even though we pass beyond primary development stages, however, the brain continues to learn throughout life, making new connections when those areas are used. Even "broken circuits" can be enhanced or even rewired. Some experiments in higher-order thinking, for example, have revealed what has been dubbed the "Mozart Effect," in which listening to classical music has been shown to increase spatial ability. In the strengthening of these circuits, mathematical ability is also enhanced.[128] Experiments with language-based learning disabled children, approximately 7 million nationally, have led some researchers to suspect that chronic middle ear infections may cause faulty auditory maps in children, which then cause reading problems because certain sounds like "b" and "d" go by too fast to recognize. Training children to hear these sounds by playing them slowly enough to recognize has produced astonishing results: with neural rehabilitation, children two years behind in language ability have been able to catch up in four weeks.[129]

But even as neural circuits can be expanded, they can also be shut down. Just as the more languages a person knows, the easier it is to learn others, so also, the more open and flexible a person's abstract thinking remains, the more open the person is to new learning and to change. With repetition, however, perceptual reasoning becomes fixed into patterns, just as verbal language becomes fixed within the parameters of cultural expression and dialect. In the visual artist, we see the perceptual logic of interconnectedness and gestalt formation kept open and alive to new influence. In the television "couch potato" we see a perceptual logic stymied by repetition and lack of challenge, rigidified into patterns of thought and behavior by messages repeated over and over again in media.

As neurological circuits become overused, they tend to become more "hard-wired" and less flexible. The more often a neural pathway is used, the stronger it becomes, and the easier it is to trigger. As disused circuits fade away, and with them the promise of more diverse thoughts and talents, the more likely we are to see things in a particular way, resolving ambiguities according to limited preestablished notions, filling in details according to the set of our own personalities.

It is as if we begin by learning to put together different notes into meaningful melodies, gradually building a musical repertoire on which we come eventually to rely for all performances. For people with limited thought repertoires, whatever the occasion, they think the same tune. (A steady perceptual diet of horror films, cartoons, or media violence in childhood, for example, may have enormous implications in the later development of values, attitudes, and behavior.) Individuals with large thought repertoires who continue to practice new compositions will retain a flexibility lost to those who settle early merely for a few basic ideas. Thus, despite the trend toward hard-wiring over time and the developmental windows open and closed within natural time clocks, our perceptual maps are also extraordinarily plastic, capable of enormous reorganization and revision when stimulated.

What we "see," then, is a combination of the processing of external stimulus by the visual system, of the simultaneous firing of particular neurons in patterns which make us conscious of what we see, of learning appropriate perceptual skills at the right time, and of prior learning which is brought to bear on present perception. Perception is a process which utilizes not only the retinal image but also the whole of a person's being as well.

Conclusion

To summarize, the stimuli that experience provides the senses is always incomplete or ambiguous, and perceptual process is still understood only in partial increments. We do know, however, that what we see is at least partially what we expect to see and is as much the product of inner-derived meaning as it is a reflection of what's "out there." As the twentieth-century counterpart of Aristotle's concept of "common sense," a quality that unifies sensual information into a single holistic perception, the Gestalt Law of Prägnanz and other subsequent perceptual theories suggest that while perceptual process is efficient in the extreme, it nevertheless is a process that reduces reality to its simplest shape and that fills in empty space with something that isn't really there. Under ordinary circumstances, perception and judgment are highly susceptible to illusion, especially in intensely pressurized and emotional situations.

Most perceptual theorists accept that perception is largely confined by individual consciousness, and that it is subject to differing sensory abilities—such as color blindness or shortsightedness. They further agree that perception is continually affected and often substantially altered by memory and emotion. Even in hindsight, particularly in a perceptual

phenomenon called "backmasking," we can alter earlier perceptions according to later ones.

Moreover, it appears that because vision is the result of a number of subsystems at work and not just a direct line to the brain from the senses, many of these subsystems function independently of each other and are beyond all introspective understanding.[130] Not only is our perception liable to distortion, it is also highly susceptible to emotional manipulation on an unconscious level, which in turn affects our conscious thinking. Lighting, shadow, and color can be changed to produce a more positive or negative emotional impact; context can be subtly suggestive enough to alter our conscious opinion of the subject within it. All of this can happen before we consciously form a judgment that we believe to be informed, objective, and unbiased—in other words, "intelligent."

This is why it is essential that we use our cognitive analytical abilities to throw the rational "off switch." It is not enough to be "visually literate." In a society in which advertising images can lure people into a sense of emotional security while undermining their health, in which political images can affect emotional response before critical analytical abilities are invoked, and in which mass media entertainment images of violence can have devastating arousal effects, the nature of our battle for survival has changed considerably since our current brains have evolved from primal environmental-response patterns.

What has evolved as a survival mechanism, therefore, can prove a detriment if, as LeDoux states, "Aggressive responses are indiscriminately elicited by thalamic signals and allowed to run their course unchecked by more detailed perceptual analyses."[131] Even associations learned through specific situations may later be generalized and activated in stressful situations. Such research conclusions have profound implications for cross-overs between mass media and real-life learning, and for the long-term potential of media response to stimulate heightened states of physiological arousal in inappropriate situations.[132]

The concept of visual intelligence therefore implies a critical appraisal of conscious perceptual information; an understanding of the emotional affect that accompanies it; and the tapping of creative problem solving ability that begins in perception. The exercise of this intelligence begins first, with a basic understanding of the highly complex process of perception: how light from the environment stimulates photoreceptors and is transformed chemically and electrically into signals in the brain; and second, with a grasp of the organizational principles which transform information into meaningfulness in higher abstract thought as well.

When reality is mediated in print photography, television, and film, what we see not only is *not* reality, but a synthetic reality highly

susceptible to manipulation. Furthermore, if it is true as hypothesized that media-induced vicarious experience may later mix with actual occurrences in memory and render them indistinguishable from one another, then media fare may play a substantial role in developing mental maps that blend media and reality together as a single mental experience, which in turn directs our interpretation of the present, further revises memory, and affects the direction of our thoughts and actions.

The essence of "visual common sense" is the first degree of "visual intelligence." It tells us that because perception is an internal, creative, problem-solving process, we may never know what is really "out there." It also tells us that good judgment (like the perceptual process that it parallels and from which it derives) is really only efficient, never sufficient, for survival—and then only in the most rudimentary of circumstances. Even on the most basic level, our susceptibility to illusion should give us pause—especially since in understanding our environment today we have come to rely so heavily on media as extensions of our senses.

It is most important, however, not merely to recognize our inherent tendency toward illusion as a basic part of perceptual process in our everyday lives, particularly as we interact with media. We must also understand that the principles of perceptual process are the keys to creative thinking as well—to reaching out beyond our past and into the future, and in doing so to recognize in relationships implied in analogy, metaphor, and symbol the means to penetrate the mysteries of the universe. If perceptual theorists are correct that the development of vision led to "strategic planned behavior and ultimately to abstract thinking,"[133] then vision is truly the gateway to advanced intelligence. Those who have the wisdom and insight to see far-reaching implications are true "visionaries."[134]

With perceptual development, however, also comes a liability to illusion and to erroneous judgment that may ultimately forsake us in our own well-being. Visual intelligence thus also implies an understanding of exactly how far we can trust our perception to tell us the truth, and an appreciation of how perceptual process can be manipulated through various media to alter our attitudes and behavior. When we are ready to be fooled by perceptual process, we are heir to manipulation by those who understand its nuances and are ready to take advantage of it. There is a story of a mason who became so disgusted by people not paying his bill when his work was completed that he built in a sheet of glass across the chimney as he was constructing it. If the people paid when the work was completed, the mason broke the glass. If not, he let them continue to puzzle over why the smoke would not go up the flue since they could

see with their own eyes that there was no obstruction. Visual intelligence implies not only recognizing that what we see may not be reality, but also breaking through the merely apparent to understand that what we see may have been engineered as well.

If Spinoza's model of the mind is correct, as current neurological thinking suggests it is, and we are doomed to first accept what we see as reality and to believe what we are told as true, it is only by deliberate thought and active higher reasoning that we can move into a wider circle of intelligence and truly appreciate what we see and understand how we come to believe.

2

THE NATURE AND POWER OF IMAGES

The Soul Never Thinks without a Mental Image.

—Aristotle

Defining the Image

The *American Heritage Dictionary* gives ten definitions of the word *image*, ranging from a reproduction of the form of a person or an object to an apparition. In between, the definition includes specialized uses of the term in physics, mathematics, and computer science, as well as more general meanings for the term that embody both its pictorial and mental aspects—including vivid description, literary metaphor and symbol, opinion or concept, and the character projected by a person or an institution, especially as it is interpreted by the mass media. The range of meanings for the verb "to image" runs likewise from external representations to internal ones, from the production or reflection of a likeness to mental visualization. What is common to all images, however, is the perceptual logic by which they are formed and the nature of the coherent whole.

Neurologically all images are by nature gestalts, made up of fragments of visual experience processed modularly and then coordinated through perceptual process into what Walter Lippmann called "pictures in our heads." They are stories, always implying more than their parts, always in process and actively seeking meaning. Because vision developed before verbal language, images are a natural part of our primal sense of being and represent the deepest recesses of ourselves. As the breadth of dictionary definitions suggests as well, images are tied to the full range of human experience and expression, ranging from practical affordance to symbolic myth. This is why an understanding of the nature and power of images begins with perceptual process but ultimately ends with the abstract picture of the world that we carry in our heads.

Although verbal language represents an evolutionary advance in that it allows us to abstract thought from experience, it, too, is of necessity grounded in perception. Its images and symbols are rooted in the visual domain of experience, and the logic of its reasoning not only exists side by side with perceptual logic but is continually mixed with it because it is essentially inseparable from it. Kinesthetist Ray Birdwhistell estimates that 65 to 70 percent of the social meaning within a conversation is carried by the visual;[1] Mehrabian estimates this to be as high as 93 percent.[2] While a debate continues among scholars on the exact nature and relationship of visual and mental images, much of it is informed by the prejudices of the arguing disciplines. Typical arguments focus on philosophy versus practice, on semantic and semiotic distinctions, on artificially segmented left and right brain functions, and on the relationship of the pictorial to linguistics. Yet the very fullness of the range of definitions found in the dictionary reflects a common thread through them in the perceptual process that is the human foundation for all of them. Perception is our chief means of knowing and understanding the world; images are the mental pictures produced by this understanding.

While, for example, every discipline has models, methodologies, and metaphors for solving problems, it is cross-fertilization that appears to be the key to creative thought. Roger vonOech, researcher and consultant on creative thinking, reminds us, for example, that the invention of Velcro was inspired by burrs in nature sticking to clothing; that Knute Rockne's four horsemen backfield shift was inspired by a burlesque chorus line; and that the idea of roll-on deodorant was adapted from the ballpoint pen.[3] Howard Gardner, at Harvard University, who has researched both intelligence and creativity and written extensively on both, insists that the educational system champions a linguistic intelligence that habituates us to look for and to accept a "right" answer according to linguistic or mathematical processing, to think vertically in terms of logic, and to overestimate the value of linear logical thinking. What perceptual logic reflects, however, is real-world, apparently alogical phenomena—filled with inconsistency, change and contradiction, and operating nonlinearly and holistically.

Most scientific breakthroughs, it seems, tend to come when a person changes fields because he or she is then both unencumbered by old thought patterns and free to perceive the problem through the paradigms of another discipline. We may also, however, create an idea or an image of art that has never existed before, extending ourselves beyond the bounds of usual thought through a creative turbulence that settles into a new and higher order of perception.

Chaos Theory helps us to visualize how this happens. An interdisciplinary movement in mathematics and the sciences which began in the 1960s, grew through the 1970s, and finally became legitimately recognized in the 1980s as one of the major contributions to thought in the twentieth century, Chaos Theory is an umbrella term for the study of the dynamics of nonlinear systems. Simply put, Chaos Theory arose out of the observation that simple deterministic systems breed complexity; that small uncertainties could suddenly be magnified and send a system into chaotic behavior, as when water begins to boil. Though seemingly random in activity, however, chaos was really a pattern repeated throughout a variety of phenomena. Although each molecule might be locally unstable, globally it revealed a pattern repeated over and over again in nature.

Smoke, for example, will rise in a steady stream from a cigarette left in an ashtray, until suddenly the stream will begin to break up and gyrate wildly in unpredictable swirls. River currents may flow smoothly until suddenly an eddy will form, swirling the water into apparently chaotic flow. In both cases, turbulence arrives in a sudden transition and seems to become unpredictable, yet, Chaos theorists realized, order can and does often masquerade as randomness. Any linear chain of events can reach a point of crisis in which the smallest single element can achieve disproportionate significance, sending elements into chaos. In this apparent disorder, however, larger, universal shapes begin to be revealed. Sensitive to and dependent on initial conditions, the pattern that the turbulence settles into is determined by an "attractor" that pulls apparently random behavior toward itself, like the eye of a hurricane. When something kicks a regular pattern to new level through turbulence, a paradigm shift occurs and a new regularity establishes itself around the attractor. In the dynamical system of perception, the neural turbulence created by external stimuli is continually being constrained by perceptual pattern recognition.

Within the last few years, physicists like Roger Penrose have joined with scholars from other fields to gain insight into how this works. In the process they have stirred considerable controversy with the speculation that consciousness and quantum mechanics may share or be aspects of the same essential mystery. Penrose and anesthesiologist Stuart Hameroff, for example, believe that the turbulence that occurs at the subatomic level in quantum mechanics may in fact also influence events at the cellular level. Within the cell, they point to microtubules, delicate skeletal type structures that are capable of transmitting messages through vibration, and suggest that these might compose a miniature connectionist network operating on its own subcellular level of informa-

tion processing. Their vibration, capable of blocking out the noise of intracellular circuitry, may allow for an optimal turbulence of mind, they believe, by keeping open an optimal number of possibilities before settling into a single state. This, they believe, could ultimately explain such phenomena as creativity, intuitive knowing, free will, and the subjective unity of experience.[4]

Part of this reasoning is the recognition that the tradition of looking at systems locally, of isolating the mechanisms and then adding them together misses the overall gestalt that is the essential identity of the phenomenon. In recognizing that Chaos and instability are not the same thing, scientists have come to appreciate that what is locally unpredictable may be globally stable, and that "real dynamical systems play by a more complicated set of rules than anyone had imagined" before.[5] Above all, Chaos theory suggests especially that a different nonlinear logic and larger perceptual view is necessary to begin to understand the world, and that in life, the number of things that can be thought about in a strictly logical manner is actually very small. As vonOech points out, the most important things can't be approached from logical understanding, but can only be approached from "intuitive" perceptions—such as the phenomena of love or our concept of God.

Thus science, like the globe itself, continues to move away from linear logic and discrete thinking toward the gestalt. Instead of recognizing and embracing this fact, however, we still tend to dismiss the apparently illogical because we do not understand it and it does not seem to fit into preconceived systems of thought. Like the Chaos theorists, vonOech suggests that we suffer from a "right answer mentality" that is deeply ingrained and conditions us not only to accept the first answer that fits, but also to stop looking for the optimum one. He suggests that education makes us so uncomfortable with errors that we learn to fear making mistakes and avoid situations where we might fail. We then learn only privately, by trial and error. Yet we learn most successfully by actively exploring, looking for multiple answers and selecting the optimum answer, not the right one. The solution to most problems, he believes, comes from broadening one's perspective and from reframing the problem in new ways to take advantage of the mind's untiring efforts at connecting apparently unrelated knowledge, experience, and feelings. Intuitively, it combines disparate information into new patterns.

Howard Gardner, in *Creating Minds* also identifies the creative personality as characterized by traits of independence, self-confidence, unconventionality, alertness, ambition, and commitment to work, and by ready access to unconscious processes.[6] His research suggests that the creative mind works according to metaphors because they help us to

understand one idea through another. Its imagination is governed by a logic that is metaphorical, fantastic, elliptical, and ambiguous. It is characterized by the ability to recognize patterns and to play. In other words, creativity is perceptually oriented and only subsequently tempered by reason. Creativity, he believes, is a "special amalgam of the childlike and the adultlike."[7] Albert Einstein, for example, envisioned the theory of relativity after imagining a ride through space in a box.

Another example of the use of nonlinear thinking can be found in the practice and art of origami (literally "folded paper"). Often thought of as a child's game, most children in Japan begin to learn origami at two or three years old, a time when spatial skills are still developing. Professor Koryo Miura, who has used origami to solve problems related to designing and packaging hardware in space where tensile strength, flexibility, and compactness are essential, insists that the kind of thinking that origami involves not only produces more practical designs, but also can easily solve sophisticated design problems by utilizing visual perceptual skills and the parallel mental processing that perception affords. He has already used origami to solve some problems deemed impossible by classical Euclidean geometry, such as trisecting an arbitrary angle, and has designed a workable folding antenna for NASA for use in deep space. He has also solved the perennial problem of map-folding as well by utilizing an apparently foolproof parallelogram pattern that allows the map to fold easily, and only in one way.[8] Both inventions are based on the bifold of curves into parallelograms, which is basic to origami.

George M. Prince, who teaches executives and others how to creatively problem solve, also stresses this special amalgam. His company, called Synectics from the Greek meaning "the bringing together of diverse elements," applies techniques of innovative thinking within practical contexts, and alerts managers and executives to the pitfalls of routine thinking—which although it is logical and predictable, is also linear, low risk and essentially uncreative. Creative thinking, however, is characterized by uncertainty and impracticality, and develops new constructs and new solutions by linking apparently illogically connected components. To stimulate creative thinking, Synectics trainers promote mental trips into the seemingly irrelevant and stress analogy and thinking in visual metaphors.[9]

Images therefore come in all forms and levels of meaning. Realistic art images, for example, not only reflect the reality of the external world, but also act as a kind of visual shorthand for expressing a mental image of the universal character of what it is like to be in the presence of what is represented. Even in the most literal image representations, we experience something of the perception of the artist, making the image an

inner as well as outer construct. Even verbal metaphors construct mental images that capture some aspect of similar experience imbedded in the essence of apparently disparate things. Symbolic visual and verbal images project a deeper reality than the one perceived, but even symbolism is constructed through processes that parallel perception and is therefore discernible only through perceptual rather than rational logic. As researcher Martha J. Farah has stated, "the [mental] imagery system shares representations with perceptual processes in the brain,"[10] utilizing the same brain structures as seeing, including the occipital, temporal, and parietal cortex.

Although many higher perceptual and cognitive functions are hemisphere-specific and "imagery and verbal thought depend upon at least partially distinct neural processes,"[11] visual, verbal and mental images, tied to our experience of and in the world, are nevertheless experientially related—whether they reflect the superficial appearance of the world or a mental image abstracted from it. As religious historian and scholar Mircea Eliade has observed: "The world speaks in symbols, reveals itself through them. It is not a question of a utilitarian and objective language. A symbol is not a replica of objective reality. It reveals something deeper and more fundamental. . . . Symbols are capable of revealing a modality of the real or a condition of the World which is not evident on the plane of immediate experience."[12] Thoreau put it even more simply in *Walden*: "The maker of this earth but patented a leaf."[13]

In developmental experience, words not only come later than images, but they are also often inadequate in communicating it, precisely because they are removed from experience and therefore lack the immediacy and power of the real world's change and relativity. Brain imaging data reveals, for example, that thinking in images is different from thinking in language, and imagery and verbal thought have different behavioral consequences.[14]

In discussing the science of "fuzzy logic," Bart Kosko, one of its leading components and popularizers, comments that

> Language ties a string between a word and the thing it stands for. When the thing changes to a nonthing, the string stretches or breaks or tangles with other strings. "House" stands for a house even after the house falls apart or burns. Our world of words soon looks like a fishing boat that drifts with thousands of tangled and broken lines.[15]

His thinking derives from the observation that, although much of science, math, logic, and culture has faith in a bivalent logic that categorizes into

things or not-things, and assumes that things do not change, in reality things are rarely if ever all or nothing, and everything changes. As scientists and computers talk in binary terms of 0s and 1s, the truth lies in between, in a "fuzzy" area that mirrors the flexibility and change of experience rather than the brittle linearity of grammar and dictionary. In reality, we use only approximate meanings of words, sentence fragments, and a great deal of facial, postural, and gestural expression to convey meaning in everyday interactions. Only in the most formal situations of writing or speaking do we use the system of formal language in a logical, linear way. When we do rely on totally verbal expression in print material and in formal speeches, we find that meaning is lost at an alarming rate, as the world continues to evolve and precise meaning is lost.

T. S. Eliot in his masterpiece *The Four Quartets* wrote that words by their very nature, "strain/ Crack and sometimes break under the burden" of communication. Their meaning slips and slides. Their substance decays into imprecision. Under the tension of communication their import sometimes perishes altogether.[16] In present experience as in the recesses of the unconscious that contain the evolutionary development of humankind, it is images, not words, that communicate most deeply. The depths that images reach are both profound and elusive to language. At best, Eliot observes, words are but "a raid on the inarticulate"; each attempt to use words to express the ineffable is a "different kind of failure."

This is why images hold a such a privileged position not only in poetry but also in relation to our innermost beings. What visual images express can only be approximated by words, but never fully captured by them. Words represent an artificially imposed intellectual system removed from primal feeling; images plunge us into the depth of experience itself.

Primal Invariance: Cave Art to Comics

This is perhaps why visiting the earliest images created by humans is such a powerful, even mystical, experience. In the French caves of Lascaux, Altimira, and in the more recently discovered Paleolithic caves near Avignon, images of mammoths, bison, woolly rhinoceroses, panthers, and owls emerge from the irregular stone walls in natural earth pigments of red, black, and ocher. With their extraordinary fluidity and delicacy of shading it is difficult to think of these images as crude or unsophisticated; rather they are primitive only in the sense that they are basic, primal, and produced with uncomplex methods, such as mixing paint in the mouth and blowing it on. The irregular surfaces of cave walls are often also incorporated into the artwork, giving it a 3-dimen-

sional life. Some researchers have also suggested that Ice Age cave art may very well have played a significant social role in the form of "elaborate ceremonies" rivaling "the best modern-day multimedia displays."[17] The presence of flutes made of bird bone near the paintings suggests that music may have been a part of the viewing experience, while in areas where sound would not carry typically have no art. Likewise in places in Lascaux where cave art is dominated by hoofed animals, acoustics allow a clapping noise to echo back and forth across the walls creating sounds similar to a stampede. In spots where images are dominated by stealthy creatures like panthers, sound is reflected in a more muted fashion.[18]

Whether they are the work of shamans or artists, their location alone makes it clear that they reflect a privileged entry into a perceptual "other world" and are part of a story of Cro-Magnon man that is now mute. Focused and distilled essences, the images are far from crude. Rather, their simplicity captures and amplifies human experience. The fact of their production on surfaces in remote labyrinths beneath the earth also suggests that they were invested with some kind of special ritual power—perhaps in the same way that naming something gives one power over it, or that primitive imitative magic attempts to manipulate natural elements. It is this power that transforms cave images into symbols and ultimately connects them with spiritual experience. Mircea Eliade observed: "For primitives, *symbols are always religious, since they point either to something real or to a World-pattern*. . . . A religious symbol not only reveals a pattern of reality or a dimension of existence, it brings at the same time a *meaning to human existence*. . . . A religious symbol translates a human situation into cosmological terms, and vice versa; to be more precise, it reveals the unity between human existence and the structure of the Cosmos."[19]

Although the word "image" is related in its root to the Latin "imitari" implying a copy or reference to the thing portrayed, the view of art as a mere imitation of nature may be a prejudice traceable to Greek art, and applicable only to a limited number of images. Just as the eye is not a passive camera, so images are never merely replicas, but often reflect deep and significant processes in the psyche. In *Art and Illusion*, for example, E. H. Gombrich suggests that "an earlier and more awe-inspiring function of art . . . did not aim at making a 'likeness' but at rivaling creation itself."[20] He gives the story of Pygmalion—in which the artist's marble statue is turned into a living woman by Venus—as an example of the perennial relationship between the creator of art and the work created. In this view, inspired by Alberti, the roots of art lie not in imitation but in psychological projection, just as humans have always projected forms into constellations in the night sky.

This is similar to Aristotle's notion of 'entelechy,' whereby the universal impresses itself on what is essentially shapeless, endowing it with its essence and thereby its direction for self-fulfillment. This projection suggests an active creation and participation in the process of life, whereas the image as imitation removes the mind of the observer from the equation, and reduces art to merely passive copy skill. When the mind of the observer is ignored, the transcendent power of analogy is likewise nullified. In simile, metaphor, and symbol, we find the essence of perceptual logic, that which separates our own intelligence from that of the machine, and above all, that part of our innermost being that reaches out to the stars.

Rather than a poor replication of nature, primitive cave art may be seen as part of a creative effort that reduces experience to its skeletal character and may in fact reflect a highly developed perceptual style, speaking worlds without words—like the wryly sophisticated cartoons of *The New Yorker* magazine, which in a few drawn lines capture layers of nuance. Moreover, such images often carry profound cultural meaning or suggest stories told with wit and intelligence through symbolism or metaphor. Paralleling the process of perception itself, such images reveal a contempt for indiscriminate attention and for superfluous detail; they eschew the irrelevant and reveal the pattern that emerges only from essential characteristics in synchrony.

Like the "key frames" which are pulled from films to act as advertisements for them, or the punch lines of well-worn jokes, a few judiciously placed lines can render a whole cultural story, complete with values, attitudes, lifestyles, and even myths—provided, of course, that they capture significant invariant characteristics. Consider, for example, a simple contemporary cartoon drawing of the late President Richard M. Nixon with an elongated nose and the caption "I am not a crook." In a caricature consisting of several pencil lines, not only is a real person in real time instantly recognizable, but an ironic disparity between the public image and the political reality is also made clear by drawing on the myth of Pinocchio, culturally disseminated through both books and Disney films. So characteristic are the features of such an image, particularly because Nixon's nose was a prominent feature in reality, that it is fairly easy for the reader to conjure the image mentally even without ever having seen it.[21] The superimposition of the mythic onto the literal creates an immediately recognizable irony that words cannot express as succinctly or as well.

In the "primitive" images of both cave art and satiric cartoons lies the essence of something "basic" and "primal," as well as a power derived not from imitation but from characteristic perceptual "invari-

ants," that is, from those characteristics—like the stripes and four legs of a zebra—that remain the same despite fluctuations in movement or change in perspective, and that allow us to recognize characteristics within a variety of circumstances. That simple lines alone have the power to evoke strong perceptions may derive at least in part from the fact that an essential part of perceptual process is the presence in the visual cortex of orientation detectors attuned to different angles. Together columns of same-angle detectors form a "map of orientation" as well as a map of the visual world.[22] Thus the process of reduction utilized by primitive drawings is not only compatible with, but also an essential part of, the functioning of perceptual process.

The perceptual power of the image may also be seen in its ability to dominate the written or spoken word when they appear together. Both written and oral forms of language must be cognitively processed first, whereas the image is perceptually processed along the same alternative pathways as direct experience. The image is therefore capable of reaching the emotions before it is cognitively understood. The logic of the image is also associative and holistic rather than linear, so that not only does the image present itself as reality, but it also may speak directly to the emotions, bypassing logic, and works according to alogical principles of reasoning. When an image is combined with words as in a comic strip, the words become secondary but the language of images remains primary. Words become "welded to the image and no longer serve to describe but rather to provide sound, dialogue and connective passages . . . Artwork dominates the reader's initial attention."[23]

This is essentially the same observation made by politicians when they supply television news editors with implicitly positive images. Whether the spoken narrative is positive or negative does not matter. The audience will attend to the image, rather than to what the reporter says. In a television interview by Bill Moyers, for example, reporter Lesley Stahl commenting on the Reagan campaign, revealed that at first,

> We just didn't get the enormity of the visual impact over the verbal
> . . . It was a White House official who finally told me . . . I did a
> piece where I was quite negative about Reagan—yet the pictures
> were terrific—and I thought they'd be mad at me. But they
> weren't. They loved it and the official outright said to me, "They
> didn't hear you. They didn't hear what you said. They only saw
> those pictures." And what he really meant was it's the visual
> impact that overrides the verbal.[24]

Image Affordance

An understanding of the nature of images, therefore, begins with understanding the inherent relationship between perceptual process and image formation, and in extending this concept into the realm of thought. Reading the image implies a reasoning based in human experience, since what is meaningful in thought is motivated by living within the real three-dimensional world environment. E. H. Gombrich saw the power of the image as lying in "the similarity between the mental activities both [nature and the manufactured image] can arouse, the search for meaning, the testing for consistency, expressed in the movement of the eye and, more important, in the movements of the mind."[25] To perceive the world, to grasp the meaning of a drawing, and to create a satirical image: each of these depends on the grasp of essential characteristics and the implications of these as symbolic—that is, as they suggest relationships or tell a story.

In everyday perceptual experience, the essential characteristics that define the essence of things, which Gibson called "invariances," become meaningful through their "affordances"[26]—that is, through what they offer us as useful within our everyday experience. Affordances may be defined as attributes of things within the environment that assert themselves to our consciousness by their potential utility or danger. Thus chairs become significant to us because they invite us to sit on them, while for the Cro-Magnon hunter, horns of animals meant the possibility of becoming impaled. Because an animal's horns probably represented the greatest danger to primitive humans, they not only became prominent features within cave art but also often seem to be exaggerated in size or elongation as well.[27] Created images thus amplify what is of significance to humans by paring down superfluous detail and by focusing on what is meaningful in experience. Readers of images in turn derive meaning by drawing on their own experience.

Affordances are thus not only an integral part of the essence of the thing, they are also intrinsically what anchors symbols to the real world of human experience. When they are exaggerated, it is because that is the way they are naturally perceived, or because that is the way the artist wishes their significance to be understood. This is why hungry people are prone to overestimate the size of a steak and victims of violent crimes may overestimate the size of their attackers. In subsequent images depicting the "reality" of such experiences, the salient features that reflect basic needs and fears may be projected through images that stretch or ignore pictorial reality to make it conform more to felt experience. In this way, "affordances" expressed within images become keys to understanding. Transfer of meaning from artist to viewer relies on a

common sharing of perceptual process and image affordance. Children's art gives us ready examples of how this works.

Children's artwork tends to focus on the general characteristics of the thing portrayed, to ignore perspective and to lose or gain features depending on their significance. Because the round shape of a chair seat is its affordance, for example, its shape may be registered in a child's drawing not as an oval, which would be consistent with perspective, but by its invariant round affordance. As psychologist Piaget has confirmed in his predicted stages of childhood development, only later does the child use "realistic" perspective to distort the shape that it knows to be round.[28] As Arnheim puts it, "If one wishes to trace visual thinking in the images of art, one must look for well-structured shapes and relations, which characterize concepts . . . the young mind operates with elementary forms . . . instead of showing a mechanical, though clumsy adherence to the model the drawing testifies to a mind freely discovering relevant structural features of the subject and finding adequate shapes for them in the medium of lines on flat paper."[29]

For a child drawing a picture of a person, for example, an oval may prove adequate to suggest the body. Two sticks are sufficient to depict legs because stick legs both afford support and are characterized by the quality of straightness. Hands and faces will often be depicted in more detail, not only because the senses are functionally important but also because facial expressions provide the most significant signals that pass between human beings. In our internal neurological maps, the face—particularly the lips—takes up a disproportionate amount of neurological space in relation to other parts of the anatomy, as do the ears, hands, and feet. So faces drawn by a young children often have eyes, nose, mouth, and ears, while the number of fingers may vary because they are irrelevant to what the hands do. (What child ever complained that the anthropomorphic Mickey Mouse had only four fingers on each hand?)

Even though young children's drawings may therefore look clumsy in contrast to the grace and fluidity of cave paintings, or naive and awkward in relation to the satirical cartoon, all reveal in their basic approach the perceptual affordances of shape, relation, and function in the things they portray. Neither the child's image nor the cave painting nor the caricature is "primitive" in the respect of being crude; all are as complex and sophisticated as perceptual process itself, and all show a profound grasp of the essential characteristics of the thing, revealing no more detail than is necessary to make the point, and including only that detail that is meaningful within the context of the action or situation.

When we see that a bison is painted with five legs, we may not presume a logic imposed by traditional Western realism in art. Arrested

in the course of running, the bison image may both anticipate the moving images of film and reveal an essential characteristic that is functionally important to the Cro-Magnon hunter encountering it. When linear perspective is ignored, we cannot assume it reflects lack of skill but rather that it reflects a perceptual sophistication closer to integrated experience. In the world of perspective in Western art, attention is paid merely to the appearance of the thing, whereas in the "naive world," images take on meaning through experience.[30]

<div align="center">Inner Necessity</div>

Plato insisted that art was an imitation and therefore twice removed from nature and inherently dangerous, but his student Aristotle perhaps more astutely recognized in art something that revealed the universal essence of the thing. The "inner necessity" which he proposed for drama is precisely that force that creates of the image a gestalt: "Of fundamental importance," Wertheimer noted,

> is the difference between processes whose factors are externality and adventitiousness and those exemplifying genuine meaningfulness. The processes of whole-phenomena are not blind, arbitrary, and devoid of meaning—as this term is understood in everyday life. To comprehend an inner coherence is meaningful; it is meaningful to sense an inner necessity . . . Meaningfulness obtains when the happening is determined not by blindly external factors but by concrete "inner stipulation." . . . a whole is meaningful when concrete mutual dependency obtains among its parts.[31]

In perception and in art, a meaningful whole is created and characterized by the *relationship* of the parts to each other. When all of the elements come together, their mutual influence creates a different entity held in balance by internal forces, which include the past experience and current needs of the person creating it. Psychologists, for example, can exploit this balance, or the lack of it, in the images of the Rorschach test, which reveals the "stress which needs exert on perception."[32] Its ambiguous images point the way to the nature of patients' personality problems when patients project onto them their own inner needs, giving them palpable form.

Art therapy, too, uses the creation of images to reveal inner disharmony and to bring forces that are out of "sync" in the person's life into conscious awareness. In this form of therapy, the client creates a picture with an inherent story; in the images, dominant aspects and affordances

depicted tend to bring to the foreground the essential characteristics of personal emotional dilemmas and to reveal to both client and therapist the forces that figure predominantly in the individual's mental struggles. Just as the nature of inner disharmony may be revealed in expressionistic images or read into ambiguous ones, conversely, intellectual harmony may reveal itself in the power to see in an image or verbal argument a basic form and the primary concepts that support it, and thereby spot internal inconsistencies or irrelevancies.

Whether in psychiatry, art, or rhetorical argument, the role of the astute critic is to reveal the essential shape of the thing and to determine how the detail presented functions integrally or not. Inner necessity is the key to understanding the logic of images because it is through it that things come to make sense, and therefore become imbued with the feel of inevitability or appropriateness—whether in the realm of the perceived image, the pictorial image, or ideas. Both perception and art are founded in the formation of hypotheses and the appropriate resolution of ambiguity. "Art is exciting," Gregory observes, "because our perception cannot quite follow where it is going. This bears analogy to the excitement of trying to understand things intellectually. . . . Both art and science can change, and enormously enrich, our perceptual hypothesis of the world and of ourselves."[33]

As gestalts, both visual and mental images synthesize portraits of reality in which inner needs are integrated with outer realities; the same process applies for both percept and concept. In this way, for example, Edvard Munch's famous 1895 lithograph *The Scream*, may be seen as a caricature because of its stylistic approach. It may also, however, be read as an abstract metaphor of existential human anguish, an anguish whose depth is beyond words and whose particular details are unimportant in the context of overwhelming horror. The face in "The Scream" bears close resemblance, in fact, to depictions of the God of Death in ancient North American rock art petroglyphs. As Arnheim observed, "Perceiving consists in the formation of 'perceptual concepts' . . . [There is] a striking similarity between the elementary activities of the senses and the higher ones of thinking or reasoning . . . the same mechanisms operate on both the perceptual and intellectual level . . . Eyesight is insight."[34]

This equation of eyesight with insight is critical, for it undermines a long history of belief that the senses are merely passive recipients of information from the environment, as well as the related conviction that because the senses are often in error, sensory input must be tested and corrected by reason—which is assumed somehow to be outside of the sphere of the senses and therefore to remain uncontaminated by them. As discussed in Chapter 1, however, it is now clear not only that reason

is heir to many errors, but that there is an inherent wisdom and enormous creative potential in nonlinear thinking as well. Arnheim's view recognizes that both perception and abstract thought imply image-making and that both are firmly grounded within human perceptual experience.

This contention—one shared by other leading perceptual psychologists, cognitive psychologists and communication researchers[35]—belies a dichotomous view of percept and concept and asserts that perceptual process itself reveals the logic which operates in both perception and cognition. (Arnheim defines the cognitive as "all mental operations involved in the receiving, storing and processing of information: sensory perception, memory, thinking, learning."[36]) This logic is primarily holistic rather than linear, and it moves along a spiral continuum of widening complexity, creating more comprehensive wholes and more abstract concepts at the same time as it moves from undifferentiated mass to greater and greater discrimination.

Persistent to the present day, the false thinking that separates perception from conception, which relegates perception to an inferior position, and which places concepts in the realm of propositional reasoning rather than parallel to percepts governed by the same processes, has resulted in a panoply of erroneous ideas—many of which have been treated in the first chapter. Chief among them, however, are that we are preeminently rational beings in control of our own thoughts, that our beliefs are founded in reality, and that linear logic can be used as the acid test for the truth of various postulates.

Perceptual process seems to reveal a deeper folk wisdom by which we make experiential judgments in tune with our evolutionary development. Sometimes in error, perceptual process allows us to assume cause and effect when there is mere association; we rationalize apparently logical reasons for what we have thought or done even when our thinking processes lie hidden from our understanding; and when stressed, we can act in the most bizarre fashion and become convinced of the most preposterous ideas. Sometimes transcendent, however, perceptual process also allows us to make connections and to discern significance, to find the eternal in the transient images of art, and to shape patterns of thinking into philosophical insights that give meaning to existence. Always, however, the logic of perception moves in ever-widening metaphors, stretching the boundaries of linear logic through analogy, expanding understanding through symbols, and arriving at places where neither experience nor imagination has ever before traveled.

From seeing the concrete shapes of trees in the external world to grasping the complex relations implicit in the inner dynamics of the

double helix of DNA, the shape of the image is formed, as a gestalt is formed, by grasping the essential shape of the thing and by filling in as much detail as is required to have the thing make sense. Like the singular body cell whose core of DNA contains millions of pieces of information, and which works in tandem with other cells to form organs and ultimately human beings, the image is the universal in the particular. DNA may be said to be the image of what the human being is destined to be, just as Aristotle believed that the universal impresses its image onto undifferentiated mass to create the forms of all things. The essence of the gestalt, of DNA imagery, and of Aristotelian entelechy is that the image ultimately gives rise to the course of its own self-fulfillment. Every form of creative endeavor and higher nonverbal thinking depend on the image.

Mental Imagery

Anthropologist Randall White correlates the explosion in technological progress in Europe about 35,000 years ago, which was characterized by stone tools and bone implements, with the development in homo sapiens of "an increased ability to think in—and communicate by means of—specific visual images."[37] This ability to think and communicate in images, White states, allowed humans to think in a three-dimensional way to solve various problems, first by abstracting a concept such as "pointedness" or "barbedness" from the environment, and then by visualizing designs such as a barbed spearpoint to use in hunting animals. He believes that it is the capacity for visual thinking combined with the consequent manipulation and sharing of images that has been responsible for our rapid evolutionary development as a species.[38]

The leap into visual thinking that White describes is particularly significant in understanding the nature and power of mental images because it effectively combines Gibson's concepts of affordance and invariance with Marr's concept of vision as a three-step process, beginning with a primal sketch in which an outline is discerned and ending with the realization of external three-dimensional depth. Visual thinking, then, can be seen as the extension of perceptual principles into the world of social discourse through metaphor.

This basic ability to think in images is indeed characteristic of some of the greatest thinkers in our own time, such as Albert Einstein, who confided to his friend Gestalt theorist Max Wertheimer that "thoughts did not come in any verbal formation. I rarely think in words at all. A thought comes, and I try to express it in words afterward."[39] In developing the General Theory of Relativity, for example, Einstein imagined a

free-falling glass elevator in which the operator drops a compact and a lipstick.[40] Nikola Tesla, the great inventor, was also a visual thinker, and built entire turbines in his mind, correcting his own design flaws before they were even built.

Brooke Hindle points out that in fact all the great industrial inventors thought in images. There is, he believes, no coincidence in the correlative appearance of both the world's first representational images and the phenomenal technological and social innovations that accompanied it.[41] In her book *Thinking in Pictures*, Temple Grandin reveals the process by which she has designed the equipment for handling cattle and hogs that has made her one of the world's most respected systems designers for the humane treatment of animals. "When I invent things," she says, "I do not use language. Every design problem I've ever solved started with my ability to visualize and see the world in pictures."[42]

An autistic who has successfully overcome most of the limitations associated with autism, Grandin believes that one indicator that visual thinking is the primary method of processing information is the extreme ability of many autistics to solve jigsaw puzzles and memorize enormous amounts of information at a glance.[43] Several well-known autistic artists, in fact, have utilized this visual ability to great advantage, producing extraordinary works of art after only a single glimpse of their subjects. Alonzo Clemons, a gifted sculptor from Boulder, Colorado, who works as a custodian at a local YMCA, for example, is a prodigious savant whose talent appeared after a serious brain injury in his childhood which left him with an IQ of about 50. Like Grandin, Clemons "photographs" the image of the animal he will sculpt and within an hour, he produces exquisite sculptures that command up to $45,000 in the Aspen gallery where his work is shown. Stephen Wiltshire, an untrained English prodigy whose drawings showed sophisticated line, perspective, and sensitivity to detail by the time he was seven years old, is typical of the type of autistic for whom Dr. J. Langdon Down coined the term "idiot savant" in 1887. With a prodigious visual memory, given only a moment to glimpse a scene, Wiltshire since childhood has been able to reproduce the most detailed architectural drawings of buildings with fidelity and ease. Within a glance, he is able to take in everything, hold it in memory, and draw it in a single line.[44]

Experiments with eidetic imagery in otherwise average children show, too, how close mental imagery can be to perceived images. When an "eidetiker" is shown a picture that is then quickly removed from view, the person will retain an "eidetic image" of it in his or her mind as if it were still there, floating in space. This eidetic image is complete and sharply detailed and may persist in the "mind's eye" for up to ten

minutes after the initial picture is removed. Directing their eyes to particular parts of the projected image when questioned, and scanning in the same manner as they would an ordinary image, "eidetikers" will report seeing details that may even have gone unnoticed on initial exposure to the image. Visual in nature, eidetic images seem to employ the same mechanisms as actual perception, even though the initial visual stimulus is absent. Haber notes that these images are not retinal in origin or memory dependent; they are, however, mutually exclusive with verbal memory, and when parts of the image are verbally described, they disappear.[45]

Although eidetikers are rare and most are children, the ability to call up visual imagery in a less vivid form in the average person is easily tested, Julian Hochberg suggests, simply by asking people to count mentally the number of windows in their houses.[46] When they attempt to do this, most people will move their eyes in accordance with their mental image in the same way eidetikers will, moving from one window to the next along the top and bottom floors until all four sides are covered. Often they will point as they move from one to the next. In experiments where patients have visualized taking a walk through their neighborhoods, researchers have found that blood flow increases to precisely those areas involved in actually seeing them.[47] In other experiments involving brain damaged patients visualizing particular points of view within a well known geographical area, other researchers have found that patients omit details from their mental descriptions that their injury would also prevent them from seeing in reality.[48]

Even in dreaming it has been found that there is a correspondence greater than chance between rapid eye movement (REM) in dream sleep and the imagined activity within those dreams. Neisser reports a case in which one dreamer, whose eye movements showed a rapid upward deflection just before awakening, reported dreaming that he had just been climbing five stairs.[49] It seems that when we mentally imagine a visual scene, our eyes and brain act as if we were looking at the scene in reality, correlating mental imagery to perceptual process. Dream images, though often vague, sometimes have the character of eidetic images, with the effect that when they are filtered through memory, we sometimes can recall their vividness so clearly that we become confused about whether something really happened or it was a dream.

At the most basic level of perception, attention is governed by change or movement and affordance. In order to survive, we have learned to pay attention to change and to potentially fear it as we make sense of the situation. We attend to anything that disturbs the nonchange in the environment and to those characteristics that present themselves favorably for our use or unfavorably for our survival. Even at the most

sophisticated level of cognitive abstraction, our attention is focused on affordances and on those patterns and relationships that enable us to understand the environment and to predict change efficiently.

This necessarily implies analogy, our basic means of extending former experience into the future and of creating understandable images for others. Analogy through metaphor or symbol is not only the basis for perceptual learning but also the form of communication between the conscious and subconscious mind. Answers to abstract problems that haunt us, for example, often take the form of metaphoric and symbolic images, such as occur in dreams or when we allow our subconscious to take over the problem, and the solution seems to come in a flash. One of the most famous examples of this is the nineteenth-century chemist Kekulé who, when puzzling over the molecular structure of benzene, dreamed the solution in the symbolic form of a snake with a tail in its mouth, which Kekulé translated correctly in chemical terms as a closed carbon ring.

Freud's genius recognized perhaps most clearly that the subconscious speaks imagistically: "Thinking in pictures . . . approximates more closely to unconscious processes than does thinking in words, and is unquestionably older than the latter both ontogenetically and phylogenetically."[50] From his experience with patients, particularly with "hysterical" paralysis cases, as in his colleague Josef Breuer's famous case of "Anna O," Freud saw the power of the subconscious to frame psychological problems and thereby to suggest its own solutions through symbolically manifested psychosomatic ailments. In the images that recur in dreams he recognized basic patterns, particularly in terms of repression and wish fulfillment, and came to believe that images were the medium of "primary process thought" characteristic of early childhood, before the superimposition of language and logic.

His protégé Carl Jung ultimately came to see in dreams something more than the mere manifestations of unresolved problems or the characteristics of wish fulfillment. For him images were symbolic stories told by the unconscious which, like conscious perception, was essentially a creative force rather than merely a passive recorder and stockpiler of experience. According to Jung, "Images and ideas that dreams contain cannot possibly be explained solely in terms of memory. They express new thoughts that have never yet reached the threshold of consciousness."[51] In this sense, the unconscious is truly imaginative: "Imagination," Jung insists,

is active, purposeful creation. . . . active imagination means that the images have a life of their own and that the symbolic events

develop according to their own logic—that is, of course, if your conscious reason does not interfere. . . . We can really produce precious little by our conscious mind. . . . We depend entirely upon the benevolent cooperation of our unconscious. If it does not cooperate, we are completely lost. Therefore I am convinced that we cannot do much in the way of conscious invention; we over-estimate the power of intention and the will. And so when we concentrate on an inner picture and when we are careful not to interrupt the natural flow of events, our unconscious will produce a series of images which make a complete story.[52]

In addition, dream images function as a bridge between conscious thought and "a more primitive, more colorful and pictorial form of expression."[53] As they move into the realm of the conscious and become understood, Jung believed, they take on a creative form and actively contribute to the maturation of the individual.[54] Often he encouraged patients to express themselves in drawn or painted images, believing that the production and examination of images aided patients in producing their own cure. Most recently, neurological researcher Rodolfo Llinás has proposed that there is a constant interplay of image and feeling in both dream and waking states between the cortex and the thalamus, which is independent of the sensory input associated with conscious awareness. Waking in this view is really just another dream state, except that it is subject to correction by the images of external reality. Waking consciousness is initiated by sensory input.[55]

In addition to the images of the personal unconscious, Jung also posits a hereditary, impersonal, and shared collective unconscious, which similarly expresses itself in archetypal images and depersonalized motifs that represent the primordial thoughts of the human species and correspond to common human needs and to "typical situations in life."[56] As such, archetypal images such as the Hero, the Redeemer, and the Dragon create the myths, religions, and philosophies characteristic of specific cultures, and even of whole historic epochs.[57] Eliade observed:

Symbolic thinking is not the exclusive privilege of the child, of the poet or of the unbalanced mind: it is consubstantial with human existence, it comes before language and discursive reason. The symbol reveals certain aspects of reality—the deepest aspects—which defy any other means of knowledge. Images, symbols and myths are not irresponsible creations of the psyche; they respond to a need and fulfill a function, that of bringing to light the most hidden modalities of being. Consequently, the study of them

enables us to reach a better understanding of man—of man "as he is," before he has come to terms with the conditions of History. Every historic man carries on, within himself, a great deal of pre-historic humanity.[58]

The forms that these images and motifs take will correspond to local traditions and myths, but the patterns they relate will be universal to the human situation. According to Joseph Campbell, they represent the "permanent conditions" of the psyche as they relate to the temporal conditions of life in the present.[59] "All the gods, all the heavens, all the worlds, are within us. They are magnified dreams, and dreams are mani-festations in image form of the energies of the body in conflict with each other. That is what myth is. Myth is a manifestation in symbolic images, in metaphorical images, of the energies of the organs of the body in con-flict with each other."[60]

To Timothy Ferris, the persistence of the mystical doctrine of cosmic unity that has persisted throughout the ages and been endorsed by the finest human minds, suggests that "the doctrine has more to do with the internal architecture of the brain than with the phenomena of the outer universe" and that "the doctrine of cosmic unity arises from the very mechanism that makes a unified mind out of the disparate parts of the human brain."[61] He proposes that true spiritual or cosmic enlight-enment occurs when introspection breaks through the level of language in the verbally persuasive and logic-oriented "mental module"—compa-rable to Gazzaniga's Interpreter—which is responsible for his unified sense of being. At this point, the mystic begins to perceive in images, abandoning logic and words to reach the heart of the program that unifies human thought.[62]

Beyond the realm of mystic images, however, lies madness: "If one could break through the integration program altogether," Ferris states, "the result might be direct exposure to the cacophonous voices of many inharmonious programs, speaking in a wild diversity of codes for which we have as yet no translation—and *that* hazardous voyage might well rob any but the most adept explorer of his sense of a coherent self and a coherent universe."[63]

In Jung's portrait of the psyche, archetypal images also play an important role in reflecting the harmony essential to mental health and functioning. Part of what Joseph Campbell called a "self-regulating psychic system," Jung's mystical mandala (Hindu for "circle") symbol-izes both cosmic unity and personal harmony. An archetypal image, it is the source of illumination and is therefore both corrective and prospec-tive in nature. The mandala has been used by the Navaho Indians to

restore individual health, in meditation to focus consciousness, and as a symbol of the center of the landscape of the soul.[64] All archetypal images, Jung believed, arise from the deepest part of the human psyche and "point forward to a higher, potential health, not simply back to past crises."[65]

The concept of using of mental imagery to bring the body and mind into the holistic balance and harmony of the cosmos, is therefore predictably one of the oldest medical practices known to humankind. Mary Baker Eddy, who founded the Church of Christ, Scientist, in America in the nineteenth century, used visualization and prayer to heal herself of injuries suffered in a fall. During her convalescence she came to believe that illness is an error of mind and that health could be restored by correcting the mental error and calling on the Divine Mind.

The understanding of the power of visualization gained wide popular acceptance in the 1950s with the publication of Norman Vincent Peale's *The Power of Positive Thinking*, which uses visualization to create a positive mental picture of achievement, and in the 1960s with Maxwell Maltz's *Psycho-Cybernetics*. Both books have remained at the top of best-seller lists for long periods, and it is not an exaggeration to say that their central theme—that you will become what you visualize yourself as being by sending messages to your subconscious—has spawned whole cottage industries of self-help books and motivational tapes throughout the United States and Europe, in areas ranging from weight loss to real estate development. The most significant areas of impact, however, have been in business strategies, sports, and medicine.

In business, the idea of belief in a vision has taken on the significance of a megatrend in the last decade, as leaders have come to realize the importance of creating a unified corporate vision sufficient to motivate associates and employees. One function of corporate advertising, for example, is to define the corporation image not only to the public but also to employees themselves so that they can project this image consistently to consumers. The slogan "Fly the Friendly Skies of United" not only tells the public that aircraft attendants will be helpful but also lets all its workers know that they will be expected to act in accordance with a certain attitude. Without a common mental image of what the company is all about, employees tend to focus only on their individual job responsibilities. But as business watchers Naisbitt and Aburdene comment, intellectual strategies alone cannot motivate people to hard work, that "only a company with a real mission or sense of purpose that comes out of an intuitive or spiritual dimension will capture people's hearts. And you must have people's hearts to inspire the hard work required to realize a vision."[66]

Among the companies Naisbitt and Aburdene cite that have successfully instilled a vision in workers and customers are Cray Research, Apple Computer, Control Data, and Federal Express. Cray Research is responsible for the world's most powerful computers. Apple Computer grew from a garage to the major competitor of IBM in personal computers through the idea of ease of use for the average person. Control Data's mission is to address society's major unmet needs as profitable business opportunities, which has rejuvenated business in a variety of inner cities, trained disadvantaged people and offered computer-based education in prisons. Federal Express began as the vision of Yale economics student Fred Smith of an air parcel service independent of passenger flights. It is worth noting that when Smith first outlined his vision in an economics paper, he received a "C" grade for it. At the core of it all is the simple realization that the visual image may be the most powerful tool that human beings have to direct the course of their own and others' lives.

In athletics, visualization techniques have been used both for developing a competitive mindset and for improving athletic performance. In a now classic study, for example, three groups of randomly chosen students took part in a basketball free-throw experiment in which the first group practiced free-throws for twenty days, the second group did not practice at all, and the third group practiced on the first and last of the twenty days, and in between visualized practicing for twenty minutes a day. At the end of the twenty days, the first group had improved their performance by 24 percent, the second not at all, and the third by 23 percent.[67] Jack Nicklaus says that his best golf shots depend only 10 percent on swing, 40 percent on setup, and 50 percent on his mental picture; Arnold Schwarzenegger insists that visualizing muscle contour helps to develop it.[68] Neurological researcher Donald Finke confirms this: "mental imagery can produce certain changes in visual motor coordination that persist even after the images are no longer formed," he believes, "the success of such mental imagery depends on clarity of detail and accuracy of performance."[69]

Such practice also has visible neurological consequences. In one study conducted at the National Institutes of Health, for example, patients taught a five-finger exercise on the piano showed a tripling in size of their brain's motor maps after practicing for only five days. For patients who only *mentally* practiced the exercise, the neurological results were the same. Because the same cell networks involved in performing a task are also involved in imagining it, and because the brain is extremely flexible and adaptable, visualization techniques may have far-reaching beneficial consequences for brain-damaged patients.[70]

Long-term medical studies done at Stanford University, the University of California at Berkeley, and the Cancer Counseling and Research Center in the 1970s and 1980s have also shown the impact of mental imagery on physical states. When counseling was included in cancer therapy in advanced cancer patients, survival rates were extended from two to three times longer than the national average.[71] As a result, most oncologists today recommend visualization exercises as a supplement to cancer therapy as a matter of course, encouraging patients to visualize the tumor and cancer cells being attacked and destroyed and to picture themselves becoming well and healthy. Because the mind not only gets messages from other parts of the body but also sends them, visualization can be thought of as a process of neurocommunication reaching into the immune system. Immune and brain cells are, in fact, in continual communication: peptides from the brain cause immune cells to proliferate; macrophages, immune cells that are the first to attack foreign cells, have been likened to "mobile synapses" that carry and release neuropeptides throughout the body. Some immune cells release peptides that affect brain functioning.[72] Thus visualization is one way to activate and direct the immune system.

Such visualization has been practiced by most American Indian tribes in some form, and has been a routine part of Eastern methods of healing from most ancient times. Even the "placebo effect" is a testament to the power of thought in self-healing, although it has puzzled Western physicians who have traditionally assigned cures to drugs and used placebos for control groups in medical experiments. What has been utilized as a supposed neutral stimulus may in fact be the reverse. According to Jerome Frank, for example, "Until the last few decades most medications prescribed by physicians were pharmacologically inert. That is, physicians were prescribing placebos without knowing it, so that, in a sense, the 'history of medical treatment until relatively recently is the history of the placebo effect.'"[73]

On the positive side, Frank cites cases of ulcers apparently cured by distilled water injections. On the negative side, violation of tribal taboos has been thought to bring about death without any apparent physical cause, the operative factor in such cases being belief. The medical technique of biofeedback utilizes basic yoga techniques to focus on a particular image and to will it to change as a means of lowering heart rate and blood pressure and controlling pain. Autogenic therapy, which involves meditative exercises in visualization of colors and abstract emotional states to boost the body's healing mechanisms, has also been shown to alter brain waves, increase white cell counts, and change blood sugar levels. Aware of the power of hypnogogic sugges-

tion, surgeons now are careful to make only positive suggestions to patients who are under anesthesia.

Metaphors of Mind

Today, perhaps under the spell of computer technoterminology, the mind is described by most neuroscientists as composed of modular processing units with specialized independent functions. Although how these units are interconnected is less well understood, some neurological researchers like Semir Zeki and Nobel laureate Francis Crick suggest that "neurons in the visual cortex fire in a somewhat rhythmical manner when they become active due to a suitable stimulus in the visual field" and that "neurons symbolizing all the different attributes of a single object (shape, color, movement, etc.) . . . bind these attributes by firing together in synchrony."[74] Zeki defines the task of the brain as one of extracting invariant features from the continually changing information from the environment to provide a unified image. He sees "no single master area" to which all the specialized areas of the brain are connected, but rather a temporal synchrony in which perception and comprehension occur simultaneously.[75]

Crick and other neural connectionists envision mind poetically, as John McCrone has commented, as the "outcome of patterns of impulses dancing across the synaptic connections that make up the circuits of the brain."[76] Crick suggests that the symphonylike correlation of these firings on or near the beat of gamma oscillation may be the neural correlate of visual awareness. He also believes that "there may be several forms of visual awareness [such as those suggested by Mann (from 2-D to $2^1/_2$-D to 3-D) and Biederman (geons)] and, by extension, even more forms of consciousness in general . . . [with] each level of visual processing coordinated by a single thalamic region."[77] Although some of his conclusions have been disputed by more conservative neurological researchers, Crick points to a particular region of the brain, the thalamus, as the location of the central processing unit (CPU, in computer jargon) that coordinates the various subsystems of awareness, just as Aristotle placed the location of the central synthesizer of "common sense" in the heart.

On the intracellular level, as mentioned earlier, some theorists like Roger Penrose and Stuart Hameroff are convinced that understanding the mind demands a new physics and ultimately a new metaphor to explain what they believe to be the quantum mechanics of consciousness. They pose an intracellular model of synchronic vibration by microtubules which, as structures with the right scale to act as amplifiers of submolecular quantum effects, may form the substrate for consciousness.[78] Thoughts and mental images, Hameroff believes, may occur when

"the coherence between the patterns rippling along the walls of a network of microtubules reaches a certain critical level."[79] In this scenario, memories would take the form of frozen wave patterns, and creative thought and intuition could utilize microtubule clusters lying in parallel in cells before "collapsing" into a single solution.[80] In this controversial model, communication occurs at two levels: between microtubules swapping vibrational signals within and between cells, and at the level of whole neurons swapping electrical signals.[81]

Perception, then, may be something very much like a neurological symphony, an ancient music capable of wonderfully new transformations of thought. Although the presence of "symphonic" patterns suggest a "hierarchy of processing units" with some exerting "some sort of global control over the others,"[82] this need not imply the presence of a conductor which exerts central conscious control over the way compositions are performed. Rather, Crick explains, it is the extrinsic *connections* of the specialized areas that determine which functions are performed. More like communications specialists than independent technical divisions, these processing units explain how experiments can show that the conscious mind *receives* information from the brain rather than *directs* it.

Timothy Ferris theorizes that the mind acts "not so much to tell the other units what to do as to try to make some coherent sense out of what they have already chosen to do . . . disguising a multiplicity of functions behind a unified facade." He describes our personal sense of unity and mental control as "an imperfect illusion, like the mechanical regent constructed by the Wizard of Oz."[83] The allusion to the Wizard of Oz is an apt one, for in the film the Wizard really is powerless to control those things he pretends to, but he has benignly fooled the people into believing that their wise and just ruler is the cause for what happens naturally of its own accord.

Michael Gazzaniga, a neuroscientist at Dartmouth College, envisions the brain as made up of constellations of semiindependent agents that carry on business as usual outside of our awareness. He calls the Wizard—the mind-regent program module—"the Interpreter," and describes it more as an after-the-fact type of public relations worker than a conductor—the subsequent synthesizer rather than the initiator of action. Its role, he believes, is to make prior decisions seem plausible *after* they are made, and to give the *illusion* that the conscious mind is in control when, in fact, it is not. In this way the Interpreter provides a subjective sense of individual unity—that is, a strong sense of self.[84] Existentially this makes perfect sense, since it is through our decisions that we come to evolve a sense of who we are. It is also fully compatible with Spinoza's view of rationality discussed earlier.

Famed criminal attorney and author Gerry Spence, who has been described as the most successful trial lawyer in the twentiethth century because he never lost a case, has commented similarly that "Jurors are too smart to be logical." Rather, he says, "They have a composite sense" that comes from the subconscious and combines all aspects of the case. When he talks to law students, he stresses that "linear logic by itself misleads. . . . We decide out of our gut and then we support it with our head."[85] Spence's remarks were made out of his own practical experience in the courtroom, but he might just as well have been speaking to the superiority of perceptual over linear logic and on behalf of Gazzaniga's mind model.

Another model on the functioning of the brain and mind which seeks to explain perception and the sense of unified being is the holographic model. Now a common special effect on such television programs as "Star Trek: the New Generation," the hologram probably first captured the popular imagination in the film *Star Wars* (U.S.A., 1977), where the hologram of Princess Leia speaks to Luke Skywalker. Simply stated, holograms are three-dimensional images that can be projected and walked around for viewing from different angles. They are produced when a single laser (an acronym for light amplification by stimulated emission of radiation) beam is split into two separate beams and the second beam is allowed to collide with the reflected light of the first. The hologram works on the principle of the interference pattern in waves, just as when the ripples in a pond created by two adjacent disturbances pass through one another when they collide in water.

The holographic image is created by capturing on a holographic plate the interference pattern created by the image and its reflection. Unlike the photographic image, which remains two-dimensional and frozen within a singular perspective, the holograph is three-dimensional, and gives the effect of a true window on reality, with the viewer of the image able to alter perspective. The perspective of the whole changes as we shift position because the image contains within each part of itself the unified whole. Thus, if a holographic image is broken into any number of pieces, each piece will contain a reflection of the whole image.[86]

First posited by Karl Pribram of Yale University in the 1960s, the holographic theory of mind suggests that vision, like memory, is not only distributed but also holographic, containing the "whole in every part." Pribram saw that the expanding ripples of electrical connections by neurons were continually crisscrossing one another in the same way holographic images were created, and he suggested that this kind of activity could account for the way memories may be recalled in whole or in part, as if we could walk around within them and resee the scene and

even resmell the odors. We envision the totality of persons and things that were present in the scene just as if we were reexperiencing them in a hologram.[87] Though this model is not widely accepted among neuroscientists, neurologist Richard Restak and others have described it as one of the least problematic models for how the brain works.[88] At the very least, it is an intriguing explanation for a variety of mental phenomena, particularly in vision at the neurological level where Fourier transforms can be used to explain the conversion of images into wave forms and back again.[89]

Of these various theoretical models, the metaphor most useful in explaining a unified sense of self as well as the impact of mental imagery on the unconscious is Gazzaniga's theory of the presence of the "interpreter," which receives and interprets information from the relatively autonomous other programs within the subconscious. Functioning independently, the Interpreter receives messages on what the subconscious is doing and then rationalizes these in retrospect—sometimes even with ridiculous excuses—to the conscious mind. The Intepreter will work, Gazzaniga believes, until it does make sense of what it receives, sometimes accepting the most improbable explanations just to have one.

In Gazzaniga's experiments in split-brain activity (i.e., in patients whose right and left brain have been severed surgically at the corpus collosum), for example, when the word "walk" is flashed only to the right side of the brain, the left hemisphere of the brain responsible for language in most people will not receive the message. When the subjects get up to go, however, they will respond to questions of why they are leaving with puzzlement or with a seemingly plausible reason ("to get a Coke"), even though it is unrelated to the true reason.

Although such scientific determinism might seem to preclude the philosophical concept of free will, researchers in Chaos theory use recent insight into the workings of dynamical systems to explain the coexistence of both. Although classical physics models assume that everything is determined by initial conditions, Chaos theorists have found nevertheless that such deterministic systems can and do generate randomness in a "spontaneous emergence of self-organization."[90] According to physicist Doyne Farmer,

> On a philosophical level, [the phenomenon of chaos] struck me as an operational way to reconcile free will with determinism. The system is deterministic, but you can't say what it's going to do next. . . . the important problems out there in the world [have] to do with the creation of organization, in life or intelligence. . . . Here was a coin with two sides. Here was order, with randomness

emerging, and then one step further away was randomness with its own underlying order.[91]

Born in the work of Edward Lorenz on weather systems at the Massachusetts Institute of Technology (MIT), Chaos theory began in 1960 in the metaphor of a butterfly—partly because of the three-dimensional shape that emerged from computer-charted elements when the system suddenly went into unpredictable turbulence resembles a butterfly; partly because of what came to be known as the "Butterfly Effect": the notion that a butterfly fluttering in the air today can initiate a storm system halfway around the globe next month.

Most important, Chaos theory has crossed the lines separating the various disciplines of science and turned the trend toward reductionism in science back toward looking for the whole and seeing more global patterns.[92] In 1980 Stephen Hawking, who then occupied Newton's chair at Cambridge University, commented in a lecture that "It is a tribute to how far we have come in theoretical physics that it now takes enormous machines and a great deal of money to perform an experiment whose results we cannot predict."[93] In his postscript specifically on "Free Will," in The Astonishing Hypothesis, Crick draws from the insights generally associated with Chaos theory to explain how it is that we can feel as if we are in conscious control when we are not: "such a machine" as the mind represents, he states,

> will appear to itself to have Free Will, provided it can personify its behavior—that is, it has an image of "itself." The actual cause of [any] decision may be clear cut, or it may be deterministic but chaotic—that is, a very small perturbation may make a big difference to the end result. This would give the appearance of the Will being "free" since it would make the outcome essentially unpredictable. . . . Such a machine can attempt to explain to itself why it made a certain choice (by using introspection). Sometimes it may reach the correct conclusion. At other times it will either confabulate, because it has no conscious knowledge of the "reason" for the choice. This implies that there must be a mechanism for confabulation, meaning that given a certain amount of evidence, which may or may not be misleading, part of the brain will jump to the simplest conclusion.[94]

Consistent with earlier discussions on the fallacies of rationality, the models proposed by Gazzaniga and by Crick suggest that most of what we do is controlled subconsciously, so that we turn our attention to

only those things of which we must be consciously aware, such as sur-
vival affordances. Thankfully, we are not aware of what the brain must
do to keep our hearts beating, or our body temperature relatively con-
stant, or even how it goes about perceiving the things around us. But the
Interpreter is also a window onto the subconscious as well as a receiver of
subconscious messages, and the models proposed by Gazzaniga and sub-
sequently by Crick and his coresearcher Koch suggest that visual percep-
tion may prove to be our most valuable metaphor in understanding how
the brain functions neurologically, how images reflect the power of the
subconscious, and how seemingly instantaneous gestalts and a pervasive
sense of holistic unity function as integral parts of consciousness.

Freud's pioneering work on the mind has already accustomed us
to the idea of a vast unconscious that is always at work yet inaccessible
to conscious thought, but because we are aware only of the conscious
workings of our minds, it is difficult to envision the organizational impli-
cations of having a hundred billion neurons firing in synchronicity in the
unconscious, working continually to build new connections of ideas, to
respond to the immediate maintenance needs of every body organ, and
to monitor the external world continuously to ensure our survival in it.
If, in fact, we were to become consciously aware of the inner workings of
our brains for just a few moments, we would either become paralyzed
by the overwhelming activity and noise, or driven to madness by the
simultaneous cackling of "voices" speaking to each other in intersecting
waves of chemical-electrical communications.

One theory of autism—a condition in which a person disconnects
from people and situations in reality—in fact, is that too many signals
get through into consciousness and overwhelm the person's sense
awareness. Tangential to this is the autistic's inability to organize and to
synthesize experience into meaningful wholes or gestalts. Victims of
autism do not "share, request or demonstrate"[95]—that is, they lack the
connectivity that is the catalyst of meaningfulness, and they live discon-
nected lives of summative rather than coherent experiences. What saves
the rest of us from this chaos and lack of coherent meaning is that aspect
of consciousness that Gazzaniga calls the Interpreter, which amalga-
mates and organizes the behavior of the separate modules and speaks
directly to our conscious awareness, efficiently translating the messages
and never letting us know more than we need to know. In other words,
it performs a role similar to that of the art therapist or the art critic, trying
to make sense of the input received from the brain and bringing it all
into a plausible harmony.

In a broad sense the Interpreter can be seen as performing the func-
tion that Gestalt psychologists saw as governing perception by synthe-

sizing elements toward stable wholes—and like the star gazer who creates meaningful patterns out of the ambiguous stars and planets in the night sky, this central consciousness finds basic schemata in various states of imprecision and clarity, even when they aren't there. Out of the forces generated by individual needs, from the input of the senses, and within the context of memory as accumulated experience, a consciousness is generated that may be characterized as a "self-image," and that is finally responsible for our seeing the way things "are." Gerald Edelman has proposed just such a neural theory of personal identity in his concept of "neural Darwinism."[96]

Eiconics

Kenneth Boulding in his theory of "Eiconics" formulated in the mid-1950s saw all conceptual knowledge as organically related to the image. He posited that the reality of the individual and the society is structured by levels of images beginning with the image in one's mind of the way the world works. This worldview mindset may be equated with the gestalt image whose primary focus is the organization and mutual influence of parts. Boulding predicates his theory on two propositions that reveal the cross-disciplinary power of the image: first, behavior is a function of mental image; and second, the meaning of a message is the change that it produces in the image.[97]

In much the same way as Wertheimer, Köhler, and Koffka saw perception as a gestalt formed by organic forces, Boulding saw all interaction as a matter of image, in that all new information is continuously tested against our internalized image of how things function. The self of each person is composed of sets of images that result from raw data from the environment being filtered through interpretation and acceptance, and to a large degree, our sense of external reality is determined by feedback from others viewing the same situations, thereby continually adjusting our world image.

He suggests that when individuals are faced with something new, they will do one of four things: (1) they will ignore it; (2) if it agrees with the image that they hold, they will accept it, adding it to their world image, which readily accepts whatever is compatible with it ("It may change the image in some rather regular and well-defined way that might be described as simple addition."[98]) ; (3) if it disagrees with the image, they will resist it ("If the resistances are very strong, it may take very strong, or often repeated messages to penetrate them, and when they are penetrated, the effect is a realignment or reorganization of the whole knowledge structure"[99]); and (4) because not all images are uni-

formly clear and unambiguous, the image may be further clarified or detailed by incoming data. According to Boulding, "Every time a message reaches him his image is likely to be changed in some degree by it, and as his image is changed his behavior patterns will be changed likewise."[100]

In Boulding's schema, it is the third alternative that is the most interesting, for either through an epiphany that immediately hits home, or through repeated bombardment, a person's image of the world may undergo a complete reorganization, and once this has happened, the person's total personality and behavior will likewise undergo a change— in Kuhn's terms a revolution in thinking will occur when the current system can no longer credibly be maintained, and the result will be a major "paradigm shift."

Beginning with the concept of genes as images incorporating our physical destiny within them, Boulding goes on to consider the dynamics of the image within the personal, social, economic, political, and organizational structures that are part of our lives. He concludes—like the early Gestalt psychologists and many contemporary neurologists—that on every functional level "image clearly does not reside in any one place or location. It is a pattern which pervades the whole . . . Behavior is response to an image, not a response to a stimulus, and without the concept of an image the behavior cannot possibly be understood."[101]

This recognition is essentially the same one Chaos theorists began to pursue a decade later in physics and mathematics. Like Eiconic theory, Chaos theory recognizes deterministic disorder—order masquerading as randomness—and acknowledges relationships that are not strictly proportional and therefore cannot be expressed in a straight line on a graph. Nonlinear systems have qualitative properties different from quantitative linear ones: as gestalts formed by the "spontaneous emergence of self-organization," they cannot be mathematically solved, and they cannot be added together.[102] As Boulding predicted, scientists found that seemingly alogical and often overlooked variable components can ultimately come to dominate and therefore determine the course of the system, sending it into apparently new and erratic directions. As James Gleik has observed: "Chaos has become not just theory but also method, not just a canon of beliefs but also a way of doing science. . . . To Chaos researchers, mathematics has become an experimental science [in which] graphic images are the key."[103]

In analogy to Chaos theory and Boulding's Eiconic theory, image represents both a mental concept of how things work and a recognition of a combination of forces, some of which may seem uncertain or unimportant, but may ultimately determine the course of the whole system.

For the individual as a whole, the dynamical system of the self includes past experience as well as images of fact and value drawn from a multitude of sources. As the individual interacts with the world, random images from life and from media are registered and tested continually against an overall sense of how things really work. General acceptance of the image by others, its relation to already ingrained sets of values, "including a value ordering of potential acts and their consequences,"[104] and knowledge gained through experience or assimilated through the culture—these become some of the elements that interact within the turbulence of perception.

Within this view, the individual is very much an open system—a structure that remains relatively constant and invariant while continually taking in and sending out variant messages within the environment. In the hierarchy of scales from the brain's neurons upward, analogous levels of organization interact on microscalar and macroscalar levels, ultimately integrating perception with self-image. This is, for example, why the early studies of media effects on the individual are so unsatisfactory, in that they sought a one-to-one correspondence between the media message and individual behavior, in a kind of naive linear cause-effect "monkey-see-monkey-do" scenario. Today, the complexity of media influence is more widely envisioned. Social Learning Theory developed in the 1970s, for example, recognizes the multiple interactive factors in complex behavior without denying the possibility of a single attitudinal or behavioral factor gaining ascendancy despite parental, peer group, or larger social unacceptability.

Conclusion

The first empirical study of mental imagery was published by Francis Galton in 1883, who then believed that there were two types of thinkers, verbal and visual. In the ongoing debate today among proponents of language-based reasoning, advocates of image processing, and those who favor a combination of both, it is generally recognized that people employ both imagistic and verbal thought, and the controversy tends to revolve around the specifics of the when, how, and use of one over the other.

Although Jung may go too far in awarding images an independent status, and psychoanalysis may rely too heavily on internalized images as the key to personality integration, there is no doubt that imagery plays a major role in the mind's working, particularly in the functioning of the subconscious and in creative thinking. Researchers from various disciplines have argued that thinking "employ[s] similar—perhaps the

same—mechanisms" as vision,[105] that "vision is the primary medium of thought,"[106] and that "our most abstract thinking may be a direct development of the first attempts to interpret the patterns in primitive eyes in terms of external objects."[107]

Mental images tend to have the characteristics associated with caricature or with cave art in that they abstract and amplify the relevant, and this relevance gives shape to the essence of the thing. The Gestalt school influenced psychology to take an eiconic turn, and its influence may be read in all of the most influential theories of mind in their ascendancy today, particularly in the relationship between perception, cognition, and behavior. The primary quality of abstract thought, for example, is its ability to grasp the form of ideas and to combine forms into more and more complex associations and gestalts. We differentiate finer and finer details when they are relevant to the task, and this in turn begets a world image on which subsequent behavior is based. In this way, whatever we see will be measured, remembered, and interpreted against the background of self-image and worldview.

The way we picture the world and ourselves in relation to it is the very core of our identity and is absolutely key in the process of communication. When Boulding described the Image, he saw it in terms of a great mental gestalt, subject to all the principles that the Gestalt psychologists outlined: simplicity, regularity, efficiency, good continuation. Although it consists of myriad parts, the image is not synonymous with its accumulated contents, but with the inner dynamic of the parts in interrelationship. Like a symphony, the music is not in the notes but between them. In its very essence our ultimate image of self and world and self-in-world is holistic: a gestalt that has a unified coherence and inner necessity.

When complex thinking becomes fuzzy, it is usually either because the form of the problem is too ambiguous and we need more information before the substance of the matter can emerge; because the true shape of the problem is obscured by the complexity of overlapping problems; or because the appropriate pattern that represents the optimum solution is elusive. New concepts in mathematics and physics yield insight into how on an intracellular level neurological activity can work according to quantum mechanics to find the best solution to problems, how in dynamical systems small elements can determine the future course of the system, and how turbulence is essential to thinking and to achieving a higher level of perception. In dynamical systems lines seem to move every which way without resolution until an internal attractor pulls it into a discernible shape. The emotional anxiety that is inherently generated by incompleteness and characterizes both mental states is

relieved only when the shape of a mental gestalt finally forms to make sense of it all. The stress that incompletion places on the psyche is noticeable from the most elementary Gestalt principle of perceiving basic shapes out of incomplete forms to the psychological strategies of advertisers who create tension by deliberate omission and then supply their product as the solution. Because their ready-made answers reduce anxiety, media images can provide the lowest common denominator of taste and sensibility, values and attitudes. This is where the power of media images ultimately resides.

What is most dangerous in media influence today may very well be simply the limited time frames and commercials that demand that the plot be formularized into certain dramatic complications before commercial breaks. As a result of the repetition of oversimplified problems and reduced choices, programs may gradually build the impression that problems are inherently simple and linear, and, worse, that simple, linear solutions are a satisfactory way to handle them. Thus to the viewer of soap operas, life experience tends to look more and more like the soap operas themselves, and the formulaic roles, appearances, and responses to problems that characterize the genre begin to delineate the imaginative parameters for real life choices. Children's cartoons make it clear exactly how girls are expected to act in various crises as they are growing up, how boys are expected to act in relation to girls and to each other, and what work and social roles each are expected to play in the larger world. MTV frames expectations for adolescents on how men and women relate to each other sexually and socially; on socially acceptable attitudes toward education, justice, parents, and authority figures; on appropriate dress, manners, and use of alcohol and other drugs. As media also speeds up, social and sexual roles are increasingly less nuanced, less sensitive, less individual, and more stereotypically circumscribed in precisely those areas that are the most meaningful in our lives. Such reduction to the lowest common denominator neither reflects the true complexity of real-life experience, nor promotes the complex thinking required to deal with the multiple factors within that experience.

II

Mediated Images

3

THE LANGUAGE OF IMAGES

Visually the majority of us are still "object-minded" and not relation-minded . . . The language of vision determines, perhaps even more subtly and thoroughly than verbal language, the structure of our consciousness. To see in limited modes of vision is not to see at all—

—S. I. Hayakawa

Language

The word *language*, derived from *tongue* is commonly used to describe a system of verbal expressions that humans use to communicate with one another in oral or in written form. It generally implies an orderly pattern indicative of a particular culture, steeped in its traditions and bound by generally understood meanings. Sometimes the word is extended beyond the verbal to include systems of signs for communication that can be composed of visual images or even body gestures. Almost always, however, the attempt to understand visual constructions as language—that is, as a system of meaning that can be used to communicate—begins problematically with the imposition of arbitrary verbal constructs on visual ones.

Yet the connection between written language and visual pictures is an intimate one. Verbal language is essentially a linear system imposed on nonlinear experience. A static system, its link with creativity and the dynamical process of experience is through verbal imagery, which connects it to the nonlinear systems of art and perception. Visual imagery, the first written language, is closely associated with direct perception and experience: "primitive" cave images in Europe and rock art in North America show how this early expression both abstracts invariants and amplifies affordance to suggest meaning. Figure 3.1, a drawing of a petroglyph in Coso Range, California, shows the abstracted figure of a male hunter. In the petroglyph, the affordances of bow and arrow for hunting,

FIGURE 3.1

Hunter Petroglyph. This drawing of a petroglyph found in Coso Range, California, shows the figure of a male hunter that extracts characteristic features essential for survival.

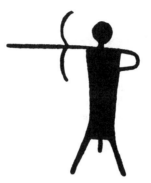

Source: After an illustration in Alex Patterson, *Rock Art Symbols* (Boulder, Colorado, Johnson Books, 1992).

and the invariants of head, torso, arms, legs, and penis clearly illustrate the function of the male in the society and tell us what is important for survival in terms of reproduction and procuring food. The bow in Navajo mythology is also a symbol of "Monster Slayer," the elder of the "War Twins" (the younger is "Born-for-Water" symbolized by an hourglass figure). Both symbols frequently occur apart from anthropomorphic contexts as well.[1]

Cave paintings in Europe dating back at least to 30,000 B.C. also suggest picture writing that communicates through common experience. By the second millennium B.C., Egyptian hieroglyphics, Hittite pictographs, and Sumerian cuneiform writing had developed. Egyptian hieroglyphics, which include both symbolic meanings and phonetic words, show the range of development of written language from representative pictures that abstract the invariances and affordances of common things, to linear symbols for abstract concepts whose meaning is removed from experience. Because the hieroglyph was associated so closely with real experience, in fact, at times the hieroglyphs of animals were incompletely painted, or their parts were visually separated so that they could not run or crawl away. When disconnected parts are depicted, they are usually separated by affordances, so that the head of a horned viper is separated from its body, and the legs of an animal are separated from its torso.

As Gregory explains, the key advantage of early pictures as language lay in their direct reflection of experience; their disadvantage lay in their prohibitive numbers. As pictures became highly stylized and conventionalized according to local usage, they became more and more removed from experience and therefore less accessible both to people within the culture and to other cultures as well. Hieroglyphics found in the ancient Egyptian tombs represent a sacred language that was used and fully understood only by the scribes. After the last scribe died, the secret of their decipherment was lost, and it was not until the Rosetta stone bearing the same text in three different scripts (hieroglyphic, demotic, and Greek) was found by one of Napoleon's soldiers in Egypt and subsequently translated by Jean-Francois Champollion in the early 1820s that the ancient script came to life again. Alphabetic languages used today are the most abstract and highly stylized means of communication, which means they must be learned in order to be used. Figure 3.2. shows Egyptian hieroglyphics that utilized characteristic shapes of parts and wholes to represent a full range of meaning from icon to abstract symbol. Figure 3.3 shows the possible evolution from hieroglyphics to alphabet.[2]

Comics and Hieroglyphics

Today the spirit of early hieroglyphics as a reflection of experience may be most alive in the visual language of comic strips or cartoons. In *Understanding Comics*, Scott McCloud explains that "Cartooning isn't just a way of *drawing*, it's a way of *seeing*." Drawing its power from our perceptual ability to focus our attention, not merely on details, but on universal patterns into which we project our own experience, cartoon projection is made possible by its lack of differentiating detail. As detail is reduced, universality is enhanced. "Cartooning," he explains, using typographic stylistics to emphasize his point, is

a form of *amplification through simplification*. When we *abstract* an image through *cartooning*, we're not so much *eliminating* details as we are *focusing* on *specific details*. By *stripping down* an image to its essential "*meaning*," an artist can *amplify* that meaning in a way that realistic art *can't*.[3]

McCloud goes on to explain that our sense of self is like this, too—a kind of sketchy arrangement of essential details. He believes that the source of our childhood fascination with cartoons is twofold: first, the reduction of nuance and detail, which inhibit our identifying with them, yields simplicity in a kind of gestaltlike reduction of things to their

FIGURE 3.2

Eisner's Micro-Dictionary of Gestures. This "dictionary" by comic strip artist Will Eisner shows characteristic gestures as visual language.

A micro-DICTIONARY of GESTURES

These very simple abstractions of gestures and postures deal with external evidence of internal feelings. They serve to demonstrate, also, the enormous bank of symbols we build up out of our experience.

Illustration by Will Eisner: Reprinted by permission of the artist and Poorhouse Press.

FIGURE 3.3

Hieroglyphics as Icons and Symbols. Egyptian hieroglyphics utilized character-istic shapes of parts and wholes to represent a full range of meaning from icon to abstract symbol.

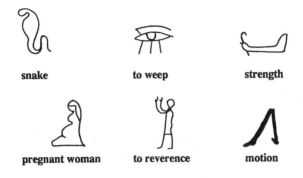

Source: After illustrations in Richard L. Gregory, *Odd Perceptions* (New York: Methuen, 1987).

simplest and therefore "best" shape; and second, the childlike features of cartoon characters themselves differentiate their appearance from that of adults and make it easier for children (and the child within the adult) to identify with them.[4] Because detail increases differentiation, it also inhibits our identifying with the people and situations depicted. McCloud describes the cartoon as a "vacuum into which our identity and awareness are pulled . . . an empty shell that we inhabit which enables us to travel in another realm." As a result, he says, "We don't just observe the cartoon, we become it."[5]

Just as anthropologists believe that cave art gives us a perceptual window into the physical and spiritual world inhabited by Cro-Magnon humans, McCloud believes that we give cartoons life by filling them up with ourselves, and that the source of their power is through an affective identification that allows for a sense of shared experience. As such, comic strips occupy a place halfway between the nonlinear, "gray area" associative logic of experience and the arbitrary "black or white" linear logic of an imposed language system. Out of common human experi-ence, comics have developed codes of "sequential art" language based on characteristic human gestures, facial expressions, and postures. These characteristic invariants form an "alphabet" used by the artist to "convey nuances, support the dialogue, carry the thrust of the story, and deliver the message."[6]

FIGURE 3.4

Hieroglyphics to Alphabet. Many hieroglyphics may live on in transmuted form in our own alphabet.

Egyptian	Protosinaitic	Phoenician	Early Greek	Greek	Latin
				A	A
				E	E
				N	N
		o	o	O	O

Source: After drawings included in W. V. Davies, Egyptian Hieroglyphics (Berkely: University of California Press/British Museum, 1987).

A comparison between the "microdictionary of gestures" developed by cartoonist Will Eisner (Figure 3.4) and the meaning and evolution of hieroglyphics (Figures 3.2, 3.3) show how the process of abstraction and stylization can ultimately evolve into the conventionalized codes of written language. Eisner has developed a dictionary of gestures based on universal human experience and expression that he has put to use as sequential narrative in comic strips. Hieroglyphic narratives similarly either recorded events or sought to reinforce mythologies, and they spoke to a broad audience about the most important parts of their existence. Eisner comments,

> Comics communicate in a "language" that relies on a visual experience common to both creator and audience . . . the reading of words is but a subset of a much more general human activity which includes symbol decoding, information integration and organization. . . . Indeed, reading—in the most general sense—can be thought of as a form of perceptual activity.[7]

In this perceptual activity, words and images become superimposed on each other: "The reading of the comic book is an act of both aesthetic perception and intellectual pursuit."[8] This pursuit is integrally involved in the development of visual language: comics employ "repetitive images and recognizable symbols. When these are used again and again to convey similar ideas, they become a language." This language,

however, is of a different sort from the verbal entirely, being based in human experience and relying on an implicit knowledge of physical laws, like gravity.

In the development of language as a translation of human experience into a system of communication, before any action or word can be standardized, it must be both familiar enough to the community to suggest its context in experience and specialized enough to avoid ambiguity. "Comprehension of an image," Eisner states, "requires a commonality of experience . . . an interaction has to develop because the artist is evoking images stored in the minds of both parties."[9] Meaning is thus derived from experiential sequence, as a thundercloud means rain, or leafbuds mean spring.[10] As British language researcher Ronald Englefield suggests:

> Every perceptible bodily movement means, for one who understands it, the purpose which it implies or the sequel which follows it. And the surviving traces of human activity, the marks of the axe, the embers of the fire, the footprints in the snow mean the actions themselves, the actors, their purposes or their circumstances, in short everything that may be inferred from them.[11]

Paul Ekman, for example, has studied interculturally the universals in human expression and concluded that facial expressions are innate, evolved behavior. While others such as Birdwhistell and Mead have argued that facial expressions are learned, culturally controlled behavior, Ekman's research shows that what is culturally learned is the display rules that allow for the appropriate expression of emotion, not the spontaneous expression of emotion itself. With illiterate, visually isolated people in New Guinea, for example, Ekman and his colleagues found that expressions mirrored those of people in literate cultures; and that people in Berkeley, California and in Tokyo, Japan—cultures with very different display rules—showed universally the same natural expressions for emotions, despite their culturally different customs.[12] He concludes that for each emotion there is a distinctive pancultural signal that has evolved phylogenetically through evolution in order to deal with fundamental life tasks common to us all.[13]

Cartoonists learn to identify these distinctive signals, to reduce them to their Gestalt "best" and most symmetrical form, and to enlarge their significance by eliminating extraneous details. Gestures and actions are similarly reduced to their invariant components and then exaggerated for emphasis. Because each frame posture represents an arrested moment selected out of a flow of movement, it then reveals through

shared experience both the implicit emotion as well as what action has led to and followed it.

According to the perceptual principle of good continuation, such frozen moments can be used to involve the imagination of the reader by causing him or her to fill in the action between the frames and to emotionally identify with the perspective of the frame. This, Eisner believes, is where the greatest potential of the comic lies because the human form is already a universal language relying on codified gestures and expressive postures based in experience and stored in memory. The viewer's response to any given scene derives from his or her position as a spectator, and this perspective can be used to evoke various emotional states.

A frame that depicts the viewpoint looking down from above, for example, signals detachment; the view from below evokes a feeling of smallness and fear; an eye-level view suggests realism. In addition to point of view, the frame itself also evokes a perceptual response: a narrow panel creates a sense of confinement; a wide frame suggests space to move.[14] Rectangular panels with straight borders indicate present tense; wavy or scalloped borders, past tense; jagged edged frames, sound or emotionally explosive action; cloudlike frames, thought. The actor bursting through the frame creates the illusion of power or threat.[15]

The concept of image as "language" as it will be discussed here is meant to suggest a system that flows from perceptual process and speaks to us on a basic, intuitive, and emotional level derived from experience. As such, it reveals the major attributes associated with perceptual principles. Although it is contained within individual consciousness and is written and read by neural processes that we do not yet fully understand, we may nevertheless track which regions of the brain are being used during certain perceptual processes and track its "grammar" through perceptual principles that run in patterns across the various disciplines of learning. Neurologically, we know in general which regions are activated when we solve mathematical problems, when we dream, or when we see. In art, we see the characteristics implied by perceptual principles.

We know, too, through the study of visual illusions that the eye postulates borders and contours; we know that the eye and brain generate colors although they appear to us as external properties of things; we know that our visual systems have evolved in stages, and that we can make general statements about perceptual processes, although there will be many individual variations. We know, above all, that the eye, as an extension of the brain into the world outside of us, is an interpreter of experience, that it is liable to illusion, and that it is also intelligent, continually solving enormously complex problems presented by the environment, apparently almost instantaneously.[16]

Because, as J. J. Gibson has suggested, perception begins with the interaction of a person with the environment, one of the most important aspects of visual language is meaning though proxemics, the study of spatial relationships.

Proxemics

Edward Hall has defined four main zones of comfort (intimate, personal, social, and public) in our relationship to our environment, and to others within the environment. At intimate distance, which ranges from contact to about 18 inches, for example, we are close enough to physically express emotion, but our vision is limited and distorted so that we do not see clearly, and we cannot see exactly what the other person is doing with his or her body. Personal distance, which ranges from $1^1/2$ to 4 feet, is a protective space that allows for immediate physical contact, lets us read expressions clearly, and allows us to see some body movements. In both of these zones, "getting close to someone" implies more than a feeling of intimacy. Trust is a major factor because our ability to read accurately and to respond is compromised. If someone we do not know or know only formally intrudes within this space, we begin to feel threatened. Shaking hands with people is one way of establishing trust within personal space, for example, since it reveals that no weapons are held.

Social distance, 4 to 12 feet, does not allow for touch and marks a "limit of domination." Public distance, defined by Hall as from 12 to 25 feet or more, is characterized by noninvolvement. At this distance, we can easily detect and respond to movement by others and therefore prepare ourselves for encounters. Strangers meeting for the first time generally keep to these distances, while people who know each other on a more intimate level feel awkward speaking to one another across it.

Although the distance for comfort zones varies from culture to culture, when a zone is inappropriately violated, we feel uneasy, anxious, or even threatened. When a close-up on television is focused on a character who is familiar and likable, it seems to feel natural, but it may still be uncomfortable when it is too extreme. Boxers, for example, often stand nose-to-nose while fight instructions are being given to intimidate their opponents. In mediated images such as television pictures or magazine covers, the camera "stands in" for us, which is why we expect close-ups of lovers kissing when we go to a movie. When, however, a portrait image is too closely cropped on a magazine cover—giving an "in-your-face" view that simulates intimate distance—we become uncomfortable, although we may not completely understand

why on a conscious level. Conversely, architecture that dwarfs us in its presence and seems to have no human scale, can make us feel insignificant and hungry for human contact. This aspect is treated in more detail under Light, Grain, Angle, and Size later in this chapter as well as in the chapter's concluding Close-Up.

Deep Structure

As Gibson noted in his ecological optics theory, spatial perception is not symbolic but experiential. It operates according evolutionary principles and is thus an open system based in past experience yet responsive to change. "Visual language" in other words, has what language theorist Noam Chomsky called "deep structure"—an innate universal grammar.

Chomsky proposed a "deep structure" for verbal language, a concept that he later refined to suggest a single language with peripheral variations; but perception may also be seen as having a phylogenetic deep structure that allows us to make sense out of our relation to the environment and to communicate with others within it. Perception, governed by a set of fixed principles within an open system, may be culturally codified or even rigidified by habits of mind or feeling or by repeated exposure. While both word and image may be related and possibly even entwined at a profoundly deep level of the psyche, the systems by which they work are different. Verbal language is abstract, essentially linear, and achieves its functionality by the application of culturally derived codes once removed from direct experience, and from explicit rules of expression. Perceptual logic, however, is holistic, immediate, and experientially rooted.

The language of images, grounded in the stuff of perceptual experience, affects us directly and involves instinct and emotion, before the linear logic derived from language can be imposed on it. In a broad sense, the meaningful organization that a verbal language implies is already inherent in the perceptual language in the gestalt, which has its own "grammar," that is, the perceptual patterns or "logic" explored in the first two chapters.

In this grammar certain patterns or principles of organization emerge: what is dominant achieves our attention; ambiguity is not tolerated; nuance is first sacrificed to pattern; pattern is later differentiated if attended to and if necessity dictates; discrimination is limited by the degree of necessity; similarities group and form patterns; associations and connections form meaningful relationships. Once begun, continuities in patterns seem to suggest stability and permanence; what is only

partially suggested is completed, smoothed, and closed; what we are accustomed to fades into the background of awareness; expectation shapes certainty. Perceptual logic fills in, leaps to conclusions, finds cause and effect through association, and is characterized by the conviction of continuity, resistance to change, attention to change, and qualified differentiation.

Perceptual process also implies a logic that seeks coherence, finds meaning in patterns and the larger shape of things, projects tendencies into the future, and thinks in metaphors and symbols. It is a logic pregnant with implication and real and potential relationships primarily creative and only secondarily critical. Its organization is holistic, amalgamatic, synthetic, dynamic, and open. Its antithesis is the linear, categorical, analytical, rigid, and deterministic.

Although the visual and the verbal are quite different, however, most semiotic thinking imposes a verbal (postperceptual) structure on the visual image. Although it is certainly true that words developed out of human beings' need to communicate and to share, and that this necessitates a culturally imposed system of naming and of abstract organization if in fact communication is to be possible, it is also true that this symbolic structure of verbal language is imposed after the fact of perception. To impose a verbal structure on visual phenomena is therefore to put the cart before the horse. Perception comes first in evolution and in the person—well before the fact of spoken language and the development of written language. Although spoken and written language both have a profound influence on perception, the organization of percepts nevertheless precedes them. It is already ordered to a certain degree by a system, however inefficient, which evolution itself has imposed. It has its own story and its own logic.

Semiotics

In an attempt to understand how visual signals may form an intelligible "language," researchers have developed various theories with specific terminologies which, though drawn from systems of verbal language, may nevertheless be helpful in addressing the process by which images relate to cumulative meaning.

At the turn of the century, for example, Ferdinand de Sassure developed the theory of semiology—the scientific study of signs within social psychology—in his Course in General Linguistics at the University of Geneva, which became disseminated through the collected notes of his students following his death in 1913. Sassure divided signs into two parts: signifier (sound or object) and signified (the concept that

it represents). Signs, Sassure believed, were arbitrary in nature, their use deriving from convention and the necessarily collective social nature of communication.

Roland Barthes, continuing this line of thinking after Sassure, focused on the verbal nature of signs, insisting that the verbal anchors the image in linguistic codes that make sense of them and that we learn through cultural assimilation. Natural signs such as photographs are merely iconic, he believed, simply being what they are, whereas cultural signs suggest a human intervention of meaning and therefore a ("motivated") code that can be culturally interpreted. Barthes' interest in the sign ultimately became structuralist, pursuing literature and social life as formal systems worthy of study in themselves as opposed to their content. In modern cultures rife with signs, for example, he saw hidden meanings latent in commercial images, as well as signs that at bottom have no substantial meaning at all.

In the United States, contemporaneously with the Swiss Sassure, Charles Sanders Peirce developed the theory of semiotics, and like Sassure, his papers were collected and published posthumously, though not until decades later. Peirce identified three classes of signs: iconic, indexical, and symbolic. An icon, or iconic sign, he defined as one that looks like what it is. His two divisions of icons, images and diagrams, both depended on resemblance, as in a portrait of a person or a likeness between the relationship of the parts, as in a map. An indexical sign, however, depends on an existential relationship: Peirce suggested, for example, that we can tell a man is a sailor by his rolling gait, just as a clock indicates the time of day or a weathercock indicates the direction of the wind but does not resemble it. Fingerprints left at the scene of a crime also imply existential relationship. Although they are characterized by a particular design, they also imply the presence of a particular person at the scene. The relationship is direct, just as a rash is indicative of a more pervasive medical condition.

Symbols, on the other hand, have abstract associations rather than experiential connections. They often seem to look totally manufactured, or arbitrary, because their meaning is determined through convention, as in the prescribed use of color in religious paintings, or the usual Oriental bow on greeting. It may be doubtful, however, that any symbols can ever be considered fully arbitrary in that at bottom there is some kind of experiential connection between signifier and signified which, however remote, makes them seem appropriate at one time. Once a gesture becomes standardized and streamlined into a sign, it is then in the situation where it can be used to denote other related ideas, and as the evolution continues, the symbols that develop from experience may seem to

be completely detached from their origins. Symbols in the form of written language may be inaccessible to those outside the culture, yet each symbol within that culture of necessity carries a history of representation, association, and relation.

As Peirce stated, in signs there may be a great deal of overlapping of categories, and little if any exclusivity. A diamond ring, for example, may be seen as an indexical sign of betrothal but also as a symbol of eternality because it is one of nature's most durable substances, or of vast wealth because of its economic value. Yet to the culturally uninitiated child, a diamond ring can also be simply what it is: something that sparkles.

On the most literal level, therefore, images may be seen as icons that suggest resemblance, implying a one-to-one relationship between what we see and what is represented. Or they may have associationist ties to reflect larger, more abstract ideas. This is where the power of images introduced in the previous chapter becomes clearest and most profound—not because their power derives necessarily from linguistic analogy, but because it arises from experiential paradigms derived from perception.

This experiential tie to the visual may be seen perhaps most clearly in sign language which conventionalizes experiential meaning through gestures. In American Sign Language (ASL), for example, the word for stag uses the hands to represent antlers. Cupping the hands can denote either a bowl or a drinking vessel according to context. Grinding the fists together denotes corn. Abstract qualities such as the color green may be shown by making the sign for grass.[17] In each of these signs we notice certain figures of speech: synecdoche (where the part is used for the whole), simile (a comparison using "like" or "as"), metaphor (an indirect comparison of similar qualities within two apparently unlike things), and symbolism (where an object is used to represent an abstract quality). According to deaf poet Curtis Robbins, there are two conflicting tendencies among deaf poets: those who follow the classical oral traditions of poetry based on acoustic values and emulating sound-oriented phenomena such as rhyme, alliteration, assonance, tone, onomatopoeia, and those who believe that only the visual, which "emphasizes imagery, metaphors, similes and the like,"[18] can complete the experience of poetry.

The "sound of visualizations" must be *seen*, according to Robbins, because "signing is a medium of expression just as writing is, but for ASL poets, writing poetry does not do justice enough to convey their visualizations."[19] To watch Robbins recite poetry in sign is an extraordinary experience, particularly when it involves Japanese haiku, the most terse and compact form of poetry. (Haiku consists of three unrhymed lines of five, seven, and five syllables and traditionally invokes some aspect of nature or the seasons.) The ASL gesture signifying "snow," for

example, is a quick and graceful flutter of the fingers; the hands perform a transcendental ballet whose meaning can truly be matched only by the soft fall of real snowflakes on an upturned face.

In everyday use of ASL, traditional signs are derived from key visual details but can be extended to represent abstract concepts through a knowledge of conventional written language that itself has already gone through the evolution of abstraction and standardization. While the ASL gesture reproduces the experience of falling snow, for example, sometimes a gestured letter will stand in for the whole word, particularly if the gesture comes to be seen as negative. Because the word for homosexual—a flip of the wrist—was clearly pejorative, for example, it has undergone a double metamorphosis from a finger run through the middle of the hair to the finger spelling of the letter q on the chin.

Because sign words developed within cultures tend to reflect cultural biases, the deaf community has also inevitably become more globally oriented. Words of choice tend to move away from ethnocentrism toward the way various people see themselves. The traditional sign for Japanese, for example, was once created by twisting the little finger next to the eye. Such a sign recognizes the visual difference between Oriental and Caucasian eye shapes, but because this has come to be seen as a pejorative stereotypical reference, ASL has recently adopted the sign that Japanese use for themselves, which impersonally reflects the geographical shape of the country.

The American word for *American*, is another example, signed by weaving the hands together and making a horizontal circular gesture in front of the body. The Russian word for American, however, was once signed by contouring a big belly and mouthing the word capitalism.[20] Where abstract concepts may be best rendered through verbal language, experiential concepts—particularly those characterized by emotion or physical realities—may be best expressed visually. Inevitably, however, because first visual language and then verbal language follows from perception, one permeates the realm of the other.

Because visual images speak with an experiential, associationistic, and holistic logic, it is important to recognize that they are particularly susceptible to manipulation by political and commercial structures. In the hands of a skillful propagandist such as Goebbels under Hitler, for example, the basic structure, ordering, and relationship of elements and events becomes elastic and can be reorganized to take on new meaning. Elements remain recognizable, but their mental relation in space and time has been transformed in precisely the same manner as the artist transforms reality on canvas. In both cases, the image of the way the world is and works can be dynamically and elementally restructured. As Boulding suggested, to accomplish such a transformation that alters the

way we see requires either an epiphanic shock, in the wake of which suddenly everything seems different, or a systematic, pervasive, and repetitive exposure to carefully crafted messages.

Of the representative schools of semiological thought developed from the work of Sassure and Peirce, only Umberto Eco has pursued semiotic meaning at this level of perception. For others, like Christian Metz, the meaning of the image is located in a linguistically based narrative construction in the combination of images found in film. Pier Paolo Pasolini argues that meaning of the image is fundamentally found in the world of the unconscious as it is manifested in memory and dreams, and that the nature of film is closest to poetry. Bill Nichols, who takes significant issue with each one of these semiotic positions, appeals to the manipulation of context, particularly to ideology and history, as a producer of meaning within and between frames as the crucial carrier of meaning.

Eco, occupying a position between the narrative semiotic of Metz and the poetic semiotic of Pasolini, recognizes the image as already containing codes that people understand by virtue of perceptual process. While other semioticians begin with the assumption that the iconic sign resembles the object represented, Eco reminds us once again that "an image possesses none of the actual properties of the object represented" and that iconic signs reproduce not reality, but "some of the conditions of perception, correlated with normal perceptive codes . . . which preside over our every act of cognition."[21]

As an example of an iconic code extant in perception, Eco cites our recognition of features that are meaningful for memory and communication, such as the characteristics of four-leggedness and stripes that codify the zebra, or the use of continuous outline to represent an object or body—as can be seen in caricature drawings. Eco dismisses the idea that the photograph is an analog of reality at the same time that he recognizes perceptual process as lying at the heart of visual semiotics.

Eco goes on, however, to envision perceptual process as digital— that is, composed of distinct and separate units combined in the process of perception. This view, although it accurately reflects the complexity of perception as composed of discrete neuron signals, when taken to its extreme, tends to reduce perception to the level of a process understandable through reductionist scientific analysis, focusing on parts rather than on whole formations, and reflecting an essentially linear, mechanical function. This approach is one shared by early researchers in Artificial Intelligence (AI). As discussed earlier, it is also antithetical to a gestalt view of perception, to a "connectionist" approach to machine intelligence, and to current dynamical systems theory as well. As Köhler wrote in 1922,

the physics of Gestalt theory . . . refers to processes . . . determined by the forces within the system itself. . . . [I]t makes a great deal of difference whether the inner distribution of substances, of vector and scalar magnitudes is throughout established by rigid connection or depends also upon the inner dynamics of the system. The more completely a system is governed by constraints, the more adequately does it exemplify a machine. The more freely the inner dynamics of a system are left to regulate themselves, the farther the system is from being a machine.[22]

Physicists Farmer and Packard also described this "spontaneous emergence of self-organization" as an essential property of all nonlinear systems. Speaking to Chaos theorists in 1985, they described it as the adaptive mechanism by which change occurs in dynamical systems as "an emergent property which spontaneously arises through the interaction of simple components." Whether these simple components are neurons in the brain, ants in a colony or bit strings, they state, "Adaptation can only occur if the collective behavior of the whole is qualitatively different from that of the sum of the individual parts. This is precisely the definition of nonlinear."[23]

The line of thinking that sees the language of images as essentially mechanistic leads to multiple problems. Above all, it ignores the dimension that Pasolini recognized as "poetic," which Metz observed as an illusive "current of signification" in narrative structure, and that separates the linear from the nonlinear, the dynamical from the rote.

Pasolini, like Eco, has argued that cinema's mode of communication is the key to its meaningfulness, but seeks this meaning in the realm of the unconscious, propounding a whole complex of "im-signs" (image-signs) such as found in memories and dreams. These im-signs, he believes, prefigure cinematic communication and provide the basis for it. He traces the language of images to the level of the instinctive and irrational and insists that this pregrammatical world has a completely different foundation from that of literary language, in which words can express abstract concepts. The image has in fact a dual nature, he argues, being both concrete and capable of expressing larger meanings symbolically and metaphorically.

In combination, too, images of classic cinema in which the camera is "invisible" may be strung in a linear sequence comparable to prose, but the true nature of their grammar is stylistic, not linguistic. This makes cinema more of a poetic art with a grammar based on conscious manipulation of the camera. Through the camera, the literal and objective nature of the image is extended into the realm of the subjective by

the intervention of the artist through such devices as close-ups, dialectical linkage, and so on. These conscious manipulations Pasolini terms "stylemes," as the true units of meaning in visual semiotics.

What Pasolini calls "grammar" in the image is therefore closely related to what has been discussed here as "perceptual logic," and this is why perceptual logic is so closely related to the creative arts: it encompasses the realm of the written word and the pictorial image and points the way to creative thought and expression. The literary work particularly of Faulkner and Joyce bear evidence of this perceptual logic: what is often called "stream of consciousness" as form is perhaps more precisely described as an amalgam formed by perceptual logic.

Seen in this way, the creative artist utilizing perceptual—often called "intuitive"—logic plays a role analogous to that of Gazzaniga's Interpreter, which synthesizes and rationalizes direct experience. Like the psychologist, the artist recognizes that the intuitive mind manufactures harmonious wholes from the cacophony of activity going on in the brain, that it interfaces between the inner workings of the unconscious and external reality, and that it creates the sense of meaningfulness essential to an integrated sense of self and to higher reasoning. Implicit in Aristotle's comment that the soul thinks in images, for example, are all of the various levels of the perceptual gestalt—organic unity, inner necessity, efficiency, harmony, synthesis—as they apply to thought, as well as to the aesthetics of art.

Literary Imagery: Breaking through Words

Imagist poet and critic Ezra Pound observed that the "masters" of great literature are able to assimilate and digest adjuncts of expression and to imbue this whole with a special character, bringing it to a state of "fullness."[24] Separating the "masters" from the "diluters" of art, Pound speaks of the special dimension that artistic synthesis gives to the imagination and insists on "phanopoeia"—the casting of images on the imagination—as the highest of the three forms of poetry. This is because images reflect the purest, most direct and most basic form by which to engage the imagination of the reader. Like the perceptual psychologist, he recognized that visual perception precedes language, and that the most meaningful bridge between minds is a parallel to "direct perception" as J. J. Gibson defined it.

The emphasis that the Imagists placed on the concrete and specific in the "direct treatment of the thing" in the Imagist movement in poetry at the turn of the twentieth century represents an attempt to retain the connection between perception and the external world without the intervention of an abstract language. Pound and his followers saw words as

representing convention—without a mutually understood rigid system, words would be meaningless; to break through their level of abstraction, they used concrete images to reach the more palpably referenced world of the perceptual image. In the process, Imagism reasserted the senses as a source of deeper understanding, turning back the tide of mistrust of the senses begun in earnest with the Protestant Reformation and ultimately triumphing in scientific rationalism.

It was this same insight into the primacy of the visual image that evolved into T. S. Eliot's theory of the "objective correlative." In his critical essay "The Metaphysical Poets," for example, Eliot describes the poet's imagination as "constantly amalgamating disparate experience . . . always forming new wholes."[25] In his famous essay on "Hamlet," he clarifies how the poet can use concrete images derived from perceptual experience to capture meaningfulness: "The only way of expressing emotion in the form of art is by finding an 'objective correlative'; in other words, a set of objects, a situation, a chain of events which shall be the formula of that particular emotion; such that when the external facts, which must terminate in sensory experience, are given, the emotion is immediately evoked."[26]

What this implies in terms of communication of ideas is that the process of perception may be the common point where seeing, imagining, and aesthetic response meet—that images evoked in art and literature reproduce the process by which they are created; that one creates as one sees, and that others are capable of perceiving a created work according to the same process by which they perceive and function in their environment. "The poetical habit," Arnheim states, "of uniting practically disparate objects by metaphor is not a sophisticated invention of artists, but derives from and relies on the universal and spontaneous way of approaching the world of experience."[27]

In his preface to *The Nigger of the Narcissus*, Josef Conrad also defines his art in perceptual terms: "All art," he states, appeals primarily to the senses and must make its appeal through the senses if its high desire is to reach the secret spring of responsive emotions. . . . It is only through complete devotion to the perfect blending of form and substance; it is only through the unremitting care for the shape and the ring of sentences, that an approach can be made to plasticity, to color, and that the light of magic suggestiveness may be brought to play over the commonplace surface of words. . . . My task which I am trying to achieve is, by the power of the written word, to make you hear, to make you feel—it is, before all, to make you see." This synthesis—which Boulding summarized with the single term "image"—begins in the perception of the artist and finds its completion in the conception of the reader through mental imagery. Once again the attempt is to break through the

conventionality that language inevitably implies and that Eliot lamented in his *Four Quartets* as inadequate in communicating direct experience.

This, I believe, is a key point in understanding the language of images, and a concept essential to nonverbally-oriented thinking: perception is a transformative process that amalgamates and makes continuous what is separate and discrete, turning digital into analog. The basic pattern or language of images may be visualized, as von Ehrenfels suggested, as a symphony in which separate notes are joined only by silence; yet in the silence between the notes the rhythm is born and the meaning emerges. Just as in the successive flashing of sequential dots where the classical "phi phenomenon" of movement is created, so it is in the silence that music speaks to us most profoundly, precisely because this is where perceptual process transforms external notes into internal percepts. Elements that compose our sense of self, including memory, emotion, and imagination, become part of the turbulence that settles into a new, higher order of perception.

For the Imagists the concrete, the specific, and the immediate were the only defense against the corruption of experience through words and reasoned discourse. Just as in *A Farewell to Arms*, where Frederic Henry observes that in the end only the names of places were sacred because abstract words falsified reality, Pound and his followers successfully turned words against themselves, forcing them to combat logocentric bias and false continuity. In their poetry, the Imagists deliberately introduced gaps to be linked through the active imagination—just as Hemingway used omission in prose, just as perceptual process fills in what is not there and forms a whole out of saccadic movements. This is essentially the same principle that Eisenstein saw in the Japanese ideograph and exploited in film in dialectical montage, discussed in more detail in Chapter 5.

Artist and theorist Georgy Kepes believed that the task of the creative artist was threefold: to learn and apply the laws of plastic organization, to learn to understand contemporary spatial experience, and to develop a dynamic iconography that would release the reserves of creative imagination and organize them into dynamic idioms.[28] By "plastic organization," Kepes meant the process of shaping sensory impressions into unified organic wholes through the dynamic interaction of external physical forces with internal psychological and physiological forces.

This process, based on Gestalt principles of proximity, similarity, continuance, and closure, worked to keep attention alive by creating the greatest amount of movement and tension in a picture or image, primarily through color, line, and the use of large and small units to create rhythm and unity. According to Kepes, the development of "vision"—an umbrella term comparable to what has been described here as "visual

intelligence"—leads not only to understanding of nature, but also to the progressive development of human sensibilities and thus to deeper and wider human experiences.

Because perception encompasses spatial relationship, color, and three-dimensionality, and because perception is neurologically routed directly through the amygdala as well as to the neocortex or "thinking brain," visual language can speak directly to the emotions and has a dynamic complexity and multiplicity of meaning that escapes verbal language. Indeed, a picture qualitatively may say a good deal more than a mere thousand words.

This is why the dispute of the elevation of the word over the image has deep roots in religious controversy, as Ernest Gilman suggests when he observes that a Platonic and Catholic view of painting would uphold "the sense of sight [as] the highest of the faculties" and see the world as a divine hieroglyph, whereas a Protestant view would distrust the visual arts and claim that "the divine medium is the creating Word, and the Christian must beware of the enticements of the eye and the delusions of the visual imagination."[29] In their objection to devotional images, Calvin and Luther ran directly counter to the Catholic, particularly Jesuit, confidence in inner visualization and the "efficacy of the visual image to embody and teach sacred truths,"[30] and they mistrusted on spiritual grounds what Hobbes and Descartes mistrusted in the senses on more general grounds as an inherent inability to discern the truth.[31]

Thus the prejudice surrounding the image and its relation to spoken and written language is a complex one, with many religious, philosophical, and political issues involved in the ascendancy of one over the other as a reflection of "true" reality. Significantly the sensual nature of the image, coupled with the prohibition against iconic idolatry in Judeo-Christian religions, which mistook the signifier for the signified, at least partially accounts for the privileged position of the word over image in Western culture. When, for example, the Talmudic scholar Maimonides defines the essence of idolatry as missing the whole concept of image, which is "true reality" or essence, he warns that the reason idols are called images is that "what was sought in them was deemed to subsist in them, and not in their shape or configuration."[32] For Maimonides, perception of spiritual essence was true image, as it was for Aristotle, and to mistake surface appearance for essence was to miss the point entirely.

Color

One of the most dramatic examples of how meaning is communicated independently of specific content or verbal analogy is in the

perception of color. In "The Case of the Colorblind Painter" in *An Anthropologist on Mars*, Oliver Sacks tells the story of an artist who, after sustaining a seemingly insignificant injury to the secondary cortex in the V4 areas, lost completely his ability to perceive color, as well as the ability to imagine or even to remember it. In addition to its inherent neurological interest, the case shows clearly the extent to which color gives meaning to our environment and to our psychological lives. Living in a now leaden-gray world, the artist frequently found himself physically nauseated and depressed, unable to look at the food he ate. Even his enjoyment of music was impaired, since—being very visual—his experience of music had been synesthetically mixed with color. Without the color, which had been a deep, inner part of his being, the artist found himself in "an inconstant world . . .whose lights and darks fluctuated with the wavelength of illumination, in striking contrast to the relative stability, the constancy, of the color world he had previously known."[33]

Like movement, depth, and form perception, color perception thus appears to be not only innate, but a perception so meaningful that it is core to our entire being. An experience derived from the presence of reflected light, color vision is ultimately a construction of the visual cortex, but the process begins in the retina, where different wavelengths of radiant energy are absorbed by chemicals in its visual receptors.

In 1672 Newton was the first to demonstrate that when sunlight, which contains an approximately equal intensity of wavelengths across the spectrum, is passed through a prism it splits into seven hues (violet, indigo, blue, green, yellow, orange, red)—three of which (red, yellow, and blue) are primary, that is, they cannot be further broken down; and three of which (orange, green, and violet) are secondary, that is, they can be produced by combinations of the primary colors. The wavelength of visible light ranges from approximately 360 nanometers (nm) to approximately 760 nanometers; and within this spectrum, receptors are specifically tuned to respond to light within only a single wavelength: violet (400–450 nm) and blue (450–500 nm) are short wavelength; green (500–570 nm) and yellow (570–590 nm) are medium wavelength; and orange (590–620 nm) and red (620–700 nm) are long wavelength.

Light and pigment also have different color properties. If, for example, yellow and blue pigments are mixed, together they will absorb (i.e., *subtract*) the other colors in the spectrum, leaving only the green, which is reflected by both together. When a substance such as glass or water transmits rather than absorbs light, it is seen as transparent or translucent. When no light is absorbed, we perceive the color as white. When all light is absorbed, we see the color as black. When light is *added*

to other light, however, the additional wavelength causes a different impression: red and green light will combine to produce yellow light; red, violet, and green will produce white light.

Because different materials absorb and reflect light differently, we tend to see them as possessing different color characteristics including hue—what we think of as the identifying color; saturation—the amount of white or black mixed with the hue to create lightness or darkness; and brilliance—the perceived intensity or dullness. Human adults with normal color vision can generally discriminate between 120 to 150 color differences across the visible spectrum. When saturation and brilliance are included, the number jumps into the millions. Although we are inclined to treat color as if it were a property—an affordance—of things in themselves, color is a subjective phenomenon that is never registered in isolation and can be perceived only in dynamic interaction.

Moreover, color is relative to context. Seen next to another color, it changes characteristics and may seem lighter, darker, or different in hue. In 1957, Edwin Land, who invented the instant Land camera and Polaroid, showed that the relationship between wavelength of light and perception is a complex one in which color is comparative and relative to changing illuminations. Land postulated a two-step process that later experiments by Semir Zeki showed as occurring in separate areas of the visual cortex, V1 where certain cells responded to wavelength, and V4 where other cells responded to color. Ultimately, however, as neurologist Oliver Sacks points out, "Color vision in real life is part and parcel of our total experience, is linked with our categorizations and values, and becomes for each of us a part of our life-world, of us . . . color fuses with memories, expectations, associations, and desires to make a world with resonance and meaning for each of us."[34]

This holistic view of color comes closer to the color theory of Goethe than to the reductionist views of Newton, for unlike Newton who saw color linearly as an automatic correlate of wavelength, Goethe believed that it was nonlinear perceptual process that was universal and to which color owed its existence. In the controversy between Newton and Goethe in the beginning of the nineteenth century, however, it was Newton's color theory which gained ascendancy; and it has only been in the last half of this century that Goethe's idea—that it was the interplay of light and shadow at boundaries that produced the effect of color in the brain—has been critically reassessed. One of the people who took Goethe more seriously than Newton was Mitchell Feigenbaum, the first person to discover the universality of scaling by which different dynamical systems behaved identically.[35] It was Feigenbaum's ideas that gave mathematical coherence to Chaos theory and gave further credence to

J. J. Gibson's insistence that the environment could be perceived directly, without complicated computations—that is, simply by perceptually grasping the ratio regularity within the system.

This "order in chaos" also perhaps helps to explain how various species perceive color differently, adapting to their particular survival needs. In certain cultures where color discrimination has not typically proven to be a requirement for survival, for example, various degrees of color blindness have been tolerated and therefore passed on genetically, increasing the numbers of color-blind people over generations. Studies across cultures have shown that rates of red and green color deficiency— the most common form of color blindness—are lowest in aborigines of Australia, Brazil, Fiji, and North America, and highest in Europe, the Far East, and Brahmins of India.[36] High rates are associated with populations that have long-developed pastoral-agricultural economies; low rates are associated with wildlife habitats where the inability to distinguish color could prove fatal because of confusion of poisonous with nonpoisonous species, or failure to distinguish a predator from the background.[37]

In industrialized environments, color blindness has also proven to be at best an annoyance and at worst a bar to certain occupations. In an effort to simplify directions, for example, many hospitals have color-coded their units, which is a boon to many brain-damaged people who can perceive colors better than numbers and to others in situations where quick recognition of help locations may be imperative. For about 1 in every 100,000 men, however, the color spectrum consists only of black, white, and grays,[38] and this can be a major problem, particularly if colors are not supplemented with other identifying marks. Men suffer more from colorblindness than women—about eight percent of all U.S. and European Caucasian males[39]—because genes for the red and green pigment are located side by side on the X chromosome.

In a cultural environment where electric toasters and coffee makers show degrees of light tan to dark brown to represent degrees of strength and "doneness," where business and government offices frequently color-code files, and even some buildings have color-coded floor levels (The James Madison Building of the Library of Congress, e.g., has discarded numbers in favor of distinctive colors for each floor), this is particularly irksome. In specific occupations requiring color signal recognition such as airplane piloting, severe color blindness may preclude employment entirely. In broad areas such as the creation and appreciation of art, or narrow ones such as landscape gardening and interior design, the disability may range from a minor handicap to talent frustration, to a considerable reduction in quality of life.

Humans and monkeys seem to have the same color categories, but other species see differently. Bees, for example, see light in the ultraviolet spectrum (from about 4 to 380 nm), but do not distinguish between green and yellow and cannot see red. Pigeons do see red, but are unable to see violet. Dogs and cats have only the most rudimentary color vision, and usually see color only when the color area is quite large.[40] In species where color display is a significant part of mating rituals, one can be confident that those colors are registered by the species and signal particular preferences. Experiments have shown, for example, that lizards will identify as female any other lizard of either sex if it is brightly colored.[41]

Although a logocentric bias has led some scholars to believe that we separate colors only on learning language, experiments have shown that preverbal infants discriminate colors before gaining language, remember some colors better than others, and use color as a cue to identifying objects and to remembering them.[42] Colors, in fact, appear to be not only one of the first distinctions made by humans, but also one of the first factors in gestalt grouping. When asked to put like things together, for example, young children will group by color first, and only later by form or function,[43] and there appears to be a pattern to color preferences in relation to maturity as well. Color preferences among children aged 5 to 9 years, for example, tend toward red, green, orange, and yellow, in that order, and these preferences cross over into food choices.[44] The attraction to red tends to increase with age, although women tend to prefer bluish reds and men yellowish reds.[45]

Once people learn language, they begin to divide the color spectrum according to different groupings and labels, depending on what is significant within the culture—drawing distinctions such as "wet," "dry," "dark," or "light," for example, instead of violet, blue, green, yellow, orange, or red. Despite differences in color terminology, however, researchers have found that landmark colors are distinguished in the same way by people all over the world, with the same type and distribution of errors for New Guinea tribesmen as for North American adults.[46]

Color, it seems, translates immediately into an emotional quality, which derives partly from personal associations; partly from experience in nature—Leonardo da Vinci commented in 1651, for example, that "Yellow corresponds to earth, green to sea, blue to sky and red to fire"; and partly from culturation. Red, for example, is associated with prosperity in India and is worn by brides in China; in Ireland green has strong political implications, while in Moslem countries it has strong religious associations.

Because the world around us appears to the normally sighted as burgeoning with color, and it is only in the relative absence of light that

we move into a realm of gray, black, and white, color is felt as more sensually pleasing and distracting than black and white, which tends to suggest more abstract or intellectual qualities. Full color photographs and paintings come alive with detail and texture, turning our attention to the external world, while black and white photography seems more introspectively dramatic, suggesting inner thoughts and character. We speak of the form of ideas and the shape of things to come, for example, but not the color.

Perhaps because of its sensual nature, color also tends to take on attributes associated with touch as well, such as softness and smoothness, and even solidity. Thus pink may seem soft, and the richer the color the more solid the object will appear. Colors are also often thought of as having temperature dimensions: red, orange, and yellow are perceived as warm, while green, blue, and violet seem cool, both in pigment and type of light. It is a distinction that is physiological as well as psychological. Experiments in body temperature within differently painted environments have shown, for example, that we will generally both feel and actually be warmer in a red room than in a blue room. Colors also move and thus achieve dimension. Warm colors tend to advance and cool to recede. On a two-dimensional surface, this creates a three-dimensional impression without the use of gradients.

Such synesthetic properties have caused color not only to be used as a reflection of nature but also as an essential part of movement in composition. Georgy Kepes, for example, believes that the chief contribution of modern art to the language of vision was the reduction of plastic composition to the most elementary shapes and to a few basic colors by both expanding space until matter was eliminated entirely and by compressing space and achieving balance through advancing and receding color planes. This new kinesis, Kepes believed, represented the final destruction of the static horizontal and vertical space of fixed perspective and the liberation of a new and dynamic perception guided by essential shapes and relationships. The job of the contemporary artist, Kepes wrote in *Language of Vision*, was to release and bring into social action the dynamic forces of visual imagery in order to liberate the inexhaustible energy reservoirs of visual associations. Artists, it seems, have always thought in advance of reductionist science, taking dynamical systems and nonlinearity as givens in their work.

Because color is particularly dynamic and laden with associations, the use of colors in the history of art often reveals paradigmatic shifts in social psychology, new understandings in perception, and symbolic meanings related to dominant religious and cultural beliefs. The color blue, for example, replaced gold as the color of heaven in the sixth

century because ground lapis lazuli was more expensive than gold and therefore more elevated psychologically.[47] When for the first time, in the nineteenth century, chrome yellow, lemon yellow, and cadmium yellow became available, what has been called "the golden age of yellow" was initiated, and artists like Turner began to explore the relationship between light and color on canvas. Traditionally, yellow had been associated with a debasement of gold, and with jealousy and inconstancy. Judas, for example, wears a yellow cloak in paintings by Van Dyck (seventeenth century) and by Giotto (fourteenth century) as symbolic of his betrayal of Christ.[48]

It was this aspect of color symbolism that was associated with Jews throughout the ages, and subsequently revived by Nazi Germany in mandates requiring Jews to wear yellow Stars of David on their clothing. In the Nazi concentration camps, colors immediately identified the "crimes" of the badge wearers: yellow for Jews, pink for homosexuals, red for political prisoners, green for habitual criminals, blue for emigrants, purple for Jehovah's Witnesses, black for vagrants.

One of the more interesting experiments in the perception of color has been in the recent psychological use of "Baker-Miller Pink" (somewhere between mauve and the color of Pepto-Bismol) in relation to violence and aggression. Initial studies in the 1980s showed that exposure to Baker-Miller Pink lowered heart rate, pulse, and respiration, and resulted in a lower anxiety and incidences of hostile behavior, which made it perfect for certain environments such as holding cells in jails and certain hospital areas.[49] Although results have been mixed and some controversy surrounds some research methodology,[50] there are numerous reports by office workers that co-workers have changed their demeanor, by hospital emergency room workers that patients seem calmer, and by prison officials that violent prisoners become more docile in mauve environments.

Blue, too, has a calming effect, and it is also often used in prisoners' day rooms and even to deter suicides on high bridges; in prison visiting areas, however, where prisoners meet briefly with friends or family, red has been used to good effect. Because it stimulates and breaks concentration, it increases brain-wave activity, and seems to lengthen the time of visits. In an office or classroom environment, however, where sustained attention is necessary and exposure is long-term, red can overstimulate and have a negative influence in terms of building aggression and interfering with the ability to concentrate on specific tasks.[51]

So powerful is the psychological effect of color that it will sometimes override all other practical considerations. This is particularly true in relation to gender stereotypes and images of power. The U.S. F117

Nighthawk—the so-called stealth bomber—which achieved a reported 75 percent strike accuracy in the Gulf War—was painted black not because black would make it less visible at night, but, according to *Aviation Week*'s Mike Dornheim, because the pastel color that would make it more difficult to spot at night was antithetical to a sinister image. A plane so masculinely powerful and so fearsome, it seemed, necessitated a more "macho" image: in short, all the aura of "Darth Vader."[52]

Fire engines, too, have fallen victim to image. Because traditionally red fire engines can be difficult to spot, particularly at dusk, many were replaced by more visible lime-yellow engines. Because yellow is also the color that the eye registers most quickly, research shows that red trucks are up to twice as likely to have intersection accidents as lime-yellow trucks. The decision to switch to lime-yellow thus makes a great deal of sense, since it allows for immediate noticeability in the wide spectrum of environmental light conditions and weather—particularly at dusk, when red engines are perceived as muddy brown. Yet fire truck manufacturers reported in 1991 that 75 percent of trucks ordered were entirely or partly red, up from 60 percent a decade earlier. People in Dallas, Texas complained so loudly when the city started ordering lime-yellow trucks in the 1970s that now when the lime-yellow trucks wear out, they are replaced by red ones.[53]

Part of the controversy over Baker-Miller Pink also stems from such psychological factors, mainly from gender image and social conditioning. When men were told, for example, that viewing pink would make them stronger, their grip in fact became stronger, and when they were told it would make them weaker, it became weaker. No matter which women were told, however, they responded with stronger grips— an effect hypothesized to be the result of an overriding emotional reaction against the stereotyping of "the weaker sex" and its cultural link to the color pink.[54]

In addition to color pigment, colored light also has pronounced emotional effects on how we see perceive situations, objects, and people. Orange light, for example, has been found to reduce muscle tone, red to act as a stimulant, and blue and green to have a relaxing effect in humans.[55] Red light has been shown to disrupt bird migration.[56] Light and dark also have significant psychological and emotional valences. Seasonal Affective Disorder (SAD), for example, which affects approximately one of every twenty adults and is characterized by depression during winter months, has been shown in some studies to be countered by exposure to light of very high illuminance (10,000 lux).[57] Variations in indoor lighting can also affect thought and attitude. At low levels (150 lux) of illuminance and in warm-white light, for example, subjects have

tended to rate others' work more highly, to employ a wider variety of vocabulary words, to collaborate more freely and openly in conflict situations, and to be more willing to help others, than at high levels of illuminance (1,500 lux) or in cool-white light.[58]

Light, Grain, Angle, and Size

As discussed earlier, human vision is also geared to daylight. Limited to forms and shadows at night (retinal rods do not achieve maximum sensitivity in darkness for about 20 to 30 minutes), humans have found that darkness as well as light can have profound effects on emotional states. Primitive humans' fear of the dark grew from the practical knowledge that they were physically susceptible to nocturnal predators, whose luminous eyes can appear especially malevolent. Waking alone in the dark can still be an especially frightening experience for children, for example, when the familiar becomes strange with sinister forms.

In the black-and-white photograph, darkness and shadow can easily be deliberately manipulated to produce desired emotional response. First, of course, the choice of indoor or outdoor and time of day when the picture is taken can either strengthen shadows or eliminate them almost entirely. Because people naturally have shadows and lines on their faces that must be flooded out by light to make them disappear, if a photo is taken indoors with a single directed light source, strong shadows will be evoked and lines emphasized. In natural sunlight, where ambient light gives a softer look and light from above creates a "halo" effect, the whole character of the face changes, and therefore our reading of the inner character of the person as well. Flattering portraiture will reveal fine details while at the same time softening the face with light; in contrast, police mug shots are deliberately unforgiving in order to bring out lines and features.

The coarseness or fineness of the grain of the film also plays an important role in light and shadow. Faster, grainier film, on the one hand, creates a harsher contrast between light and dark and tends to ignore subtle gradations in between; slow film with a fine grain, on the other hand, captures more subtlety in a range of grays and creates a softer, warmer appearance. A fast developer will further enhance the effect of menace created by shadow contrast, as will enlargement of grainy film. The use of a fast film, fast developer, and enlargement can therefore accent natural shadows to the point of gloom or menace. In addition, underexposing film in developing gives a darker, gloomier image, but overexposing creates a lighter sense. These effects can be manipulated not

only to create film-noir newsreel-type effects, but also to make the ordinarily menacing or morally repugnant seem beautiful as well.

In the controversial film *Pulp Fiction* (U.S.A., 1994), for example, director Quentin Tarantino used 50 ASA film stock—the slowest made—which shows almost no grain and has a visually lustrous appearance, giving colors a sensual vividness and objects and action exquisite detail and texture. To use it, the set must be completely bathed in light, which also allows for depth of field. The overall effect is one of truly sensuous luminosity, a kind of psychological sheen that settles on the action, endowing it with a special alertness, crispness, and beauty. Thus even though Tarantino's film is enmeshed in violence, stupidity, and insensitivity, the action nevertheless appears visually exciting, aesthetically pleasing, and even eloquent. Because of the built-in contrast between the repulsive action with inane dialogue and aesthetically beautiful cinematography, the film is a very disturbing example of perceptual dissonance that is ultimately resolved by making violence sensually appealing. This is discussed further in Chapter 8.

In the same vein, Tim Burton's *Batman* (U.S.A., 1989), whose subject is the classic superhero fighting for justice in Gotham City, manages to create a deep sense of malaise with sets pervaded by dirt and darkness. Although the popular television series and the film based on it (*Batman*, U.S.A. 1966) were both bathed in light and an intrepid optimism, Burton's film places the same characters in a world pervaded by cynicism as well as crime. Sets trail into dark and threatening corners, windows and light are almost nonexistent, and a dull griminess covers everything but the dark interior of Wayne Manor, where a display of grisly weapons and armor are given their own room. In this world, character idiosyncrasy becomes deep psychotic perversity; greed becomes a darker and more sinister lust; and people's psyches are swallowed up by what George Gerbner called "mean world syndrome."

The language of camera angles is also highly manipulative emotionally and is perhaps one of the simplest and easiest to understand examples of visual language grounded in perceptual experience. In camera angle, the literal is united with the symbolic, bridging the two worlds of logical and creative thinking within the psychology of the image. As the expression "seeing eye to eye" suggests, for example, action recorded at eye level at a comfortable distance suggests natural vision and equality of status or importance, but when the angle shifts to slightly higher or lower than eye level, a subtle attitude creeps into the image, which sometimes comments directly, sometimes ironically, on the subject and action included in the frame. It seems appropriate, for example, to shoot the Lincoln Memorial in Washington, D.C., from a low

angle, matching the content of the shot with the "feel" of respect commanded by it. When combined with light, angle can further enhance natural shading—like a flashlight held beneath the chin. Although it is rare that a person would use such extreme lighting except perhaps in relation to a horror film, a very subtle camera angle and harsh light can create deep furrows out of lines and a troubling darkness about a face.

If the angle is extreme, the attitude becomes emphatic. Low angles (shot from beneath with the camera looking up at the subject) give the subject a sense of importance, power, and respect, particularly in relation to the viewer who is placed in the position of a small child. An enormous campaign poster of a political candidate placed behind the podium where he or she is speaking (such as Welles uses in a famous scene in *Citizen Kane* to emphasize the political heights from which Kane is about to fall) makes that person seem larger than life, especially as an amplified voice booms over the public address system.

When a figure is viewed from a low-angle, the effect is one of power alone. When it is also back-lit (with lighting from behind with the figure at least partially obscuring the light source) or bottom-lit (with lighting from below) the effect of power can also be very menacing—a technique often used in horror films. But when a figure is lit as with light from above, the resultant halo effect can add a moral dimension of purity or goodness. When a figure is seen from a very low angle against the sky, this effect is ethereally enhanced, and the powerful symbolism of the sky imbues the figure with a visionary quality by association.

In contrast, when film is shot from a high place looking down on the figure (that is, high angle), the reverse effect is achieved, and the figure looks small, helpless, and insignificant. In Nazi propaganda posters, for example, the Aryan family, the Nazi soldier, the worker in the field, the Hitler youth: all are always shown from low angle and bathed in light and color. Likewise in National Socialist Democratic Party children's books, German workers and officers are depicted in high angle and bright colors; Jews, however, are shown caricatured with dark complexions, ill-shaven and scowling, inevitably from a high angle, and predominantly in black and white.

When distance is added to low or high angle shots, the effect is again multiplied. An extreme long shot taken from a helicopter looking down on the city makes people look like ants, and their individuality and significance is proportionally diminished. As a film director, Alfred Hitchcock used this device in *The Birds* to show a shift in nature's usual balance of power, particularly in attack scenes that begin literally from a bird's-eye view: birds fill the screen with their size, but below in long shot, diminutive people look like insect prey.

When distance is reduced as in a close-up, a reversed meaning is created: suddenly the individual becomes interesting and important. Facial features seem to reveal internal thoughts and emotions, and we feel ourselves in a one-on-one relationship of empathy with the person. If, however, the close-up is too extreme, this, too, becomes threatening because experientially it feels like a violation of our personal space. At a close distance especially, eyes become very important, and even a point of view shot takes on menacing features if the person is staring directly into our eyes as if to challenge or to defy us. This is why faces appearing on wanted posters naturally look more hostile than separate features might warrant, and why close-up models in advertisements so rarely look directly into the camera. The effect of a direct stare is at best uncomfortable and at worst inflammatory.

Relative size, which is closely related to distance, also has enormous psychological impact on perception because it, too, has implications of importance as well as impact on our sense of personal space. Larger things are seen as having more importance, and large open spaces often seem to trivialize the presence of people. Similarly, large open offices spaces with multiple desks in regimented rows tend to sap individuality and self-esteem. As mentioned earlier, in interpersonal relations, space is an especially important dimension and is both personally and culturally derived. Extreme close-ups, for example, intimidate and may therefore antagonize. As Hall has noted, different cultural groups have different space needs, and an intercultural cocktail party may very well end with one group backed uncomfortably against the wall trying to escape into a greater social space while the other group with a different concept of appropriate social and personal space talks comfortably at them in their faces.

Time is also an attribute of the image, not merely in terms of historicity (e.g., in what particular period a painting was done or on what date a photograph was taken) but also in an existential sense. As French semiologist Roland Barthes points out, for example, we always are aware that what we see in a photograph has no projective presence, but only a past: a "then" as opposed to a "now." Yet such images also exist outside of time as well, as Barthes himself acknowledges in his essay on "The Face of Garbo," where he comments that her face represents a "fragile moment when the cinema is about to draw an existential from an essential beauty, when the archetype leans towards the fascination of mortal faces, when the clarity of the flesh as essence yields its place to a lyricism of Woman."[59] While time seems suspended in the face of Garbo, which holds the camera as one of the longest close-ups in film history in *Queen Christina* (U.S.A., 1933), it is also elusive in the consciousness of

the average person who must measure it in relation to experience, as within the context of a specific activity. When the image of that activity is recalled as a holistic experience, it retains the time within it and thereby makes it real.[60]

Conclusion

Just as the eye is not a camera, so too a photograph is not a copy of reality. Photographs are, in fact, only areas and gradients of color and/or shade on pieces of paper, and tales of missionaries who have shown photographs to uncomprehending natives attest to the fact that at least to some extent, we must *learn to see* the semblance between objects existing in three-dimensional space and those captured by light on two-dimensional surfaces.[61] When we assume that pictures do not lie if there has been no intervention between what exists "out there" and the finished photograph, we may need to be reminded that flatness alone creates an enormous gulf between reality and its depiction in print, and this gap creates an ambiguity that only perceptual process, experience or imagination can overcome. When, for example, we see a photograph of a man standing with a cityscape in the background, we do not assume that the person has a small building on his head, even though on the flat surface of the picture, it seems to rest squarely on top of it.

Gombrich insisted that the roots of art lay not in imitation but in psychological projection. According to this view what we see is a product of our imaginative projection of what it is like to be in such an environment (assuming we are familiar with high-rise buildings), and the amalgam of past experience and perceptual process allows us to interpret the shadows on the piece of paper appropriately. Although Gombrich has been cited by both sides in the debate over the superiority of words or images, at bottom what he suggests is that the perceived similarity between the actual situation and the picture is more the result of the *process* by which we interpret them both, than from any true correspondence between the two. What allows us to see one as the reflection of the other is that both are rooted in the same search for meaning that we bring to life in general: in both, perceptual process works to separate figure from ground, to make sense out of the relationship of objects, and to interpret gradients as depth. The language of visual images is the language of perceptual experience, just as words are abstract symbols meant to communicate the essence of that experience.

This implies that while "realistic" images in photography or art are neither copies nor explicit "conventions," neither are they arbitrary. In perceptual process, images form in response to external change and

internal attention to it, and this is as "real" as it gets. When we come to see photographs as forms and details reflective of the external world—just as we quickly learn to discern shapes in clouds or the face of the Man-in-the-Moon, for example—we are using the same phylogenetic skills that allow us to see the shapes of arguments or the form of political institutions of which Boulding has spoken. In all these instances, perceptual process moves from apprehension of the general shape to an appreciation of particular detail and mixes with motivation, memory and experiential context to form a gestalt—that is, a meaningful image that contains a story.

Thus the nature of the image is both a formative *process* by which meaningfulness is achieved as well as a *product* of vision or thought by which the essential identity of a thing is grasped. This is the essence of what T. S. Eliot meant by "objective correlative" in poetry when he organized images to formulate emotion; believing that specific images could be sequenced in such a way as to re-create in the reader the emotion originally experienced by the poet. In this way, through metaphor the poet can move back beyond words to the primal experience with its latent emotion intact. Such a sequence would mimic the perceptual process of raw experience itself on all levels. It also particularly implies drawing on the phylogenetically older limbic system, which is the basis for our emotional involvement.

The prejudice for the verbal and against the visual dominates and confuses almost all intellectual discussion on the visual image to date, and this experiential emotion embedded in the image is precisely what some religious thinkers have mistrusted as dangerous because it remains in the realm of the sensual. Images therefore exist not only in dimensions of shape and form, and in levels of meaning from literal to metaphoric to symbolic, but also in contextual frames of immediacy and mythic timelessness. They can be simple or multilayered, and they can be manipulated into reflecting political or philosophical ideologies.

Although the semiotic terms ultimately derived from spoken language help us to speak of these aspects of the image, the power of the image is rarely linear and categorical, but rather derives from experiential logic, which is cultural, holistic, and associationistic. As Boulding observed, image meaning also moves in paradigmatic shifts: when the situation is exactly right, the image can instantly clarify meaning or perhaps even change the whole course of a person's thinking or a nation's political life.

The power of each image, whether it is produced in art, photography or in the mind's eye, may be seen as composed of a number of psychological implications related to various content factors—color,

lighting, angle, focus, size, distance, shape, texture, and tone. Each separate element has its own impact, and in combination, these factors ultimately create a whole mindset that affects each part, just as each part affects the whole. Selective perception, past experience, personal and cultural attitudes and values—all of these combine in a variety of ways to interpret and fill in perceptual stimuli to build a rationally and emotionally meaningful communication. The "language" of images as grounded in the grammar of perceptual process mediates between the self and the external world.

The following close-up explores the power and integrity of photographic and digital images, particularly in relation to conscious manipulation of perceived reality by print mass media.

Close Up

Manipulating Public Images in the Age of Digitalization: J.F.K. Marries Marilyn; O.J. Metamorphoses from Black to White

I saw JFK marry Marilyn Monroe and I have the picture to prove it!

—*Sun* cover story headline

Cut and Paste

The January 10, 1995 issue of the tabloid *Sun* shows on its cover a photograph of the late President John F. Kennedy in a tuxedo with a green bow tie and the late Marilyn Monroe next to him in a long white wedding gown, holding a bouquet of white roses surrounded by green ferns. The headline reads "I SAW JFK MARRY MARILYN MONROE . . . and I have the picture to prove it!" The story, which is relegated to page 27, tells the near-death experience of a woman who claims to have been a friend of Marilyn Monroe when they were aspiring actresses together. The victim of a car crash, she reports that she lapsed into unconsciousness, met Monroe who was excited because she was about to marry JFK in the spirit-world, and when she awoke, found their wedding portrait framed on the bedside table. The story is not unusual for the *Sun* which, like the *National Enquirer* and other popular tabloids, often relates on its front pages dreams, visions and tales of the afterlife as if they were facts in this one.

What is unusual about the story, however, is the quality of the photograph—not because it is so believable, but because it isn't. Unlike the "spirit" photographs sometimes used by charlatans in the nineteenth century to convince portrait-sitters that they were indeed surrounded by the spiritual presence of a loved one, and which were the product of simple double exposure, the Monroe/JFK photograph immediately appears "off." Never mind that the shadows are all wrong. What stands

out is that the two heads look pasted on other bodies, like those comic stand-up boards of buxom bikinied women and muscle men in tourist spots—just put your head through the hole and send a funny postcard to a friend. JFK's head is too big for his heavy torso and his arms are far too short. Marilyn's head faces forward when the twist of her body posture and neck would indicate that it should be in profile. It may be that no one was meant to take it too seriously (although there are many people who undoubtedly did), so perhaps no effort was made to make the photo believable. What is more likely, however, is that the photograph was simply handled amateurishly—and this itself is highly unusual at a time when anyone with a personal computer can scan-in and alter a traditionally processed photograph, or work directly on an image downloaded from a digital camera.

The technique of paste and cut to create a new image is nothing new. It has been used for years to manufacture compromising images of political figures, to get the right look for an advertisement, in tabloid "news" photographs to place celebrities together who were photographed separately, or to show UFOs hovering over New York City. What is fairly recent, however, is the ability to "doctor" reality without the fraud being detected, and today manipulation of the photograph is faster, easier, and more convincing than ever before. When the August 26–September 1, 1989 cover of *TV Guide* sported a photograph of the head of Oprah Winfrey on the body of Ann Margret, for example, the effect was indeed believable. Skin tones, shadows, proportions, and positioning were truly convincing, and no doubt many were fooled into believing that this was indeed the butterfly beneath the image of the dowdy supporting actress of *The Color Purple*, an accurate image of "the richest woman on TV" whose struggles with weight gain had been continually in the public eye. Looking sensuously beautiful, the lithe composite "Oprah" is apparently sitting atop a pile of money, her earrings and dress glittering in the lights which consistently illuminate her face, shoulders, and arms with a golden glow. Skin tones are especially convincing, despite the fact that the composite women are of a different race, and the healthy sheen that emanates from her skin is especially alluring.

Digital Images

The traditional photographic process that has characterized image duplication for over 150 years involves a time-consuming series of chemical reactions beginning with the capture of light on silver halide film and ending with the transference or fixing of the image onto paper or a transparency through "development" processing. The final image is

analog, that is, it is composed of a series of continuous gradients that are analogous to the gradients seen in the world around us.

Digital imaging, however, involves a completely different process. It captures an image electronically on a light-sensitive silicon chip containing hundreds of thousands of pixels ("picture" + "element") that measure light, color, and contrast. Because each pixel is square and uniform, it can be changed at will in the computer, with the level of resolution dependent on the number of pixels. As in an Impressionist painting, the separate pixels blend together in perceptual process, so that we become aware of their true nature only when grossly enlarged. One of the most important differences between film and digital images is this resolution. In 1995, for example, while Kodachrome film had a resolution equivalent to 18 million pixels, the best current digital camera had a resolution of less than one-tenth of this. As this capability continues to improve, however, other characteristics of digital imaging inevitably have made it the medium of choice, particularly for altering images. If an image is analog to begin with, it must be converted into a digital image (i.e., into data represented by 0s and 1s), by a converter scanning device before it can be manipulated on the computer screen. Once converted, however, because each pixel is represented by a number stored in memory, reproduction becomes a matter of mathematics rather than chemical processing, so that each image is a true one and it is impossible to tell which generation any "copy" represents.

Once information is in digital form, it also becomes extremely easy to store, alter, and transmit. Because each pixel can be enlarged on the computer screen and individually changed, the image can be manipulated at will: elements can be added or deleted and changed in color or brightness. Areas can also be copied and the copies pasted down so that background areas can be repeated indefinitely to fill in gaps where other elements have been removed. People can be made fatter or thinner, the color of their hair and eyes changed; divorced spouses can be removed from family portraits, and new family assemblies created to include great grandparents dead long before the youngest family member was born. When the image is finished, it can then be printed out and transmitted anywhere in the world instantly via telephone lines or satellite.

One area where all of these characteristics have been put to particularly beneficial use is in the age enhancement of photographs in cases of missing children. Because children change appearance so quickly, photographs of missing children soon lose their efficacy; and because of their utility in creating a truer current likeness, age progression through digital manipulation of images has become an important tool for law enforcement. According to the National Center for Missing and Exploited

Children, over 350,000 cases of child abduction are reported each year. Usually it is a case of one parent abducting the child, but the hope of tracking the possible whereabouts is slim because of limited sharing of information among law enforcement agencies, and because of dated photographs. At the Center, to create a more current image when the child has been missing for more than two years, the last photo is studied in combination with photos of other family members at the age the child has currently attained, and a likely composite is generated according to typical growth patterns. In the cases of children recovered in this manner, the computer-generated photographs have proven to be uncannily accurate in portraying a true image of the child.

Because the process of digital imaging is so amenable to such kinds of editing, it has also been the first choice of artists, commercial designers, and print periodicals from its earliest appearance. And because such images can be easily and immediately transmitted, they are also the choice of newspaper photographers. When George Bush was inaugurated as president of the United States, for example, Associated Press photos of the swearing-in ceremony were ready for the front page only forty seconds after they were taken.[62]

Manipulation by Stages

Traditional photographs may be altered in four basic ways: in the set-up of model, camera and lighting before the photograph is taken; in the way the photograph is taken; in the processing of the film; or by the addition or deletion of elements to the processed photograph, followed by rephotographing the whole. Portrait photographers are especially adept at setting up the scene and subject so that it will appear in the most flattering light. Light sources such as from a fire, candle, neon tubes, or incandescent bulbs can dramatically alter the way we interpret personality; shadows can be filled in or deepened. Angles are carefully chosen, and subjects posed according to their "best side." Subjects in profile, for example, tend to appear more remote because in profile shots, shape and form dominate facial expression; they therefore tend to invite less empathy but perhaps more admiration, as if they belonged to a more abstract or distant world of ideas. Subjects may also be photographed in contexts that provide a complimentary editorial environment, such as shelves of books as a backdrop for an intellectual portrait, or a negative one like a jail cell. Occasionally, what have been assumed to be historically accurate photos have been discovered to have been "staged" because various clues in the set-up or subjects suggest manipulation.

One famous example is photographs of the Civil War taken in 1863 by Alexander Gardner, where the same dead soldier in rebel uniform is

seen felled behind a wall of piled stones nearly enclosed by large rock foundations, his musket still standing, and then again as a Northern soldier in a field with his gun lying beside his head. Clearly the same corpse had been posed for the most aesthetic or editorial effect.[63] In another, more famous case early in the twentieth century, two young girls in Cottingley, England insisted they saw fairies, and after they were mockingly teased for it, succeeded in producing a photograph of one of the girls behind a ring of apparently real tiny winged nymphs.

The case drew much controversial attention at the time, but it was not until much later in life that one of the women admitted that they had drawn wings onto figures cut from a children's book and set up the "fairies" with simple hat pins to take the picture. The photo took on an uncanny reality for two reasons: the photo had not been double-exposed or touched-up in any way, yet the figures of the fairies had obviously been moving, even erratically, when the photo was taken. (The convincing movement, it turned out, had been caused merely by the vagaries of natural breezes on the paper cut-outs stuck into the grass.) Because the set-up is the easiest point at which to alter factors that contribute to the overall effect, most manipulation of traditional photographs tends to take place here, while the film is still in the camera.

After the set-up is done, various other "stylemes"—to use Pasolini's term—can be used to further manipulate the image. In addition to warmly diffused or strident lighting, the camera lens can romanticize the subject through soft focus or "harden" the subject through sharp focus. Different focal lenses can bring the background into clarity, such as with a wide angle lens, so that the field takes on equal importance to the subject or even comments on the foreground figure; or they can flatten or blur the background into insignificance, as with a telephoto lens that has as very shallow depth of field. Full color can make festive what black and white would make depressing; angle and distance have powerful connotations for emotional involvement and attitude toward the subject; what is included within or excluded from the frame can profoundly alter contextual interpretation and connotative meaning. Before any photograph is taken, therefore, a number of decisions have already deeply affected the finished product.

This is why it is often said that there is no such thing as an objective photograph, since attitude and tone is already "built into" the image by the photographer. Within official arenas such as passport photography or police work, such editorial manipulation is avoided by technical specifications that are regulated to ensure uniformity and minimize photographer discretion.

In the processing and postprocessing stage, a variety of techniques can be used to alter the print, including over- or underexposure or treat-

ing the negative to cover lines or remove unwanted objects or people from the image. If parts are masked off or cut out, however, the natural gradients of the photograph are disturbed and an unnatural sharp edge appears in the final image. Because when film is developed an emulsion grain is formed by the clumping of molecules, if this grain is subsequently disturbed by pen, pencil, or paint, or specific sections are erased, alteration is easily detectable. If parts are added to a photo after it is developed, they must match exactly before the composite can be convincingly rephotographed. Because any difference in proportion, color, brightness, focus, lighting, or camera angle is an immediate perceptual signal, any additions must be photographed under nearly exactly the same conditions as the primary photo and reflect the exact position that would naturally have occurred as depicted. Some historically significant photos have been accurately identified, for example, not only by context but also by the angle of the sun at a particular time of year.

Even when doctored photographs are rephotographed, alterations such as retouchings and montages never disappear entirely because traditional photography is an analog representation and therefore extremely difficult to alter without obvious effect. Unlike a digital image which is broken down into discrete units, the traditionally processed photograph appears as a continuous and unbroken sequence of subtle gradations. This makes it extremely difficult to rework a photograph because there are no individual units—cells in a grid—on which to work after the image is fixed. There are only ever-increasing and subtle gradations that it is nearly possible to re-blend convincingly. The final surface of the image is so smoothly coherent that reworking immediately stands out.

Nevertheless, the history of photography is filled with such alterations. Alain Jaubert, for example, has chronicled a number of cases of photographic attempts to manipulate public sentiment or rewrite history.[64] One of the most politically significant of which is the erasure of Trotsky from a May 5, 1920 photograph of Lenin addressing a crowd. In the photo, Lenin appears alone on a platformed podium; yet in another photo clearly taken at the same moment or almost immediately after, Trotsky appears at his side halfway up the stairs to the platform. When Stalin rose to power, he not only eliminated Trotsky from official photographs as a matter of policy, but he also had himself placed into films in situations where he was never a historical presence. In one ironic twist, Mikhail Romm's *Lenin in October* (U.S.S.R., 1937) which falsely placed Stalin in almost every scene with Lenin as a supporter and adviser, was revised under Brezhnev to delete the then politically incorrect Stalin from the film. Thus the revised version, politically motivated as well, is closer to the actual truth than the original film was.[65]

To show how easily such politically significant images could be digitally created, in 1988 *Life* magazine digitally lifted images of President Ronald Reagan, Palestine Liberation Organization Yasser Arafat, and Israeli Prime Minister Yitzak Shamir from separate photographs and created a combined photo of the three at a summit meeting. The entire process took only two and a half hours, even though it involved digital scanning, adjusting sizes, lighting and skin tones, and painting in a new background. Despite the political incredulity of the time, the photo was convincing. This impression and the fact that such manipulations as the erasure of Trotsky occur at all not only points up the extent to which photographs are generally trusted as faithful recordings of actual events, but also underlines the larger significance of documentary images within social and political constructs. Particularly in the case of journalistic photos, the public has grown accustomed to believing that what they see is an actual moment, frozen in time.

Since its invention in 1839, photography has not only inspired unwarranted trust but also passed its credibility on to video. Public credibility given the videotape that recorded the beating of Rodney King by Los Angeles police in 1992, for example, may be said to have been directly related to the L.A. street riots. These erupted in the city when the verdict of not-guilty was brought in by a majority white jury at the subsequent trial of four police officers involved in the beating. Had the public not seen and readily believed the video footage taken by a bystander, the related riots would likely not have occurred, nor would the L.A. police force have been exposed to the national public scrutiny that ultimately formed at least part of the credibility given to the "planted evidence" defense in the O. J. Simpson trial two years later.

Yet the manipulation of videotape for political or other ends is now as feasible in video as in photography because of sophisticated digital compositing techniques. In 1992, for example, Diet Coke commercials created by R/Greenberg Associates, a New York company specializing in special effects, revived Louis Armstrong, Humphrey Bogart, and James Cagney from the dead to endorse their product by convincingly colorizing film images of the celebrities and inserting them into sequences crafted to feature the footage seamlessly.

By the end of 1995, the manipulation of images in print was so common a practice that even kids' magazines were using digital manipulation techniques as a means of figurative language and explaining how it was all done. The August 1995 cover of *Sports Illustrated for Kids*, for example, showed Cal Ripken with his arm around Lou Gehrig when Ripken was about to break Gehrig's record of playing 2,130 games in a row. Inside the cover, an article "How We Created the Cover" shows

how an original photo of Gehrig and Ruth was used as a base, how Ripken was photographed in black and white with his arm around another person in the exact pose of Gehrig, and then lifted from this photo and inserted into the original.

The Narrative Factor

When still images go beyond the literal level of simply reflecting a neutral reality, that is, when they begin to encompass metaphoric and symbolic meanings, they also take on narrative significance as well, implying action immediately preceding and following the frame, as in a well-drawn comic strip. Just as in perceptual process, the part implies the whole: photographs capture a moment that implies a situation; hence such expressions as "a picture is worth a thousand words." Just as Hemingway sought to capture the pregnant detail that would suggest the story below the surface, so photographers seek to record the critical moment that implies a larger reality. On the tabloid side, this ability of the photograph to tell a story often results in photographs typical of Italian *paparazzi*, who will seemingly go to almost any lengths to capture intimate moments of public figures and celebrities, such as nude photos of Great Britain's royal family members.

For serious photojournalists, however, the critical moment is one that can act as the climax of a story or capture its essence in such a way that it becomes an objective correlative for a profoundly shared national emotion, a metaphor of social or political significance, or a symbol summarizing some form of transcendent human struggle. Such photographs might include such moments as Harry S Truman holding up the *Chicago Daily Tribune* headline reading "Dewey Defeats Truman," or Margaret Bourke White's photo of Ghandhi sitting cross-legged on the floor at the age of 76 reading, his spinning wheel in the foreground, his simple bed behind him. Similarly, the nation's mourning seemed to be forever frozen in the photograph of Jacqueline Kennedy dressed in black, holding little John's hand at John F. Kennedy's funeral; its despair captured in Dorothea Lange's portraits of migrant workers and the unemployed during America's great economic depression of the 1930s.

When a still visual image exists apart from other images (that is, not part of a sequence of accumulated meaning beyond the individual frame), the visual takes on the emotional valence not only of the gestalt created by the interaction of the elements but also the feel of the immediate surroundings as well. (An exquisite oil portrait hung in a mahogany paneled library, for example, has a totally different affective valence from the same portrait hung in a public restroom.) In advertising, art directors try to capture in their images the essence of the product benefit in rela-

tion to the target market; in politics portraits for posters and buttons seek to embody qualities of leadership, vision, charisma. Magazine covers also try to capture the crux of major news stories or personalities, and to convey in their cover images something of their editorial attitude toward the subject.

Yet the projected image is only half the message. The feelings of the perceiver also provide a charged field that completes the meaning. If the portrait is highly positive, and the viewer holds the subject in high esteem, all of the valences may be said to be positive. But if a cognitive dissonance exists—as when a Nazi death camp survivor sees a flattering portrait of Hitler—the whole of the image may take on a totally different character. Whenever we have preconceived notions of a person, place or idea, a kind of "closed whole" already exists, and the next encounter with it will have to be strong enough to produce a whole paradigm shift in order to alter the valence.

Additionally, because the resultant gestalt also refers to or signifies something else, each image works on various levels, from literal to metaphoric to symbolic, ranging from the immediate and personal, to the cultural, organizational and political, to the mythic and timeless. What begins as a rhythmic dance among biological neurons in visual perception can end in a spiritual "cosmic dance," or in the ersatz euphoria of materialistic, sexual, or political exploitation. Embedded in each image created for a public audience is an implicit storyline that the viewer participates in and completes according to what is suggested by the stylemes of the image, the perceptual principles of good continuation and closure, and his or her own values, attitudes, and experience.

Credibility Issues

When the image is a photograph used on the cover of a respected magazine, it not only carries the credibility of photography, but also the trust that the reputation of the periodical bestows on it. This is why, for example, when *National Geographic* in 1982 digitized an image for its cover and moved one of the great pyramids at Giza to fit within its yellow cover frame, it created an international storm of controversy. Critics rightly saw in the simple movement ramifications that could ultimately destroy the credibility of all visual recordings, yet the magazine's editor explained, also rightly, that the effect only mimicked in substance what the photographer would have captured had he moved a few feet.

Even though such credibility may be desirable in any kind of mass media, it is also essential in areas such as trial evidence or scientific research where falsified evidence may have the direst consequences. The Federal Food and Drug Administration (FDA), for example, relies on the

integrity of images to evaluate drugs, and scientists commonly use electronic cameras to record DNA bands on gels that could eventually end up as evidence in a murder trial, as it did in the O. J. Simpson trial of 1994–1995. In 1991, the FDA adopted a set of guidelines for "Good Automated Laboratory Practices" that require laboratories to archive original unedited data and to document any and all changes; by 1993, the National Institutes of Health (NIH) held its first conference session on plagiarism and scientific misconduct in digital images.[66]

Because there is no way to discriminate between "cleaning up" a digital image and falsifying one, detection of fraud can only be accomplished by creating some kind of tamperproof record of the original image. This is feasible only if the original image is a true one, however, and only when it is informative in its original state. "Photographs" of Mars and Venus sent back to Earth via satellite are really composed of millions of bits of information that must be interpreted, cleaned of "noise," and digitally enhanced, for example, in order to give a truthful image of what planets really look like close up. Computer-generated images are also commonly generated as models, and many art images have no counterpart in reality at all, having been built from scratch electronically on a computer, as has become common in filmmaking. At the heart of the dilemma that makes computer enhanced images of distant planets seem innocuous and the erasure of Trotsky historically monstrous is the fact that one has required the intervention of the digital artist to reveal the truth, while the other has required the absence of human intervention to maintain it.

The privileged position as a credible reflection of reality that the photograph has traditionally held over representational drawings and paintings probably ultimately derives from the amount of influence that the artist exerts over his or her material. In nonphotographic artwork, we assume that what we see has already been interpreted and therefore contains a certain amount of emotional or intellectual bias—indeed it is the synthesis of elements as they are transformed by the personality and ability of the artist that gives the work its value and interest. We have come to expect, however, that photographs will not have been manipulated, and because we have become accustomed to believing that photographs don't lie, we are already prone to overlook the manipulation built into them.

Because we tend to believe the photograph as an accurate portrayal of reality, we also tend to read the *external* effects of lighting, lens, angle, framing, editing, and cropping as *internal* attributes of the subject. This tendency to project photographic treatment as a property of the subject is clearly one of the most dangerous aspects of the "seeing is

believing" attitude, because it projects onto the subject a seeming "reality" that has no basis in fact. If the photograph can be undetectably altered, it can also be loaded with deliberately exploitive emotional connotations while still retaining the crucial sense of credibility that has come to be associated historically with the "objective" photograph.

Such exploitation and manipulation appears truly sinister, particularly when it is associated with areas where truth is considered sacrosanct, as in justice, science, and journalism. When these areas become corrupted, the whole superstructure of the society is threatened. Although some magazine cover manipulations may seem inoffensive because they merely overcome the inability or inconvenience of getting subjects together for the "shoot" in the same place at the same time (as on the 1993 *Ladies Home Journal* cover featuring Mary Hart and Jaclyn Smith with television news anchor personality Connie Chung who was photographed separately); or because they reflect obviously ironic or satiric comments on reality (as in *Spy* magazine's covers featuring Michael Jackson as a nun and Hillary Clinton as a dominatrix, *Time* magazine's cover with a pig's head on a man's formally business-suited body with the question "Are men really that bad?" or *Texas Monthly's* cover of Governor Ann Richards "dirty dancing" with her Republican opponent Clayton Williams), they nevertheless carry a ring of reality and a built-in attitude that can easily affect the way the subject is perceived. Indeed that is part of their purpose. When in 1992, Ann Richards' head was placed on a model's body dressed in white leather and sitting astride a Harley Davidson, for example, *Texas Monthly* art director D. J. Stout was asked how he ever got her to pose for such a picture—this despite the fact that the magazine policy is reportedly to use only the most outrageous images inconceivable as fact.[67]

Images of O.J.

In 1994, all of these issues related to manipulation and credibility seemed to come to a head in the controversy surrounding two magazine covers featuring the same public figure. On June 27, *Time* magazine featured a cover illustration of O. J. Simpson, credited as a "photo-illustration" by Matt Mahurin who had previously done other such work for *Time* covers. The photo was a doctored version of the "mug shot" taken by Los Angeles police on Simpson's arrest for the double murder of his former wife, Nicole Brown Simpson, and her friend Ronald Goldman outside her home about two weeks earlier. The same day, *Newsweek* ran the original photo taken by L.A. police.

It was the difference between the covers that caused the controversy. The *Newsweek* cover shows the Simpson photo cut out in front of

its banner name, hiding from view the "s" and part of both "w"s. Above the banner two other stories are announced, one on health care and the other on gays. The background for Simpson's portrait is a uniform whitewash, his jacket is blue, and the cover story title, run in large letters across his chest reads "TRAIL OF BLOOD" in capitals. Beneath this are the identification numbers and letters used in mug shots, including "Los Angeles Police: Jail Div."

The *Time* cover, however, shows the TIME letters superimposed over Simpson's forehead. The photo has a more ambiguous focus and is considerably darker in hue. Where Simpson's skin appears more golden brown on the *Newsweek* cover, on the *Time* cover, it is deeply bronze-brown-black. Shadows surrounding him and around the border are black, as is his hair, jacket, and heavy beard stubble. The cover story title across his chest reads "An American Tragedy" in upper- and lowercase shadowed letters.

Because the *Time* cover was so much darker, many Black journalists and even the NAACP's Benjamin Chavis accused *Time* of racism and a "legally prejudicial attempt to make him look sinister and guilty."[68] According to *Time* managing editor James Gaines, however, nothing of the sort had been intended, and he retorted that "One could argue that it is racist to say that blacker is more sinister."[69] The cover was chosen, he said, because it seemed more dramatic. Gaines's comment, however, acknowledges only the darkness of skin tone in the illustration while ignoring the editorial darkness of the shadows and blackness characteristic of a figure looming in the night, not quite clearly seen. While Simpson's image emerges from the background in *Newsweek*, it remains fully behind the print foreground in *Time*. What this does perceptually is to essentially reverse the usual figure-ground relationship, so that the image of Simpson reverts to background placing him behind horizontal and vertical bars of the name, distancing him emotionally from the reader.

Certainly it is true that the *Time* cover *is* more dramatic: it is fully bright red, black, and bright white, with only sepia skin tones revealing that it is a full color photo. Much of the darkness, in fact, derives from the brightness of the light surrounding Simpson's head, which is too bright and does not diffuse or soften. Rather it hardens and antithesizes. Just as research has shown that warm-white low-level lighting seems to encourage feelings of calm and cooperation, so conversely, too-bright, unforgiving lighting induces negativity and irritation. In this respect, where the *Newsweek* cover is neutral, the *Time* cover is antagonistic. *Time*'s cover, in fact, lives up to its headline by suggesting a metaphor for the ambiguous "American Tragedy," but it seems to be a tragedy of

stereotypically black versus white mired in bloody violence. It is not there in print: it is there in the dramatic impact of black, white, and red all over.

The *Newsweek* cover is busier, milder in tone, and without the drama of contrasts. Its reds are faded, its blacks are grays, and its white backdrop is nondescript neutral. Although in both covers, O.J. is looking straight into the camera, because of the lighting, in the *Newsweek* cover he looks merely vacant; in the *Time* cover, we cannot read the expression of his dark eyes.

When Gaines insightfully commented in his editorial address to readers the following week that if there were anything wrong with the cover, it was that "it was not immediately apparent that this was a photo-illustration rather than an unaltered photograph," he gets to the heart of the matter: whether the sinister qualities that emerge on the cover were intended to evoke racial fears or not, they were, after all, clearly intended to evoke *some* unspecified emotion—and to this end, the cover was carefully changed for a reason. This at a time when most Americans found themselves caught up in the drama surrounding the murders and Simpson's arrest, and in the process necessarily confronting their own attitudes on interracial marriage and domestic violence.

It was not the first time *Time* had stimulated controversy through one of its covers, nor was it the last. Only a couple of months earlier, on April 4, 1994, *Time* ran a cover photo of President Clinton with White House Senior Adviser George Stephanopoulos, which had been cropped to exclude Press Secretary Dee-Dee Myers from the picture, and had been darkened considerably. The original photo had been innocuous, taken at a routine scheduling meeting: President Clinton has his hand to his forehead as if caught in the middle of a neutral gesture. His face looks tired, and within the photograph's true context, we see a man contemplating how to handle too heavy a schedule. The *Time* cover, however, creates a different negative context that makes his fatigue look like guilt. The photo is in black and white and is identified by the overblown words in bright yellow: "Deep Water" and below this in smaller print in six lines of dramatic reverse type (white on black): "How the President's men tried to hinder the Whitewater investigation." Within this verbal framework, the high-angle view of the shot adds to the contextual impression that Clinton is losing power and racked with worry and guilt. The essential ambiguity of the image is falsely clarified by association with the Whitewater banking scandal.

Another source of controversy developed from the magazine's "Man of the Year" December 25, 1995–January 1, 1996 double-issue cover, which featured Newt Gingrich. While the cover was not digitally

manipulated, it is an excellent example of how photography may be manipulated before the fact, through lighting and gels, and after the fact by too-close cropping. Because of the too-bright lighting and the most unappealing shades of yellow, green, and purple to light his face, Gingrich appears to have a black eye and the complexion of a chronic drunkard. The photo, cropped too close, not only highlights his beard stubble but also violates the reader's intimacy zone, promoting a vague sense of discomfort.

On March 18, 1996 *Time* ran a photo of Hillary Clinton that showed her face under extremely bright light against a totally dark background. This, like the O. J. Simpson cover earlier, evoked visual guilt without narrative evidence. Its specifically directed bright lighting creates a negative impact by suggesting a film noir–type police grilling and by emphasizing unnaturally harsh lines and shadows. The lower 40 percent of the cover reads: "Exclusive Book Excerpt/THE TRUTH ABOUT WHITE-WATER."[70] Although the Gingrich cover roused public opinion to the point where *Time* magazine lamented that it was damned if it did and damned if it didn't digitally manipulate the cover, *Time* was clearly editorializing through its images and some readers responded appropriately to it. The Hillary Clinton cover stirred no such controversy.

The Simpson covers for *Newsweek* and *Time* on the surface seem to show a similar kind of true context versus distortion situation, but they also offer an additional consideration: although the *Newsweek* cover was ignored in the indignation over the *Time* cover, the effect of both nevertheless hinged on the emotionally loaded use of a mug shot as an appropriate image. It is probably fair to say that most people associate such images with someone who has already been determined to be guilty of a crime, so strong is the valence of the jailhouse context. Both covers apparently achieved the intended effect: both *Time* and *Newsweek* magazines predictably increased sales for their Simpson cover editions. *Time* sales, however, increased disproportionately, almost tripling the previous week's newsstand sales, either because of the photograph and topic or because of the controversy it generated.

The *Time* cover publicity commotion was, in fact, a precursor of the media coverage to follow, as well as an accurate omen that the major theories and evidence of the murder trial would revolve around credibility and racism. Not only did the issue over color in *Time*'s photo-illustration tap broader cultural conflicts, but it also prefigured just how important image would become during the trial proceedings, from the significance of celebrity image in terms of media coverage, to the tainted public image of the Los Angeles Police Department, to the issue of the reliability and interpretation of DNA images as scientific evidence.

At the close of the trial, as a spoof on the power of image to impact thought, *Wired* magazine ran another doctored image of O. J. Simpson on its September 1995 cover. The low-angle photographic image in three-quarter profile, is of a blonde, blue-eyed O. J. in a dark business suit, striped tie, and white button-down shirt, standing out against a dark purple richly textured background. Placed in front of the magazine title and partially obscuring several letters, the composite image of "photography and digital collage" shows O. J. as a powerful, arrogant, intellectual upper-middle-class white entrepreneur. Of the cover's intent, editor and publisher Louis Rossetto explained, "We wanted to make people stop and think about how race influences their perception of O.J. and the trial, and especially how the media influences our perception of reality."[71]

By the end of the trial the media had not only influenced everyone involved, but had also redirected a number of lives: within the year, names of all the attorneys, the police officers, and most witnesses involved in the case had become household words; chief members of the prosecuting and defense teams had written books; testifying police officers and witnesses were making regular guest appearances on nightly talk shows, chief prosecutor Marcia Clark signed with the William Morris Agency, and Judge Lance Ito was reported to have been offered a million dollars to star in a new version of "People's Court."[72] The *Newsweek* and *Time* editions that followed the trial verdict increased their previous press runs by 100,000 copies, and CNN, which provided gavel-to-gavel coverage of the pretrial hearing and trial, released a three-part video series, "The People vs. O. J. Simpson" retailing for $29.98.[73] More is said of this phenomenon in the next chapter.

4

VIDEO'S MOVING IMAGES

Television? Chewing Gum for the Eyes

—Frank Lloyd Wright

Video Experience and the Nature of the Image

For many people the term "moving image" applies equally to television and to film; indeed the idea of seeing a film at home on television seems almost synonymous with seeing one in a theater. Yet the nature and experience of the video image differs from film in substantial ways, including viewing circumstance, viewer attention and expectation, image resolution, light and dark contrast, size and use of screen, and even dramatic plot pacing. Because of this, it is a very different aesthetic experience from watching a film in a theater to watching a movie made for television. This chapter explores the properties of the video image particularly as it is shaped and conventionalized by television, how the viewing experience differs with aesthetic limitations imposed by the medium and by commercial considerations, and how the image can be manipulated to influence viewers.

In contrast to the group dynamics and large-screen experience of film-going, television watching has become more of a casual, solitary, and activity-oriented experience, one continually susceptible to distracting influences. In the early 1950s, fully 80 percent of TV sets in use had two or more viewers. Today, however, it is estimated that at least half of all prime-time watching involves a solitary viewer.[1] The increase in the number of in-home TV sets, more highly targeted programs, and a wider array of viewing options such as cable stations, VCR film rentals, DVDs (Digital Video Discs), video discs and tapes for self-improvement, premium movie channels, pay-per-view, and channels dedicated to such things as home shopping, real estate, weather, and news: all of these have turned television sets into more personalized, multipurpose instru-

ments. Technological developments have also brought cable television providers into the realm of on-line computer services. That television use should become an individualized experience is perhaps as functionally inevitable as it is aesthetically appropriate in relation to the nature of the on-screen close-up image. Over thirty years ago, Marshall McLuhan presaged that within the new electronic age, "uniqueness and diversity [could] be fostered under electronic conditions as never before,"[2] and it is clear that we are now experiencing just such a diversity of use.

From its beginnings, critics have argued back and forth among the positions that television is a functional medium, that it is a tool for the communication of art, and that "television" is itself an art with its own peculiar characteristics, limitations, and aesthetic. Those who have stressed TV's function as a medium have not been surprised at its becoming more personalized and adaptable to a variety of uses, since electronic appliances inevitably become more ubiquitous and more adaptive to individual needs as they become cheaper to produce, as with electronic calculators, computers, and telephones. TV has thus developed into a multipurpose tool for individual use and gratification, a main line of current research.

Some researchers and theorists see in this trend such socially destructive phenomena as the breakdown of the family and lament this tendency of everyone to retreat to his or her own room to watch or use the TV in isolation. They recall the early days of television when watching was a group-oriented experience and programs were anticipated and discussed as films continue to be. Yet shared experience and sometimes animated interaction was possible in the early days of one-television-set-per-household because TV shows were necessarily produced with a mixed-group, mass audience in mind. Today, however, other "families" of people with similar interests continue to have group conversations, but in a variety of different places. Instead of the family laughing at "Uncle Milty," individual family members watch separately—70 percent of all American homes have at least two television sets, and 34 percent have three or more.[3] They then recombine in primary groups composed of individuals from other families, perhaps to discuss a sports game seen the previous weekend on ESPN—a cable channel dedicated exclusively to sports—or to discuss news items or personalities of particular business interest. Groups still converse, but more often it is after the fact of watching an event or news story, and probably the closest thing to earlier family program participation is now the impersonal communal gathering at "sports bars" to watch events on big screen TVs.

Instead of mass marketing television programs, then, current programming decisions are based on individual viewer demographics (age,

education level, income, etc.) and psychographics (values, attitudes, opinions, interests), which are "sold" to advertisers who want to reach particular groups. One of the hardest groups to reach by television, for example, is working executives, and some of the most expensive television "buy" spots have traditionally been on Sunday morning, on such classic programs as "Face the Nation," "This Week with David Brinkley," and "Meet the Press." Other groups in demand are men and women between 18 and 34 years old who spend at greater levels than older viewers, and males 18 to 49 years old, who are most likely to watch sports programs. This is why in 1994, for example, "Murder She Wrote," which had a household Nielsen rank of 16, commanded only $116,000 for a thirty-second spot, while "Lois and Clark," which had a Nielsen rank of 94, cost $132,000 per thirty-second ad slot.[4] It also explains why 30 seconds on the 1994 Super Bowl cost $900,00 and $1 million in 1995—three times the cost of the highest rated primetime shows. Segmented viewership, combined with the proliferation of available channels through technology, are manifestations of television's natural tendency toward individualized viewing. As television programming ceases to reflect a common cultural narrative, television ceases to be a mechanism for the narrative coherence vital to maintaining a common shared sense of ethos, an ethos that was part of the legacy television inherited from film.

The major exception to this is when families and friends still gather in groups around the home television screen to share the delight, concern, and grief associated with national triumphs or disasters such as the first moon landing, the events surrounding the assassination and funeral of President Kennedy, the Space Shuttle Disaster that claimed the lives of all the astronauts on board, or the first day of the Persian Gulf War—January 17, 1991—which drew a viewing audience of 5.4 million households.[5] This tendency to come together in front of the television set not only taps the group psychology more characteristic of film viewing, but also reveals television's primary advantage as instantaneous, long-range "tele"vision. Despite this grouping in times of extraordinary pride or grief, and the initial family gatherings around "the tube" to watch "family programs" spurred more by economic necessity and novelty interest in the new medium, however, television viewing has always naturally been more of an individual experience because of the size of the set, the limited resolution of the image, and the consequent nature of its close-up personalized image, all of which gives TV its own particular aesthetic. Even larger projection screens have not changed these attributes: they have merely enlarged them for better distance visibility.

The television picture is in fact, not a "picture" at all in the sense that a photograph is, for it exists only instantaneously when an electron

gun at the back of the cathode ray tube shoots electronic signals line by line toward the inside face of the TV screen. The beam moves in imperceptible lines across the screen from the upper-left-hand corner, down the screen, and back up in a zigzag pattern across 525 lines. When the beam momentarily hits any of the thousands of phosphorescent dots, it glows with an intensity determined by the strength of the beam and then disappears in the next electron beam scan 1/30 of a second later. Because the brain cortex does not register the signals separately but instead receives a single signal from a neural motion detector, as discussed in Chapter 1, we perceive movement where there are only changing light patterns and shapes where there are only contrasting shades of light. Anticipated in the work of the Impressionist and Pointillist painters who captured visual experience by reducing images to separate dots and strokes of pure color, the principle is also manifest in the child's toy which allows one to create pictures by placing different colored pegs in a lit peg board.

When television first appeared, programs were broadcast live. In the mid 1950s, this changed and videotape recording and editing, though bulky and expensive, were used to record studio productions and to edit and play back programs. For news, however, for the next twenty years 16 mm film was still used until portable 3/4-inch video recorders and electronic minicams became available. Stations quickly substituted analog video for analog film, taking advantage of video's immediate image playback, which bypassed time-consuming film processing.

By 1990, digital video had entered the scene, allowing for further flexibility and reduced costs as well. Once converted from analog signals, digital data can be compressed and encoded before transmission, requiring less space. In addition, because it is necessary to transmit only the differences between the digital frames (frame deferencing) instead of re-creating the whole content of the image for each frame, the amount of information is also considerably reduced. It is this technology that allows hundreds of channels to be economically broadcast to worldwide audiences via satellite.

In addition, as discussed previously, the switch from analog to digital allows not only for retaining original quality from one generation to the next but also for the possibility of altering the video image without detection as well. In a totally digital system, no analog original exists for comparison, and any manipulation of frames within the production, postproduction and broadcast stages of video images is potentially undetectable. Because video moves at 30 frames per second, alternating every frame would indeed be a time-consuming task; but just as the photographer has smoothing, burnishing, and editing capabilities, so also

video allows for alteration of key frames, with the application of algorithms automatically achieving a smoothing of the action between frames ("in-betweening") in a manner similar to the "morphing" effects first seen in science fiction films. Advertisers have been quick to pick up on the technological capabilities, and morphing is now used economically in a wide variety of television commercials.

What is true of digital video, of course, is also true for digital audio, allowing both images and sounds to be "sampled" from other sources and edited into key video frames to gain a realistic image and voice. Because any analog recording can be digitized, any filmed or videotaped image from the past can be placed convincingly into news footage. Just as Forrest Gump met Presidents John F. Kennedy and Lyndon Johnson in film, so Winston Churchill can now be interviewed by Dan Rather on the advisability of deployment of United Nations troops in Serbia. The danger, of course, lies not so much in the possibility that the dead can be brought back to video life as in the appearance of unaltered reality without its actuality—as for example, in a faked videotape of the President declaring war on a Middle Eastern country being used to justify an attack on American forces situated there for peacekeeping purposes. Both analog and digital video appear the same on the TV screen, thus their inherent credibility remains the same, despite the vastly larger capability of the latter for deception.

The process by which we perceive television images is a manifestation of perceptual closure explained in Gestalt perceptual theory. This forms the basis of Marshall McLuhan's now widely disseminated theory on "hot and "cool" media, at the heart of which lies his now-famous dictum that "the medium is the message." Called "the oracle of the New Communications" by *Newsweek* when his revolutionary ideas began to catch the popular imagination, McLuhan was sharply criticized by some academics who described his ideas as confused, rambling, and without a coherent theoretical base. Yet he was also lauded by others for his insight into the way in which media use would ultimately affect the way we think and perceive within our total experience. Today his views on electronic media experience continue to have pervasive impact.

Television, according to McLuhan, is a "cool" medium because its low definition demands a correspondingly high involvement in order to complete the process of image-making and meaningful construction which the television screen only begins. A "hot" medium is filled with data, like a photograph, while a "cool" medium provides very little information, like a cartoon. As a result, "cool" media require a high degree of participation in the process of filling in, while "hot" media, as prepackaged products, require very little active work. A primary difference

between cinema and television, he felt, was that while TV was "cool," cinema was "hot," demanding minimal involvement because of its high definition or production values. In this respect, anticipating film discussion in the next chapter, one may see in Eisenstein's dialectical montage a device for "cooling" down the film medium by engaging the viewer in intellectual and emotional debate. Pudovkin, however, because of his stress on continuity and linking montage may be seen as "hotting" up the medium.

McLuhan, then, extends Gestalt perceptual principles into mass media technology by observing that television represents "the supremacy of the blurred outline, itself the maximal incentive to growth and new 'closure' or completion, especially for a consumer culture long related to the sharp values that had become separated from the other senses. . . . What electric implosion or contraction has done inter-personally and internationally, the TV image does intra-personally or intra-sensually."[6] He thus explains the depth involvement of viewers with TV characters as stemming from the process by which the image itself is formed. This is why the medium is the message.

Low and High Definition

This process and its resultant low definition image naturally also place a number of constraints on the way in which television programs are shot, and therefore also on how programs are written to both capitalize on media advantages and turn media limitations into media virtues. Because of low definition, for example, television is generally limited to a range of close-up shots, with establishing shots used sparingly because they lack detail. Where, for example, films like John Ford's westerns, David Lean's *Dr. Zhivago*, or Robert Wise's *The Sound of Music* derive much of their plot and character development from the use of the land, taking full advantage of the wide film screen's panoramic sweep and vivid color, television works best in small physical and psychological spaces. Close-up shots place an unrelenting demand on actor expression, and the interaction among personalities becomes the main substance of television programming. Most drama takes place inside rooms and buildings, and human problems become the focus of conflict.

Where the large screen and stereo sound of the theater invite exterior shots of nature as in *Dances with Wolves* (U.S.A., 1990), extravagant pageantry as in the excesses of Cleopatra (U.S.A., 1963), and the dazzling sights and sounds of "Omnimax" theater, the small screen focuses on psychological probing and utilizes interesting and easily differentiated faces to achieve a personal intimacy that other media lack. Where the

large screen can easily encompass broad action as an integral part of conflict, on the small screen reaction shots predominate. Nothing makes the difference clearer than watching on television a film that has artfully utilized its own medium. *Thelma and Louise* (U.S.A., 1991), for example, a film about human confinement by social roles, effectively contrasts the open spaces of the West with the limited gender roles that victimize the two women as human beings. As they drive in a convertible through breathtaking "Marlboro country" toward inevitable tragedy, the contrast between their apparent freedom and the reality of the legal and social noose which tightens around them becomes ironically clear. The conclusion of the film, where they choose suicide by driving over the rim of the Grand Canyon, is a symbolic microcosm that captures in a single gesture both the grand promise of American freedom and the mechanized forces that have closed the women off from it.

The film on television, however, not only fails to capture the grand sensual scope that is an integral part of the film's gender message, it also changes the focus to an interpersonal one, and viewers tend to see people in conflict rather than a larger social commentary. The background, visually uninteresting because of less vibrant color and poor resolution, becomes merely a backdrop for interpersonal action and intrapersonal reaction. The same is also true for the film *Grand Canyon* (U.S.A., 1991), which uses the image of the Grand Canyon at the end of the film in a reverse way to suggest the possibility of black and white to transcend embittering and destructive racist forces.

The grand theme of war provides another excellent example of the difference in treatment necessitated by a respect for the difference in medium: anyone who has seen *Gone With the Wind* (U.S.A., 1939) on the large screen remembers vividly the burning of Atlanta, the pathos that the camera achieves as it sweeps back to an aerial extreme long shot to reveal thousands of wounded solders. The film masterfully integrates human drama with the tragic demise of a whole culture. For generations who have seen the film only on television, however, the film is remembered as a love story alone. Ken Burns's *Civil War* series, however, which was made for public television, rightfully filtered the tragic scope of the war through the consciousness of the participants, achieving the psychological penetration and tragic awareness that *Gone with the Wind* could not. In this respect, McLuhan correctly describes the film-goer as a "passive consumer of actions," and the television viewer as a "participant in reactions."[7]

This is why seeing a film in a theater is such a different experience from seeing one at home: they are truly different media with different characteristics, beginning with image resolution, color, and the size and

nature of the screen. When, for example, a cinemascope film is shown on the television screen, it must be converted from one medium into another, and as the film is transferred to tape, a decision must be made on whether to "letterbox" the film—that is, to reproduce the proportions of the film screen, which has a 16:9 aspect ratio, to fit the television screen, which has a 4:3 aspect ratio, by placing a band across the top and bottom of the screen, making the screen in effect even smaller with poorer quality resolution than before—or alternatively, to follow the action on the film screen with the video camera, and eliminate the "extra" background. The problem, of course, is that when the film has been expertly directed and shot, there is no extra, and background essential to the scene is cut. Or if, for example, you have two people at opposite ends of the film screen speaking to one another across a distance that is meant to be both real and symbolic at the same time, the whole meaning of the scene is lost when, as is likely, on the television screen the camera switches from one to the other as the dialogue progresses, showing essentially no distance between them at all. In either case, any fine detailing, usually an integral part of the fabric of the theme, plot, and character development of any well-made film, will blur into insignificance on the television screen.

If the film is shown on commercial television, the problem of plot pacing is also significant. Broadcast television time is a function of discreet salable units for advertising, and therefore of commercial breaks, which usually occur every fifteen or so minutes after the viewer is "hooked" in the first half hour. Rarely, however, do these coincide with dramatic intervals written into a film script. The alternative, movies written for and made for TV, are more acceptable on the screen, but they tend to look like any other TV program, only longer. This is because not only are they still constrained by the same television screen characteristics, but their plot development, like other programs, is also strictly regimented by commercial breaks that require the action to build suspense just before the break in a regular series of minor crises within the larger scope of the movie. In the hands of the inept, this can mean a boring series of the same kinds of action, repeated over and over until the movie ends.

In addition to having poorer resolution, the standard electronic television screen has the added problem of also never being quite as light or dark or as clearly defined as in film, which is projected as an analog image onto a large format film screen in a darkened viewing area. Television white and black are really only shades of electronically lit gray, and color is necessarily limited in vibrancy and strength by the nature of the medium.

The advent of high definition television (HDTV) in combination with commercial free premium cable stations and pay-per-view, has promised to change this. Television production done in high definition utilizes 1,125 lines instead of 525, has greater contrast range and a wider color palette than standard television, and utilizes the 16:9 aspect ratio of film. But although HDTV is now a reality, it requires high definition for all elements of the video system: HDTV special camera head with special HDTV lenses, electronics, and viewfinder with a 16:9 aspect ratio, camera control units, videotape recorders, monitors, and video projection equipment. Changes in these will effect only new programming; high definition will have no effect on programming not originally recorded in high definition. Thus viewing reruns of old television shows not recorded in high definition but shown on high definition television sets on HDTV will feel as peculiarly uncomfortable and aesthetically unsatisfactory as when movies, which are by their analog nature high definition, initially appeared on television screens. Moreover, as HDTV becomes established, the aesthetic that governs standard television will again change, becoming a kind of hybrid form somewhere between television and film, with cameras still limited in movement, with commercial interruptions likely built into the format, but with a more sensuous dimension to color and space, and more detail.

As digital video players replace standard VCR tapes, bringing in digital sound and stunning visual quality of richer, brighter colors and sharper edges, the visual experience of film on "television" screens pushes TV technology more toward high-definition screens. Yet this change will occur gradually, for Americans are wedded to the VHS system, with 9 out of 10 homes owning a VHS system. DVDs hold a tremendous amount of digital data in the microscopic indentations read by laser beams, and can hold several movies, yet are currently unable to record. The greatest advance for this technology will be in DVD-ROMs, which have up to 25 times the data storage capacity of CD-ROMs.

The two-dimensional flatness of the television image is also an area of technological development as well as of aesthetic concerns. Because the image lacks depth, a number of standard television devices have become part of the television aesthetic. To create a sense of depth, artificial aerial shots, extreme angles and sidelighting have become standard, as have fast cuts and sharp edits. This, too, will change somewhat with the advent of HDTV and DVD, but the real advancement in this area is in three-dimensional television. Although adequate "3-D" effects can now be achieved with glasses in a film setting, the flatness of television's image makes it an even more desirable medium for the application of new 3-D technology. A number of countries have explored

various technologies to make 3-DTV possible, but currently the most successful has been the Japanese company Sanyo which, in concert with Japan's national public television network, has developed a flat screen with surface ridges, called lenticular lenses, which pick up left—and right—side images from anterior projectors. The ridges keep the images separate and direct them to the proper eye to create the illusion of 3-D without glasses. As with HDTV, however, only programs shot utilizing special equipment and several cameras will be able to be seen in 3-D on the specially designed television screen.

One of the limitations that television is unlikely ever to overcome, however, is that it will always be subject to other distractions. As a relatively small piece of furniture, or even as a full wall-screen, it exists in a room usually filled with books, games, windows, a telephone, reminders of uncompleted chores, exercise equipment, and even VCR tapes or videodiscs of films and previously recorded programs. Even in specially outfitted "entertainment centers," not only is television watching subject to the lure of other activities, but it is also subject to internal stresses in the form of multiple channel offerings (eventually well over one hundred). In addition to an increased number of choices, the viewer also has a heretofore unprecedented amount of control over the screen, giving rise to such viewing phenomena as multiple viewing screens, "zapping" (switching channels with one's remote control), channel "surfing" or "grazing" (leaping through channel offerings and lingering at interesting moments), and "zipping" (fast-forwarding beyond commercials or uncomfortable or boring program or movie segments that viewers have prerecorded).

The ultimate viewer control would of course be a form of interactive TV that would make available any type of programming, past or present, and any type of information desired by the viewer. This is the present direction of the medium. Some degree of interaction has been available through wireless devices like the LinX unit, used by Interactive Network, and Zing, from Zing systems, which when they debuted allowed viewers to play along with game shows such as *Jeopardy* and *Wheel of Fortune*, to second-guess the quarterback during football games, to respond to incentives from advertisers, to browse other channels while watching one, to customize their television sets for favorite channels, and to play video games on dedicated channels. In 1996, Bell Atlantic initiated an interactive TV trial involving 200 families and providing more TV channels than the usual cable service. Although Bell Atlantic estimated that it would have to spend $11.5 billion to eventually reach 11.5 million homes, costs are expected to come down since the passage of a communications reform bill in February 1996.

As the legal and regulatory review of interactive services continues into the next millennium, Internet services and other interactive services already available, such as video on demand, bill paying, and shopping, continue to move us away from a cultural unity and more and more toward isolated use and entertainment based on momentary experience. In addition, video screens have also become stations for a variety of other computerized interactions such as personal banking and household surveillance.

The O.J. Phenomenon

When television's entertainment capacity for in-depth emotional involvement is combined with its role as credible "window on the world," we see not only television at its most artful and perhaps most dangerously deceptive, but also at its most popular. Nowhere can this be better seen than in the television coverage and ratings associated with the capture, arrest, pretrial hearings and trial in the O. J. Simpson murder case, dubbed the "Trial of the Century" by media, and in the follow-up books and television shows devoted to the verdict afterward. All major broadcast network channels covered the pretrial events and the final trial verdict, while CNN (Cable News Network) and Court TV provided gavel-to-gavel coverage of all events. According to *Advertising Age*, coverage boosted CNN's rating and revenues about 50 percent, providing approximately $25 million in incremental revenues, and Simpson-related marketing estimated as generating as much as $1 billion in gross merchandising and media sales.[8]

In O. J. Simpson, who had been a prominent football celebrity as both player and anchorman prior to the especially vicious murder of his former wife and her male friend, the television medium found its perfect focus—not only because of Simpson's own fame, but also because the inherent psychological drama of the situation was perfect for television: on-the-spot mobile helicopter coverage of the "chase" on the Los Angeles freeway gave us very little external action, but lots of interesting camera angles as well as suspense through running commentary. The subsequent arrest gave viewers the immediacy, spontaneity, and authenticity of live action coverage as well as the opportunity for emotional depth-involvement in a high interest situation of love, sex, and murder. Even after the sun set on the evening of his arrest, viewers continued to watch the dark gray on their television sets, caught by the internal drama. Pretrial hearings that followed added three more factors for additional media interest: serial dramatic development of psychological action—with its full penetration of inner character and the direst of

possible consequences in the balance; the topical complications of race relations and domestic violence; and a real-life window into the mysterious workings of the law.

Television is at its best when it is most immediate and most involving, and the pretrial hearings—with their focus on human emotion and the accompanying use of zoom reaction shots, quick cuts to the faces of judges, prosecutors, and defense attorneys, and a handsomely photogenic athlete, already an established hero, protesting his innocence—did not disappoint viewers who watched day after day. When the action lulled, especially when knotty legal arguments took center stage, cameras cut away to television commentators who supplied necessary information on DNA testing and legal process, as well as social commentary on racism, the psychology of murder as the ultimate domestic violence, and the love triangle as its perennial theme. In the courtroom, the presence of three races (judge, defendant, and chief prosecutor) and both sexes (prosecution and defense attorneys) allowed for maximum viewer identification in a serial drama with an inevitably simple outcome. On CNN alone, several weeks into the Simpson case, more than 5.5 million viewers watched the real-life soap opera unfold. Nielsen Media Research estimated that 51 million viewers watched the final trial verdict on television—a figure that did not include the millions more workers grouped around office TVs.[9] It was irresistible, and it was television doing what television does best.

The extended murder trial, which followed the pretrial hearings and ultimately cost the City of Los Angeles about $9 million, continued the commentary and live courtroom coverage. As it wore on day after day, however, it took on the attributes of both television soap-opera and cinéma-vérité, moving back past a stream of images and even the preoccupation with celebrity image to again encompass a narrative statement on the culture as a whole. With its soap-opera-like continuing storyline, audience involvement with the characters, daily "cliff-hangers," discredited witnesses, plot twists, side plots involving attorneys and witnesses, press conferences with victim family members and the inevitable surprise witness, the trial seemed more like staged television than live court proceedings. Ultimately, however, this was real people, in a real situation, and live in front of the camera, and, as such, the trial represented the ideal of cinéma-vérité, in which the filmmaker does not become involved in the action itself yet no attempt is made to hide the impact of the camera on the lives of the people being filmed. It was a cultural narrative that pulled people together within a common viewing experience, yet it also pushed them apart in their individual attempts to make sense of it all.

As the trial wore on, there was a growing sense not of real people acting out their lives, but of real people acting within the context of the media occasion, and the trial took on a drama of its own, with the script developing as the drama went on. Rather than a window on the reality of a murder trial, then, the spectacle became a staged event of people caught up in their own celebrity, playing at once before a private jury audience and a larger public one, always cognizant of both. Thus the trial had the effect not so much of uniting viewers within a common narrative but of separating them into stereotypical factions, and of ultimately turning everyone involved into a celebrity, investing the apparently mundane with the importance with which media coverage invests everything it touches. Above all, the trial revealed media in all its self-reflexive importance—like the print ads and point of purchase supermarket displays that crow "as seen on TV" as if it were a legitimate selling feature of the product. What became important was not a common interest in justice so much as the tracking of segmented ways of thinking, and ultimately the presence of the media itself glamorized and transformed everything related to the tragedy. In the end, the trial itself became the story, spawning books by participating attorneys and witnesses, and providing content for a variety of television programs.

In 1994, Court TV also televised the trial of Lyle and Erik Menendez who killed their parents and captured the attention of the entire country with their testimony of physical and sexual abuse as a defense. When the trial ended in a hung jury, the court decided not to allow television cameras into the court for the 1995 retrial of the brothers precisely because of the amount of interest generated by the media. In the retrial itself, however, lessons learned from the brothers' first trial and the Simpson trial were put into practice, and the Los Angeles coroner who seemed to have questionable competence in his court appearances in both earlier trials was not asked to retestify. Instead, a California Silicon Valley engineering firm specializing in accident and disaster reconstruction was asked to put together a computer generation of the crime from verified police photos; and jurors watched the crime enacted rather than listen to coroner testimony, signaling a new trend in trial argumentation away from the critical examination of "expert" witnesses to a simulated and highly sanitized visual version of events that would be more easily understood by a jury—and which incidentally also tends to bypass the critical function which cross-examination serves. While the critical examination of the coroner in the first trial cast doubts about his competence, no one questioned the reality of the photographs or the computer simulation. For its part, the press responded with news articles focused on the lack of television cameras, the novelty of computer simulation and the

theatrical behavior of attorneys, with one reporter commenting that of all the high-priced attorneys involved, "the fast-talking Abramson [representing Erik Menendez] has put on the best show."[10] The second "show" resulted in a guilty verdict for both brothers.

As one of the few cases ever where celebrity, murder, media technology, and science have combined to such an extent,[11] the Simpson trial also marked an ironic turning point in the realization of the possibility of long-term cinematic narratives, such as Von Stroheim yearned for in his 1924 film *Greed* (U.S.A.), which originally ran eight hours but was cut to just under two hours to make it tolerable for the audience. The case had no precedent in the widespread ramifications of its media effects both on the lives of the participants and on the attitudes of the general public:

By the spring of 1995, a poll by the American Bar Association found that almost half of those surveyed reported that the trial had caused them to lose respect for the jury system, and a series of polls, including one conducted by CNN confirmed that the nation was splitting along racial lines: although almost three-quarters of white Americans polled believed that O.J. was probably guilty, between 60 percent to three-quarters of Black Americans polled believed that a police conspiracy was not only possible but probable. By the end of the trial in October 1995, a series of television spin-offs such as CNN's "Burden of Proof" were already in place, and "Murder One," a program that borrowed heavily from material drawn from the Simpson trial had already been scripted, cast, and premiered for the public audience on ABC. Parades of witnesses had been interviewed on television talk shows.

By the end of the trial itself, in the ultimate in media reflexivity, reporters were interviewing each other about their own media participation; a whole cottage industry had grown up around the trial from "Don't Squeeze the Juice" T-shirts to made-to-order books by trial participants; several trial-related web sites had sprung up on the Internet; and Ted Turner, who launched the 24-hour news cable network CNN in 1980 as a major step in the establishment of a McLuhanesque media "global village," had become vice-chairman of, and principal shareholder in, Time-Warner.

Rarely, however, does television attentiveness reach the peak it did in the Simpson trial, simply because there are few issues of such high common interest, and also because the medium rarely utilizes all of its advantages so well at the same time. The only regularly scheduled program that consistently utilizes the best aspects of the medium in terms of immediacy, emotional involvement, serial suspense with simple yet definitive outcome, the possibility of viewer anticipation of complex strategy within simple rules, colorful commentary, and the ubiquitous

presence of arousal stimuli, is the annual Super Bowl, which draws a viewership of up to 100 million people. It is also an event which, because it is characterized by stimuli of socially accepted violence and sexy cheerleaders, has become the subject of much debate about television effects and the link between physical abuse of women by male partners.[12]

Although increased choices, remote controls, and interactive devices have not altered the reality of media gatekeeping or the dominance of consolidated economic interests in media, the individualized use they imply has changed the way in which television is watched, and consequently the way its programs and commercials are structured and delivered, turning the once mass-marketed image into an increasingly micromarketed one. And as it becomes more and more interactive, television as a tool becomes more and more individualized and less involving as a group activity, more an instrument mimicking sensation and less a vehicle for social understanding.

Sensation, Information, and Dreams

Yet as it becomes more and more a tool of immediate sensate experience, it also ironically moves farther away from its original role as a "trustworthy" extension of our own senses, moving us instantaneously to remote places and introducing us to extraordinary new people and experiences. At least part of the power of television lies in the viewer's conviction that, like photography, the television screen is a window on reality. As one educator and critic put it, "the television viewer is in a position to make a rational criticism, in the sense that he regards television mainly as a means of disseminating real information. . . . The viewer *believes* in television, for generally speaking, he is convinced that the small screen, unlike the large screen [of cinema] opens a window on the real lives of people."[13]

While creating a sense of reality, however, images stream past with a rapidity that itself defies rational reflection and in effect, creates a new media reality. Bypassing critical thinking, both TV "action news" and popular television shows have drawn from the popularity of MTV in the 1980s and begun to merely surface-view the appearance of reality while at the same time exploiting the depth of the viewer's emotional involvement by turning entertainment into a vicarious adrenaline rush. By 1996, the most popular drama on TV, "ER," a television show set in a hospital emergency room, came to illustrate this new reality perfectly. Created by Michael Crichton, whose formula for success was to speed up the pace of television, the show's pilot included 45 stories and 87 speaking parts. Meteorically rising to the status of the number one drama on TV, the

show quickly drew an average audience of 25 million viewers to its rapid, continuous action. Its style is characterized by a new kind of "long-take" in which the camera moves incessantly, quickly changing scenes without cuts but maintaining a sense of continuity through a single camera pushing through various corridors and rooms, like a roller-coaster ride. Technical medical terms provide impressive sound-bites that substitute for dialogue, and the movement is so fast-paced that it is impossible to communicate any complex information.

This continuous, rapid stream of overstimulation is at the heart of McLuhan's dictum that "the media is the message." Several researchers have concluded that the action and change which are characteristic of the television medium independent of its content, may in fact be responsible for television's negative effects, especially in terms of promoting aggression by acting as a general arousal stimulus.[14] This capacity for mimicking truth without cognitively exploring it can indeed be dangerous, as Gerbner has warned: "The convergence of communicative technologies confers controls, concentrates power, shrinks time, and speeds action to the point where reporting, making and writing history merge. . . . Instant history is made when access to video-satellite systems blanket the world in real time with selected images that provoke immediate reactions, influence outcome, and then quick-freeze into received history."[15]

Another question closely related to amount of viewership is how people actually watch television when they do watch. One 1986 Oxford University study of television attentiveness, involving twenty families videotaped while the television set was on, revealed, for example, that people actually watched their television screens only about half the time they were in use; that one-fourth of viewers were engaged in eating, reading, talking, or some other activity while the set was on, and that one-fifth of the total time the set was on, nobody was watching it at all.[16] These findings parallel those of earlier similarly structured studies in the United States in the early 1960s and 1969–1970, which showed viewers fully attentive only 60 percent and 64 percent of the time respectively,[17] figures that are fairly close to most self-reported studies conducted over the past forty years. Although the studies are often used as examples of television use and of viewing inattentiveness in general, it is important to note that group attentiveness may operate by entirely different principles from individual attentiveness.

In terms of what happens in individual attentiveness, research is divided between those who believe that television viewing is not dissimilar from any other activity and those who believe that it causes major changes in brain-wave patterns. When an individual is involved in conscious thought, the brain does not operate in synchronous rhythm, but

when the brain lets down its alertness, it moves into a more hypnotic alpha rhythm, more characteristic of daydreaming. As we become more relaxed, the left hemisphere of the brain, which processes information logically and analytically, becomes inactive, allowing the right hemisphere to process information uncritically and emotionally. Some researchers have found that analytical processing slows down or stops and that viewer's focused attention changes to alpha waves, within as soon as thirty seconds of watching television.[18] Corporate public opinion researcher Herbert Krugman, for example, has commented that while response to print is characterized by fast brain waves and mental activity, "response to television might be fairly described as passive and composed primarily of slow brain waves."[19] In other words, we become emotionally but not logically involved in the medium, and images stream into our psyche, accepted without critical analysis.

Such a state, which is also characteristic of daydreaming, implies a vulnerability to suggestion that makes viewers particularly susceptible to emotional manipulation at a critical point in attitude and idea formation. Because, as discussed earlier, the logic and grammar of television is often composed of emotionally charged images linked only by association, the experience of watching powerful images may "feel" as if they are logically related, just as things seem to make sense in dreams but are nonsensical when we reflect on them when we awaken. The logic and language of visual communication derives from subconscious perceptual patterns, which is why visual art can speak so clearly to our emotions and instincts, and it therefore wields considerable power.

Many media critics like the semiologist Paolo Pasolini have, in fact, closely paralleled the television experience to dreaming. Peter Wood, for example, suggests that television may have a therapeutic value parallel to dream analysis that derives from their inherent similarities: both television and dreams are highly visual and highly symbolic, and both involve a high degree of wish fulfillment. Both are composed of occurrences and images that are disjointed and trivial; both have powerful content "most of which is readily and thoroughly forgotten; and both "make consistent use—overt and disguised—of materials drawn from real experience."[20] He argues that like Freudian "dream-work," television involves not only dramatization but also condensation, which compresses, combines, fragments, and omits elements; displacement, which substitutes apparently more acceptable elements for latent ones; and inversion, which translates thoughts into ambiguous images with multiple, often contradictory, meanings. The ultimate importance of it all, he suggests, probably lies in the commonly shared value of working through various forms to get to deeper significance.

But what if these "television-daydreams" lead not to analysis but to an acceptance of distorted images as reality? The recognition of the emotional power of the visual image and its ability to tap subconscious material, the ability of associative image networks to mimic left-brain analytical logic while actually bypassing critical judgment, and the speed with which images appear and disappear on the screen: these are very real concerns—concerns wedded to the nature of television watching itself, not simply to the content of what is watched. Joanne Morreale, for example, who has closely analyzed Ronald Reagan's utilization of media in his bid for presidential reelection, believes that the process of critical inattention that parallels daydreaming "increases the possibility that viewers will be taken in by the manipulation of frames," and she attributes the success of Reagan's presidential campaign to the well-planned imagery and engineered associations of his media campaign.[21]

Manipulating TV Images

Since one of the main characteristics of the television image is its capacity for the instantaneous transmission of electronically produced images and therefore for extending our own senses into simultaneously occurring situations without apparent intervention or manipulation, television, like the photograph, carries with it a sense of authenticity and immediacy that no other media can match. Yet no electronic transmission can occur without prior conscious manipulation of the image by staging, framing, and cutting; and the relative rarity of live, spontaneous broadcasting implies further manipulation in planning, editing, and dubbing. With the advent of digital video, the possibilities for visual manipulation become endless. With only a very brief delay in broadcast time, whole sequences may be altered to give a totally different effect. As critics have continually pointed out, film and video as art forms and as communication media are consciously manipulated to produce specific effects—whether in the realm of aesthetic response or in the pursuit of ratings and advertising revenues.

Manipulation, then, is an essential part of the process of mediating the message. As Marshall McLuhan has noted: "Everybody experiences more than he understands. Yet it is experience, rather than understanding, that influences behavior, especially in collective matters of media and technology, where the individual is almost inevitably unaware of their effect on him."[22] The 1953 coronation of Queen Elizabeth II of Great Britain yields insight into this point: While various government officials were opposed to televising the event, fearing that it would undermine the dignity of the ceremony, the young queen nevertheless overruled

their judgment, recognizing the power of the image to involve the entire country in the proceedings. Precautions were taken, however, to arm a "censor" with a button that would immediately cut off transmission should any of the cameramen try to take close-up shots of the Queen, since it was felt that this would turn the spectacle from an affair of state into a personal and emotionally exploitive event. Medium close-ups ultimately were included, however, despite the precautions: the censor, watching the newly crowned Queen emerge radiant through the ceremonial pomp with the utmost composure, became so rapt in the image that he forgot to press the censor button.

The issue, therefore, is not whether media are manipulative, since the reality of the video image is never the same event experienced by a participant, but rather whether the manipulation is inherently tied to the aesthetic characteristics of the medium, such as close-up shots on the small screen, or whether for political or economic ends, media characteristics have been carefully orchestrated to achieve certain predictable yet subliminal effects.

The most obvious form of manipulation is, of course, content selection, since neither film nor video occurs in real time and dramatic impact must be consciously programmed. Yet selective image content can also be used to create a positive or negative impression of particular personalities or situation. Examples of this are commonly seen in news coverage of contemporary scandals which utilize still shots with positive valence (victim) or negative valence (accused). Often, for example, teenage victims will be shown in graduation pictures with bright smiles, while alleged or convicted felons will be shown in rumpled casual clothing, while frowning, hiding their faces, slouching, or looking down or away. At the high point of his involvement in a sex scandal, newscasters often included taped footage of Michael Jackson in concert, grabbing his genitals. In the media coverage surrounding the Tanya Harding/Nancy Kerrigan scandal that centered around the 1993 Winter Olympics, Harding was depicted as unsmiling, tough, aggressive, or unfeminine in press photographs, while Kerrigan was always shown smiling and attractively "feminine."

Often we respond to this type of manipulation consciously and in ways that reinforce preexisting notions of our own, but just as frequently the manipulation of elements is much more subtle, and because the television image is fleeting, we do not have the opportunity to consciously analyze it. Nor do we examine the assumptions of fact that often accompany media images, particularly in news formats, or the weight of authority that accompanies certain genres, as the newscaster in his or her anchor role or the narrator within a documentary format.[23]

While selective content is a manipulative practice across media, other techniques of orchestrating the television image derive exclusively from the television medium itself. Television news programs, for example, are concerned to a great extent with both likability and credibility factors in the images presented, and as a result, they continually juggle small talk, friendly close-ups, action footage, and frequent camera changes with more subtle credibility techniques such as directly addressing viewers in a kind of social-personal-professional exchange, and devices such as engaging full screen location backgrounds for news stories and the placement of symbolic visuals in an over-the-shoulder corner screen format.

Engineering of the image is most impactful when the complex of positive, negative, or neutral emotional valences derived from image content, editing context, and the viewer's own attitudes and ideas can be structured to a single purposeful end, and the image is so subtly altered that it still seems natural. The controversial case of the O. J. Simpson cover image (discussed in Chapter 3's Close-Up), which appeared in *Time* magazine during pretrial hearings and subsequently drew accusations of racism, may be seen as an example of just such an attempt at subtle manipulation. Ultimately the Simpson image became a point of controversy, primarily because as a still image, it could be studied, analyzed, and interpreted. Television viewing, however, offers little opportunity for this, since even freeze-frame images such as those used on newscasts are fleeting at best. As Krugman has noted, "The mode of response to television is . . . very different from the response to print . . . response of the brain is clearly to the media and not to content. . . ."[24]

Because on-the-screen images change rapidly, and because the size of the television screen allows us to view it centrally without searching the parts to create the whole as with a film screen, TV images tend to be read as a whole impression. This means not only that television watching is less active than reading a book or watching a film, but also that it is seldom analyzed for the emotional valence of the images shown. Soft lighting and make-up will give a friendly appearance; hard lighting a mistrustful one, and as we absorb the impression, we begin to use that impression as information in the formation of ideas. An image projected with consistently positive valences and read approvingly by viewers in turn may have a positive impact on the acceptance of other issues connecting with that image. In relation to political images, for example, Kennamer and Chaffee have shown that "to favor the candidate of a given party might imply accepting his positions of various issues, or attributing to him virtues such as honesty, intelligence or leadership. . . [This] can be viewed as affective utilization of "information" The

structuring process is part of a cognitive activity occasioned by the primary election and stimulated by the intensive media campaign leading up to it."[25] Thus, visually planned affective images can be used to manipulate attitude positively or negatively at the same time they masquerade as genuine information.

Joe McGinnis's *The Selling of the President 1968*, Kathleen Jamieson's *Packaging the Presidency: A History of Presidential Campaign Advertising*, Stephen Bates's *The Spot*, and Joanne Morreale's *A New Beginning* chronicle in depth the process by which political images become viewer-held beliefs and images substitute for reality. It is a significant advancement in relation to Marshall McLuhan's criticism of Theodore White's 1960 *The Making of the President*, where McLuhan, who predicted Kennedy's election on the basis of his positive television image, lambastes White for considering "the 'content' of the debates and the deportment of the debaters, but," he says, "it never occurs to him to ask why TV would inevitably be a disaster for a sharp intense image like Nixon's and a boon for the blurry, shaggy texture of Kennedy."[26]

In this media-induced reality, effective television camera language can be deceptively simple, just as it is in photography: camera angles that are too extreme have a negative valence, as does too-bright lighting on the face. When negative valences accumulate—as when a person is consistently treated in extreme close-up and lit slightly too brightly so that sweat appears, with the camera placed so that he or she must always look slightly away from it, or when facial cuts are alternated with quick clips of nervous gestures such as drumming fingers or crossing and recrossing the knees, a negative impression—in this case of dishonesty—can be created that has no substance in fact, but is merely suggested. When, however, projected images are combined with effective cultural symbols like the American flag or Arlington National Cemetery, and powerfully emotional icons like the image of Abraham Lincoln or Marilyn Monroe, the positive valence increases and the emotional effect becomes even more powerful.

A continually growing body of research lends insight into how the use of TV's tools contribute to its meaning as mass medium and as art form, revealing how television pictures communicate significant meaning beyond the verbal text and how this meaning is understood by television audiences.[27] Based on the assumption that "the audio-visual language used in television is designed to be easily understood because it must convey common meanings to a vast, diverse audience in a brief time span,"[28] Graber, for example, has developed a gestalt coding method which "focuses on the totality of meaning that results from the interaction of verbal and visual story elements, external settings, and the

decoding proclivities of the news audience"[29] and which takes into account contextual content repetition of news events.[30] Salvaggio has found similarly in film that "there is an explicit syntax which the film maker is aware of and consults before producing a sequence,"[31] that these common meanings or codes are likely to fall within predictable ranges[32] and are gained through the cumulative experience of watching.[33] Tarroni comments: "There can be no art without a public, for ultimately art is only *communication*. Works of art *cannot exist without the perceptive capacity of the public*. By using an instrument, a material and a technique, the artist *gives concrete form* to his work. . . . television is *always*, and above all, a means of *communication*, even though in some cases it can be an art."[34]

Foremost among the instruments for manipulating this communication are camera lens, angle, and camera distance. Some of these derive their meaning from our own "common sense" experience with body language and personal comfort zones—such as looking someone in the eye as a sign of honesty and openness, or not bringing the camera in too close if the circumstance calls for reserve and intellectual reasoning. Some derive meaning from conventions associated with the medium as it has developed, such as the use of the close-up in reaction shots when we expect an emotional response to a verbal exchange or particularly tense situation, or black-and-white footage to signal a "you-are-there" type of documentary realism. In addition, certain techniques, such as cutting in midsentence or not cutting an overly long pause create a sense of uneasiness in the viewer and make the person treated seem either inarticulate, reticent to talk, or even dishonest.

One particularly interesting study of verbal and visual storytelling by H. M. Kepplinger, which traced campaign coverage for the office of Chancellor of the Federal Republic of Germany, illustrates how artful camera usage can influence opinion in a mass audience and determine political outcome. The focus of the study was to determine how professional camerapeople would use camera perspective to produce a variety of affective responses. Over three-fourths of those surveyed agreed that "a cameraman using merely optical means is able to make any person appear in a particularly positive or negative way."[35] While others have studied the success of obtaining desired effects,[36] Kepplinger's study focused on the ability of journalists to present "deliberately or unconsciously . . . candidates as they actually saw them . . . with relative freedom since the video coverage was exactly analyzed and checked neither by the management nor by the parties."[37]

Thus, although there appears to be a universal visual language of shots, angles, and distance that is readily understood by viewers, rarely

is this language taken into account for script analysis or censure. Although verbal scripts are systematically routed through a channel for censure or modification, visual language is not and thus can be used freely to visually editorialize or to create another message altogether, a message readily understood by viewers in the course of their television watching. Kepplinger found, for example, that to create a sympathetic impression of power, ease, and skill, the majority of professional camera operators chose an eye level or slightly low angle shot.[38] None of the professionals surveyed chose an extreme close-up to give a sympathetic view: it negatively impacts viewers who feel uneasy because of the "in-your-face" invasion of personal space that it implies. To deliberately create a negative impression of weakness and emptiness in a personality to be handled unsympathetically, the majority chose an extreme angle shot. Kepplinger found the outcome of the election correlated positively and specifically with the positive video coverage of the winning party and with the negative coverage of the losing parties.

The following Close-Up examines how this language worked in the context of one political documentary that played a significant part in destroying the presidential ambitions of a U.S. Senator.

CLOSE-UP
MANIPULATING PUBLIC IMAGE
THROUGH TELEVISION IMAGE: "TEDDY"

All politics has changed because of you [the television media]. You've broken all the machines and ties between us in Congress and the city machines. You've given us a new kind of people. Teddy, Tunney. They're your creatures, your puppets. No machine could ever create a Teddy Kennedy. Only you guys.

—Lyndon Johnson

Image as Document

If, as Johnson[39] suggests in the above quote, the television media created Teddy Kennedy, it also has played a significant role in destroying his presidential ambitions as well. "Teddy"—an hour-long *CBS Reports* "documentary," written by Roger Mudd, aired on November 4, 1979, on CBS-TV. In the program, both visual and verbal constructs subvert the lingering aura of the Kennedy "Camelot" myth, and we are left with the image of an ineffectual and irresponsible man of dubious character, helplessly surrounded by chaos, and dominated by his mother. It is a carefully engineered effect that results from Kennedy's serious misjudgment of Mudd's intentions, his lack of verbal preparation, and an insufficient appreciation of the powerful techniques of media manipulation.

It was not a mistake his older brother John Kennedy made when running for the Senate and ultimately for the presidency. With winsome, athletically good looks, and armed with a wry and self-deprecating sense of humor, John F. Kennedy carefully orchestrated his own image through the media. Lillian Brown, a pioneer consultant in media image, recalled in a recent *New York Times* interview, for example, that "JFK" was an avid student of media: "He wanted to understand what cameras and lights and lenses did to him. . . . He would walk behind the cameras

and ask the technical people: 'How do you mix the audio? Why do you have this light there?' He was interested in every little detail."[40] This interest is at least part of the reason that in the famous Kennedy–Nixon debates of 1960, JFK emerged looking like a president, while Nixon, sweating and without proper make-up, looked like a shifty used-car salesman. The polls afterward told the media story: those who watched the pair spar on television thought that JFK had won, while those who listened on the radio thought Nixon had won.

In one particularly interesting essay on the "Logic of Politics" published in 1963, eleven years prior to Nixon's resignation in the wake of the "Watergate" scandal in order to avoid impeachment for dishonest acts, Edwin Shneidman explored the impact of the television image transmitted by Nixon and Kennedy during the 1960 debates, translating verbal logic as it is filtered through the medium of television into the personality traits which their styles of thinking seemed to imply to a viewing audience. Utilizing thematic apperception analysis, he prophetically concludes that "whereas Kennedy's image came through as a 'doer,' albeit he might impulsively so some 'wrong' things, Nixon's image came through as a man who might 'deliberately' do the wrong things, but they would be done with careful attention to detail."[41]

Not being prepared for the media was a mistake that Nixon did not repeat, though Ted Kennedy did. In the Mudd interview, Ted Kennedy never realized that there actually was a debate going on: both he and his staff apparently thought that, since Mudd was a friend of Joan Kennedy's, the documentary would follow along the same lines as so many other nostalgic treatments of Jack and Bobby.[42] He couldn't have been more wrong. Not only did Mudd verbally attack him by continually harping on the Chappaquiddick accident that resulted in the death of Mary Jo Kopechne ("Kennedy, you know, you were drinking, you lied, and you covered up!"), and extrapolating political quagmires into personalized ineptitude ("Well, you haven't had a vote yet on National Health Insurance, Senator. What kind of leader are you? . . . You can't get it out of subcommittee."), but Mudd also carefully engineered the program's visuals to remind viewers continually of the Chappaquiddick incident, to suggest his mother's dominance, and to show Kennedy as an inarticulate, immoral, and indecisive bungler amid chaos.

TV Devices

To create the effect, Mudd relies on a variety of basic devices in verbal and visual manipulation: content selection in the amount of coverage devoted to the Chappaquiddick incident and to inane and incomplete action; placement of shot sequences for negative association by

affective transference; emotionally loaded language and inappropriate terms to exploit connotative meaning; voice-overs which, with the authority of both the newscaster and documentary format, negatively interpret and recontextualize neutral visuals or contradict them for ironic contrast; camera shots framed to include emotionally loaded content; inclusion of shots which emphasize the trivial and in turn trivialize the candidate; exclusion of shots that would suggest the serious and professional; discontinuous visual and verbal editing cuts to create a sense of confusion; and consistently unflattering or uncomfortable camera angles and distance.

When the program opens, for example, the Kennedy clan of children, nieces, and nephews are headed for an annual camping trip. Here Mudd uses a handheld shaky camera that wanders aimlessly among the preparations without showing a single completed action. In voice-over, Mudd focuses primary attention on Kennedy's relationship to his mother and describes him as an ineffectual dilettante overwhelmed by chaos: "This is probably the way a mother whose son is running for the presidency would like a documentary about him to begin," Mudd says,"—a nice walking shot of the two of them as he sets off with her grandchildren on a summer camping trip. In recent years he has become its male head. For this trip he has become its cruise director, carefully excluding from the picture any non-Kennedy, giving up in frustration when not everyone falls in line."

The use of a neutral visual image is negatively recontextualized by voice-over. It is also made visually annoying through the use of a shaky handheld camera. A selection of contentless scenes deemphasize Kennedy's significant senatorial stature by showing a trivial lifestyle and describing him as in the role of a "cruise director." The continuation of this framing and tone is particularly apparent in footage of the annual Robert Kennedy Tennis Tournament that follows. There, Joan and Ted Kennedy are seated side-by-side, apparently enjoying a particular match. Mudd's voice-over, however, suggests not only a frivolous lifestyle and suspicious coterie, but also a family situation in which the police could be seriously interested, and thus succeeds in changing the relatively positive valence of the visual image to a negative one: "It is a command performance," Mudd tells us. "Even for Joan Kennedy, whose appearances with her husband are now so rare that the marriage seems to exist only on select occasions [so] that the two together not only attract the New York paparazzi, but also New York's plain clothes police." This schema, inappropriate for a serious interview with a serious candidate, is sustained throughout the program and sets and continually reinforces the contextual framework for the interpretation of the man.

Thus, when we arrive at Kennedy's Senate office, the sequence is a direct parallel to the "cruise director sequence" at the Kennedy compound

in Hyannisport. On his work in the U.S. Senate, Mudd emphasizes Kennedy's moods rather than his work or senatorial obligations, and continually restates verbally and visually the theme of the "little-boy-whose-domineering-mother-would-be-proud" first established by the program title "Teddy." We see a great deal of activity and lionizing going on with a stress on "celebrity" performance, preoccupation with his mother, and ineptitude. In his office on the phone, we see Kennedy apparently forgetting Boston Congressman Markey's name and then seemingly hypocritically conversing with him as if they were old friends. Shots are consistently done in high angle as opposed to point-of-view, so that we always seem to be looking slightly down on him. An overly long scene shows an office discussion about arrangements for Kennedy's mother to visit with the Pope and the dedication of the John F. Kennedy Library. And as we watch, Mudd describes Kennedy's staff as "trotting" flunkies desperate "to elicit a 'yes' or a 'no' or some indication on which way Kennedy wants to go on a speech, a trip, a dinner, the John F. Kennedy Library dedication."

After giving brief lip-service to Kennedy's reputation as a "first-class senator" who attracts "quality staff people" to his office, Mudd cuts to a clip of Kennedy stumbling over a name: "We have the agenda before us. The first issue is the nomination of Abner Victor—uh, Ab—Micf—." This quick clip is cut short before Kennedy recovers, and the shot is replaced by him moving about the office but accomplishing nothing. Mudd again reminds us that this a celebrity rather than a serious senatorial presence: "The press seems to move with him, like camp followers—hoping for some new favored comment about his candidacy." We then see a clip of the press asking questions that begin with a suggestion of indecision ("What would have to happen for you to make up your mind?'") and end with a trivial question on ice cream ("One last question, Senator. There have been reports that you have been stopping eating ice cream. Is that correct?")

As with the camping expedition, Kennedy and his office, Mudd tells us, can just barely cope: "Requests for a piece of him choke the office phone lines," Mudd tells us. "Soon after he said he was reassessing his presidential candidacy, the calls jumped from five hundred a day to a thousand a day, as he knew they would. . . . But somehow in their upbeat, half-spoken, semichaotic way, Kennedy and his staff juggle all the requests." Visuals show us a busy office; Mudd's voice-over translates it into chaos and ineffectuality.

Again and again Mudd interprets neutral visuals as negative, especially in relationship to Edward's Kennedy's ability to take leadership. First, Mudd depicts Kennedy as totally ineffectual in dealing with the children and the chaos of his own family; then this apparent lack of leadership and organizational ability is extended into an inability to take

competent control of his office in Washington; finally, the theme is restated at the program's conclusion where he is contrasted unfavorably with his brothers. When Mudd concludes that "he is not, despite what he professes, truly his own man" and that he has surrendered his independence to his family without measuring up to the Camelot mystique, we believe it despite the absence of any logical argument, for we have seen him dominated by family, ineffectual in directing it, told what to do or say by political aides, and moving without getting anywhere.

Chappaquiddick

One program part that seems to present even more serious visible evidence of possibly criminal behavior, but is filled with fallacious reasoning, is a sequence of footage taken on Chappaquiddick that purports to reenact the events of the evening of the infamous accident from Senator Kennedy's point of view. From a camera mounted on the frame of the car—rather than from the inside of the car, where shock absorbers would have reduced the impression—we go over a road ten years after the fact. Utilizing all of the force behind the assumption that seeing is believing, Mudd himself reviews in voice-over the testimony of Kennedy about the night of Mary Jo Kopechne's death as he shows contemporary video footage of the area. The discrepancies between Kennedy's report and the visual are obvious and damning to Kennedy's credibility. Mudd follows the "on-the-scene" sequence with an interview with Kennedy on the event as Kennedy sits with his back to the water. The effect is a prolonged mockery of Kennedy's veracity.

Closely akin to this type of manipulation is the more subtle use of the camera itself within various shot sequences, as in the use of the extreme close-up. Because the distance which the extreme close-up represents violates personal space, the effect is very disconcerting, as if the camera were seeking out a hidden truth, a kind of "grilling-the-suspect" shot characteristic of gangster movies. In "Teddy," of the 115 shots of Senator Kennedy alone or as the focal point of the action, 82 are shot in extreme close-up, and 21 are in close-up. The result is a feeling of unease watching Kennedy on camera, while the effect for Mudd is the reverse: Roger Mudd is never shown in extreme close-up, and is shown in close-up only 11 of the times he appears on camera. The rest of his appearances are either in medium point-of-view shot or long shot—shots that a number of researchers have associated with establishing credibility.[43]

In addition, research has shown that a full screen location background can result in the speaker being rated as more credible, clear, interesting, relaxed, and professional; as well as in the report being seen as more complete and important.[44] One of the program's most effective

long shots of Mudd at the Chappaquiddick Dyke Bridge illustrates this well: Mudd is first shown in a medium point-of-view shot as he speaks directly to the viewer about the questions facing the viewer in the election; the camera then pulls out to a long shot to reveal the Chappaquiddick Bridge in the background as Mudd raises the issue of Kennedy's character.

Mother's Image

Research has also shown that the most effective placement of symbolic visuals is in an over-the-shoulder corner screen format.[45] This type of shot is used extensively by Mudd, with the effect of continuing the emphasis on Kennedy's attachment to his mother: When he interviews Kennedy in Washington, Kennedy is seated in an armchair. On a table just over his left shoulder are photo portraits of his mother and father, included quite deliberately in the framing, leaving Kennedy left of center on the screen as a result. Shortly after the interview begins, the camera shifts to include only Rose Kennedy in the frame; when the camera shot accidentally centers on Kennedy at one point, leaving the picture of Rose out of the frame, the camera is quickly jogged back to include it. Kennedy is never centered in the frame in any of the senate office footage, except when he is shown in unflattering extreme close-up. Had an American flag been used in the background instead of "Teddy's" mother, the effect would have been quite different and added a completely different attitude to the program.

In fact, in terms of the time in which images appear on the screen during the 56-minute program, Rose Kennedy, personally or pictorially, is present 13 minutes; water is present in the background for 23.5 minutes; and family, including Rose Kennedy, occupies 16.5 minutes of the total program. Since both charges of reckless driving and Kennedy's related custom of being chauffeur-driven are primary issues in Mudd's skeptical review of the Chappaquiddick accident, it is not surprising to find that images that would normally be considered politically insignificant are strongly in evidence throughout the program as well. These include cars—particularly a specific sequence of Ted Kennedy driving an amusement park "Bumper" car and having fun smashing into other members of the family—and an extreme high-angle shot of him being chauffeured to his office in Washington. Recreation in relation to water also figures prominently, with the first and final shots of the program showing Kennedy relaxing as he sails off the Cape islands. To make the important editorial link with the Chappaquiddick incident, the opening shot of Teddy relaxing on the water is followed by one of Rose Kennedy and "Teddy" leaving the Mary Jo Kopechne funeral.

Stills in video can also be important carriers of affective "information," since they startle us by halting the pattern of video movement. Freeze frame shots are used to punctuate segments before and after commercial breaks in the program. Of these, none are positive. The closing freeze frame that punctuates Mudd's verbal close is, for example, an unflattering high-angle shot of Kennedy wearing reading glasses, with his mouth open. Other freeze frames include uncomfortably near close-ups of Kennedy with confused or otherwise unflattering expressions.

The verbal correlative to this is the enhancement of the effect of Kennedy's inarticulateness by cutting him off in midsentence, and reserving complete sentences for the most part to either peripheral participants like Chief Dominick Arena, who supervised the preliminary legalities in the aftermath of the Chappaquiddick accident, and to Roger Mudd himself. Continually, Kennedy is seen in action without arriving at a destination, and he is often cut off in midsentence, while Mudd never is. Mudd seems solid, sure, and honest, where Kennedy seems ambivalent, dishonest, overwhelmed, and confused. In the process of subverting Kennedy's image under the guise of exposing it, Mudd also succeeds in reaffirming his own image as the consummate articulate journalist, a vigorous truth-seeker and guardian of American morality.

Political Consequences

Before the program, a July CBS poll gave Kennedy a 53–16 lead over Carter, and an October ABC-Harris poll gave Kennedy a 63–32 margin over Carter nationally. Media consensus seemed to be that if Edward Kennedy chose to run, he would win,[46] but by mid-January the momentum was reversed. After the Iowa caucuses, the ABC-Harris poll showed Carter with a 60–28 lead over Kennedy, and Carter's presidential popularity index showed the largest short-term increase in Gallup's history.[47] "Without question," one critic noted, "the Mudd interview played an important part in the decline and fall of Edward Kennedy."[48] William F. Buckley, Jr., commented in the *National Review* that in "Roger Mudd's already famous CBS documentary . . . Senator Kennedy turned in a performance so awful, so unconvincing, as to cause a general alarm everywhere except in the Carter White House."[49] As discussed earlier, the response makes clear our tendency to attribute the effect of the invisible manipulation to the character of the person victimized by it. Conversely, while Kennedy's fortunes fell, Mudd's own stature rose—subsequently winning a Peabody Award for Excellence for the program and being promoted to senior political correspondent in Washington for *NBC News*. At the same time "Teddy" also established a prototype for subsequent popular programming such as "Hard Copy" and "Inside Edition."

Described widely by political analysts at the time as the beginning of a "Mudd Slide" for Kennedy, the program appears to have accomplished both a discrediting of Kennedy as a presidential candidate and a promotion of Mudd as a valuable media commodity. The program did not, of course, constitute the total cause of Kennedy's fall from public grace—the memory of Chappaquiddick; the reality of Kennedy's inarticulateness in the program; the Iranian hostage situation that emerged the same day the program was broadcast; various mistaken tactical decisions; weak political organizational factors; lack of interview preparation; and inability to create a strong camera presence: all of these have been cited as dominant reasons for Kennedy's failure to gain the presidential nomination. The one factor, however, on which political observers seem to agree is that Kennedy's appearance on the *CBS Reports* special was unequivocally devastating to his political image and his presidential ambitions.

The program is an excellent study in television artifice so well done that it appears natural and authentic. To produce a visual editorial artfully disguised as documentary, Mudd took full advantage of audience expectations about the documentary genre and the credibility it evoked; he used the tools of the medium (camera lens and distance, framing, lighting, selective content, editing) to build a negative sense of the person; he exploited the psychological characteristics of the medium (probing intimacy, focus on personality, sense of authenticity) to trivialize and criminalize the politician; and he put it all together through the conventions of the media (documentary format, anchorman credibility) to turn Kennedy's political image into a "type" that could not be taken seriously, and to enhance his own media image.

While it is clear that the relationship between media and politics has always been a "mutually parasitic" one,[50] there was no mutual benefit to be derived by either Kennedy or his family from the Mudd program. Rather, the program represents the darker side of the media, which "resolutely pursue[s] political leaders into a smarmy underworld that they, the media, construct,"[51] and sets the tone for a barrage of programming that followed and would use the same visual effects to affect the interpretation of content.[52]

Both the artfulness of Mudd and the naïveté of even the most politically—though not visually—astute critics at the time, however, is evidenced by the fact that critical response to the program then focused primarily on Kennedy's inarticulate verbal responses to Mudd's questions and not at all on Mudd's visual manipulations. Although Kennedy's verbal performance was a clearly a poor one, it is also clear that Mudd succeeded in visually and verbally engineering the editorial

creation of a media persona for Kennedy. At another time, even the negative impression resulting from Kennedy's media naïveté might have been forgotten or overcome. But because the interview came at the critical point of presidential "surfacing," during which a candidate must begin living up to the electorate's expectations about "honesty, candor, physical and emotional stamina, intelligence, humor and grace,"[53] the program seems to have irrevocably tarnished Kennedy's image. It also succeeded in refocusing the significant issues of Kennedy's candidacy unrelated to his character, and in recontextualizing his relation to the Kennedy myth as well. Above all, it succeeded in visually sabotaging the presidential candidate without ever presenting a rational argument against him.

5

FILM LOGIC AND RHETORIC

The film might be one of the mightiest means of spreading knowledge
and great ideas, and yet it only serves to litter people's brains.

—Tolstoy

Perception and the Development of Montage

The art of film ultimately derives from the process of perception:
from our ability to see a reflection of real experience in a single, two-
dimensional image, and from our perceptual bias for detecting move-
ment. Whatever understanding can be brought to the still image—such
as the meaning of close-ups, camera angles, lighting, and context—is
also applicable to film, but to this is added the magic of motion. Because
this movement depends on the joining of images, the art of film also
implies the capacity to manipulate meaning through editing as well.

The meaning of the first film frame depends not only on its content
but also on how that content is perceptually treated to create attitude, as
discussed earlier. It is also dependent on the nature of the succeeding
frame for its meaning, because the second frame gives it direction and
helps to place it in a meaningful context. This dependence of the first film
frame on the second for meaning is characteristic of the phenomenon of
"backward masking," which may be seen as an example of top-down
perceptual processing in which a successive event, prior knowledge, or
assumptions can affect the interpretation of earlier events in reverse time.[1]

The second image also depends on the first for meaning as well, for
it derives at least part of its meaning from its origins, from what it was a
split second before. Without the two in combination, there is no direction
and therefore no context from which to interpret meaning. As the film
frames continue to be physically displaced by succeeding ones, the
shape of the whole begins to emerge as a gestalt, and the configuration
takes on a unified meaning in which each separate element plays a

significant part. This is how meaning is derived in film, just as in all other art: as Eliot observed, no artist "has his complete meaning alone . . . What happens when a new work of art is created is something that happens to all the works of art which preceded it. . . . The past [is] altered by the present as much as the present is directed by the past."[2]

This is the simple essence of the illusion of film: the image of the photograph in *combination* with the illusion of movement. Today, as frames move past the projector lens at the standard speed of 24 frames per second, because each frame is progressively different from the one before, and because it is too fast for us to perceive each frame separately, what we see is not individual photographs in succession, but life itself unfolding before us.

As discussed earlier, the movement we see in film is indistinguishable in perception from real movement in real time. Images flow past us in a steady stream in the same way that in real life there is an optic flow of information in perceptual process. As the flow continues, all that has come before creates a context for the understanding of what comes next, and the stream of images involves us as if we were observing reality itself. This illusion not only allows for a totally different experience from the still image, but also compounds film's potential influence. By mimicking perception itself, film has the capacity not only to imitate life, but to direct thought as well.

As Tolstoy recognized, film represents the fullest expression of perception brought to the level of art; but it is also as Béla Balázs noted an instrument of profound mass influence:

> We must be better connoisseurs of the film if we are not to be as much at the mercy of perhaps the greatest intellectual and spiritual influence of our age as to some blind and irresistible elemental force. And unless we study its laws and possibilities very carefully, we shall not be able to control and direct this potentially greatest instrument of mass influence ever devised in the whole course of human history. . . . the mentality of the people, and particularly of the urban population, is to a great extent the product of this art, an art that is at the same time a vast industry. Thus the question of educating the public to a better, more critical appreciation of . . . films is the question . . . of the mental health of . . . nations. Nevertheless, too few of us have yet realized how dangerously and irresponsibly we have failed to promote such a better understanding of film art.[3]

Although television was still in its infancy when Balázs spoke of the power of film, it is clear that all visual mass media, especially tele-

vision, now share this power. Marshall McLuhan observed that all visual media have precipitated a transition in the way we see from linear connections to configurations,[4] and warned that the way we watch television and experience film is changing the way we perceive in the world as well as the way we think about it.

Film Origins

In 1877, photographs taken by Eadweard Muybridge finally solved a centuries-long debate on whether or not a horse's hooves ever completely leave the ground when running. They also settled a wager involving California Governor Leland Stanford. After hundreds of attempts, Muybridge finally got a photograph of a horse with its feet off the ground, and Stanford won his bet. Later John D. Isaacs devised an electrical shutter control and timing device that allowed for a systematic picture series of animal locomotion, frame by frame, for up to 24 still cameras[5]—a device that launched Muybridge on a long and successful career of photographing movement. Not long after Isaacs's system proved successful, at the urging of Jean Louis Meissonier, Muybridge went to France and displayed his by then numerous photographs to eminent artists who at first were incredulous, finding them suspicious at best. Artists—who have always believed their eyes—had recorded very different gaits in the animals they portrayed, capturing in their work not an actual moment frozen in time, which was impossible for the human eye to see, but rather what seemed a logical step in the overall graceful effect of that movement. As film historian Terry Ramsaye commented, "The camera was not yet established as an instrument of scientific verity."[6]

To prove that the photographs were indeed accurate recordings of the fragmented actions of animals, Meissonier produced a small progression of the individual photographs, mounted them on a praxinoscope (a revolving glass disc with slots which, when illuminated, would cast an image onto a screen) and showed the horses in motion. These were the first moving pictures. The first motion pictures on celluloid strip were created in Thomas Edison's laboratory by him and his assistant William Dickson, but their kinetoscope, though it paved the way for the development of the art of film, did not progress beyond the idea of a visual accompaniment to the phonograph and an individual peep-show. It could record images but could not project them to a group.

In Paris in 1895, Louis Lumière was the first to show films to a paying audience. The son of a photographer and himself a successful manufacturer of photographic products, Lumière saw the ability of film to capture life in natural movement as its chief asset. Lumière's new

invention—the Cinématographe—which he developed with his brother Auguste, incorporated both camera and projector in one, and with it he continued to delight people for years with the novelty of scenes of daily life: workers leaving the Lumière Factory in Lyon, a train arriving at the station, Auguste helping to feed his baby. The Lumières also produced films with the first rudimentary plots. In one, for example, a gardener is tricked by a boy who steps on the garden hose. When the puzzled gardener looks into it, he is then splashed as the boy releases his foot. Apparently believing, as Sigfried Kracauer suggested, that "films come into their own when they record and reveal physical reality,"[7] the Lumières held up for examination small moments of life. The charm of their films lay in their ability to see something special in the everyday and to capture the pulse of human existence as the still photograph never could.

In film, audiences could see what they ordinarily did not, or could not, see: patterns in the ebb and flow of human life, distant boats leaving a coastal harbor never visited, or even the most ordinary domestic scenes imbued with larger-than-life significance. As it became clear that audiences loved the novelty of movement and imaginary travel, Lumière sent out skilled photographers to distant places to sell his invention and to capture the first newsreel footage. Through them, within a few years of his first public film showing, Lumière had gathered an impressive collection of historical footage, including the coronation of Czar Nicholas of Russia and the inauguration of President McKinley in the United States. Audiences marveled at this new ability to transcend the limits of time and space.

The other side of film's capabilities is seen in the work of Georges Méliès, an inveterate showman, conjurer and illusionist, who after the premiere of the Cinématographe unsuccessfully begged the Lumière brothers to sell him their machine. He did, however, go on to develop his own and very quickly learned another aspect of film's potential. Because each frame was a separate unit, the camera could be stopped at any given point and then started up again, making it the technological equivalent of the theatrical trap door. By 1902 he had mastered the art of film stagecraft and had produced what is today his best-known film, the delightful *A Trip to the Moon*, complete with disappearing imps, chorus girls, comic scientists, and an inauspicious landing in the Man-in-the-Moon's eye, captured in thirty different scenes. By this point Méliès had already made several more serious contributions to the art of film as well: his credits include the first stop-motion special effects, the first film studio with artificial lighting, the first time-lapse photography, and even the first complex multiple exposure, where he himself appears in the

same frame as seven different persons.[8] In 1907, his film *Tunneling the English Channel* even prophetically fantasized the President of France and England's Edward VII dreaming together of an underwater tunnel between Dover and Calais.

Today film theorists point to these early filmmakers as representing the two main divergent tendencies in film art—one toward documentary and the other toward fantasy. Perhaps nothing makes the difference between Lumière and Méliès clearer, however, than a difference in coronation newsreels: where Lumière had his men film the real coronation of Czar Nicholas, Méliès "re-created" the coronation of Edward VII in his studio even before the event actually took place.[9]

Neither Lumière who went back to his factory when the novelty of movement and recording of simple realities wore off, nor Méliès who ultimately went bankrupt when audiences tired of his style of visual gimmickry, however, ultimately grasped the full potential of film or understood the implications of their pioneering work. Rather it took individual geniuses like Chaplin, Eisenstein, and Welles; large-scale efforts by the American film studios; and European sensibilities expressed in the wake of war to reveal the full gamut of the film possibilities they merely hinted at. It is doubtful, for example, that Lumière could have imagined the power of the Italian neorealists to reveal the humanity beneath the degradation of war, or that Méliès could have foreseen how far his gimmickry would progress in the production of today's special effects action films.

Editing and Perceptual Process

The first significant use of innovation in film in the United States is associated with David Wark Griffith. His *Birth of a Nation* (U.S.A., 1914) and *Intolerance* (U.S.A., 1916) were landmarks in the development of film, primarily because he was the first to fully appreciate that film worked the way the mind worked, and he made the camera move in anticipation of the way the mind encountered real experience. Prior to his innovations, hundreds of motion pictures had been made from stage plays, capitalizing only on the film's natural advantage over the actual stage in terms of scenery and numbers of people in crowd scenes. The French Film d'Art reel production of *Queen Elizabeth* in 1912, for example, was merely a recording of the stage play. The essential differences which ultimately came to conclusively separate film from other art forms had scarcely been touched on.

Porter's *The Great Train Robbery* (U.S.A., 1903) produced by the Edison Studio, for example, is considered a highly innovative film for its time because it was a full ten minutes long, had a fairly complex story-

line, and used a pan shot and a close-up of "Bronco Billy" shooting his revolver at the audience to conclude it. Otherwise, the camera acted as a spectator fixed from a particular distance and angle, the frame was seen as a stage, and no attempt was made to guide the attention of the spectator. Although it also used the by-then standard film tricks of an inset to show passing scenery and the interframe special effects substitution of a dummy for a character thrown off the train, in comparison to Griffith's *Birth of a Nation*, 185 minutes at 16 frames per second, and *Intolerance* at 115 minutes at 24 frames per second, it is amateurish at best.

In his films, Griffith not only abandoned the theater's proscenium arch and the fixed long shot which paralleled theater seating, he also developed the use of expressive lighting and camera angles. In addition, he pioneered the dramatic use of intercutting to create visual simile while telling parallel narratives (*Intolerance* has four); developed crosscutting (intercutting and alternating separate narrative plots) as a dramatic technique; and perfected the art of achieving psychological tension by progressively shortening the duration of shots. He also used symbolic juxtaposition—as with prison walls dissolving into flowering meadows, children playing in a field where once there was war—to expand standard literary devices into a filmic dimension, and the techniques of fading out and in to mimic states of mind and to direct and redirect attention. A man of technical imagination in an industry which lacked it, Griffith perfected camera and editing techniques that he had not discovered and also standardized previously erratic devices of film expression: high-angle shots of soldiers charging past the camera, extreme long shots revealing the scope of battle scenes, close-ups of action intensified by camera masking devices, extensive intercutting of long, medium, and close-up shots timed to both quicken the action and suggest the confusion of conflict, and still shots to capture pathos, as in corpses in the battlefield.

One can see exactly how institutionalized the techniques of Griffith have become by comparing his early films to such dissimilar classics as Mike Nichols's *The Graduate* (U.S.A., 1967), which, for example, utilizes every device exploited by Griffith, including the final desperate chase scene of *Intolerance* which is transformed into *The Graduate*'s antihero Ben trying to prevent the marriage of the woman he loves to another man. In the chase, Ben seems to be running and getting nowhere—a reflection of a central theme of the work—as the camera lens zooms in at the same time the camera itself dollies out. Depth cues in the ambient flow that Gibson later identified as signaling movement in real experience are absent, so that what we see is the background scene receding in relation to him. Because the background stays flat, he seems only to be running in place.

Although D. W. Griffith is often described by film theorists as a man confined by anachronistic Victorian social principles, maudlin sentimentalism, and a deep and sincere racial bigotry, he nevertheless was the first to realize the potential of film's spatial and temporal plasticity, inviting the viewer to become one with the camera and to see the battle as no one person ever can—from above and below, near and far, according to the essential drama of the visual message. With Billy Bitzer at the camera, he directed audience attention, anticipated questions and supplied visual answers. He assembled apparently disparate elements, manipulated the camera to parallel the natural workings of the mind, and utilized the viewer's perception to create a unified story.

In the process Griffith also showed himself to be an effective propagandist, filtering content in such a way as to fit his own vision of the world and of history, adapting *Birth of a Nation*, for example, from Thomas Dixon, Jr.'s sympathetic portrait of the Ku Klux Klan, *The Clansman*, with most of its bigotry intact. But the film experience electrified audiences. Standing ovations greeted its initial release, and according to Lillian Gish's memoirs, the film recovered its total cost of approximately $91,000—a staggering sum at that time—in two months of playing to sell-out crowds at the Liberty Theater in New York.[10] Clearly Griffith had succeeded in producing an effect on his audience, and from Griffith's innovations, film grew into its own as an art form by finding its capabilities and limitations through the mobility of the camera, the variability of the lens, and editing's capacity to transform time, space, and distance. From Griffith onward, only the screen was perceived as fixed, with all other elements now elastic and open to manipulation. Although Griffith himself lacked breadth of intellectual vision, his work was not lost on those with the ability to understand the perceptual implications of the new medium.

One of the first of these was the German psychologist Hugo Münsterberg who saw most clearly that the camera paralleled mental action and reached its peak capability in the emotional response of the viewer. A friend and colleague of William James and Santayana, and eventual chairman of the philosophy department at Harvard, he brought to film a breadth of philosophical and psychological perspective otherwise absent from the critical scene. In 1916, after seeing Griffith's films again and again, he wrote the first major psychological study of how film works, *The Photoplay: A Psychological Study*. In it, Münsterberg discusses how film parallels perceptual process: its events, he insisted, were "completely shaped by the inner movements of the mind. . . . We do not see the objective reality, but a product of our own mind which binds the pictures together."[11] Each characteristic functioning of film, Münsterberg

states, has its counterpart in perception: the camera close-up, angle, composition, image size, and lighting mechanistically parallel the activity of "attention" that operates on the world of sensation and motion. Editing parallels the memory and imagination in its ability to compress and expand time and space, to create rhythm, and to conjure flashbacks and dream scenes. Story narrative parallels the quality of emotions to direct all lower processes.[12]

Anticipating the Gestalt psychologists, Münsterberg saw that, as with everyday experience, the film's impact is derived from the mind's ability to organize its perceptual field and create a relationship among the parts. The art of cinema was thus intrinsically bound to linear narrative through unity of action. Like later perceptual psychologists, he did not confuse the image with the reality. Instead, Münsterberg posited that film "can act as our imagination acts. It has the mobility of our ideas which are not controlled by the physical necessity of outer events but by the psychological laws for the association of ideas. . . . The photoplay obeys the laws of the mind rather than those of the outer world."[13] In the same way that the mind creates a coherent reality out of perceptual experience, Münsterberg believed, it also creates meaning out of film. Ultimately, he contends, the film experience is integrated on an emotional level, which he saw as the highest level of perceptual integration.

Clearly, if the film could grasp total attention, direct the mind toward certain ideas, and move the emotions, it also had great propagandistic value. This fact was not lost on Soviet filmmakers who, caught up in the Russian Revolution, saw from Griffith's work that film could indeed be used as the raw material from which emotions and ideas were constructed. In the hands of Lev Kuleshov, Vsevolod Pudovkin, and, above all, Sergei Eisenstein, the techniques of Griffith became a chief means of disseminating a Marxist ideology, an art grounded in the means of production—the material of film itself—and its studied arrangement.

Kuleshov Workshop

As the initial novelty of moving pictures began to wear off and the possibilities of film as an art form became apparent through the work of Griffith, the young Soviets of Revolutionary Russia—fascinated by film and imbued with ideologic enthusiasm—found themselves in an extraordinary situation. With the Old Guard crumbling around them and the new Marxist-Leninist order stretching to establish itself as the one legitimate government, all the parts of Russia—its people, its philosophic ideas and political ideals—were coming apart and re-forming into a new whole. The truly perceptive artists of the time were caught up in the process and

all areas of artistic expression were revitalized. In film, theater, art, and literature, masters like Kuleshov, Pudovkin, Eisenstein, Meyerhold, Mayakovsky, and Pasternak participated synergistically in a cross-pollination of ideas sustained by a pervasive sense of social evolution.

As artistic innovation was spurred by political change, film—the newest art form and most revolutionary communication vehicle—became especially important. Not only was it attuned to the political tenets of dialectical materialism because of its dynamic nature, but it also spoke a universal visual language. Unlike any other mass medium or art form, film could speak directly, explicitly, and silently to the 160 million people living outside the great cities, most of whom were illiterate and had little or no understanding of the ideological conflicts involved in the Revolution. Because of this unique position, film became an integral part of the agit-trains sent out to the provinces to educate the masses on the new socialist order.[14] Equipped with printing plant, film laboratory, and cutting room, the trains were as revolutionary a concept in mass communication as the ideas they disseminated.

In each town visited by the agit-trains, pamphlets and books were also distributed, meetings held, paintings and drawings of other districts exchanged, concerts and theater performances given, and films shown in the streets at night. One agit-steamboat, the Red Star, boasted a full film crew and towed a barge cinema that seated 800 people.[15] Lunacharsky, Education Commissar at the time, commented on the film's importance in the New Order: "The moving picture will be utilized to the very fullest extent for amusement and education. The story of humanity will be told in pictures [without] bloodshed and violence . . . race or religious bigotry and hatred: the cinema will be used to teach citizenship and love of humanity."[16] The dream was infectious, and film was to be the prime medium of its transmission.

Before the 1917 upheaval, Russian cinema had been generally both ponderous and vacuously ornamental. By the reign of Stalin, Soviet cinema again became heavy and unremittingly didactic under the political imperative of "socialist realism." In 1935, for example, under political pressure Lev Kuleshov stated that his film theories, developing in 1916 and later published in 1928 in his *Art of Cinema*, were "deeply erroneous." He was speaking in Stalinist terms that condemned American bourgeois cinema, that spoke of himself and his followers as having been "gulled" by the "petty bourgeois morality" of American capitalism implicit in all American films. He was calling his Kuleshov Group "uncritical" in its study of "montage" (from the French "cutting"), decrying the "great harm" that had come from it, and stating that the ideological purpose of film determined its quality, "especially since the material

of cinema is reality itself, life itself, and reflected and interpreted by the class consciousness of the artist."[17] But in the period of 1916 to 1928 it was different. Then the air was electric, ecstatic—it was a unique period of political revolution and artistic experimentation, and the new art of cinema was welcomed both aesthetically and pragmatically.

It was Lev Kuleshov who first studied the effect of film on the audience, discovering that foreign films were more popular than Russian films, and that American films "elicited the maximum reaction, the greatest noise and applause."[18] "We noticed," he said, "that in a particular sequence of a Russian film there were, say, ten to fifteen splices, ten to fifteen different set-ups. In the European film there might be twenty to thirty such set-ups, while in the American film there would be from eighty, sometimes upward to a hundred, separate shots."[19] Through this observation, he and his fellow students came to realize that the cause of film's impact lay within its system of alternating shots and therefore that montage, not the shots themselves, were the basis of cinematography:

> We examined how a motion picture is constructed. In order to determine the main strength of the cinematographic effect, we took one strip of film, cut it apart into its separate shots and then discussed where the very "filmness" in which the essence of filmic construction lay.[20]

The key to the successful film, and therefore to the art of cinema, he realized, was threefold: the division of the scene into montage pieces; the shooting of each separate moment so that only its action was visible; and the synecdochic use of simple detail in close-up to reflect the dramatic essence of the situation.

When in his film *Engineer Prite's Project* (1917–1918) Kuleshov had to improvise shots to complete the film in his actors' absence, he also realized the possibility of creating something on film which did not exist in reality. He then began a series of now-famous experiments in which he controlled meaning entirely through editing. First, through a series of shots, he discovered how to use "creative geography." In an apparently seamless sequence, he filmed his wife Khoklova walking along a Moscow street, the actor Obolensky walking along the Moscow River, the two spotting one another and smiling at Boulevard Prechistensk, clasping hands at Gogol's monument, then turning and looking, followed by a shot of the White House in Washington, D.C., and finally with the couple climbing the stairs of the now-demolished Cathedral of Christ the Savior. After splicing, of course, it was clear that Kuleshov had

succeeded in creating a new whole out of intrinsically unrelated parts, of performing the miracle of placing the lovers together though they had been at totally different places, and even of moving the White House to Moscow. According to Kuleshov, from this experiment they learned that the basic strength of cinema lay in montage and its possibilities of breaking down and reconstructing material.[21]

His next experiment involved putting together a totally new person out of the cinematic parts of different people by taking the eyes, lips, hands, body, etc. of different women and so constructing a film as to make it appear that all were part of one person. Next he tested the ability of montage alone to convey and evoke emotion in the viewer. Described by Pudovkin in *On Film Technique*, the experiment consisted of taking close-ups of the well-known Russian actor Mosjukhin with a neutral expression and joined them with other bits of film in three different combinations. In the first combination, the close-up of Mosjukhin was joined with a bowl of soup. In the second, Mosjukhin was joined to a shot of a coffin in which a dead woman lay. In the third, the actor was followed by a little girl playing with a toy bear. When the Kuleshov Group showed the three combinations to an audience, the public raved about the Mosjukhin's acting. They pointed to "the heavy pensiveness of his mood over the forgotten soup"; they were moved by "the deep sorrow with which he looked on the dead woman"; and they admired "the light, happy smile with which he surveyed the girl at play." In all three cases, of course, the face was exactly the same.[22]

Kuleshov remembers the experiment somewhat differently, but both Pudovkin and he agree on its effectiveness. The Group concluded that "with correct montage, even if one takes the performance of an actor directed at something quite different, it will still reach the viewer in the way intended by the editor, because the viewer himself will complete the sequence and see that which is suggested to him."[23] In effect, the viewer's perception was in the hands of the film editor.

William Mitchell recently showed how this could be managed today by manipulating a news photograph of President George Bush and Prime Minister Margaret Thatcher. In an article in *Scientific American* he edited a photograph of them together in three different ways to create three different meanings. In one, George Bush and Thatcher are walking side by side, apparently in conversation. He is to her left and his head is turned toward her as if talking; her head is turned slightly down and toward him as if listening. The next photograph separates them and places Thatcher ahead of Bush. The pair is now looking directly away from one another, as if avoiding conversation. The third image brings them closer together, as if he is whispering in her ear. The effect of the

first photograph is cordiality; the second, anger; the third, comfortable intimacy.[24]

This approach, which in film makes the frame content subordinate to the editing function, directly depends on a perceptual logic that connects two separate elements and fills in the whole through the principle of good continuation. If this good continuation is absent, however, and the viewer left without a context, Kuleshov believed that the result would be frustration and confusion. When a jump cut is made between unrelated scenes—that is, when we "jump" from one scene to another totally different one—he reasoned, the completion could not take place because the sequential framework is missing. "Therefore," he states, "the direction or motion of the last frame of the preceding shot and of the first frame of the successive shot must coincide."[25] Kuleshov's view of montage closely parallels von Ehrenfels' Gestalt concept of melody discussed earlier.

Pudovkin: Linkage Montage

Although Kuleshov made several films utilizing these insights, it remained for his students, Pudovkin and Eisenstein to most fully explore the propaganda possibilities implied by strategically guiding perception. Like the Lumière brothers and Méliès, however, Pudovkin and Eisenstein took film montage in different directions based on differing understandings of perceptual process.

Pudovkin kept closely to the montage linkage which Kuleshov espoused, stressing narrative continuity. In his theoretical works, he describes how the camera as active observer enables the viewer not only to "see the object shot, but [also] to apprehend it," and how the director must analytically dissect a scene into component parts, selecting only the essential, and then combine these into a new perceptual whole. Throughout his discussion there is continual stress on shots not as pieces but as related parts: "a film is only really significant when every one of its elements is firmly welded to a whole."[26]

Although Pudovkin's understanding of film "parts" is more gestaltlike than summative, he nevertheless still approached the parts of the film linearly, with logical narrative development as the key to meaning. In a film sequence, he believed, there must be expressed "a special logic that will be apparent only if each shot contains an impulse towards the transference of the attention to the next." "The film," he tells us, "is not simply a collection of different scenes. Just as the pieces are built up into scenes endowed, as it were, with a connected action, so the separate scenes are assembled into groups forming whole sequences."[27] By linking scenes in such a way as to coincide with the natural thought processes of the viewer, he believed, the director could control the

content and direction of the viewer's thoughts without interference from other forces competing for attention. This, he was sure, was where the film's real potential for effective propaganda lay: more than any other medium, film has the capacity to control virtually our whole attention and our receptive environment. In his essay "On Editing," Pudovkin tells us, "There is a law in psychology that . . . if an emotion give birth to a certain movement, by imitation of this movement the corresponding emotion can be called forth . . . editing is in actual fact a compulsory and deliberate guidance of the thoughts and associations of the spectator."[28]

In using linking montage to gently guide thought, Pudovkin was essentially stressing a combination of first, Aristotelian linear narrative to tell an involving story thath moved forward by causal action; and second, the perceptual logic which the Gestalt theorists identified as the Law of Good Continuation, which linked scenes visually, propelling them forward through an association of ideas leading to an inevitable conclusion. The approach is essentially linear and narrative, and represents the most basic level of perceptual logic.

Pudovkin's contemporary Sergei Eisenstein, however, developed an opposite approach to film montage, based on Marxist-Leninist thought. Exploiting the psychological need to resolve perceptual tension, he modeled his montage on the Hegelian dialectic of thesis-antithesis-synthesis, presenting two opposing elements that forced the viewer to resolve the conflict. Opposition in form and content became an essential part of his design in mise-en-scène (i.e., everything within the film frame, including the position and relationship of parts to each other) and in editing film sequences where he used conflict to develop dynamic visual arguments. To transform the art of narrative film into the art of visual rhetoric, he combined ideology and perceptual tension, and relied on the principle of perceptual closure to manipulate the emotions of the viewer. He was convinced that political conviction would come with perceptual resolution.

Eisenstein: Dialectical Montage

As the director of the First Moscow Worker's Theater in 1922, for example, Sergei Eisenstein tells us: "I was one of the most unbending supporters of LEF [the Revolutionary Left Front], where we wanted the new, meaning works that would correspond to the new social conditions of art."[29] Already comfortable through his engineering studies with the concept of conflicting tensions balanced to create a third directional force, Eisenstein merged his own linguistic abilities—he read and spoke Russian, English, French, and German—with the Hegelian-Marxian dialectic to form what he called "intellectual montage." It was,

in effect, a rhetorical argument created out of film language, structured as much by perceptual process as by the philosophical dictates of dialectical materialism.

During the final cutting of his 1927 film *October*, Eisenstein described this link between image and thought: "Lenin said 'the cinema is the most important of all the arts.' We firmly believe this, [that] the innovations of our cinema in form, organization, and technique have been possible only as a result of our social innovations, as a result of our social order and the new modes of thought it has stimulated."[30]

By colliding images to create deliberate perceptual dissonance, Eisenstein evolved a blueprint theory for making images function as a universal language. Inspired by the Japanese ideogram, he deliberately avoided the narrative continuity characteristic of then-contemporary film in favor of a tension between images in time, space, shape, and rhythm. He set his images in counterpoint, reasoning that a dialectical collision of images would force the viewer to resolve the conflict and to derive a meaning not implicit in any of the individual film frames. This is at least partially what McLuhan meant when he recognized that "the message of the movie medium is that of transition from linear connections to configurations."[31] For Eisenstein, the significance of film as an art form rested in the relationship between the images resolved as a completed gestalt in the mind of the viewer. The process required the viewer to be an active participant in constructing the meaning of events shown on the screen.

The Japanese ideogram illustrates simply and clearly what Eisenstein had in mind in formulating his dialectical montage theory. Fascinated by both the Japanese language and the symbolic potential of Kabuki Theater, Eisenstein was excited by the ability of the ideogram to create a new idea solely through the juxtaposition of separate hieroglyphs. In his 1929 essay "The Cinematographic Principle and the Ideogram," he explains that the ideogram's combination of "two hieroglyphs of the simplest series is to be regarded not as their sum, but as their product, that is, as a value of another dimension . . . By the combination of two 'depictables' is achieved the . . . graphically undepictable."[32] The picture of an ear next to the drawing of a door, for example, yielded the concept of listening; the picture of a knife and a heart yielded sorrow. In combination concrete images in linear succession take on abstract meanings embedded with the emotion and connotation associated with experience rather than appearance.[33] This in effect created a dynamical system out of a sequential linear one. In this system, Marxist ideology acted as an attractor: the turbulence between montage shots, like the dynamical forces between hieroglyphs in the ideogram, would,

Eisenstein believed, ultimately settle in to a higher level of perception—that is, socialist thought.

Thus from visual depictions based in experience, abstract concepts would arise that had no counterpart in either. In Eisenstein's view, because visual language was experiential, it would engage the viewer emotionally and intellectually. Because its content was ideologically correct, the propaganda would persuade both on an affective and cognitive level. In this way, Eisenstein's view of montage as dialectical also parallels the basic concepts of the Gestalt theorists Wertheimer, Köhler, and Koffka, Eisenstein's contemporaries. For them, it will be remembered, in the formation of a gestalt, the parts interacted dynamically with all other parts of the whole, and the Law of the System directed the order of their synergistically changing relationships. Eisenstein similarly observes: "The shot is a montage cell. Just as cells in their division form a phenomenon of another order, the organism or embryo, so, on the other side of the dialectical leap from the shot, there is montage. By what, then is montage characterized and, consequently, its cell—the shot? By collision. By the conflict of two pieces in opposition to each other."[34]

Building on the work of Griffith, Einstein thus nevertheless departed from its theoretical underpinnings. In "Dickens, Griffith and the Film Today," Eisenstein describes how the summative montage of Griffith stops short of its propagandistic potential: "For us, [Griffith's] quantitative accumulation . . . was not enough: we sought for and found in juxtapositions more than that . . . a means before all else of revealing the ideological conception . . . we were extending the frame of parallel montage into new quality, into a new realm: from the sphere of action into the sphere of significance."[35]

Beginning with the same assumptions as Münsterberg about correspondences between the function of film and the process of perception, but disassociated from Münsterberg's idealism, Eisenstein believed that the ultimate application of montage was in propaganda: "Step by step," he tells us, "by a process of comparing each new image with the common denotation, power is accumulated behind a process that can be formally identified with that of logical deduction. . . . [This] leads to the formal possibility of a kind of filmic reasoning. While the conventional film directs the emotions, this suggests an opportunity to encourage and direct whole thought processes as well."[36]

The power to create and to direct thought, Eisenstein felt, lay in the dynamic energy of images juxtaposed in dominant counterpoint in time, space, line, place, volume, and light. It was the perfect synthesis of philosophy, art, and science—the ultimate integration: "The projection of the dialectic system of things into the brain, into creating abstractly, into

the process of thinking, yields: dialectic methods of thinking; dialectical materialism—Philosophy. The projection of the same system of things, while creating concretely, while giving form, yields: Art."[37] In effect, in Eisenstein's view, film as art was able to create a forceful rhetorical argument for Marxist ideology and thus engage the viewer's perception and direct his or her thought.

The efficacy of Eisenstein's ideas is evidenced by the fact that even though foreign audiences were generally initially unsympathetic to the Marxist-Leninist doctrine his films represented, they nevertheless applauded wildly at the end. Eisenstein's pianist Lev Arnshtam described that when the red flag (the flag of revolution, which had been hand-tinted in the individual prints) was raised in *Potemkin*, it brought a stormy ovation. Some Germans sitting in the back row yelled something in German, someone sang "The International" in French, and everyone stood and applauded.[38] When Douglas Fairbanks and Mary Pickford saw the film premiere in Berlin in May 1926, *Die Rote Fahne* quoted Fairbanks as saying, "*The Battleship Potemkin* was the most powerful emotional experience in my life."[39] Later, Fairbanks brought the film to America and signed Eisenstein to make a picture for United Artists on any subject he wished.[40] By October 1926, David O. Selznik had written to one of the heads of Metro-Goldwyn-Mayer (MGM) Studios suggesting that Potemkin was worth the same study as a Rubens or a Raphael," and that "the firm might well consider securing the man responsible for it."[41] Even Albert Einstein was impressed. Writing to Eisenstein in 1930, his fellow director Leonid Obolensky, a member of the original Kuleshov Workshop present when Einstein first viewed the film, wrote: "The old man apparently having seen cinema for the first time, was literally stunned. . . . He approved, exclaimed, proclaiming to the viewers in a provocative roar. It is a pity you were not there. . . ."[42]

For a clearer understanding of how these dramatic effects were achieved, it is worthwhile taking a close look at several of Eisenstein's montage sequences, which in structure illustrate both the simple Gestalt Law of Prägnanz, by which they maintain a complex pattern under constantly changing conditions, and that moment which Köhler termed "insight," when a spontaneous realization gives meaning and organization to what is perceived. The famous Odessa Steps sequence of *Potemkin* serves as a good example. When Eisenstein saw them, he immediately realized their cinematic potential:

the very run of the steps themselves helped conceive the scene, and by its "flight" animated the director's fantasy. And it appears that the panic-stricken "run" of the crowd "flying" down the steps is

the material embodiment of those initial feelings caused by the first sight of these very steps . . . the Odessa Steps sequence became the determining scene, the very backbone of the organic structure and laws of the film.[43]

As filmed, this sequence clearly illustrates Eisenstein's use of counterpoint to create the dialectical conflict of montage. In the steps themselves, for example, we see the horizontal lines that seem to crush the people below as the camera follows the boots and bayoneted guns of the anonymous Cossack soldiers as they massacre men, women, and children in their wake. In this oppressive sequence, only their dehumanized hands, bayonets, boots, and shadows are shown. In contrast, the previous scene focuses on the animated and giving spirit of the people, visually stressing the vertical lines of the Odessa columns, the upright sails of the boats joining the battleship, the support pillars of the Odessa bridge, and even the top-mast of the Battleship Potemkin herself as the residents of Odessa wave to the revolutionaries and bring food to the ship.

In addition to linear counterpoint, Eisenstein also utilizes conflict between the "light" and "dark" purposes of the peasants and the troops. He alternates shots to create a physical sense of explosion within the mind of the viewer as the rifles are fired; he stretches real time into filmic time by repeated shots from varying angles in the "flight" down the steps; he produces maximum tension through a quickening montage rhythm. He also uses tension between geometrical planes—triangles, circles, diagonals with shot set-ups, alternating them for maximally disturbing effect. Conflict is also created between long shots of the masses and shots of individuals. All of these are designed to direct mental process by creating an objective correlative of Marxist ideology through a concrete chain of events that induce emotional response, just as Eliot attempted in poetry. Eisenstein himself seems to paraphrase Eliot when he comments that "the image planned by author, director, and actor is concretized by them in separate representational elements and is assembled—again and finally—in the spectator's perception. This is actually the final aim of every artist's creative endeavor."[44]

Immediately following the Odessa Steps sequence is one of Eisenstein's most famous uses of montage where a sculptured lion apparently rises out of slumber to protest the slaughter on the Steps. Using separate images of different stone lions in positions of sleep, arousal and full alertness respectively, Eisenstein is able to produce apparent motion because the images are joined at a higher level of perceptual processing. Although Balázs criticizes this montage sequence as a kind of visual trickery not organically derived from the unified film

idea, and film theorists like V. F. Perkins and Herbert Marshall have pointed out various inconsistencies of overall effect, Eisenstein himself defends the sequence as a culmination of the previous action, raising form to the level of ideological content: "The effect," he says,

> is achieved by a correct calculation of the length of the second shot. Its superimposition on the first shot produces the first action. This established time to impress the second position on the mind. Superimposition of the third position on the second produces the second action: the lion finally rises.[45]

Serving as a rising counterpoint to the Odessa Steps sequence, the stone lion montage, one of the most powerful sequences in film history, was itself the result of a serendipitous gestalt. Not a part of the original shooting script, unanticipated by the director, the Lions sequence was invented by Eisenstein when he saw the three different sculptures on location. Because the sequence does not make perfect sense in terms of narrative line, its effect is an excellent example of gestalt formation in the mind of the director and the viewer. According to Eisenstein, "Chance brings about a sharper and more forceful decision, but in the same key, and the accidental grows into the body of the film as an integral law."[46] In the same sequence, linear narrative and Aristotelian plot unity are transformed by Eisenstein into a true gestalt and an objective correlative of Marxist thought. Montage became the means of expressing the abstract through concrete images, and director as author became a catalyst for transforming ideology into art. In Eisenstein's hands, form, content, and effect became one: instead of using images to support a narrative line, he structured them to create a perceptual event.

Unfortunately, both politics and the advent of sound in film prevented Eisenstein's and others' work from developing much further. When Eisenstein returned from his goodwill tour of Western Europe and America in 1932, the whole outlook in Soviet cinema had changed. The subtleties of the efforts of Kuleshov, Pudovkin, and Eisenstein to direct thought ideologically through art were ultimately crushed beneath the weight of the official Soviet stance on socialist realism. Although they were allowed to teach film, most of their work after 1929 was to be disgraced or halted in midproduction because of ideological or political concerns. None would ever again achieve the spontaneity, the emotional impact or the intensity of intellectual tension and vibrancy of this earlier period. With the end of their early work, the revolutionary spirit that infused it was also dissipated.

From Long Take to CG

At the other end of the spectrum from montage is the "long take"—in which the flow of events is uninterrupted by cuts or different set-ups. Although the camera moves to change angle or follow the action, events are allowed to unfold in real time, and dramatic tension must be generated within the frame rather than through editing.

No one was better at this than Charlie Chaplin (1889–1977). Acting as director, actor, and script writer, he designed the sets, developed the gags, improvised the script, and directed everyone with perfectionist exactitude. After a childhood of deprivation, discovered by Mack Sennett at the beginning of a career in vaudeville, Chaplin rose within a few years to become perhaps the most famous and best loved persona in the world. By 1915, toys and miniature statuettes were advertised, and Charlie squirt rings had made their debut.[47] At the height of his career Chaplin made a movie a month.

In France especially, his name became the generic word for motion picture comedy, and going to the movies was synonymous with seeing "a Charlot." By 1917, he had become his own producer, opting for artistic control rather than the million dollars a year, plus signing bonus, offered him by Mutual Film Corporation.[48] Like Eisenstein who after the Revolution had all the artistic freedom implied by the backing of the new Soviet government, Chaplin now had the money and artistic control he needed to exercise his genius. This genius lay in three areas: the development of his character "The Tramp," his ability at mime, and his skill at framing the shot and revealing its inherent drama in uninterrupted sequence.

The essence of the Tramp's charm lay in his archetypal humanity: he was the quintessential little guy facing obstacles at every turn, surviving through his own ingenuity in a menacing world, mustering up impossible dignity when he inevitably loses at love and luck. Where Eisenstein created a dialectic between frames, Chaplin placed his character within the frame and watched the conflict unfold. Symbolically his costume and behavior reflected this dichotomy between winner and loser, millionaire and tramp—his top half the impoverished gentleman, his trousers and shoes those of a clown. As "the Tramp" he adopts the manners of a man of society—in *The Gold Rush* (U.S.A., 1925) for example, he displays impeccable manners even when, starving, he is forced to eat his shoes; as a millionaire later in the film, he wears an elegant smoking jacket and fur coat, but scratches himself, and stuffs his face. Always his actions are inappropriate to the situation, and always the props he utilizes are put to a totally different purpose than the one

for which they were manufactured.[49] The effect is of a man in disguise: dressed as one, he acts like the other—always the opposite of what he appears, always subverting the meaning of the larger situation in trying to cope with it. This is Chaplin's visual and emotional dialectic and the source of much of his humor.

Because Chaplin's character is a continual study in contradiction, the result of our need to get these together is laughter. His comedy is based almost entirely on the absurdity of inappropriate actions, the unbearable hurt that only the most sensitive and caring person leaves himself open to, and the assertion of the human spirit within the most degrading or humiliating of circumstances. In the Tramp's archetypal ability to muster dignity against overwhelming forces, and rise like a phoenix out of psychological and economic devastation, the viewer finds renewed faith in the human spirit and relief in laughter.

Because his art was one of mime, verbal nuance did not matter. Verbal repartee is the stuff of sophisticated comedy, such as we see in the "Lubistch touch," but Chaplin's hold on his audience was more profound, based in universal human experience. Because of this, he needed film sequences that were undisturbed and flowed in real time rather than the dramatic cuts of Eisenstein's montage. Physical and emotional action were the substance of his art, and human experience his theme. The long take allowed his audience to identify with his experience; his calculated use of close-ups revealed his heart. Just as Eisenstein was adept at manipulating the direction of his shots and cutting on the action to create tension resolved in political conviction, Chaplin was a master at establishing dissonance relieved in laughter. Eisenstein's abrupt dialectic montage and singular political viewpoint is paralleled by Chaplin's juxtaposition of heterogeneous elements and a collision of expectations within an Aristotelian narrative flow.

As with Eisenstein, however, the tension between humor and pathos that Chaplin achieves derives from a change of shots. Because long shots allow us to see action from an objective distance where the story unfolds before us in shape and form, the Tramp's getting into trouble is almost always a ballet of form as well as a circumstance of one gag unfolding after another. In *Modern Times* (U.S.A., 1936), for example, just when he finally succeeds in getting a job, the workers go out on strike. He sneaks a ride on the back of an explosives truck to get away from the ensuing riot, but is thrown off, still clutching its red warning flag. Arrested for inciting an insurrection when a group of workers start to follow the red flag, he ends up in jail. Just when we think he's finally going to win, circumstances overwhelm him and he loses again. Throughout his films, just when we are laughing at the situation in long

shot, he gives us a close-up of the hurt and pain accompanying it. The long shot is essentially external and physical; the close-up essentially internal and psychological.

Chaplin also gains humor by use of the unexpected and through tension between illusion and reality. In *The Gold Rush*, for example, Charlie lovingly fixes a New Year's Eve dinner (which is beyond his means) for Georgia, the woman he loves, and several of her friends who have accepted his invitation as a joke. While they are at the saloon celebrating without giving him a thought, he waits for them in vain and dreams a fantasy of being the charming host, entertaining the women with his wonderful "dance of the rolls." The casual cruelty evident in the contrast is the basis for the film's pathos; it is enhanced by the camera's quiet close-ups of Charlie's beaming face in his dream juxtaposed with long shots of the bar room's coarse levity.

As a result of his seamless match of camera and plot, Chaplin was able to touch a deep chord all over the world in those familiar with physical or emotional privation. Even the fantasy shots where Charlie turns into a chicken in the eyes of his starving cabin mate combine pathos and reality. As Truffaut put it: "Chaplin was not the only filmmaker to describe hunger, but he was the only one who knew it and this is what audiences all over the world felt when his two-reelers began appearing in 1914."[50] Chaplin himself commented in his autobiography, "I did not have to read books to know that the theme of life is conflict and pain. Instinctively all my clowning was based on this. My means of contriving comedy was simple. It was the process of getting people into and out of trouble."[51]

In *Modern Times* this contrast between feeling and insensitivity, humanity and indifference is extended into the modern plight of the individual subsumed within a vast, mechanized industrial complex. As the opening title announces: "*Modern Times* is the story of industry, of individual enterprise—humanity crusading in the pursuit of happiness." The film tells the story of a factory worker who has a nervous breakdown because of the inhumanely repetitive work on an assembly line. In one unforgettable scene, Charlie is sucked up by the machinery itself and threaded through its gears—a visual metaphor for what the great realist film critic and theorist André Bazin called "the only cinematographic fable equal to the dimension of the human distress of the twentieth century facing social and industrial mechanization."[52] By this time, the figure of the Tramp had truly become archetypal, an image understood and loved by global audiences.

Although Chaplin always denied that his films were political, and his general audiences understood his humanism, like the Russian film-

makers discussed earlier, he was also nevertheless attacked politically from all sides, particularly for *Modern Times*: In the United States, critics accused him of "leftist" tendencies, and Germany and Italy banned the film for its communist sympathies. In the Soviet Union, however, he was denounced for parodying the high production goals associated with "stakhanovism,"[53] a Stalinist policy that urged workers to surpass quotas in order to upgrade the country's factory output. It was natural that because Chaplin's films touched the heart, they would also touch the mind, and Chaplin ultimately was caught in the anticommunist paranoia of post–World War II as well. When in 1952, on a trip to London to attend the premiere of *Limelight* (U.S.A. 1952), he was refused reentry into the United States by the U.S. Attorney General unless he submitted to a politically motivated investigation involving his moral character. Whether he intended it or not, Chaplin created a tension in his films that was resolved in his viewers' own perceptual predispositions.

Sound and Mental Imagery

In the sound film, narrative soon became driven by dialogue, and in the transition from silence to the "talkies," a dichotomy appeared between visual action grounded in experience and abstract ideas expressed as speech. As a result, what was once understandable globally became intelligible only to those who understood the language, and the archetypal images of Chaplin's silent films were replaced by social comedies nuanced by conventional language. From the global experiential and emotional experience of a Chaplin film, the movies moved into a local cognitive and sophisticated realm of social repartee and dialogue. The movement paralleled the evolution of iconic pictographs to verbal language.

Chaplin's art was ultimately the art of pantomime, and although he continued to make silent films in the midst of "the talkies," he was uncomfortable with the new medium, which increasing revealed the essence of character through words rather than through visual movement and archetypal gesture. Yet his two transition films of the 1930s do show sound in a different mode, as a complement to the unspoken word. In *Modern Times*, in which he wrote the musical score and the filmscript, for example, he limited sound to music (which had always been expected to accompany silent film), to special sound effects (which often in silent film had been produced by various musical instruments or handy rudimentary special effects devices), to the voice of the "Big Brother" type loudspeaker, and a nonsensical multilanguage tune he sings as a waiter. This is significant, because the first two had always been a part of silent film— even the smallest theater had a piano accompaniment to the screen

action, and large film palaces elaborate orchestras—but spoken language as such was now a tyrannical tool or gibberish.

In the pictograph, Eisenstein saw the essence of visual language as experiential meaning. It was the basic principle for his montage theory, and he knew that sound meant the subversion of montage, subordinating dialectic mise-en-scène and editing to narrative continuity and Aristotelian plot line. Chaplin, too, recognized that the addition of verbal language meant that comedy would shift from the sight gag to the kind of witty dialogue represented by Mae West. In films of both geniuses, sound was subordinate to the visual: Eisenstein envisioned sound as useful only as a counterpoint to the action and therefore as something that could be exploited to create further tension; Chaplin saw it as a complement to the image that could be used like punctuation but not as content. It is, for example, no mistake that in *Modern Times* the only coherent sounds as language come from the Tramp's nemesis, the factory owner who watches even the factory lavatories to be sure no one is malingering there.

With sound came narrative continuity driven by dialogue, and the art of mime revealed in the long take and the politics of the dynamically persuasive rhetoric of dialectical montage were subsumed by studio mass production systems. As films went indoors to accommodate sound stages, once again the camera became static, and in the hands of lesser directors, the theater tradition of dialogue at first threatened to turn film again into a medium for recording rather than for intrinsically creating drama.

On the positive side, however, sound could not only be artistically controlled and duplicated across all film showings, but it could be used to enhance the action without deliberately calling attention to itself. In silent film, for example, the medium often obtrusively strained to simulate sound visually by showing the mechanism from which it originated, as in the close-up of a factory whistle blowing to show the noon break or the end of the work day, or a rooster crowing, followed by a shot of the sun on the dawn horizon.

Ironically, too, however, the advent of sound also finally allowed for the dramatic use of silence—something that before had not been possible. In the film masterpiece *All Quiet on the Western Front* (U.S.A., 1930), for example, the director Lewis Milestone intentionally left the concluding scene in which the dead look back toward earth totally quiet. Although this was changed against his wishes in its final release form, the film has now been restored with his original intention in mind.

Because suddenly sound had not only to synchronize with visual image but also to match mental image, film stars were also sometimes

adversely affected by the advent of sound, and a number of silent film stars did not make the transition into "talkies" because their real voices were at odds with their screen images. John Gilbert's voice, for example, was greeted with audience giggles in his first sound film and his career was effectively ended—despite the fact that he had a perfectly respectable voice by everyday standards. Although it has been suggested that poor technology—even a plot by Louis B. Mayer—was responsible for his poor vocal quality on film, it was ultimately the power of the mental image in the audience that prematurely terminated his film career.[54] Garbo, on the other hand, successfully made the transition because her low sultry voice added an even deeper dimension to her screen persona.

Even when real speaking voices were perfectly serviceable for the "talkies," singing voices were often dubbed to fit the image. In *Singin' in the Rain* (U.S.A., 1952), which is set in this era and parodies the dilemma of the voice too déclassé for sound, for example, Jean Hagen plays the silent star whose real voice is hopeless for sound, and Debbie Reynolds the actress whose acceptable voice is dubbed in for her. In reality, Jean Hagen had a fine voice, which she altered for the role; Debbie Reynolds, however, had a singing voice that the studio thought unacceptable. In the film's climax where Jean Hagen's "true voice" is revealed as the curtain is lifted, she is mouthing a song live onstage while Debbie Reynolds sings behind the curtain. The studio decided to substitute Reynolds's singing voice at this point—ironically with Hagen's real voice. Hagen thus dubs for Reynolds dubbing for her.[55]

Beginning with the precedent of sound's first feature film *The Jazz Singer* in 1929, songs were often included in film dramas and these were usually dubbed by real singers. In the Jane Froman story *With a Song in My Heart* (U.S.A., 1952), for example, Susan Hayward plays Jane Froman, while the real Jane Froman dubs the singing for her. To match the singing voice to screen image, the studio sometimes found unusual substitutes. When Lauren Bacall was called on to sing a song in *To Have and Have Not* (U.S.A., 1944), for example, the studio had difficulty finding a female voice low enough to be convincing—eventually, however, they found one in Andy Williams.[56]

Although sound film ultimately became dominated by verbal continuity in the great studio era of the 1930s and 1940s, those who understood the power of sound to create mental imagery kept it subservient to the image and used it to complement the visual. Orson Welles not only stretched the visual conventions of the Hollywood style of narrative as far as they could go in camera movement, angle, and editing, for example, but he also brought to film his radio expertise, creating mental

imagery to compensate for the lack of elaborate sets. For the mau-
soleumlike castle "Xanadu" of *Citizen Kane*, for example, Welles faded
minimal sets into darkness at the edges and used voice echoes. When
Kane the politician is speaking to an audience in a large hall, we hear the
size of the crowd rather than see it. Sound was also used to startle, too,
as for example, when "News on the March" blasts onto the screen, and
an added dimension of realism was achieved through overlapping
voices. Because of radio, Welles also knew how to use silence, too, partic-
ularly as pleasant posthoneymoon banter degenerates into the unspoken
in the montage breakfast sequence, and when he gradually fades the
busy background sounds of the political rally and press room into the
empty surround of Xanadu. Much of Welles's landmark versatility in
making the film may, in fact, be attributed to his trying to make the
visual experience as elastic as the audio one that first earned him his
fame.

In the practical arena, Peter Wollen suggests that the full impact of
sound was all-pervasive and initiated a basic aesthetic paradigm shift
that resounded through the medium and the industry as a whole. He
includes in its effects the elimination of orchestras from theaters; the rise
of bank influence in the industry due to the enormous sound conversion
costs; and the replacement of carbon lights that hummed with tungsten
lights that didn't, but that also, because they were at the red end of the
light spectrum, in turn necessitated the change from orthochromatic
film, which was blind to red, to panchromatic stock. This, in its turn
brought changes in make-up.[57]

In addition, while silent films could be shot on location, the needs
of the sound stage brought film indoors to the studio, and the whole
business of scriptwriting was transformed. Because sound had to be syn-
chronized, the hand-cranked camera became instantly obsolete and
every aspect of production became as automated as possible. Only later,
with the use of magnetic tape, which transformed dubbing and mixing,
was a greater portability initiated, bringing cameras outdoors again, and
providing impetus for the cinéma vérité movement with its stress on
realism.[58]

In 1971, Dolby sound was introduced into feature film in *A
Clockwork Orange* (G.B., 1971) although not as a part of the optical track,
and in 1983, Lucas film THX acoustically tuned surround sound (which
depends on a separate system external to the film for its effect) was intro-
duced in *Return of the Jedi* (U.S.A., 1983). With these innovations, sound
became a major part of the viewing experience because both Dolby and
THX significantly reduced the noise that completed the visual experi-
ence. The first feature film to exploit digital sound was Disney Studio's

Dick Tracy (U.S.A., 1990), which required special outfitting of theaters with a playback system with six-track optical stereo, as well as the development of a special 70 mm film stock to accommodate the optical sound track. Just as with the digital photograph, digital technology not only allows for the exact reproduction of sound, but also for its easy manipulation—serving to clarify and direct audio as an integral part of visual experience.

Digital audio systems have therefore also created successive film revolutions, making possible the reconfiguration of digitally altered sounds such as special effects, and of audio tracking by listeners of natural and action sounds—like a bullet being fired within a defined space—heard as it literally travels across the screen. Just as early Hollywood film attempts at recording sound during filming gave way to the "Foley Stage"—a totally silent environment where sounds can be dubbed in later in perfect synchronization with the picture, today, dozens of tracks are mixed together for the final sound track and digital audio systems make possible ultrarealistic sound effects never before technically realizable. Much of the effect of VR environments, for example, derives from sound as well as sight to complete the illusion. Even the pioneering film ride "Back to the Future" utilizes eleven sound channels to support the total experience.

As THX moves into television, and TV sets are transformed into "home entertainment centers," however, its effects become increasingly disconcerting, primarily because picture definition is still low—particularly in contrast to analog film, which by its nature has extraordinary clarity, depth, and luminosity. The experience of watching a relatively low-definition picture with high-definition sound is inevitably disappointing, unless the contrast between sounds and picture is deliberately exploited. In the television show "The Simpsons," for example, sound effects to accompany the action are prerecorded from real life with technically exacting equipment, digitally cleaned and programmed onto a guitarlike instrument, and then "played" to accompany the visuals. Much of the humor from the program relies on the contrast between the animation and the enhancement of realistic sounds, with animated action becoming funnier the more realistic the sound gets.

Hollywood Style and Linear Narrative

The traditional Hollywood film done in what has come to be known as "Hollywood style" came into its own when sound first appeared; and in the period between 1930 and 1950, Hollywood led the world in defining the form and dramatic formula for popular film. Although other film influences developed out of the two extremes of

documentary realism and formalism that were initiated by Lumière and Méliès, none of the various smaller movements, particularly those outside the United States, ever achieved the impact of the Hollywood film. Flaherty's *Man of Aran*, for example, is traceable back to Lumière; Vertov's *Kino-Eye* to Méliès. The cinéma vérité movement, on the one hand, grew from the ideal of the camera as a revealer of truth as it occurred in real life; German expressionism and experimental film, on the other hand, expressed fantastical internal states as external sets.

By the 1930s, however, as film developed into a glamorous and powerful industry, the big Hollywood studios were in place. Assembled to fulfill the function of a "dream machine," they were in a perfect position to dominate the concept of film entertainment. Working full time in almost assembly-line fashion, the studios produced films within then fairly well established formulas and sent them out to the rest of the world. Already audiences had developed a number of expectations about various film genres, and directors and producers had learned how to short-cut tedious talk and trivial actions by relying on audience knowledge of film conventions as well as literary traditions. Like preordained gestalts, genres were filled with familiar characters and situations, and audiences seemed to know instinctively what the shape of the whole and the formulas implied. Such cinematic conventions as white and black hats in westerns distinguished good guys from bad guys, and sharing a cigarette cued the audience mentally to fill in the torrid love scene that the camera had omitted.

The style of Hollywood cinema, drawn from techniques used by D. W. Griffith, also at this time generally conformed to Aristotelian plot structure in its narrative techniques: the story had a definite beginning, middle, and end; each scene developed from the previous one; and action was generated from character. As Münsterberg first suggested, the camera naturally seemed to anticipate perceptual process as a kind of roving eye that scanned and ultimately fixated attention on significant aspects of the scene. As the camera moved from establishing shot to medium shot to close-up, events on the screen seemed to unfold in an orderly progression. In Hollywood style, the storyline takes first priority.

In the traditional Aristotelian plot narrative, this means that action moves from a state of equilibrium into rising action by the intervention of an inciting incident, which establishes a conflict. This conflict becomes more and more intense until it reaches the point where it must be resolved one way or another at a point of climax. Then the consequences of this are shown, the loose ends are wrapped up, and a new balance is achieved. Events from the beginning cause those in the middle, and those in the middle cause those in the end. Because the action ultimately

stems from the nature of the characters themselves, by vicariously identifying with the roles of the stars on the screen, we also come to realize various truths about the nature of humanity or the course of existence.

Although real life is chaotic—we are continually bombarded with stimuli demanding our attention, and incidents seldom have true beginnings, middles, and ends—life in classical Hollywood film seems coherent and logical within its given context. We suspend our disbelief for approximately ninety minutes, and we emerge wiser because, as we identify with the protagonist, our own problems and emotions find a cathartic outlet. One of the functions of art as it is classically defined is to help us to see the deeper meaning and larger pattern of events within our own lives.

In classical Hollywood cinema, the camera aids us in this. The editing is seamless and the camera acts like a pointing finger to guide us through events by directing our attention to what is important. Narrative is always developed linearly in a clear cause and effect line, and character becomes the cause of events, moving the action forward as a result of internal motivation and turmoil. Anticipating the way we observe life around us, the camera moves in as we come to understand the context for the action and become interested in the characters themselves. As the action moves forward, we reflect on it and the themes it reveals; the "invisible" editing of the Hollywood style moves us seamlessly from outside appearances to inward revelations.

In John Ford's classic Hollywood film *Grapes of Wrath* (U.S.A., 1940), based on Steinbeck's novel, for example, we are introduced to the Joad family which, because of drought and foreclosure by the banks, is dispossessed of its land. The family's subsequent journey to California and the brutal economic exploitation which it finds there not only mirrored the experience of many Oklahoma farmers in the 1930s "dust bowl" migration, but also spurred an awareness of social injustice with which many more people could and did identify. Some historians believe, in fact, that were it not for the onset of World War II—so powerful was the narrative impact and so dire was the widespread human plight that it revealed— the novel and the film might together have precipitated a massive social upheaval and perhaps even political revolution.

The script, the camera, and editing of the film conspire in creating this impact. In the first six minutes of Ford's film, we move inexorably forward and inward, from the extreme long shot which establishes the dust bowl environment, to a long shot of the cafe where an unseen truck driver and waitress exchange repartees, to a medium shot of Tom Joad convincing the truck driver to give him a lift, to a medium close-up two shot of their conversation inside the truck cab, to a close-up of each of

them in turn, ending with Tom Joad's revelation that he is a murderer and ex-convict. The procedure is then repeated with Joad meeting the preacher "Reverend" Casey, who introduces the theme of loss of spirit, both in himself and in the people who have been forced off the land they have worked for generations.

In this Hollywood classic, the first six minutes introduce the central character, his inner conflict and the themes which will be developed throughout the rest of the film. The editing always moves shots in the same direction and the camera always anticipates the next level of interest. There are an average of approximately three cuts per minute, but the length of time varies between shots according to the amount of significant information introduced visually and the amount of time necessary to reflect on the meaning of the words, actions, and visual figures and contextual fields. Everything in this film leads us into a particular thought pattern, focusing on visual and verbal cause and effect, suggesting comparisons and contrasts, building metaphors, and allowing time for the absorption of emotions and ideas.

The classical Hollywood style film that comes to its full fruition in *Grapes of Wrath* demands sustained attention, intellectual reflection, and emotional empathy. Its themes related to personal and social conflict represent microcosmic and macrocosmic tensions that can be resolved only in complexly nuanced ways, and the adult who understands the social and psychological causes and effects embedded within the film comes away with a deep appreciation of the both the dark side of the American Dream and a transcendent faith in human dignity. Filled with cultural and archetypal symbols, the film—like the novel on which it is based— speaks to profound levels of awareness in the human odyssey.

Only in moments of deliberate reflection can we begin to comprehend life's meaning. Because film is an art dependent on artistic manipulation at every turn, it too requires the same kind of deliberate reflection in order to recognize the meaning of its messages and the impact they have on us. The best Hollywood films like *Grapes of Wrath* give us an opportunity for both; content and editing are deliberately constructed to direct our attention and timed to give us opportunity to absorb significant mise-en-scène information. Thematic unity provides food for thought long after we have left the theater. When film is perfectly in "sync" with our thoughts, it can be a profound mass influence—as history has shown us in films like Eisenstein's *October* and *Potemkin*, Riefenstahl's *Triumph of the Will* and *Olympiad*.

In contrast to Eisenstein's films with their exciting rhetoric, jolting us first into an emotional and then a cognitive mindset based on Marxist thought, the Hollywood film worked in the reverse fashion, moving us

emotionally through what we understood, remaining linear and fluid—
never calling attention to camera work or editing, always guiding
thought gently and apparently seamlessly toward a conclusion with no
loose ends and perfect unto itself. Whether the film reflected foolishness
or wisdom, it was complete, predictable, and compellingly larger, more
ideal, and more easily understood than real life. The structured gestalt of
the classical Hollywood film was the world into which Salinger's
Holden Caulfield wanted to escape: structured from daydreams, it was
whole, innocent, something to be counted on.

Color Comes to Black and White

The first films, of course, were in black and white, and although
rudimentary forms of color film appeared as early as 1906 in Great
Britain in the work of George Albert Smith, and the first U.S. Technicolor
film appeared with a synchronized sound track in 1928, geniuses like
Chaplin recognized that the black-and-white world of film was a special
one which not only seemed to more fully involve the imagination, but
which also emphasized shape and form in a way which was amenable to
comedy and to serious drama alike. To film *Grapes of Wrath* in color, for
example, is to immediately detract from its internal themes, its character
revelation, and the symbolic gradations of its conflicts.

Just as in still photography, where black and white has an elegance
and nuance that emphasizes internal states, the addition of color to film
tends to emphasize the sensual surfaces of setting, costume and emotion.
Because Technicolor had become a practical option for film makers by
the end of the 1930s,[59] and colored television was popular by the end of
the 1950s, today's audiences are likely to feel somewhat sensually
deprived when confronted with a black-and-white film, however; and
when media mogul Ted Turner acquired MGM's films and used digital
technology to "colorize" black-and-white films, for example, many audi-
ence members who had grown up on color media (and had therefore
never learned how to read a black-and-white film) were pleased.

Yet others, often referred to as "film purists," were outraged by the
"tampering." To them, the colorizing process created a hybrid horror, not
simply because of the color change itself, but because the directorial
masters of the black-and-white medium were artists who worked within
the medium, utilizing its characteristics of pure contrast and emphasis
on depth and rhythm to advantage. Even comedy—such as that repre-
sented by Chaplin's costume—and musicals planned in black and white
took on significance and elegance of form through the absence of distrac-
tion from color. One of the most beautiful (and longest) dance sequences
ever filmed, for example, is "The Continental" musical number by Fred

Astaire and Ginger Rogers in *The Gay Divorcee* (U.S.A., 1934). In the scene, costumed entirely in black-and-white variations of tuxedos and gowns, backed up by choruses of similarly clad dancers, Rogers and Astaire weave in and out of center stage with a fluidity never matched again. The camera work is seamless, and the effect of movement and rhythm is enhanced by the dramatic use of the true black and white—something possible in film, but not on television. On the "silver" screen, which was truly luminescent, the contrast and vibrancy of true black and white created an effect impossible to achieve through color.

Although many directors undoubtedly have settled for black and white over the years when they would have preferred color, particularly if what they wanted to achieve was visual spectacle or sweeping costume drama, many others—like director Woody Allen—have deliberately chosen black and white in an era of Technicolor because of the nature of their material, the mood they have wanted to create, or merely the stability of the medium.

Film noir ("black cinema"), a film style characteristic of detective and mystery films of the 1940s, for example, used chiaroscuro lighting effectively to create an overall effect of loneliness, alienation, and pessimism in character struggles against half-seen, oppressive forces. In these dark black-and-white melodramas—like John Huston's *The Maltese Falcon* (U.S.A., 1941) and Billy Wilder's *Double Indemnity* (U.S.A., 1944), whose themes revolved around greed, lust, violence, and fear, and whose action took place primarily at night or in dim alleyways, cheap offices, and hotel rooms—low-key lighting heightens suspense and mystery, while high contrast creates sinister, elongated shadows. Severe camera angles are also used for emotional effect: low camera angles give figures a looming and menacing quality, tilted or "Dutch" angles multiply the effect of strangeness and discomfort.

Although color was readily available if expensive, many film noir makers chose black and white because of its ability to reflect moral ambiguity, to create dramatic tension, to reveal the dark side of human existence, to emphasize shape and form, and to focus on the psychology of characters. In some instances, of course, directors were forced to use black-and-white film by their studios because of the expense implicit in Technicolor film, but the most effective directors used the advantages of black and white to achieve dramatic impact. This impact is to a great extent lost to the modern audience, not only because many of the films that were deliberately created in black and white have been "bastardized" by colorization, but also because the only place to see many of these films is on television, where only a limited range of grays, and no true black or white, is available.

In contrast, musical comedies and romances use high-key lighting to leave only the fewest and most insignificant shadows, filling in space with light and emotional optimism. Front lighting and soft focus fill in facial lines and beautify, while special filters, soft lights, with warm colors romanticize scenes. Where black-and-white film tends to emphasize psychology, shape, and form, full color and high-key lighting—particularly the vividness of Technicolor as opposed to inferior color processing—create a feeling of lightness and sensuality. Just as black and white was the ideal medium for the film noir concept, so too, the best full color films integrate color with plot and theme. *The Wizard of Oz* (U.S.A., 1939), for example, uses the bleak middle grays of the Kansas landscape to contrast effectively with the comic full-color high-key lighting of Oz. Through color *Gone with the Wind* (U.S.A., 1939) captures the romantic and sensual antebellum luxuriance of the South so beautifully that when it fades after the war, its disappearance has a double impact. James Ivory's *A Room with a View* (Great Britain, 1985) uses the transcendental sensuality of Nature as a metaphoric comment on the stifling inhibitions of the Edwardian social landscape.

The effect of lighting and color style can be seen even more directly in the differences in the treatment of comic book figures and adventures between Tim Burton's *Batman* (U.S.A., 1989), briefly mentioned earlier, and Richard Donner's *Superman* (U.S.A., 1978). The former is dark, grimy, and pessimistic, the latter is romantic and nostalgic. *Batman* uses camera and lighting effects similar to those of film noir to capture the corrupt and degraded side of modern urban existence, and although it is shot in color, it uses only the most subdued tones or high contrast shock values. It barely seems to suggest color at all because of the domination of black and shadow and low-key lighting. Extreme high-angle shots looking down on the city give the impression of people with the significance of ants, and this combined with the colorless sets are reminiscent of the drab physical and psychological landscapes seen in film noir. The film *Superman*, however, is characterized by high-key lighting and low-angle shots that build stature. All scenes and costumes are dominated by red, white, blue, and gold, meshing color effects perfectly with theme and action.

Nowhere, perhaps, is the strategic use of color seen more clearly than in two examples: In *Spellbound* (U.S.A., 1945), where Alfred Hitchcock includes only two frames in Technicolor—at the end of the film in a close-up shot of a gun firing to startle us with the reality; and in *Lust for Life* (U.S.A., 1956), in a dissolve-in shot from one of van Gogh's paintings, in which Vincent Minnelli ordered an entire cornfield dyed a deeper golden color to reflect the artist's psychological reality.

2-D to 3-D

Movement also plays a major role in film viewing by turning a flat screen into a window onto a world with depth. Rather than watching "moving pictures" on a flat screen, in a manner similar to viewing paintings in a gallery or watching an essentially static slide presentation, what we see when we go to the movies is a continuous flow of movement in life. Characters and things on the screen seem to have depth because as soon as people or objects on a 2-dimensional surface begin to move in space, and therefore reveal different angles, the effect of a third dimension is created. Termed the "kinetic depth effect," the phenomenon prompts us to what Coleridge called a "willingly suspension of disbelief," and allows us to enter into a world of action. We view this world, as it were, through a two dimensional window. Motion parallax (the sense of far things moving past us slowly and near things moving swiftly) is invoked as the camera eye moves in and around the movie scene.

From time to time, particularly in response to television's encroachment on film audience in the 1950s, film producers have developed a variety of B-grade movie special effects to enhance this effect. William Castle's gimmicky "Emergo," for example, used a prop skeleton in *House on Haunted Hill* (U.S.A., 1958) rolled down a wire above the heads of the audience. "Percepto" in *The Tingler* (U.S.A., 1959), used a low-voltage electric shock in certain seats to jolt unwary theater-goers into screaming at a certain point in the story. Even odors made their film debut, with "Smell-O-Vision" in *A Scent of Mystery* (U.S.A., 1960), which pumped scents like pipe tobacco, garlic, and wood shavings to each theater seat on cue from the film's smell-track. "Odorama" in *Polyester* (U.S.A., 1982) supplied "scratch and sniff" scent cards with a variety of repulsive odors, including skunk, to viewers who were cued when to scratch and sniff by numbers flashed on the screen.

Ultimately, however, none of these gimmicks could compare to the development of films made to be viewed as 3-D *experience*, which rely on binocular disparity to create a sense of actually being in the scene itself. Human beings, who have binocular vision (two chambered eyes separated by a distance of about 2.5 inches) receive two slightly different retinal images, which when fused by the brain, create a sense of depth.

Based on the same principle as the stereoscope, which shows two pictures of slightly differing views—one as would be seen by the right eye, and the second as would be seen by the left eye, 3-D movies are filmed with twin lenses and projected, in perfect synchronicity, onto a screen as overlapping images. Polarized glasses then filter the light so

that the light from the projector with the right-eye view is not perceived by the left and vice-versa. The truly 3-D movie, however, would be autostereoscopic (without the need for 3-D glasses) and would utilize all depth cues, not simply binocular disparity to create a 360° walk-around environment, with a 360° parallax. The traditional 3-D movie never really achieves the sense of the observer moving about in the ambient optic array, however, because the recorded scene, in which only the *camera* utilizes motion parallax, remains constant.

More recently, various entertainment industries have utilized development in 3-D technologies to simulate a sense of real experience, however, both with an apparatus and without one. The IMax Corporation, for example, utilizes 3-D glasses with increased lens size and high-efficiency polarizing filters to view "IMax 3D®" within an unrestricted peripheral view environment with a five story IMax® screen, and cordless electronic liquid crystal glasses to view a wide-field dome screen in "IMax Solido®." Both extend the traditional technology of the 1950s 3-D film into a wide-angle, ultrahigh resolution multisurround experience. (IMax film is three times larger than normal 70 mm film and fed horizontally through a "rolling loop" projector, while traditional films are shot in 35 mm film and projected vertically at 24 frames per second.) Shooting at higher speeds in a larger frame generates crisper, clearer images and higher resolution.[60]

A variety of corporations and experimental laboratories throughout the world have also been working for years to develop autostereoscopic television, with standard display screens viewed without polarized glasses. Vision III (U.S.A.), for example, aired the first live-action 35 mm 3-D television commercial for McDonald's "Double Zestaburger," in five U.S. markets for the first time in August, 1992. The SCA™ autostereoscopic camera used parallax scanning to inexpensively produce a sense of added dimension by artificially creating motion parallax in images on a single strip of 33 mm film. With the utilization of standard focal length and zoom film lenses, the resulting effect, while not exactly 3-D, did succeed in producing the effect of a window view, with objects existing beyond it in natural space. In 1990 in Japan, Nagoya University College of Medical Technology experimented with spatial modulation to develop distance-reproducing type 3-D TV, and by 1992 had developed an electrooptical display utilizing spatial light modulators for medical use.

As of this writing, a wide variety of 3-D tools have been developed, especially for the medical field, which have proven invaluable in extending human vision beyond its inherent limits in medical practice, in training surgeons through the use of simulated biomedical problems

and in preplanning and guiding them through actual surgical operations. In 1993, Boston University, for example, pioneered the use of "3DScope," which uses two cameras at the end of a surgeon's probe to send back a color picture to a TV monitor. In the procedure, surgeons wear special 3-D glasses that convert the image into a depth experience through binocular disparity.

The result is a minimization of invasiveness in surgical procedures, with smaller incisions and easier spatial maneuverability for the surgeon, and shorter hospitalization periods and improved recuperation time for patients. In microsurgery, robot "slaves," developed by laboratories such as the Biorobotic Laboratory at McGill University in Canada, allow surgeons to use virtual surgical tools to perform delicate operations on the cornea, brain, hand, and foot. By interfacing with the patient through a computer, viewing can be enhanced through a 3-D optical display system, motion can be scaled, and hand tremor can be eliminated. In 1992, the Human Interface Technology Lab of the University of Washington in Seattle developed a technique to scan 3-D images directly onto the human retina, eliminating the awkwardness of head mounted displays in VR altogether, while at the same time increasing performance capabilities.

SFX

Within this context, one can begin to see fairly clearly how visual capability and the legacy of both Lumière and Méliès has set the pattern for both science and entertainment today. Although the earliest special effects (SFX) such as disappearances were achieved simply by stopping and recranking the camera, as in the dummy substituted for the man thrown from the train in Edwin S. Porter's "The Great Train Robbery" (U.S.A., 1903) or Eisenstein's stone lions succeeding each other in *The Battleship Potemkin*, it was not long before the magic of Méliès suggested the possibility of stop-action animation to create the illusion of fantasy creatures moving in real time and space.

The most famous of these was *King Kong* (U.S.A., 1933), which broke box office records and still delights audiences—perhaps because of the archetypal appeal of the beauty and beast, or because its thematic treatment of media exploitation still seems fresh. Designed and worked by animation genius Willis O'Brien, the 18-inch armature covered with flexible rubber, cotton, latex, and finally with rabbit pelts became one of the most popular film stars ever, stunning audiences with the life-like scenes done in painstaking detail. Utilizing rear projection, stop-action animation, and a frontal glass screen, the film took over a year to make. Not only did it establish stop-action animation as a major film technique,

but it also elevated monsters and fantastic creatures to star status. As early as 1909, matches and cigarettes had been animated in the film "Princess Nicotine," but Kong was the first creature to take on an almost human personality that had filmgoers rooting for the ape instead of the pilots in the final death scene. It also inspired one of the first virtual reality rides at Universal Studios to immerse people in a real time and space encounter with a giant mechanical Kong.

Other sympathetic and villainous apes followed, including the less memorable but technically more advanced animated *Mighty Joe Young* (U.S.A., 1949), which utilized an aluminum armature with 150 moving parts. *Planet of the Apes* (U.S.A., 1968) introduced the first believable men in monkey suits, utilizing prosthetic devices and breathable foam latex to create the illusion of apes on a social and intellectual par with human beings, and initiating an audience interest which lasted through four film sequels and a television spin-off. Perhaps the most believable "ape" of all, however, was "Digit," an animatronic gorilla in the docudrama *Gorillas in the Mist* (U.S.A., 1988), which befriends research scientist Dian Fossey, played by Sigourney Weaver. The mechanical puppet was the first man in a monkey suit to be anatomically correct, with a fully mechanized head, false eyes, and arm extensions controlled from inside. It took eight months to build and six people to operate, but it was so realistic that it completely fooled audiences.

Thus what Méliès started without any real intention of deception, Hollywood perfected as part of the verisimilitude of the narrative tradition, ultimately integrally weaving illusions so technologically perfect that audiences would think they were seeing reality itself. Like "Digit," many of these realistic illusions are anatomically correct animatronic models, like the humpback whales used in *Star Trek 4* (U.S.A., 1986) and the 50-foot, 7-ton tyrannosaurus rex of *Jurassic Park* (U.S.A., 1993). Currently it is this aspect of film which dominates the entertainment market.

The innovation most responsible for turning seeing into believing, and for propelling the film industry toward fantasy rather than documentary, however, was the introduction of computers that could handle vast amounts of data and allow for computer generation (CG) and digital manipulation of images. *Willow* (U.S.A, 1988) was the first feature film to apply "morphing" to regular film sequences, in which one character is transformed digitally into another. Because computers have the capacity to correlate key points choreographed to "before and after" shots, and to interpolate the coordinates between them, they make possible what no other kind of editing or frame manipulation can. (This "in-betweening" is also part of the process used in age enhancement of photographs with missing children mentioned earlier.)

George Lucas's Industrial Light and Magic ("ILM"), begun in 1979, was one of the first to exploit this capacity in film to produce realistic special effects. In *The Empire Strikes Back* (U.S.A., 1980), for example, the mechanical Giant Imperial Walkers and animallike "Tontons," were done as stop-action animation, yet without the strobing effect that accompanied earlier efforts. This effect, which creates a slight hesitating awkwardness, is just barely perceptible but occurs because when each frame is shot as a still image, the elements aren't in real motion as real actors would be. The addition of computers, ILM found, allowed for the possibility of conferring a truer sense of motion on the fast-moving Tontons by replicating the more natural effect of "motion-blur."

As computers began to replicate the sense of real creatures moving in animated frames, fantastic creatures began to take on a believability they previously lacked. The dragon in *Dragonslayer* (U.S.A., 1981), for example, is fully and fiercely credible through both excellent computer tracked animation and motion blur, and is by far the best part of the Disney film. In *Jurassic Park*, ILM generated a whole stampede sequence that could not be animated because of the complexity of moving twenty-four dinosaurs in synchronization, frame by frame. By creating a single CG character, however, ILM was able to multiply it, stagger the moves to make it appear that each dinosaur was moving in a slightly different way, and scan the images onto the film. Necessitating 250 billion bytes of digital information, *Jurassic Park* made digital technology itself an equal performer.

The Last Action Hero (U.S.A., 1993) like the earlier Woody Allen film *Purple Rose of Cairo* (1985), played with the relationship between film and real life by having characters move into and out of the different realities implied by the rules of each "genre," with the difference that *The Last Action Hero* added a quick scene of Humphrey Bogart, extracted from *Sirocco* (U.S.A., 1951), in which he turns around and seems to look at the contemporary players. In the scene, Bogart is left in the black and white of the earlier film, and the scene is built to include the clip as part of the natural action. It is a delightful touch to an otherwise fairly predictable movie and shows the good taste to keep Bogart in his own domain instead of trying to "update" the verisimilitude. Again, the scene is produced digitally by importing both digitized films, matching them to the previously determined visual points, softening the edges around Bogart with an airbrush tool to blend the transition, and putting the result back onto film. Previously, Woody Allen used time-consuming and difficult traditional photographic methods to place his title character Zelig (*Zelig*, U.S.A., 1983) into a variety of situations with famous figures, including Babe Ruth, Adolf Hitler, Franklin Roosevelt, and Eugene O'Neill, but in

1994, ILM achieved even more realistic and far more extensive effects through the use of CG.

The superiority of CG over traditional film altering techniques can also be seen in the contrast of two films in which the leading man died before the film was completed. In *The Crow*, when Brandon Lee was killed in an accident during shooting, the film was completed by digitally cloning his face onto his film double. In 1952, when the same situation occurred in *My Son John* when Robert Walker died, the film had to be completed by keeping a double in the shadows, using out-takes from previous films, and rolling the film backwards and forwards again in one instance to achieve a longer sequence. Although Walker's death scene just minimally works, editors had to mask complementary areas of frames in two separate films and combine them. The death scene finally shows Walker through a car window, which essentially opens onto another film. Although slight jumps in the scene (which would have been imperceptible in the donor scene shot for Hitchcock's *Strangers on a Train* [U.S.A., 1951]) make viewing slightly uncomfortable, the device works enough to conclude the film because the perceptual principle of good continuation helps it make sense. Digitized images, however, can be cloned and altered at will and edited in seamlessly.

One of the most common uses of digital techniques to provide a convincing reality marries traditional special effects with computer graphics tools to erase or partially alter parts within scenes. One of the simplest effects, for example, is the erasure of wires to hold characters who appear to fly in film. Before digital capabilities, analog erasure would look as crude as it does in photography, and therefore thin piano wires were often used to produce the effect of flying. Early examples can be seen in Edwin S. Porter's short film "The Eagle" (U.S.A., 1907), in which D. W. Griffith as actor battles with an eagle flying with a child in its talons, and Douglas Fairbanks's silent classic *Thief of Baghdad* (U.S.A., 1924), where a carpet is made to "fly" suspended from a crane over the rooftops of Baghdad. In the perennial classic *Wizard of Oz* (U.S.A., 1939), the effect of flying Winged Monkeys was created by moving suspended miniatures across the stage set and also by little men wearing electric motors on their backs to flap their wings. By this time, in order to avoid seeing the wires in the final film, they were made so thin they would often break, injuring actors and even stunt persons.

Because of digitalization, such risk is no longer necessary. Thicker, safer suspension cables can be easily erased from film by simply copying a convincing part of the neighboring background and digitally "pasting" it over the wires on the frame. In *Terminator 2: Judgment Day*, for example, Arnold Schwarzenegger rides a motor cycle suspended by

heavy cables and thus apparently performs daring leaps effortlessly, and an android melts through bars—a feat performed by joining two pieces of film and digitally rippling parts of the frame to show the transition.

Other special effects have also been rendered far less dangerous because of computer capabilities and many otherwise fatal and near-fatal accidents have been avoided. Margaret Hamilton, in playing the wicked witch in Wizard of Oz, for example, was then required to physically drop through the floor by means of an elevator in order to disappear in a fiery puff of smoke. In the process, however, her broom and hat caught fire, burning off the skin of her right hand, her eyebrow, and eyelashes, and searing her upper lip and eyelid. Worse, because the make-up was essentially poisonous, made with copper to give the appearance of green skin, it had to be scrubbed off with alcohol. When she refused to do another stunt involving riding her flying broomstick on her return from the hospital six weeks later, a double was brought in who also landed in the hospital—blown off her broomstick when the pipe beneath her exploded. Director Victor Fleming had ordered the pipe hidden beneath her body in order to allow the costume to flow freely.[61]

Over a half century later, however, Forrest Gump (U.S.A., 1994), showed just how sophisticated and effective digital technology could be in substituting for reality. Although no dangerous stunts were required for the film, ILM succeeded in creating a crowd scene of 100,000 people at the Washington monument from a small representative group; a championship Ping-Pong match by supplying the Ping-Pong ball after the sequence was filmed; and interviews with past Presidents Kennedy, Johnson, and Nixon through exacting choreography, and painstaking digital manipulation and morphing. Even Kennedy's thumb was digitally created and placed over Gump's; mouths of the presidents were altered literally bit by computer bit to match film script dialogue.

Although digitalization has made special effects safer and more realistic, however, not all special effects are feasible in CG, and many are still done according to the same approaches of the 1930s. Disaster films like 1974's Earthquake and The Towering Inferno, for example, depend on miniatures, slow-motion special effects and special pyrotechnics. The Star Wars series (U.S.A., 1977 on) combines miniature models shot in high speed against a blue screen (which is later filled in with film footage), various optical effects, animation, and full-scale mechanical effects.

One of the most unfortunate current examples of full-scale mechanical effects gone awry is the more recent Twilight Zone the Movie (U.S.A., 1983). In the making of the film, Actor Vic Morrow and two children died when a helicopter's blades went haywire, and the helicopter crashed, and decapitated Morrow and drowned the children—

resulting in a full-scale investigation in criminal negligence involving directors Steven Spielberg and John Landis. In the process, many of the dangerous practices in the film industry were laid bare, with the film-makers complaining that the general movie audience was to blame because it had become so jaded that it demanded continually more spectacular special effects in films.

Certainly audience response continues to bear this out. Although Spielberg's *Jurassic Park* taxes narrative credibility with its assumptions about DNA and lax park security, for example, the special effects are extra-ordinarily real and carry the whole movie, which according to industry statistics earned $100 million within nine days of its release, despite its PG-13 rating. *Terminator 2* made $31.8 million in its first weekend in 1991, and *Lethal Weapon 3* earned $33.2 million when it premiered.

In view of this trend, it is not surprising that many envision that the fate of film in the near future will be intertwined with the develop-ment of Virtual Reality as films move closer and closer to re-creating the impossible and involving the spectator as much as possible within the experience from the inside. Thus in addition to visual domes, some spe-cially equipped theaters have introduced movable platforms that mimic the movie rides of theme parks like Universal Studios and Disney World. Disney's *Aladdin* ride, for example, which uses the popular film as a springboard, was the first to combine individual VR headgear and inter-active video technology to involve the participant in the action. Unlike the film, the ride takes the viewer into and through the streets and allows the user to go where he or she wants. Because of computer tech-nology, the visual and physical orientation of the apparatus follows not the camera, but the whim of the person immersed in the "ride."

The Third Phase

Now involving millions of dollars to produce, such experiences bring us back full circle beyond narrative story to the idea of immediate and novel experience that film represented to its first audiences. Instead of continuing the direction of intellectual reflection that a thought-pro-voking narrative might be designed to produce, the trend is toward raw experience itself, for its own sake, without the intervention of any broader meaning or context.

If the art of the film is defined by the manipulation of time and space, the art has thus moved from simple two-dimensional movement that reflected a slice of life and invited us to look on reality in a special way, to total immersion in artificial experience that involves all of the senses but allows time only for feeling and immediate response—with intellectual reflection precluded.

The technological innovations that have made Virtual Reality possible have also, therefore, begun a third evolution in film, into fragmented sensory stimulation. Although it will take further technological development to transform viewing a film into experiencing Virtual Reality, the impact of high-definition images and Dolby and THX sound have nevertheless already initiated a movement away from film as a cognitive/emotional experience and into a purely emotional one with delayed cognitive consequences. Perhaps the most significant aspect of this trend is that the way we perceive visual media ultimately impacts the way we see life. As we move into a faster- and faster-paced world, relief is sought in faster-paced entertainment to block the world out. In the process we move not toward the control and sanity that intelligent reflection provides but toward immediate gratification through sensual stimulation.

Conclusion

Albert Einstein discovered that light consists of particles. He also hypothesized that an atom ready to rearrange itself and thus give off light of a particular frequency can be stimulated to do so by introducing an identical neighbor in its vicinity. By lining up these particles, a steady coherent emission of light that is extraordinarily pure and intense can be produced. Before Einstein's theories, physicists had supposed that light consisted simply of waves—but its behavior puzzled them because it was inconsistent. When the first laser was built in the early 1960s, Einstein's principle was fully realized, and according to Nigel Calder, it "completely reconcile[d] the conflicting views of light, as particles or waves. Put the vibrant particles in step with one another and they make a regular wave."[62]

The power of film, like the power of the laser beam, derives essentially from its double nature. At once the art of mise-en-scène and of montage, its intensity is the result of each image and the mutual influence exerted by adjacent frames on each other. As the reflection of a world found and revealed, film carries in itself all the potential for enlightenment in which the documentary reveled. As a technological invention with the capacity of altering the appearance and experience of that world, it also ultimately represents a potential for the manipulation of that reality, particularly at the most significant point where impressions are first formed in perceptual process, through the emotions. Whether for political or entertainment purposes, for good or ill, film now more than ever attests to Balázs' observation that film is "potentially [the] greatest instrument of mass influence ever devised in the whole course of human history."

Marshall McLuhan observed that when we watch television, we are held at least partially by the interplay of light and shadow on the tube, transfixed much the same way that primitive man was by fire, less aware of program content than of the medium itself with its shifting pixels of light. Always at least partially aware of our situation and environment, we observe the action on the screen and are drawn to its light.

When we go to see a film, however, we have a totally different kind of experience. Unlike television, action in a film doesn't occur as if we were looking into a window and observing what is happening inside. Rather, when we watch a film, we become part of it, enveloped by it, our eyes free to look at various parts of the screen. While our eyes move very little in relation to small screen television and we are always aware of our surroundings, in watching a film we are lifted out of ourselves as we become the camera. In a film we lose a sense of our physical limitations and enter into a world where time, space, and the possibilities of occurrence become very flexible. Years can be covered in minutes, seconds; we can move inside of things, change our viewpoint from near to far instantaneously; mice can talk and dance; bicycles can fly; trees can wait during the day to swallow us up while we are asleep at night. Or we can be awed simply by seeing life recorded as it is played out in everyday circumstances yet transformed by big screen significance.

Film differs from other visual art forms in at least several important ways: it moves, it can manipulate meaning between its images, and it involves a number of people, necessitating different experts for its production and the approval of masses of people to recoup its costs. Like the photograph, film captures a semblance of reality on a flat surface and allows for manipulation of various stylistic elements in reproducing its images; like painting, it allows for the expression of states contrary to reality, and for artistic expressiveness; like sculpture, it captures a third dimension, primarily through movement, lens, and lighting. Unlike the photograph, however, it reflects life more fully by adding the dimension of movement, and unlike most works of art, the typical film is produced by a variety of experts, is subject to marketplace pressures, and is made to be distributed to and seen by mass audiences. Various films, of course, distinguish themselves from others by ignoring one of these attributes while emphasizing another, but all films contain the extraordinary power of altering our perceptions and our image of the world.

As suggested earlier, traditional film, like traditional photography, is analog in nature—which has made it difficult to manipulate its content, but does allow for (probably even insists on) manipulation of attitude. Yet it is also digital in nature, too: because each frame is a discrete element, it may be subtracted or rearranged to form new meanings.

Because of these unique characteristics, primarily of movement and potential stagecraft, from its very inception cinema found itself turning in two opposing directions, and the history of film theory is dotted with critics and theorists who have championed one over the other: artistic manipulation of the medium in favor of a larger vision, or photographic realism of frame and sequence.

Today the divergent film tendencies of reality and imagination introduced by Lumière and Méliès are rapidly converging into the total sensual-surround experience of the virtual reality movie ride—the newest direction in visual entertainment. Accompanying this transformation in form is a significant perceptual paradigm shift that not only signals a change in the way in which we experience film itself, but which also in turn brings about a shift in the way we perceive the world around us. In the summer of 1910, when the great Russian writer Tolstoy lamented that "the film might be one of the mightiest means of spreading knowledge and great ideas, and yet it only serves to litter people's brains,"[63] he not only both accurately summed up the social and aesthetic worth of the Russian cinema at the time, but he also portended its future direction in interactive entertainment as well.

The following "Close-Up" takes a social and psychological perspective on image, focusing on 1986's top grossing film in the U.S.A. and the second top grossing film worldwide. It explores significance of the film in two areas: first, as it reflects the trend away from linear narrative toward a different kind of propagandistic montage composed of perceptual fragmentation through strings of images via the influence of MTV (the Music Television channel). Second, it illustrates not only the perceptual levels on which film images operate, but also the effect that these images ultimately may have in the formation of social images, as Boulding defined them, and as they become manifested in internalized concepts, social behavior, and personal responsibility.

Reader discretion is advised, however: this Close-Up contains sexually explicit material that may shock or offend.

CLOSE-UP
TAILHOOK "TOP GUNS": LIVING UP TO THE IMAGE

Happiness is a warm gun.

—The Beatles

The 1986 film *Top Gun* was a remarkable box office success, grossing over $100 million within six months of its release, surpassed that year in box office receipts worldwide only by the Australian film *Crocodile Dundee*. It's theme song, "Take My Breath Away" won an Academy Award, and the picture was nominated for best editing.

Top Gun is a significant film, however, not only because of its earnings but also because it marks the full penetration of MTV style into film. More than any other single influence, in fact, MTV—begun in the 1980s—bears the primary responsibility in the change from classical Hollywood sequential narrative, use of camera, editing pace, and style to one more closely akin to Eisenstein's montage, that is, to a rapid bombardment of sensual images edited to rhythm of pulsating music. The style is the visual and auditory equivalent of an adrenaline rush. As such, it is perfectly suited for what Daniel Goleman referred to as "emotional hijacking." A study done by doctors at the Whiting Institute a resident mental health facility in Middletown, Connecticut, for example, showed that prolonged periods of MTV viewing resulted in increased hallucination and belligerence, as well as in overt acts of hostility toward the staff, especially female staff. The elimination of MTV, however, reduced the number of aggressive incidents by 37 percent.[64] For this susceptible group, the emotional hijacking was both real and prolonged.

In contrast to MTV, the Hollywood style movie—especially in black and white—looks boring, slow, and plodding. Because the MTV style implies continual sensual titillation, when it is transferred to film—particularly with the addition of Dolby sound or the THX acoustical system—the experience is absorbing and sensually immersive. Where

Grapes of Wrath used seamless cuts on an average of three per minute to draw us into character as a precipitator of the action, for example, *Top Gun* cuts sharply from one image to the next, approximately every two-and-a-half seconds. As a result, instead of being pulled into character, we stay on the surface, which "MTV-style," is glossy, sexy, and slick.

The longest "takes" in the film, in fact, run about four or five seconds, and these occur only when the protagonist's friend is killed and an attempt is made at some reaction shots and exchange of dialogue. Throughout the rest of the film, however, as in Eisenstein's montage, spoken dialogue is constrained by the brevity of the pulsating shots, and most conversation takes the form of quick repartee to synchronize the verbal pace with the images and the rock 'n' roll beat of the soundtrack. ("We always saw the pilots as rock 'n' roll stars of the sky," said *Top Gun* producer Jerry Bruckheimer of the film.[65]) When longer sentences do occur, they "rove over" into the next shots and help to create an artificial sense of continuity between images.

The second major significance of the film derives from its effectiveness as a propaganda vehicle for the U.S. Navy. On its surface, *Top Gun* action plotted on paper looks like just about every flier movie since William Wellman's 1927 academy award winning *Wings*: The *Top Gun* story revolves around a brash young Navy pilot whose "call name" is "Maverick" (played by Tom Cruise), and his inevitable sidekick "Goose," both of whom earn a place in the navy's "Top Gun" school at Miramar Naval Air Station's "Fightertown, U.S.A." through flying ability and daring. The plot follows a traditional route: the protagonist meets a girl and falls for her; his friend is killed while flying; the hero subsequently loses his nerve; finally, he pulls himself together in combat, comes out a hero, and wins back the girl. In the process he also avenges a smear on his family's military name.

What differentiates this film from the usual formula is both its style and its blatant propagandistic intent. The U.S. Navy not only cooperated fully in the making of the film, but also allowed filmmakers to shoot on location and to use actual "Top Gun" instructors to perform dangerous stunt work. Former naval aviator U.S. President George Bush himself gave his blessing to the film. Tom Cruise and Secretary of the Navy John Lehman posed for pictures together. Nancy LaLuntas, navy public affairs person, called the film "an excellent opportunity to tell about the pride and professionalism that goes into becoming a navy fighter pilot."[66] Researcher Jean Zimmerman describes how the navy capitalized on the opportunity and on how the image projected by the film affected the pilots already in the service:

Recruiters set up desks in movie theater lobbies, in order to take advantage of the postfilm euphoria. And the film's influence didn't stop at the theater. *Top Gun* created an image of the naval aviator that reverberated through officers clubs and flight lines. More than a few pilots imagined themselves cut of the same cloth as Maverick, the fighter jock that Tom Cruise portrayed in the movie. But it wasn't exactly that the pilots wanted to be Tom Cruise. What they thought they saw, when they watched *Top Gun*, was Tom Cruise wanting to be them.[67]

Male Image

Ultimately, however, *Top Gun* is not about pride and professionalism, but the navy's own masculine image of itself elevated to the level of myth. In the world of the action pilot, action is ritualized, masculinity is equated with raw sexual power, and men live on the edge in an obsessively competitive male hierarchy.

Like the male myth embedded within the genre of the Western movie, the jet fighter pilot in the navy represents the ultimate gunfighter on the last frontier open to male aggression. In the film this is described as "the lost art of aerial combat." To keep the art alive, we are told, the U.S. Navy's Fighter Weapons School selects the top 1 percent of naval fliers to go through a five-week intensive aerial combat training course, and then assigns points in aerial combat simulations to determine who among the top 1 percent is the very best—the "Top Gun." In the all-male world of jet planes and nuclear missiles, "Maverick" like the cowboy who rides into town alone, is an orphan. With only one friend— "Goose," the traditional devoted "sidekick" basking in his hero's aura— Maverick enters a world devoted to lone combat in which self-contained adversaries meet in aerial showdowns. Like the "Top Gun" of the inevitable western shoot-out, he must prove himself the best by his nerve and his skill at weapons. In the high-tech world of modern aviation, this is sublimated into high-tech potency, erotic flight, and the weapons of war.

The "Top Gun" masculine mystique also requires the denigration of anything female. In the film's *Top Gun* locker room, "Pussy" is the worst possible put-down. One officer's pep talk, "This school is about combat. There is no second place," is responded to by one flier, "The plaque for the alternates is down in the Ladies' Room." As Deborah Tannen has explained,[68] men in general tend to hold an image of the world in which they see themselves as individuals within a hierarchical social order based on power and accomplishment, in which they are

either one-up or one-down. In this view, life is a contest in which individuals must struggle to preserve independence and to avoid failure; conflict is a necessary means by which status is negotiated, primarily through action. Women, however, see the world as a network of connections based on friendship and cooperation, where conversations are used for confirmation, support, and consensus. In this view, life is full of outside forces that threaten the survival of the community and conflict is seen as a threat.

Women, therefore, have no place in the naval pilot mystique—except as they are transformed into men acting as female surrogates in traditional mothering roles or as masculinized women. Maverick's one friend, "Goose" (short for the affectionate "Mother Goose") takes the desexualized role of wife and mother, looking after Maverick emotionally, but never encroaching on his freedom. Although Goose is married with children, even Goose's wife tells Maverick that he loved flying with Maverick even more than being with her. When Goose is killed in aerial combat maneuvers, it seems inevitable—not only because it is traditional Hollywood fare to leave the hero completely bereft before he can ride out of town into the sunset alone on his horse in the "wilderness" motif western, or if he stays, submit to inevitable domestication in the "garden" motif western—but because *Top Gun* is ultimately about hypermasculinity, and all the young men in the film who are allied with women lose their nerve or die. In the first 10-minutes of the film, for example, it becomes clear that Maverick has "the right stuff" for combat, but the pilot who is then the top candidate for Top Gun school, "Cougar," does not. When he faces death, Cougar freezes and loses his nerve because he cannot stop thinking about his wife and the son he has never seen. Back on board the ship he confesses that he's "lost the edge," that he's "holding on too tight." He resigns, a failure.

Maverick, however, who has proven himself a hero by "engaging" the enemy, has earned his rite of passage into "Top Gun" school. In sexual imagery reminiscent of the opening scene in *Dr. Strangelove* (G.B., 1964) where director Stanley Kubrick focuses on one airplane connected to another in the process of refueling, Maverick "engages" a Russian MiG by flying above it in a missionary-position-type maneuver, and gives the other pilot "the finger." If there is a single dominant motif, in fact, it is that war is a high-altitude, high-powered erotic sport engaged in exclusively by an elite all-male society—one that confers ultimate destructive capabilities through communal ritual and the sublimation of the individual to the male group identity. Like the other all-male societies of contact sports, the players wear team helmets and sport sharp, body-hugging uniforms.

Thus, although the film demanded a love interest as part of the traditional formula, in *Top Gun* women are depicted not as people but as strategic objectives. The local bar is a "target-rich environment," where picking up women is considered "target practice." It is, however, not the real thing, which is found only in aerial combat. As J. Hoberman comments in *The Village Voice*, "*Top Gun* doesn't posit sex as aggression, it reformulates aggression as sex."[69] Airfields are covered with planes retailored into sleeker, streamlined phallic symbols, and everywhere technological hardware gleams. Thumbs are always up, and heat-seeking missiles become a sexual turn-on. Just watching an aerial dog fight prompts one Top Gun School candidate to moan to his flight partner that he is becoming sexually aroused—to which his friend replies, "Don't tease me." Later in real air combat, the comment is repeated by another pilot eagerly anticipating enemy aircraft: "They must be getting close," he says, "I'm getting a hard-on."

Even the female lead in the film, a Ph.D. in astrophysics played by Kelly McGillis, is decidedly masculine. Described by Hoberman as "a virtual penis in a wig"[70] she wears a leather jacket and jeans, drives a Porsche too fast, sports the "call name" "Charlie," and is self-confessedly seduced by her desire to hear about Maverick's encounter with a Russian MiG. (Christine "Legs" Fox, Charlie's real-life counterpart at Miramar, was brought into a Paramount meeting by the navy to show them the kind of woman who fitted in with the all-male "Top Gun" environment.[71]) Film scenes are filled with laughable techno-tease banter about negative thrust and G-force, while rock 'n' roll music pounds loudly and rhythmically in the background. In the only personal love scene in the film, Maverick and Charlie speak only of flying, and it is not surprising that the scene was put in only as an afterthought following the preview. The morning after they make love, Maverick leaves a paper airplane on Charlie's pillow. Clearly, sex is flying. This is the primary archetypal image of the film and a main source of its power.

Earlier in the film, fliers are warned at their first briefing, "no engagements below ten thousand feet." This is the "Top Gun" rule, and there are no exceptions. At least part of this sensuality transference from women to gleamingly powerful machines is created visually by superb cinematography directed at the sky, by forward thrusting engines, by the sexually pulsing beat of the music score, and by the fast-paced action. The rest is supplied by images of power which, rather than inviting sensuality, imply an auto-erotic male bonding. On the ground, best friends Maverick and "Goose" lament "You've Lost That Lovin' Feelin'" and Goose pounds out "Great Balls of Fire" on the piano as sounds and images of screaming jets leave balls of red turbothrust in their wake. They kid each other with terms of endearment, calling each other "dear" and "honey."

The "Top Gun" masculine mystique requires both the desire to win to the exclusion of all else and the toughness, pain, and violent aggression that have long characterized both the western movie and its legacy, the arena of professional sports. The Top Gun attitude, in fact, immediately brings Vince Lombardi to mind: "There is no room for second place," Lombardi has said. "There is a second-place game, but it's a game for losers played by losers. It is and always has been an American zeal to be first in anything we do, and to win and to win and to win."[72] (Bobby Knight, basketball coach for Indiana University, put a box of sanitary napkins in the locker of players who didn't perform aggressively enough in the game.[73]) As Rob Edelman points out, "*Top Gun* divides the world into winners and losers. . . . It simplistically translates complex issues and conflicts into us-against-them sporting contests in which the 'enemy' is objectified and depicted as faceless aggressors."[74]

In *Top Gun*, however, the phallic focus is narcissistically sensual. Beautiful young male bodies pose as if in "Mr. Universe" bodybuilding competition, play volleyball like gladiators with their shirts off, and each simulated aerial combat is followed by lingering seminude locker room scenes. Yet in the air, pilots on both sides become robots playing the deadliest of high-tech games, video-game style, sharing a totally male world of autoerotic power. Rivalry between Ice Man and Maverick for "Top Gun" begins immediately in the film, and all that follows unfolds a high-powered competition that reaches its climax in aerial combat.

Women are excluded from participation in this world because they threaten masculine independence and the "frontier" way of life which privileges aggressive violence in favor of domestic cooperation. James Conlon sees in the film a reflection of the "soldier male," described by Freudian psychoanalyst Klaus Theweleit as someone not yet individuated or fully mature. The "soldier male" is both antagonistic toward women and obsessively fascinated by machinery. Caught between wanting to push women away and wanting "to penetrate them, to have them very near," he satisfies both urges in the extreme forms of rape and killing, and to a lesser degree in subjugating and humiliating them. He also seeks to make himself invulnerable through a "man of steel" image in his military physique, in becoming unaffected by emotions, in surrounding himself with armor.[75] Aerial combat unites all these things: independence, aggression, male bonding, and sexual fulfillment—all in one action.

Mythic Levels

Top Gun therefore draws energy not only from the raw sensual beat of its structure, but also from mythic levels which define and celebrate

the male warrior: Maverick is the Slayer of the Red Dragon, the youth of archetypal myth who goes forth bravely to save the community and returns a hero and a man. In the beginning of the film, this heroism is somewhat foolhardy, and outside the traditions of the pilot community, but as he goes through the rites of passage in Top Gun School and becomes initiated, he learns communal responsibility, and purified of self, in the climactic scene slays the dragon (a Russian MiG, although the word "Russian" is never used) and comes back into the community as a hero and teacher.

In terms of social image, the ethos of tradition in the navy defines masculinity in a strictly military way, yet allows the men on the edge more latitude in their behavior than others, presumably because they face primal danger more directly and because the survival of the larger, weaker, and essentially feminine society depends on their hunting prowess. The overlap among the navy myth, the myth of the frontier West and American football are fairly obvious in the film. *Top Gun* combines patriotism, intense individualism, competitive spirit, with the excitement of the hunt. Film scenes are filled with red balls of fire from jet engines, tight white uniforms and blue skies. A predominance of low-angle shots add psychological stature to the ramrod medium-height of Cruise, and the medium-high angle shots for "Charlie," who is always shown reclining, slumping, or leaning.

The single exception to this in the film is when the camera in an extreme low-angle shot records Charlie's legs in stiletto heels and short leather skirt as she walks up the aisle, in effect establishing her *lack* of credibility in the male environment before she tries unsuccessfully to give a lesson to the new recruits. As Erving Goffman points out of women in advertisements, a canting posture is tantamount to "acceptance of subordination, submissiveness and appeasement."[76] Stiletto heels accentuate the curvature of the legs, imply a threat, and make serious work improbable. In the end, she moves out of the environment altogether to Washington, and it is Maverick—who has undergone trial by combat—who takes the role of true teacher.

The film also derives power from other archetypal myths—particularly as seen the myth of Icarus who dares to fly close to the sun, and the myth of Narcissus, who falls in love with his own male reflection and is forever cut off from the possibility of loving a woman. Brannon and David (1976) also define four traditional masculine norms: No Sissy Stuff, to avoid the stigma of anything remotely feminine; The Big Wheel: success, status, and respect; The Sturdy Oak: toughness, self-assurance, and self-reliance; Give 'Em Hell: the aura of aggression, violence, and daring.[77] In the film, each of these is incorporated into the navy pilot

image both through the action and through pictorial images of seminude pilots, planes taking off with enormous thrust and breaking through the sound barrier, gunners locking onto targets and blasting them out of the air again and again.

Most of all, however, the film derives its impact from primal visual and sound images that pound a sexual rhythm throughout. In the opening sequence where Maverick engages a Russian MiG and Cougar freezes, which lasts about eleven and a half minutes, there are approximately 277 cuts. If Kuleshov was correct in his thinking that montage is the key not only to the film's ability to hold attention but also to direct thought, then *Top Gun* must stand as one of the most effectively edited films in history. The film as a whole is in continuous movement, coming to rest in sound and cutting rhythm only after Goose's death, and then alighting only momentarily. Most of the pace of the film continues in variations of from 2 to 3 seconds for each shot, dominated by phallic images, sounds of engines thrusting, and a steady, restless beat. In short, it was indeed a perfect propaganda vehicle for navy recruiting, reflecting, and confirming an image of high-tech eroticism guaranteed to attract young men into the service.

On the other side of the image, however, is the masculine paradigm that sees women as flat, functional objects rather than as full human beings—a world of what Arnheim called "paralyzed constructs."[78]

As Arnheim observes in *Visual Thinking*, concepts, which consist of perceptual patterns, are never differentiated beyond necessity, but are refined beyond maximum generality only when an awareness of a need for further refinement presents itself.[79] This is exemplified by what Mark Gerzon has called "the John Wayne syndrome." In his interviews of Vietnam War veterans for his book *Choice of Heroes*, he found that the image of John Wayne charging up a beachhead and returning with a suntan figured prominently in the fantasies that caused them to embrace the war. "The John Wayne syndrome" he tells us, "is an explicit, if unwritten code of conduct, a set of masculine traits we have been taught to revere since childhood."[80] William Manchester tells this story of wounded Vietnam troops who, having bought the fantasy and then experienced the reality, rejected the false image forever: One evening, he recalls, John Wayne unexpectedly put in a special guest appearance for the men who had been brought down in litters from their hospital beds to see a film in the hospital theater. Suddenly standing before them in cowboy boots and spurs, wearing a 10-gallon hat, bandanna, and chaps, and sporting two pistols, Wayne grinned and said, "Hiya, guys!" Expecting uproarious applause, instead what greeted the hero of *The Green Berets* (U.S.A., 1963) was absolute silence. Then the booing started:

"This man was a symbol of the fake machismo we had come to hate, and we weren't going to listen to him. . . ."[81]

The phenomenon of feeling the pressure to conform to a normative masculine image, called "sex role strain" by Joseph Pleck in *The Myth of Masculinity*, goes a long way in explaining the machismo appeal of the Western film star and the seemingly natural correlation between the cowboy and the fighter pilot. The epitome of the traditional view of "a real man," Maverick is self sufficient, stoic, athletic, sexually indefatigable, and tops in competition. A "soldierly male" in Theweleit's terms, he is both disdainful of women and surrounded by multiple symbols of male armor. It is not a surprise that critic David Denby called the film "the most brazenly eroticized recruiting poster in the history of warfare."[82]

In its imagery, pace and Dolby sound, *Top Gun* swept audiences worldwide up into a truly exciting and sensuous world. By the continuity implied in associative perceptual logic, U.S. Navy pilots who were lionized in the film began to see their own image in a more sensually exciting way—as "maverick flyboys living on the edge by day and partying by night."[83] As one navy pilot commented, "All *Top Gun* did was walk in to the Miramar O[fficers] Club and turn the camera on. . . . That whole mentality there, they just showed it in all its cockiness. It verified it. A lot of guys felt they'd been recognized."[84]

Tailhook

For the navy pilots who got caught up in the narcissistic image represented by Cruise (who in fact is an inch shorter than the mandatory five-feet ten-inch height requirement for naval officers), the nature of their annual gatherings at "Tailhook" conventions (so named for the plane hook that the pilot must lower to grab a deck wire on board aircraft carriers) began to change, until finally behavior became so extreme that a Navy scandal occurred in 1991 as a result of the unacceptable behavior exhibited at the annual meeting.[85] The scandal rocked the navy and forced many in it to review the image that defined its culture.

In its investigation taken over from the Navy when it was sure that it could not, or would not, investigate with the appropriate zeal, the Department of Defense Inspector General reported that

> Many officers told us they believed they could act free of normal constraints because Tailhook was an accepted part of a culture in some ways separate from the main stream of the Armed Forces. . . Some senior officers blamed the younger officers for rowdy behavior and cited a *Top Gun* mentality. They expressed their belief that

many young officers had been influenced by the image of naval officers portrayed in the movie *Top Gun*. The officers told us that the movie fueled misconceptions on the part of junior officers as to what was expected of them and also served to increase the general awareness of naval aviation and glorify naval pilots in the eyes of many young women.[86]

As discussed earlier, Boulding in his theory of "Eiconics" posited that image is the basis of behavior and that the meaning of any message—such as the film *Top Gun*, for example—is the change that it produces in the image. All new information is continuously tested against each person's internalized image of the way things work. Indeed the self is composed of sets of images filtered through feedback from others viewing the same situations. The inner culture of the navy gives the first clues to the image which dominated at Tailhook conventions. As one lieutenant described it to Tailhook investigators,

> Naval aviation, to an extent, shaped a certain attitude, reinforced that attitude. . . . We were always taught to be . . . the first at the O[fficers] Club, the last to leave the O Club, the ones to get the "chicks,". . . the wildest, most adventurous, both in the cockpit and out of it. . . . Naval aviation rewards those that are the wildest, and to an extent, we all conform, and not because we didn't want to. We enjoy that lifestyle, being able to go out and drink and have a good time.[87]

In his book *Fall From Glory: The Men Who Sank the U.S. Navy*, Gregory Vestica traces the Tailhook culture back to the beginnings of the Vietnam War when sailors on leave made port calls at Subic Bay. The Cubi Point Officers Club there had to be continually rebuilt because of the destruction, and Vestica tells the story of the crew on the *Kitty Hawk* sending a check for $3,000 to cover club damages of $1,500, with the message that the other $1,500 was for the next time. Finally, the devastation became so bad that a special cinder-block annex was built, complete with steel mesh-covered lights. In the bars surrounding the Bay, officers relaxed by feeding baby chicks to alligators at "Pauline's" and watching dancing girls perform erotic acts with coins and beer bottles. The teenage girls who worked Marilyn's were called "LBFMs" ("little brown f-ing machines") by Navy personnel.[88]

Squadron skippers would initiate "green" officers by assigning one or two officers to take them around the bay or to one of the other thousands of joints in the surrounding area, where they would find young

prostitutes or engage in drinking or sex games. In the drinking contests, the men had to drink a number of pitchers of beer within a limited time. According to Vestica, although they were allowed to go to the bathroom to urinate, if someone vomited, the whole team lost. This meant that those who needed to vomit did so in the pitcher and then drank it again. The game of "smiles" was also popular among officers. This consisted of a LBFM performing various sexual activities under the table at which the men were grouped. The only navy rule apparently enforced was the PCOD—the "pussy cut-off date"—which meant no intercourse within thirty-one days of returning home, because it took an average of thirty days to treat a case of venereal disease.[89]

By the time the navy left in 1992, Vestica states, there were "at least three generations of street kids who had grown up as male and female prostitutes working the bars around Subic Bay. Not only did the navy approve of the activity, it knowlingly hired prostitutes to work in some of the officers clubs."[90] In 1991, a navy commander included a prostitute as a prize in a navy raffle to raise money for navy police; sign-up sheets for sexual services were provided in all bachelor quarters.[91] Because the top levels of navy command condoned and participated in such occurrences, degenerate behavior was normalized. Not only were naval officers killed while drinking and carousing, but the navy also created a subculture in which debauchery was expected, in which women were seen only as sex toys, and in which lack of positive leadership allowed behavior to degenerate to the lowest possible common denominator.

Group Image

The effects of group psychology have been well explored since the time of Breuer and his acolyte Freud: "When individuals come together in a group," Freud states, "all their individual inhibitions fall away and all the cruel, brutal and destructive instincts, which lie dormant in individuals as relics of a primitive epoch, are stirred up and find free gratification."[92] Actions and passions of group members are mutually enhancing, and emotional release is infectious. Behind the Apollonian consciousness, Nietzsche reminds us, lies a Dionysiac realm: "Throughout the range of ancient civilization . . . we find evidence of Dionysiac celebrations . . . [characterized by] a complete sexual promiscuity overriding every form of established tribal law; all the savages of the mind were unleashed on those occasions."[93] Freud explains:

> In a group the individual is brought under conditions which allow
> him to throw off the repressions of his unconscious instinctual

impulses. . . . We can find no difficulty in understanding the disappearance of conscience or of a sense of responsibility in the circumstances. It has long been our contention that "social anxiety" is the essence of what is called conscience. . . . On the whole, therefore, it is not so remarkable that we should see an individual member of the group doing or approving things which he would have avoided in the normal conditions of life.[94]

Contemporary psychologist Philip Zimbardo also reminds us that such deindividuation is a "complex, hypothesized process in which a series of antecedent social conditions lead to changes in perception of self and others, and thereby to a lowered threshold of normally restrained behavior. Under appropriate conditions what results is the release of behavior in violation of established norms of appropriateness."[95]

After the Vietnam War, a whole generation of navy pilots had entered into the image, but without the combat experience that had been used to justify the debauchery. The advent of the Gulf War gave them the taste of combat experience, but the situation had changed, and the old Subic Bay stories which had become part of the internal myth could not be reenacted in a society where alcohol was prohibited and Muslim women were segregated. What they had instead were two cruise liners with about 100 Philippine women imported for the use of U.S. personnel.[96] As a result, they felt cheated out of the "real" fighter pilot lifestyle. What was most salient about this lifestyle, Zimmerman comments, is that its popularization increased "exponentially" through *Top Gun* and that it proved incredibly attractive to the people just outside it, primarily the aviation community's wanna-bes.[97]

The effect of this was also enhanced by the group mentality fostered by the navy. Although convention behavior was well within the traditions of the navy subculture, and must be partially explained by it, the buffed-up sanitized and simplified image of Tom Cruise drinking hard and womanizing gave the Tailhook pilots a special way of seeing themselves that made the behavior at Subic Bay seem acceptable in the Las Vegas Hilton. Especially since "after *Top Gun*, adulation from the outside matched that within the Navy. There were legions of women—they flocked to the O Clubs every week—who didn't mind one bit being patted on the fanny by a Navy aviator."[98] The problem was that in Las Vegas, at Tailhook '91, most of the female officers *did* mind, but the male officers of the gauntlets, and even top-level commanders, could not see them as anything other than LBFMs. Even the executive director of the Tailhook Association described an incident where a minor was stripped and sexually molested against her will as "more along the line of a prank" than anything serious.[99]

The Pentagon's 300-page report explicitly recognizes the influence of *Top Gun* in such incidents, dating the first gauntlet—where women were accosted as they got off the elevator, groped, and their clothes torn away—to the release of the film. According to the report, incidents dating from the time of the film included high-ranking Naval officers dancing with strippers, entering a banquet on horseback, and using a chainsaw to demolish a wall between two suites. "Perhaps the most common rationale," the report states, "was that such behavior was 'expected' of junior officers and that Tailhook was comprised of 'traditions' built on various lore.[100] Ultimately, the Department of Defense report concluded:

> Tailhook 91 is the culmination of a long-term failure of leadership ... What happened at Tailhook 91 was destined to happen sooner or later in the "can you top this" atmosphere that appeared to increase with each succeeding convention. Senior aviation leadership seemed to ignore the deteriorating standards of behavior and failed to deal with the increasing disorderly, improper and promiscuous behavior.[101]

The level and pervasiveness is apparent in an incident at a Tailhook convention in 1986, the year of *Top Gun*'s release, in which John Lehman, the secretary of the Navy, joined in a striptease performed by a hired hooker, lying beneath her while she performed. "'That's what I call leadership,' said Bob Lawson, a Tailhook official who witnessed the act. 'It's just the wrong kind.'"[102] By Tailhook '91, it was out of control. Sexism was openly expressed by officers wearing T-shirts that stated Women Are Property and He-Man Women-Haters Club and lapel pins stating Not in My Squadron in contempt of women in aviation. Women coming off the elevator on the third floor were forced to pass through a gauntlet where they were sexually assaulted and drinks were thrown at them.

One underage girl was invited into one of the suites where she became intoxicated, and then was thrown out into the corridor where the gauntlet stripped her of her clothing, sexually molested her, and left her for hotel personnel to pick up. Some women were corralled by groups of men, herded into one of the hospitality suites, and forced to drink from a rigged rhinoceros dildo that dispensed Kaluha and cream.[103] The Pentagon report details testimony on twenty-two hospitality suites. The Department of Defense investigation interviewed over ninety people who were molested during the convention. The damage done to the premises between Thursday afternoon and late Saturday night was $23,000.[104]

Because *Top Gun* had been filmed on site at Miramar, and because top naval officers themselves proclaimed the connection between the *Top Gun* image and escalation of Tailhook degenerative behavior, the "Fightertown" hospitality suite of the Miramar Naval Air Station is of particular interest. Here, the entertainment consisted of a disc jockey each evening, a stripper for Friday evening, two strippers for Saturday evening, and pornographic movies shown throughout the weekend. Behavior included group "ball walking," entertaining underage females, strippers performing in the style of Marilyn's at Subic Bay, sado-masochistic and lesbian acts, and open sexual intercourse.[105] The cost of keg beer and margaritas for this suite alone totaled approximately $2,000 for two days.

In brief, what Tailhook '91 events show is the power of image and affect when no "off-switch" is cognitively applied. Investigators noted that several officers who had expressed the attitude that stripping and sexually molesting a minor civilian in the gauntlet was "no big deal," became visibly shaken when they were later shown a photograph of the young woman, nude from the waist down, being escorted through the hallway by security men as naval officers looked on.[106]

Among the immediate consequences that the scandal initiated were the early resignation of one admiral and the investigation of 140 other officers in one or more incidents of sexual assault, indecent exposure, and conduct unbecoming an officer. In the end, however, the navy closed ranks around its men, and the only person who suffered career-wise was the first woman naval officer to report the outrageous conduct. Harassed and stigmatized beyond endurance, Paula Coughlin resigned her commission the following year.

The perceptual significance of *Top Gun* that connects it to the Tailhook scandal lies in the concept of the image. The film not only came to crystallize and glamorize to naval pilots an image that reflected a lifestyle—one that had been loosely tolerated for years before it became rigidified into a certain kind of "masculine" behavior; it also served as a priming agent in an out-of-control situation fostered by disinhibition and deindividuation. As the forces of the group psychology took over, the "Top Gun" image became both the initiator of group behavior and an a dynamical attractor for its turbulence. Like Boulding who believed that the measure of impact is the change induced in the image, McLuhan tells us that the message of "any medium or technology is the change of scale or pace or pattern that it introduces into human affairs."[107]

Although *Top Gun* as a film cannot be held especially responsible for any of the particular occurrences at the Tailhook conventions, it is clear from the testimony of those involved that it was a significant catalyst in

crystallizing and glamorizing a masculine image that was as degrading on one side as it was seemingly heroic on the other. Although it is tempting to assume in relation to the film that because pulsating imagery disappears quickly, it therefore leaves little impression, such an assumption does not take into consideration the impact of continued repetition of patterns on our expectation of the way things are or the way they work, nor does it take seriously the fact of the significant moment in experience which—particularly when preceded by repeated patterns in visual experience—may change the internal structure of the person's world image, altering personal or social perspective. Without the opportunity for or encouragement of cognitive reflection, fleeting sensual images are fleeting only in actual time. In perceptual time, they may not only linger but also determine the course of future thoughts and actions.

III

Controversial Images

6

ADVERTISING IMAGES:
SEDUCTION, SHOCK, AND THE UNWARY

Advertising is the art of arresting the intelligence long enough to get money out of it.

—Stephen Leacock

Ads as Gestalts

For many people, as Jonathan Price put it in his book title of the late 1970s, advertisements are still "the best thing on TV." Advertising has, in fact, become so entertaining and so highly targeted that even in print media, many people read ads as avidly as the editorial content of their magazines. It has also been so successful at what it does, that in discussions of visual literacy, advertising is often the first topic on the agenda. How it achieves this success is a matter of careful perceptual strategizing and structuring. Lighting, colors, camera angles, tone, every detail of every item shown, the placement of elements, every word—each of these is scrutinized, discussed, tested for its impact. In a national ad campaign nothing is left to chance.

The concept of visual intelligence in advertising therefore implies the ability to understand, first, that the industry spends billions of dollars each year not to entertain, or even to inform, but to sell. If an ad doesn't sell the product or the idea, it is not doing its job. Second, it implies that messages are framed in the most subtle and effective way possible to reach the target audience (someone in a position to buy the product or act on the idea), to make them receptive to the message, and ultimately to act on it. Like the poet T. S. Eliot, every art director and copywriter in advertising is searching for the perfect objective correlative—the string of images in illustrations and words that will serve as a metaphor for the product experience.

This is why the perceptual gestalt has significance for advertisers: the way elements are combined to create a total effect or impression is

more important than fact or rational logic: "Most readers," the advertising guru Bill Bernbach has observed, "come away from their reading not with a clear, precise, detailed registration of its contents on their minds, but rather with a vague, misty idea which was formed as much by the pace, the proportions, the music of the writings as by the literal words themselves."[1] The key to an ad's significance, he recognized, lies in the way the relationship creates meaning—in how the form and structure of each element contributes to single, stable message. Impact is achieved by the appropriate synthesis of primary visual and secondary verbal elements mutually reinforcing each other; the perceptual reception of the message is determined by the set of thoughts and emotions that are part of the consumer, and the ability of the advertisement to reach both. Ads that don't achieve an emotional resonance do not succeed.

As Less and others have noted, the history of advertising in the twentieth century has been characterized by the steady movement away from function ("What does the product do?"), with its emphasis on rational copy, to the identification of the consumer and the nature of the social meaning ("What does the product mean in terms of the type of person I am and how I relate to others?").[2] As a result, personal and social image have become the stuff of which advertising is made, and advertising's visual language has come to play an integral role in the way our culture is defined and in how people interact with one another in it.

In both print and television advertising, this means that the advertisement functions as a metaphor. The consumer identifies with the advertising image, and the product within that image becomes intimately linked with the satisfactions inherent in the scenario. Without directly stating a causal relationship between Newport cigarettes and an active young lifestyle, for example, the advertiser uses the associative perceptual logic of the viewer to make the product seem an essential part of visual story, and the product a metaphor for the socially rewarding experience depicted. Linear logic cannot achieve this; rather the success of the ad depends on the formation of a gestalt in which all of the parts become inseparable within the whole. This type of approach, which is often called "image advertising," establishes goods as pictographic symbols linked holistically with positive social experience through perceptual logic.

As Gestalt psychologists first realized, ambiguity is also a powerful ally in drawing us into the image depicted, completing it with our own needs and desires. This is the "amplification of ambiguity" that Scott McCloud described as characteristic of the cartoon image. In advertising, this means that the image is structured specifically enough to attract the

appropriate audience, and ambiguously enough for consumers to read themselves into it. It must also, however, suggest a promise of something better by increasing the number and type of associations that can be generated from the image. The perceptual logic or visual grammar of these associations may work on a number of levels, from personal meaning to social sharing. As meanings become shared through repeated exposure in mass media, individuals can then use product-image associations as vehicles for priming attitudes and behavioral associations in other consumers.

Advertising, then, has both deep personal and broad social implications. Not only does it appear to speak to our personal needs, preferences, and fantasies, but it also becomes a means of social discourse as well, providing a common reference of meaning. As an integral part of social language and therefore of the cultural system, it confirms self-identity and helps to define the normative values of the target-group-as-subculture. As the shared vocabulary of advertisements grows, advertising images may then become vehicles for self-expression, as when people sport clothes with designer labels or logos on the outside, or part of the vocabulary of social or political discourse, as in the famous "Where's the beef?" fast-food slogan cum presidential campaign slogan. As John Berger has emphasized in *Ways of Seeing*, advertising has moved in to fill a void in the democratic society that class-structured societies do not share, providing people with ready-made and easily understood labels with which to communicate their own social status, personality, and lifestyle. Some anthropologists believe that the very first evidences of body ornamentation served the purpose of delineating social roles, and that this in turn increased the "ability to think in and communicate by means of specific visual images."[3] Compared to brand recognition and overt logos and labels today, only T-shirts represent a more obvious means for sending social messages.

As both propagandists and advertisers realize, and as Münsterberg first suggested about the impact of film, images are also the surest route to the emotions, and therefore a primary means of influencing attitudes before critical thought is engaged. LeDoux, Zajonc, and others have shown, too, that affective impact can be achieved even before product recognition is consciously registered, and these effects can be retained for a considerable time.[4] Advertising has also long recognized the need to speak to human emotions first. Bill Backer, one of the most successful creatives in advertising, for example, in stressing the necessity of freshness and originality in coming up with an abstract solution to the consumer's perceived needs, says he has "never been afraid of portraying decent, honest emotions as long as they are not being used to manipulate people toward a point that isn't true."[5] Whatever the message, it must

achieve an emotional resonance in order to become integrated into the self. Tony Schwartz, who first articulated advertising "resonance" as a theory of communication, comments that the "viewer's brain is an indispensable component of the total communication system [of advertising]. His life experiences, as well as his expectations of the stimuli he is receiving, interact with the communicator's output in determining the meaning of the communication."[6]

The most effective advertising communication is therefore one that achieves a matched layering of basic self-image, manufactured and mediated image, and product image—whatever the product may be, from clothing to political figures. In such messages, the sense of the self becomes bonded with what is sold, so that in the loosest association, they just seem to "fit," while at the deepest and most profound level of association, they seem inseparable from one's own identity. Thus certain brands of clothing seem to be "just right" for us, or we become emotionally biased toward political ideas or figures that seem to represent what we are and care about. Without emotional commitment or the affectively integrative "common sense" that emotional synthesis implies, there is no motivation to change attitudes or behavior.

To achieve an impact which will move the consumer from liking to buying a product, ad directors and copywriters, as the two essential parts of the advertising creative team, know that the first step is to gain attention; the second, to gain interest and likability through involvement; the third, to persuade by connecting a consumer problem with the product as its solution; the fourth, to motivate movement in attitude or action. Advertising techniques used to persuade consumers to buy are similar to those exploited in film by Pudovkin and Eisenstein; that is, they utilize the natural perceptual process of good continuation to complete a message along the lines laid down by the creative elements, so that the consumer sees the product use as fitting naturally within the setting, or they set up a cognitive dissonance that the consumer will resolve in favor of the product as the solution to the tension precipitated by the ad.

When the whole comes together to create a single impression, tension is relaxed and a stable memory trace is formed. Ads where all the elements work toward a common resolve tend to be remembered, while ads where elements are vague, unrelated, or leading off into different directions go unnoticed or are easily forgotten.[7] Repetition is also a major factor in the "sell." As Zajonc and others have shown, almost any element repeated often enough will achieve acceptance and likability. The more we see an ad, the more disposed we become toward the product.

Tension and Closure

The perceptual tendency to complete the gestalt is what actively involves the viewer in the formation of the commercial message. Marlboro cigarette outdoor billboards, for example, sport a close-up of the head and shoulders of a rugged cowboy next to the large, red, vertical letters "b o r o." The association of the cowboy with Marlboro cigarettes, begun by Leo Burnett in the 1950s, is such a long-standing one that the reader easily fills in the "Marl" portion of the brand name mentally, and the passive reader is instantly turned into an active participant in making the message. J & B Scotch several years ago began utilizing a similar advertising device around Christmastime when it took clever advantage of both its trademark colors—red and green—and popular Christmas carol lyrics to link seasonal gift giving and party consumption to its brand. On a trademark green background are only two words, in bright red, with a brief sentence beneath connecting them to "holiday cheer":

<div align="center">

ingle
ells
The holidays aren't the same without J & B.

</div>

This is the essence of what Marshall McLuhan meant in his controversial theories on "hot" and "cool" media. "Hot" media allowed for little filling in, where "cool" media forced viewer participation in the completion of meaning. In art, McLuhan tells us that "spectator becomes artist in oriental art because he must supply all the connections."[8] In literature, the interaction of words and consequent mental images may be the result of similarly intricately planned designs: out of a seemingly infinite number of exacting choices, authors can produce exactly the right effect through suggestive imagery at the same time they evoke and utilize the experiential background of the perceiver to identify with characters and to amplify vicarious experience. This is the essence of Hemingway's "iceberg" theory of writing, where the author depicts only the top eighth of the iceberg. The art, of course, hinges on the ability to maximize reader response through the most minimal of stimuli—that is, omission. In *A Moveable Feast* Hemingway commented that "you could omit anything if you knew that you omitted, and the omitted part would strengthen the story and make people feel more than they understood."[9] McLuhan, too, observed that we always perceive more than we understand.

Because emotions tend to be diffused easily through the limbic system, in response to ads that force the viewer to make the connection

between the visualized gratifications and the advertised product, people may confuse the purchase of things with emotional satisfactions sought in other parts of their lives, and even feel better when they buy something. When the overall image of the ad is powerful enough, it generates a gestalt "insight" in which the product is seen as the solution to the suggested problem. Thus when we go on to purchase the product, we actually *do feel* better about taking a step toward a solution, even if in reality it is an unproductive one.

Creative advertising strategy therefore implies effective psychological targeting, tight artistic control of elements first to generate and then to relax tension, and a "hook" for emotional involvement. As the ad comes together perceptually, the forces at work form meaning interwoven with the needs of the consumer. The effective ad reaches out, taps the consumer cognitively and emotionally, and seduces him or her into identifying with the product user. Each ad tells a story in which the product-as-hero transforms the consumer in some desirable way—such as being more competent, intelligent, or attractive—and projects the imagination into a desirable social context—usually one where the person using the product is sexually or socially desirable, personally at ease, and self-confident as a result of product use.

Although such scenarios are often seen as manipulative, it is also important to recognize that advertising has no subversive monopoly on them. All effective communication reaches the individual both emotionally and cognitively in much the same way: the first rule of rhetoric is to win goodwill; the first step for motivating a person to any action is to invest them personally in the cause, subject or problem. One of the reasons advertising is so powerful an influence within the society is that it never forgets or takes for granted the emotionally involving side of the message and because its main tool is the visual image.

Advertising at its most effective is therefore humanistic, speaking directly to people about the things they care about, showing them simply and clearly how the represented product or service will help them solve a particular problem or serve a particular need. The best ad people in the business have always understood both this and the value of honesty and down-home integrity, and they have respected the intelligence and dignity of their target audiences. And for the most part, people have appreciated this, turning to advertisements ranging in scope from high-image consumer ads, to yellow page listings, to trade ads for information about new products, absorbing advertising into their lives as part of personal discussions and political campaigns. Consumers have even found some campaigns inspirational—like the serialized New England Telephone campaign beginning in July of 1988, which featured

episodes of an estranged father and daughter who gradually overcame their differences and spoke to each other at Christmas; or Bill Backer's now classic Coca-Cola "Hilltop Campaign," which expressed the multi-cultural ideal "to teach the world to sing in perfect harmony." Bill Bernbach, who was responsible for the best of the early Volkswagen ads, also understood this. "Nothing," he said, "is so powerful as an insight into human nature."[10]

The Big Idea

Some ads like Backer's Coca-Cola ad hit you right away: they capture the imagination through a brilliantly executed Big Idea—the advertising counterpart of the archetypal image. Although a "Big Idea" is difficult to define, we know it when we see it. David Ogilvy, founder of Ogilvy & Mather who himself generated a number of big ideas when he actively headed his own agency including the images of Manhattan Shirts' "Man with the Eye-Patch" and the Pepperidge Farm horse-drawn wagon, suggests that a Big Idea is one that is unique, makes other art directors and copywriters wish they had thought of it first, is in full accord with the product's marketing and creative strategy, and can last for thirty years.[11]

Of the two divergent schools of thought about advertising, these men represent the ideal that advertising is an invaluable source of product information for the consumer, that creativity in advertising comes through knowledge of and respect for the product and consumer, and that advertising is the primary lubricant that keeps the economy moving in response to consumer needs—promoting intelligent choice and spurring production efficiency through competition. What all of these three creative admen have had in common besides their communi-cation expertise is their refusal to misrepresent the truth or to use cheap shock value simply to call attention to their products. Ogilvy, for example, resigned the lucrative Rolls-Royce account when the company sent five hundred defective cars to the United States.[12] Bernbach refused to take on cigarette advertising clients even though they would be clearly lucrative accounts because the product killed people. "All of us who professionally use the mass media," Bill Bernbach said, "are the shapers of society. We can vulgarize that society. We can brutalize it. Or we can help lift it onto a higher level."[13]

Yet advertising has a dark side, too. At its worst, it may use any and every device to call attention to its product—such as when Levi Strauss recently placed a pair of $55 "Dockers" khaki pants under plastic shields in Manhattan bus shelters to kick off a new campaign. The

message included along with them was "Apparently they were very nice pants." Levi Strauss, according to *Ad Age* had even factored the cost of the expected vandalism into its campaign, they were so sure that the pants would be stolen. Gannett finally removed the Docker ads after accusations that Levi Strauss was deliberately trying to provoke criminal behavior.[14]

Advertising may exploit basic human needs by indirectly promising human fulfillment through use of a product that may have the reverse effect in reality—as in beer ads where everyone at the bar is apparently well liked by everyone else, having a wonderful time, and engaged in witty repartee—a myth that anyone who has refrained from alcohol for only one evening in barroom can dispel. Because the romantic images in liquor and cigarette advertising have such little basis in fact, advertisers go to even greater lengths to sanitize them. Rarely does anyone in a liquor, wine, or beer ad seem to *already* have drunk what is in front of them, even though we seem to join them in the middle of the party, and cigarette ads today rarely, if ever show smoke at all.

Occasionally, advertisers borrow from a popular interest or from an exciting or deeply evocative human situation, exploiting sincere emotion in the service of banal goods. Or they may attempt to cash in on some of the most significant or profound aspects of our lives by associating them with comparatively trivial product benefits. Under the guise of social protest, for example, Luciano Benetton has for years exploited free media publicity to subsidize Benetton in-house advertising through what it calls "social awareness" campaigns which deliberately provoke controversy by deliberately flouting convention and by tapping fears associated with violence, death and disease. In 1991, for example, Benetton ran ads featuring a baby girl right after her birth with umbilical cord still attached, a priest and a nun kissing, and an angelic white girl with blonde ringlets next to a black boy with his hair shaped like two horns. These images sparked controversy; however, controversy turned to outrage when Benetton ran ads around the time of the Gulf War that showed several rows of crosses in a cemetery and then showed a soldier's bloody uniform as a commentary on the war in Bosnia in 1994.

When the company sued several German retailers for nonpayment of merchandise and franchise fees, retailers countersued claiming that Benetton's controversial ad campaigns had destroyed their business, which they say had plunged 30% to 50% since 1992. One group of retailers estimated the number of Benetton outlets as dropping by almost one-third as a result of the "tasteless ads."[15] One German retailer posted a sign stating: "No Benetton—because we too condemn the scandalous ads with war, disease and death" after the windows of his four stores were spray-painted with slogans like "No ads with dead soldiers."[16]

While other suits against Benetton have been initiated worldwide, including in the United States, in France a court awarded damages to an AIDS support association that claimed Benetton had exploited the disease by showing an actual AIDS victim surrounded by his grieving family at the moment of his death. In the United States, where Benetton has 150 outlets and does roughly $100 million of the $2 billion worldwide business,[17] the company has reduced prices and changed their attitude toward a more conservative one. In the process, their advertising copy clearly reveals a lingering iconoclastic adolescent appeal. Copy for one ad, for example, reads: "Your best dress . . . the one your mother really hates, the one you wish you had in six other colors, the one you sometimes think you love more than your boyfriend. But let's not get started on that one."

Such examples give credibility to the view that advertising is really a potent economic force without a social conscience, which employs effective communication tools to sell products people do not need; is dedicated to artificially creating consumer demands; and is amorally adept at substituting consumerism and product choice for meaningful social action and critical decision making. Without the creative ability to get the product noticed in legitimate ways, advertisers often resort to borrowed interest and cheap psychological closure, hoping to perceptually associate their products with the basic needs they exploit.

Embeds and Subliminal Advertising

Perennially one of the most interesting and controversial subjects has been "subliminal advertising." Several authors have in fact built careers on trying to convince people that mind control through images projected and perceived below the level of their conscious awareness not only works but also is widely practiced. Advertisers, it is claimed, modify ice cubes to suggest little breasts and phalluses, or embed sexual orgies in plates of clams. For the most part, the public has been receptive to the idea: A 1985 study by Block and Van den Bergh, for example, found that although consumers are generally skeptical of subliminal techniques used for positive ends like self-improvement, they are nevertheless "confident of subliminal advertising's effectiveness to sell products."[18]

Historically, the public's concern dates primarily from a now discredited study by James M. Vicary—the person who claimed that as part of a six-week research experiment he tachistoscopically flashed on the screen of a New Jersey movie theater the words "Drink Coca-Cola" and "Eat Popcorn" below the level of the audience's awareness (for 1/3,000th of a second every five seconds) during the screening of the film *Picnic*. At

intermission, he claimed, patrons then rushed to the refreshment stand to consume statistically significant amounts of Coke (a 57.6% increase) and popcorn (an 18.8% increase). As a result of this claimed success, Vicary formed the Subliminal Projection Company whose purpose was to project "invisible commercials on TV and movie screens."[19]

Although Vicary's claims were questioned at the time, a number of advertising agencies—much to their later embarrassment—initially hired him as a consultant. The study has since been labeled as patently fraudulent, however, as has his conviction that subliminal advertising would have its greatest impact on TV, since as researchers Smith and Rogers have observed, current electronics make it "technologically impossible to project a television image faster than the human eye could perceive."[20] The standard television video display is refreshed 60 times per second, with only half the lines refreshed on each scan. This means that the minimal presentation interval of 33.3 ms would considerably exceed tachistoscopic times in most laboratory experiments, making the message detectable. As with print ads, if a message is added in such a way as to make its presence undetectable, either the message doesn't motivate the consumer or does so by only a fraction of the success of supraliminal messages.[21]

Advertisers, too, have decided that they are much more interested in getting people to keep their messages *consciously* in mind while they are contemplating a purchase; they consistently deny using subliminal devices, even while researchers like Bryan Key continue to find the letters SEX on Ritz crackers and in Norman Rockwell paintings. But if advertisers and artists really are not using subliminal embeds, how does Key continue to find such sexual images in a variety of ads? Psychologists have asserted that if and when suggestive images and words do appear, they are likely to be the result of either the image producer's subconscious asserting its needs unbeknownst to the artist, or the consumer's imagination finding "faces in the clouds."[22]

Despite generally positive results from subliminal research studies in general as discussed in Chapter 1, it appears that for advertising, subliminal effects have limited usability. Positive effects in research studies utilizing subliminals have generally been of small magnitude, and in advertising-specific studies, completely supraliminal messages (messages above the awareness threshold) have proven significantly more effective than subliminal ones. In one study, for example, the use of subliminal advertising alone achieved an increased in sales of 1 percent; a mixture of subliminal and supraliminal advertising achieved an increase of 282 percent; and supraliminal advertising alone achieved a sales increase ranging from 1,802 percent to 3,383 percent.[23]

To be considered effective in advertising, researcher Sid Dudley suggests, messages "must induce not just action, but the desired action from a significant number of consumers."[24] And it is just this that subliminal advertising studies have failed to do in terms of influencing choice, increasing sales, and promoting brand recall. The preponderance of research has shown no evidence that subliminal stimulation can directly influence goal-oriented behavior[25] or that various subliminally embedded, sexually oriented stimuli in print materials influence consumer product preference.[26]

One area where *supraliminal* advertising "embeds" have been particularly effective is in the planting of products within films, so that they become a natural affordance of character, as with the Ray-Ban Aviator sunglasses in the film *Top Gun*. Earlier, in 1984, when Cruise starred in *Risky Business* wearing 1952-style Ray-Ban "Wayfarers," sales increased twenty times. Ray-Ban now places its glasses in 160 films and TV shows each year.[27] Camel cigarettes are featured in Disney movies *Who Framed Roger Rabbit* (U.S.A., 1988) and *Honey, I Shrunk the Kids* (U.S.A., 1989). In 1989, Philip Morris paid $350,000 to have Lark cigarettes featured in the James Bond film *License to Kill* (U.S.A., 1989), but the tobacco industry agreed to stop the practice in 1991 after the Federal Trade Commission began investigating whether the product placement violated a 1971 ban on broadcast tobacco advertising, since the film was also shown on television.[28]

In other countries where cigarette advertising has been banned, more and more tobacco names have appeared on gear in films, and even on items such as record album covers. In the United States, the practice began as early as the 1930s,[29] but the power of such commercial product embeds became obvious only when, in *E.T.—the Extraterrestrial* (U.S.A., 1982), the film's protagonist Elliot shared some of the candy with the alien "E.T." Sales of Reese's Pieces candy subsequently soared 70 percent. *MAC & Me* quickly capitalized on the phenomenon, telling the story of an alien who befriends a crippled child and lives off Coca-Cola. In 1990, in *Ghost*, Patrick Swayze carries Reeboks; in *Pretty Woman*, Julia Roberts drinks Diet Pepsi; in *Home Alone* the family flies American Airlines and Nestlé's "Juicy Juice" is featured.[30]

In an ironic and unintentional reversal, in *It Happened One Night* (U.S.A., 1934), when Clark Gable took off his shirt to reveal a bare chest, men's undershirt sales reportedly dropped 40%.[31] Clearly, star appeal and image have extraordinary power in influencing not only the psychology of viewers but also their pocketbooks as well. Advertisers today regularly pay for the privilege of having their products "hyped" in film.

Effective manipulation in advertising therefore seems to come primarily through supraliminal perception coupled with lack of general

consumer awareness that products are embedded in the storyline as ads. As Bargh has argued, however, the true significance of subliminal effects lies in our lack of critical awareness of the ways in which we may be affected unconsciously by biases, whether subliminally induced or not and then misattribute the source of our attitudes by assigning them to the person or thing itself rather than to our own feelings. In the process, we further justify prejudices as if they were trustworthy judgments, and these judgments in turn affect subsequent perceptual processing.[32] If, as some researchers have indicated, subliminal perception is a visual, right-brain activity inconducive to verbal experiments, we may be particularly susceptible to prejudice through visual processing.[33]

Ultimately, true subliminal conditioning may be achieved not through tachistoscopic flashings or pictorial embeds, but rather through supraliminal additions of products into the storyline or through visual manipulations such as color, camera angle, size, and distance. These impact our feelings about the subject without our necessarily being fully aware that the characteristics we seem to see in the person or product are really contained in the way the medium is manipulated.

Advertising and Color

Because color speaks immediately to our emotions and has such an intense effect on us, it, too, has become of primary interest to researchers, medical doctors, psychologists, and, of course, to advertisers searching for the most persuasive appeal. Merchandisers who wish shoppers to stay longer and buy more are particularly interested in the subliminal effects of color. A blue retail environment, for example, has been found to stimulate the inclination to shop, to browse and eventually to purchase, while red invokes tension in shoppers and has the opposite effect.[34]

Because yellow is also the color the eye registers most quickly, it has been found to be a good choice for taxis and school buses—and it also makes heavy things seem and feel lighter. But too bright a yellow decor can cause anxiety, and in restaurants it can lead to more complaints to the chef. In restaurants decorated in red, people tend to eat faster than in blue-decorated ones, since bright red stimulates glandular activity and induces hunger. It is no coincidence that fast-food restaurants are characteristically red and yellow. Green is relaxing, but ill-advised in restaurants because a green environment makes food look less appetizing unless it is in the form of natural plants. In packaging, however, it tends to connote freshness.[35] Chartreuse seems to be the most universally disliked shade of green, associated with sickness and slime.

In buying decisions, color becomes especially important because people tend to read the immediate image of the product as a whole rather than the words on the label—culturally, for example, green and orange colors on a carton have come to signify "orange juice"; a red and white carton signifies whole milk, and a blue-and-white carton skim milk.[36] When a milk carton is designed in green and orange, there will very likely be a number of disappointed shoppers at home. Similarly, red and white cartons in the juice section of a supermarket are unlikely to sell well. Most shoppers go by color codes, especially in logos and package designs that instantly signal the product in a kind of visual shorthand. Any marketer who doesn't understand this shortly "pays the price" in loss of sales.

This is why package designers like Alvin Schechter say that "Color isn't the most important thing; it's the only thing. . . . color goes immediately to the psyche and can be a direct sales stimulus."[37] When Canada Dry sugar-free ginger ale changed from a red to a green-and-white can, for example, sales increased more than 25 percent. Presumably the green and white signaled a product with a more natural, laid-back taste.[38] When Barrelhead Sugar-Free Root Beer cans changed from blue to beige, people in taste tests insisted that the new stuff was more like good old-fashioned root beer in frosty mugs than the stuff in the blue can, even though the root beer was exactly the same.[39]

Such examples show clearly that the selection and experience of a product can be as much a result of mental image as of product content, and that much of this stimulation comes from color association and past experience. This is why package design is such an important part of marketing: it acts as point-of-purchase advertising that works its effect at precisely the point when the consumer is making a product choice. This choice, it seems, has very little to do with whether a person generally likes or prefers a particular color or design. Rather it has to do with how well the package design and color communicate an idealized image of the product experience contained within the package. Corona beer provides an excellent example of the nuances of this aspect of product image.

In the early 1980s, Corona beer, which had been the leading brand in Puerto Rico began losing its market share. Research into the product and package showed that years before, the brewery had had a problem with leakage in its steel cans, and the image of the product as flat persisted long after the problem had been solved. In addition, as more United States products flooded the Puerto Rican market, the Singing Farmer logotype that graced the label tended to mark it as provincial, something that apparently made it seem less desirable. Even though in

blind taste tests the beer was rated extremely high, sales sagged. The marketing solution was to change the beer's overall image by switching to aluminum cans and redesigning the package to give it a more upbeat look. It worked, and record sales were achieved for the local brew.

Three years later, however, as the market changed and sales flagged, a new round of testing revealed that U.S. beer was being perceived as more full-bodied than Corona—despite the fact that, again in blind taste tests, drinkers still preferred Corona. The problem, it seemed, was not to give the beer but the can more "body." To do this, package designers added a deep red color to the basic design. The result was that in comparative taste tests—which included Corona beer in the old can, Corona beer in the new can, and the major U.S. competition—drinkers were amazed at the improvement in the native beer: it was now just as full-bodied as the competition, and tasted much better than before.[40]

This is why color, as one of the most important aspects of brand image, has come to be recognized as so important in packaging. Some companies, in fact, have been able to claim exclusive rights to colors and color combinations in their product categories—such Owens-Corning's pink insulation and Eastman Kodak's combination of yellow, black and red for film packaging.

The Sex Sell: Women's Bodies and Normative Images

Because the primary source of an ad's power lies in the perception of the viewer, exploitative advertising sometimes utilizes deep-seated fears or needs to sell products through evocative sexual or violent images. This technique is especially used in relation to parity products—that is, products that have little or nothing to differentiate them from the competition in the marketplace—or when the product has little or no tangible benefit to the consumer. By taking advantage of our perceptual tendency to translate association into cause and effect, advertisers can tap the power of this imagery by presenting their products as an integral part of the solution to basic physical needs or social anxieties, even when such an association violates rational logic. When the target audience is in adolescence, when sexual and social insecurities are peak, self-confidence low, and peer pressure high, the approach appears to be particularly effective.

Thus a product that seems to relieve the anxieties surrounding puberty, and at the same time enhance a natural egocentrism and emotional excitability, can exploit the adolescent's lack of experience simply by melding the product, ego, and sexual and social acceptability at the center of the ad's artificial world. "Jeans," for example, which were

originally rather unromantically called dungarees and used as heavy-duty work wear, have become associated through effective advertising with sexual gratification, and are primarily targeted to adolescents. Calvin Klein was the first to fully exploit this approach on a large scale when it launched a campaign for designer jeans in 1980 with Brooke Shields as its celebrity attractor. In the ad, the seductive nymphet looks into the camera and asks: "Do you want to know what comes between me and my Calvins? Nothing." Sales response was immediate. So effective was the approach that Klein launched a new fragrance, Obsession brand perfume, five years later using totally nude models and ambiguous group sex motifs in ads that returned $30,000,000 within ten months.

Thereafter, such advertising became commonplace, and the ability of the innuendo sex sell to break through the clutter diminished proportionately. This meant that Calvin Klein would have to escalate the sex and celebrity or find an alternative strategy. It chose to escalate. By 1992, for example, in the new *New Yorker* magazine Calvin Klein was running ads using music idol Markey Mark in Calvin Klein briefs and unzipped jeans straddled by a topless model also in Calvin Klein briefs and unzipped. But then the competition escalated, too. Diesel Jeans ran an ad of a model lying on a zebra skin, wearing only a black bra and jeans with fly flap fully open and no briefs, with the headline "How to control wild animals." Request Jeans launched a series of ads including a man and woman in bed together, and a fully nude woman in profile just clutching a pair of jeans to her naked breasts. Guess Jeans meanwhile were showing models in haystacks with full cleavage with no jeans in the picture at all. Thus, all of this "sex sell" not only changed the jeans image to one of sexy attire, it also firmly established a sex image competition among brands.

Inevitably by the time total nudity had been reached, this meant that the only place left to escalate into was perversity, and by 1995 Calvin Klein print and television ads had begun to take on the overt appearance of child pornography, with images of scantily clad adolescents in suggestive poses. In Calvin Klein print ads, young girls were shown seated in short skirts with legs spread open or with hands cupped ready to apparently reveal already partially exposed breasts; in television ads, an off-camera voice asked a model to take off a shirt or a pair of pants. Although by this point public tolerance of the sex-sell in general had increased simply by virtue of its ubiquity, public ire was kindled by the use of sets typical of child pornography magazines and films and models who either were teenagers or looked like them. A variety of public voices, including citizen groups and a major column by Jeff Greenfield in *The New York Times* decried the attempt to invoke the cheap

lasciviousness of pornography; and threats by child welfare and religious organizations to boycott stores finally caused Calvin Klein to cancel its campaign.

The Campaign, originally slated to run through October, was canceled in August of 1995, having run less than two months in print, on TV and on city buses. Shortly after its cancellation, the Federal Bureau of Investigation announced plans to investigate the campaign, but dropped them when all models were shown to be within legal age range, and Klein ads proved to be just shy of the legal prohibition forbidding the actual display of genital and pubic areas. Calvin Klein had expected it all, including the fact that the controversy also predictably spurred product awareness. The extra publicity enhanced the product's iconoclastic aura, and therefore the psychological appeal to its young target market, sufficiently to boost sales considerably. In contrast, another less successful act of desperation to break through the clutter led Lee Authentic Clothing to introduce a spot in 1995 showing a young woman peeling off her clothes in front of her boyfriend and then diving into a lake. Because this was now run-of-the-mill stuff, however, they decided to run it in reverse action in order to get attention.

The significance of such images lies not only in their lack of ethical creativity and their exploitation of psychological and social needs, but also in the normative power that the images exert on society as a whole and on adolescents in particular. Perhaps nothing makes this clearer than the steadily declining differences between "glamour" images in fashion photography and the images that adolescents choose for themselves in photographs. In a study of the contrasting images between fashion magazines and class photographs for high school yearbooks in the Minneapolis–St. Paul area, for example, photographer/professor Charles Lewis has found that from the mid-1980s onward—parallel to the introduction and growth in popularity of MTV—there has been a radical shift in the kinds of images that teens have requested of themselves in high school yearbooks—from the traditional full-face close-up to a three-quarter or full-body pose, often in recline, surrounded with "their stuff"—like football helmets—around them. The focus of their eyes, he observes, has shifted from a straightforward, open look to a sideways glance suggestive of fashion glamour poses, and for the first time in class pictures, gels are being use to achieve a certain "look."

He also points to other trends: the increasing digital placement of children into photographs with their favorite cartoon characters, and portrait photography for adult women, mostly in their twenties and early thirties, as a kind of total experience involving complete "makeovers" of hair and make-up, with alcohol served during sittings. The

final photographic product, achieved with the sale of lingerie by photographers themselves, resembles what has been traditionally viewed as "boudoir photography," a kind of "soft-porn" approach to portraiture. He concludes not only that consumers are taught what they should want to look like and be by images in the marketplace, but also that there has been a steady increase in the commodification of the self as well, in themes characterized by raw eroticism, focus on opulence, and fantasy.[41]

Such objectification and the placement of things and people as parts in relation to one another, together with the "blocking" or position of these elements within a given scene, are characteristic of the growing trend toward integration of the artificial image into personal lives. These images suggest both a social and cultural context in which "things" are of great importance, and a merging of traditional roles and personal images into commercially driven media templates. Erving Goffman was one of the first to define the variety of codes derived from gender display. These codes, he believes, both reveal power characteristics such as competence and control and also conventionalize them through mass distribution. Women in advertisements, for example, are often found in "canting" positions (lowered head, lying prostrate with feet stretched out) such as dogs might assume to signal recognition and acceptance of others' dominance, a position that Lewis finds increasingly creeping into high school graduation photos. Any position that removes a person from readiness to act may be used to signal submission as well, and where Goffman notes that women are often shown in product advertisements as leaning on men, standing precariously with knees bent, lying prone, or in positions lower than men, Lewis finds that this now characterizes yearbook photos as well.

Goffman notes that women are also shown more often wearing less serious expressions (smiling, covering the face, laughing) and attired in less serious costumes, indicating that they are playing at roles—not wearing clothes as part of a functional identity, which is characteristic of men. Like children, women are often shown sucking things, putting strange things in their mouths, and hanging on, while men usually have both hands free to maneuver and stand or sit firmly. While traditionally, for example, soldiers and workers as images of power and authority are typically shown in low angle with eyes steadfastly fixed on a distant goal and feet solidly planted, ready for action, American advertisements of women rarely if ever portray them in this fashion. Women's hands tend to caress; men's to grasp firmly. Men teach, act, and show; women listen, languish, and appear to drift mentally.[42] All of this, Goffman's argument implies, adds up to a commercially manufactured image that is so culturally pervasive that it becomes not only an internalized mental

measure of normative role behavior for the society but also a kind of gender propaganda to perpetuate it as well.

Marxist critic John Berger suggests, too, that advertising images have a solid historical foundation in the world of art where typically "men act" and "women appear."[43] "This unequal relationship," he states, "is so deeply embedded in our culture that it still structures the consciousness of many women."[44] So much so, in fact, that they assess their own worth as people by how men perceive them and incorporate the perspective of the male gaze into all that they survey and see in themselves. "The 'ideal' spectator," Berger says, "is always assumed to be male and the image of the woman is designed to flatter him."[45]

According to Naomi Wolf, advertising imagery is largely responsible for this by creating a generalized atmosphere that is both absorbed by women from their earliest age and reinforced by judicial process. Although the feminist movement did much to improve awareness of the situation, the boomerang rebound against it (discussed extensively by Susan Faludi in *Backlash*), Wolf believes, has resulted in an oppressive mood and a reemphasis on beauty that has political overtones as well. According to Wolf, "The backlash is all the more oppressive because the source of the suffocation is so diffuse as to be invisible,"[46] but its presence is keenly felt. Research shows, for example, that women's self-esteem is appreciably lowered after repeated exposure to idealized images in fashion magazines. These images, which are digitally manipulated to create even more unrealistic bodies and features, many feminist critics agree, emphasize make-up and a cult of thinness at the expense of both mental and physical health.

According to Wolf, professional beauty qualification (PBQ) has also become widely institutionalized as a criterion for hiring and promoting women. Citing television journalism as typical, Wolf describes a "double image—the older man, lined and distinguished, seated beside a nubile, heavily made-up female junior—which has become the paradigm for the relationship between men and women in the workplace."[47] By the 1980s, the news man was a fully defined individual whose aging gained him prestige; the newswoman, however, was only an appearance chosen first for youth and beauty and then trained in delivery skills. By 1991 women news anchors were twenty years younger and paid 23 percent less than their male counterparts.[48] What this ultimately translates into, according to Wolf, is that for men individuality and maturity is power, but for the female "anchorclone," generic replacement is the inevitable result of aging and experience.[49] As young women increasingly equate beauty with the anorectic image projected by models (who average 23 percent leaner than the average woman), and

therefore become increasingly dissatisfied with their own image, they fall victim to anorexia nervosa and bulimia.

Although eating disorders were thought to be relatively rare before the 1970s, with the onset of a new fashion image in the late 1960s and early 1970s, a variety of eating disorders began to surface, particularly bulimia and anorexia. By the 1980s, numbers had reached alarming proportions. One 1992 study, a repeat of one done a decade earlier, involved a group of 800 women and 400 men at a selective northeastern university. Testing for factors including drive for thinness, bulimia, maturity fears, perfectionism, and interpersonal mistrust, the study found that body dissatisfaction and the desire to lose weight were still the norm for more than 70 percent of young women, with 1 in 10 of them reporting "symptoms that would represent clinical or nearly clinical eating disorders."[50] Anorexia and bulimia can be as physically addicting and deadly as nicotine for some women, yet it is clearly glamorized in the world of marketing and advertising.[51]

Plato believed that the normative image, which revealed the ideal to our minds, was our remaining sense of a perfect world left behind at birth. Today this normative image tends to be developed through media. In such an artificial world, appearance is everything: going out without make-up is equated to literally with going out without one's "face" on, and perpetual hunger is common. Even legally, the beauty norm is well-established: some federal judges have upheld the right of employers to set appearance standards as a criteria for employment. "No woman is so beautiful" according to Wolf, "that she can be confident of surviving a new judicial process that submits the victim to an ordeal familiar to women from other trials: looking her up and down to see how what happened to her is her own fault."[52]

One particularly chilling story which illustrates the inherent power of this "beauty myth" is told by Mary Kay Ash, founder of Mary Kay Cosmetics, in her autobiography *Mary Kay*. The story is chilling for two reasons: first because of the bizarre reasoning involved, and second because Mary Kay herself uses the subject as an example of "success" to be emulated. In the story, a Mary Kay Cosmetics sales representative and former model is told that she may go blind. If she has an operation right away, she will have a 50 percent chance of sight, but if she waits, she will gradually lose her sight until it vanishes completely. Incredibly, the woman opts for certain blindness because "the thought of being unable to do her hair and make up her face was unbearable,"[53] and the interim could give her the time she needs to learn to put on her make-up correctly without being able to see. (She does this by placing cosmetics in the refrigerator and putting them on cold so she can feel them more

keenly.) At the time of Mary Kay's writing, the woman was blind, but impeccably rouged and lipsticked, selling Mary Kay cosmetics from jars marked in Braille. The importance of the external normative image was so strong that faced with the choice of life without "her face" or living in perpetual darkness, she chose to be seen rather than to see.

The Sex Sell: Men and Their Machines

It has also often been pointed out that a parallel cultural preoccupation with image exists between American men and their cars. S. I. Hayakawa comments, for example, that "the automobile is certainly one of the most important nonlinguistic symbols in American culture," that "it is one of our ways of telling others who we are," that automakers are the "grammarians of this nonverbal 'language.'"[54] Although it is probably more accurate to say that advertising agencies are the grammarians in this "language," Hayakawa's point is well taken in terms of the inordinate influence of advertising in general on cultural values, attitudes, and lifestyles, and of car advertising in particular in relation to personal preoccupations with speed and power. In his classic essay "Sexual Fantasy and the 1957 Car," Hayakawa states wryly that by 1957 the automobile industry had apparently decided that transportation was only a secondary reason for buying a car, and that its primary function was to allay "men's sexual anxieties."[55] Hayakawa found evidence for this in excessive horsepower allowing for speeds up to 125 miles per hour, rocket ship styling that suggested a Freudian impotence, and the sacrifice of "*all* else—common sense, efficiency, economy, safety, dignity, and especially beauty—to psychosexual wish fulfillment."[56]

Although today's cars no longer sport the giant fins of the 1957 Plymouth Fury, and motivational researchers have become more reality-oriented in terms of mileage, the car today still remains a significant part of our own advertising of who we are, and perhaps it is not too far a stretch to suggest a mythical connection between it and the wings of Icarus as a symbol of freedom and power. It is also a symbol that overlaps sign categories and exists among all economic levels: as an icon in a car ad, the car looks like what it is; as an indexical sign, it is associated with travel, new places, and new experiences; and as a symbol, particularly in terms of sexual potency, it transforms the power associated with the machine in the last century into the power of the individual.

In 1900, Henry Adams saw in the dynamos at the World's Fair a symbol of infinity and "began to feel the forty-foot dynamos as a moral force, much as early Christians felt the cross."[57] It seemed to him that "man had translated himself into a universe which had no common scale of mea-

surement with the old"[58] and that this new power had taken the place of the productive spiritual power symbolized by the Virgin and expressed in the great European cathedrals, built by successive generations of men. In the 1920s, F. Scott Fitzgerald saw similarly in the proliferation of the automobile a dynamic force that had irrevocably altered the social order and the way people interacted with their environment and with each other. Spirituality had dissolved into a "pathetic wistfulness," and the world had no more outposts "to grasp his imagination." Yet in fifteen minutes, anyone could be out of sight.[59] From its beginning as a mere mechanism, the automobile grew into an image that ultimately transformed the whole of the society with its power, but left it nowhere to go. At least part of the success of Fitzgerald's Gatsby as a literary symbol derives from the power of the automobile as a cultural symbol of success and its ironic personal emptiness. In Sassure's terms, the automobile now presents itself as a signifier without the signified, a symbol of freedom without its possibility. As Barthes has observed, "The sign is ambiguous: it remains on the surface, yet does not for all that give up the attempt to pass itself off as depth."[60] Tellingly, automobiles in advertisements aimed at youth and middle income fantasizers are rarely still and usually focus on the journey and on speed, sports handling, or the power to handle rugged terrain.

In upscale cars, the appeal comes through the status of "having arrived," and these are often treated as if they were works of art, stationary and lit for viewing. David Ogilvy for example is credited with introducing Rolls-Royce as a viable American choice and later with increasing Mercedes-Benz sales fourfold through his advertising through print ads designed to capture upscale interest and prestige. Neither of Ogilvy's famous ads suggests speed, toughness, or handling, but rather artistic workmanship. The Rolls ad, for example, shows a one-third page illustration of a gleaming car with the headline "At 60 miles an hour the loudest noise in this new Rolls-Royce comes from the electric clock," and the Mercedes headline reads: "You give up things when you buy the Mercedes-Benz 230S. Things like rattles, rust, and shabby workmanship." Both ads are very heavy on copy, featuring carefully chosen engineering and synecdochic details which, like the electric clock, suggest far more than themselves alone. A master at his craft, Ogilvy always found the precise line of detail that would suggest the whole and create an emotionally loaded and vivid personality image in his reader's mind.

Joe Camel and the Marlboro Man: Images that Kill

According the Center for Disease Control, over 430,000 people die every year of tobacco-related causes—well over 1,000 people a day. After

years of debate over the possibility of banning tobacco ads altogether, with Tobacco companies continually winning the legislative battle as well as the battle for new smokers, President Clinton in August 1995 gave the federal Food and Drug Administration the go-ahead to assert regulatory power over tobacco, primarily as a drug delivery system for nicotine. As the reasons for his decision, he stated that "When Joe Camel tells young people that smoking is cool, when billboards tell adolescents that cigarettes may make them thin and glamorous, then our children need our wisdom and our experience." The initiative recognized that nicotine addiction is a pediatric disease, and that nicotine is an essential design feature of cigarettes.[61]

In the United States, approximately one billion packs of cigarettes are sold annually to children under eighteen years of age.[62] The World Health Organization estimates that worldwide, of adolescents who continue to smoke, "half will be killed by tobacco . . . 200 million to 300 million children and adolescents under twenty currently alive [will be] eventually killed by tobacco."[63]

First believed to have curative powers, tobacco was introduced into Jamestown, Virginia, in 1612. By the end of the eighteenth century tobacco was firmly entrenched as a plantation crop, and by the end of the nineteenth century, both the mass production of cigarettes and campaigns against smoking had begun. By the 1920s, however, cigarette sales had also reached $1 billion a year, primarily because of the impetus given the tobacco industry when cigarettes were included in soldiers' rations in World War I.

By the end of the 1930s, scientists knew of the major health risks, but it was not until 1964 that U.S. Surgeon General Luther Terry publicly confirmed the link between tobacco, cancer, heart disease, and other serious illness. In what many believe was the beginning of several misguided efforts to curb the industry, warning labels were required in 1966 (giving tobacco companies the legal defense implied by assumption of the risk and seemingly absolving them from further disclosure on harmful effects). In 1971 a legislative ban on radio and television advertising of cigarettes was enacted (this relieved tobacco companies of producing antismoking ads under the Fairness Doctrine). In 1986, the U.S. Surgeon General declared second hand smoke to be dangerous, and in 1993 the Environmental Protection Agency followed suit, declaring it to be a general health hazard.

In 1988, when the U.S. Surgeon General declared nicotine to be addictive, tobacco companies denied it. Appealing to the Constitution's First Amendment "freedom of speech" guarantee (exclusively sponsoring the 200th anniversary of the Bill of Rights in 1989, for example) and

with arguments that their advertisements contain important information for the potential consumer, tobacco companies continued to outwardly deny the validity of studies linking cigarettes to nicotine addiction and to cancer and other health risks. Yet beginning in 1994, internal documents from the tobacco industry began to emerge that belied this, showing that addictive levels of nicotine had been deliberately manipulated. By the 1960s, documents revealed, top Brown and Williamson and other tobacco executives knew that nicotine was addictive and that their own laboratory experiments showed that cigarettes cause cancer. Brown and Williamson subsequently conspired to misrepresent its own supposedly independent research findings by funneling damaging research results through its lawyers, who were bound by attorney-client privilege, and by disposing of damaging documents from their own research.[64]

Such documents lend insight into the question of why people have started to smoke and continued to smoke even while knowing the dangers of it. Because tobacco's capacity for addiction is apparently stronger than cocaine or heroin,[65] tobacco companies knew that they had to lure people into smoking before they fully realized they would become addicted, and that they had to counteract growing rational awareness with emotional appeals, primarily through alluring visual imagery. Because minors tend to smoke heavily advertised brands, and relatively few people switch brands, they also knew that if they could capture young smokers, they could retain brand-loyal smokers for the rest of their lives. Most smokers become addicted to cigarettes when they are minors,[66] and if people do not start smoking by the time they are eighteen or nineteen years old, the probability is they will not start at all. Recent studies by the University of California, San Diego cancer and control program, clearly establish the association between tobacco marketing and youth smoking. Young people are especially susceptible to marketing, particularly to advertising images.

Youngsters, for example, who could name a favorite cigarette ad such as the Joe Camel cartoon, or owned a Marlboro T-shirt, were found to be nearly four times as likely to smoke as other youngsters.[67] Introduced by R. J. Reynolds in 1913, Camel cigarettes did not change its image until 1987, when it first introduced Joe Camel and the "smooth character" campaign. When it did, the campaign was embraced by children: In 1991, three articles appearing in *Journal of the American Medical Association* (JAMA) revealed that approximately 30 percent of 3-year-old children and 91.3 percent of 6-year-old children correctly matched a picture of Old Joe—Camel's "smooth character"—to a picture of a cigarette, making Old Joe Camel as well recognized as Mickey Mouse.[68]

Camels was also the brand of choice among 12–17-year-old males and the most named brand among 12–13-year-olds.[69]

The campaign turned the brand around, making it the number 6 brand in the $40 billion annual market. It also showed a disproportionate influence on smokers under 18 years of age, whose choice of Camel cigarettes jumped from .5 percent to 32.8 percent within three years of the start of the campaign.[70]

Both Camel and Marlboro brands have appeared regularly in films, on billboards, in promotional displays at youth-oriented events, in sporting events on television, and in personal paraphernalia such as T-shirts, posters, and caps. Their logos appear on video arcade games, children's toys, and candy products.[71] The repetition of these images—namely of the trade characters "Old Joe" Camel and the Marlboro Man—goes a long way in explaining why children and teenagers make up 90 percent of all new smokers.[72] When they do become smokers, 90 percent become persistent daily users, and 55 percent become dependent.[73]

Cigarette advertising, like advertising for jeans, relies almost totally on visual images, repetition, and adolescent psychological appeals. Joe Camel, for example, as a cartoon trade character perennially surrounded by cartoon females and at the center of everyone's attention and admiration, has been inordinately successful. As a discussed in Chapter 2, we give cartoons life by filling them up with ourselves, giving them power through our own identification with them and through the shared sense of experience which the ubiquitous images of advertising provides.

Astride a motorcycle or lounging in "cool" settings such as bars, jazz combos, and tropical beaches, the Bogart–Blues Brothers–Brando-on-a-motorcycle–James Dean–like camel always has a cigarette hanging from his lip or held prominently but casually between his fingers. Drawn from the original camel logo on the pack, the trade character has an added adolescent smugness and a self-conscious virility in his cartoon transformation that the original realistic camel on the pack lacks since it is merely an animal in the desert. Unlike the original, the cartoon "Old Joe" wears and uses "gear" that the smoker with "camel cash" coupons can also order from a hard goods catalog. The catalog features items like sunglasses, lighters, cards, T-shirts, and a Sony Discern CD player.

Some critics have even suggested an uncannily close physical resemblance between Joe's face and male genitalia—an accusation that R. J. Reynolds denies. *Village Voice* critic Leslie Savan insightfully comments that "The double message—it's a dick; nope, it's a camel—can be far more potent than explicit sex or explicit wholesomeness."[74] Perceptual ambiguity, like the "Face-or-Vase" and "My Wife or My Mother-in-Law"

images discussed in Chapter 1, can be extremely effective devices for grabbing and holding attention.

Just as Freud suggested that the processes of condensation and displacement are used by the psyche to evade its censor, so, too, cigarette advertisers have used apparently inoffensive yet symbolically loaded images to evade legislative censure. The positive illustration "condenses" the logically disparate images of cigarette smoking and social-sexual behavior into a single, emotionally persuasive image, while the cigarette "displaces" explicit sexual referents. The resulting message? Smoking is a socially positive, sexy act.

Because much of visual communication takes place almost instantaneously at the subconscious and emotional level, and because approximately 98 percent of typical cigarette ad space is occupied by a positive image, the primary impact of the message is felt visually and emotionally rather than verbally and rationally. The mandatory cigarette warning label is placed outside of the scene, a "tack-on" of verbiage in an otherwise visual narrative. Visual design elements invariably draw the eye away from it, and its own verbal format renders it once removed from the immediate world of the image. (Would the effect be the same, e.g., if the verbal warning were replaced by an inset *picture* of diseased lungs?)

The social image of tobacco in advertising is thus the reverse of its true physical picture. Recognizing that consumers read visual language more quickly and easily than verbal language, and that youthful consumers—like adult consumers—block out negative messages in favor of positive messages, advertisers and their agency representatives have traditionally played a psychological and semantic game with legislators and the public in order to keep profits high. Through images of Old Joe surrounded by admiring females in "cool" settings, and through the archetypal mythic appeal of the independent cowboy, tobacco companies have succeeded in seducing potential smokers while they are children and adolescents.

Although cigarette manufacturers still deny that they are attempting to appeal to children, and advertising agencies with cigarette accounts have traditionally attempted to defend their product messages by saying they were directed only at persuading existing adult smokers to switch brands, the facts seem to belie both statements. Only about 10 percent of smokers change their brand in any given year, yet the year of Old Joe's introduction, the tobacco industry spent $3.27 billion on cigarette advertising and promotions—a figure much larger than would be warranted by brand switching.[75] The campaign was also a failure in appealing to adults, but not to children. Studies

show that the Old Joe Camel cartoon is much more successful at mar-
keting Camel cigarettes to children who think the Joe Camel ads look
"cool," than to adults for whom the "Joe Camel" character has far less
appeal.[76]

Although Joe Camel character has become of primary interest
because of its appeal to children, no archetypal advertising symbol has
had the total impact nor lasted longer than the Marlboro Man. The first
filtered cigarette launched in the U.S., in the 1930s Marlboro was first
positioned as a woman's cigarette when men were smoking nonfilter
brands. The positioning was changed, however, because more men
smoked than women, and Philip Morris realized that it had neglected a
prime market—"post-adolescent kids who were just beginning to smoke
as a way of declaring their independence from their parents."[77]

Fashioned by Leo Burnett in concert with Jack Landry of Philip
Morris in 1955, according to Meyers, the Marlboro Man was the result of
"months trying to come up with the right image to capture the youth
market's fancy. At last it latched onto the concept of the weathered-
looking cowboy riding off into the sunset—a perfect symbol of indepen-
dence and individualistic rebellion."[78] According to Burnett, the
Marlboro man was designed to "sell flavor in the cigarette, masculinity
in the smoker," and although the concept originally was devised with
various roles including a stevedore, a miner, and a truck driver, the
cowboy was chosen because it was an archetypal image which thou-
sands of westerns, fact and folklore had reinforced: "the ultimate man's
and woman's man."[79]

The image of the Marlboro Man fit Leo Burnett's advertising con-
victions perfectly, for like Jung, he believed that the most effective
images have an appeal deep in the psyche: "The most powerful advertis-
ing ideas are non-verbal, and take the form of statements with visual
qualities made by archetypes. Their true meanings lie too deep for
words."[80] The immediate success and the enduring quality of the image
has borne him out: the Marlboro Cowboy took the brand from seventh
position in the United States to first position in the world—a position
which it has retained for forty years. In Nigeria, the cowboy is black; in
Australia, he is in the outback; in Hong Kong, he is a ranch owner, but
everywhere in the world the Marlboro Man has retained the same look,
personality, and same profound archetypal appeal. In the JAMA studies,
Marlboro was the brand most frequently named in all male adolescent
groups and the brand of choice among youth, increasing in youths and
young adults up to the age of 24 and then gradually decreasing.[81]

As both Boulding and McLuhan observed, the entrenchment of
such archetypal images as the Marlboro Man and Old Joe is evidence of

their inherent power. Because such images are stable and resistant to contrary messages, according to Boulding, "change will be slow no matter how swiftly the messages themselves course through the channels of communication."[82] Because advertisers like Leo Burnett have been so adept at creating such commercial archetypes—as evidenced by the appeal of Burnett's Tony the Tiger, Charlie Tuna, the Jolly Green Giant, the Pillsbury Doughboy, and Morris the Cat—the staying power of these images is not easily undone.

One of the most visually intelligent men in the advertising industry, Leo Burnett understood the power of the visual image and advised his creative teams to mine the archetypal power within the image to appeal to the deepest part of the consumer psyche:

> a strong man on horseback, a benevolent giant, a playful tiger. The richest source of these archetypes is to be found at the roots of our culture—in history, mythology and folklore. Somewhere in every product are the seeds of a drama which best expresses that product's value to the consumer. Finding and staging this *inherent drama of the product* is the creative person's most important task: Do not lean on tricks, devices or "techniques." Keep the advertising relevant—shun irrelevant approaches in headlines and illustrations, no matter how clever they are.[83]

Conclusion

Visual language is more concise and more easily and quickly processed than verbal language, and the best "creatives" in advertising have been quick to seize on the value of images in reaching their potential consumers. Effective advertising visuals not only stop the viewer but also begin the communication process by simplifying the product message to its most quickly and easily understood form. Advertising images thus act as condensed cultural symbols, visually reduced statements that suggest a storyline that targeted consumers complete in their own imaginations, with themselves as the leading character, although significantly the product remains the hero. As such, they represent the epitome of the dynamic concepts of gestalt simplification, Gibsonian affordance, and perceptual closure.

Within the buying dynamic, consumers are both product users and self-identification seekers, buying products and services which are not only useful to them but which, in being used, also confirm self-image. In turn, their product use sends out meaningful messages to others about themselves. If a certain brand of blue jeans can effectively position itself

as "young, sexy, and on-the-move," for example, those same jeans, in being worn, will send out the signal that the wearer is also "young, sexy, and on-the-move." The same, of course, is true of status automobiles, celebrity-endorsed cosmetics, even orange juice. In this way advertisements become a vocabulary for a public discourse steeped in consumerism.

Although this makes consumers active players through their use of advertising, they are nevertheless always placed in a response mode reacting to the images that advertisers have created. These images tend to become more normalized by repetition as consumers become more accustomed to them and incorporate their images and their implied norms of appearance, gender roles, and social interaction into their own lives. When products fall short of their promise, consumers are then more likely to feel less adequate about themselves as persons.

In the attempt to break through the clutter without using a Unique Selling Proposition (USP) or meaningful product benefit, advertisers sometimes resort to more and more outrageous images to grab attention. This approach, however, often based on borrowed interest, as with images of sex or violence, is susceptible to an upward spiral of ever-increasing shock in order to get attention. For the consumer repetition accustoms and desensitizes, and that which once shocked inevitably comes to be seen as ordinary. This in turn necessitates another push of the envelope by the advertiser.

One alternative to this overstimulation spiral is the use of archetypal images that reach deeply into the psyche. In this respect, some advertising has been devastatingly successful not only in selling destructive products but also in clouding its method of communication. So successful has cigarette advertising been in this that over 430,000 people die of its images each year, initially victimized by a lack of awareness that images are the most potent form of perceptual language.

7

POLITICAL IMAGES:
PUBLIC RELATIONS, ADVERTISING, AND PROPAGANDA

The nation that expects to be ignorant and free expects what never can and never will be.

—Thomas Jefferson

Perhaps no single group has been more involved with image at all of its levels of signification than politicians—from the public conception of who the person is and what he or she "stands for," to the carefully constructed images disseminated to the media as "news," to the archetypal and nationalistic imagery used in political ads. Political imagery, in fact, cuts horizontally across the vertical currents of public relations, advertising, and propaganda. Nowhere is this more apparent than in the political images surrounding presidential campaigns, propaganda, and war.

Hill and Knowlton's PR War Effort

The Gulf War in which America interceded against Iraq on behalf of Kuwait in 1991 provides a variety of examples of how images can be particularly effective in emotionally moving mass audiences through visual stories, and in functioning as political rhetoric to manipulate public sentiment and influence foreign policy. In war, images are particularly crucial in defining the reasons for becoming involved, for rallying the support of the nation and maintaining morale, and for motivating soldiers to kill or die. All wars depend heavily on imagery for their maintenance and support.

For most Americans raised in a predominantly Judeo-Christian culture, the Middle East is a political and social enigma. When Iraq invaded Kuwait in August 1990, few Americans understood the basic issues of the conflict, yet they supported America's intervention in it. Watching key televised events, they believed they were seeing history

unfolding and they trusted their eyes and hearts in interpreting and understanding it. Yet much of what they saw and understood was manipulated for effect:

In 1990, for example, an anonymous Kuwaiti refugee named "Nayirah" delivered an emotional appeal before a congressional caucus hearing, a news event that moved the nation to moral outrage. She had personally witnessed a number of atrocities in Kuwait when Iraqi troops invaded, she said, but one image that she used was particularly compelling: in one hospital, newborn babies were torn away from their incubators and left to die. It was a powerful image, described with tearful sincerity. Those who did not see and hear her testimony as it was given caught it on the evening news, and most newspapers immediately featured her story in the most prominent way. It thus reverberated through the American society. President Bush used it as a touchstone symbol of inhuman depravity in several of his speeches on the war and on Saddam Hussein.

That November, as the United Nations was debating the use of force against Iraq to drive its forces out of Kuwait, another young woman, Fatima Fahed, testified to other atrocities, giving detailed firsthand accounts of the horrors inflicted there by the Iraqis. Again, the nation was moved by the stories and the attractive young woman. Videotapes taken before the U.S.-led invasion showed other morally repugnant actions, as when apparently peaceful Kuwaiti demonstrators were openly fired on by Iraqi troops.

What was significant about all of these news events is that none of it was what it seemed. In truth, the New York Public Relations firm of Hill and Knowlton had been hired by an organization called "Citizens for a Free Kuwait," funded primarily by the Emir of Kuwait specifically to develop support for American and United Nations (U.N.) intervention. According to subsequent revelations by John R. MacArthur in the *New York Times*, Morgan Strong in *TV Guide*, ABC's 20/20, and CBS's *60 Minutes*, Hill and Knowlton on behalf of their client had scripted, costumed, and rehearsed the fictional scenarios with the two women in order to incite the American public indignation: Nayirah in reality was the daughter of Kuwait's ambassador, and Fatima Fahed was the wife of Kuwait's minister of planning and a practiced Kuwaiti TV personality. Videotape footage shot inside Kuwait was recontextualized to make Iraqis appear to be the aggressors when the reverse apparently was true in the particular situations recorded. Although none of this suggests that Iraqis committed no atrocities, what it does suggest is that much of the support for the Gulf War was the result of a well-orchestrated, well-funded, and highly successful public relations effort paid for by a foreign government.[1]

Another one of the things that made this war unusual was that it was the first fully televised one. Although reporters extensively covered the Vietnam war on television, for example, the coverage rarely was live, and it was not continuous. In the Gulf War, however, CNN gave continuous 24-hour coverage, and as a result, viewers gained a false sense of seeing what was really happening and came to believe certain ideas that had no foundation in reality.

After the war began, the engineering of television imagery reverted to the military, which according to Reagan image-maker Michael Deaver, was a masterful "combination of Lawrence of Arabia and Star Wars."[2] The entire war lasted four weeks, cost the American public $61 billion and, according to secret reports and a Red Cross estimate, the lives of up to 200,000 Iraqi and 150 U.S. soldiers.[3] People were glued to their TV sets for hours on end, even when coverage consisted of only small blips on the screen, trusting that what they heard was true. One of the images that seemed to epitomize the war to many people was the image of a bomb being accurately placed down a target chimney. It was replayed again and again on CNN, which achieved its highest ratings ever, reaching up to almost 11 million homes during television primetime.

On TV, it seemed that the American combat technology was unbeatable: we could put our bombs exactly where they were meant to go, and this implied a clean technowar closer to the kind played in video games than in real life.[4] Video technology, was, in fact, an important part of what has been dubbed by media critics as "The Nintendo War" both because the war coverage, with simulations filling in for true action, made it look that way, and because soldiers fighting in the war saw their experiences within this context. While research by Morgan, Lewis, and Jhally showed that heavy viewers were more inclined to believe that "the war was being fought cleanly and efficiently with smart bombs that were damaging only buildings,"[5] in reality, of the 88,500 tons of bombs dropped, 70 percent missed their targets.[6]

In fact, the more people watched, the researchers found, the less they understood about what they were seeing or even about the basic issues that caused the war in the first place. Although heavy viewers were likely to know the names of the chief players and the weapons in the war, such as Joint Chiefs chairman General Colin Powell and General Norman Schwarzkopf, and the name of the "Patriot" missile, for example, they were also more likely to mistakenly believe that Kuwait was a democracy before the war. They were also less likely to know that the United States had sided with Iraq in the Iran–Iraq war, or that the United States had told Iraq before the invasion that there would be no ramifications if it invaded Kuwait.[7]

Much of this was the result of tight military control that not only censored reports but also restricted journalists' freedom to visit the front, to talk to troops, or to see war damage without military escort.[8] Journalists from nonparticipating countries found it difficult or impossible to get visas, pools were established so that the total number of journalists allowed access to information was severely curtailed, reports were censored and had to be distributed for common use, and journalists who attempted to step outside the rules faced loss of credentials and deportation.[9] According to communication researcher Nohrstedt, the result was media coverage that fulfilled only military and propagandistic aims but that lacked any tangible evidence of human suffering: "There was no body count as in Vietnam, and the image of a clinical, computerized war, which glorified the technological superiority of the alliance, penetrated all media."[10]

Although some military criticism was directed at reporter Peter Arnett's coverage of the bombings of what Arnett called a baby-formula factory (which the military called a production facility for biological weapons) and a civilian bomb shelter (which the military identified as an underground military command center),[11] what the public saw for the most part was a steady stream of computer simulations of the action, live-action "smart bombs" apparently hitting their targets, and interviews with military strategists.

What the public did not see, however, was combat itself, the resolution by House Banking Committee chairman Henry Gonzalez to impeach President Bush, massive public rallies in opposition to the war that erupted in Japan, Spain, North Africa, and other nations, or what soldiers referred to as their "turkey shoot" of fleeing Shiite and Kurdish conscripts.[12] Although part of the reason for this lack of coverage was military control of information, part of it was also due to pressure from advertisers who did not want their products viewed within negative contexts— that is, "surrounded by images of death, pain and destruction."[13] Because advertisers were "skittish about war coverage," lost advertising revenue totals rose as the war went on, for a combined sum of at least $125 million for the three commercial networks and $18 million for CNN, which had raised its rates to reflect its increased audience.[14]

In 1985, Neil Postman had argued that "viewers know that no matter how grave any fragment of news may appear . . . it will shortly be followed by a series of commercials that will, in an instant, defuse the import of the news, in fact render it largely banal."[15] In Gulf War news, this relationship is reversed: instead of networks showing concern that the presence of happy commercials would trivialize serious news, advertisers were asserting their economic right to withhold support from

images that might prime a grim attitude toward their products—fears that have been at least partially supported by some research[16]—leaving newscasters with the prospect of making violence positive, even entertaining, of treating only soft stories, or of losing their financial support. This primary concern over a positive context for messages in order to sell advertising time has obvious though significant dysfunctional consequences for news reporting in general; when lives are bartered for television rating points to keep sponsors happy, it has also profound ethical and moral implications for the media industry and the public.

In the Gulf War, people believed they were seeing reality unfolding before them instead of understanding that they were really seeing only a version of events, primarily because no intermediary was immediately visible. In part precipitated by a public relations firm on behalf of a client, in part controlled by political and military motives, and in part filtered by networks in their drive to create the "proper mindset" for reception of commercials, the images which emerged were both less accurate and less informative than people suspected. As a result, viewers came to feel that they were indeed in a position to make informed political judgments.

This sense of immediacy and truthfulness which is the result of watching a steady stream of images interpreted with authority is what George Gerbner warned about as "instant history"—that is, history constructed by technology which "concentrates power, shrinks time, and speeds action to the point where reporting, making and writing history merge."[17] This alteration of history is made possible by the ambiguity of the image—such as the dim blips of missiles seen in the night sky on relatively low resolution TV screens—and the verbal context that interprets it. Such images are responded to immediately and emotionally, without introspection or recognition of complexity. Like the images of *Top Gun*, images of the Gulf War made people feel a kind of conditioned reflex to the image without giving them either the time to reflect or the accurate and complex information necessary to do so. As Condry put it: "People saw the Patriots go into the sky like a Nintendo game, blowing up the Scuds, they thought. Words contrary came later and failed to change those impressions."[18] As discussed earlier, people not only believe what they see, but they must be highly motivated to critically examine it; when they do, they often persist in believing what they think they saw, even after it has been proven false.

When image and voice-over conflict, people will believe the image and ignore the voice-over. Control of the image, therefore, implies perceptual control as well because as Gerber states, "Images of actuality appear to be spontaneous and to reveal what really happens. They do not need logic to build their case."[19] They in fact bypass logic altogether

unless a conscious effort is made to review them. Received directly as "truth," however, there is little motivation to return to images and to analyze them, except in cases such as the O. J. Simpson images which were frozen in time onto the reviewable covers of national print magazines, and seen by people already sensitive to issues of stereotype. On television and in film, however, images are rapid and transient, disappearing faster than we can comprehend their meaning. They are therefore even more susceptible to manipulation through content and context. As one German publication commenting on Gulf War coverage put it: "The impatient television gobbles up all time for consideration, all time for checking and weighing information—the time that democracy urgently requires. . . . Democracy can protect itself only by rediscovering slowness."[20] Because it is clear that media technology is not going to slow down, it is vital that intelligent analysis and critical speculation be introduced into the process of viewing. In other words, TV coverage of the Gulf War provides us with some of the most persuasive arguments for the development and exercise of visual intelligence.

Political Advertising and Public Image

One of the more disturbing political uses of television apart from war coverage, but just as crucial to the workings of democracy, is the manipulation of political public image by advertising experts—people who know how to package and sell their product and how to use media effectively.

In 1952, the Republican Party made United States political history by becoming the first to use television spot ads to promote presidential ambitions—at a time when there were only about 19 million television sets in the country. In so-called "The Man from Abilene" spots, Dwight Eisenhower, from a podium in a studio, in low-angle shot, responded benevolently to questions posed by "ordinary citizens" below and to the left, who looked up at him admiringly. The spots were exceptional because prior to this, candidates had simply purchased half-hour segments of air time to explore issues and state positions; this time the political spots were done as commercials by a professional advertising agency—Batten, Barton, Durstine & Osborn (BBDO)—carefully shot in separate frames and edited together to achieve the desired effect. But what may be most notable is the fact that political audiences did not expect nor suspect the technical manipulation involved: Eisenhower was never in the company of the questioners, his television delivery technique was carefully choreographed, and the dramatic lighting and camera angles were professionally manipulated to give Eisenhower

stature and credibility. His glasses were removed; his clothes were changed.

In short, techniques that had formerly been reserved for commercial sales had moved unsuspected into the political arena, and the result was a landslide victory. Rosser Reeves, one of the most influential advertising men ever in the business and the one who wrote the spots, commented later of Eisenhower, "The man is very good. He handled himself like a veteran actor."[21] Reeves believed in the power of the television image. He had previously tried to convince Thomas E. Dewey to use television advertising against Truman when there were fewer than half a million sets in the country. Dewey refused, thinking it would be undignified. If undignified, it was, however, effective. The Republican National Committee was so pleased by the results that it kept BBDO on retainer to dispense media advice as needed. BBDO subsequently continued to supervise visuals—including cue cards, charts, graphs—and rehearsed four cabinet officers for a television panel in the spring following the election.[22]

Although the "Man from Abilene" spots were a "first" for television, professional advertising men had been in fact actively involved in politics from the turn of the century. In 1916, for example, a four-page insert was placed in the *Saturday Evening Post* and other magazines by Erikson, the GOP's advertising agency, urging Theodore Roosevelt to run for president; by 1917, Congress was for the first time considering the regulation of political ads. In 1918, Albert Lasker, then a partner in the powerful Lord & Thomas ad agency, supervised publicity and speechwriting for Warren G. Harding and even acted as a "bag-man" in paying off one of Harding's mistresses before the election.[23] By 1940, so many admen were involved in political campaigning that Dorothy Thompson lamented that the advertising "hard sell" had become a staple: "The idea is to create the fear, and then offer a branded antidote."[24]

Twelve years after the "Man from Abilene" spots, this "hard sell" technique of getting a vote in less than a minute was perfected to the point where a political commercial caused so much controversy that, while it ran only once on September 7, 1964 during "Monday Night at the Movies,"—like the Orwellian 1984 Apple commercial on the 1984 Super Bowl—it was repeated over and over again in the context of "news." The ad generated by the Doyle Dane Bernbach (DDB) advertising agency for Lyndon Johnson was the now infamous "Daisy" commercial, which shows a little girl counting and plucking the petals from a daisy, and then looking up as an ominous voice-over counts down to a nuclear explosion. Johnson's own voice tells us that "we must love one

another or die," and a voice-over announcer tells us that we should vote
for Johnson because the "stakes are too high for you to stay home."

As Jeff Greenfield comments in *The Real Campaign*, "What the ad's
creator, Tony Schwartz, had done was to demonstrate a power of televi-
sion never applied to political commercials until then: the power to
make implied arguments through the use of voice and image, without
the need to argue those positions."[25] While Johnson's opponent,
Goldwater, was never mentioned by name, nor any argument on the
probability of Goldwater's policies resulting in nuclear war was pre-
sented, the message was devastatingly clear and effective, uniting three
powerful images: child, daisy, and dreaded nuclear bomb mushroom
cloud. Although the Democrats spent little more than half the
Republican advertising budget of $16 million on their commercials,
DDB's manufactured daisy/bomb image dominated the campaign—
combining "Kuleshov effect" and the advertising hard-sell at its best—
and completely overpowered the earlier "In your heart you know he's
right" ads for Goldwater done by the Leo Burnett Advertising agency.

Although political and advertising slogans had always resembled
one another verbally, the "Daisy" commercial announced full force that
it would now be *visual* rhetoric that would carry the day politically, and
subsequent campaigns relied heavily on the same kinds of hard-sell
images based on fear. Two of the most effective were the "red telephone"
ad for Mondale run in 1984 and the "Willie Horton" ads used by Bush
against Dukakis in 1988. When focus groups held during the 1984
primary campaign revealed that in a recession they would prefer Gary
Hart as President, but in an international crisis, they would prefer
Mondale, the red phone as symbol of potential nuclear war with the
U.S.S.R. was born, and the Hart campaign never recovered. The "Willie
Horton" ads used by Bush against Dukakis tapped primal fears and
drove home the image of a liberal whose prison furlough program was
putting criminals back out on the street to prey on the public. Utilizing
the image of a revolving door, the ad featured men walking into prison
and directly out again. Both the ominous red telephone and the revolv-
ing door became symbols that touched the core of voters' political and
social fears.

Reagan's 1984 campaign, which ultimately defeated Mondale, was
also one of the most visual and successful political campaigns ever
waged, utilizing almost $25 million, more than half the entire campaign
budget, on high-production value political advertisements.[26] It was the
most visual presidential campaign yet waged, one that succeeded in sub-
stituting national and archetypal symbols for a discussion of issues and
images for information. The epitome of this approach is seen in the

Republican National Convention's substitution of a political campaign film for the usual nominating speech, which—as part advertisement and part documentary—"marked the coming of age of the televisual campaign film."[27] The move to substitute the visual for the usual verbal rhetoric was daring and unprecedented, yet it clearly showed the faith which the Reagan campaign, under the guidance of the BBDO ad agency's "Tuesday Team" had in the power of images as visual rhetoric.

Written by Phil Dusenberry, BBDO's executive creative director and originator of the "Pepsi Generation" commercials, the film sequenced levels of images ranging from slice of life moments and documentary footage of political events to emotionally loaded cultural symbolism. In the film, interviews with the elderly are joined to clips from the attempted assassination of Reagan, footage of the Normandy invasion, images of the Statue of Liberty under repair, and American flags being waved, raised, saluted, and admired. Archetypal images reminiscent of those used in "Marlboro" ads also appear, with Ronald Reagan as the Marlboro Man riding his horse on his California ranch. The images move in visual cycles, beginning with idealized images of earth, developing into slice-of-life images of people at work, and closing in political images of Reagan mixing with the people, in the hospital or at the White House. The film's closing is a montage of images of the land, its people, its patriotic symbols, and finally Reagan himself with arms over his head in a victory sign.

When the chairman of the Democratic National Committee strenuously objected to the airing of the film as part of convention coverage, complaining that the Democratic Mondale campaign film had not been aired because it had been considered a commercial, the controversy ironically ensured that it would be seen, since it was now a news event. As a news event, the networks had few reservations about showing it at least in part; in the end, both CNN and NBC aired the whole eighteen-minute film, and ABC and CBS aired excerpts. The blurred association among political coverage, structured news events and news coverage of actual events created only temporary discomfort, however, for as researcher Joanne Morreale points out, by the next presidential election, both Bush and Dukakis had developed the same kind of films to precede their acceptance speeches at their respective conventions. Both were aired without generating any controversy at all.[28]

By the 1992 election, in fact, candidates had become so visually oriented and so public-relations savvy that two tools of image manipulation dominated the scene: "VNRs" and focus-group research. VNRs (video news releases), like their public relations print counterpart "press releases," are pieces written and developed to support a particular point

of view. The idea is to produce a visually slick video with carefully managed content that resembles a news report closely enough to get favorable press coverage without paying for it and to influence decision making in some way, from product purchase to political voting. Traditionally, such well done press releases in print have appeared so similar to actual news articles that presses have often merely changed a few words and run them "as is." Sometimes reporters will add their own bylines, but with only a few alterations, submit them substantially unchanged.

In the case of VNRs, visual footage is often used in part or in full because stations have cut back on personnel in recent years—particularly after the losses incurred in their coverage of the Gulf War—and such professionally done "freebies" are welcome. They fill in for an overtaxed staff; and in contrast to relatively unexciting news, VNRs are visually rich stories that serve the station's purposes by keeping audience interest. The danger, of course, is that they are in fact biased sources masquerading within a trusted context as objective ones. VNRs may also bump significant but nonvisual stories simply because they are slicker and more visually interesting to watch, the product of more time, effort and money by vested interests. When reporters take the material and add their own names to them, the stories also take on the additional credibility associated with reputation.

In the 1992 presidential election, VNR successes inspired candidates to take a hard look at the traditional campaign trail techniques. For candidates, the decision to purchase satellite time (for about $600 an hour), and produce and distribute spots from a central location or to beam into interviews by local news anchors is both a cost-effective and a politically strategic one. Local anchors are often awed by the possibility of interviewing a presidential candidate live and conduct their interviews accordingly: questions become predictable and soft, and the overall tone remains uncritical and celebrity-driven. By staying in one place, candidates also have the potential of reaching television stations nationwide at a total cost of about $20,000—as opposed to the $50,000 cost for a thirty-second commercial during newscasts, if it is allowed at all.[29] Ultimately, such satellite interviews accomplish three image-oriented achievements: at low cost, they enhance the local anchor's image by joining him or her with a presidential candidate, thereby making the interview more desirable for the station and easier for the presidential candidate to get local access; they make the candidate appear more grass-roots oriented and attuned to local concerns; and they allow for the kind of target-marketing and nuanced image tailoring that is the lifeblood of all successful advertising campaigns.

Just after announcing his presidential candidacy, Bill Clinton con-
ducted about forty interviews with stations in twenty-five states without
ever leaving the local Arkansas television studio.[30] Thus able to bypass
scheduling red-tape at the national broadcast level, he avoided the prac-
ticed scrutiny of top network journalists, and easily reached and
impressed localized audiences by directly addressing their particular
concerns—all without purchasing more expensive advertising time or
suffering travel inconvenience and the financial and physical energy
drain that it implies. As the underdog in the election, this was more
advantageous to Clinton than to Bush who already had national expo-
sure and was building a platform on international issues.

At the same time, focus groups (small representative groups of
people brought together to speak about various areas of concern, and led
by qualified professionals) conducted at various stages of their cam-
paigns allowed both Clinton and Bush the opportunity to tailor make
their public images and broadcast their messages in a form most palat-
able to voters. When a fifty-one-minute Bush campaign speech got no
significant audience response from a focus group until its conclusion, for
example, a commercial with a different slant was shot the next day in
time for the New Hampshire primary.[31] When the Gennifer Flowers
scandal broke during Clinton's campaign, and focus groups registered
that they were impressed that he went out and met groups of reporters,
the campaign launched a successful "meet the press" strategy. When
focus groups didn't like his hair, he had it restyled.[32]

Such focus groups were first conceived to study the effect of the
American propaganda series directed by Frank Capra of *It's a Wonderful
Life* (U.S.A., 1946) fame. The series, which consisted of seven feature
films[33] and was originally designed for showing to the armed forces, also
became part of a research effort that tested how successful the films actu-
ally were in raising morale and in motivating soldiers to the war effort.
The "focused interview," where individuals were asked specific in-depth
questions, was an essential part of the evaluation, and one that yielded
surprising results—showing that some scenes even provoked reactions
opposite to what was intended. Initially disappointing to behavioral sci-
entists because the series seemed to have little effect in changing atti-
tudes, ultimately, however, the very fact of its limited effects led
researchers to understand more about the complexity of the process of
media influence and to abandon a simple formalized theory of direct
manipulation and persuasion techniques in favor of more subtle, multi-
variate models.

The focus-group approach also had profound effects on research
methodology for future advertising and politics. Marketers—the first to

adopt the qualitative research method—found focus groups helpful in gaining consumer motivational insights and even in formulating language for ads to which consumers could relate; later as politicians began to adopt successful marketing and advertising techniques for their own purposes, candidates used focus groups to track attitudes hidden in traditional voter opinion polls, to formulate promises and concerns for political platforms adapted to what people wanted to hear, to identify opponent vulnerabilities, and to head off problems down the road. By 1992, it was estimated that voters saw not a single ad that had not been tested before a focus group first.[34]

What all of this ultimately means is that the voting public cannot afford to be naive about the way visual political messages are formed, how a specific impact can be engineered, or about the possible bias of the television message. The electronic media has created a politics of image different from its counterpart in print journalism—one where political figures become media celebrities, VNRs masquerade as hard news, and both TV personalities and political personalities alike manipulate the media to gain the highest audience approval ratings. Politics thus has evolved into a business of manufactured images. Its visual language has become a means of influencing attitudes in subtle and often undetected ways, and whoever controls the visual message wields power in shaping public opinion.

In the twentieth century, nothing illustrates the danger inherent in this power better than Adolf Hitler or the images of the Third Reich.

Images of Hitler

Among the most powerful images and symbols used by any politician is the flag. Because of this, it is not surprising that the foundation of Hitler's careful political design and the importance of symbolism can be seen in the design of the Nazi flag, which he used effectively to incorporate mythic and cultural meanings into the everyday level of existence. As propaganda researcher Zeman notes,

> The flag was the centerpiece of the Nazi decorative scheme. . . . It was the subject matter of many of their songs: it provided the hypnotic, repetitive pattern for the backcloth of their public meetings. . . . The red stood for socialism: the white of the central circle for nationalism. But the significance of the swastika—a Sanskrit word for good fortune and well-being—the main part of the emblem . . . became the symbol of infinity, of the sun, of recreation; it was found on the textiles of the Incas, on relics in the excavations in

Troy, in the catacombs in Rome. It was one of the sacred signs of Buddhism . . . For Hitler, the sign had . . . racial connotations, symbolizing the victory of the Aryan man and of creative work, which "in itself has been eternally antisemitic."[35]

Because the flag as a cultural symbol embodied powerful archetypal yet ambiguous meanings, it was central to Hitler's vision and ubiquitous throughout the Reich's propaganda efforts. Such layering of meaning suggests the archetypal through the specific; as the semiotician Peirce noted, in signs there may be a great deal of overlapping of categories, and little if any exclusivity. In director Leni Riefenstahl's *Triumph of the Will* (Germany, 1936), for example, Hitler dramatically uses the ceremony of the "blood flag"—the official flag stained with the blood of Nazi martyrs—to touch the new flags presented to his Storm Troops. Symbolically this allowed the blood of the dead to flow into the blood of the living and give military purpose to the present. At each flag presentation, as Hitler pauses grimly and rifles are fired, national pride is channeled into war.

All visual and verbal images repeated in Nazi propaganda similarly flow into and out of cultural past and present; the ubiquitous Nazi flags, flames, banner insignias, and especially the swastika itself, are rife with associations on every level and are designed to bring the memory of the past into current consciousness. In addition, Hitler invoked religious symbolism, incorporating in his speeches the Catholic imagery into which he was born, deliberately conjuring the myth of the savior and its association with blood. In *Triumph of the Will*, for example, Hitler tells his Hitler Youth, "You are flesh from my flesh; blood from my blood," and admonishes Party members: "Our total image will be that of a holy order; only the best will be Party members. Today we expunge what is bad. What is bad has no place among us. It is our will that this state will last 1,000 years. The Party is a symbol of eternity." Combining religious fervor with militant nationalism through the flag, he reminds his soldiers of the humiliation of World War I by listing the major battles, lowering flags to the ground, and then with a snap, raising them with the proclamation, "You are not dead; you live in Germany." As the parade of flags approaches Hitler's raised platform in the film, soldiers are so closely packed together that the mass has the appearance of rippling water, which literally parts, like a Red Sea. Of the spectacle, William Shirer says in his *Berlin Diary* that "Borrowing a chapter from the Roman church," Hitler was "restoring pageantry and colour and mysticism to the drab lives of twentieth century Germans." The Nuremberg meetings, he says, "had something of the mysticism and religious fervor of an Easter or Christmas Mass in a great Gothic cathedral."[36]

Black and white photos of Adolf Hitler that were created especially for an advertising campaign conceived by Goebbels in 1935 also show how attention to image can be effective in manipulating public opinion. Mass produced as coupons included in packages of cigarettes, the photos show Hitler in various situations and poses designed to enhance his public image and personal aura. The pictures could be mounted alone or pasted into a special album manufactured just for this purpose. Almost all of the ad campaign photos are taken outside, from a slightly low or low angle and lit by natural sunlight. Hitler is shown genial, relaxed, sociably mixing with other people, usually with a child whom he affectionately hugs, pats, or gazes on dotingly. In one exception to this format, Hitler is shown in uniform at a (democratically) round dinner table, at a slight distance from the camera, talking sociably with a smiling Goebbels and others. The shot is taken from a slightly high angle, and prominent in the foreground is a large symbolic pot with a large ladle.[37] The high angle accomplishes two things: it allows us to see into the half-full pot, and it emotionally registers Hitler as one of the people. The "one-pot" meal was a nationalistic drive to save money that could then be given to Nazi charities.

This was when Hitler's popularity and power was on the rise. When he achieved absolute power, other people disappeared from pictures of him, and official portraits always showed him from a low angle and always with a serious expression. This was quite deliberate. Hitler felt that any sign of human weakness in a photographic image or portrait painting could be fatal to the public image of strength that he and his propaganda efforts had so carefully constructed. His concern over public image was so strong that he refused regular physical examinations, particularly when he felt ill, because he was sure the news would leak out.[38]

His official photographer Heinrich Hoffmann, for example, was not allowed to publish any photos of Hitler that showed him playing with his Scots terrier because it was not a German breed, or wearing the glasses he always used for reading, because this could reveal a physical weakness and an intellectualism that the Party had associated with the Jews.[39] He understood well the power of the image and dramatic presentation, and from his first political ambitions, he planned a visual campaign to create a new German culture by controlling artworks and films and by promoting a particular style of public and government architecture. For every detail, the psychological effect of the visual was weighed, and while Hitler ultimately proved inadequate in military strategy, the visuals that delineated his rule were consistently effective. For example, while other 1932 presidential candidates included slogans on their

campaign posters, Hitler's election poster shows only his face lit as if from within. His eyes are darkly riveting and serious, and the name "Hitler" is reversed out against a totally dark background.

Both in his official portraits and in Leni Riefenstahl's propaganda films that he himself commissioned, Hitler appears as if bathed in light from above, and always above the crowd. The painted portrait by Fritz Erler, which constituted the main exhibit at the Great German Art Exhibition in 1939, is typical: viewed from a low angle, standing firm on granite blocks symbolizing the power of the Third Reich, Hitler is placed against a dark shadow, but is unnaturally bathed in light about his head, shoulders, and boots. At the beginning of *Triumph of the Will* when Hitler emerges from the clouds and, standing, rides through the city in his open car, sunlight dances on him. Low-angle close-ups of his hand out-stretched in the Nazi salute are particularly effective as light seems to emanate *from* them. Both he and the Reich's eagle, shot low angle against the sky, figure predominantly throughout.

Because Adolf Hitler also understood that relative size, closely related to distance, has psychological implications of importance, he paid close attention to it, particularly in public spaces. Believing that he had a natural talent for architecture, for example, he instructed his Reich architect, Albert Speer, on the monumental scale for the architecture that was to be an integral part of the Third Reich. Speer called Hitler's concept "architectural megalomania,"[40] designing structures and choreo-graphing architecturalized propaganda images on a grand scale for him, including the Nuremberg rallies, where 200,000 troops became solid columns supporting the platform from which Hitler addresses them en masse before 100,000 spectators. This image, captured so well in *Triumph of the Will*, was a crucial one both literally and figuratively within Nazi propaganda, for its whole purpose was to immerse the individual within the mass and to surface and exploit a latent mythic German unity.

As the official record of the Sixth Nazi Party Congress held at Nuremberg, September 4–10, 1934, the film's action as well as its sets were entirely manufactured for the proper visual and emotional effect, both as a spectacular mass meeting and as a propaganda film—Goebbels called it "the great film vision of the Führer."[41] The architecture of the halls and stadium, and all of the ceremonies, parades, marches, and pro-cessions were designed with the film camera in mind as the chief means of spreading propaganda. To the outside world, Hitler was determined, Germany would appear a undefeatable massive fortress. Within Germany itself, mass rallies, demonstrations, and parades would form the societal glue that would unify the cause and turn individual con-sciences into group-think. Speer himself invented the "cathedral of light"

which took place at night within a symbolic sacred ring enclosed by anti-aircraft searchlights. Of the effect, Speer said,

> The actual effect surpassed anything which I had imagined. The hundred and thirty sharply defined beams, placed round the field at intervals of forty feet, were visible to a height of twenty to twenty-five thousand feet, after which they merged into a general glow. The feeling was of a vast room, with the beams serving as pillars of infinitely high outer walls.[42]

In the architectural plans for a Nuremberg Party Rally Site which was never built, Speer designed a 400,000 seat stadium so large it could encompass a building three times the pyramid at Cheops, and a statue 60 feet taller than New York's Statue of Liberty. Hitler's plan for a new Berlin, inspired by the Champs Elysées of Paris, also included buildings proportionate to the psychological power of the Third Reich. As Speer describes it, Hitler wanted an arch of triumph 400 feet high (the Arc de Triomphe is 160 feet high), and a central avenue two and a half times longer.[43] Of Hitler's new capitol building, the Reich Chancellery in Berlin, which was the only building of Hitler's new planned capitol ever to be built, Hitler purportedly told Speer: "On the long walk from the entrance to the reception hall they'll get a taste of the power and grandeur of the German Reich."[44] The reception hall was Hitler's only disappointment because he felt it should have been three times larger.

Although parts of the Chancellery, such as the Cabinet Room, were never used, the building itself nevertheless fulfilled its symbolic function perfectly, for it was of a size and proportion to reflect the larger than life blood-myth of the German people. This myth had also been at least partially fostered by size and image in the national legacy of nineteenth-century political chauvinism, and was induced frequently to overcome the sting of the German defeat in World War I. Pictorially, Boulding suggests that a grand nationalistic though delusionary image had also been fostered through school atlases of the old German Empire. Because the United States and Germany each occupied a full page in the atlas, the visual impression was one of equal power. German youth may thus have been led to form a mental image that seriously overestimated German capabilities in relation to those of the United States in the first World War.[45]

This placement of parts in relation to one another and the "blocking" or position within a given scene was always a conscious part of every design of the Third Reich, particularly in relation to roles and power within social and cultural contexts. For example, when Speer inadvertently discovered the plans for the Soviet pavilion that was to be

built next to the German one at the 1937 Paris World's Fair, he threw out
his original plans and designed the German pavilion as if it were check-
ing the onslaught of the Soviet pavilion that had a pair of 33-foot Soviet
figures striding triumphantly toward the German pavilion. Speer's
design, for which he earned a gold medal, involved a cubic mass ele-
vated on stout pillars, with a giant eagle grasping a swastika in its talons
and looking down from a tower onto the Russian sculptures.[46] Such posi-
tioning left little doubt in the psychology of balance of power.

Both the Nazis and the Soviets were particularly attuned to such
visual power, and both exploited architecture and mass rallies in the
same way. Both also believed fully in the power of film, and both pro-
moted and kept tight control over them. Hitler himself was profoundly
affected by film, particularly by the architecture of such films as Fritz
Lang's *Metropolis* (Germany 1926), and before the war he is reported to
have seen every film, both domestic and foreign, to be distributed in
Germany, usually ending each evening with a showing of two films after
dinner. When censors were in disagreement on a film, it was Hitler who
passed judgment.[47] Hitler even legislated the moral content of German
films, mandating, for example, that any female character who broke up a
marriage die before the film's end.

Under Goebbels as Minister of Propaganda, the industry was
tightly controlled: Goebbels personally viewed every one of the 1,363
films produced during the twelve years of the Third Reich, as well as all
newsreels, cartoons, documentaries, and shorts. Under his orders, film
trucks were dispatched throughout the Reich, special showings were
given at reduced rates, and each official newsreel of the action at the
front was released everywhere on the same day. Many films were cen-
sored or banned; all were scrupulously checked for ideas that might con-
flict with Nazi ideology. *Tarzan of the Apes* (U.S.A., 1931), for example,
was banned because it ran counter to Nazi doctrine on "hereditary
biology."[48] So strong was the control that it lingered well after the Reich's
demise. In 1965, for example, when *The Sound of Music* opened at the city
Palast in Munich, one-third of it was missing. The film stopped at the
point when Maria wedded Von Trapp in order to avoid showing their
escape from Nazi Germany.[49]

Image and Group Psychology

Because Hitler and Goebbels were aware that people's actions are a
reflection of their own self-images, and that self-image is achieved
through interaction with others, they were also extraordinarily successful
in channeling the Nazi vision through images of group psychology in

vast live demonstrations, in uniforms for practically every political function, and particularly in art where as part of "Kulturpolitik," "degrading" art (such as works by French Impressionists and German Expressionists) was expunged from German museums, and books were banned and burned to "purify the public libraries" of dissenting world visions. Hitler's ultimate goal was to establish a new national image, a pervasive mindset in which new forms of creative expression would find inspiration in a mystic and heroic German past, a past that Hitler associated with the music of Wagner and a Nazi interpretation of Nietzsche. In such authoritarian structures as Hitler envisioned, history shows us, image becomes all-important as a societal glue, defining prepackaged roles, and channeling dissatisfaction toward scapegoats such as intellectuals and Jews. Such an image must also be continually supported by ritual and ceremony, even by overt coercion, and group psychology must be utilized to pressure individuals into social conformity and to encourage their identification with a charismatic leader.

Through his use of symbols and ritual, Hitler was able to meld the Germany of the present with its mythic past and so transform a nation in chaos into what Freud called "a group mind." According to Freud, in the group mind, the key figure is the leader who becomes the individual members' superego and takes over their critical faculties as the group conscience. The nature of the attachment of the members to the leader is found in a desexualized libido, libido being the energy force (eros) of the life instinct to establish unity and to bind together to preserve this unity. The leader draws from a basic group-forming instinct as strong as the instinct for life itself, yet maintains no emotional attachments and must be independent, self-confident, and of "masterly nature." In short, the leader represents all those qualities unavailable to common group members, but toward which they continually yearn.

According to Freud, as discussed earlier, the ultimate result of the formation of a group is an emotional intensity raised to a pitch that would seldom if ever be reached outside the group. It is a pleasurable experience for the group members to surrender themselves completely to their passions, losing a sense of individual limitation, and the emotional release is infectious: as it effects the same release in another, the passion is mutually enhanced and intensified. Because the group is naturally inclined to extremes, it is excited only by excessive stimulus, which means that the leader's argument need have no logical force: "He must only paint in the most forcible colors, he must exaggerate, and he must repeat the same thing again and again."[50]

Albert Speer, an upper-middle-class intellectual who might be thought of as naturally resistant to such manipulation, commented:

"Both Goebbels and Hitler had understood how to unleash mass instincts at their meetings, how to play on the passions that underlay the veneer of ordinary respectable life." Goebbels well knew how to whip up "wilder and wilder frenzies of enthusiasm and hatred."[51] All of this repelled Speer, yet he too was transformed in listening to Hitler speak:

> He spoke urgently and with hypnotic persuasiveness. The mood he cast was much deeper than the speech itself, most of which I did not remember for long. Moreover I was carried on the wave of the enthusiasm which, one could almost feel this physically, bore the speaker along from sentence to sentence. It swept away any skepticism, any reservations. Opponents were given no chance to speak. This furthered the illusion, at least momentarily, of unanimity. Finally, Hitler no longer seemed to be speaking to convince; rather he seemed to feel that he was expressing what the audience, by now transformed into a single mass, expected of him.[52]

Such staging emphasizes the role that image plays in relation to words, for in such displays, the words matter very little except as they serve to build the general mythic image of the unified Reich—which was everywhere supported by flags, banners, and lighting effects—and provide verbal touchstones like an objective correlative for the primal passions, such as the vilification of Jews. "In such an atmosphere," Shirer commented, "every word dropped by Hitler seemed like an inspired word from on high. Man's—or at least German's—critical faculty is swept away at such moments, and every lie pronounced is accepted as high truth itself."[53]

Conclusion

Arguing that there is in fact an "old" print politics and a "new" politics that invests political messages with the personality and characteristics of electronic media, researchers Robinson and Sheehan in 1983 concluded that the electorate has come to see politics the way the networks present it, not the way it once appeared in traditional print. In their view "the media agenda becomes the public agenda; the tenor of the media influences the tenor of the times; exposure to television fosters a political response in keeping with its own style and substance."[54] Television thus changed political coverage not only by influencing the presentation of the message to accommodate the medium and then altering its content accordingly, but also by establishing its own issues, which in turn have been exploited by politicians, demagogues, and the military who understand both the medium and how to tap into its vulnerabilities.

Within the media-created political environment, political figures alter delivery styles to become more like credible anchor persons; action news-type "media events" dominate political coverage; media personalities become more like politicians with their own career agenda, just as politicians become more like media personalities, issuing VNRs that can be easily translated into news stories. These skills arising from visual awareness are generally unmatched by the viewing public, who still tend to treat what they see as truth, rather than as deliberate constructions driven by political or economic motivations. Even research analysis of news and political coverage still tends to ignore the significance of visuals, with the effect that often the visual substance of the message and its effects go unexamined. As Bruce Gronbeck noted even in 1978, "Historically, verbal acts have occupied most of the attention of communication analysts . . . [because] 'rhetoric' and 'communication' traditionally have been defined in terms of 'words' and . . . 'political communication' has been dominated by researchers nurtured in speech communication departments in universities."[55]

Images from the Gulf War, however, reveal how manipulated images can exploit apparently objective news and documentary forms to produce a semblance of truth through "images of actuality" that "appear to be spontaneous and to reveal what really happens." Images from advertising and propaganda show how cultural and archetypal images and symbols can be used to tap the personal psyche, and while there gain strength and grow. The Third Reich showed how attitudes and behavior can be controlled at every level of personal, social, and political existence through the manufacture of visual images that bypass linear logic and convince by association.

Ultimately, all images are both political and personal, because their ramifications extend into both conscious and unconscious realms and affect every area of our existence: the nation that expects to be *visually* ignorant and free expects what never can and never will be.

8

MEDIA IMAGES AND VIOLENCE

They're guilty of murder. We all are—me, too.

—Ted Turner, CNN

By the time a student graduates from high school, he or she has spent an average of about 13,000 hours in school and 25,000 hours in front of the television set. Today, because of the increasing amount of violence on television, this means 18,000 hours of visual conditioning dominated by violence. The American Medical Association has estimated that by the time a child completes elementary school, he or she has already witnessed well over 8,000 murders and 100,000 acts of violence. The National Coalition on Television Violence estimates that children in homes with premium cable channels or a VCR will witness 32,000 murders and 40,000 attempted murders on the screen by the time they are 18 years old. In the inner city, estimates for media exposure to violence go far beyond this.

Exactly what effects this exposure causes has been the source of continuous debate from the early days of television, with media gate-keepers insisting that the programming is a response to audience interest and demand, and media's critics insisting that television itself creates the demand and in turn promotes ever-increasing violence within the society. Because visual media are only part of the many influences in our lives that combine to formulate attitudes and behavior, however, research has always been vulnerable to the chicken-or-egg question of which came first: Do violent television programs and films encourage violence? Or do people who have a predisposition to violence simply prefer violent programs and movies? The problem of a variety of other potential causes for violent behavior has also promoted an inevitable circle of finger pointing in fixing responsibility.

To further complicate the problem, terms used in research studies and in describing research results are often confusing and even may connote unintended positive or negative valences in differing contexts.

"Aggression," for example, may generally be defined as hostile action toward either people or property, but some research indicates that it is important to separate hostile responses from aggressive responses in evaluating them.[1] Aggression may also take a variety of forms from violence to verbal assault; it may be apparently provoked or unprovoked; and many studies in aggression have included extreme criminal and violent acts, while others have not. Conclusions, therefore may be over-generalized to include situations to which they do not apply.[2]

The term "violence," too, has generated confusion, although it has generally been defined in media research as overt physical action against people that hurts, kills, or threatens to do so. In some studies (in many Canadian studies, in particular), however, destructive acts against property have also been included. Many statistics used to describe violence on television, for example, include such things as car wrecks in the number of violent incidents.

In all, over 2,500 books and articles have been written on the effects of television and film on viewer behavior.[3] Hundreds of studies have been examined, and yet there is as yet no clear-cut agreement on exactly what to conclude from them in terms of linear causes and effects. Many researchers and theorists, however, see media violence not as a direct cause necessarily but rather as a perceptual influence and a major environmental factor in developing destructive attitudes and a predisposition to violence. Some earlier studies have dealt with television as a catharsis for individual anger and frustration through vicarious experience, while others have seen media as a priming effect that promotes behavioral violence. Social Learning Theory and Cultivation Theory place media influence within a complex of causative factors and look at it as having far-ranging personal and social implications.

The primary focus of this discussion will be on how violent media images, including destructive actions against people and property, may contribute to producing a mental image of the way the world works, and how this mental image in turn may influence subsequent perception. When the image of violence is accompanied by excitement, the "emotional memory" remains and may be primed into violent action by a variety of causes, including pleasure seeking. As has been argued throughout, it is ultimately the image that determines behavior. In the formation of this image, media plays an important role, sometimes a crucial one.

Physical Causes of Violence

Violence has, of course, many potential causes. Attention Deficit Disorder with Hyperactivity (ADDH or ADHD), for example, is known

to predispose people to violent behavior. The result of genetic factors, possible brain damage particularly due to oxygen deprivation during birth, and some environmental factors, ADDH has proven in general to be a fairly reliable predictor of violent tendencies. Hyperactivity, impulsiveness, limited attention span, emotional outbursts, a tendency to take risks, and a low level of tolerance for frustration are all symptoms of the disorder, which affects approximately 3 percent of American children. Schizophrenics, too, show a susceptibility to violence, as do people diagnosed with "psychopathic personality disorder."[4] While there has been much controversy surrounding exactly what constitutes psychopathy, however, what is generally agreed on is the process by which violence works neurologically.

Most neuroscientists concur that the sites within the brain that are most important in triggering behavioral violence are the amygdala, the hippocampus, and hypothalamus within the limbic system, and the frontal and prefrontal areas of the brain.[5] "In the presence of a barely measurable electrical impulse within the limbic system," author and neurologist Richard Restak comments, for example, "Our much vaunted rationality can be replaced by savage attacks and seemingly inexplicable violence."[6] He cites cases such as that of lawn maintenance worker David Garabedian whose legal defense for killing a woman while he was treating her lawn with insecticides was based on chemical brain poisoning by the products with which he was working. Chlorpyrifos, the chemical mixed and spread by Garabedian, is known to interfere with neural transmissions in the brain, and therefore with cognitive inhibition. When Mrs. Muldoon yelled and scratched at him for urinating on her property, the normally mild-mannered young man strangled her and then threw boulders weighing fifty or sixty pounds at her head. Garabedian's description of what happened to him is remarkably like what Daniel Goleman has described as an "emotional hijacking."[7]

Such emotional "hijackings," first discussed in Chapter 1, can appear to be totally foreign to the person's nature and outside of his or her own control. Although Garabedian's example is an extreme one, what such incidents of violence have in common with other people's everyday behavior is that in the fundamental principles of brain activity, the preeminent role is played by inhibition.[8] Anything that physically decreases inhibition, like alcohol, also increases the likelihood of violence. In the world of street-drugs, for example, "PCP" (phencyclidine) shuts off the emotional parts of the brain from the influence of the cortex and therefore isolates it from the forces of judgment and reasoning. The combination of marijuana, which generally reduces aggression, and PCP can result in explosive and deadly violence.[9]

Just as chemicals can result in the reduced desire or the inability to throw the cognitive "off-switch" to violent behavior, media, too, can interfere by virtue of its speed and sensual stimulation. As experiments revealing a dual perceptual processing system have shown, emotion can be accessed either directly from the stimulus through the thalamus to the amygdala particularly by signaling danger, or more indirectly through a cognitive pathway, from the stimulus to the thalamus, to the cortex, then to the amygdala and hippocampus. In other words, a given stimulus does not have to reach the cortex, the seat of consciousness and higher reasoning, to be processed and emotionally learned.

In neurological experiments involving fear conditioning, for example, it has been found that "declarative memory" (explicit, consciously accessible information) is mediated by the hippocampus, while "emotional memory" (the emotional state, such as fear, evoked by significant events) may be created in the thalamo-amygdala pathway. Emotional learning, therefore is mediated by a different system from conscious processing; it operates independently of conscious awareness and "exerts a powerful influence on declarative memory and thought processes."[10] Emotional and declarative memories are the result of parallel processing, and both are seamlessly combined in conscious experience to form new declarative memories. In this way emotional memory exerts a major influence on later experience.

Childhood is an especially important time in the formation of emotional and declarative memory, because the emotional memory system develops earlier, the hippocampus later. Neurological researchers Jacobs and Nadel, for example, theorize that we may be unable to remember traumatic events experienced early in life because the hippocampus has not yet fully matured to the point where it is able to form conscious memories. The emotional memory system, however, forms and stores unconscious memories of these events that may then affect mental processing and behavior later in life—even though the process by which this occurs remains unconscious.[11]

This may be why Canadian and U.S. studies show a positive correlation between early exposure to television and later physical aggressiveness.[12] The critical period, according to psychiatrist and epidemiologist Brandon Centerwall, is preadolescent childhood. Although later variations in exposure may not exert additional influence, the "aggression-enhancing effect of exposure to television is chronic, extending into later adolescence and adulthood."[13]

Color, shape, and movement reach us quickly and directly on a crude and undifferentiated emotional level, primarily because phylogenetically, our survival depends on it. Appreciation for the transcendent

humanistic qualities that make empathy, love, and social conscience possible, however, is gained through cognitive refinement to which emotional valences are added. Although we respond immediately to apparent danger, and the impact of it stays with us, we must *learn* to appreciate others and to empathize with them. Although these mix together to form a basis for further judgments, they are essentially different functions, reaching emotion through different pathways. ADDH syndrome shows us that both self-discipline and empathy must be continually taught, and that reactions that involve violence can be and are reduced through appropriate training.

Desensitivity

Desensitization, however, can also be taught, and has become a standard behavioral technique to reduce anxiety levels in coping with a variety of phobias, just as chemically it is a standard means of therapy in treating environmental allergies. Typically, desensitization in treating anxiety disorders combines anxiety stimuli with relaxation stimuli, reducing anxiety with gradual conditioning. The technique works perceptually because the amygdala learns that it can ignore a stimulus once it becomes familiar. After the initially exciting stimulus becomes familiar, the threshold of sensitivity is raised and it takes a more intense stimulus to break through.[14] What is true for allergies and phobias is apparently also true for violence.

Cline et al., for example, found in a study of boys aged 5 to 14 that heavy viewers of violence were less affected emotionally by violent sequences than were those with little exposure to violence.[15] There is also evidence that the desensitization children gain from viewing extends into real life situations as well, so that seeing violence in media makes them less emotionally involved in real violence.[16] Child psychiatrist John Meeks explains that desensitization is a defense mechanism that turns the extraordinary into the ordinary to avoid fear.[17] Continual exposure, however, also creates an impression of normalcy; and the more a child accepts violence as normal, the more likely he or she is to use violence as a natural response in situations of fear, frustration, or even anxiety.[18] A 1992 survey by the American Psychological Association reported that "heavy viewers behave more aggressively than light viewers . . . [and] hold attitudes and values that favor the use of aggression to solve conflicts."[19]

At the same time, other studies have shown that children who are heavy viewers also tend to become less reflective, put less effort into schoolwork, spend less time reading, score lower on academic achieve-

ment tests and on some measure of intelligence, and spend less time with friends, on hobbies, and in outdoor play activities.[20] Although in reviewing a number of these studies at the end of the 1980s, researcher Daniel Anderson found that many were flawed in some way, he ultimately concluded that media "messages form the ways in which you think about the world. Traditionally, societies use stories to teach their children about expectations, about ways to deal with life's problems, about the values supported by the culture. Stories become metaphors, lessons learned throughout life."[21] With the lack of cognitive intervention, something that parents and others must deliberately promote, media stories form the maps by which children learn to navigate life.

In the formation of this map, television and film effectively utilize the color and movement of violent scenes to fascinate and to hold attention; but without the time to cognitively process the meaning of the imagery and to think through its implications, there is no check on the map's accuracy. If the viewing experience is not offset by a cognitive "off-switch," violence can become an integral part of the perceptual map.

Attitudinal Studies and Image: Mean World Consequences

Remembering Boulding's dictum that behavior is response to an image, rather than to a stimulus, it becomes easier to see that it is not simply the single program or film incident that has the greatest impact, but rather the cumulative impact of many images of violence on the individual. Just as the U.S. Navy created the culture in which a variety of uncivilized behavior became acceptable and even commonplace within certain environments, so the continual messages of violence repeated on television and in film create an image of the world that we come to accept and act on.

Research by Gerbner and others shows how the impact of repeated messages can reorganize the whole knowledge structure implied by image. Under the umbrella theory of "cultivation process" Gerbner has traced how "mean world syndrome" can come about when, with the repeated exposure to negative messages, people can become convinced that the world they live in is an inherently dangerous and primarily mean one.[22] What viewers learn from the heavy violence on TV is that "in such a mean and dangerous world, most people 'cannot be trusted,' that 'most people are just looking out for themselves,' that you can't be too careful in dealing with them, and that they will take advantage of you if they have the chance."[23]

When people believe what they see and what they see is a world enmeshed in violence, they expect violence to happen to them, arm

themselves for it, and also inadvertently actualize what they fear—all without understanding how the process has worked or the actual reality behind their fears. What emerges from this continually violent visual landscape is a marked tendency to judge the real world by the exaggerated and violent one seen on TV. Haney and Manzolati have shown, for example, that heavy viewers tended to accept TV themes that are not accurate in reality. These include the assumptions drawn from TV viewing that criminality is a personality trait rather than something that can be promoted by a variety of conditions; and that police are justified in violating the law when tracking down suspects.[24] Heavy viewers also tend to overestimate street crime and to underestimate white-collar crime. Bryant, Corveth and Brown found that after just a six-week dose of heavy viewing of action-adventure programs, viewers became more generally anxious and fearful.[25] British researchers also found that heavy television viewers tended to exaggerate risks from a whole variety of sources such as lightning, flooding, and terrorist bomb attacks.[26] At the same time people become more generally fearful, they also ironically become more desensitized to specific incidents. Through field interviews and content analysis of major print and electronic news sources, Graber, for example, has found that people are more influenced by media images of crime than by official statistics, and that they tend to become desensitized to crime information when there is an excessively large amount of coverage.[27]

The reasons for this excessive coverage in news media is probably more closely related to media competition than to audience demand. In a 1995 nationwide survey, *USA Today* found, for example, that over 96 percent of Americans were very or somewhat concerned about violence, sex, and vulgar language on TV, and 73 percent preferred newscasts with violent images edited out.[28] Networks continue to use violent images as a way of capturing and keeping attention, however, because competition for television ratings, advertising dollars, and box office receipts necessitates getting and keeping attention in the easiest and cheapest way possible. Because our natural interest is spurred by survival instincts, seeing blood compels us to check out the situation that contains it. Even the color red naturally excites us—a device that product package designers and art directors have used to advantage for a good deal longer than television has existed. Together sex and violence are the cheapest common denominator by which to get and hold attention, even though people would prefer to become involved at a higher cognitive level.

The epitome of the cynicism that such coverage inspires and of the spiraling use of violence as an action-packed attention-getter can be seen in Warner Brothers' film *Under Siege* (U.S.A., 1990) which has no plot other than the take over of a ship by extortionists and the retaking of the

ship single-handedly by a "hero" who perpetrates every possible kind of violence on people and things. In the film, for an hour and a half, people are blown up by microwave oven bombs, impaled on spikes, crushed beneath steel beams, hung from the ceiling, drowned, destroyed by missiles, shot, strangled, slashed, and knifed. In the end, the protagonist, played by Steven Seagal, after being ripped by a grappling hook, tears out the throat of one man, and subsequently tells the villain, played by Tommy Lee Jones, that "You and I—we're puppets in the same sick play. We serve the same master. He's a lunatic and he's ungrateful and there's nothing we can do about it." Given this premise, it can hardly matter how many people are destroyed or in what fashion. In the final victory scene, Seagal takes out Jones' right eye and drives a dagger through the top of his head.

By 1995, the combination of violence and cynicism had escalated to the point where *Entertainment Weekly* dubbed fall television "the Mean Season," and described the dominant film trend as "bleak chic," with over a dozen new films fitting the description of "brooding, hyperintense dramas with unsympathetic characters," filled with serial killers, alcoholism, death row, and Armageddon.[29] One of the films, *Seven*, which was number one at the box office for over a month, shows a man force-fed to death, a woman's nose cut off, and a rape torture scene beyond any previous limits. *Entertainment's* review of the film, intending a compliment and revealing how perceptual continuation operates to involve us in the film, commented that "Director David Fincher's canniest trick was to reveal just enough clinical carnage so that we re-create the killings in our heads."[30] One critic concludes that the trend is just reality settling in: "Bleak times breed bleak entertainment," and describes the phenomenon as a rebellion against "the get-happy Hollywood formula" of the 1980s represented by "pure" cops like Arnold Schwarzenegger and "sweet" prostitutes like Julia Roberts.[31]

Faced with having to live in this world, psychologists tell us, many children become traumatized and respond defensively. In a 1993 nationwide study of twelfth graders, 35 percent stated that they didn't believe they would live long enough to become old because they assumed they would be shot.[32] The assumption that other people's motives must always be selfish or destructive, the willingness to see them not as human beings but as irritating objects that we have the right to remove if they get in our way, and the absolute cynicism and moral relativity that all this implies is at the heart of the "mean world."

The implications of believing in such a mean world are far-reaching. Studies show that most children who carry guns to school do it because they're afraid of violence, not because they plan on becoming

violent. Once a conflict starts, however, and aggression levels begin to rise, the probability of using the gun to settle the conflict greatly increases, primarily because boys are afraid of losing respect if they back down. Because media oversimplifies the complex issues of life and presents violence as desirable and even inevitable, young people are increasingly choosing violence as an appropriate way of resolving conflict. And since conflict *is* an inevitable part of life, the opportunities for violent confrontation are always present. As a result, many schools are now in the position of having to install metal detectors to spot weapons as students arrive, and problem-solving techniques such as mediation are becoming staples within the curriculum.

One massive study of five representative Massachusetts communities in 1992, for example, revealed a microcosmic picture of the attitudes, values, media habits, and behavior in students from the seventh to the eleventh grade.[33] Results showed that a significant percentage of students had been involved in violence and that a vast majority of students—72 percent—had witnessed actual violence within the previous month. Forty-two percent of males and 41 percent of females had been involved in a physical fight in the previous month. One in four males reported they had carried weapons. Behind the violence, attitudes that lead to it form a pattern consistent with media imagery: Over 60 percent of male respondents said they felt safer with a weapon. Nearly two-thirds of males agreed that women who dress in sexy outfits are asking for sex. Forty-three percent of males said women brought violence on themselves. Thirty-three percent of females agreed.

The study also showed a statistically significant connection between television viewing habits and violent attitudes: A majority of respondents preferred movies that contained violence. These respondents were also more disposed to approve of violence against women and more likely to believe that it is acceptable to force sex on a woman. Overall, the study showed a significant positive correlation between television and movie viewing patterns and acceptance of rape, sexual assault, violence, and alcohol use.

Deborah Prothrow-Stith, associate dean at Harvard University School of Public Health and author of *Deadly Consequences* recounts an incident that occurred while she was treating emergency room patients in a Boston hospital. A young man, the victim of a gunshot wound, was confused and surprised that the wound actually hurt.[34] At first wondering how this was possible, Prothrow-Stith, with more emergency room experience, came to understand quite well that the media reality of violence without consequence was more powerful to many television watchers than the cause-effect logic of everyday thought.

The media image, it seems, feeds into our natural tendency to believe what we see on an affective level rather than on a rational one. Once drawn into the image, it is only with effort that we counteract initial acceptance, and because the images flow by so fast and are so sensually stimulating that any rational examination of content can occur only after the program or film has been viewed. Under the stress of visual excitement, we do not critically assess ideas presented to us but accept the stream of images and what is associated with them. Later, when we critically evaluate what we have seen, we may understand that certain scenes were unrealistic, but the affective valence of excitement and glamour nevertheless may still remain attached. Subsequent thought cannot vitiate prior experience of the image: it can only put it into a larger context. This may be why, despite our intellectual recognition that weapons kill, maim, and cripple people, as a society we are nevertheless in the process of accepting a level of violence as a normal way of life which other cultures find outrageously shocking, and we continue to seek out and be "entertained" by it in films and television programs.

How Violent Is TV?

Throughout the 1980s, "blood, rapes, car wrecks, and screaming victims" tripled according to the American Academy of Pediatrics, and Saturday morning was the most relentlessly violent time on TV.[35] In the fall of 1987, 80 percent of all children's programming was produced by toy companies, with the biggest sellers that Christmas predictably being GI Joe and He-Man toys.[36] The TV homicide rate rose 27 percent between 1991 and 1992.[37] By 1992, MTV imagery proved to be even a greater source of gratuitous violence for adolescents than the Big Three commercial networks *combined*, and a full 25 percent of 1992 prime-time fall television shows contained very violent material.

By 1993 adult television news was also catching up to children's programming, portraying a world where violence was the norm. Because violence is of natural interest to people, because competition among media have created a climate where "if it bleeds, it leads," and because new media technology allows immediate transmission of widely dispersed stories of violence, news media have become saturated with violence, minimizing the traditional distance between broadsheet newspapers and supermarket tabloids, legitimate news casts and sensationalist news-type shows such as "Hard Copy," "A Current Affair," and "Top Cops." Studies by the Center for Media and Public Affairs showed, for example, that even though violent *adult* crime had leveled off, crime-related media news coverage doubled between 1992 and 1993.[38]

In 1993, one television station in North Lauderdale Florida taste-lessly aired footage of the actual shooting of a woman by her former husband at the grave site of their daughter. The station, alerted to the man's intent, sent a news crew to the site, taped the scene and aired it, as did a number of other stations nationwide. Some media professionals believed this amounted to complicity in the crime.[39] By 1994, talk shows had even begun to feature murderers and the women who love them, and the serial killer Jeffrey Dahmer answered questions like "Why the cannibalism?" for viewing audiences of several talk shows. A Diane Sawyer interview of the infamous murderer Charles Manson broke audience records in yet another television news magazine debut.[40]

In 1992, *TV Guide* commissioned a study of a typical day in the life of television to determine exactly how much violence was then being shown on TV. During an eighteen-hour period, they monitored programs on ABC, CBS, NBC, Fox, PBS, a nonaffiliated station WDCA, and cable stations WTBS, USA, MTV, and HBO. The results were disturbing: apparently more violence was flowing into the nation's homes than at any other time in American television history—a total of 1,846 acts of "purposeful, overt, deliberate behavior involving physical force or weapons against other individuals."[41] Findings showed that cartoons were the most violent (471 violent scenes), followed by "promos" for TV shows (265), movies (221), toy commercials (with 188), music videos (123), commercials for films in theaters (121), TV dramas (with 69), news (62), tabloid reality shows like "Hard Copy" (with 58), sitcoms (52), and soap operas (34).

In 1994, a comparative study done by the Center for Media and Public Affairs of the same day's programs on the same 10 broadcast and cable stations as in the 1992 *TV Guide* study in order to determine how much progress had been made through open political and social pres-sure. Rather than decrease, however, the number of violent scenes had increased by 41 percent for a total of 2,605. Although the number of violent scenes had remained the same during prime time programming, the amount of violence shown in news programs and "reality" shows had increased by 150 percent. Most of the television violence occurred in the early morning and the afternoon, when young children were most likely to be watching. MTV violence had also increased.[42] Despite growing pressure, the overall amount of violence on television was growing, not the reverse.

Imitative Violence

Throughout the ages, various theories have emerged to explain violence and to cope with it. Catharsis Theory, based on Aristotle's

concept of drama, for example, suggests that witnessing and vicariously experiencing a particular emotion reduces the likelihood of real behavior related to it. Studies by Feshbach in the 1960s and early 1970s, too, seemed to show that the level of aggression for men in a state of anger decreased as a result of watching a film of a prize fight.[43] Producers, writers, and directors who have seen violence as an integral part of their craft avidly supported the theory, but later researchers have disputed Feshbach's findings. Aggression, it seems, isn't purged but rather is fueled by violence.[44] In males involved in violent activity, for example, the level of testosterone generally held responsible for violent tendencies goes up as the violent activity continues, not the other way around.

In contrast to Catharsis theory, General Arousal/Priming Effect theory suggests that when individuals, particularly children, are in a state of arousal, they will most likely behave in a manner parallel to most recently observed behavior. Some researchers have in fact found that young children's aggression increased simply as a result of watching television, whatever the program. As rate of change and character movement increased, general arousal was stimulated independently even of violent content.[45] Such theories and research support the understanding that the medium itself is indeed the message, establishing a fertile ground for mediated behavioral suggestions that act as priming effects. Seen in combination with recent research confirming that imagined action can result in the same brain changes as real action, such priming effects suggest a sequence of mental and physical rehearsal that is indeed disturbing.

After intensive study of violence in the media, as early as 1969 the Milton Eisenhower Commission concluded that if children identify with the characters portrayed on television and perceive that their behavior is both justified and effective, they may be especially susceptible to imitation.[46] In a series of experiments Berkowitz found that the key elements in imitative behavior were character identification, justification, and reward of aggressive acts.[47] Comstock also found that imitative behavior may be explained by such factors as reward or tacit approval of violent behavior in the television model, the degree to which the viewer can identify with the circumstances depicted, and the portrayal of violence as justified and intentional within a highly exciting format.[48]

In another series of experiments, which gradually evolved into his Social Learning Theory of Aggression, Albert Bandura found that film and television reduce children's inhibitions against violence, increase aggressive behavior, and teach children how to attack others.[49] He posited that people must learn aggressive behavior, and they do learn it when they attend to it because it is distinctive, simple, and prevalent;

when they observe it as being evaluated positively; and when it is apparently useful. When the viewer can identify with the character and the situation, if he or she mentally or actively rehearses the aggressive behavior, or sees it acted out by others with positive feedback, and if the behavior does not conflict with other held beliefs or values, the person is likely to imitate it.[50] In other words, if the aggressive behavior is exciting enough to be noticed and seems to be socially approved and successful, it will become a natural part of learning about life and will be seen as applicable to other situations in which analogous results are desired. If violent behavior seems to get a person what he or she wants, such as social acceptability, individual respect, or even goods or money, violent behavior will be practiced.

For younger children, Centerwall explains, imitation needs no complex reasoning: "Children have an instinctive desire to imitate, they do not possess an instinct for determining whether a behavior ought to be imitated. They will imitate anything, including behavior [that is] destructive and antisocial."[51] Until ages 3 or 4, children are unable to tell the difference between fact and fantasy, even with adult coaching. For them, television is a source of factual information about how the world works.[52]

In 1983, Wilson and Hunter compiled 58 incidents of movie-inspired violence from 1970 through 1982,[53] and in 1987, Juliet Lushbough Dee reviewed fifteen court decisions in which a child or young adult was seduced into violence by television, films, or rock music.[54] Among Dee's accounts is the story of Jeremy Nezworski, a six-year-old who hanged himself accidentally while emulating a scene on "The Scooby-Doo Show" in which a character placed a pillowcase over his head and put a rope around his neck.

In view of such evidence it is doubly dangerous that children and adolescents are the target audience for the most violent of images, including toy commercials. More than 150 hours of "children's programming" airs each week, dominating weekday afternoons and Saturday mornings. University of Pennsylvania researchers observed, for example, that 1992 set a new record for violent acts in children's television shows, with 32 violent acts per hour in daytime and six in prime-time.[55] In 1995, such children's programming represented an estimated $500 million in annual profits, not including licensing fees for run-away hits like "Mighty Morphin Power Rangers,"[56] a children's program made for the Fox TV network, which typifies precisely the kind of action which researchers claim inspires imitation. The show features six teenagers who "morph" (metamorphose) into armored warriors to battle various alien monsters. Characters in the program are attractive, active, and use Ninja and kick-

boxing techniques to overcome all manner of foes. Within the context of the program they are socially well-liked, and the violence they perform has little or no observable consequences other than to bring them success and admiration—all factors that researchers claim as significant in the perpetuation of imitative violent behavior. Averaging 211 violent acts per hour,[57] the show has not surprisingly become a symbol not only of how violence can be effectively taught, but also of the pandemic of violence emanating from America to the rest of the world.

In October 1994, in Oslo Norway, for example, "Mighty Morphin Power Rangers" was taken off the air when three children, one age 5 and two age 6, stoned and kicked their 5-year-old playmate and left her to freeze to death, emulating what they had seen done on the Murdock cartoon show.[58] New Zealand also subsequently banned the program, and two Canadian networks followed suit after the Canadian Broadcast Standards council censured it when numbers of mothers complained that their children became aggressive after watching.[59] The Canadian decision represented the first decision related to the Canadian Violence Code that came into force in January 1994.

In the U.S. in April 1995, a 2-year-old Mississippi boy bled to death after his play companions poked him in the stomach with a pipe wrench as they acted out swordplay they had seen on the program.[60] Instead of following Canada's lead, the creators of the series joined with Twentieth Century Fox to make a movie based on the TV series, spending over $40 million on production in anticipation of grossing over $100 million at the box office. When *TV Guide* author James Kaplan voiced concern over the violence when he was shown a representative scene where some creatures were exploded into bloody puddles by the Rangers, the president of Fox Family Films intending to *reassure* him, stated, "With the combination of sound effects and music, . . . it'll look over-the-top *funny*"[61] (italics mine).

In 1993, a 7-year-old boy in the Philippines watching *Robocop* on TV, angry when the maid changed the channel, went to his father's closet where he knew a gun was kept, checked to see if it was loaded, and then pointed it at the maid's head and pulled the trigger.[62] About the same time in France, three 10-year-old boys battered a homeless man to death with a wooden beam and dropped his body down a well, just to play–act out what they had often seen their media heroes do—Bruce Lee, Jean-Claude Van Damme and "Rocky." After murdering the man, unaffected, they simply went home to watch TV.[63]

As bizarre as these incidents may seem to adults, they seem perfectly normal to the children involved at the time of their occurrence. Another incident involving two 10-year-old boys and a 2-year-old child

in Great Britain emphasizes just how natural and casual a part how of children's behavior violence has become: the two older boys abducted the toddler from a shopping mall where they lured him away from his mother and dragged him crying and kicking 2 1/2 miles to a railroad crossing, telling concerned adults along the way that he was their little brother. At the crossing, they battered him with stones and bricks, splashed paint in his eyes, smashed his skull with a 22 pound iron bar, and laid his half-naked body across a railroad track, where it was later sliced in half by an oncoming train.

The London *Daily Mirror* called the boys "freaks of nature" with normal faces but "hearts of unparalleled evil." But what is most interesting about them is that they are so normal. After killing the child, they went to a video store and casually spent the rest of the afternoon. Among the influences cited by the judge in the case was "exposure to violent video films," especially one titled *Child's Play 3*, which contained scenes similar to what the boys actually did.[64] As one of the boys came to understand that what he did might have been wrong, he began to have dreams and fantasies of becoming a hero, of moving back the clock and rushing to rescue the boy he himself had tortured and killed.

Authorities in Great Britain and France tried to isolate the factors of the cases that might lead to such incidents—such as situations of prolonged abuse, mounting frustration due to poverty or lack of social acceptance, a sense of hopelessness about the future—but none of these have seemed exceptional. Rather, what seems to emerge is much simpler—a picture of normal children acting out what they have seen, which looked like it would be exciting and fun. What the adults who marveled over the horror of the incidents could not understand was that they possessed mental maps of reality different from the children who had experienced only the generally nonconsequential violence of television and film.

Such imitation is not limited to children, but extends to adolescents and adults as well. Wayne Wilson and Randy Hunter studied 58 incidents of alleged movie-inspired violence from 1970 through 1982, including the Ronnie Zamora trial in 1978 in which it was contended that Zamora killed his 82-year-old neighbor while "involuntarily intoxicated by television." In another case, after seeing the television movie *Born Innocent*, three teenage girls imitated a scene in which a girl is raped with a bottle. During the reenactment, a male lookout called out "Hey, are you doing it just like they did in the picture?"[65] The raped girl's parents filed a suit against NBC in an attempt to hold the company liable for television-inspired violence, but the U.S. Supreme Court refused to overturn a California ruling that television networks cannot be found liable unless they deliberately seek to incite such violence.[66]

In June 1995, after days of watching and rewatching *Natural Born Killers* (U.S.A., 1994), three young men, two age 20 and one 18, viciously murdered a handicapped and defenseless 65-year-old-man in his bed in Avon, Massachusetts, stabbing him 27 times, first with a Bowie knife and then when it became too slippery from the blood, with a large hunting knife, breaking the man's wrists with the violence of the blows and opening his chest from clavicle to spine. The victim had formerly dated the mother of one of his murderers, but there was no apparent motive other than mere acquaintance and opportunity.

After the murder the young men went to a girlfriend's house and joked to her "Haven't you ever seen *Natural Born Killers* before?" The following morning at breakfast, one of the young men joked about the murder, gurgling water in his throat, imitating the sound of the victim's death chortle. In interviews, the young men disclosed that they liked the film so much they decided to emulate it with a real murder.[67] "We know what we did was bad," the teenager told police, "but we didn't know this guy so we weren't going to cry about it."[68]

Earlier, in February, a 15-year-old interrupted a telephone conversation with a friend in which they were talking about killing their parents and then taking off on a killing spree in imitation of *Natural Born Killers*. He then took his father's 12-gauge shotgun, shot his mother in the face and his father through the head and returned to his phone conversation. The boy had previously exchanged notes with friends about *Natural Born Killers* and said that he would like to live the story himself.[69] Motion Picture Association of America (MPAA) representative Barbara Dixon defended the film, saying that she thought director Oliver Stone's motive was "a pure one: to show the glamorization by the media who commit atrocious acts."[70] Whatever Oliver Stone's motives, however, once on the screen, images take on a life of their own, enhanced by artful cinematography, more exciting and important by their aesthetic appeal and glamour.[71]

In November 1995, the film *Money Train*, featured a pyromaniac who squirts gasoline into subway token booths and sets them on fire, their clerks within. Released in New York City, the movie shortly thereafter apparently inspired two young men to recreate the crime almost exactly, setting a clerk on fire in his tollbooth with no way to escape the conflagration. Other similar immolations and deaths followed.

In 1993, a Massachusetts murder of a teenager told a similar story. On June 3, in Wrentham, Massachusetts, two young men, one 21, and the other 17, allegedly tortured and murdered a friend, another 17-year-old, Jimmy Tracy, whose battered, stabbed, and drowned body was recovered the next day by a fisherman in a local pond. A witness described

how the two had taken the boy's shoes to prevent his escape and then for an hour tortured and beat him unmercifully, kicking him in the face, holding his head beneath the water to drown him, and finally stabbing him in the throat when he gained consciousness.[72] After the murder, the two young men stripped the victim of his clothing, covered his body with a blanket and talked about how easy it was to kill their friend. The 17-year-old attacker is quoted as saying, "This isn't that hard. I feel like I'm in a movie," and remarking that the "adventure" was similar to the film *Stand by Me* where a group of teenagers discover a body. Coolly, he is quoted as boasting, "We didn't find this. We made it."[73]

The presiding judge commented in the case that "most of society's ills seem to have been arrayed in this account."[74] We don't have to look far afield to find other examples of violence specifically and explicitly related to media influence by participants themselves. What makes these murders especially chilling is the relative youth of those involved, the emotional distance which characterized the brutality, and the direct link by participants of their behavior to media influences. These particular incidents are no longer unusual. According to the Federal Bureau of Investigation's (FBI) annual report of national crime statistics for 1994, the number of minors arrested for murder rose 158 percent in ten years.

Violence suggested in film has also led to self-destruction as well. In 1993, two young men died and two others were critically injured in separate incidents in New York, New Jersey, and Massachusetts when they repeated a scene from the movie *The Program* in which a drunken athlete lies on a busy highway as cars and trucks speed by. Despite the negative treatment of the action in the film, the young men emulated it to prove their manhood.[75] One of the most widespread examples of imitative violence, however, has been associated with the film *The Deer Hunter*, in which scenes depicting Russian roulette seemed to test the nerve and masculinity of the participants. Thirty-five victims in separate incidents directly imitated the film. Other films of the 1970s that precipitated deadly imitation include *Magnum Force* and *The Warriors*.[76]

As a result of their research into imitative violence, Wilson and Hunter suggest that a three-step standard be used to determine a causal connection between media violence and real violence that could be used in determine the guilt or innocence of media. Evidence must show, without twisting the direction of the film's content, that first, the individual identifies strongly, even obsessively with a particular film; second, the movie is key in perseverating already existing viewer beliefs; and third, the movie has, in fact, moved the person from thought to action. Such a standard, they claim, would help juries determine whether or not the movie might be unrelated to action yet serve as a mask for another motive.[77]

Such a standard recognizes that there is no direct cause and effect correspondence between a violent act seen and one imitated without internal receptivity to the idea. It also recognizes that a chain of events can reach a point of crisis in which the smallest single element can achieve significance out of all proportion to the rest of the system. When media effects theorists oversimplify the causative factors in media violence to a reductionist linear cause-effect response, they rarely find such simple connections. Alternatively, however, when theorists take the opposite view that the number of influences within a person's life are so numerous and complex that no single media event can make an impact, they in effect deny that any one factor in a person's life can have a substantial effect on it.

What nonlinear systems dynamics reveals, however, is that there is a larger, universal shape toward which things tend. This shape is sensitive to and dependent on initial conditions; moreover, it is determined by an attractor which establishes a central theme around which apparently random behavior revolves, delimited by a boundary delicately sensitive to its environment. The accumulation of a great many instances in dynamic systems is not summative or predictive. Yet a great many events, plotted as separate and unique points within three-dimensional space, reveal both an attractor and a larger pattern, allowing the possibility of predicting the general shape while the individual points remain unpredictable.

When children imitate directly what they see as interesting and fun, the system is a simple one and yields a behavior pattern with which most people are familiar. In adults, this is more complex. Where violence appears to be random and generally unpredictable, it may in fact be constrained by a media attractor. Because violence is a relatively easy way to grab attention and keep it, it has also become the number-one way of getting viewers to tune in to begin with. This is why the most violent programming next to cartoons is found in promotions for television shows and films. David Rintells, former president of the Hollywood Writers Guild, has testified before Congress that networks have not only encouraged but requested violent scenes from writers. These scenes then become the focus of promotional announcements intended to grab viewers' attention. The result of such blanket violence is not only a natural desensitization but also a distorted sense of reality.

Long-Term Studies

In 1973, Joy, Kimball, and Zabrack studied the effect on a rural community in Canada when television was first introduced there that

year. Using two other similar communities as control groups in the double-blind study, they found that over a two-year period, aggression evidenced by biting, hitting and shoving had increased by 160 percent in the community where television had just been introduced. The increase, which affected boys and girls equally, was generally distributed rather than attributable to specific groups with an explainable predisposition to violence. The rate of violence in the two control communities remained the same.[78]

Leonard Eron and Rowell Huesmann who have done several of the most comprehensive long-term studies in this area, followed 875 children from 1960 to 1981, from the point when they were 8 years old. After controlling for baseline intelligence, aggressiveness, and socioeconomic status, they found that at age 8, the children who watched programming with violence in it, including Saturday morning cartoons, were more likely to be cited as meaner and more aggressive in their play by teachers. At 19, they were more likely to be in trouble with the law. At 30, they were more likely to be convicted of violent crimes and to be abusive toward their spouses and children. The amount of television children watched at age 8 predicted the amount of violence they perpetrated later in life. Second- and third-generation effects also appeared, as children who watched more television were more likely to punish their own children more severely than those who had watched less television.[79] Summarizing his research findings as chairman of the Commission on Violence and Youth of the American Psychological Association, Eron testified before Congress in 1992: "There is no longer any doubt that viewing a lot of televised violence is one of the causes of aggressive behavior, which may lead to crime and violence in the society." If media violence is reduced, he testified, "fully 10 percent of interpersonal aggression would be eliminated within the society."[80]

Brandon Centerwall, in studying the relationship between the introduction of television and homicide rates among whites in the United States, Canada, and South Africa, used the advent of television and the rise in crime rates in the U.S. and Canada after the introduction of television to accurately predict homicide rates in South Africa. After the introduction of television in the 1950s, the homicide rate doubled in the United States and Canada within ten to fifteen years. During the same period in South Africa, where television was banned until 1975, the homicide rate dropped by 7 percent. After the introduction of television into South Africa, however, homicide rates increased 130 percent between 1975 and 1987.[81]

In explaining his findings, Centerwall notes that he found none of the alternative explanations of economic growth, civil unrest, age distri-

bution, urbanization, alcohol consumption, capital punishment, or availability of firearms satisfactory. Recognizing that blacks in South Africa lived under very different circumstances from those in the United States, for example, Centerwall used statistics only for white crimes. Knowing statistics can be a murky business at best, he used only homicide figures, which are highly reliable. Antiwar unrest and civil-rights activity in the United States were not paralleled in Canada, yet the U.S. and Canada showed the same rise in violent crimes. South Africa was comparable in economic development, book, newspaper, radio and cinema industries, so that television could be isolated as a factor from other media influences. In all three countries homicides rose within five to seven years and doubled within fifteen to twenty years—the amount of time, Centerwall believes, required for television influence to come of age.

The pattern he uncovered has held up consistently in every regional, racial, and international comparison Centerwall has made. Although he does not count out other factors that contribute to violence, his conclusion is that if "television technology had never been developed, there would today be 10,000 fewer homicides each year in the United States, 70,000 fewer rapes, and 700,000 fewer injurious assaults."[82]

The New Violence

Although it is certainly true that the world has always been a violent place, and that violence has always been a part of media, a new kind of violence has appeared since about the beginning of the 1980s which is different in several important ways from the violence of television and films before then. From a being a part of film content whose significance is drawn from a tacit understanding on the part of the audience that violence is socially unacceptable, and that it represents an extreme response resulting from a build-up of internal and external forces, violence has become normalized into a way of seeing the world. It has, in other words, become what scientists might call a "strange attractor." The operable attractor in the "old violence" was a social order where all of the forces were constrained by a sense of justice and a realization of violence as undesirable, a last resort when the working pattern of the system was threatened.

The New Violence is the result of a new pattern, a paradigm shift in media action where violence is not depicted as the product of a significant build-up of forces or a last resort, but as something pervasive, taken casually, lightly, and even humorously. Rather than being tacitly socially unacceptable, violence is now predominantly depicted as a natural part of the social landscape, an inevitable presence. As an attractor, it has also become inseparable from cinematography's aesthetic.

When violence occurs in the films of the Hollywood big studio era, for example, as a rule it is part of the dramatic tension of the film to anticipate it, fear it, and see the importance and irrevocable finality of it. In films like *Ben Hur*, for example, the chariot race is not only an exciting event but one that is treated as significant in the way the action is shot, in the music that accompanies those shots, and in the editing techniques that heighten the suspense. Violence in the film is not only integral to plot, it is also taken seriously and gravely by the participants. Events build toward a violent climax, and as they build, a sense of dis-ease and foreboding is heightened in the audience. In contrast, the high-speed chases of the New Violence are choreographed sequences of violent movement in which men and machines are mangled and destroyed with the most flamboyant and colorfully spectacular pyrotechnics. Where one is gut-wrenching, the other is beautiful.

In most traditional Hollywood films before 1980, a character who enjoys or laughs during violence is typically treated as seriously deranged and essentially evil. Even though John Wayne shot a number of American Indians on the screen, for example, the western genre was always careful to let us know that he did not like doing it, but that it was somehow necessary. In the 1976 film *The Shootist*, for example, although Wayne kills several people, he makes sure that the adolescent who looks up to him understands what it really means to kill a man, and the violence is treated realistically, particularly in its psychological impact on the characters. In contrast, in 1983 *Make Them Die Slowly* boasted in publicity releases and posters that it was "the most violent film ever"—so violent it was banned in thirty-one countries.

This type of violence built throughout the 1980s, reaching a plateau in 1990 in what was realistically dubbed by news tabloids as "Cinema's Summer of Blood." Films that summer included *Cold Steel* with 147 violent acts an hour, and *Die Hard II*, with a total of 200. *Total Recall* not only boasted 110 acts of violence an hour and 35 slayings—over half of which were perpetrated by "good guy" Arnold Schwarzenegger, it also combined violence with laughs in what was developing into a dubiously comic Schwarzenegger style. As he shoots his wife in the head, for example, he wryly comments: "Consider this a divorce." In *True Lies* where he plays a secret spy, when his wife learns of his work and asks him if he has ever killed people, he answers that he has killed a lot—"but they were all bad!" By 1995, Japanese "rape tapes" depicting the stalking of women, sexual attacks on young girls, and gang rapes of both were flooding American "adult bookstores" and eagerly purchased by Americans at two-and-a-half times the purchase price of American "adult videos."

In Quentin Tarantino's *Pulp Fiction* (U.S.A., 1994), a protagonist's gun goes off accidentally inside the car splattering brains and blood everywhere. This is meant to be funny. The scene not only trivializes violence and death, but also makes it a source of comedy, particularly as the two "hit men" try to clean up "mess." Heralded as representing a new kind of realism, Tarantino's film earned the 1994 Palme d'Or and was named the best film of 1994 by the National Society of Film Critics. Although some critics praised Tarantino for his originality, his concept was far from new: it was merely an update of Laurel and Hardy getting into "another fine mess," with the mess redefined as casual violence and the protagonists and their conversation inane and boorish. In theaters, there were two deeply divided reactions: those with media savvy found the film delightfully funny; those without it were deeply disturbed at the new attitude as much in evidence in the audience as in the film itself.

What may be most dangerous of all in the New Violence, however, is the combination of high-tech special effects and aesthetics in scenes choreographed to make violence seem not only exciting but also visually beautiful. Beginning with disaster films in the 1970s with such films as *Towering Inferno* (U.S.A., 1974) where a human torch plummets thousands of feet and numerous others are incinerated, the aesthetics of violence grew with evolving cinematography and reached a plateau in David Lynch's *Wild at Heart* (U.S.A., 1990). Even though the film also won the Palme d'Or at the Cannes Film Festival in 1990, at the first screening 100 people walked out, and at the next screening, 120 people left. An excessive, indulgent and exploitative exercise in autoeroticism, its visual fullness nevertheless made palatable an extensive cast of bizarre sadists, schizophrenics, murderers, and rapists, primarily because its perverse acts were made to be cinematically beautiful.

In one climactic scene, for example, a hired killer—a mulatto cripple—achieves a sexual orgasm as at the count of ten he shoots a man in the back of the head. In other scenes, a head is blasted off by a shotgun and bounces a couple of times in dust; a dog runs away with a hand; a child is raped. The film opens with a man's head smashed first against a wall, then stairs, and then a marble floor until his brains ooze out. Yet the film is truly beautiful to watch, and even in a series of sequential flashbacks of the protagonist's father burning up slowly as he staggers about a blazing house, we watch emotionally disconnected, as if it were fireworks or a sunset. The result is a truly perceptually dangerous film, marrying malevolence, violence, and perversity with an aesthetically pleasing form. When natural larger-than-life importance is combined with a seductive more-beautiful-than-life presentation, the effect is that violence itself seems an attractive, sensually pleasing, even erotic activity.

Herein lies the double irony of emotional perceptual processing: because color, shape, and movement reach us directly on a crude and undifferentiated emotional level, and because humanistic qualities are gained through cognitive refinement, we respond to film's color and movement with a natural fascination, but without the time to cognitively process the meaning of the imagery and to think through its implications. No cognitive "off-switch" is thrown because there is no time for reflection, and film content and aesthetic become wedded as new experience. In this new emotional-cognitive construct, violence is aesthetically pleasing.

Psychologists also tell us that there is another hidden danger in viewing violence because it produces a natural thrill derived from extreme emotional states that is as basic as the sex drive. Psychiatrist Lenore Terr, in *Too Scared to Cry*, for example, relates this pleasure to the natural release of potent neurotransmitters. The resultant pleasurable sensation of this release is characterized by both a slowed sense of time and an intensity of detail beyond the ordinary experience of everyday life.[83] Because of this, watching violence can become addictive—just as running and other intense physical activities that produce a pleasurable "high" can also become addictive.

The Public Trust

The national airwaves are considered by the federal government to belong to the public, and the Federal Communications Commission (FCC) monitors broadcast media to ensure they are operating in the "public interest, convenience and necessity." If the FCC determines that a broadcast network has violated the public trust, it has the power and the obligation to refuse to renew its license to operate. For nearly half a century, the debate has continued over whether violence on television is in the public interest.

In 1952, when television was still young and the amount of violence it contained was tame by today's standards, the first Congressional hearing on television and violence was convened, citing controlled experiments by the National Institute of Public Health which showed that children who watch a lot of violence tended to be more aggressive than the norm. In 1968, the Milton Eisenhower Commission on the Causes of Violence following the Robert Kennedy and Martin Luther King assassinations concluded that violence on television encourages violent forms of behavior. The Commission declared itself as "deeply troubled by television's portrayal of violence, pandering to a public preoccupation with violence that television itself has helped to generate."[84]

In 1972, Surgeon General Jesse Steinfeld stated, "It is clear to me that the causal connection between [television and violence] is clear enough to warrant appropriate and remedial action."[85]

As a result of growing public concern, CBS commissioned a study in the 1970s involving 1,565 teenage boys that controlled for a hundred variables to determine differences between light and heavy television viewers and acts of violence. The study showed that teenage boys who had watched an above-average amount committed 49 percent more acts of assault, rape, major vandalism, and animal abuse.[86] ABC also commissioned a study by Temple University that had similarly disappointing results for the network: in two surveys, 22 and 34 percent of young male felons imprisoned for violent crimes said that they had learned their techniques from television and consciously and usually successfully imitated them. As children they had watched an average of six hours of television daily. The ABC study was published only in a limited edition and was not released to the public or to the scientific community.[87]

In 1976, after a review of the effects of television violence on children and youth, the American Medical Association declared that "TV violence threatens the health and welfare of young Americans," committed itself to remedial action, and encouraged active opposition to violent programming.

In 1982, the National Institute of Mental Health released a ten-year follow-up report to the U.S. Surgeon General's study that concluded that "violence on television does lead to aggressive behavior by children and teenagers."[88] Also that year an NBC study was released, done by four researchers, three of whom were employed by NBC. Their conclusion— that television had no effect on children's behavior—was received skeptically, and other researchers reviewing the data came to different conclusions. Although NBC ultimately admitted that television violence had increased physical aggressiveness "to a small extent" (about 5 percent), Centerwall in studying the data observes that because extreme examples of aggression and violence fall at the end of the population bell curve, a mere 8 percent of the population shift from below average aggression to above-average aggression results, not in a small increase but in a doubling of the homicide rate.[89]

By 1990, the American Psychological Association cited over 1,000 published research studies showing a correlation between media violence and negative attitudes and behavior and issued a policy statement that pediatricians should advise parents to limit children's television viewing to one to two hours per day.[90] U.S. Senator Paul Simon, concerned about the pervasiveness of television violence, publicly announced that he had found nearly 3,000 scholarly articles and studies

on the harmful effects of television viewing. As a result, Simon drafted the Television Violence Act, passed in 1990, to provide a three-year antitrust exemption for television networks so that members of the industry could meet and develop industrywide guidelines to reduce the amount of violence on television.

Under growing Congressional pressure threatening direct media regulation, executives in the television industry finally met in August 1992 with members of the Citizens National Task Force on TV Violence—including among others the American Medical Association, the National Parent Teachers Association, the American Psychiatric Association, and the International Association of Chiefs of Police—to discuss warning labels and the reduction of gratuitous violence. The summit provided a major forum for industry self-regulation, and as a result, television executives agreed to set up an outside monitor each year to detail the violence on TV and state who was responsible for it. When the results of the first independent monitoring effort showed an increase in violence and suggested new policies for writing and airing it, TV executives denounced the findings.

This study, funded by the National Cable Television Association and conducted by a research team at the University of California at Santa Barbara concluded early in 1996 that "the risks of viewing the most common depictions of television violence include learning to behave violently, becoming more desensitized to the harmful conse- quences of violence, and becoming more fearful of being attacked." Charged with assessing TV violence within context and determining if the violence was relevant to character or plot development, whether it was excessive or gratuitous, and whether its consequences were ade- quately conveyed, researchers found in studying 2,500 hours of pro- gramming that perpetrators of violent acts are unpunished approximately three-fourths of the time; that about half of all violent acts showed no negative consequences in harm or pain; that a quarter of violent incidents involve handguns, which can trigger aggressive thought and behavior, and that only 4 percent of programs containing violence emphasized nonviolent alternatives in solving problems.[91] They also considered time of day and audience composition.

The main idea behind the legislation and the summit had been to spur networks to effective self-regulation and thereby avoid federal intervention into private industry. Efforts at industry self-regulation, however, have been met with a certain amount of skepticism by media critics. By 1993, mincing few words on the media's willingness to police itself, even CNN founder Ted Turner, testifying before the House Energy and Commerce Television Communications Subcommittee, commented

with double irony on the need for federal regulation: "Unless you keep the gun pointed at their heads, all you'll get is mumbly, mealy-mouthed BS," he stated, "They just hope the subject will go away."[92] Recent history bears out this view.

For example, in 1990 the Children's Television Act was passed requiring stations to air programs "specifically designed" to meet "the educational and informational needs of children." In attempts to bypass the intent of the legislative licensing restriction, networks responded by airing "educational programming" at odd hours like 5:30 A.M. and by classifying as "educational" programming such shows as the "Jetsons," the "Flintstones," and a Donahue show on teenage strippers.

By 1995, the list had broadened to include such programs as "America's Funniest Home Videos" and "Biker Mice." "Biker Mice" is a typical "educational" program: the show revolves around the adventures of animated blue mice who, forced from their home on Mars by evil Plutarkians (who have carted off the planet's topsoil), band together to fight pollution, hang out, listen to rock music, and party a lot. Even the creator of "Biker Mice" Rick Ungar says, "You can't say children will come away with a better appreciation of the environment because they won't."[93] In response to such programming, FCC chairman Reed Hundt proposed that networks air three-hours per week minimum of programming that has education as a "significant purpose" and runs between 6:00 A.M. and 11 P.M., and that these programs be identified prominently to the public through schools or in newspapers to make parents more aware and networks more accountable. Networks responded that this was unrealistic.

In 1993, the four major broadcast networks—ABC, CBS, NBC, and Fox announced that they would begin providing warning labels to let parents know the amount of violence contained in a program. Concern over keeping out violent programming also led to legislation passed in 1996 requiring a "V-Block" device on television sets, which would allow parents to electronically block from the screen all shows carrying a coded warning for violence or sexually explicit material. Although the inexpensive V-chip will keep out such programs at home, however, it does not solve the problem of kids' going next door to the neighbor's house to watch forbidden shows, nor does it protect nonwatchers from the violence that is condoned and promoted on TV. Most of all, it does not address the issue of getting good programming on television.

Brandon Centerwall, in keeping with the suggestions of the American Academy of Pediatrics, suggests that a time-channel lock should be used by parents to limit children's television viewing by amount as well. With technology already required by the Television

Decoder Circuitry Act of 1990 that provides built-in closed-captioning circuitry for the hearing impaired, an electronic lock would allow parents to preset television sets for specific programs, times, and channels.[94]

Another more comprehensive approach is represented by the Canadian Association of Broadcasters (CAB) code for license renewal, enacted in 1994. The code includes an outright ban on gratuitous violence, no airing of programs before 9:00 P.M. that contain violent scenes suitable for adults only, a ban on any program that "sanctions, promotes or glamorizes any aspect of violence against women," as well as guidelines for the reporting and depiction of violence on news programs, for the development of a national classification system advising viewers of program content and age suitability, with special attention to children's programs.[95] In addition to adopting a code for Broadcasters, Canada also focused on implementing media literacy programs within its schools and set up mechanisms for a continuing dialogue among educational, medical, media, and citizen groups.

Video Games

As socially destructive as television and film violence can be, many believe that they pale in comparison to video games, which reward a "penchant for control, competition and destruction," and which actively involve players—overwhelmingly males between 13 and 30 years old—within the violence. While research has found that girls do not enjoy video games, boys find them to be the most psychologically arousing medium. It is also the one on which they concentrate most intensely.[96] Unlike TV or film, video games are intentionally interactive, and players must participate in causing the violence, usually winning the most points for the most outrageously cruel acts.

Since 1990, video games have surpassed all toys as the most popular present for children, representing a $7 billion industry in the United States. Traditionally, the most violent ones are the most popular. In 1993, for example, it was estimated that 75 percent of video games relied on violent content: Mortal Kombat, then America's top-grossing arcade game featured heroes decapitating people, ripping out their hearts, or tearing off their heads. During that Christmas season under public pressure, Toys "R" Us, Bradlees, and FAO Schwartz pulled off the shelves Sega's "Night Trap"—which featured vampires who stalk women, drill holes in their necks, and hang them from meat hooks. Soon thereafter Nintendo put out a slightly sanitized version of "Mortal Kombat," but when it started to lose money, and when the company received thousands of telephone calls and letters from young people

demanding the more graphic version where the winner can gain extra points by ripping out a victim's spinal column, they re-released the more violent version. Even though video game makers have followed network and cable's lead in agreeing to label their games for violence and sex content, and have formed panels to monitor violence in their respective media, labeling signals only a forewarning of content, not a change in content itself.

An important part of mental maps evolving from media, video games reinforce the concept of violent action as an appropriate response when threatened, and they condition the player to respond quickly and without hesitation by rewarding the most violent play alternatives. Research comparing more and less aggressive versions of video game play, television program content, and dart game play, has shown that any activity performed in a more aggressive mode increased reported hostility[97]—an observation that reconfirms what we learned in the Gulf War—that playing video games is very effective rehearsal for real-life responses. Childhood play is the best training ground for adult action.

Like violence or cigarettes, video games can also be addictive. "Doom," a multiplayer video game in which players can destroy monsters or each other with chain saws or shotguns, for example, was introduced to the market place in 1993 by giving away the first episode on the computer Internet, and then selling the subsequent ones once the customer got hooked. Acknowledging that their marketing strategy was similar to the way drugs are dealt, the Id software company increased profits from $1.5 million to $10 million within their first year, introducing "Doom II" in 1994.[98]

In 1993, it was estimated that on average, students with computers spent 1.5 hours a day interacting with computer games. By 1995, Nintendo had developed a 32-bit (the higher the bit the higher the resolution and the realism) game system called "Virtual Boy" with virtual reality technology which immerses players in a three-dimensional stereo-surround world with high-resolution images; concurrently, film elements also moved into interactive CD-ROM formats with titles like "Corpse Killer," directed by John Lafia who also did *Child's Play 2*, and *Under the Killing Moon*, which allowed viewers to use computers to direct the plot. By the end of 1995, "Mortal Kombat 3" was available on shelves in a 32-bit version, and Nintendo had developed a 64-bit system for release in 1996. As violent computer games become faster and more three-dimensional, as if players were actually participating in a movie, the line between fantasy and reality gets thinner, and the potential increases for developing a generation addicted to even higher resolution violence in reality.

Although most of the impact of such visual media experience cannot be linearly correlated with specific violent acts, there can be little doubt that the cumulative influence of hours of television watching, video game play and movie mayhem cannot help but influence the perceptual process by which human beings incorporate the world around them into the essence of themselves, and in turn affect the social order as a whole.

Conclusion

Film and television are media particularly suited to emotional learning because their language is experientially based. Verbal language facility is cognitively based and takes a great deal of time to master—we learn to read gradually, becoming more and more proficient over years of practice, expanding our thinking into ever-widening circles of complexity and sophistication. As we grow in verbal ability and read more widely, we become aware of different perspectives, of differing philosophies, of false prophets and charlatans, of the multigrained complexity of truth seeking.

Visual media, however, presents a view of reality that simply seems to be there. The world of visual media announces itself to our senses as reality, so that before we are capable of understanding that it is a manipulated and artificially constructed world, before we become experientially sophisticated enough to judge the nuances of manufactured visual "realities," we accept these self-contained visual worlds as true.

As we add each media experience to our understanding of the world, an image of how the world works grows within us, and, as Boulding suggested, it is this image of the world that determines our actions. Everything we do is relative to this holistic image that acts as an open system, actively seeking invariance, searching for the patterns that will help us make sense of our environment.

There is at present a double norm within the society: one that respects human value, and one that dominates visual media. It is a very adult, very sophisticated thinker who can separate out these never wholly distinct worlds and understand the nuances of their interrelationship. For the child, as for the many adults who write to their favorite soap opera characters as if they actually existed in real life, these worlds begin as one and only gradually, with a great deal of help from thinking adults do they separate into alternate worlds.

Even films that seem tame and acceptable, like Spielberg's *Jurassic Park*, reflect society's double-think in relation to children and media violence. Despite the fact that the film was made clearly with a children's

audience in mind, for example—as evidenced by its ubiquitous market-
ing tie-ins with McDonald's and toy manufacturers—the film carried a
PG-13 warning because of several intensely violent scenes. Ironically,
even the rating itself served to increase allure for the children's audience,
always hungry to understand the "adult" world. Spielberg himself
would not allow his own children to see his film; yet clearly other chil-
dren's parents did: gross domestic earnings surpassed $300 million and
made it one of the top-grossing films of all time.[99]

Even if the violent behavior of children and adults can in specific
instances be directly traced to specific media effects, it is clear that the
major contribution of media is to the way we see the world. This world
image begins to be formed with our earliest experiences, as we read our
parents' expressions and mimic them. When visual media is introduced
into this world, it contributes to emotional memory, which is never
erased. In this way, television and film have contributed substantially to
a perceptual climate in which violence has come to be seen as normal
simply by virtue of its ubiquity. It is this aspect of media's public trust
that caused Ted Turner to observe to a congressional committee in 1993
that "television violence is the single most significant factor contributing
to violence in America" and to proclaim himself and other media
moguls as murderers.[100]

As our understanding of perceptual process becomes clearer and
the preponderance of evidence correlating social and media violence
grows, the argument over whether the consumption of violent images
causes violence or whether the tendency to violence in people is merely
legitimated and glamorized by the pervasiveness of violence in the
media seems more and more naive. Both contribute substantially to the
picture in our minds that determines the way we perceive reality, the
way we interpret the past, and how we project our perception into the
future through analogy.

Today the picture that millions of young people have in their minds
is filled with a holistic view of violence both as entertainment and as an
unavoidable fact of everyday life. In the end, the combination of the two
pervasive attitudes—the entertainment value of violence and its
inevitability—have both worked to desensitize people to violence and rob
them of a sense of control over their own behavioral options. At the same
time, practical problem-solving skills are reduced to the lowest level by
media's selling of violence as the preferred solution, and violence is glam-
orized and promoted as a number one entertainment option.

When we are tempted to shrug off the effects of media violence
because we ourselves have become inured to it by saying that violence
has always been a part of the human scene, or by resigning ourselves to

adapting to its pervasiveness in our everyday lives, it is wise to remember that we ourselves are responsible for this world. As Myriam Medzian points out, at least thirty-three different societies exist today in which both war and interpersonal violence are extremely rare.[101] Thus violence is far from inevitable, unless we choose to make it so by promoting it. The "New Violence" in media is the harbinger of a new American culture characterized by low interpersonal involvement and by the attitude that violence is an apparently suitable solution to interpersonal conflict, a source of entertainment and enjoyment, and an effective vehicle for personal and social expression. Acceptance of violence is now a deep, shared experience of the young and a way of seeing formed by repeated exposure to media.

In 1993, the Vatican Council for Social Communications insightfully recognized in its *Aetatis Novae* ("At the Dawn of a New Era"), that "Much that men and women know and think about life is conditioned by the media; to a considerable extent, human experience is an experience of media."[102] The overwhelming preponderance of research to date bears this out. Media educates by informing people about their culture and themselves and their roles in that culture. It helps to define expectations about sexual roles, cultural codes, and myths, as well as about the actual behavior of individuals in their society. Television does this through content and through method, and in the process, it develops in us an additional visual sophistication that allows us to absorb the images at a faster pace than ever before, without any parallel increase in critical understanding. As media entertains us, it also legitimizes extremes of behavior and emotion, even robbing us of our sensibilities by overstimulating them and overexposing them to ever-increasing excitement. The longer video game players play, the better they get at responding from game training without thinking.

Just as film, TV, and videogame producers have not proven averse to capitalizing on what amounts to a social epidemic of violence, so, too, weapons makers are eager to supply weapons to those who practice violence and to those who fear it. As a result, the pervasiveness of weapons has become mind-boggling: It has been estimated that there are 211 millions guns in this country—one for every adult and half of our nation's children.[103] The U.S. firearms industry generates up to $25 billion in business annually. Revenue from the sale of guns and ammunition doubled between 1987 and 1993.[104] In the United States there are more gun dealers than there are gas stations, and about 5 million new guns hit the U.S. market every year.[105] The result of such widespread availability of weapons is that according to Federal Bureau of Investigation statistics, in 1994 alone 23,305 people were murdered.[106]

As the National Rifle Association (NRA) is fond of saying, however, guns don't kill people; people do. Yet this reduction of the argument to its most simplistic level cannot reduce the culpability of those within the society who not only feed off violence but also help to create a cultural image of violence as a natural and necessary way of life and that to cope, we must literally be forearmed. The NRA has actively courted women as members, encouraging them to develop a "personal safety strategy" that includes a weapon. Various "Bang-Bang Boutiques" have also sprung up offering various women's weapons accessories. One such shop, "Love Leathers, Inc.," in Washington state offers gun-toting purses, urging women to "be safe, feel feminine and be stylish!"[107]

Although it has similarly been argued that media are not responsible for people's actions, that people are, we must still take very seriously the connections that even participants themselves have made. Those who insist that only the individual is responsible for his or her own actions may ultimately be correct; but too narrow and naive a view of how perceptual process works is likely to draw the circle of responsibility too narrowly. Excluding decision makers in the media from the realm of personal responsibility—from the gatekeeper whose eye is on bottom-line profits to the writer whose employment depends on an expertise at emotionally manipulating audiences—is tantamount to exonerating the poisoner of the reservoir and blaming the people who unwittingly drink from it for their own illness. Today watching television and films seems as automatic an action as drinking a glass of water. We rarely think about its quality, except in response to a public warning.

When Turner, referring to media executives, testified before a congressional subcommittee in 1993, "They're guilty of murder. We all are—me, too," he was placing responsibility for violence at the feet of an industry that has perennially denied its culpability in the face of evidence that media is one of the main influences in helping to create a world in exchange for profit in which gore and death are made glamorous and exciting, and where we have become inured to the pain of others.

This is the second, third, and fourth generation brought up on a steady diet of continually escalating media violence, and its sense of what is normal and effective behavior is very different from that of adults who even as children watched violent Saturday morning cartoons. In the new media developing from the 1980s and into the 1990s, the stakes are greater, the violence more extreme and varied, the pace faster, the excitement higher, and the sensitivity to others lower.

Conclusion

Intelligent brains could hardly have developed without eyes. . . . Eyes freed the nervous system from the tyranny of reflexes, leading to strategic planned behaviour and ultimately to abstract thinking. We are still dominated by visual concepts. Our problem now is to understand the world of objects without being limited by what we have learned through the senses.

—R. L. Gregory

Today advances in technology have given commercial and political interests the ability to manipulate the way we see and comprehend our world before our understanding of visual messages has fully matured. Few of us today understand how perception works, how cognition and emotion function, and how manipulation of attitudes, ideas and values can be accomplished. Fewer still, it seems, appreciate the implications of this. Intellectually, we are still at the level of "seeing is believing" while technologically, photographs can be and are altered for desired effects; realistic monsters are created that never existed; violence, deadly products, and socially destructive lifestyles are promoted en masse; and people can be transported via telepresence to other locations and via Virtual Reality to artificially constructed worlds they may never wish to leave.

To raise our "visual IQs" to the level of our technological capabilities, we must gain a basic understanding of how our perception works, particularly in relation to supposedly "rational" judgment, and of how images communicate emotionally and cognitively to the various levels of our beings. We must come to realize not only the inherent power of the image itself, but also how the simple juxtaposition of one image next to another can affect our thinking and feeling in radical ways, and how in rapid succession images can ultimately form convincing arguments which, when received and believed, can change the values, attitudes and lifestyles of critical masses, and even topple governments. We must develop a critical understanding of how media can and does manipulate images to affect thought and emotion—how images of sex and violence in advertising and film can work to erode rational self-interest and moral judgment, and how political images designed to motivate voters may ultimately undermine a political process that relies on informed decision-making.

As Marshall McLuhan anticipated when he observed that visual media have precipitated a transition in the way we see from linear connections to configurations, the way we watch television and experience film is changing the way we perceive the world and the way we think about it. Although our ability to process the visual image and absorb its meaning has increased, there has been no comparable time for reflection built into the visual presentation of television or film, nor is there generally motivation in the visual format to later reflect on the immediate experience. We absorb the message as it is structured, but do not critically evaluate it. As visual media become faster paced and more sensually specific, they will also ultimately envelop us within the experience. Sensory stimulation then truly *becomes* the meaning, and critical analysis is merely irrelevant. Although it is true that today's technology cannot be uninvented, it is also true that it does not have to be: informed use is the first step toward a creative revolution and away from the automatic acceptance of what is.

Derived from perception and tempered by cognition, visual intelligence represents the potential within all of us to integrate seeing with critical awareness. As Gregory notes, the eyes have freed the nervous system from the tyranny of reflexes and given us the ability to move from a level of mere response to one where we can use perceptual principles to think and reason abstractly. In short, our eyes have also opened the doors to creative and strategic thought, allowing us in the most metaphoric sense to truly "see" at last. Yet whether or not this potential is realized depends on the development and exercise of visual intelligence.

Like all other aspects of intelligence, visual intelligence stems from universal perceptual principles operating within an open system. It may be creatively enhanced or it may be codified and rigidified by a combination of internal and external influences—such as habits of mind or feeling, or by repeated exposure to similar patterns in media. An extension of a deep structure that allows us to make sense out of our relation to the world, visual intelligence is first manifested as we become aware as infants and it develops as we are continually subjected to various influences within the environment as we grow. In the process, we begin as open and flexible, and our abstract thinking as creative and metaphoric, seeking and finding connections and relationships. With training, however, repetition fixes our perceptual reasoning into fixed patterns and customary responses to situations, just as verbal language becomes fixed within the parameters of grammar. Today, television and other visual media are the primary trainers in our visual worlds.

As Bandura has emphasized, visual learning is the key to understanding behavior in general through symbolic modeling—that is, through the extension of specific media actions to other generalizable situations. As

Tan states, for example, "If a television viewer observes and learns that a specific act is a preferred and effective means of resolving interpersonal conflict, he or she may accept the principle that aggressive behavior in general is an acceptable and effective means of solving problems."[1] In other words, once violence is incorporated within one's image of how the world works, it may become a preferred mode of future behavior.

Prefiguring Social Learning Theory, Boulding posits that "it is not the message which is important but the transformation of the image which it produces. A society may have very rapid transmission of messages, yet if its images are stable and resist the impact of the messages change will be slow no matter how swiftly the messages themselves course through the channels of communication."[2] What this implies in terms of media criticism is that it is not the single film or incident of violence that is important but the cumulative impact on the individual and how it changes the way he or she sees the world.

George Gerbner observed what he ultimately came to call "mean world syndrome" as a result of the change in worldview brought about by the impact of repeated messages, and he demonstrated through long-term research study the salience of Boulding's contention that such repetition results in "a realignment or reorganization of the whole knowledge structure," under the umbrella theory of "cultivation process." According to Gerbner and others, "Television has become the primary common source of socialization and everyday information of an otherwise heterogeneous population. The repetitive pattern of television's mass-produced message and images forms the mainstream of a common symbolic environment."[3] This media environment has in effect replaced other unifying forces such as religion, which were so influential in preindustrial society. It has also taken over the function of cultural storytelling which images performed in primitive cultures. Such images, though their continual repetition of mythic and ideological patterns serve "to define the world and legitimize the social order."[4] This is the essence of what Neil Postman meant in *Amusing Ourselves to Death* when he referred to television as a kind of "societal glue," and what Marshall McLuhan in *Understanding Media* observed as the inherent closeness of the media image to cave art, with the television image functioning in the same way as the image in preliterate tribal cultures.

Accordingly, such media effects as "mean world syndrome" come about when repeated exposure to messages reaches a critical point and then alters the whole orientation that we speak of as "worldview." People continually bombarded by a variety of forms of violence in media eventually can become convinced that the world they live in is an inherently dangerous and primarily mean one, where few people can be

trusted, and where communal values are rare or nonexistent.[5] As research shows, the result of overkill is a fundamental change in total outlook. People predictably act as if the world portrayed by media were a reality, and this behavior in turn inadvertently pushes the society toward actualizing it, initiating a self-fulfilling prophecy on a gigantic scale.

This implies two basic qualities in the image: an inherent stability that makes it resistant to all but the most relentless repetition, and a vulnerability to change when personal self-image or the image that the society has of itself—together with its attendant value system—is weak, ambiguous, or fragmented. When this is the case, single messages may have great clarification and directional impact, as well as a progressively cumulative impact, especially if they seem acceptable or appropriate within the individual's social or experiential context. A number of researchers, for example, have identified a "Priming Effect" where observed behavior is likely to trigger related thoughts and result in imitative behavior. So-called "copy-cat crimes" inevitably seem to spring up after media attention has been drawn to specific actions such as skyjackings or suicides.[6] In everyday experience, race fans know that the only reckless driving they see will occur immediately after the race on the way out of the track, and it is an old joke that "I went to the fights last weekend and a hockey game broke out." After more than four decades of focused study, media researchers now generally agree that watching violence increases the likelihood of acting in a violent manner, and while some effects are undoubtedly transient, each subsequent exposure and action increases the predilection to such action.[7]

In his conversations with Bill Moyers just before the end of his life in 1987, Joseph Campbell lamented that today's society exists in just such a state of fragmentation and vulnerability. What was needed, he believed, was a unifying cultural myth, what Boulding called "image," which would help individuals growing up in it to relate more clearly to "the wisdom of life" and to see their specific roles and responsibilities within the larger ethos. "If you want to find out what it means to have a society without any rituals," he told Moyers, "read the *New York Times*."[8] What one finds there, he suggested, is a picture of a society without myths where children are allowed to age without a sense of what their society expects of them or what it needs to adequately sustain its sense of itself and to ensure its survival: "Society has provided them no rituals by which they become members of the tribe, of the community. All children need to be twice born, to learn to function rationally in the present world, leaving childhood behind."[9]

Youths become involved with gangs, Campbell believed, because of the lure of ritual and belongingness that the society fails to offer them.

He saw in their fragmented lives a susceptibility to self-destructive and socially destructive messages as well as an attempt to define their own initiations and morality. In tribal societies, ceremonies associated with birth, maturation, marriage, and death translated life crises into impersonal patterns and timeless forms, and social duty reinforced and validated the value of the individual.[10] Because we lack what Boulding called a shared "public image"—that is, a myth that is useful, creative, and productive of organic growth—what we have today is a media milieu increasingly characterized by images of distorted sexual identity and violence as entertainment.

Visual intelligence therefore suggests that the question before us as a society is not one of simply being able to "read" and converse in images, or even of understanding the effects of actual or vicarious visually oriented experience. Rather it is the question of whether the command of the various dialects of visual language as expressed by various media, the associative logic they employ, and the profound emotional power they tap and release will be the province of individual intelligence and cumulative social wisdom, or it will remain exclusively in the realm of special interest groups driven by short-sighted economic or other motives. Visual intelligence ultimately implies an understanding of the power of the visual image both to reveal and to reshape the world.

The great existentialist philosopher Gabriel Marcel described the product of this closing down of perception as "functional man." As we grow, Marcel comments, "each one of us becomes the centre of a sort of mental space arranged in concentric zones of decreasing interest and participation. It is as though each one of us secreted a kind of shell which gradually hardened and imprisoned him; and this sclerosis is bound up with the hardening of the categories in accordance with which we conceive and evaluate the world."[11] The real challenge of life, he reminds us, is to keep ourselves in a permeable state, receptive to the spirit that envelops us, gives us hope, and lets us communicate with, or "engage," others and the world around us. This permeability and perceptual logic may be most apparent in the artist who speaks to us through metaphor and symbol, but it is also a way of seeing that each of us can develop. In science, too, imagery has emerged as a fundamental skill in solving practical problems. Like the globe itself, science continues to move away from linear logic and discrete thinking toward perceptual logic and the process of gestalt formation. Permeability and cross-fertilization are indispensable keys to all creative thought.

The relationships that arrest our attention within the environment and the principles that govern the universe are not at odds. Rather they are reflections of the same profoundly deep rhythms of existence. These

nonlinear relationships cannot be expressed in a straight line on a graph. A higher, multidimensional logic and wider perceptual view is necessary to begin to understand the world. This is the essence of visual intelligence.

In a very real sense we must return to the eyes of the child to undo our logical conditioning and begin to see the true relations of things. Yet we must also exercise a critical awareness in relation to manufactured images that distort these relations. Although it is becoming clearer that visual thinking may be the key to broadening perspective and reframing problems in new ways, the nation as a whole is immersed in a visual environment that discourages this ability and in its stead offers a seemingly endless succession of commercial television programs, films, and advertisements that exploit images to tap the psyche and direct it in increasingly more simplistic and destructive directions. As the complexities of modern society demand more and more innovative answers, our lack of visual intelligence stunts not only our ability to think in new and creative directions but also our appreciation of human life itself, of the human potential for spiritual growth and creative expression, and of the interrelatedness of all things.

What is needed to achieve visual intelligence is a paradigm shift in our thinking away from a logocentric bias and toward a growing awareness that images are a means of communication that runs deeper and is ultimately more powerful than words in its ability to condition attitudes and to form thoughts. Only when we recognize the way in which images communicate can we begin to deal appropriately with the effects of those images and to fully appreciate the horizons that visual thinking opens for creative thought. While the ability of the image to speak directly to the emotions and to the deepest part of the psyche is the great gift of images in the realm of art and literature, and the holistic logic of perception is the key to opening up the mind, it is also a curse to the uninitiated who do not understand the range and profundity of its power.

NOTES

Introduction

1. Donis A. Dondis, *A Primer in Visual Literacy* (Cambridge, MA: MIT Press, 1973), 6–7.

2. See Donis A. Dondis, *Television Literacy: Critical Television Viewing Skills* (Boston: Boston University School of Public Communication).

3. Warren Berger, "The Amazing Secrets of a Television Guru," *New York Times*, 10 July 1994, sec. H, p. 25.

4. Elisabeth Busmiller, "The Tuesday Team Wants America to Feel Good," *Adweek*, 29 October 1984, 71.

5. David Pearl, Lorraine Bouthilet, and Joyce Lazar, eds., *Television and Behavior: Ten Years of Scientific Progress and Implications for the Eighties*, Vol. II (Washington, DC: U.S. Government Printing Office, 1982), 87.

6. Béla Balázs, *Theory of the Film* (New York: Dover, 1970), 17.

7. John S. Mayo (remarks to Bell Laboratories Technology Symposium, Toronto, Canada, October 13, 1993).

8. R. A. Braden and J. A. Hortin, "Identifying the Theoretical Foundations of Visual Literacy," in *Television and Visual Literacy*, eds. R. A. Braden and A. D. Walker (Bloomington: International Visual Literacy Association, 1982), 169.

9. Marshall McLuhan, *Understanding Media: The Extensions of Man* (New York: Signet, 1964), 292.

10. Howard Gardner and Joseph Walters, "A Rounded Version," *Multiple Intelligences* (New York: HarperCollins, 1993), 17.

11. Ibid, 17–18.

12. Ibid., 21.

13. Richard A. Knox, "Brainchild," *Boston Globe Magazine*, 5 November 1995, 40.

14. Margaret S. Livingstone, "Art, Illusion and the Visual System," *Scientific American*: 85.

1. Perception and Visual "Common Sense"

1. Jacob Jacoby, Wayne D. Hoyer, and David A. Sheluga, *MisCompre-hension of Televised Communications* (New York: Educational Foundation of the American Association of Advertising Agencies, 1980), 89.

2. Temple Grandin, an accomplished autistic who is a professor of animal sciences at Colorado State University, has written and lectured extensively on autism as it is characterized by an immaturity in limbic system development, primarily in the amygdala. This immaturity, she feels, is responsible for her own lack of "social intuition" and inability to recognize subtleties of facial expression and fit into the flow of social conversation. See Temple Grandin, *Thinking in Pictures* (New York: Doubleday, 1995).

3. R. S. Lazarus, "Thoughts on the Relations between Emotions and Cognition," American *Psychologist* 37 (1982): 1019–1024.

4. R. B. Zajonc, "The Interaction of Affect and Cognition," in *Approaches to Emotion*, eds. K. R. Scherer and Paul Eckman (Hillsdale, NJ: Lawrence Erlbaum, 1984), 239.

5. Two early theories relating emotion to cognition were the James-Lange theory, posited by William James in 1884, which saw subjective emotion as necessarily preceded by cognition, and W. B. Cannon's theory posited in 1927 that emotion is directly perceived without cognitive intervention. Contemporary theories by Schacter and Lazarus follow the former tradition; Zajonc the latter.

In 1952, P. D. MacLean introduced the term "limbic system" to describe an integrated neural network comprised of cortical areas of Broca's limbic lobe, which includes the hippocampus, and certain subcortical nuclei associated with the limbic cortex, which includes the amygdala. MacLean believed that the hippocampus was the key site for emotional processing, and that the limbic system represented an early evolutionary development in emotional experience and expression. The limbic system's functions, he believed, preceded the more complex intellectual and linguistic functions of the neocortex. MacLean's limbic system theory of emotion dominated thought from the 1950s until well into the 1980s. Now, however, the differentiation of older and newer evolutionary structures is held to be less clear. The hippocampus, for example, which is now believed to play a key role memory processing, may be involved in some of the brain's most complex cognitive functions. By 1982, Brodal [See A. Brodal, *Neurological Anatomy* (New York: Oxford University Press, 1982)] declared the limbic system concept to be useless. [For a lucid summary of limbic system thought, see also J. LeDoux, "Emotion and the Limbic System Concept," *Concepts in Neuroscience* 2, no. 2 (1991), 169–199.]

6. Joseph LeDoux, "Emotional Memory Systems in the Brain." *Behavioral and Brain Research* 58, nos. 1–2 (1993): 69–79.

7. See Joseph LeDoux, "Sensory Systems and Emotion," *Integrative Psychiatry* 4 (1986) 237–248.

———. "Emotion and the Limbic System Concept," *Concepts in Neuroscience* 2, no. 2 (1991), 169–199.

———. "Emotional Memory Systems in the Brain," *Behavioral and Brain Research* 58, nos. 1–2 (1993): 69–79.

———. "Emotion, Memory and the Brain," *Scientific American* 27, no. 6 (June 1994: 50–57.

8. Zajonc, "The Interaction of Affect and Cognition," 241.

9. LeDoux, "Sensory Systems and Emotion," 241.

10. Daniel Goleman, *Emotional Intelligence* (New York: Bantam Books, 1995), 26.

11. Ibid., 27.

12. R. Adolphs, D. Tranel, H. Damasio, and A. Damasio, "Impaired Recognition of Emotion in Facial Expressions Following Bilateral Damage to the Human Amygdala," *Nature* 372 (1994): 669–672.

13. Oliver Sacks, "An Anthropologist on Mars" in *An Anthropologist on Mars* (New York: Vintage Books, 1995), 287–288.

14. M. H. Ederlyi, *Psychoanalysis: Freud's Cognitive Psychology* (New York: W. H. Freeman, 1985), 64.

15. G. S. Klein, D. P. Spence, R. R. Holt, and S. Gourevitch, "Cognition without Awareness; Subliminal Influences Upon Conscious Thought," *Journal of Abnormal and Social Psychology* 57 (1958): 255–66; J. Bressler, "Illusion in the Case of Subliminal Visual Stimulation," *Journal of General Psychology* 5 (1931): 244–250; W. R. Kunst-Wilson and R. B. Zajonc, "Affective Discrimination of Stimuli That Cannot Be Recognized," *Science* 207 (1980): 557–558; M. O'Grady, "Effect of Subliminal Pictorial Stimulation on Skin Resistance," *Perceptual and Motor Skills* 44, no. 3, pt. 2 (June 1977): 1051–1056.

16. LeDoux, "Sensory Systems and Emotion," 241.

17. Norman F. Dixon, *Preconscious Processing* (New York: John Wiley & Sons, 1981), 125.

18. Ibid., 1.

19. R. B. Zajonc, "On the Primacy of Affect," *American Psychologist* 39 (1984): 117. See also R. B. Zajonc, "Feeling and Thinking: Preferences Need No Inferences," *American Psychologist*, 35 (1980): 151.

20. Zajonc, "On the Primacy of Affect," 122.

21. Dixon, *Preconscious Processing*, 265.

22. F. Pratto and J. A. Bargh, "Stereotyping Based on Apparently Individuating Information: Trait and Global Components of Sex Stereotypes Under Attention Overload," *Journal of Experimental and Social Psychology* 27 (1991): 26–47.

23. John Bargh, "Automatic Information Processing: Implications for Communication and Affect," in *Communication Affect, and Social Cognition*, eds., L. Donohew, H. Sypher, and E. T. Higgins (Hillsdale, NJ: Lawrence Erlbaum, 1988): 9–32; John Bargh, "Conditional Automaticity: Varieties of Automatic Influence in Social Perception and Cognition," in *Unintended Thought*, eds., J. S. Uleman and J. A. Bargh (New York: Guilford Press, 1989): 3–51.

24. Jon A. Krosnik, Andrew L. Betz, Lee Jussim, and Ann R. Lynn, "Subliminal Conditioning of Attitudes," *Personal and Social Bulletin* 18, no. 2 (April 1992): 152–162.

25. K. K. Dion, E. Berscheid, and E. Walster, "What Is Beautiful Is Good," *Journal of Personality and Social Psychology* 24 (1972): 285–290.

26. See Joseph Bruner, *In Search of Mind: Essays in Autobiography* (New York: Harper & Row, 1983).

27. E. McGinnies, "Emotionality and Perceptual Defense," *Psychological Review* 56 (1949): 244–251.

28. C. Fisher, "Dreams and Perception: The Role of Preconscious and Primary Modes of Perception and Dream Formation," *Journal of the American Psychoanalytic Association* 2 (1954): 389–445; C. Fisher and I. H. Paul, "The Effect of Subliminal Visual Stimulation on Imagery and Dreams: A Validation Study," *Journal of the American Psychoanalytic Association* 7 (1959): 35–83; H. Shervin, "Subliminal Perception and Dreaming," *Journal of Mind and Behavior* 7 nos. 2, 3 (Spring/Summer): 379–395.

Eriksen reviewed these and pointed out that interpretation of results could be challenged on the grounds of loose criteria for interpreting imagery (a dream bicycle, e.g., could be interpreted as a match for a truck in the picture); reluctance of subjects to mention items they were not truly sure of in making their original reports but that might be unhesitatingly mentioned in the context of reporting dreams; and the high probability of associating proper items within a given context, as when an image of water might conjure up a boat or wharf as well. See Charles W. Eriksen, "Discrimination and Learning without Awareness: A Methodological Review," *The Psychological Review* 67, no. 5 (September 1960): 295–296.

29. See R. F. Bornstein, D. R. Leone, and D. J. Galley, "The Generalizability of Subliminal Mere Exposure Effects: Influence of Stimuli Perceived without Awareness on Social Behavior," *Journal of Personality and Social Psychology* 53

(1987): 10070–1079; W. R. Kunst-Wilson and R. B. Zajonc, "Affective Discrimination of Stimuli That Cannot Be Recognized," *Science* 207 (1980): 557–558; J. J. Seamon, N. Brody, and D. M. Kauff, "Affective Discrimination of Stimuli That Are Not Recognized: Effects of Shadowing, Masking and Cerebral Laterality," *Journal of Experimental Psychology: Learning, Memory and Cognition* 9 (1983): 544–555; J. J. Seamon, N. Brody and D. M. Kauff, "Affective Discrimination of Stimuli That Are Not Recognized: II. Effect of Delay Between Study and Test," *Bulletin of the Psychonomic Society* 21 (1983): 187–189; W. R. Wilson, "Feeling More Than We Know: Exposure Effects Without Learning," *Journal of Personality and Social Psychology* 37 (1979): 811–821.

30. R. B. Zajonc, "Attitudinal Effects of Mere Exposure," *Journal of Personality and Social Psychology* 9 (1968): 52–80; R. B. Zajonc, "Feeling and Thinking: Preferences Need No Inferences," *American Psychologist* 35 (1980): 151–175; R. B. Zajonc, "The Interaction of Affect and Cognition," in *Approaches to Emotion*, eds., K. R. Scherer and P. Eckman (Hillsdale, NJ: Earlbaum, 1984), 259–270; W. R. Kunst-Wilson and R. B. Zajonc, "Affective Discrimination of Stimuli That Cannot Be Recognized," *Science* 207 (1980): 557–558.

31. J. Garcia and K. W. Rusiniak, "What the Nose Learns from the Mouth," in *Chemical Signals*, eds., D. Muller-Schwarze and R. M. Silverstein (New York: Plenum, 1980), 141–156, in Zajonc, "On the Primacy of Affect," 121.

32. See R. Alopho et al., "Impaired Recognition of Emotion in Facial Expression Following Bilateral Damage to the Human Amygdala," *Nature* 372 (1994): 669–672; and A. Damasio, *Descartes' Error: Emotion, Reason and the Human Brain* (New York: Putnam, 1994).

33. Daniel T. Gilbert, "How Mental Systems Believe," *American Psychologist* 46, no. 2 (1991): 107–117.

34. This initial acceptance and trust, for example, explains not only why we accept ideas more readily when we are in an emotional state, but also why without a trouble signal, such dangerous weapons such as letter bombs can work with deadly effect. Disguised "booby traps" are often successful, even in combat conditions where, under considerable stress, soldiers whose neural networks are in a continuous state of anxiety will eventually not be able to think straight and will proceed without fully evaluating the situation. By the time danger is signaled and soldiers consciously recognize their errors, it may be too late.

Conversely, we sometimes reject the truth of what we cannot readily see or fit into the context of our previous thinking. Joseph Lister had a difficult time convincing fellow physicians of the presence of microscopic germs because people couldn't see them—and if they couldn't see them, they *felt* they couldn't really be there.

35. LeDoux, "Sensory Systems and Emotion," 241.

36. Gilbert, 107–119.

37. Ibid., 107.

38. LeDoux, "Sensory Systems and Emotion," 241.

39. Semir Zeki, "The Visual Image in Mind and Brain," *Scientific American* (September 1992): 75–76.

40. Timothy Ferris, *The Mind's Sky* (New York: Bantam Books, 1992), 74–75.

41. See C. A. Kiesler and S. B. Kiesler, "Role of Forewarning in Persuasive Communications," *Journal of Abnormal and Social Psychology* 8 (1964): 547–549 ; J. Fleming and A. J. Arrowood, "Information Processing and the Perseverance of Discredited Perceptions," *Personality and Social Psychology Bulletin* 5 (1979): 201–205; D. M. Wegner and G. Coulton with R. Wenzlaff, "The Transparency of Denial: Briefing in the Debriefing Paradigm," *Journal of Personality and Social Psychology* 49 (1985): 338–346; J. P. Tousigant, D. Hall, and E. F. Loftus, "Discrepancy Detection and Vulnerability to Misleading Post-Event Information," *Memory and Cognition* 14 (1986): 329–338; Daniel T. Gilbert, D. S. Krull, and P. S. Malone, "Unbelieving the Unbelievable: Some Problems in the Rejection of False Information, " *Journal of Personality and Social Psychology* 59 (1990): 601–613.

42. Jolie B. Solomon, "Procter and Gamble Fights New Rumors of Link to Satanism," *Wall Street Journal*, 8 November 1984, 1, 18.

43. Roger Manvell sees this scene and Charlie's eating of the shoe as direct parallels to the cannibalism and the reportedly real consumption of a moccasin in the tragedy of the 1840s Donner Party, an account of which was reprinted in 1922, three years before *The Gold Rush* was completed.

This famous film scene has also proven to be the inspiration for a number of subsequent adaptations, including a recent Budweiser commercial where one of two friends stranded on a desert island sees his companion undergo several hallucinatory transformations, ending in the image of a bottle of Budweiser beer. From a technical point of view, the evolution of the image is interesting in another respect: the original special effect in the *Gold Rush* was accomplished simply with superimposition. The commercial was done with sophisticated "morphing " techniques through computer silicon graphics (see Chapter 5, Film Logic and Rhetoric herein). The degeneration of the scene into commercial trivialization ironically parallels the evolutionary advancement of visual technology.

44. Richard L. Gregory, *The Intelligent Eye* (New York: McGraw-Hill, 1970), 11.

45. G. Harman, "Epistemology," in *Handbook of Perception*, eds. E. C. Carterette and M. P. Friedman (New York: Academic Press, 1974), 1: 41–55.

46. Charles Kelsey, "Detection of Visual Information," in *The Perception of Visual Information*, eds. William R. Hendee and Peter N. T. Wells (New York: Springer-Verlag, 1993), 30–31.

47. Ibid., 31–32.

48. J. Barnes, "Aristotle," and "Perception: Early Greek Theories," in *Oxford Companion to the Mind*, ed. R. L. Gregory (New York: Oxford University Press, 1987), 38–40; 603–604.

49. In the seventeenth century Descartes proposed the mind and body as distinctly separate entities and, as Owen J. Flanagan notes in *The Science of the Mind* (Cambridge, MA: MIT Press, 1984), "raised directly or indirectly, virtually all the significant issues related to the foundations of the science of the mind," including the issue of distinguishing between belief and understanding. Spinoza rejected Descartes' view in favor of "substance monism," which united body and mind as manifestations of divine reality. Locke established an empirical model that separated the object from the perception of it through the intermediary senses, and Newton continued this line of thinking, searching for the tenuous causal links between the senses and the mind that give rise to internal perceptions of external objects. Kant, who laid the substantive and methodological foundations of modern cognitive psychology, proposed that we supply meaning to experience through a priori innate mental structures, and rejected Hume's empiricism, which emphasized that all knowledge originates in the senses.

50. For cogent discussions of how image memory functions and is susceptible to change, see Antonio Damasio, *Descartes' Error: Emotion, Reason and the Human Brain* (New York: Putnam, 1994); and Rodolpho R. Llinás and D. Paré, "Dreaming and Wakefulness," *Neuroscience* 44, no. 3 (1991): 521–535.

51. E. Bruce Goldstein, *Sensation and Perception*, 3rd ed. (Pacific Grove, CA: Wadsworth, 1989), 79.

52. Ibid., 78.

53. David Lyon, "Vision Theory Explains Why We See a World Without Holes," *The World* (8 February 1984), 11; J. J. Gibson, "Outline of a Theory of Direct Visual Perception," working paper, Cornell University, Ithaca, New York, 1969.

54. James J. Gibson, "Outline of a Theory of Direct Visual Perception," working paper, Cornell University, Ithaca, New York, 1969.

55. James J. Gibson, "Ecological Optics," *Vision Research* 1 (1961): 254.

56. Ibid., 258.

57. James J. Gibson, "Outline."

58. Peter F. Sharp and Russel Philips, "Physiological Optics," in *The Perception of Visual Information*, eds. William R. Hendee and Peter N. T. Wells (New York: Springer-Verlag, 1993), 128.

59. See Oliver Sacks, "To See and Not See," in *An Anthropologist on Mars* (New York: Vintage Books, 1995), 108–152.

60. For contrasting views on innate versus learned ability, see Jan B. Deregowski, "Pictorial Perception and Culture," November 1972, in *Image Object and Illusion: Readings from Scientific American* (San Francisco: W. H. Freeman and Company, 1974), 79–85; and Julian Hochberg and Virginia Brooks, "Pictorial Recognition as an Unlearned Ability: A Study of One Child's Performance," *American Journal of Psychology* 75 (1962): 624–628.

61. Ulrich Raff, "Visual Data Formatting," in *The Perception of Visual Information*, eds. William R. Hendee and Peter N. T. Wells (New York: Springer-Verlag, 1993), 197–198.

62. See Bart Kosko, *Fuzzy Thinking* (New York: Hyperion, 1993).

63. Richard L. Gregory, quoted in Raff, 198.

64. David H. Freeman, "Quantum Consciousness," *Discover* (June 1994): 90.

65. Richard L. Gregory, *The Intelligent Eye* (New York: McGraw-Hill, 1970), 13.

66. Semir Zeki, "The Visual Image in Mind and Brain," *Scientific American* (September 1992): 71.

67. Ibid., 73.

68. Ibid.

69. E. Bruce Goldstein, 50.

70. James J. Gibson, "Outline."

71. Oliver Sacks, "To See and Not See," in *An Anthropologist on Mars* (New York: Vintage Books, 1995), 108–152.

72. See Richard L. Gregory, *Concepts and Mechanisms of Perception* (London: Duckworth, 1974). Also referenced with other interesting cases in Oliver Sacks, "To See and Not See."

73. Steven Pinker, "Visual Cognition: An Introduction," *Visual Cognition*, ed. Steven Pinker (Cambridge, Massachusetts: MIT Press, 1985), 3.

74. See Gerald M. Edelman, *Bright Air, Brilliant Fire: On the Matter of the Mind* (New York: Basic Books: 1992).

75. Alison Bass, "Hidden Memories," *Boston Globe*, 18 March 1996, 25, 27.

76. Ibid., 27.

77. Ibid., 258.

78. See James J. Gibson, *The Senses Considered as Perceptual Systems* (Boston: Houghton Mifflin, 1966).

79. See David Marr, *Vision* (New York: W. H. Freeman, 1982).

80. Goldstein, 212–220.

81. Bela Julesz, "A Brief Outline of the Texton Theory of Human Vision," *Trend Neuroscience* 7 (1986): 41–45.

82. Richard S. Lazarus, "Commentary [on LeDoux's 'Sensory Systems and Emotion: A Model of Affective Processing']," *Integrative Psychiatry* 4 (1986): 246.

83. S. Stansfeld Sargent and Kenneth R. Stafford, *Basic Teachings of the Great Psychologists*, rev. ed. (New York: Dolphin Books, 1965), 132.

84. Erich von Hornbostel, "The Unity of the Senses," in *Source Book of Gestalt Psychology*, ed. Willis D. Ellis (New York: Harcourt Brace & World, 1938), 214, 216.

85. Kurt Koffka, *Principles of Gestalt Psychology* (1935; reprint, New York: Harcourt, Brace & World, 1963), 53.

86. Ibid., 23.

87. Semir Zeki, "The Visual Image in Mind and Brain," *Scientific American* (September 1992): 76.

88. Margaret Livingstone and David Hubel, "Segregation of Form, Color, Movement, and Depth: Anatomy, Physiology, and Perception," *Science* 240 (6 May 1988): 747.

89. Richard L. Gregory, "Seeing Backwards in Time," *Nature* (5 January 1995): 21.

90. Zeki, 71.

91. Joseph and Barbara Anderson, "The Myth of Persistence of Vision Revisited," *Journal of Film and Video* 45, no. 1 (1993): 10. See also: Joseph and Barbara Anderson, "The Myth of Persistence of Vision," *Journal of the University Film Association* 30, no. 4 (Fall 1978): 3–8.

92. G. A. Orban, "Processing of Moving Images in the Geniculocortical Pathway," *Visual Neuroscience*, eds. J. D. Pettigrew, K. J. Sanderson, & W. R. Levick (New York: Cambridge University Press, 1986), 121–144; J. Timothy

Petersik, "The Two-process Distinction in Apparent Motion," *Psychological Bulletin* 106, no. 1 (1989): 107–127.

93. Albert Michotte, *The Perception of Causality* (New York: Basic Books, 1963) quoted in E. Bruce Goldstein, *Sensation and Perception*, 3rd ed. (Pacific Grove, CA: Wadsworth, 1989), 307.

94. Koffka, 110.

95. We are, in fact, intolerant of the unfinished and incomplete to such a degree that it is almost impossible not to automatically respond to such things as simple as "knock–knock" jokes; also, if someone gives the familiar "Dat–Dat-dit-dit-Dat" rap on the table, inevitably, people will complete it with a "Dat Dat" mentally. Often at least one person in any given group will actually rap twice on the table to complete it. This aspect of perception which abhors the incomplete has been effectively exploited in a variety of ways by a wide spectrum of communicators from fine artists to commercial advertisers.

96. Edward T. Hall, *The Hidden Dimension* (New York: Anchor Books, 1982), 88.

97. Koffka, 109.

98. Ibid., 126.

99. Bela Julesz, "Texture and Visual Perception," in *Image Object and Illusion: Readings from Scientific American* (San Francisco: W. H. Freeman, 1974), 59–70.

100. W. E. Hill, "My Wife and My Mother-in-Law," *Puck*, 6 November 1915, 11.

101. Koffka, 153.

102. Julesz, "Texture and Visual Perception," 69.

103. Michael J. McCarthy, "Mind Probe," *Wall Street Journal*, 22 March 1991, sec. B, p. 3.

104. Margaret Livingstone and David Hubel, 747.

105. G. H. Fisher, "Preparation of Ambiguous Stimulus Materials," *Perception and Psychophysics* 2, no. 9 (1967): 421–422.

106. Matthew Hugh Erdelyi, "A New Look at the New Look: Perceptual Defense and Vigilance," *Psychological Review* 81, no. 1 (Jan 1974), 1–25.

107. E. H. Gombrich, *Art And Illusion: A Study in the Psychology of Pictorial Representation* (Princeton: Princeton University Press, 1960), 249.

108. Ibid., 132.

109. Howard Rheingold, *Virtual Reality* (New York: Simon and Schuster, 1991), 44, 45.

110. Ibid., 144.

111. Jane E. Steven, "Virtual Therapy," *Boston Globe*, 30 January 1995, 25.

112. "Virtual Reality," *Business Week*, 5 October 1992, 97.

113. "Anatomy of a Fastball," *Business Week*, 5 October 1992, 98.

114. "Is Virtual Reality Real Enough for the Courtroom?" *Business Week*, 5 October 1992, 99.

115. Jaron Lanier and Frank Biocca, "An Insider's View of the Future of Virtual Reality," *Journal of Communication* 42, no. 4 (1992): 162–165.

116. Ibid., 166.

117. Ibid., 164.

118. See Ann Marie Barry, "Advertising and Channel One: Controversial Partnership of Business and Education," in *Watching Channel One*, ed. Ann DeVaney (Albany: State University of New York Press, 1994), 102–136.

119. Michael Shapiro and Daniel G. McDonald, "I'm Not a Real Doctor, but I Play One in Virtual Reality: Implications of Virtual Reality for Judgments about Reality," *Journal of Communication* 42, no. 4 (1992): 100–101.

120. See H. Cantril, *The Invasion from Mars* (1940; reprint New York: Harper and Row, 1966).

121. Shapiro and McDonald, 100–101.

122. Marshall McLuhan, *Understanding Media: The Extensions of Man* (New York: Signet, 1964), 30.

123. N. Z. Medalia and O. N. Larsen, "Diffusion and Belief in Collective Delusion: The Seattle Windshield Pitting Epidemic," *American Sociological Review* 23 (1958): 221–232.

124. Gombrich, 249.

125. Sharon Begley, "Your Child's Brain," *Newsweek*, 19 February 1996, 56.

126. Ibid.

127. Ibid., 57.

128. Ibid.

129. Ibid., 62.

130. Jeremy Wolfe, "Hidden Visual Processes," *Scientific American* 248, no. 2 (1983): 94–98.

131. LeDoux, "Sensory Systems and Emotion," 242.

132. Ibid.

133. Gregory, 13.

134. G. Lakoff and M. Johnson, *Metaphors We Live By* (Chicago: University of Chicago Press, 1980), 48.

2. The Nature and Power of Images

1. R. L. Birdwhistell, *Kinesics and Context* (Philadelphia: University of Pennsylvania Press, 1970), 158.

2. A. Mehrabian, "Communication Without Words," *Psychology Today* 2 (1968), 51–52.

3. See Roger vonOech, *A Whack on the Side of the Head* (New York: Warner Books, 1990).

4. John McCrone, "Quantum States of Mind," *New Scientist* (20 August 1994): 35–37.

5. vonOech, 44, 48–49.

6. Howard Gardner, *Creating Minds* (New York: HarperCollins, 1993), 23–24.

7. Ibid., 365.

8. Professor Koryo Miura interview, *Beyond 2000*, Beyond Productions Pty Ltd. in association with the Discovery Channel, 1993.

9. See George M. Prince, "Synectics," in *Group Planning and Problem-Solving Methods in Engineering*, ed. Shirley A. Olsen (New York: John Wiley & Sons, 1982).

10. Martha J. Farah, "The Neurological Basis of Mental Imagery: A Component Analysis," *Visual Cognition*, ed. Steven Pinker (Cambridge, Massachusetts: MIT Press, 1984), 269.

11. Martha J. Farah, "The Neurological Basis of Mental Imagery," *Trends in Neuroscience* 12, no. 10 (1989): 398.

12. Mircea Eliade, *The Two and the One*, trans. J. M. Cohen (New York: Harper & Row, 1965), 201.

13. Henry David Thoreau, *Walden* (New York: Amsco, n.d.), 246.

14. Farah, *Neuroscience*, 395.

15. Bart Kosko, *Fuzzy Thinking* (New York: Hyperion, 1993), 5.

16. T. S. Eliot, "Burnt Norton," *The Four Quartets*, in *T. S. Eliot: The Complete Poems and Plays, 1909–1950* (New York: Harcourt, Brace & World, 1971), 121.

17. William F. Allman, "The Dawn of Creativity," *U.S. News & World Report*, 20 May 1996, 56.

18. Ibid., 56–57.

19. Eliade, *The Two and the One*, 202, 207.

20. E. H. Gombrich, *Art and Illusion* (Princeton: Princeton University Press, 1969), 93.

21. When a stamp with Nixon's image was issued on a special edition of the most common denomination postage stamp in 1995, Nixon's nose was noticeably *underplayed*, perhaps for this very reason.

22. Colin Blakemore, "The Baffled Brain," in *Illusion in Nature and Art*, eds. R.L. Gregory and E. H. Gombrich (London: Gerald Duckworth, 1973), 26–29.

23. Ibid., 122–123.

24. Lesley Stahl, interview by Bill Moyers, "Illusions of News," *The Public Mind: Image and Reality in America with Bill Moyers*, Alvin H. Perlmutter, Inc. and Public Affairs Television, 1989.

25. E. H. Gombrich, "Illusion and Art," in *Illusion in Nature and Art*, ed. R. L. Gregory and E. H. Gombrich (London: Gerald Duckworth & Co., 1973), 208.

26. James J. Gibson, "The Theory of Affordances," in *The Ecological Approach to Visual Perception* (Boston: Houghton Mifflin, 1979), 127–143.

27. Nixon's nose in this respect may be seen as a metaphorical extension of perceptual affordance into the realm of abstract thought—a kind of "intellectual affordance," because its presence is "satiriz-able" through analogy with a nose-related cultural myth that deals with the tangible consequences of lying.

28. Jean Piaget, *The Child's Conception of Space* (New York: W. W. Norton, 1967), 214.

29. Rudolph Arnheim, *Visual Thinking* (Berkeley: University of California Press, 1969), 255.

30. James J. Gibson, "The Information Available in Pictures," *Leonardo* 4 (1971): 27–35.

31. Max Wertheimer, "The General Theoretical Situation," in *Source Book of Gestalt Psychology*, ed. Willis D. Ellis (New York: Harcourt Brace & World, 1939), 16.

32. Rudolph Arnheim, *Art and Visual Perception* (Berkeley: University of California Press, 1974), 51.

33. R. L. Gregory, "Pre-script," in *Odd Perceptions* (New York: Methuen, 1987), 3.

34. Ibid., 46.

35. Among the most influential perceptual psychologists mentioned herein are Gibson and Gregory. For excellent discussions of imagery-related issues of conceptual mapping, cognitive semantics and "experientialist cognition," see also George Lakoff and Mark Johnson, *Metaphors We Live By* (Chicago: University of Chicago Press, 1980); Mark Johnson, *The Body in the Mind: The Bodily Basis of Reason and Imagination* (Chicago: University of Chicago Press, 1987); George Lakoff, *Women, Fire and Dangerous Things: What Categories Reveal About the Mind* (Chicago: University of Chicago Press, 1987); Ronald Langacker, *Foundations of Cognitive Grammar*, Vol. 1 (Stanford: Stanford University Press, 1987).

36. Arnheim, *Visual Thinking*, 13.

37. Randall White, "Visual Thinking in the Ice Age," *Scientific American* (July 1989), 98.

38. Ibid., 99.

39. Quoted in Temple Grandin, *Thinking in Pictures* (New York: Doubleday, 1995), 183.

40. Howard Gardner, *Creating Minds* (New York: HarperCollins, 1993), 122.

41. White, 99.

42. Temple Grandin, *Thinking in Pictures* (New York: Doubleday, 1995), 27, 20.

43. Ibid., 26.

44. Oliver Sacks, *An Anthropologist on Mars* (New York: Vintage Books, 1995), 205.

45. Ralph Haber, "Eidetic Images," in *Image, Object and Illusion: Readings from Scientific American* (San Francisco: W. H. Freeman and Company, 1974), 123–131.

46. Ulric Neisser, "The Processes of Vision," in *Image, Object and Illusion: Readings from Scientific American* (San Francisco: W. H. Freeman and Company, 1974), 10.

47. Farah, *Neuroscience*, 395.

48. Ibid., 397.

49. Ibid., 9.

50. Sigmund Freud, *The Ego and the Id* (New York: W. W. Norton, 1960), 19.

51. Carl G. Jung, "Approaching the Unconscious," in *Man and His Symbols*, ed. Carl Jung (New York: Dell, 1964), 26.

52. Carl G. Jung, *Analytical Psychology: Its Theory and Practice* (New York: Pantheon Books, 1968), 192–193.

53. Jung, "Approaching the Unconscious," 32.

54. Jung, *Analytical Psychology*, 194.

55. See Rodolpho R. Llinás and D. Paré, "Dreaming and Wakefulness," *Neuroscience* 44, no. 3 (1991): 521–535, and Oliver Sacks, "The Last Hippie," in *An Anthropologist on Mars* (New York: Vintage Books, 1995), 57.

56. Carl G. Jung, "The Concept of the Collective Unconscious," *Archetypes and the Collective Unconscious* (1936), in *The Portable Jung*, ed. Joseph Campbell (New York: Penguin Books, 1971), 59–69.

57. Jung, "Approaching the Unconscious," 68.

58. Mircea Eliade, *Images and Symbols*, trans. Philip Mariet (New York: Sheen and Ward, 1969), 12.

59. Joseph Campbell, *The Power of Myth* (New York: Doubleday Anchor, 1991), 47.

60. Ibid., 46.

61. Timothy Ferris, *The Mind's Sky* (New York: Bantam Books, 1992), 95.

62. Ibid., 96.

63. Ibid., 97.

64. M.-L. von Franz, "The Process of Individuation," in *Man and His Symbols*, ed. Carl Jung (New York: Dell, 1964), 230–235.

65. Joseph Campbell, "Introduction," in *The Portable Jung*, ed., Joseph Campbell (New York: Penguin Books, 1971), xxii.

66. John Naisbitt and Patricia Aburdene, "Ceos in New Society Will Be Visionaries," *Advertising Age*, 16 September 1985, 60.

67. Alan Richardson, *Mental Imagery* (New York: Springer, 1969), 56–57.

68. Michael Murphy and Rhea White, "The Psychic Side of Sports," quoted in John Naisbitt and Patricia Aburdene, "CEOs in New Society Will Be Visionaries," *Advertising Age*, 16 September 1985, 60.

69. Ronald Finke, "Mental Imagery and the Visual System," in *The Perceptual World*, ed. Irvin Rock (New York: W.H. Freeman, 1988), 185.

70. Marilyn Chase, "Inner Music: Imagination May Play Role in How the Brain Learns Muscle Control," *Wall Street Journal*, 13 October 1993, sec. A, p. 6.

71. O. Carl Simonton and Reid Henson, *The Healing Journey* (New York: Bantam Books, 1992), 4–5.

72. Joel L. Swerdlow, "Quiet Miracles of the Brain," *National Geographic* 187, no. 6 (June 1995), 25–26.

73. Jerome Frank, *Persuasion and Healing* (Baltimore: Johns Hopkins Press, 1961), 66.

74. Francis Crick, *The Astonishing Hypothesis* (New York: Simon and Schuster Touchstone, 1994), 244–245.

75. Zeki, Semir. "The Visual Image in Mind and Brain." *Scientific American* (September 1992): 69–76.

76. John McCrone, "Quantum States of Mind," *New Scientist* (20 August 1994): 36.

77. Crick, 246–247.

78. McCrone, 38.

79. Ibid.

80. Ibid.

81. David H. Freeman, "Quantum Consciousness," *Discover* (June 1994): 90–97.

82. Crick, 250.

83. Timothy Ferris, *The Mind's Sky* (New York: Bantam Books, 1992), 74, 77, 81.

84. Michael S. Gazzaniga, *The Social Brain* (New York: Basic Books, 1985), 189.

85. Gerry Spence, interviewed by Larry King, "Larry King Live," Cable News Network, 26 September 1995.

86. Michael Talbot, *The Holographic Universe* (New York: HarperCollins, 1991), 14–17.

87. See Karl Pribram, *Languages of the Brain* (Monterey, CA: Wadsworth, 1977).

88. Richard Restak, M. D., *The Brain* (New York: Warner Books, 1979), 253. See also Richard Restak, M. D., *The Mind* (New York: Bantam Books, 1988) and PBS *The Mind Parts* 1–9.

89. Talbot, 27–30.

90. Quoted in James Gleik, *Chaos: Making a New Science* (New York: Penguin Books, 1987), 252.

91. Ibid., 251-252.

92. Ibid., 5-8.

93. Ibid., 7.

94. Francis Crick, *The Astonishing Hypothesis* (New York: Simon and Schuster Touchstone, 1994), 266.

95. Richard Restak, *The Mind* (New York: Bantam Books, 1988), 24.

96. See Gerald M. Edelman, *Bright Air, Brilliant Fire: On the Matter of the Mind* (New York: Basic Books, 1992) and *Neural Darwinism: The Theory of Neuronal Group Selection* (New York: Basic Books, 1987).

97. Kenneth Boulding, *The Image* (Ann Arbor, MI: University of Michigan Press, 1956), 6–7.

98. Ibid., 7.

99. Ibid., 12.

100. Ibid., 7.

101. Ibid., 42–43.

102. James Gleik, *Chaos: Making a New Science* (New York: Penguiun Books, 1987), 23, 24, 252.

103. Ibid., 38, 39.

104. Ibid., 51.

105. Neisser, 11.

106. Arnheim, *Visual Thinking*, 18.

107. Richard L. Gregory, *The Intelligent Eye* (New York: McGraw Hill, 1970), 31.

3. The Language of Images

1. Alex Patterson, *Rock Art Symbols* (Boulder, Colorado: Johnson Books, 1992), 53.

2. W. V. Davies, *Egyptian Hieroglyphics* (Berkely, California: University of California Press/ British Museum, 1987), 60.

3. Scott McCloud, *Understanding Comics: The Invisible Art* (Northampton, Massachusetts: Kitchen Sink Press, 1993), 30–31.

4. Ibid., 36.

5. Ibid.

6. Will Eisner, *Comics and Sequential Art* (Tamarac, FL: Poorhouse Press, 1985), 103.

7. Eisner, 7-8.

8. Ibid., 8.

9. Ibid., 13.

10. F. R. H. Englefield, *Language: Its Origin and Its Relation to Thought* (London: Elek/Pemberton, 1977), 19.

11. Ibid.

12. Paul Ekman, "Expression and the Nature of Emotion," in *Approaches to Emotion*, eds., K.S. Scherer and Paul Ekman (Hillsdale, NJ: Lawrence Erlbaum, 1984), 319–321.

13. Ibid., 340.

14. Will Eisner, 89.

15. Ibid, 44–46.

16. See R. L. Gregory, "Is Consciousness Sensational Inference?" *Odd Perceptions* (London: Methuen, 1986), 48–57.

17. Englefield, 41–42.

18. Curtis Robbins, "Visualizations of a Silent Voice: A Deaf Poet's View," in *Visual Communication*, eds. Judy Clark-Baca, Darrell Beauchamp, and Roberts Braden (Blacksburg, VA: International Visual Literacy Association, 1992), 495.

19. Ibid., 497.

20. Jennifer Senior, "Sign Language Reflects Changing Sensibilities," *New York Times*, 3 January 1994, 1.

21. Umberto Eco, "Articulations of the Cinematic Code," in *Movies and Methods*, ed. Bill Nichols (Berkeley: University of California Press, 1976), 594.

22. Wolfgang Köhler, "Some Gestalt Problems," in *A Source Book of Gestalt Psychology*, ed. Willis D. Ellis (New York: Harcourt Brace, 1938), 61.

23. Quoted in James Gleik, *Chaos: Making a New Science* (New York: Penguin Books, 1987), 339.

24. See Ezra Pound, "How to Read," *Literary Essays* (Norfolk, CT: New Directions. 1954), 15–40.

25. T. S. Eliot, "The Metaphysical Poets," in *Criticism: The Major Texts*, ed. W. J. Bate (New York: Harcourt Brace Javanovich, 1970), 532.

26. T. S. Eliot, "Hamlet and His Problems," in *The Sacred Wood*, 4th ed. (London: Methuen & Co., 1969), 100.

27. Rudolph Arnheim, *Art and Visual Perception* (Berkeley: University of California Press, 1974), 454.

28. Georgy Kepes, *Language of Vision* (Chicago: Paul Theobald, 1967), 14.

29. Ernest B. Gilman, "Word and Image in Quarles' *Emblemes*," *Critical Inquiry* 6 (1980): 390.

30. Ibid., 391.

31. Ibid., 410.

32. Moses Maimonides (1135–1204), *The Guide of the Perplexed*, 2 vols., trans. Shlomo Pines (Chicago: University of Chicago Press, 1963), 1:22, in W. J. T. Mitchell *Iconology: Image Text Ideology* (Chicago: University of Chicago Press, 1986), 32.

33. Oliver Sacks, "The Case of the Colorblind Painter," in *An Anthropologist on Mars* (New York: Vintage Books, 1995), 21.

34. Ibid., 28–29.

35. Gleik, 163–180.

36. R. H. Post, "Population Differences in Red and Green Color Vision Deficiency: A Review and A Query," *Social Biology* 29, no. 3–4 (1982): 299–315.

37. Ibid., 312.

38. Joan Stepheson, "Seeing Yellow," *Science Digest* (September 1986): 24.

39. Julie Ann Miller, "Research Update: From the 1989 Meeting in Phoenix of the Society for Neuroscience," *Bioscience* 40 (February 1990): 87.

40. Marc Bornstein and Lawrence Marks, "Color Revisionism," *Psychology Today* (January 1982): 70.

41. William E. Cooper, "Aggressive Behavior and Courtship Rejection in Brightly and Plainly Colored Female Keeled Earless Lizards," *Ethnology* 77, no. 4 (1988): 265–278.

42. Bornstein and Marks, 64–69.

43. Jules Davidoff, "The Mind's Color Palette," *New Scientist*, 10 April 1993, 35.

44. Lynn Walsh et al., "Color Preference and Food Choice Among Children," *Journal of Psychology* 124, no. 6 (1990): 645–653.

45. Mike Berry, "Do You Think Pink?" *Orlando Sentinel Tribune*, 14 February 1993, sec. K, p.1.

46. Davidoff, 35.

47. Louisa Buck, "Hue and Eye," *New Statesman & Society*, 18 October 1991, 29.

48. Ibid., 30.

49. Alexander Schauss, "Application of Behavioral Photobiology to Human Aggression: Baker-Miller Pink," *International Journal of Biosocial Research* 2 (1981):1–9; Alexander Schauss, "The Physiological Effect of Color on the Suppression of Human Aggression: Research on Baker-Miller Pink," *International Journal of Biosocial Research* 7, no. 2 (1985): 55–64; James Gilliam, "The Effects of Baker-Miller Pink on Physiological and Cognitive Behavior of Emotionally Disturbed and Regular Education Students," *Behavioral Disorders* 17, no. 1 (1991): 47–55; Peter Bennett, Alan Hague, and Christopher Perkins, "The Use of Baker-Miller Pink in Police Operational and University Experimental Situations in Britain," *International Journal of Biosocial and Medical Research* 13, no. 1 (1991): 118–127; Pamela Profusek and David Rainey, "Effects of Baker-Miller Pink and Red on State Anxiety, Grip Strength and Motor Precision," *Perceptual and Motor Skills* 65, no. 3 (1987): 941–942.

50. D. Piggins and R. D. Nichols, "The Pink Room Effect: Tranquilization or Methodological Transgression?" *Atti della Fondazione Giorgio Ronchi* 37, no. 2 (1982): 281–286.

51. Berry, 1; Rebecca Ainsworth, Loerna Simpson, and David Cassell, "Effects of Three Colors in an Office Interior on Mood and Performance," *Perceptual and Motor Skills* 76 (1993): 235–241; see also F. Birren, *Color Psychology and Color Therapy* (Hyde Park, NY: University Books, 1950).

52. Mike Dornheim, interview, *Wings*, Discovery Channel, 1992.

53. "Form & Function," *Wall Street Journal*, 14 August 1991, sec. B, p. 1.

54. Jeffrey Smith, Paul Bell, and Marc Fusco, "The Influence of Color and Demand Characteristics on Muscle Strength and Affective Ratings of the Environment," *Journal of General Psychology* 113 (July 1986): 289–297.

55. Sally Dutczak, "The Effects of Cool-white, Full Spectrum Flourescent, and Color Adjusted Diffused Lights on Severely Physically and Mentally Handicapped Children," *International Journal of Biosocial Research* 7, no. 1 (1985): 17–20.

56. Wolfgang Wiltschko et al., "Red Light Disrupts Magnetic Orientation of Migratory Birds," *Nature* 364, no. 6437 (1993): 525–527.

57. N. E. Rosenthal, "Antidepressant Effects of Light in Seasonal Affective Disorder," *American Journal of Psychiatry* 142 (1985):163–170; see also M. C. Blehar and N. E. Rosenthal, *Seasonal Affective Disorders and Phototherapy* (New York: Guilford Press, 1989).

58. Robert A. Baron, Mark S. Rea, and Susan G. Daniels, "Effects of Indoor Lighting (Illuminance and Spectral Distribution) on the Performance of Cognitive Tasks and Interpersonal Behaviors: The Potential Mediating Role of Positive Affect," *Motivation and Emotion* 16, no. 1 (1992): 1–33.

59. Roland Barthes, "The Face of Garbo," *Mythologies*, trans. Annette Lavers (New York: Noonday Press, 1990), 57.

60. For example, in the 1994–1995 O. J. Simpson trial, dubbed "the trial of the century" (like the trials of Lizzie Borden and Bruno Hauptmann before it), Chief Attorney for the Prosecution Marcia Clark in her summary trial statement suggested that the jury envision "one round of a boxing match" as the length of time in which a murder could possibly take place. This image made possible within a specific time frame actions which, because of their horrendous import, seem to stretch time out in the mind, like the slow motion killings at the conclusion of *Bonnie and Clyde* (U.S.A., 1967). Mentally, time seems to expand proportionately in relation to the significance of the action. Where time seems elusive in general human experience, the context of an image helps to make it seem more palpable and real.

61. Jan B. Deregowski, "Pictorial Perception and Culture," in *Image, Object and Illusion: Readings from Scientific American* (San Francisco: W. H. Freeman and Company, 1974), 79–85.

62. Bennett Daviss, "Picture Perfect," *Discover* (July 1990): 57.

63. William J. Mitchell, *The Reconfigured Eye* (Cambridge, MA: MIT Press, 1992), 44–45.

64. Alain Jaubert, *Making People Disappear: An Amazing Chronicle of Photographic Deception* (McLean, VA: Pergamon-Brassey's International Defence Publishers, 1989).

65. Patrick Robertson, *The Guiness Book of Movies Facts & Feats*, 4th ed. (New York: Abbeville Press, 1991), 183.

66. "Easy to Alter Digital Images Raise Fears of Tampering," *Science* 263 (January 1994): 317–318.

67. Jean Marie Angelo, "Altered States," *Folio* 23, no. 3 (1994): 62.

68. James R. Gaines, "To Our Readers," *Time*, 4 July 1994, 4.

69. Ibid.

70. When we discussed this in one of my classes at Boston College, one of my students pointed out that the impression was of a "deer caught in the headlights"; another that Hillary Clinton's forehead is positioned exactly where the "horns" created by the "M" in TIME appear!

71. Maureen Dezell, "Names and Faces," *Boston Globe*, 19 August 1995, 22.

72. Joe Mandese and Jeff Jensen, 41.

73. Joe Mandese and Jeff Jensen, "'Trial of the Century,' Break of a Lifetime," *Advertising Age*, 9 October 1995, 2.

4. Video's Moving Images

1. Ed Papazian, ed., *TV Dimensions '93* (New York: Media Dynamics, 1994), 49.

2. Marshall McLuhan, *Understanding Media: The Extensions of Man* (New York: Signet, 1964), 276.

3. Betsey Sharkey, "The Secret Rules of Ratings," *New York Times*, 28 August 1994, sec. H, p. 1.

4. Ibid., 29.

5. Elizabeth Kolbert, "As Ratings Languish, CNN Faces Identity Crisis," *New York Times*, 24 August 1994: sec, D, p. 6.

6. McLuhan, 280.

7. Ibid., 278.

8. Joe Mandese and Jeff Jensen, "'Trial of Century,' Break of a Lifetime," *Advertising Age*, 9 October 1995, 2.

9. Ibid., 41.

10. Adam Pertman, "New Menendez Trial: A Hard Sell," *Boston Globe*, 20 November 1995, 3.

11. In 1924, a hearing was held to determine whether or not live radio coverage should be given to the trial of Nathan Leopold and Richard Loeb over the Chicago Tribune's station WGN, but public opinion was opposed, and the station decided against the broadcast. In 1935, cameramen and reporters swelled the size of Flemington, New Jersey by over one-third in covering the trial of Bruno Hauptmann in the kidnapping and murder of aviator Charles Lindbergh's baby. It was the first time flashbulb cameras were allowed into the courtroom, and reporters turned the proceedings into such a media circus that most courtrooms banned cameras altogether shortly thereafter. By 1980, most states had lifted the bans, and in 1991, Court TV, a 24-hour cable network dedicated exclusively to actual courtroom trials, broadcast the William Kennedy Smith rape trial, sharing its feed with the other networks and using a 10-second sound delay to delete the name of his accuser and a computer-generated dot to blur her face. In 1992, Dr. Sam Sheppard was tried for his wife's murder by both the press and the legal system, and press coverage and the fact of an unsequestered jury was later held at issue when the U.S. Supreme Court overturned the conviction.

12. See Ian Maitland, "Feminists' Misuse of Statistics Is Grossly Unfair to Both Sexes," *Star Tribune*, 8 August 1994: sec. A, p. 9; also Christina Hoff Sommers, *Who Stole Feminism?: How Women Have Betrayed Women* (New York: Simon & Schuster, 1994).

13. E. Tarroni, "The Aesthetics of Television," in *Television: the Critical View*, ed. H. Newcomb (New York: Oxford University Press, 1979), 456.

14. A. C. Huston et al., "Communicating More Than Content: Formal Features of Children's Television Programs," *Journal of Communication* 31 (1981): 32–48; D. Greer et al., "The Effects of Television Commercial Form and Commercial Placement on Children's Social Behavior and Attention," *Child Development* 53 (1982): 611–619.

15. George Gerbner, "Persian Gulf War, the Movie," in *Triumph of the Image: The Media's War in the Persian Gulf—a Global Perspective*, eds. H. Mowlana, G. Gerbner, and H. I. Schiller (Boulder, CO: Westview, 1991), 244.

16. *TV Dimensions '93*, 302.

17. Ibid., 303.

18. See Merrelyn Emery and Fred Emery, "The Vacuous Vision: The TV Medium," *Journal of the University Film Association* 32 (1980): 27–31; Herbert Krugman, "Brainwave Measures of Media Involvement," *Journal of Advertising Research* 11 (1971): 3–9; Jerry Mander, *Four Arguments for the Elimination of Television* (New York: Morrow, 1978); Kate Moody, *Growing Up on Television* (New York: Times Books, 1980).

19. Herbert Krugman, "Electroencephalographic Aspects of Low Involvement: Implications for the McLuhan Hypothesis," (Cambridge, MA: Marketing Science Institute, 1970): 11–13.

20. Peter Wood, "Television as Dream," in *Television as a Cultural Force*, ed. Douglass Cater and Richard Adler, in *Television: the Critical View*, ed. H. Newcomb (New York: Oxford University Press, 1979), 521–523.

21. Joanne Morreales, *A New Beginning: A Textual Frame Analysis of the Political Campaign Film* (New York: State University of New York Press, 1991), 25–26.

22. McLuhan, 277.

23. Bill Nichols, "Voice of Documentary," *Film Quarterly* 36 (1983): 34–48.

24. Krugman, 12.

25. J. D. Kennamer and S. H. Chaffee, "Communication of Political Information During Early Presidential Primaries: Cognition, Affect, and Uncertainty," in *Communication Yearbook* (1982), 631.

26. McLuhan, 287.

27. See D. Altheide, *Media Power* (Beverly Hills, CA: Sage, 1985); J. T. Lanzetta et al., "Emotional and Cognitive Response to Televised Images of Political Leaders," in *Mass Media and Political Thought*, eds. S. Krause and R. M. Perloff (Beverly Hills, CA: Sage, 1985), 85–116; J. Meyerowitz, *No Sense of Place: The Impact of Electronic Media on Social Behavior* (New York: Oxford University Press, 1985); D. A. Graber, "Portraying Presidential Candidates on Television: An Audiovisual Analysis," *Campaigns and Elections* 7 (1986): 14–21; D. A. Graber, "Television News Without Pictures?" *Critical Studies in Mass Communication* 4, no. 1 (1987): 74–78.

28. Graber, "Portraying Presidential Candidates on Television: An Audiovisual Analysis," 75.

29. Ibid., 74.

30. D. A. Graber, "Content and Meaning: What's It All About?" *American Behavioral Scientist* 33, no. 2 (1989): 144–152.

31. J. Salvaggio, *The Mass Media Election* (New York: Praeger, 1980), 132.

32. See N. Cantor and J. Kihlstrom, eds. *Personality, Cognition and Social Interaction* (Hillsdale, NJ: Lawrence Erlbaum, 1981); P. Ekman, ed. *Emotion In the Human Face*, 2nd ed. (New York: Cambridge University Press, 1983); R. Lau and D. Sears, eds. *Political Cognition* (Hillsdale, NJ: Lawrence Erlbaum, 1986).

33. See D. A. Graber, *Processing the News: How People Tame the Information Tide* (New York: Longman, 1984); G. Millerson, *Effective TV Production* (New York: Hastings, 1976).

34. Tarroni, 439–440.

35. H. M. Kepplinger, "Visual Biases in Television Campaign Coverage," *Communication Research* 9, no. 3 (1982): 434.

36. R. K. Tiemens, "Some Relationships of Camera Angle to Communicator Credibility," *Journal of Broadcasting* 14 (1969–1970): 483–490; L. M. Mandell and D. L. Shaw, "Judging People in the News–Unconsciously: Effect of Camera Angle and Bodily Activity," *Journal of Broadcasting* 17 (1972–73): 353–362; T. A. McCain, J. Chilberg, and J. Wakshlag, "The Effect of Camera Angle on Source Credibility and Attraction," *Journal of Broadcasting* 21 (1977): 35–46; L. K. Davis, "Camera Eye-Contact by the Candidates in the Presidential Debates of 1976," *Journalism Quarterly* 55 (1978): 431–437.

37. Kepplinger, 445.

38. Ibid., 435, 436.

39. David Halberstam, *The Powers That Be* (New York: Dell, 1979), 15–16.

40. Nurith C. Aizenman, "When Presidents Wear Makeup," *New York Times*, 24 July 1994, 41.

41. Edwin Shneidman, "Logic of Politics," in *Television and Human Behavior*, eds. Leon Arons and Mark May (New York: Appleton-Century-Crofts, 1963), 195.

42. Gregory W. Bush, *American History American Television* (New York: Frederick Ungar, 1983), 335.

43. Davis, 431–437; Mandell and Shaw, 353–362; McCain et al., 35–46; Tiemens, 483–490.

44. G. O. Coldevin, "Experiments in TV Presentation Strategies," *Educational Broadcasting International* 11, no. 1 (1978): 17–18.

45. G. O. Coldevin, "Experiments in TV Presentation Strategies: number 2," *Educational Broadcasting International* 11, no. 3 (1978): 158–159.

46. J. Greenfield, *The Real Campaign* (New York: Summit, 1982), 56.

47. Paul R. Abramson and Aldrich Rohde, *Change and Continuity in the 1980 Elections* (Washington, D.C.: Congressional Quarterly Press, 1982), 23.

48. Greenfield, 54.

49. William F. Buckley, Jr., "On the Right: Mud on His Face," *National Review*, 7 December 1979, 1580.

50. R. P. Hart, P. Jerome, and K. McComb, "Rhetorical Features of Newscasts About the President," *Critical Studies in Mass Communication* 1, no. 3 (1984): 261. See also C. R. Smith, "Television News as Rhetoric," *Western Journal of Speech Communication* 41 (1977): 147–159; R. L. Barton and R. B. Gregg, "Middle East Conflict as News Scenario," *Journal of Communication* 32, no. 2 (1982): 172–185 ; H. H. Owsley and C. M. Scotton, "The Conversational Expression of Power by Television Interviewers," *Journal of Social Psychology* 123 (August 1984): 261–271.

51. Hart et al., 280.

52. See H. S. Friedman, T. I. Mertz, and M. R. DiMatteo, "Perceived Bias in the Facial Expressions of Television News Broadcasters," *Journal of Communication* 30, no. 4 (1980): 103–111; M. Edwardson, D. Grooms, and S. Proudlove, "Television News Information Gain from Interesting Video vs. Talking Heads," *Journal of Broadcasting* 25 (1981): 15–24.

53. Judith Trent, "Presidential Surfacing: the Ritualistic and Crucial First Act," *Communication Monographs* 45 (November 1978): 285.

5. Film Logic and Rhetoric

1. R. L. Gregory, "Seeing Backwards in Time," *Nature* 373 (5 January 1995): 21–22; V. Ramachandran and S. Cobb, Nature 373 (5 January 1995): 66–68.

2. T. S. Eliot, "Tradition and the Individual Talent," in *Criticism: the Major Texts*, ed. W. J. Bate (New York: Harcourt Brace Javanovich, 1970), 529.

3. Béla Balázs, *Theory of the Film* (New York: Dover, 1970), 17.

4. Marshall McLuhan, *Understanding Media: The Extensions of Man* (New York: McGraw Hill, 1964), 27.

5. Terry Ramsaye, *A Million and One Nights* (1926; reprint, New York: Simon & Schuster, 1986), 21–37.

6. Ibid., 39.

7. Sigfried Kracauer, *Theory of Film* (New York: Oxford University Press, 1960), ix.

8. This feat in *The One Man Band* (France, 1900) was repeated by Buster Keaton in 1921 in *The Playhouse* (U.S.A., 1921) in a minstrel show scene in which the film was masked and then exposed nine times. In the sequence his various characters talk to each other and respond appropriately in almost perfect syn-chrony. Keaton plays all of the other characters in the film as well, including all the members of the band, the audience, and other acts.

9. In 1898, two years after film was first introduced to Russia by the Lumière Cinematographe, Francis Doublier, a nineteen-year-old Frenchman sent to capture the Russian market by the Lumière brothers, showed an entirely fabricated and successful film that out-Kuleshoved Kuleshov's own later experiments in montage. In the Jewish districts of South Russia, Doublier was confronted with questions about why pictures of Dreyfus did not appear in the program— Dreyfus's situation having just been widely publicized because of Zola's J'Accuse and the subsequent suicide of Colonel Henry of the French War Office. Without any documentary film footage of the kind, but with the true instinct of a Hollywood film mogul, Doublier used his ingenuity to triumph over circumstance and succeeded in constructing what turned into a box office sensation out of various old film clips he had on hand.

In a discussion with Jay Leyda described in *Kino: A History of the Russian and Soviet Film Kino: A History of the Russian and Soviet Film*, 3rd ed. (Princeton: Princeton University Press, 1983) 18–23, Doublier disclosed how out of a scene of a French army parade, Paris street scenes including a large building, a shot of a Finnish tugboat, and a scene of the Nile Delta, "with a little help from the audience's imagination, these scenes told the following story: Dreyfus before his arrest, the Palais de Justice where Dreyfus was court-martialed, Dreyfus being taken to the battleship, and Devil's Island where he was imprisoned, all supposedly taking place in 1894." Doublier could have told his audience the truth-that the Lumière cinematographe was not even operational until early in 1895, but instead he chose to transform characters and geography by association and interrelationship into a profitable fabrication of reality.

10. Frank E. Beaver, *On Film* (New York: McGraw Hill, 1983), 78.

11. Hugo Munsterberg, *The Film: A Psychological Study* (1916; reprint, New York: Arno Press, 1970), 171–172.

12. Ibid., 173–190, passim.

13. Ibid., 97.

14. Jay Leyda, *A History of the Russian and Soviet Film*, 3rd ed. (Princeton: Princeton University Press, 1983), 132.

15. Ibid., 138, 139.

16. Ibid., 137.

17. Lev Kuleshov, "The Principles of Montage," in *Kuleshov on Film*, ed. and trans. Ronald Levaco (Berkeley: University of California Press, 1974), 191–195.

18. Ibid., 45–46.

19. Ibid., 187.

20. Lev Kuleshov, "The Art of Cinema," in *Kuleshov on Film*, ed. and trans. Ronald Levaco (Berkeley: University of California Press, 1974), 44.

21. Ibid., 52.

22. Vsevolod I. Pudovkin, "Types of Actors," in *On Film Technique*, trans. Ivor Montagu (London: Vision Press, 1950), 168.

23. Ibid., 154.

24. William J. Mitchell, "When Is Seeing Believing?" *Scientific American* (February 1994): 68–69.

25. Pudovkin, "Types of Actors," 55.

26. Vsevolod I. Pudovkin, "Film Director and Film Material," in *On Film Technique*, trans. Ivor Montagu (London: Vision Press, 1950), 118.

27. Vsevolod I. Pudovkin, "The Plastic Material," in *On Film Technique*, trans. Ivor Montagu (London: Vision Press, 1950), 71.

28. Ibid., 73.

29. Sergei Eisenstein, "A Personal Statement," in *Six Essays and a Lecture*, ed. Jay Leyda (Princeton: Princeton University Press, 1968), 13.

30. Sergei Eisenstein, "Soviet Cinema," in *Six Essays and a Lecture*, ed. Jay Leyda (Princeton: Princeton University Press, 1968), 23.

31. Marshall McLuhan, *Understanding Media: The Extensions of Man* (New York: McGraw Hill, 1964), 27.

32. Sergei Eisenstein, "Cinematographic Principle and the Ideogram," in *Film Form: Essays in Film Theory*, trans. and ed. Jay Leyda (New York: Harcourt Brace Javanovich, 1949), 29–30.

33. Ibid.

34. Ibid., 37.

35. Sergei Eisenstein, "Dickens, Griffith and the Film Today," in *Film Form: Essays in Film Theory*, trans. and ed. Jay Leyda (New York: Harcourt Brace Javanovich, 1949), 239, 245.

36. Sergei Eisenstein, "A Dialectic Approach to Film Form," in *Film Form: Essays in Film Theory*, trans. and ed. Jay Leyda (New York: Harcourt Brace Javanovich, 1949), 45,48.

37. Ibid., 45.

38. Lev Arnshtam, "Johann Bach and *The Battleship Potemkin*," in *The Battleship Potemkin*, ed. Herbert Marshall (New York: Avon, 1978), 112–113.

39. "Douglas Fairbanks and Mary Pickford on *Potemkin*," *Die Rote Fahne*, 7 May 1926, in *The Battleship Potemkin*, ed. Herbert Marshall (New York: Avon, 1978), 130.

40. "Famous Director Signed by Fairbanks," *Weinberg Scrapbooks of Film Reviews*, vol. 1 (New York: Museum of Modern Art), in *The Battleship Potemkin*, ed. Herbert Marshall (New York: Avon, 1978), 215.

41. David O. Selznik to Mr. Harry Rapf, memorandum, 15 October 1926, in *The Battleship Potemkin*, ed. Herbert Marshall (New York: Avon, 1978), 189.

42. L. L. Obolensky to S. M. Eisenstein, Moscow, 3 June 1930, in *The Battleship Potemkin*, ed. Herbert Marshall (New York: Avon, 1978), 132.

43. Sergei Eisenstein, "The Twelve Apostles," in *The Battleship Potemkin*, ed. Herbert Marshall (New York: Avon, 1978), 45.

44. Sergei Eisenstein, "Word and Image," in *Six Essays and a Lecture*, ed. Jay Leyda (Princeton: Princeton University Press, 1968), 31.

45. Eisenstein, "A Dialectic Approach to Film Form," 56.

46. Eisenstein, "The Twelve Apostles," 44.

47. Roger Manvell, *Chaplin* (Boston: Little Brown & Co., 1974), 95.

48. Ibid., 104.

49. André Bazin saw Chaplin's use of props as a form of psychological displacement in which their traditional social roles are undermined. Chaplin subverts these roles by drawing them into complicity in his own world. Through the perspective of Bruno Bettelheim, Truffaut compares Chaplin's attitude toward his props to autism as a defense mechanism. Just as the autistic child makes foreign use of familiar objects, so Charlie uses objects in strange ways in a world that he can't quite grasp and can handle only in small moments.

50. François Truffaut, "Chaplin and Bazin," *Essays on Chaplin*, ed. and trans. Jean Bodon (New Haven, CT: University of New Haven Press, 1985), xii.

51. Charles Chaplin, *My Autobiography* (New York: Simon & Schuster, 1964), 211.

52. André Bazin, "Time Validates *Modern Times*," *Essays on Chaplin*, ed. and trans. Jean Bodon (New Haven, CT: University of New Haven Press, 1985), 7.

53. Bazin explains that in the Soviet Union, an award named for Aleksei Stakhanov was given for surpassing work production quotas. Stakhanov had in one month produced 700 percent more than his factory's individual production quota, and thus became a cultural and political hero. The Tramp in *Modern Times*

seemed to ridicule something which the Soviet government considered profoundly important.

54. *When the Lion Roars* (Hollywood, CA: Metro-Goldwyn-Mayer, 1992), filmstrip.

55. Patrick Robertson, *The Guinness Book of Movie Facts and Feats*, 4th ed. (New York: Abbeville Press, 1991), 154.

56. Ibid., 153.

57. Peter Wollen, "Cinema and Technology: a Historical Overview," in *Readings and Writings: Semiotic Counter-Strategies* (London: Thetford Press, 1982), 172.

58. Ibid.

59. The first two-color additive process technicolor film was produced in 1917. The first three-color technicolor film produced was a Walt Disney cartoon in 1932. The first feature film made entirely in color was Mamoulian's *Becky Sharp* (U.S.A., 1935), which is a poor wash in comparison to films later in the decade such as *Gone With the Wind* (U.S.A., 1939) and *The Wizard of Oz* (U.S.A., 1939).

60. Even 2-D, 70 mm. films are rare. The best include *Lawrence of Arabia* (G.B., 1962), *Ryan's Daughter* (G.B., 1971), and *Far and Away*, (U.S.A., 1992).

61. Ibid., 277–279.

62. Calder, 28–29.

63. Leyda, 43.

64. Bradley Waite, Marc Hillbrand, and Hilliard Foster, "Reduction of Aggressive Behavior After Removal of Music Television," *Hospital and Community Psychiatry* 43, no. 2 (1992): 173.

65. Jean Zimmerman, *Tailspin* (New York: Doubleday, 1995), 36.

66. Ibid., 32.

67. Ibid., 33.

68. See Deborah Tannen, *You Just Don't Understand: Women and Men in Conversation* (New York: Ballantine Books, 1990).

69. J. Hoberman, "Top Gun," *Village Voice*, 27 May 1986, 59.

70. Ibid.

71. Zimmerman, 33.

72. Myriam Miedzian, *Boys Will Be Boys* (New York: Doubleday, 1991), 196.

73. Ibid., 202.

74. Rob Edelman, "Top Gun," *Cineaste* 15, no. 2 (1986): 41.

75. James Conlon, "Making Love, Not War," *Journal of Popular Film and Television* 18 (Spring 1990): 21–22.

76. Erving Goffman, *Gender Advertisements* (New York: Harper Torchbooks, 1976), 46.

77. See R. Brannon and D. David, eds. *The Forty-Nine Percent Majority: The Male Sex Role* (Reading, MA: Addison-Wesley, 1976).

78. Ibid., 46.

79. Rudolph Arnheim, *Visual Thinking* (Berkeley: University of California Press, 1969), 28–43.

80. Mark Gerzon, *A Choice of Heroes: The Changing Face of American Manhood* (Boston: Houghton Mifflin, 1982), 34.

81. William Manchester, "The Bloodiest Battle of All," *New York Times Magazine*, 14 June 1987, 84.

82. David Denby, "Top Gun," *New York*, 19 May 1986, 102.

83. Leonard Novarro, "Aviators' Group Started as Way to Let Off Steam: Club Blames Film for Recent Behavior," *Boston Globe*, 24 April 1993, 6.

84. Zimmerman, 52.

85. See Ann Marie Barry, "Tailhook 'Top Guns': Visual Templates in the Use and Abuse of Power," *Journal of Visual Literacy* 14, no. 1 (1994): 51–59.

86. U.S. Department of Defense, Office of the Inspector General, *Tailhook 91*, Part II (Washington, DC: Government Printing Office, 1992), X-2.

87. Zimmerman, 55.

88. Gregory Vestica, *Fall From Glory: The Men Who Sank the U.S. Navy* (New York: Simon & Schuster, 1995), 240–245.

89. Ibid.

90. Ibid., 245.

91. Ibid.

92. Sigmund Freud, *Group Psychology and the Analysis of the Ego* (1921), trans. James Strachey (New York: Bantam Books, 1960), 15.

93. Frederich Nietzche, *The Birth of Tragedy* (New York: Doubleday, 1956), 25-26. Quoted in Philip Zimbardo, "Human Choice: Individuation, Reason, and Order versus Deindividuation, Impulse and Chaos," *Nebraska Symposium on Motivation 1969*, University of Nebraska Press, 17 (1969): 248–249.

94. Freud, 9.

95. Zimbardo, 251.

96. Zimmerman, 56.

97. Ibid., 55.

98. Ibid., 52.

99. U.S. Department of Defense, Office of the Inspector General, *Tailhook 91*, Part II (Washington, DC: Government Printing Office, 1992), VI-11. The report issued by the Naval Investigative Service (NIS) stated that "there is still little understanding [on the part of the aviators] of the nature, severity and number of assaults which occurred involving both civilians and officers. A common thread running through the overwhelming majority of interviews . . . was—'What's the big deal?'"

A later report by the Pentagon Inspector General showed that this attitude ran through the topmost ranks as well. Senior Navy admirals had deliberately sabotaged their own investigation to protect other Navy admirals, the report states, and quotes Rear Admiral Duvall (Mac) Williams, Jr., who headed the inquiry, as comparing female pilots and Naval officers to "go-go dancers" and "hookers."

100. Ibid., X-1.

101. Ibid., X-5.

102. Ibid., 246.

103. Ibid., X 1–11.

104. Ibid., Part I, enclosure 3.

105. Ibid., E-55–56.

106. Ibid., VI-11.

107. Marshall McLuhan, *Understanding Media: The Extensions of Man* (New York: Signet, 1964), 24.

6. Advertising Images: Seduction, Shock, and the Unwary

1. "Bill Bernbach said . . ." (New York: DDB Needham Worldwide Advertising, n.d.), 20.

2. William Less, Stephen Kline, and Sut Jhally, *Social Communcation in Advertising* (New York: Methuen, 1986), 232–234.

3. Randall White, "Visual Thinking in the Ice Age" *Scientific American* (July 1989): 98.

4. H. Shervin, "Subliminal Perception and Dreaming," *Journal of Mind and Behavior* 7 nos. 2, 3 (1986): 379–395; H. Shervin, "Subliminal Perception and Repression," in *Repression and Dissociation: Implications For Personality Theory, Psychopathology and Health*, ed., J. P. Singer (Chicago: University of Chicago Press, 1990): 103–119; H. Shervin and L. Luborsky, "The Measurement of Preconscious Perception in Dreams and Images: An Investigation of the Poetzl Phenomenon," *Journal of Abnormal and Social Psychology* 58 (1958): 285–294.

5. Bill Backer, *The Care and Feeding of Ideas* (New York: Random House, 1993), 13.

6. Tony Schwartz, *The Responsive Chord* (New York: Anchor Books, 1974), 25.

7. For a contrast in the level of effectiveness achieved by different advertisements, see Philip Ward Burton and Scott Purvis, *Which Ad Pulled Best?* (Lincolnwood, Ill.: NTC Business Books, 1987).

8. Marshall McLuhan, "Introduction," *Understanding Media: The Extensions of Man* (New York: Signet, 1964). viii.

9. Ernest Hemingway, *A Moveable Feast* (New York: Charles Scribner's Sons, 1964), 75.

10. "Bill Bernbach said . . . ," 12.

11. David Ogilvy, *Ogilvy on Advertising* (New York: Vintage Books, 1983), 16.

12. Ibid., 11.

13. Ibid.

14. Eugene Secunda, "Calvin Klein, Levi's ads? Well, That's Show Business," *Advertising Age*, 9 October 1995, 14.

15. Dagmar Mussey, "Benetton, German Retailers Squabble," *Advertising Age*, 6 February 1995, 46.

16. "Store Owners Rip Into Benetton," *Advertising Age*, 6 February 1995, 1.

17. Jeanne Whalen, "U.S. Ads Take More Restrained Tone," *Advertising Age*, 6 February 1995, 46.

18. Martin Block and Bruce G. Vanden Bergh, "Can You Sell Subliminal Messages to Consumers?" *Journal of Advertising* 14, no. 3 (1985), 62.

19. "Ads You'll Never See," *Business Week*, 21 September 1975, 30–31; Herbert Bream, "What Hidden Sell Is All About," *Life*, 31 March 1958, 104–114, in Sid C. Dudley, "Subliminal Advertising: What Is the Controversy About?" *Akron Business and Economic Review* 18, no. 2, (1987), 7.

20. Stuart Rogers, "How a Publicity Blitz Created the Myth of Subliminal Advertising," *Public Relations Quarterly* (Winter 1992–1993): 12–16. According to Rogers, Vicary netted approximately $4.5 million in retainers and consulting fees from advertising agencies before he disappeared in 1958 leaving "no bank accounts, no clothes in his closet, and no hint where he might have gone." Authors like Wilson Bryan Key avidly keep the legacy alive through a variety of books on "subliminal advertising." Rogers wryly notes that at last report in 1992, Key had earned in book sales what Vicary earned in consulting fees.

21. Kirk H. Smith and Martha Rogers, "Effectiveness of Subliminal Messages in Television Commercials," *Journal of Applied Psychology* 79, no. 6 (1994): 867.

22. Del Hawkins, Rogert J. Best, and Kenneth Coney, *Consumer Behavior* (Plano, TX: Business Publications, Inc, 1983), 283–285; "KIng Lear: Sexual Pitches in Ads Become More Explicit and More Pervasive," *The Wall Street Journal*, 18 November 1980, 1, in Sid C. Dudley, "Subliminal Advertising: What Is the Controversy About?" *Akron Business and Economic Review* 18, no. 2, (1987): 14.

23. Ibid., 13.

24. Sid C. Dudley, "Subliminal Advertising: What Is the Controversy About?" *Akron Business and Economic Review* 18, no. 2, (1987): 12.

25. Timothy Moore, "Subliminal Advertising: What You See Is What You Get," *Journal of Marketing* 46 (Spring 1982): 38–47.

26. Myron Gable, Henry T. Wilkens, Lynn Harris and Richard Feinberg, "An Evaluation of Subliminally Embedded Sexual Stimuli in Graphics," *Journal of Advertising* 16, no. 1 (1987), 26–31.

27. Patrick Robertson, *The Guinness Book of Movie Facts and Feats*, 4th ed. (New York: Abbeville Press, 1991), 191.

28. Randall Rothenberg, "Critics Seek F.T.C. Action of Products as Movie Stars," *New York Times*, 31 May 1991: sec. D, p. 1, 5.

29. Ibid.

30. Ibid.

31. Robertson, 119.

32. See discussion, Chapter One and John Bargh, "Automatic Information Processing: Implications for Communication and Affect," in *Communication*

Affect, and Social Cognition, eds., L. Donohew, H. Sypher, and E. T. Higgins (Hillsdale, NJ: Erlbaum, 1988), 9–32; John Bargh, "Conditional Automaticity: Varieties of Automatic Influence in Social Perception and Cognition," in *Unintended Thought*, eds., J. S. Uleman and J. A. Bargh (New York: Guilford Press, 1989), 3–51.

33. Ronnie Cuperfain and T. K. Clarke, "A New Perspective of Subliminal Perception," *Journal of Advertising* 14, no. 1 (1985): 36–41. Researchers Ehrlichman, Barrett, Farah, and others have found, however, that this may be too simplistic—that spatial ability and higher visual perceptual processing appear to be associated with the right hemisphere, but not image generation per se. See M. J. Farah, "The Neurological Basis of Mental Imagery: A Component Analysis," in *Visual Cognition*, ed., Steven Pinker (Cambridge, MA: MIT Press, 1985), 245–271.

34. Joseph Belizzi and Robert Hite, "Environmental Color, Consumer Feelings, and Purchase Likelihood," *Psychology and Marketing* 9, no. 5 (1992): 347–363. See also Julie Baker, Michael Levy, and Dhruv Grewal, "An Experimental Approach to Making Retail Store Environmental Decisions," *Journal of Retailing* 68, no. 4 (1992): 445.

35. See Berry, sec. K, p. 1; K. Jacobs and J. Suess, "Effects of Four Psychological Primary Colors on Anxiety State," *Perceptual and Motor Skills* 41 (1975): 207–210; N. Kwallek, C. M. Lewis, and A. S. Robbins, "Effects of Office Interior Color on Workers' Mood and Productivity," *Perceptual and Motor Skills* 66 (1988):123–128.

36. Don Nichols, "Milk Marketing: Pet Project," *Incentive* 163, no. 11 (1989): 42–43, 75.

37. Ronald Alsop, "Color Grows More Important in Catching Consumers' Eyes," *Wall Street Journal*, 29 November 1984, 37.

38. Ibid.

39. Ibid.

40. John Lister, "That Delicate Concept of Nuance," *Advertising Age*, 29 September 1986, 40.

41. Charles Lewis, "Striking the Marketplace Pose: The Convergence of Advertising and Portrait Photography" (paper presented at the meeting of the International Visual Literacy Association and Illinois Association for Educational Communications and Technology Conference, Chicago, IL, 20 October 1995).

42. Erving Goffman, *Gender Advertisements* (New York: Harper Torchbooks, 1976), 1–9.

43. Berger, 47.

44. Ibid., 63.

45. Ibid., 64.

46. Naomi Wolf, *The Beauty Myth: How Images of Beauty Are Used Against Women* (New York: Doubleday Anchor, 1991), 4.

47. Ibid., 34.

48. Edwin Diamond, "New-Girl Network," *New York Magazine*, 10 June 1991, 20.

49. Wolf, 34.

50. Todd Heatherton, Patricia Nichols, Fary Mahamedi, and Pamela Keel, "Body Weight, Dieting, and Eating Disorder Symptoms Among College Students, 1982 to 1992," *American Journal of Psychiatry* 152, no. 11 (1995): 1628.

51. Ibid., 6.

52. Ibid., 36.

53. Mary Kay Ash, *Mary Kay* (New York: Barnes and Noble, 1981), 113.

54. S. I. Hayakawa, "Why the Edsel Laid an Egg: Motivational Research vs. the Reality Principle," *The Use and Misuse of Language*, ed. S. I. Hayakawa (Greenwich, CT: Harper & Brothers, 1962), 169.

55. S. I. Hayakawa, "Sexual Fantasy and the 1957 Car," in *The Use and Misuse of Language*, ed. S. I. Hayakawa (Greenwich, CT: Harper & Brothers, 1962), 165.

56. Ibid., 166.

57. Henry Adams, "The Dynamo and The Virgin," *The Education of Henry Adams* (Boston: Houghton Mifflin, 1918), 380.

58. Ibid., 381.

59. F. Scott Fitzgerald, "What Became of Our Flappers and Shieks?" *McCall's Magazine*, 12 October 1925, 42.

60. Roland Barthes, "The Romans in Films," *Mythologies*, trans. Annette Lavers (New York: Noonday Press, 1990), 28.

61. David A. Kessler, "Nicotine Addiction in Young People," *New England Journal of Medicine* 333 (20 July 1995), 186–189.

62. Joseph R. DiFranza and Joseph B. Tye, "Who Profits From Tobacco Sales to Minors?" *Journal of the American Medical Association* 263 (23–30 May 1990), 2,784–2,787.

63. Rebecca Voelker, "Young People May Face Huge Tobacco Toll," *Journal of the American Medical Association* 274 (19 July 1995), 203.

64. Richard A. Daynard and Graham E. Kelder, Jr. "Waiting to Exhale," *Boston Sunday Globe*, 11 February 1996, 81.

65. Philip J. Hilts, "Is Nicotine Addictive? It Depends on Whose Criteria You Use," *New York Times*, 2 August 1992, sec. C, p. 3.

66. U.S. Public Health Service. Office of the Surgeon General. Center for Chronic Disease Prevention and Health promotion. Office on Smoking and Health. *Reducing the Health Consequences of Smoking: Twenty-Five Years of Progress: A Report of the Surgeon General*. (Rockville, MD: U.S. Department of Health and Human Services, 1989.

67. Dolores Kong, "Study Finds Cigarette Ads Most Powerful Influence on Young," *Boston Globe*, 18 October 1995, 10.

68. DiFranza et al., 3,145, 3,148.

69. John P. Pierce, Elizabeth Gilpin, David M. Burns, Elizabeth Whalen, Bradley Rosbrook, Donald Shopland, and Michael Johnson, "Does Tobacco Advertising Target Young People to Start Smoking?" *Journal of the American Medical Association* 266, no. 22 (1991): 3,154.

70. Ibid., 3,151.

71. Paul M. Fischer, Meyer P. Schwartz, and John W. Richards, Jr., Adam O. Goldstein, and Tina H. Rojas, "Brands Logo Recognition by Children Aged 3 to 6 Years," *Journal of the American Medical Association* 266, no. 22 (1991): 3,148. See also J. W. Richards and P. M. Fischer, "Smokescreen: How Tobacco Companies Market to Children," *World Smoking Health* 25 (1990), 12–14; A. Blum, "The Marlboro Grand Prix: Circumvention of the Television Ban on Tobacco Advertising," *New England Journal of Medicine*, 324 (1991): 913–917.

72. Joseph R. DiFranza, John W. Richards, Jr., Paul M. Pallman, Nancy Wolf-Fillespie, Christopher Fletcher, Robert Jaffee, David Murray, "RJR Nabisco's Cartoon Camel Promotes Camel Cigarettes to Children," *Journal of the American Medical Association* 266, no. 22 (1991): 3149.

73. Hilts, sec. C, p. 3.

74. Leslie Savan, "Let's Face It" (November 27, 1990), in *The Sponsored Life* (Philadelphia: Temple University Press, 1994), 104.

75. J. B. Tye, K. E. Warner, and S. A. Glantz, "Tobacco Advertising and Consumption: Evidence of a Causal Relationship," *Journal of Public Health Policy* 8 (1987): 492–508.

76. Di Franza et al., 3,149–3,151.

77. W. Meyers, *The Image-Makers: Power and Persuasion on Madison Avenue* (New York: New York Times Book, 1984), 70.

78. Ibid.

79. Broadbent, 47.

80. Ibid., 3.

81. Pierce et al., 3,154, 3,156.

82. Kenneth Boulding, *The Image* (Ann Arbor, MI: University of Michigan Press, 1956), 93.

83. Broadbent, 3–4.

7. Political Images: Public Relations, Advertising, and Propaganda

1. It was reminiscent, in fact, of the newspaper magnate William Randolph Hearst's role in the Spanish American War. According to biographer W. A. Swanberg in *Citizen Hearst* (New York: Charles Scribner's Sons, 1961), 107–108, when his Cuban news correspondent Frederick Remington wired Hearst from Havana, "Everything is quiet. There is no trouble here. There will be no war. I wish to return," Hearst's reply—celebrated in Orson Welles' *Citizen Kane*—was: "Please remain. You furnish the pictures and I'll furnish the war."

2. Quoted in Herbert Schiller, "Manipulating Hearts and Minds," in *Triumph of the Image*, eds. Hamid Mowlana, George Gerbner, and Herbert Schiller (Boulder, CO: Westview, 1992), 23.

3. George Gerbner, "Persian Gulf War, the Movie," in *Triumph of the Image*, eds. Hamid Mowlana, George Gerbner, and Herbert Schiller (Boulder, CO: Westview, 1992), 253.

4. J. Khoury, "Video Game Mentality and Images of the Gulf War" (paper presented at the annual meeting of the International Visual Literacy Conference, Chicago, IL, 21 October 1995).

5. Michael Morgan, Justin Lewis, and Sut Jhally, "More Viewing, Less Knowledge," in *Triumph of the Image*, eds. Hamid Mowlana, George Gerbner, and Herbert Schiller (Boulder, CO: Westview, 1992), 226.

6. Tom Wicker, "An Unknown Casualty," *New York Times*, 20 March 1991, sec. A, p. 29.

7. Morgan, 221–226.

8. Stig A. Nohrstedt, "Ruling By Pooling," in *Triumph of the Image*, eds. Hamid Mowlana, George Gerbner, and Herbert Schiller (Boulder, CO: Westview, 1992), 119.

9. Ibid., 119–120.

10. Ibid., 126.

11. William J. Small, "A Report—The Gulf War and Television News: Past, Future and Present," *Mass Comm Review* 19, nos. 1, 2 (1992): 6–7.

12. Schiller, 26–27.

13. Morgan et al., 230.

14. Small, 9.

15. Neil Postman, *Amusing Ourselves to Death* (New York: Penguin, 1985), 104.

16. Marvin Goldberg and Gerald Gorn, "Happy and Sad Programs: How They Affect Reactions to Commercials," *Journal of Consumer Research* 14, no. 3 (1987): 387–403.

17. Gerbner, "Persian Gulf War, the Movie," 244.

18. J. Condry, "Live from the Battlefield," *IEEE Spectrum* 28, no. 9 (1991): 48.

19. Ibid., 246.

20. "Reporters in the Gulf Rally 'Round the Flag," *Die Zeit* (April 1991), quoted in William J. Small, "A Report—The Gulf War and Television News: Past, Future and Present," *Mass Comm Review* 19, nos. 1, 2 (1992): 8.

21. Stephen Fox, *The Mirror Makers* (New York: Vintage Books, 1985), 310.

22. Ibid., 310.

23. Ibid., 308.

24. Ibid.

25. Jeff Greenfield, *The Real Campaign* (New York: Summit, 1982), 17.

26. Richard Morgan and Dave Vadehra, "Reagan Leads Mondale in Ad Awareness Race," *Adweek*, 3 September 1984, 19. See also Joanne Morreale, *A New Beginning* (Albany: State University of New York Press, 1991), 4. Morreale's book analyzes Reagan's political film in detail and explores its symbolic forms and rhetorical devices as evidence of the need to "re-frame contemporary political discourse."

27. Morreale, 3.

28. Ibid.

29. David Lieberman, "Fake News," *TV Guide*, 22 February 1992, 16.

30. Ibid., 15–16.

31. Elizabeth Kolbert, "Test Marketing a President," *New York Times Magazine*, 30 August 1992, 20.

32. Ibid., 60, 68.

33. *Prelude to War* (1943), which received an Academy Award for best documentary; *The Nazis Strike; Divide and Conquer* (1942); *The Battle of Britain* (1941); *The Battle of Russia* (1943), which recieved an Academy Award nomination for best documentary; *The Battle of China* (1944); and *War Comes to America* (1945).

34. Kolbert, 60.

35. Z. A. B. Zeman, *Nazi Propaganda* (London: Oxford University Press, 1973), 9.

36. William Shirer, *Berlin Diary* (New York: Knopf, 1941), 18.

37. Frederic V. Grunfeld, *The Hitler File* (New York: Random House, 1974), 298–301.

38. Albert Speer, *Inside the Third Reich* (New York: Macmillan, 1970), 104–106.

According to Speer and others, Hitler's health was an obsession, and from 1935 onward, Hitler was convinced that he was dying. Despite this, he determined to keep a powerful image and resisted treatment from top surgeons.

Eventually, however, he fell under the exploitive and destructive influence of Dr. Theodor Morell, who was introduced to him by his photographer Hoffman whom he had cured of a problematic ailment. Morell was at worst a medical quack and at best an unorthodox and ambitious experimenter who treated Hitler with such things as intestinal bacteria, plant extracts, and drugs from a variety of sources including bull testicles. Caught up in his own image, Morell patented the medicines and promoted them through his fashionable consulting rooms, which were lined with inscribed photographs of well-known actors and film stars. Eventually Hitler became a chronically ill addict under Morell's medical control.

39. Grunfeld, 274.

40. Speer, 50–70.

41. Grunfeld, 193.

42. Speer, 59.

43. Ibid., 66–68.

44. Ibid., 103.

45. Boulding, 68.

46. Speer, 81.

47. Siegfried Kracauer, *From Caligari to Hitler* (New York: Noonday Press, 1959), 277; Grunfeld, 276.

48. Robertson, 181.

49. Ibid.

50. Sigmund Freud, *Group Psychology and the Analysis of the Ego* (1921), trans. James Strachey (New York: Bantam Books, 1960), 14.

51. Speer, 17.

52. Ibid., 16.

53. Shirer,19.

54. M. J. Robinson and M. A. Sheehan, *Over the Wire and on TV: CBS and UPI in Campaign '80* (New York: Russell Sage Foundation, 1983), 262, 265.

55. Bruce Gronbeck, "The Function of Presidential Campaigning," *Communication Monographs* 44 (November 1978): 276.

8. Media Images and Violence

1. Sidney Manning and Dalmas Taylor, "The Effects of Viewing Violence and Aggression: Stimulation and Catharsis," *Journal of Personality and Social Psychology* 31 (1975): 180–188.

2. Some sociological and psychological studies, for example, use laboratory situations where provoked and unprovoked subjects administer what they perceive to be electric shocks to another person who acts as if shocked. When a subject continues to inflict apparent pain on another in such a situation, aggression is assumed to be negative and rated on a scale of intensity. However, in general usage the term may also be used to imply a righteous, even violent response to apparently unprovoked aggression, as in the country's aggressive response to the bombing of Pearl Harbor, which initiated our involvement in World War II. Some researchers like Myriam Miedzian, for example, have chosen to avoid the term "aggression" altogether, particularly because it may semantically mask unprovoked violence as acceptable social response.

3. Myriam Miedzian, *Boys Will Be Boys* (New York: Doubleday Anchor Books, 1991), 211.

4. Richard Restak, *The Mind* (New York: Bantam Books, 1988), 299–311.

5. Ibid., 279.

6. Ibid., 280.

7. Ibid., 292–297.

8. Ibid., 283.

9. Ibid., 283.

10. Joseph E. LeDoux, "Emotion, Memory and the Brain," *Scientific American*, 270, no. 6 (1994): 57.

11. Ibid.

12. Brandon Centerwall, "Exposure to Television as a Cause for Violence," in *Public Communication and Behavior*, Vol. 2 (Orlando, FL: Academic Press, 1989), 1–58.

13. Brandon Centerwall, "Television and Violence: the Scale of the Problem and Where We Go from Here," *Journal of the American Medical Association* 267, no. 22 (1992): 3,060.

14. LeDoux, "Emotion, Memory and the Brain," 55.

15. Victor Cline, Roger Croft and Steven Courier, "Desensitization of Children to Television Violence," *Journal of Personality and Social Psychology* 27, no. 3 (1973): 360–365.

16. Margaret Thomas, Robert Norton, Elaine Lippincott, and Ronald Drabman, "Desensitization to Portrayals of Real-Life Aggression as a Function of Exposure to Television Violence," *Journal of Personality and Social Psychology* 35, no. 6 (1977): 450–458.

17. Barbara Meltz, "Understanding the Poison of Violence," *Boston Globe*, 23 March 1995, sec. A, p. 4.

18. Ibid.

19. American Psychological Association, "Big World, Small Screen," American Psychological Association: 1992.

20. John P. Murray and Barbara Lonborg, *Children and Television: A Primer for Parents* (Boys Town, NE: The Boys Town Center for the Study of Youth Development, n.d.), 2–3.

21. See Daniel Anderson, *Impact on Children's Education: Television's Influence on Cognitive Development* (Washington, DC: U.S. Department of Education, 1988).

22. George Gerbner, et al., "The 'Mainstreaming' of America: Violence Profile no. 11," *Journal of Communication* 30, no. 3 (1980): 10–29.

23. George Gerbner, L. Gross, M. Morgan, and N. Signorelli, "Living with Television: The Dynamics of Cultivation Process," in *Perspectives on Media Effects*, ed. Jennings Bryant and Dolf Zillmann (Hillsdale, NJ: Lawrence Erlbaum, 1986), 28.

24. Craig Haney and John Manzolati, "Television Criminology: Network Illusions of Criminal Justice Realities," in *Readings about the Social Animal*, ed., Elliot Aronson, (San Francisco: W. H. Freeman, 1980).

25. Jennings Bryant, Rodney Corveth, and Dan Brown, "Television Viewing and Anxiety: An Experimental Examination," *Journal of Communcation* 31, no. 1 (1981): 106–119.

26. Barrie Gunter and Mallory Wober, "Television Viewing and Public Perceptions of Hazards to Life," *Journal of Environmental Psychology* 3 (1983): 325–335.

27. See Doris Graber, *Crime and the Public* (New York: Praeger, 1980).

28. Dan Olmsted and Gigi Anders, "Turned Off," *USA Weekend*, 2–4 June 1995, 4–6.

29. Benjamin Svetkey, "Bleak Chic," *Entertainment Weekly* no. 299, 3 November 1995, 32.

30. Owen Gleiberman and Ken Tucker, "The Week: In Theaters: Seven," *Entertainment Weekly* no. 299, 3 November 1995, 49.

31. Svetkey, 34–35.

32. Barbara Meltz, "Understanding the Poison of Violence," *Boston Globe*, 23 March 1995, sec. A, p. 4.

33. Patricia Ould, "Increase the Peace" Panel Member Presentation, Sponsored by City of Peabody, MA, in Cooperation with Essex County District Attorney Kevin Burke, State Representative Sally Kerans, and others, Cablevision Cablecast 16 June 1993.

34. Deborah Prothrow-Stith, *Deadly Consequences* (New York: Harper-Collins, 1991), 110.

35. Charles S. Clark, "Is There Too Much Murder and Mayhem on TV?" *Boston Sunday Herald*, 13 June 1993, 33.

36. Anita Diamont, "TV's War with Violence," *Boston Globe Magazine*, 27 March 1994, 7–8.

37. Charles S. Clark, "Tuning Out the Violence," *Boston Sunday Herald*, 13 June 1993, 33.

38. Brian McGrory, "Relationship of Crime News, Fear is Debated," *Boston Globe*, 4 April 1994, 4.

39. Clark, "Too Much Murder," 32.

40. McGrory, 1.

41. Neil Hickey, "How Much Violence Is There?" in *Violence on Television: Special Report by the Editors of TV Guide* (New York: TV Guide, 1992), 2–3.

42. Elizabeth Kolbert, "Study Reports TV Is Considerably More Violent Despite Outcry," *New York Times*, 5 August 1994, sec. A, p. 13.

43. Seymour Feshbach, "The Stimulating Various Cathartic Effects of the Vicarious Aggressive Activity," *Journal of Abnormal and Social Psychology* 63, no. 2 (1961): 381–385.

44. See Thomas Baldwin and Colby Lewis, "Violence in Television: The Industry Looks at Itself," in *Television and Social Behavior*, Vol. 1, eds., George Comstock and Eli Rubinstein (Washington, DC: Government Printing Office, 1972), 290–373; also, James H. Watt, Jr., and Robert Krull, "An Examination of Three Models of Television Viewing and Aggression," *Human Communication Research* 3, no. 2 (1977): 99–112.

45. See A. C. Huston et al., "Communicating More Than Content: Formal Features of Children's Television Programs," *Journal of Communication* 31 (1981): 32–48; also D. Greer et al., "The Effects of Television Commercial Form and Commercial Placement on Children's Social Behavior and Attention," *Child Development* 53 (1982): 611–619.

46. National Commission on the Causes and Prevention of Violence. *To Establish Justice, To Insure Domestic Tranquility: Final Report of the National Commission on the Causes and Prevention of Violence* (Washington, DC: Government Printing Office, 1969), 188.

47. Leonard Berkowitz, *Aggression: A Psychological Analysis* (New York: McGraw Hill, 1962), 229–255; see also Leonard Berkowitz, "The Effects of Observing Violence," *Scientific American* 210, no. 2, (1964): 35–41; Leonard Berkowitz, "Some Determinants of Impulsive Aggression: the Role of Mediated Associations with Reinforcements for Aggression," *Psychological Review* 81, no. 2 (1974): 165–176.

48. George Comstock, "Types of Portrayal and Aggressive Behavior," *Journal of Communication* 27, no. 3 (1977): 189–198.

49. Albert Bandura, "What TV Violence Can Do to Your Child," in Otto Larsen, *Violence and the Mass Media* (New York: Harper and Row, 1968), 123–139.

50. See Albert Bandura, *Aggression: A Social Learning Analysis.* (Englewood Cliffs, NJ: Prentice Hall, 1973); also Albert Bandura, *Social Learning Theory* (Englewood Cliffs, NJ: Prentice Hall, 1977).

51. Brandon Centerwall, "Television and Violent Crime," *The Public Interest* (Spring 1993): 56.

52. Ibid., 58.

53. Wayne Wilson and Randy Hunter, "Movie-Inspired Violence," *Psychological Reports* 53, no.2 (1983): 435–441.

54. Juliet Lushbough Dee, "Media Accountability for Real-Life Violence: A Case of Negligence or Free Speech?" *Journal of Communication* 37 (Spring 1987): 107–138.

55. Ibid.

56. Michael Blowen, "When You Get Right Down to It, Good Children's TV Is Just Good TV," *Boston Sunday Globe*, 19 November 1995, sec. A, p. 9.

57. Barbara Meltz, "Beware Power Rangers' Mixed Messages," *Boston Globe* 1 December 1994, sec. A, p. 1, 5.

58. Doug Mellgren, "TV Show Nixed after Girl's Brutal Murder," Associated Press, 19 October 1994.

59. "Canada Station Cancels Power Rangers," *Boston Globe*, 3 November 1994, 70.

60. Frederic M. Biddle, "Focus on Profit Blurs Picture for Educational TV," *Boston Sunday Globe*, 9 April 1995, 1, 8.

61. James Kaplan, "It's Morphin Time!" *TV Guide*, 24–30 June 1995, 20.

62. "Boy Watching 'Robocop' Kills Maid," Associated Press, 9 October 1993.

63. "Boy Accused in Murder Eager for Christmas," *Boston Herald*, 29 November 1993, 2.

64. "Freaks of Nature," *London Daily Mail*, 25 November 1993, 1; see also William Miller, "England Tries to Fathom Horrific Crime," *Boston Globe*, 26 November 1993, 19.

65. Court deposition quoted in Wayne Wilson and Randy Hunter, "Move-inspired Violence," *Psychological Reports* 53, no. 2 (1983): 435.

66. Ibid.

67. Ann E. Donlan, "We're 'Natural Born Killers,'" *Boston Herald*, 28 June 1995, 1, 7.

68. Ibid., 7.

69. Charles M. Sennott, "Violence at Home: Chilling Cases of Slain Parents," *Boston Globe*, 14 March 1995, 3.

70. Ed Hayward, "Killing Prompts Fresh Dole Assault on Hollywood," *Boston Herald*, 28 June 1995, 6.

71. Presidential hopeful Bob Dole, an outspoken critic of violence as entertainment, held up a copy of the *Boston Herald* and described the incident on the Senate floor as a story that "should send shivers down the spines of all

Americans" and one that exemplified the connection between real world criminality and "films that revel in mindless violence and loveless sex."

72. Paul Langer, "Portrayal of Sharon Slaying Chills Court," *Boston Globe*, 8 June 1993, 27.

73. Ibid.

74. Langer, 1.

75. "Road Dare Game Similar to Stunt in Film Kills 2," *Boston Globe*, 20 October 1993, 6.

76. Wilson and Hunter, 437–440.

77. Ibid. Wilson and Hunter use as an example the case of a young Texas mother, apparently a paranoid schizophrenic, who in 1980 stabbed her four-year-old daughter and cut out her heart, convinced that her child was a "demon." The source of this idea, her attorneys argued, was *The Exorcist* and *The Exorcist II*, which she had watched a week earlier. The jury found her not guilty by reason of insanity after they watched tapes of both films.

78. L. A. Joy, M. M. Kimball, M. L. Zabrack, "Television and Children's Aggressive Behavior," in *The Impact of Television: A Natural Experiment in Three Communities*, ed., T. M. Williams (Orlando, FL: Academic Press, 1986), 303–360.

79. L. Rowell Huesmann, "Psychological Processes Promoting the Relation Between Exposure to Media Violence and Aggressive Behavior by the Viewer," *Journal of Social Issues* 42, no. 3 (1986): 125–139.

See also: L. Rowell Huesmann and Leonard D. Eron, *Television and the Aggressive Child* (Hillsdale, NJ: Lawrence Erlbaum, 1986), 45–80; Leonard D. Eron and L. Rowell Huesmann, "The Control of Aggressive Behavior by Changes in Attitudes, Values, and the Conditions of Learning," *Advances in the Study of Aggression* (Orlando, FL: Academic Press, 1984), 139–171; Leonard D. Eron, "Parent-Child Interaction, Television Violence, and Aggression of Children," *American Psychologist* 37, no. 2 (1982): 197–211; Eron, Leonard D. and L. R. Huesmann. "Adolescent Agression and Television." *Annals of the New York Academy of Sciences* 347 (1980): 319–331.

80. Quoted in "Does TV Violence Cause Real Violence?" in *Violence on Television: Special Report by the Editors of TV Guide* (New York: TV Guide, 1992), 6; and in "The New Face of Television Violence," in *Violence on Television: Special Report by the Editors of TV Guide* (New York: TV Guide, 1992), 6.

81. Brandon Centerwall, "Television and Violence: the Scale of the Problem and Where We Go from Here," *Journal of the American Medical Association* 267, no. 22 (1992): 3,060–3,061.

82. Ibid. See also Brandon Centerwall, "Exposure to Television as a Risk Factor for Violence," *American Journal of Epidemiology* 129 (1989): 643–652.

83. See Lenore Terr, *Too Scared to Cry: Psychic Trauma in Childhood* (New York: Harper and Row, 1990).

84. National Commission on the Causes and Prevention of Violence. *To Establish Justice, To Insure Domestic Tranquility: Final Report of the National Commission on the Causes and Prevention of Violence* (Washington, DC: Government Printing Office, 1969).

85. U.S. Public Health Service. Office of the Surgeon General. Scientific Advisory Committee of Television and Social Behavior. *Television and Growing Up: the Impact of Television Violence: Report to the Surgeon General.* (Washington, DC: Government Printing Office, 1972).

86. William Belson, *Television and the Adolescent Boy* (1978), in Brandon Centerwall, "Television and Violent Crime," *The Public Interest* (Spring 1993): 64.

87. Cited in Brandon Centerwall, "Television and Violent Crime," *The Public Interest* (Spring 1993): 64–65.

88. National Institute of Mental Health, *Television and Behavior: Ten Years of Scientific Progress and Implications for the Eighties* (Rockville, MD: National Institute of Mental Health, 1982).

89. Centerwall, "Television and Violent Crime," 65–66.

90. American Academy of Pediatrics, Committee on Communcations, "Children, Adolescents, and Television," *Pediatrics* 85 (1990): 1,119–1,120.

91. Paul Farhi, "Researchers Link Psychological Harm to Violence on TV," *Boston Globe*, 7 February 1996, 4.

92. "TV's Turner Blames TV for U.S. Violence," *Boston Herald*, 26 June 1993, 12.

93. Aaron Zitner, "Kid's TV: It's Elementary but Regulators and Advocates Can't Even Agree on What 'Educational' Means," *Boston Sunday Globe*, 19 November 1995, sec. A, p. 8.

94. Centerwall, "Television and Violence," 3,062.

95. "Canada and Media Violence: An Overview," *Clipboard* 8, no. 1 (1993): 4–5.

96. Robert W. Kubey and Reed Larson, "The Use and Experience of the New Video Media Among Children and Adolescents," *Communication Research* 17 (February 1990): 107–130.

97. P. J. Favaro, The Effects of Video Game Play on Mood, Physiological Arousal and Psychomotor Performance. Hofstra University, New York, 1983.

98. Peter H. Lewis, "Virtual Mayhem and Real Profits," *New York Times* 3 September 1994, 35, 37.

99. *Entertainment Weekly,* 9 July 1995, 101.

100. "TV's Turner," 12.

101. Robert R. Holt, "Converting the War System to a Peace System," cited in Meriam Medzian, *Boys Will Be Boys* (New York: Doubleday Anchor Books, 1991), 76.

102. *Vatican Council for Social Communication,* 1993 Aetatis Novae (Rome: Vatican Council for Social Communication, 1993), quoted in Don Walker, "Media Literacy: The Vatican Echoes McLuhan," *America* 6 March 1993, 4.

103. "Guns by the Numbers," *USA Today,* 29 December 1993, sec. A, p. 3.

104. Mark Memmott, "Gun Industry Has Hidden Economic Impact," *USA Today,* 29 December 1993, sec. B, p. 3,

105. Cited on *Adam Smith,* ed. in chief Adam Smith, Educational Broadcasting Corporation, Boston: WBUR, 6 January 1994.

106. Talbot, 7.

107. Carol Flake, "Arms and the Woman," *Boston Globe Magazine,* 27 March 1994, 9.

Conclusion

1. Alexis Tan, "Social Learning of Aggression from Television," in *Perspectives on Media Effects,* ed. Jennings Bryant and Dolf Zillmann (Hillsdale, NJ: Lawrence Erlbaum, 1986), 49.

2. Boulding, 90.

3. George Gerbner et al., "Living With Television: The Dynamics of Cultivation Process," in *Perspectives on Media Effects,* ed. Jennings Bryant and Dolf Zillmann (Hillsdale, NJ: Lawrence Erlbaum, 1986), 18.

4. Ibid.

5. George Gerbner et al., "The 'Mainstreaming' of America: Violence Profile no. 11," *Journal of Communication* 30, no. 3 (1980): 10–29.

6. R. T. Holden, "The Contagiousness of Aircraft Hijacking," *American Journal of Sociology* 9, no. 4 (1986): 876–904; D. P. Phillips, "Airplane Accidents, Murder and the Mass Media," *Social Forces* 58, no. 4 (1980): 1001–1024; D. P. Phillips, "Suicide, Motor Vehicles and the Mass Media: Evidence Toward a Theory of Suggestion," *American Journal of Sociology* 84 (1979): 1150–1174; D. P. Phillips, "The Influence of Suggestion on Suicide: Substantive and Theoretical Implications of the Werther Effect," *American Sociological Review* 39 (1974): 340–354.

7. See F. Andison, "TV Violence and Viewer Aggression: A Cumulation of Study Results 1956–1976," *Public Opinion Quarterly* 41 (1977): 314–331; A. Bandura, *Aggression: A Social Learning Analysis* (Englewood Cliffs, NJ: Prentice Hall, 1973); L. D. Eron and L. R. Huesmann, "Adolescent Aggression and Television," *Annals of the New York Academy of Sciences* 347 (1980): 319–331; J. Ronald Milavsky, et al., *Television and Aggression: the Results of a Panel Study* (New York: Academic Press, 1982); J. Murray, *Television and Youth: 25 Years of Research and Controversy* (Boys Town, NE: Boys Town Center for the Study of Youth Development, 1980); David Pearl, Lorraine Bouthilet, and Joyce Lazar, eds., *Television and Behavior: Ten Years of Scientific Progress and Implications for the Eighties*, Vol. II. (Washington, DC: Government Printing Office, 1982); Eli A. Rubenstein, "Television and Behavior: Research Conclusions of the 1982 NIMH Report and Their Policy Implications," *American Psychologist* (July 1983): 820–825; J. L. Singer and D. G. Singer, *Television, Imagination and Aggression: A Study of Preschoolers' Play* (Hillsdale, NJ: Erlbaum, 1980).

8. Campbell, *The Power of Myth*, 8.

9. Ibid., 9.

10. Joseph Campbell, *The Hero with a Thousand Faces*, Bollingen Series XVII (1949; reprint, Princeton: Princeton University Press, 1973), 383.

11. Gabriel Marcel, "On the Ontological Mystery," in *The Philosophy of Existentialism*. New York: Citadel Press, 1991, 41.

BIBLIOGRAPHY

Abramson, Paul R., and Aldrich Rohde. *Change and Continuity in the 1980 Elections*. Washington, DC: Congressional Quarterly Press, 1982.

Adams, Henry. "The Dynamo and The Virgin." In *The Education of Henry Adams*. Boston: Houghton Mifflin, 1918.

Adolphs, R., D. Tranel, H. Damasio, and A. Damasio. "Impaired Recognition of Emotion in Facial Expressions Following Bilateral Damage to the Human Amygdala." *Nature* 372 (1994): 669–672.

Ainsworth, Rebecca, Loena Simpson, and David Cassell. "Effects of Three Colors in an Office Interior on Mood and Performance." *Perceptual and Motor Skills* 76 (1993): 235–241.

Allman, William F. "The Dawn of Creativity," *U.S. News & World Report*, 20 May 1996, 53–57.

Altheide, David L. *Media Power*. Beverly Hills, CA: Sage, 1985.

American Academy of Pediatrics, Committee on Communciations. "Children, Adolescents, and Television." *Pediatrics* 85 (1990): 1,119-1,120.

American Psychological Association, "Big World, Small Screen," American Psychological Association, 1992.

"Anatomy of a Fastball." *Business Week*, 5 October 1992, 98.

Anderson, Daniel. *Impact on Children's Education: Television's Influence on Cognitive Development*. Washington, DC: U.S. Department of Education, 1988.

Anderson, Joseph and Barbara. "The Myth of Persistence of Vision Revisited." *Journal of the University Film Association* 30, no. 4 (Fall 1978): 3–8.

Anderson, Joseph and Barbara. "The Myth of Persistence of Vision Revisited." *Journal of Film and Video* 45, no. 1 (1993): 3–12.

Andison, F. "TV Violence and Viewer Aggression: A Cumulation of Study Results 1956–1976." *Public Opinion Quarterly* 41 (Fall 1977): 314–331.

Angelo, Jean Marie. "Altered States." *Folio* 23, no. 3 (1994): 62.

Arnheim, Rudolph. *Art and Visual Perception*. Berkeley: University of California Press, 1974.

————. *Visual Thinking*. Berkeley: University of California Press, 1969.

Associated Press Bulletins: 9 October 1993–9 October 1994.

Ash, Mary Kay. *Mary Kay*. New York: Barnes and Noble, 1981.

Backer, Bill. *The Care and Feeding of Ideas*. New York: Random House, 1993.

Baker, Julie, Michael Levy, and Dhruv Grewal. "An Experimental Approach to Making Retail Store Environmental Decisions." *Journal of Retailing* 68, no. 4 (1992): 445–460.

Balázs, Béla. *Theory of the Film*. New York: Dover, 1970.

Baldwin, Thomas and Colby Lewis. "Violence in Television: The Industry Looks at Itself." In *Television and Social Behavior*, Vol. 1: Content and Control, eds. George Comstock and Eli Rubinstein. Washington, DC: Government Printing Office, 1972, 290–373.

Bandura, Albert. *Aggression: A Social Learning Analysis*. Englewood Cliffs, NJ: Prentice Hall, 1973.

————. *Social Learning Theory*. Englewood Cliffs, NJ: Prentice Hall, 1977.

————. "What TV Violence Can Do to Your Child." In *Violence and the Mass Media*. ed. Otto Larsen, New York: Harper and Row, 1968, 123–139.

John Bargh. "Automatic Information Processing: Implications for Communication and Affect." In *Communnication Affect, and Social Cognition*, eds. L. Donohew, H. Sypher, and E. T. Higgins. Hillsdale, NJ: Lawrence Erlbaum, 1988, 9–32.

————. "Conditional Automaticity: Varietes of Automatic Influence in Social Perception and Cognition." In *Unintended Thought*, eds. J. S. Uleman and J. A. Bargh. New York: Guilford Press, 1989, 3–51.

Bargh, J. A., and P. Pietromonaco. "Automatic Information Processing and Social Perception: The Influence of Trait Information Presented Outside of Conscious Awareness on Impression Formation." *Journal of Personality and Social Psychology* 43 (1982): 437–449.

Barnes, J. "Aristotle." In *Oxford Companion to the Mind*, ed. R. L. Gregory. New York: Oxford University Press, 1987, 38–40.

————. "Perception: Early Greek Theories." In *Oxford Companion to the Mind*, ed. R. L. Gregory. New York: Oxford University Press, 1987, 603–604.

Baron, Robert A., Mark S. Rea, and Susan G. Daniels. "Effects of Indoor Lighting (Illuminance and Spectral Distribution) on the Performance of Cognitive Tasks and Interpersonal Behaviors: The Potential Mediating Role of Positive Affect." *Motivation and Emotion* 16, no. 1 (1992): 1–33.

Barry, A. M. "Advertising and Channel One: Controversial Partnership of Business and Education." In *Watching Channel One*, ed. Ann DeVaney. Albany: State University of New York Press, 1994, 102–136.

———. "Tailhook 'Top Guns': Visual Templates in the Use and Abuse of Power." *Journal of Visual Literacy* 14, no. 1 (1994): 51–59.

Barthes, Roland. *Mythologies*, trans. Annette Lavers. New York: Noonday Press, 1990.

Barton, R. L., and R. B Gregg. "Middle East Conflict as News Scenario." *Journal of Communication* 32, no. 2 (1982): 172–185.

Bazin, André. "Time Validates *Modern Times*." In *Essays on Chaplin*, ed. and trans. Jean Bodon. New Haven, CT: University of New Haven Press, 1985.

Beaver, Frank E. *On Film*. New York: McGraw Hill, 1983.

Begley, Sharon. "Your Child's Brain," *Newsweek*, 19 February 1996, 55–62.

Belizzi, Joseph, and Robert Hite. "Environmental Color, Consumer Feelings, and Purchase Likelihood." *Psychology and Marketing* 9, no. 5 (1992): 347–363.

Bennett, Peter, Alan Hague, and Christopher Perkins. "The Use of Baker-Miller Pink in Police Operational and University Experimental Situations in Britain." *International Journal of Biosocial and Medical Research* 13, no. 1 (1991): 118–127.

Berger, John. *Ways of Seeing*. New York: Penguin Books, 1977.

Berkowitz, Leonard. *Aggression: A Psychological Analysis*. New York: McGraw Hill, 1962.

———. "The Effects of Observing Violence." *Scientific American*, 210, no. 2, (1964): 35–41.

———. "Some Determinants of Impulsive Aggression: the Role of Mediated Associations with Reinforcements for Aggression."*Psychological Review* 81, no. 2 (1974): 165–176.

"Bill Bernbach said . . ." New York: DDB Needham Worldwide Advertising.

Birdwhistell, R. L. *Kinesics and Context*. Philadelphia: University of Pennsylvania Press, 1970.

Birren, F. *Color Psychology and Color Therapy*. Hyde Park, NY: University Books, 1950.

Blakemore, Colin, "The Baffled Brain." In *Illusion in Nature and Art*, ed. R. L. Gregory and E.H. Gombrich. London: Gerald Duckworth & Co., 1973, 19–49.

Blehar, M. C., and N. E. Rosenthal. *Seasonal Affective Disorders and Phototherapy.* New York: Guilford Press, 1989.

Block, Martin, and Bruce G. Vanden Bergh. "Can You Sell Subliminal Messages to Consumers?" *Journal of Advertising,* 14, no. 3 (1985): 59–62.

Blum, A. "The Marlboro Grand Prix: Circumvention of the Television Ban on Tobacco Advertising." *New England Journal of Medicine* 324 (1991): 913–917.

Bornstein, Marc, and Lawrence Marks. "Color Revisionism." *Psychology Today* (January 1982), 64–73.

Bornstein, R. F., D. R. Leone and D. J. Galley. "The Generalizability of Subliminal Mere Exposure Effects: Influence of Stimuli Perceived without Awareness on Social Behavior." *Journal of Personality and Social Psychology* 53 (1987): 10,070–1,079.

Boston Globe, 8 July 1991–18 March 1996.

Boston Herald, 8 June 1993–28 June 1995.

Boston Sunday Globe, 9 April 1995–19 November 1995.

Boston Sunday Herald, 13 June 1993–19 November 1995.

Boulding, Kenneth. *The Image.* Ann Arbor, MI: University of Michigan Press, 1956.

Bowers, K. S. "On Being Unconsciously Informed and Influenced." In *The Unconscious Reconsidered,* eds. K. S. Bowers and D. Meichenbaums. New York: Wiley, 1984, 227–272.

Braden, R. A., and J. A. Hortin. "Identifying the Theoretical Foundations of Visual Literacy." In *Television and Visual Literacy,* eds. R. A. Braden and A. D. Walker. Bloomington, IL: International Visual Literacy Association, 1982, 169–179.

Brannon, R., and D. David, eds. *The Forty-Nine Percent Majority: The Male Sex Role.* Reading, MA: Addison-Wesley, 1976.

Bressler, J. "Illusion in the Case of Subliminal Visual Stimulation." *Journal of General Psychology* 5 (1931): 244–250.

Broadbent, Simon, ed. *The Leo Burnett Book of Advertising.* London: Hutchinson, 1984.

Bruner, Joseph. *In Search of Mind: Essays in Autobiography.* New York: Harper & Row, 1983.

Bryant, Jennings, Rodney Corveth, and Dan Brown. "Television Viewing and Anxiety: An Experimental Examination." *Journal of Communcation* 31, no. 1 (1981): 106–119.

Buck, Louisa. "Hue and Eye." *New Statesman & Society*, 18 October 1991, 29.

Buckley, Jr., William F. "On the Right: Mud on His Face." *National Review*, 7 December 1979, 1580.

Burton, Philip Ward and Scott Purvis. *Which Ad Pulled Best?* Lincolnwood, IL: NTC Business Books, 1987.

Bush, Gregory W. *American History American Television*. New York: Frederick Ungar, 1983.

Busmiller, Elisabeth. "The Tuesday Team Wants America to Feel Good." *Adweek*, 29 October 1984, 71.

Calder, Nigel. *Einstein's Universe*. New York: Greenwich House, 1979.

Campbell, Joseph. *The Hero With a Thousand Faces*. Bollingen Series XVII. 1949. Reprint, Princeton: Princeton University Press, 1973.

Campbell, Joseph, ed. *The Portable Jung*. New York: Penguin Books, 1971.

———. *The Power of Myth*. New York: Doubleday Anchor, 1991.

"Canada & Media Violence: An Overview." *Clipboard* 8, no. 1 (1993): 1–6.

Cantor, N., and J. Kihlstrom, eds. *Personality, Cognition and Social Interaction*. Hillsdale, NJ: Lawrence Erlbaum, 1981.

Cantril, H. *The Invasion from Mars*. 1940. Reprint, New York: Harper & Row, 1966.

Centerwall, Brandon. "Exposure to Television as a Cause for Violence." In *Public Communication and Behavior*, Vol. 2, ed. George Comstock. Orlando, FL: Academic Press, 1989, 1–58.

———. "Television and Violence: the Scale of the Problem and Where We Go from Here." *Journal of the American Medical Association* 267, no. 22 (1992): 3,059–3,063.

———. "Television and Violent Crime." *The Public Interest* (Spring 1993): 58–71.

Chaplin, Charles. *My Autobiography*. New York: Simon & Schuster, 1964.

Cline, Victor, Roger Croft, and Steven Courier. "Desensitization of Children to Television Violence." *Journal of Personality and Social Psychology* 27, no. 3 (1973): 360–365.

Coldevin, G. O. "Experiments in TV Presentation Strategies." *Educational Broadcasting International* 11, no. 1 (1978): 17–18.

———. "Experiments in TV Presentation Strategies: number 2." *Educational Broadcasting International* 11, no. 3 (1978): 158–159.

Comstock, George. "Types of Portrayal and Aggressive Behavior." *Journal of Communcation* 27, no. 3 (1977): 189–198.

Condry, J. "Live From the Battlefield," *IEEE Spectrum* 28, no. 9 (1991): 48.

Conlon, James. "Making Love, Not War." *Journal of Popular Film and Television* 18 (Spring 1990): 18–24.

Cooper, William E. "Aggressive Behavior and Courtship Rejection in Brightly and Plainly Colored Female Keeled Earless Lizards." *Ethnology* 77, no. 4 (1988): 265–278.

Cuperfain, Ronnie, and T. K. Clarke. "A New Perspective of Subliminal Perception." *Journal of Advertising* 14, no. 1 (1985): 36–41.

Crick, Francis. *The Astonishing Hypothesis*. New York: Simon and Schuster Touchstone, 1994.

Davidoff, Jules. "The Mind's Color Palette." *New Scientist*, 10 April 1993, 35.

Daviss, Bennett. "Picture Perfect." *Discover*, July 1990, 54–58.

Dee, Juliet Lushbough. "Media Accountability for Real-Life Violence: A Case of Negligence or Free Speech?" *Journal of Communication* 37 (Spring 1987): 107–138.

Denby, David. "Top Gun," *New York*, 19 May 1986, 102.

Deregowski, Jan B. "Pictorial Perception and Culture." In *Image, Object and Illusion: Readings from Scientific American*. San Francisco: W. H. Freeman and Company, 1974, 79–85.

Diamont, Anita. "TV's War with Violence." *Boston Globe Magazine*, 27 March 1994, 7–8.

Diamond, Edwin. "New-Girl Network." *New York Magazine*, 10 June 1991, 20–21.

DiFranza, Joseph R. and Joseph B. Tye. "Who Profits From Tobacco Sales to Minors?" *Journal of the American Medical Association* 263, no. 20 (1990): 2,784–87.

DiFranza, Joseph R., et al. "RJR Nabisco's Cartoon Camel Promotes Camel Cigarettes to Children." *Journal of the American Medical Association* 266, no. 22 (1991): 3,149–3,152.

Dion, K. K., E. Berscheid, and E. Walster. "What Is Beautiful Is Good." *Journal of Personality and Social Psychology* 24 (1972): 285–290.

Dixon, Norman F. *Preconscious Processing*. New York: John Wiley & Sons, 1981.

———. *Subliminal Perception: the Nature of a Controversy*. London: McGraw-Hill, 1971.

"Does TV Violence Cause Real Violence?" In *Violence on Television: Special Report by the Editors of TV Guide*. New York: TV Guide, 1992, 6+.

Damasio, Antonio. *Descartes' Error: Emotion, Reason and the Human Brain*. New York: Putnam, 1994.

Dondis, Donis A. *A Primer in Visual Literacy*. Cambridge: MIT Press, 1973.

———. *Television Literacy*. Boston: Boston University School of Public Communication. 1981.

Dudley, Sid C. "Subliminal Advertising: What Is the Controversy About?" *Akron Business and Economic Review* 18, no. 2, (1987): 16–18.

Dutczak, Sally. "The Effects of Cool-White, Full Spectrum Flourescent, and Color Adjusted Diffused Lights on Severely Physically and Mentally Handicapped Children." *International Journal of Biosocial Research* 7, no. 1 (1985): 17–20.

"Easy to Alter Digital Images Raise Fears of Tampering." *Science* 263 (21 January 1994): 317–318.

Eco, Umberto. "Articulations of the Cinematic Code." In *Movies and Methods*, ed. Bill Nichols. Berkeley: University of California Press, 1976, 590–607.

Edelman, Gerald M. *Bright Air, Brilliant Fire: On the Matter of the Mind*. New York: Basic Books, 1992.

———. *Neural Darwinism: The Theory of Neuronal Group Selection*. New York: Basic Books, 1987.

Edelman, Rob. "Top Gun." *Cineaste* 15, no. 2 (1986): 41.

Erdelyi, Matthew Hugh. "A New Look at the New Look: Perceptual Defense and Vigilance." *Psychological Review* 81, no. 1 (1974): 1–25.

———. *Psychoanalysis: Freud's Cognitive Psychology*. New York: W. H. Freeman, 1985.

Edwardson, M., D. Grooms, and S. Proudlove. "Television News Information Gain from Interesting Video vs. Talking Heads." *Journal of Broadcasting* 25 (1981): 15–24.

Ekman, Paul, ed. *Emotion in the Human Face*, 2nd ed. New York: Cambridge University Press, 1983.

———. "Expression and the Nature of Emotion." In *Approaches to Emotion*, eds., K. S. Scherer, and Paul Ekman. Hillsdale, NJ: Lawrence Erlbaum, 1984, 319–343.

Eisenstein, Sergei. *Film Form: Essays in Film Theory*, ed. and trans. Jay Leyda. New York: Harcourt Brace Javanovich, 1949.

————. *Six Essays and a Lecture,* ed. and trans. Jay Leyda. Princeton: Princeton University Press, 1968.

Eisner, Will. *Comics and Sequential Art.* Tamarac, FL: Poorhouse Press, 1985.

Eliade, Mircea. *Images and Symbols,* trans. Philip Mariet. New York: Sheen and Ward, 1969.

————. *The Two and the One,* trans. J. M. Cohen. New York: Harper & Row, 1965.

Eliot, T. S. *T. S. Eliot: The Complete Poems and Plays, 1909–1950.* New York: Harcourt Brace & World, 1971.

————. "The Metaphysical Poets." In *Criticism: The Major Texts,* ed. W. J. Bate. New York: Harcourt Brace Javanovich, 1970, 529–534.

————. *The Sacred Wood,* 4th ed. London: Methuen & Co., 1969.

————. "Tradition and the Individual Talent." In *Criticism: the Major Texts,* ed. W. J. Bate. New York: Harcourt Brace Javanovich, 1970, 525–529.

Ellis, Willis D., ed. *A Source Book of Gestalt Psychology.* New York: Harcourt Brace, 1938.

Emery, Merrelyn, and Fred Emery. "The Vacuous Vision: The TV Medium." *Journal of the University Film Association* 32 (1980): 27–31.

Englefield, F. R. H. *Language: Its Origin and Its Relation to Thought.* London: Elek/Pemberton, 1977.

Erdelyi, M. H. "A New Look at the 'New Look': Perceptual Defense and Vigilance." *Psychological Review* 81 (1974): 1–25.

Eriksen, Charles W. "Discrimination and Learning Without Awareness: A Methodological Survey and Evaluation." *Psychological Review* 67 (1960): 279–300.

Eron, Leonard D. "Parent-Child Interaction, Television Violence, and Aggression of Children." *American Psychologist* 37, no. 2 (1982): 197–211.

Eron, Leonard D., and L. Rowell Huesmann. "The Control of Aggressive Behavior by Changes in Attitudes, Values, and the Conditions of Learning." *Advances in the Study of Aggression.* Orlando, FL: Academic Press, 1984, 139–171.

————. "Adolescent Aggression and Television," *Annals of the New York Academy of Sciences* 347 (1980): 319–331.

Farah, Martha J. "The Neurological Basis of Mental Imagery." *Trends in Neuroscience* 12, no. 10 (1989): 395–398.

Favaro, P. J. *The Effects of Video Game Play on Mood, Physiological Arousal and Psychomotor Performance.* Hofstra University, New York, 1983.

Ferris, Timothy. *The Mind's Sky*. New York: Bantam Books, 1992.

Feshbach, Seymour. "The Stimulating Various Cathartic Effects of the Vicarious Aggressive Activity." *Journal of Abnormal and Social Psychology* 63, no. 2 (1961): 381–385.

Freeman, David H. "Quantum Consciousness." *Discover* (June 1994): 89–98.

Finke, Ronald. "Mental Imagery and the Visual System." In *The Perceptual World*, ed. Irvin Rock. New York: W.H. Freeman, 1988, 179–185.

Fischer, Paul M., Meyer P. Schwartz, John W. Richards, Jr., Adam O. Goldstein, and Tina H. Rojas. "Brands Logo Recognition by Children Aged 3 to 6 Years." *Journal of the American Medical Association* 266, no. 22 (1991): 3,145–3,148.

Fisher, C. "Dreams and Perception: The Role of Preconscious and Primary Modes of Perception and Dream Formation." *Journal of the American Psychoanalytic Association* 2 (1954): 389–445.

Fisher, C., and I. H. Paul. "The Effect of Subliminal Visual Stimulation on Imagery and Dreams: A Validation Study." *Journal of the American Psychoanalytic Association* 7 (1959): 35–83.

Fisher, G. H. "Preparation of Ambiguous Stimulus Materials." *Perception and Psychophysics* 2, no. 9 (1967): 421–422.

Fitzgerald, F. Scott. "What Became of Our Flappers and Shieks?" *McCall's Magazine*, 12 October 1925, 42+.

Flake, Carol. "Arms and the Woman." *Boston Globe Magazine*, 27 March 1994, 9.

Flanagan, Owen J. *The Science of the Mind*. Cambridge, MA: MIT Press, 1984.

Fleming, J., and A. J. Arrowood. "Information Processing and the Perseverance of Discredited Perceptions." *Personality and Social Psychology Bulletin* 5 (1979): 201–205.

Fox, Stephen. *The Mirror Makers*. New York: Vintage Books, 1985.

Frank, Jerome. *Persuasion and Healing*. Baltimore, MD: Johns Hopkins Press, 1961.

Freud, Sigmund. *Group Psychology and the Analysis of the Ego* (1921). Trans. James Strachey. New York: Bantam Books, 1960.

———. *The Ego and the Id*. New York: W. W. Norton, 1960.

Freeman, David H. "Quantum Consciousness." *Discover* (June 1994): 90.

Friedman, H. S., T. I. Mertz, and M. R. DiMatteo. "Perceived Bias in the Facial Expressions of Television News Broadcasters." *Journal of Communication* 30, no. 4 (1980): 103–111.

Gable, Myron, Henry T. Wilkens, Lynn Harris, and Richard Feinberg. "An Evaluation of Subliminally Embedded Sexual Stimuli in Graphics." *Journal of Advertising* 16, no. 1 (1987): 26–31.

Gaines, James R. "To Our Readers." *Time*, 4 July 1994, 4.

Gardner, Howard. *Creating Minds*. New York: HarperCollins, 1993.

———. *Multiple Intelligences*. New York: HarperCollins, 1993.

Gazzaniga, Michael S. *The Social Brain*. New York: Basic Books, 1985.

Gerbner, George. "Persian Gulf War, the Movie." In *Triumph of the Image: The Media's War in the Persian Gulf—A Global Perspective*, eds. H. Mowlana, G. Gerbner and H. I. Schiller. Boulder, CO: Westview, 1991, 242–265.

Gerbner, George, L. Gross, M. Morgan, and N. Signorelli. "Living with Television: The Dynamics of Cultivation Process." In *Perspectives on Media Effects*, ed. Jennings Bryant and Dolf Zillmann. Hillsdale, NJ: Lawrence Erlbaum, 1986, 17–40.

———."The 'Mainstreaming' of America: Violence Profile no. 11." *Journal of Communication* 30, no. 3 (1980): 10–29.

Gerzon, Mark. *A Choice of Heroes: The Changing Face of American Manhood*. Boston: Houghton Mifflin, 1982.

Gibson, James J. *The Ecological Approach to Visual Perception*. Boston: Houghton Mifflin, 1979.

———. "Ecological Optics." *Vision Research* 1 (1961): 254–260.

———. "Outline of a Theory of Direct Visual Perception." Working paper, Cornell University, Ithaca, New York, 1969.

———. *The Senses Considered as Perceptual Systems*. Boston: Houghton Mifflin, 1966.

———. "The Information Available in Pictures." *Leonardo* 4 (1971): 27–35.

Gilbert, Daniel T. "How Mental Systems Believe." *American Psychologist* 46, no. 2 (1991): 107–119.

Gilbert, Daniel T., D. S. Krull, and P. S. Malone. "Unbelieving the Unbelievable: Some Problems in the Rejection of False Information." *Journal of Personality and Social Psychology* 59 (1990): 601–613.

Gilliam, James. "The Effects of Baker-Miller Pink on Physiological and Cognitive Behavior of Emotionally Disturbed and Regular Education Students." *Behavioral Disorders* 17, no. 1 (1991): 47–55.

Gilman, Ernest B. "Word and Image in Quarles' *Emblemes*." *Critical Inquiry* 6 (Spring 1980): 385–410.

Gleiberman, Owen, and Ken Tucker. "The Week: In Theaters: *Seven.*" *Entertainment Weekly* No. 299, 3 November 1995, 49.

Gleik, James. *Chaos: Making a New Science.* New York: Penguin Books, 1987.

Goffman, Erving. *Gender Advertisements.* New York: Harper Torchbooks, 1976.

Goldberg, Marvin, and Gerald Gorn. "Happy and Sad Programs: How They Affect Reactions to Commercials." *Journal of Consumer Research* 14, no. 3 (1987): 387–403.

Goldstein, E. Bruce. *Sensation and Perception*, 3rd ed. Pacific Grove, CA: Wadsworth, 1989.

Goleman, Daniel. *Emotional Intelligence.* New York: Bantam Books, 1995.

Gombrich, E. H. *Art and Illusion: A Study in the Psychology of Pictorial Representation.* Princeton: Princeton University Press, 1960.

———. "Illusion and Art." In *Illusion in Nature and Art*, ed. R. L. Gregory and E. H. Gombrich. London: Gerald Duckworth & Co., 1973, 193–244.

Graber, D. A. "Content and Meaning: What's It All About?" *American Behavioral Scientist* 33, no. 2 (1989): 144–152.

———. *Crime and the Public.* New York: Praeger, 1980.

———. "Portraying Presidential Candidates on Television: An Audiovisual Analysis." *Campaigns and Elections* 7 (1986): 14–21.

———. *Processing the News: How People Tame the Information Tide.* New York: Longman, 1984.

———. "Television News without Pictures?" *Critical Studies in Mass Communication* 4, no. 1 (1987): 74–78.

Grandin, Temple. *Thinking in Pictures.* New York: Doubleday, 1995.

Greenfield, Jeffrey. *The Real Campaign.* New York: Summit, 1982.

Greer, D., R. Potts, J. C. Wright, and A. C. Huston. "The Effects of Television Commercial Form and Commercial Placement on Children's Social Behavior and Attention." *Child Development* 53 (1982): 611–619.

Gregory, Richard L. *Concepts and Mechansims of Perception.* London: Duckworth, 1974.

———. *The Intelligent Eye.* New York: McGraw Hill, 1970.

———. *Odd Perceptions.* New York: Methuen, 1987.

———. "Seeing Backwards in Time." *Nature* 373 (5 January 1995): 21–22.

Gronbeck, Bruce. "The Functions of Presidential Campaigning." *Communication Monographs* 45 (November 1978): 268–280.

Grunfeld, Frederic V. *The Hitler File*. New York: Random House, 1974.

Gunter, Barrie and Mallory Wober. "Television Viewing and Public Perceptions of Hazards to Life." *Journal of Environmental Psychology* 3 (1983): 325–335.

Haber, Ralph. "Eidetic Images." In *Image, Object and Illusion: Readings from Scientific American*. San Francisco: W. H. Freeman and Company, 1974, 123–131.

Halberstam, David. *The Best and the Brightest*. New York: Penguin Books, 1983.

———. *The Powers That Be*. New York: Dell, 1979.

Hall, Edward T. *The Hidden Dimension*. New York: Anchor Books, 1982.

Aronson, Elliot, ed. *Readings about the Social Animal*. San Francisco: W. H. Freeman, 1980.

Harman, G. "Epistemology." In *Handbook of Perception*, eds. E. C. Carterette and M. P. Friedman. New York: Academic Press, 1974, 41–55.

Harmetz, Aljean. *The Making of The Wizard of Oz*, 2nd ed. New York: Limelight, 1987.

Hart, R. P., P. Jerome, and K. McComb. "Rhetorical Features of Newscasts about the President." *Critical Studies in Mass Communication* 1, no. 3 (1984): 260–286.

Hawkins, Del, Rogert J. Best, and Kenneth Coney. *Consumer Behavior* (Plano, TX: Business Publications, Inc, 1983).

Hayakawa, S. I., ed. *The Use and Misuse of Language*, ed. S. I. Hayakawa. Greenwich, CT: Harper & Brothers, 1962.

Heatherton, Todd, Patricia Nichols, Fary Mahamedi, and Pamela Keel. "Body Weight, Dieting, and Eating Disorder Symptoms Among College Students, 1982 to 1992." *American Journal of Psychiatry* 152, no. 11 (1995): 1623–1629.

Hemingway, Ernest. *A Moveable Feast*. New York: Charles Scribner's Sons, 1964.

Hickey, Neil. "How Much Violence Is There?" In *Violence on Television: Special Report by the Editors of TV Guide*. New York: TV Guide, 1992.

Hill, W. E. "My Wife and My Mother-in-Law." *Puck*, 6 November 1915, 11.

Hoberman, J. "Top Gun." *Village Voice*, 27 May 1986, 59.

Hochberg, Julian, and Virginia Brooks."Pictorial Recognition as an Unlearned Ability: A Study of One Child's Performance." *American Journal of Psychology* 75 (1962): 624–628.

Holden, R. T. "The Contagiousness of Aircraft Hijacking." *American Journal of Sociology* 9, no. 4 (1986): 876–904.

Holender, D. "Semantic Activation Without Conscious identification in Dichotic Listening, Parafoveal Vision and Visual Masking." *Behavioral and Brain Sciences* 9 (1986): 1–66.

Huesmann, L. Rowell. "Psychological Processes Promoting the Relation Between Exposure to Media Violence and Aggressive Behavior By the Viewer." *Journal of Social Issues* 42, no. 3 (1986): 125–139.

Huesmann, L. Rowell and Leonard D. Eron. *Television and the Aggressive Child.* Hillsdale, NJ: Lawrence Erlbaum, 1986, 45–80.

Huston, A. C., et al. "Communicating More Than Content: Formal Features of Children's Television Programs." *Journal of Communication* 31 (1981): 32–48.

"Is Virtual Reality Real Enough for the Courtroom?" *Business Week,* 5 October 1992, 99.

Jacobs, K., and J. Suess. "Effects of Four Psychological Primary Colors on Anxiety State." *Perceptual and Motor Skills* 41 (1975): 207–210.

Jacoby, Jacob, Wayne D. Hoyer, and David A Sheluga. *MisComprehension of Televised Communications.* New York: Educational Foundation of the American Association of Advertising Agencies, 1980.

Jacoby, L. L., and M. Dallas. "On the Relationship Between Autobiographical Memory and Perceptual Learning." *Journal of Experimental Psychology: General,* 1, no. 10 (1981): 306–340.

Jaubert, Alain. *Making People Disappear: An Amazing Chronicle of Photographic Deception.* McLean, VA: Pergamon-Brassey's International Defence Publishers, 1989.

Johnson, Mark. *The Body in the Mind: The Bodily Basis of Reason and Imagination.* Chicago: University of Chicago Press, 1987.

Joy, L. A., M. M. Kimball, and M. L. Zabrack. "Television and Children's Aggressive Behavior." In *The Impact of Television: A Natural Experiment in Three Communities,* ed., T. M. Williams. Orlando, FL: Acdemic Press, 1986, 303–360.

Julesz, Bela. "A Brief Outline of the Texton Theory of Human Vision." *Trend Neuroscience* 7 (1986): 41–45.

———. "Texture and Visual Perception." In *Image, Object and Illusion: Readings from Scientific American.* San Francisco: W. H. Freeman 1974, 59–70.

Jung, Carl G., ed. *Man and His Symbols.* New York: Dell, 1964.

————. *Analytical Psychology: Its Theory and Practice.* New York: Pantheon Books, 1968.

————. "The Concept of the Collective Unconscious." *Archetypes and the Collective Unconscious* (1936). In *The Portable Jung*, ed. Joseph Campbell. New York: Penguin Books, 1971, 59–69.

Kaplan, James. "It's Morphin Time!" *TV Guide*, 24-30 June 1995, 14–20.

Kelsey, Charles. "Detection of Visual Information." In *The Perception of Visual Information*, eds. William R. Hendee and Peter N. T. Wells. New York: Springer-Verlag, 1993, 30–51.

Kennamer, J. D., and S. H. Chaffee. "Communication of Political Information during Early Presidential Primaries: Cognition, Affect, and Uncertainty." *Communication Yearbook* (1982), 628–650.

Kepes, Georgy. *Language of Vision.* Chicago: Paul Theobald, 1967.

Kepplinger, H. M. "Visual Biases in Television Campaign Coverage." *Communication Research* 9, no. 3 (1982): 432–446.

Khoury, J. "Video Game Mentality and Images of the Gulf War." Paper presented at the annual meeting of the International Visual Literacy Association, Chicago, IL, 21 October 1995.

Kiesler, C. A., and S. B. Kiesler. "Role of Forewarning in Persuasive Communications." *Journal of Abnormal and Social Psychology* 8 (1964): 547–549.

Kosko, Bart. *Fuzzy Thinking.* New York: Hyperion, 1993.

Kihlstrom, J. F. "The Cognitive Unconscious." *Science* 237 (1987): 1145–1152.

Klein, G. S., D. P. Spence, R. R. Holt, and S. Gourevitch. "Cognition without Awareness; Subliminal Influences upon Conscious Thought." *Journal of Abnormal and Social Psychology* 57 (1958): 255–66.

Knox, Richard A. "Brainchild." *Boston Globe Magazine*, 5 November 1995, 22–48.

Koffka, Kurt. *Principles of Gestalt Psychology.* 1935. Reprint, New York: Harcourt, Brace & World, 1963.

Köhler, Wolfgang. "Some Gestalt Problems." In *A Source Book of Gestalt Psychology*, ed. Willis D. Ellis. London: Routledge & Kegan Paul Ltd., 1938, 55–70.

Kolbert, Elizabeth. "Test Marketing a President." *New York Times Magazine*, 30 August 1992, 20.

Kracauer, Siegfried. *From Caligari to Hitler.* New York: Noonday Press, 1959.

————. *Theory of Film.* New York: Oxford University Press, 1960.

Krosnik, Jon A., Andrew L. Betz, Lee Jussim, and Ann R. Lynn. "Subliminal Conditioning of Attitudes." *Personal and Social Bulletin* 18, no. 2 (1992): 152–162.

Krugman, Herbert. "Brainwave Measures of Media Involvement." *Journal of Advertising Research* 11 (1971): 3–9.

———. "Electroencephalographic Aspects of Low Involvement: Implications for the McLuhan Hypothesis." Cambridge, MA: Marketing Science Institute, 1970, 11–13.

Kubey, Robert W., and Reed Larson. "The Use and Experience of the New Video Media Among Children and Adolescents." *Communication Research* 17 (February 1990):107–130.

Kuleshov, Lev. *Kuleshov on Film*, ed. and trans. Ron Levaco. Berkeley: University of California Press, 1974.

Kunst-Wilson W. R., and R. B. Zajonc. "Affective Discrimination of Stimuli That Cannot Be Recognized." *Science* 207 (1980): 557–558.

Kwallek, N., C., M. Lewis, and A. S. Robbins. "Effects of Office Interior Color on Workers' Mood and Productivity." *Perceptual and Motor Skills* 66 (1988): 123–128.

Lakoff, George, and Mark Johnson. *Metaphors We Live By*. Chicago: University of Chicago Press, 1980.

Lakoff, George. *Women, Fire and Dangerous Things: What Categories Reveal about the Mind*. Chicago: University of Chicago Press, 1987.

Langacker, Ronald. *Foundations of Cognitive Grammar*. Vol. 1. Stanford, CA: Stanford University Press, 1987.

Lanier, Jaron, and Frank Biocca. "An Insider's View of the Future of Virtual Reality." *Journal of Communication* 42, no. 4 (1992): 150–172.

Lanzetta, J. T., et al. "Emotional and Cognitive Response to Televised Images of Political Leaders." In *Mass Media and Political Thought*, eds. S. Krause and R. M. Perloff. Beverly Hills, CA: Sage, 1985, 85–116.

Lau, R., and D. Sears, eds. *Political Cognition*. Hillsdale, NJ: Lawrence Erlbaum, 1986.

Lazarus, Richard S. "Commentary" [on LeDoux's "Sensory Systems and Emotion: A Model of Affective Processing." *Integrative Psychiatry* 4 (1986) 245–247], *Integrative Psychiatry* 4 (1986) 245–247.

LeDoux, Joseph."Thoughts on the Relations Between Emotions and Cognition." *American Psychologist* 37 (1982), 1,019–1,024.

———. "Emotion and the Limbic System Concept." *Concepts in Neuroscience* 2, no. 2 (1991): 169–199.

———. "Emotion, Memory and the Brain." *Scientific American* 270, no. 6 (1994): 50–57.

———. "Emotional Memory Systems in the Brain." *Behavioral and Brain Research* 58, nos. 1–2 (1993): 69–79

———. "Sensory Systems and Emotion." *Integrative Psychiatry* 4 (1986): 237–243.

Less, William, Stephen Kline, and Sut Jhally. Social *Communication in Advertising*. New York: Methuen, 1986.

Lewis, Charles. "Striking the Marketplace Pose: The Convergence of Advertising and Portrait Photography." Paper presented at the annual meeting of the International Visual Literacy Association, Chicago, IL, 20 October 1995.

Leyda, Jay. *Kino: A History of the Russian and Soviet Film*, 3rd ed. Princeton: Princeton University Press, 1983.

Lieberman, David. "Fake News." *TV Guide*, 22 February 1992, 16.

Lister, John. "That Delicate Concept of Nuance." *Advertising Age*, 29 September 1986, 40.

Livingstone, Margaret S. "Art, Illusion snd the Visual System," *Scientific American*: 78–85.

Livingstone, Margaret, and David Hubel. "Segregation of Form, Color, Movement, and Depth: Anatomy, Physiology, and Perception." *Science* 240 (6 May 1988): 740–749.

Llinás, Rodolpho R., and D. Paré. "Dreaming and Wakefulness." *Neuroscience* 44, no. 3 (1991): 521–535.

London Daily Mail, 25 November 1993.

Lyon, David. "Vision Theory Explains Why We See a World Without Holes." *The World*, 8 February 1984, 11.

Manchester, William. "The Bloodiest Battle of All." *New York Times Magazine*, 14 June 1987, 42+.

Mandell, L. M., and D. L. Shaw. "Judging People in the News—Unconsciously: Effect of Camera Angle and Bodily Activity." *Journal of Broadcasting* 17 (1972–73): 353–362.

Mander, Jerry. *Four Arguments for the Elimination of Television*. New York: Morrow, 1978.

Mandese, Joe and Jeff Jensen. "'Trial of Century,' Break of a Lifetime." *Advertising Age*, 9 October 1995, 2, 41.

Manning, Sidney and Dalmas Taylor. "The Effects of Viewing Violence and Aggression: Stimulation and Catharsis." *Journal of Personality and Social Psychology* 31 (1975): 180–188.

Manvell, Roger. *Chaplin.* Boston: Little Brown and Company, 1974.

Marcel, A. J. "Conscious and Unconscious Perception: Experiments on Visual Masking and Word Recognition." *Cognitive Psychology,* 15, (1983): 197–237.

Marcel, Gabriel. *The Philosophy of Existentialism.* New York: Citadel, 1991.

Marr, David. *Vision.* New York: W. H. Freeman, 1982.

Marshall, Herbert, ed. *The Battleship Potemkin.* New York: Avon, 1978.

Mayo, John S. Remarks to Bell Laboratories Technology Symposium, Toronto, Canada, 13 October 1993.

McCain, T. A., J. Chilberg, and J. Wakshlag. "The Effect of Camera Angle on Source Credibility and Attraction." *Journal of Broadcasting* 21 (1977): 35–46.

McCloud, Scott. *Understanding Comics: The Invisible Art.* Northampton, MA: Kitchen Sink Press, 1993.

McCrone, John. "Quantum States of Mind." *New Scientist* (20 August 1994): 35–38.

McGinnies, E. "Emotionality and Perceptual Defense." *Psychological Review* 56 (1949): 244–251.

McLuhan, Marshall. *Understanding Media: The Extensions of Man.* New York: Signet, 1964.

Medalia, N. Z., and O. N. Larsen. "Diffusion and Belief in Collective Delusion: The Seattle Windshield Pitting Epidemic." *American Sociological Review* 23 (1958): 180–186.

Miedzian, Myriam. *Boys Will Be Boys.* New York: Doubleday Anchor Books, 1991.

Mehrabian, A. "Communication Without Words." *Psychology Today* 2 (1968), 51–52.

Meyerowitz, J. *No Sense of Place: The Impact of Electronic Media on Social Behavior.* New York: Oxford University Press, 1985.

Meyers, W. *The Image-Makers: Power and Persuasion on Madison Avenue.* New York: New York Times Book, 1984.

Michotte, Albert. *The Perception of Causality.* New York: Basic Books, 1963.

Miedzian, Myriam. *Boys Will Be Boys.* New York: Doubleday,1991.

Milavsky, J. Ronald, Ronald Kessler, Horst Stipp, and William S. Rubens. *Television and Aggression: the Results of a Panel Study.* New York: Academic Press, 1982.

Miller, Julie Ann. "Research Update: From the 1989 Meeting in Phoenix of the Society for Neuroscience." *Bioscience* 40 (February 1990): 87–89.

Millerson, G. *Effective TV Production.* New York: Hastings, 1976.

Mitchell, W. J. T. *Iconology: Image Text Ideology.* Chicago: University of Chicago Press, 1986.

———. *The Reconfigured Eye.* Cambridge, MA: MIT Press, 1992.

———. "When Is Seeing Believing?" *Scientific American* (February 1994): 68–69.

Moody, Kate. *Growing Up on Television.* New York: Times Books, 1980.

Moore, Timothy. "Subliminal Advertising: What You See Is What You Get." *Journal of Marketing* 46 (Spring 1982): 38-47.

Morgan, Michael, Justin Lewis, and Sut Jhally. "More Viewing, Less Knowledge." In *Triumph of the Image*, eds. Hamid Mowlana, George Gerbner, and Herbert Schiller. Boulder, CO: Westview, 1992, 216–233.

Morgan, Richard, and Dave Vadehra. "Reagan Leads Mondale in Ad Awareness Race." *Adweek*, 3 September 1984, 19.

Morreales, Joanne. *A New Beginning: A Textual Frame Analysis of the Political Campaign Film.* Albany, NY: State University of New York Press, 1991.

Munsterberg, Hugo. *The Film: A Psychological Study.* 1916. Reprint, New York: Arno Press, 1970.

Murray, John P., and Barbara Lonnborg. *Children and Television: A Primer for Parents.* Boys Town, NB: The Boys Town Center for the Study of Youth Development, n.d.

Murray, J. *Television and Youth: 25 Years of Research and Controversy.* Boys Town, NB: Boys Town Center for the Study of Youth Development, 1980.

Mussey, Dagmar. "Benetton, German Retailers Squabble." *Advertising Age*, 6 February 1995, 46.

Naisbitt, John, and Patricia Aburdene. "CEOs in New Society Will Be Visionaries." *Advertising Age*, 16 September 1985, 60.

National Commission on the Causes and Prevention of Violence. *To Establish Justice, To Insure Domestic Tranquility: Final Report of the National Commission on the Causes and Prevention of Violence.* Washington, DC: Government Printing Office, 1969.

National Institute of Mental Health. *Television and Behavior: Ten Years of Scientific Progress and Implications for the Eighties.* Rockville, MD: National Institute of Mental Health, 1982.

Neisser, Ulric. "The Processes of Vision." In *Image, Object and Illusion: Readings from Scientific American.* San Francisco: W. H. Freeman and Company, 1974, 4–11.

"The New Face of Television Violence." *Violence on Television: Special Report by the Editors of TV Guide.* New York: TV Guide, 1992, 6.

New York Times, 20 March 1991–3 September 1994.

Nichols, Bill. "Voice of Documentary." *Film Quarterly* 36 (1983): 34–48.

Nichols, Don. "Milk Marketing: Pet Project." *Incentive* 163, no. 11 (1989): 42–43, 75.

Nietzche, Frederich. *The Birth of Tragedy.* New York: Doubleday, 1956.

Nohrstedt, Stig A. "Ruling By Pooling." In *Triumph of the Image,* eds. Hamid Mowlana, George Gerbner, and Herbert Schiller. Boulder, CO: Westview, 1992, 118–127.

Ogilvy, David. *Ogilvy on Advertising.* New York: Vintage Books, 1983.

O'Grady, M. "Effect of Subliminal Pictorial Stimulation on Skin Resistance." *Perceptual and Motor Skills* 44, no. 3, pt. 2 (1977), 1,051–1,056.

Orban, G.A. "Processing of Moving Images in the Geniculocortical Pathway." *Visual Neuroscience,* eds. Jd. Pettigrew, K.J . Sanderson, and W. R. Levick. New York: Cambridge University Press, 1986, 121–144.

Orlando Sentinel Tribune, 14 February 1993.

Owsley, H. H., and C. M. Scotton. "The Conversational Expression of Power by Television Interviewers." *Journal of Social Psychology* 123 (August 1984): 261–271.

Papazian, Ed, ed. *TV Dimensions '93.* New York: Media Dynamics, 1994.

Patterson, Alex. *Rock Art Symbols .* Boulder, Colorado: Johnson Books, 1992.

Pearl, David, Lorraine Bouthilet, and Joyce Lazar, eds. *Television and Behavior: Ten Years of Scientific Progress and Implications for the Eighties.* Vol. II. Washington, DC: Government Printing Office, 1982.

Petersik, J. Timothy. "The Two-Process Disctinction in Apparent Motion." *Psychological Bulletin* 106 no. 1 (1989): 107–127.

Phillips, D. P. "Airplane Accidents, Murder and the Mass Media." *Social Forces* 58, no. 4 (1980): 1,001–1,024.

———. "The Influence of Suggestion on Suicide: Substantive and Theoretical Implications of the Werther Effect." *American Sociological Review* 39 (1974): 340–354.

———. "Suicide, Motor Vehicles and the Mass Media: Evidence Toward a Theory of Suggestion." *American Journal of Sociology* 84 (1979): 1,150–1,174.

Piaget. Jean. *The Child's Conception of Space.* New York: W. W. Norton, 1967.

Pierce, John P., et al. "Does Tobacco Advertising Target Young People to Start Smoking?" *Journal of the American Medical Association* 266, no. 22 (1991): 3,154–3,158.

Piggins, D., and R. D. Nichols."The Pink Room Effect: Tranquilization or Methodological Transgression?" *Atti della Fondazione Giorgio Ronchi* 37, no. 2 (1982): 281–286.

Pinker, Steven, ed. *Visual Cognition.* Cambridge, Massachusetts: MIT Press, 1985.

Pleck, Joseph. *The Myth of Masculinity.* Cambridge, MA: MIT Press, 1983.

Post, R. H. "Population Differences in Red and Green Color Vision Deficiency: A Review and A Query." *Social Biology* 29, no. 3–4 (1982): 299–315.

Postman, Neil. *Amusing Ourselves to Death.* New York: Penguin, 1985.

Pound, Ezra. "How to Read." *Literary Essays.* Norfolk, CT.: New Directions, 1954, 15–40.

Pratto, F., and J. A. Bargh. "Stereotyping Based on Apparently Individuating Information: Trait and Global Components of Sex Stereotypes Under Attention Overload." *Journal of Experimental and Social Psychology* 27 (1991): 26–47.

Pribram, Karl. *Languages of the Brain.* Monterey, CA: Wadsworth, 1977.

Prince, George M. "Synectics." In *Group Planning and Problem-Solving Methods in Engineering,* ed. Shirley A. Olsen. New York: John Wiley & Sons, 1982.

Profusek, Pamela, and David Rainey. "Effects of Baker-Miller Pink and Red on State Anxiety, Grip Strength and Motor Precision." *Perceptual and Motor Skills* 65, no. 3 (1987): 941–942.

Prothrow-Stith, Deborah. *Deadly Consequences.* New York: HarperCollins, 1991.

Pudovkin, Vsevolod I. *On Film Technique,* trans. Ivor Montagu. London: Vision Press, 1950.

Raff, Ulrich. "Visual Data Formatting." In *The Perception of Visual Information,* eds. William R. Hendee, and Peter N. T. Wells. New York: Springer-Verlag, 1993, 160–201.

Ramachandran, V., and S. Cobb, *Nature*, 373 (5 January 1995): 66–68.

Ramsaye, Terry. *A Million and One Nights*. 1926. Reprint, New York: Simon and Schuster, 1986.

Restak, Richard. *The Brain*. New York: Warner Books, 1979.

———. *The Mind*. New York: Bantam Books, 1988.

Rheingold, Howard. *Virtual Reality*. New York: Simon and Schuster, 1991.

Richards, J. W., and P. M. Fischer. "Smokescreen: How Tobacco Companies Market to Children." *World Smoking Health* 25 (1990), 12–14;

Richardson, Alan. *Mental Imagery*. New York: Springer, 1969.

Robbins, Curtis. "Visualizations of a Silent Voice: A Deaf Poet's View." In *Visual Communication*, eds. Judy Clark-Baca, Darrell Beauchamp and Roberts Braden. Blacksburg, VA: International Visual Literacy Association, 1992, 493–501.

Robertson, Patrick. *The Guinness Book of Movie Facts and Feats*. 4th ed. New York: Abbeville Press, 1991.

Robinson, M. J., and M. A. Sheehan. *Over the Wire and on TV: CBS and UPI in Campaign '80*. New York: Russell Sage Foundation, 1983.

Rogers, Stuart. "How a Publicity Blitz Ceated the Myth of Subliminal Advertising." *Public Relations Quarterly* (Winter 1992–1993): 12–16.

Rosenthal, N. E. "Antidepressant Effects of Light in Seasonal Affective Disorder." *American Journal of Psychiatry* 142 (1985):163–170.

Rubenstein, Eli A. "Television and Behavior: Research Conclusions of the 1982 NIMH Report and Their Policy Implications." *American Psychologist* (July 1983): 820–825.

Sacks, Oliver. *An Anthropologist on Mars*. New York: Vintage Books, 1995.

Salvaggio, J. *The Mass Media Election*. New York: Praeger, 1980.

Sargent, S. Stansfeld and Kenneth R. Stafford. *Basic Teachings of the Great Psychologists*. Rev. ed. New York: Dolphin Books, 1965.

Savan, Leslie. "Let's Face It" (November 27, 1990). In *The Sponsored Life*. Philadelphia: Temple University Press, 1994, 104.

Schacter, D. L. "Implicit Memory: History and Current Status." *Journal of Experimental Psychology: Learning, Memory and Cognition* 13, (1987): 501–518.

Schauss, Alexander. "Application of Behavioral Photobiology to Human Aggression: Baker-Miller Pink." *International Journal of Biosocial Research* 2 (1981):1–9.

———. "The Physiological Effect of Color on the Suppression of Human Aggression: Research on Baker-Miller Pink." *International Journal of Biosocial Research* 7, no. 2 (1985): 55–64.

Schiller, Herbert. "Manipulating Hearts and Minds." In *Triumph of the Image*, eds. Hamid Mowlana, George Gerbner, and Herbert Schiller. Boulder, CO: Westview, 1992, 23–29.

Schwartz, Tony. *The Responsive Chord*. New York: Anchor Books, 1974.

Seamon, J. J., N. Brody, and D. M. Kauff. "Affective Discrimination of Stimuli That Are Not Recognized: Effects of Shadowing, Masking and Cerebral Laterality." *Journal of Experimental Psychology: Learning, Memory and Cognition* 9 (1983): 544–555.

———. "Affective Discrimination of Stimuli That Are Not Recognized: II. Effect of Delay Between Study and Test," *Bulletin of the Psychonomic Society* 21 (1983): 187–189.

Secunda, Eugene. "Calvin Klein, Levi's Ads? Well, That's Show Business." *Advertising Age*, 9 October 1995, 14.

Sharp, Peter F., and Russel Philips. "Physiological Optics." In *The Perception of Visual Information*, eds. William R. Hendee and Peter N. T. Wells. New York: Springer-Verlag, 1993, 1–29.

Shapiro, Michael, and Daniel G. McDonald. "I'm Not a Real Doctor, But I Play One in Virtual Reality: Implications of Virtual Reality for Judgments about Reality." *Journal of Communication* 42, no. 4 (1992): 194–114.

Shervin, H. "Subliminal Perception and Dreaming." *Journal of Mind and Behavior* 7 nos. 2, 3 (1986): 379–395.

———. "Subliminal Perception and Repression." In *Repression and Dissociation: Implications for Personality Theory, Psychopathology and Health*, ed. J. P. Singer. Chicago: University of Chicago Press, 1990, 103–119.

Shervin, H., and L. Luborsky. "The Measurement of Preconscious Perception in Dreams and Images: An Investigation of the Poetzl Phenomenon." *Journal of Abnormal and Social Psychology* 58 (1958): 285–294.

Shirer, William. *Berlin Diary*. New York: Knopf, 1941.

Shneidman, Edwin. "Logic of Politics." In *Television and Human Behavior*, eds. Leon Arons and Mark May. New York: Appleton-Century-Crofts, 1963, 178–202.

Silverman, L. H., and J. Weinberger. "Mommy and I Are One: Implications for Psychotherapy." *American Psychologist* 40, (1985): 1296–1308.

Simonton, O. Carl, and Reid Henson. *The Healing Journey*. New York: Bantam Books, 1992.

Singer, J. L., and D. G. Singer. *Television, Imagination and Aggression: A Study of Preschoolers' Play*. Hillsdale, NJ: Lawrence Erlbaum, 1980.

Small, William J. "A Report—The Gulf War and Television News: Past, Future and Present." *Mass Comm Review* 19, nos. 1, 2 (1992): 3–13.

Smith, C. R. "Television News as Rhetoric." *Western Journal of Speech Communication* 41 (1977): 147–159.

Smith, Jeffrey, Paul Bell, and Marc Fusco. "The Influence of Color and Demand Characteristics on Muscle Strength and Affective Ratings of the Environment." *Journal of General Psychology* 113 (July 1986): 289–297.

Smith, Kirk H., and Martha Rogers. "Effectiveness of Subliminal Messages in Television Commercials." *Journal of Applied Psychology* 79, no. 6 (1994): 866–874.

Somers, Christina Hoff. *Who Stole Feminism?: How Women Have Betrayed Women*. New York: Simon & Schuster, 1994.

Speer, Albert. *Inside the Third Reich*. New York: Macmillan, 1970.

Star Tribune, 8 August 1994.

Stepheson, Joan. "Seeing Yellow." *Science Digest*, September 1986, 24.

"Store Owners Rip into Benetton." *Advertising Age*, 6 February 1995, 1.

Svetkey, Benjamin. "Bleak Chic." *Entertainment Weekly* No. 299, 3 November 1995, 32–36.

Swanberg, W. A. *Citizen Hearst*. New York: Charles Scribner's Sons, 1961.

Swerdlow, Joel L. "Quiet Miracles of the Brain." *National Geographic* 187, no. 6 (1995): 2– 41.

Talbot, Michael. *The Holographic Universe*. New York: HarperCollins, 1991.

Tan, Alexis. "Social Learning of Aggression from Television." In *Perspectives on Media Effects*, eds. Jennings Bryant and Dolf Zillmann. Hillsdale, NJ: Lawrence Erlbaum, 1986, 41–56.

Tannen, Deborah. *You Just Don't Understand: Women and Men in Conversation*. New York: Ballantine Books, 1990.

Tarroni, Elizabeth. "The Aesthetics of Television." In *Television: the Critical View*, ed. H. Newcomb. New York: Oxford University Press, 1979, 437–461.

Terr, Lenore. *Too Scared to Cry: Psychic Trauma in Childhood*. New York: Harper and Row, 1990.

Thomas, Margaret, Robert Norton, Elaine Lippincott, and Ronald Drabman. "Desensitization to Portrayals of Real-Life Aggression as a Function of Exposure to Television Violence." *Journal of Personality and Social Psychology* 35, no. 6 (1977): 450–458.

Thoreau, Henry David. *Walden.* New York: Amsco, n.d.

Tiemens, R. K. "Some Relationships of Camera Angle to Communicator Credibility." *Journal of Broadcasting* 14 (1969–1970): 483–490.

Tousigant, J. P., D. Hall, and E. F. Loftus. "Discrepancy Detection and Vulnerability to Misleading Post-Event Information." *Memory & Cognition* 14 (1986): 329–338.

Trent, Judith. "Presidential Surfacing: the Ritualistic and Crucial First Act." *Communication Monographs* 45 (November 1978): 218–292.

Truffaut, François. *Essays on Chaplin,* ed. and trans. Jean Bodon. New Haven, CT: University of New Haven Press, 1985.

Tye, J. B., K. E. Warner, and S. A. Glantz. "Tobacco Advertising and Consumption: Evidence of a Causal Relationship." *Journal of Public Health Policy* 8 (1987): 492–508.

USA Today, 29 December 1993.

USA Weekend, 2–4 June 1995.

U.S. Department of Defense. Office of the Inspector General. *Tailhook 91.* Washington, DC: Government Printing Office, 1992.

U.S. Public Health Service. Office of the Surgeon General. Center for Chronic Disease Prevention and Health Promotion. Office on Smoking and Health. *Reducing the Health Consequences of Smoking: 25 Years of Progress: A Report of the Surgeon General.* Rockville, MD: U.S. Department of Health and Human Services, 1989.

U.S. Public Health Service. Office of the Surgeon General. Scientific Advisory Committee of Television and Social Behavior. *Television and Growing Up: the Impact of Television Violence: Report to the Surgeon General.* Washington, DC: Government Printing Office, 1972.

"Virtual Reality." *Business Week,* 5 October 1992, 97.

Vestica, Gregory. *Fall From Glory: The Men Who Sank the U.S. Navy.* New York: Simon & Schuster, 1995.

Voelker, Rebecca. "Young People May Face Huge Tobacco Toll." *Journal of the American Medical Association* 274 (19 July 1995): 203.

VonOech, Roger. *A Whack on the Side of the Head.* New York: Warner Books, 1990.

Von Franz, M.-L. "The Process of Individuation." In *Man and His Symbols*, ed. Carl Jung. New York: Dell, 1964, 230–235.

Von Hornbostel, Erich. "The Unity of the Senses." In *A Source Book of Gestalt Psychology*, ed. Willis D. Ellis. London: Routledge & Kegan Paul Ltd., 1938, 210–216.

Waite, Bradley, Marc Hillbrand and Hilliard Foster. "Reduction of Aggressive Behavior After Removal of Music Television." *Hospital and Community Psychiatry* 43, no. 2, (1992): 173.

Walker, Don. "Media Literacy: The Vatican Echoes McLuhan." *America*, 6 March 1993, 4–5.

Wall Street Journal, 18 November 1980–13 October 1993.

Walsh, Lynn, Ramses Toma, Richard Tuveson, and Lydia Sondhi. "Color Preference and Food Choice Among Children." *Journal of Psychology* 124, no. 6 (1990): 645–653.

Washington Post, 1 May 1992.

Watt, Jr., James H., and Robert Krull. "An Examination of Three Models of Television Viewing and Aggression." *Human Communication Research* 3, no. 2 (1977): 99–112.

Weeks, J. "Patriot Games: What Did We See on Desert Storm TV?" *Columbia Journalism Review* (July/August 1992): 13–14.

Wegner, D. M., G. Coulton, and R. Wenzlaff. "The Transparency of Denial: Briefing in the Debriefing Paradigm." *Journal of Personality and Social Psychology* 49 (1985): 338–346.

Welles, Peter. "Problems and Prospects in the Perception of Visual Information." In *The Perception of Visual Information*, eds. William R. Hendee and Peter N. T. Wells. New York: Springer-Verlag, 1993, 335–343.

Wertheimer, Max. "The General Theoretical Situation." In *A Source Book of Gestalt Psychology*, ed. Willis D. Ellis. London: Routledge & Kegan Paul Ltd., 1938, 12–16.

Whalen, Jeanne. "U.S. Ads Take More Restrained Tone." *Advertising Age*, 6 February 1995, 46.

White, Randall. "Visual Thinking in the Ice Age." *Scientific American* (July 1989): 92–99.

Wilson, W. R. "Feeling More Than We Know: Exposure Effects Without Learning." *Journal of Personality and Social Psychology* 37 (1979): 811–821.

Wilson, Wayne and Randy Hunter. "Movie-inspired Violence." *Psychological Reports* 53, no. 2 (1983): 435–441.

Wiltschko, Wolfgang, Ursula Munro, Hugh Ford, and Roswitha Wiltschko. "Red Light Disrupts Magnetic Orientation of Migratory Birds." *Nature* 364, no. 6437 (1993): 525–527.

Wood, Peter. "Television as Dream." *Television as a Cultural Force*, ed. Douglass Cater and Richard Adler. In *Television: the Critical View*, ed. H. Newcomb. New York: Oxford University Press, 1979, 521–523.

Wolfe, Jeremy. "Hidden Visual Processes." *Scientific American* 248, no. 2 (1983): 94–103.

Wolf, Naomi. *The Beauty Myth: How Images of Beauty Are Used Against Women.* New York: Doubleday Anchor, 1991.

Wollen, Peter. *Readings and Writings: Semiotic Counter-Strategies.* London: Thetford Press, 1982.

Zajonc, R. B. "Attitudinal Effects of Mere Exposure." *Journal of Personality and Social Psychology* 9 (1968): 52–80.

———. "Feeling and Thinking: Preferences Need No Inferences." *American Psychologist* 35 (1980): 151–175.

———. "The Interaction of Affect and Cognition." In *Approaches to Emotion*, eds., K. R. Scherer, and P. Eckman. Hillsdale, NJ: Lawrence Earlbaum, 1984, 239–245.

———. "On the Primacy of Affect." *American Psychologist,* 39 (1984): 117–123.

Zeki, Semir. "The Visual Image in Mind and Brain." *Scientific American* (September 1992): 69–76.

Zeman, Z. A. B. *Nazi Propaganda.* London: Oxford University Press, 1973.

Zimbardo, Philip. "The Human Choice: Individuation, Reason and Order Versus Deindividuation, Impulse and Chaos." *Nebraska Symposium on Motivation 1969*, University of Nebraska Press, 17, 237–307.

Zimmerman, Jean. *Tailspin.* New York: Doubleday, 1995.

Audiovisual Media

"Adam Smith," ed. Adam Smith, Educational Broadcasting Corporation, Boston: WBUR, 6 January 1994.

Gerry Spence, "Larry King Live," interview by Larry King, Cable News Network, 26 September 1995.

"Illusions of News," *The Public Mind: Image and Reality in America with Bill Moyers.* Alvin H. Perlmutter, Inc. and Public Affairs Television, 1989.

Mike Dornheim. "Wings," interview, Discovery Channel, 1992.

The Mind, Parts 1–9. PBS.

Ould, Patricia. "Increase the Peace" Panel Member Presentation, Sponsored by City of Peabody, MA, in cooperation with Essex County District Attorney Kevin Burke, State Representative Sally Kerans, and others. Cablevision Cablecast, 16 June 1993.

Professor Koryo Miura. "Beyond 2000," interview, Beyond Productions Pty Ltd. in association with the Discovery Channel, 1993.

When the Lion Roars. Metro Goldwyn Mayer, Hollywood CA, 1992, filmstrip.

INDEX